MEMORY

OF THE

WORLD

MEMORY OF THE WORLD

Published jointly by the United Nations Educational,
Scientific and Cultural Organization (UNESCO),
7, place de Fontenoy, 75352 Paris 07 SP, France, and
HarperCollins Publishers Ltd., Westerhill Road,
Bishopbriggs, Glasgow G64 2QT, United Kingdom

Text © UNESCO 2012
Maps © Collins Bartholomew Ltd 2012
Photographs © as per credits on page 606-607

First edition 2012

ISBN (UNESCO) 978-92-3-104237-9
ISBN (HarperCollins) 978-0-00-748279-5

For more information, please contact:
Memory of the World Programme
1, rue Miollis
75732 Paris Cedex 15
Tel: +(331) 45 68 44 97

www.unesco.org/webworld/en/mow

Printed and bound in Thailand

www.unesco.org/publishing

Collins

MEMORY
OF THE
WORLD

United Nations
Educational, Scientific and
Cultural Organization

Memory of
the World

Contents

Foreword .. 9

The emotional power of documents 11

World map and Memory of the World Register 12

The book is ordered by the date the documents were
recorded. Each entry has a timeline at the top of the page.

The Hittite cuneiform tablets from Bogazköy 24

Rigveda .. 26

Papyrus Erzherzog Rainer .. 28

Commemorative stelae of Nahr el-Kalb,
Mount Lebanon .. 30

The Phoenician alphabet ... 32

Huang Di Nei Jing 黄帝内经 (Yellow Emperor's
Inner Canon) ... 35

Ancient Naxi Dongba literature manuscripts 36

Mashtots Matenadaran ancient
manuscripts collection ... 38

Saiva manuscripts in Pondicherry 40

Codex Argenteus – the 'Silver Bible' 42

Codex Purpureus Beratinus 44

Vienna Dioscurides .. 46

Earliest Islamic (Kufic) inscription 48

Holy Koran Mushaf of Othman 50

Lucca's historical diocesan archives 52

The Book of Kells .. 54

Laghukālacakratantrarājatikā (Vimalaprabhā) 59

The collection of the Al-Biruni Institute
of Oriental Studies .. 60

Philippine Paleographs (Hanunoo, Buid,
Tagbanua and Pala'wan) .. 61

Georgian Byzantine manuscripts 62

Deeds of sultans and princes 65

Illuminated manuscripts from the Ottonian
period produced in the monastery of Reichenau
(Lake Constance) .. 66

Enina Apostolos, Old Bulgarian Cyrillic manuscript
(fragment) of the 11th century 68

Kandilli Observatory and Earthquake Research
Institute manuscripts .. 70

Codex Suprasliensis ... 71

The works of Ibn Sina in the Süleymaniye
Manuscript Library .. 72

Al-Tafhim li Awa'il Sana'at al-Tanjim 76

Ostromir Gospel (1056–1057) 78

Bayeux Tapestry ... 80

Archangel Gospel of 1092 ... 83

Illuminated codices from the library of the Bratislava
Chapter House .. 84

Medieval manuscripts on medicine and pharmacy 86

The Arnamagnæan manuscript collection 87

Miroslav Gospel – manuscript from 1180 90

Tabula Peutingeriana ... 92

Song of the Nibelungs, a heroic poem from
medieval Europe ... 94

Magna Carta, issued in 1215 96

Printing woodblocks of the Tripitaka Koreana 98

MS. GKS 4 2°, vol. I–III, Biblia Latina. Commonly
called 'The Hamburg Bible' 100

Hereford Mappa Mundi .. 102

The King Ram Khamhaeng inscription 104

Library Ets Haim–Livraria Montezinos 108

The manuscript of Ubayd Zakoni's Kulliyat and
Hafez Sherozi's Gazalliyt .. 110

Collection of medieval manuscripts of the
Czech Reformation .. 112

The Deed For Endowment: Rab' i-Rashidi
(Rab i-Rashidi Endowment) 114

Batu Bersurat, Terengganu (Inscribed Stone
of Terengganu) .. 116

La Galigo .. 117

Persian illustrated and illuminated manuscripts 118

Collection of Nezami's Panj Ganj 120

Baegun hwasang chorok buljo jikji simche
yojeol (vol. II) .. 122

Khitrovo Gospel ... 123

The Annals of the Joseon dynasty 124

Kitab al-ibar, wa diwan al-mobtadae wa al-khabar 125

Slavonic publications in Cyrillic script of the
15th century ... 126

Treasures from National Archives and Library
organizations ... 127

Corpo Cronológico (collection of manuscripts on
the Portuguese discoveries) 128

Radziwills' Archives and Niasvizh (Nieśwież)
Library collection ... 130

Collection of Gothic architectural drawings 134

'Bayasanghori Shâhnâmeh' (Prince Bayasanghor's 'Book of the Kings')137

Stone stele records of royal examinations of the Le and Mac dynasties (1442–1779).......................138

The Hunminjeongum manuscript141

The Malatesta Novello Library...................................142

The 42-line Gutenberg Bible, printed on vellum146

Bibliotheca Corviniana ...149

Library of the Cistercian Abbey of Clairvaux at the time of Pierre de Virey (1472)150

Mainz Psalter at the Austrian National Library.............153

Santa Fe Capitulations..154

Treaty of Tordesillas ...156

Sound Toll Registers ...158

Letter from Pêro Vaz de Caminha159

Archives Insolvente Boedelskamer Antwerpen.............160

Universalis cosmographia secundum Ptholomaei traditionem et Americi Vespucii aliorumque Lustrationes ...162

Tabula Hungariae ..164

Beatus Rhenanus Library...165

Sixteenth to eighteenth century pictographs from 'Maps, drawings and illustrations' Archives of Mexico ..168

Negros y Esclavos archives ...169

Collection of Mexican codices172

Colección de lenguas indígenas....................................174

Bašagic collection of Islamic manuscripts176

Collection of the Center of Documentation and Investigation of the Ashkenazi community in Mexico ...179

Nicolaus Copernicus' masterpiece 'De revolutionibus libri sex'....................................180

Codices from the Oaxaca Valley183

Châtelet de Paris banner register from the reign of Francis I (National Archives Y9, France)..............184

Collection of the manuscripts of Khoja Ahmed Yasawi ...186

American colonial music: a sample of its documentary richness ...188

Business archives of the Officina Plantiniana190

Documentary fonds of Royal Audiencia Court of La Plata (RALP) ...191

The Confederation of Warsaw of 28th of January 1573 ..194

Tarikh-e-Khandan-e-Timuriyah196

Administrative documents of Astan-e Quds Razavi in the Safavid era ..198

Ben Cao Gang Mu 本草纲目 (Compendium of Materia Medica)...200

Tolstoy's personal library and manuscripts, photo and film collection .. 202

Jesuits of America ... 206

Codex Techaloyan de Cuajimalpaz 208

Documentary heritage of enslaved peoples of the Caribbean ... 209

El Primer Nueva Corónica y Buen Gobierno 212

Uigwe: The royal protocols of the court of Joseon dynasty... 213

Archives of the Dutch East India Company.................. 214

Donguibogam: 'Principles and Practice of Eastern Medicine'...218

Sejarah Melayu (The Malay Annals)219

Dutch West India Company (Westindische Compagnie) archives... 220

The IAS Tamil medical manuscript collection 222

Quebec Seminary collection, 1623–1800 (17th–19th centuries)... 224

Seungjeongwon Ilgi, the diaries of the royal secretariat ...227

Book for the Baptism of Slaves (1636-1670).............. 228

Mining maps and plans of the Main Chamber – Count Office in Banská Štiavnica 230

Collection of 526 prints of university theses from 1637 to 1754 ..2

Biblioteca Palafoxiana ...233

Hikayat Hang Tuah ...236

Records of the Qing's Grand Secretariat....................239

Lu.'Altan Tobchi': Golden History written in 1651........ 240

The Atlas Blaeu–Van der Hem.....................................242

Golden Lists of the Qing dynasty imperial examination.. 244

Letters from and to Gottfried Wilhelm Leibniz.......... 246

Archives of the Danish overseas trading companies ... 248

Hudson's Bay Company archival records 250

Arquivos dos Dembos / Ndembu archives.................253

Woodblocks of the Nguyễn dynasty.............................254

Records of the French occupation of Mauritius..........256

Privateering and the international relations of the
Regency of Tunis in the 18th and 19th centuries..........258

Collection of 18th-century maps of the
Russian empire...260

Newspaper collections, Russian Federation 264

Collection of Arabic manuscripts and books.............. 266

Jean-Jacques Rousseau, Geneva and
Neuchâtel collections ... 269

Stockholm City Planning Committee archives............ 270

Emanuel Swedenborg collection..................................272

Archives of the Middelburgsche Commercie
Compagnie..274

Linné collection ..276

Mongolian Tanjur ...279

Qing dynasty Yangshi Lei archives 280

The literary estate of Goethe in the Goethe and
Schiller Archives...285

Ilseongnok: Records of Daily Reflections.................... 286

The Endeavour journal of James Cook......................... 288

National Education Commission archives.................. 290

Documentary heritage of the Viceroyalty of the
Río de la Plata .. 292

Colombeia: Generalissimo Francisco
de Miranda's archives ... 294

The Convict Records of Australia................................. 298

Original Declaration of the Rights of Man and
of the Citizen (1789–1791)... 302

Introduction of the decimal metric system,
1790–1837 ... 306

The Leprosy Archives of Bergen 308

The Vienna City Library Schubert collection 311

The masterpieces of Fryderyk Chopin..........................314

Kinder- und Hausmärchen (Children's and
Household Tales) ... 317

General Archive of the Nation: Writings
of The Liberator Simón Bolívar 320

The Søren Kierkegaard archives323

Final document of the Congress of Vienna324

Registry of Slaves of the British Caribbean
1817–1834 ..326

Csoma archive of the Library of the Hungarian
Academy of Sciences ..328

The Bleek collection..329

Ludwig van Beethoven: Symphony no. 9,
D minor, op. 125 ..332

Royal archives (1824–1897)..334

Catecismo corticu pa uso di catolicanan di Curaçao
(first catechism written in Papiamentu language)336

Manuscripts and correspondence
of Hans Christian Andersen ... 340

Records of the Indian indentured labourers.................344

Farquharson's Journal..345

Epigraphic archives of Wat Pho....................................346

János Bolyai: Appendix, Scientiam Spatii absolute
veram exhibens..348

Brahms collection ... 350

Memory of the Suez Canal ...352

The Treaty of Waitangi ..356

The Emperor's collection ..358

Alfred Nobel family archives .. 360

Colonial archives, Benin ...362

The A.E. Nordenskiöld Collection 364

'José Martí Pérez' fonds .. 366

Archival documents of King Chulalongkorn's
transformation of Siam (1868–1910) 369

Arnold Schönberg estate .. 370

Jinnah papers (Quaid-i-Azam)372

Dainu Skapis – Cabinet of folksongs............................374

Silver men: West Indian labourers at the
Panama Canal..376

Henrik Ibsen: A Doll's House ..379

Nikola Tesla's Archive.. 380

Benz patent of 1886..382

Correspondence of the late Sultan of Kedah
(1882–1943)..385

The Historical Collections (1889–1955) of
St Petersburg Phonogram Archives............................. 386

German records of the National Archives.................. 388

Manifesto of the Queensland Labour Party
to the people of Queensland...391

The 1893 Women's Suffrage Petition 394

Early cylinder recordings of the world's musical
traditions (1893–1952)..397

Lumière films ... 398

Fonds of the Afrique occidentale française (AOF)402

Historic ethnographic recordings (1898–1951)
at the British Library..404

The historical collections (1899–1950) of the Vienna
Phonogrammarchiv..406

Letter journals of Hendrik Witbooi408

Russian posters of the end of the 19th and
early 20th centuries ...412

Collection of Latin American photographs
of the 19th century...415

Presidential papers of Manuel L. Quezon....................416

Sakubei Yamamoto collection ..418

The Story of the Kelly Gang (1906) 422

Desmet collection..425

Roald Amundsen's South Pole Expedition
(1910–1912) .. 428

Collection of Jewish musical folklore (1912–1947)........ 430

Original records of Carlos Gardel –
Horacio Loriente collection (1913–1935).......................432

Archives of the International Prisoners of War
Agency, 1914–1923..434

The Battle of the Somme .. 438

Collection of Russian, Ukrainian and Belarusian
émigré periodicals 1918–1945 442

League of Nations archives 1919–1946443

Constantine collection...446

First flight across the South Atlantic Ocean in 1922.... 449

Kalman Tihanyi's 1926 patent application
'Radioskop'..452

Metropolis – Sicherungsstück Nr. 1: Negative of the
restored and reconstructed version (2001)...................454

C.L.R. James collection ..456

Documentary heritage on the resistance and
struggle for human rights in the Dominican Republic,
1930–1961 ..457

Sir William Arthur Lewis papers458

Thor Heyerdahl archives..461

Ingmar Bergman archives .. 464

The Wizard of Oz (Victor Fleming, 1939), produced
by Metro Goldwyn-Mayer .. 466

Warsaw Ghetto archives (Emanuel Ringelblum
archives)... 470

Astrid Lindgren archives...474

The Appeal of 18 June 1940..476

Diaries of Anne Frank...478

Archive of Warsaw Reconstruction Office 482

Archives of the Literary Institute in Paris
(1946–2000) ... 486

Federal Archives fonds..488

Audiovisual documents of the international
antinuclear movement 'Nevada-Semipalatinsk'..........490

UNRWA photo and film archives
of Palestinian refugees ... 492

Los Olvidados .. 494

Nita Barrow collection.. 496

The Archives of Terror.. 498

John Marshall Ju/'hoan bushman film and
video collection, 1950–2000 ...500

Traditional music sound archives.................................. 502

Neighbours, animated, directed and produced
by Norman McLaren in 1952 504

José Maceda collection ...505

Derek Walcott collection... 508

The Family of Man...510

Christopher Okigbo collection512

Eric Williams collection ..514

The Mabo case manuscripts...516

Original negative of the Noticiero ICAIC
Latinoamericano...519

Construction and fall of the Berlin Wall and the
Two-Plus-Four-Treaty of 1990 520

Criminal Court Case No. 253/1963 (The State versus
N. Mandela and Others)..525

Network of information and counter information
on the military regime in Brazil (1964–1985)527

First Byurakan Survey (FBS or Markarian survey).........528

Aral Sea archival fonds... 530

Landsat Program records: Multispectral Scanner
(MSS) sensors ..532

Human Rights Archive of Chile.....................................538

Tuol Sleng Genocide Museum archives...................... 540

Human rights documentary heritage, 1976–1983.........543

Liberation Struggle Living Archive Collection..............544

Human rights documentary heritage, 1980546

Twenty-One demands, Gdańsk, August 1980..............549

National Literacy Crusade ..552

Radio broadcast of the Philippine People Power
Revolution...554

The Baltic Way – Human chain linking three states
in their drive for freedom .. 556

Country by country index ...562

Index of inscriptions...570

Contact information ...583

Acknowledgements and photo credits606

Foreword

by Irina Bokova
Director-General of UNESCO

©UNESCO

UNESCO launched the *Memory of the World* Programme in 1992 to protect and promote the world's documentary heritage through preservation and access – access to encourage protection, and preservation to ensure access.

This vision was vindicated a few months later, when on 25 August 1992, 1.5 million books in the Bosnia National and University Library in Sarajevo were destroyed. With this, a chapter of the history of humanity vanished. Too much of our heritage is lost like this in the heat of conflicts and through the twists and turns of history. Too much also lies hidden and inaccessible in libraries, museums and archives. This documentary heritage carries the memory of human experience. It is a vehicle for identity and a wellspring of knowledge and wisdom. For twenty years, UNESCO has worked to capture and to share this wealth for the benefit of all.

The UNESCO *Memory of the World Registry* contains today 245 documentary items from all parts of the world – from clay tablets, manuscripts and films to photographs, maps and web pages. This Register is our flagship to preserve, raise awareness and promote access to the documentary treasures of humanity. Preserving this heritage is important for maintaining the cultural heritage and identity of all societies. It safeguards our memories as a force shaping us as social beings in a common humanity.

The Memory of the World encourages every country to establish a national register and propose items for the international register. Heritage can be recorded on any of the carriers used to safeguard memories. These range from listings of archives relating to historical figures, such as Nelson Mandela and Alfred Nobel, to major historical events, voyages of exploration that have transformed the world, and the records of scientific discoveries and anthropological recordings. The scope is as vast, indeed, as is human experience.

Anne Frank's *Diaries* or the *Epigraphic Archives of Wat Pho* need little explanation today. However, other items on the Register, such as the *Sakubei Yamamoto collection* and the *1824-1897 Royal Archives* of Madagascar, may be less well-known but are no less emblematic of human ingenuity.

This book reveals this heritage in all of its diversity. For twenty years, the Memory of the World programme has gone from strength to strength. We must now take it ever further – by increasing nominations from all countries and by raising the visibility of preserving sources of knowledge of outstanding significance. Memory of the World is coming of age at a time when preserving our documentary heritage is more important than ever.

Irina Bokova

The emotional power of documents

Roslyn Russell PhD
Chair, International Advisory Committee
UNESCO Memory of the World Programme

Among the 245 inscriptions on the UNESCO Memory of the World Register is the *Tuol Sleng Genocide Museum archives* from Cambodia. One photograph in the archives shows a young mother cradling a baby. It is an image that brings to mind countless others of the same subject – a mother and child – especially images of the Madonna and the Christ Child, the essence of serenity and spiritual grace.

But learning of the fate that met this particular mother and child can evoke an almost unbearable pain in the viewer – for these two individuals, after having been meticulously documented in this photograph, were taken out and killed, as were the other subjects of the photographs in the *Tuol Sleng Genocide Museum archives*. These documents form a historical record, to be sure, but they also deliver a powerful emotional charge – and remind us of things that never should be forgotten, or repeated.

World significance, provenance and authenticity, and rarity and uniqueness are key values when assessing the suitability of a nomination of documentary heritage for inscription on the UNESCO Memory of the World Register. However, we must never forget the reasons why documents are so important to us, and why we believe so passionately in their preservation. The historical evidence that documents convey is one reason; others are the beauty and craftsmanship, or the technical innovations some documents display. The capacity of documents to engage our emotions and connect us to people and events in the past is another.

Archivists, librarians and museum curators who work with collections relating to Indigenous people can testify to the powerful emotions that flow when these people find their families mentioned in documents, or see photographs or film footage of their ancestors, or hear recordings of voices speaking their language.

Holy books and writings can also evoke strong emotional responses in members of particular faith systems. For a believer, a document associated with a saint or a prophet is not just a physical object; it possesses a spiritual power over and above its historical significance, or its value as an original, rare or unique item.

The popularity of exhibitions of documents indicates how compelling these can be in connecting people with the past. An exhibition curator explains why visitors flock to see displays of letters by writers, artists, scientists, philosophers, inventors, and political figures: 'We see the writers' words directly, unfiltered. The manuscripts give a sense of the authors' daily lives, friendships, concerns and ambitions, their work and their leisure.' Original music manuscripts can have the same emotional power, as the viewer sees the erasures, the corrections and the resolutions that lie behind a finished score. Even the pen strokes can convey the passion and intensity of composition. There are few objects of material culture that are more imbued with the personality of their originators than documents such as these.

It is the task of the UNESCO Memory of the World Programme to ensure that future generations will be able to access these documents and experience their emotional power, as well as to learn about the historical memories that they convey, or appreciate their beauty and craftsmanship.

Memory of the World Register

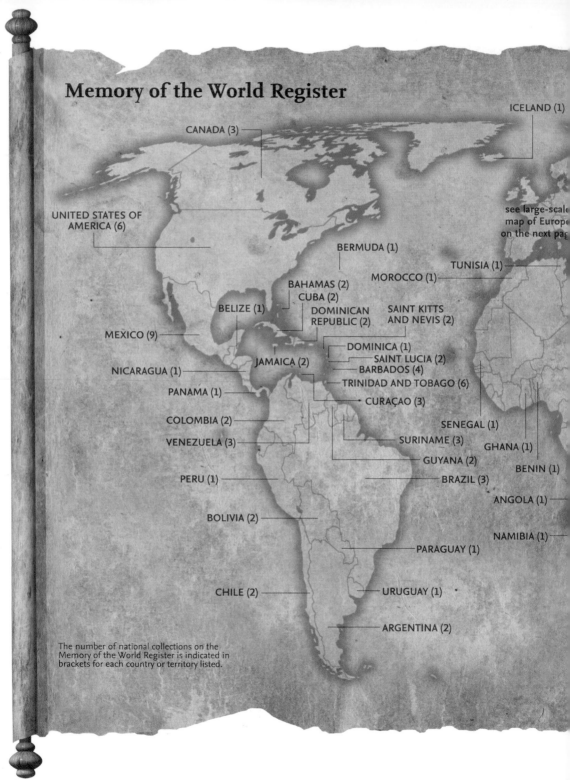

ICELAND (1)

CANADA (3)

UNITED STATES OF
AMERICA (6)

see large-scale
map of Europe
on the next page

BERMUDA (1)

TUNISIA (1)

MOROCCO (1)

BAHAMAS (2)

CUBA (2)

BELIZE (1)

DOMINICAN
REPUBLIC (2)

SAINT KITTS
AND NEVIS (2)

MEXICO (9)

DOMINICA (1)

SAINT LUCIA (2)

JAMAICA (2)

BARBADOS (4)

NICARAGUA (1)

TRINIDAD AND TOBAGO (6)

PANAMA (1)

CURAÇAO (3)

COLOMBIA (2)

SENEGAL (1)

VENEZUELA (3)

SURINAME (3)

GHANA (1)

GUYANA (2)

BENIN (1)

PERU (1)

BRAZIL (3)

ANGOLA (1)

BOLIVIA (2)

NAMIBIA (1)

PARAGUAY (1)

CHILE (2)

URUGUAY (1)

ARGENTINA (2)

The number of national collections on the
Memory of the World Register is indicated in
brackets for each country or territory listed.

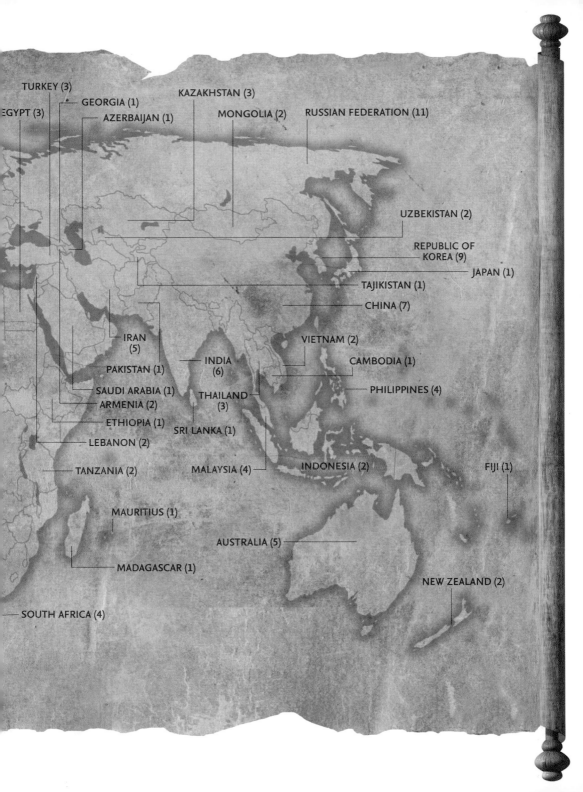

TURKEY (3)

GEORGIA (1)

EGYPT (3)

AZERBAIJAN (1)

KAZAKHSTAN (3)

MONGOLIA (2)

RUSSIAN FEDERATION (11)

UZBEKISTAN (2)

REPUBLIC OF KOREA (9)

JAPAN (1)

TAJIKISTAN (1)

CHINA (7)

VIETNAM (2)

IRAN (5)

INDIA (6)

CAMBODIA (1)

PAKISTAN (1)

PHILIPPINES (4)

SAUDI ARABIA (1)

THAILAND (3)

ARMENIA (2)

ETHIOPIA (1)

SRI LANKA (1)

LEBANON (2)

TANZANIA (2)

MALAYSIA (4)

INDONESIA (2)

FIJI (1)

MAURITIUS (1)

AUSTRALIA (5)

MADAGASCAR (1)

NEW ZEALAND (2)

SOUTH AFRICA (4)

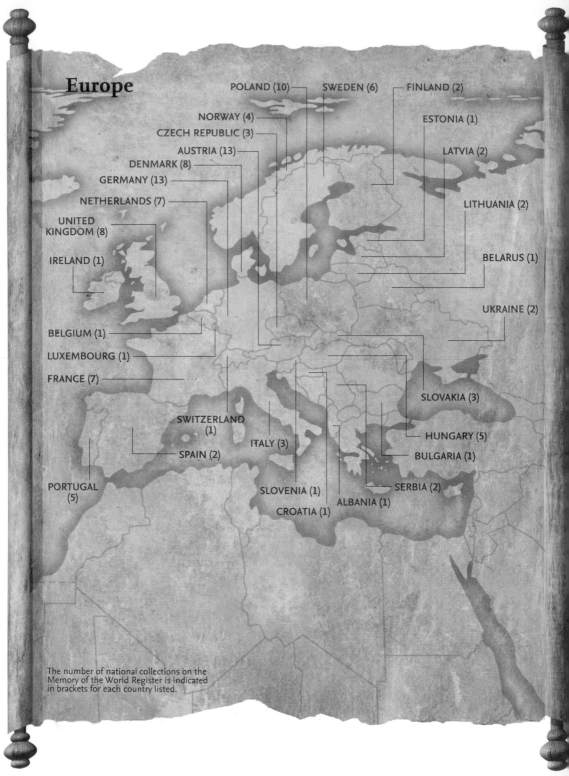

Europe

POLAND (10) SWEDEN (6) FINLAND (2)

NORWAY (4)

ESTONIA (1)

CZECH REPUBLIC (3)

LATVIA (2)

AUSTRIA (13)

DENMARK (8)

GERMANY (13)

LITHUANIA (2)

NETHERLANDS (7)

UNITED
KINGDOM (8)

BELARUS (1)

IRELAND (1)

UKRAINE (2)

BELGIUM (1)

LUXEMBOURG (1)

FRANCE (7)

SLOVAKIA (3)

SWITZERLAND
(1)

HUNGARY (5)

ITALY (3)

BULGARIA (1)

SPAIN (2)

SERBIA (2)

PORTUGAL
(5)

SLOVENIA (1)

ALBANIA (1)

CROATIA (1)

The number of national collections on the
Memory of the World Register is indicated
in brackets for each country listed.

Memory of the World Register

Albania
Codex Purpureus Beratinus......................................44

Angola
Arquivos dos Dembos / Ndembu archives*........................ 253

Argentina
Documentary heritage of the Viceroyalty of the Río
de la Plata ..292

Human rights documentary heritage, 1976–1983 543

Armenia
Mashtots Matenadaran ancient manuscripts
collection ..38

First Byurakan Survey (FBS or Markarian survey)............... 528

Australia
The Endeavour journal of James Cook288

The Convict Records of Australia................................298

Manifesto of the Queensland Labour Party to the people
of Queensland... 391

The Story of the Kelly Gang (1906).........................422

The Mabo case manuscripts .. 516

Austria
Papyrus Erzherzog Rainer......................................28

Tabula Peutingeriana ...92

Vienna Dioscurides..46

Collection of Gothic architectural drawings...................... 134

Bibliotheca Corviniana*149

Mainz Psalter at the Austrian National Library153

Tabula Hungariae*..164

The Atlas Blaeu–Van der Hem 242

The Vienna City Library Schubert collection311

Final document of the Congress of Vienna324

Brahms collection... 350

Arnold Schönberg estate370

The historical collections (1899–1950) of the Vienna
Phonogrammarchiv..406

Azerbaijan
Medieval manuscripts on medicine and pharmacy86

Bahamas
Registry of Slaves of the British Caribbean
1817–1834*..326

Farquharson's Journal .. 345

Barbados
Documentary heritage of enslaved peoples of the
Caribbean ..209

Silver men: West Indian labourers at the Panama
Canal*.. 376

Federal Archives fonds..488

Nita Barrow collection496

Belarus
Radziwills' Archives and Niasvizh (Nieśwież) Library
collection*.. 130

Belgium
Bibliotheca Corviniana*149

Archives Insolvente Boedelskamer Antwerpen.....................160

Business archives of the Officina Plantiniana190

Belize
Registry of Slaves of the British Caribbean
1817–1834*..326

Benin
Colonial archives, Benin......................................362

Bermuda
Registry of Slaves of the British Caribbean
1817–1834*..326

Bolivia
American colonial music: a sample of its documentary
richness*...188

Documentary fonds of Royal Audiencia Court of
La Plata (RALP) .. 191

Brazil
Dutch West India Company (Westindische Compagnie)
archives*...220

The Emperor's collection 358

Network of information and counter information
on the military regime in Brazil (1964–1985)...................... 527

Bulgaria

Enina Apostolos, Old Bulgarian Cyrillic manuscript (fragment) of the 11th century ...68

Cambodia

Tuol Sleng Genocide Museum archives540

Canada

Quebec Seminary collection, 1623–1800 (17th–19th centuries) ...224

Hudson's Bay Company archival records250

Neighbours, animated, directed and produced by Norman McLaren in 1952 ...504

Chile

Jesuits of America ..206

Human Rights Archive of Chile ..538

China

Huang Di Nei Jing 黄帝内经 (Yellow Emperor's Inner Canon) .. 35

Ancient Naxi Dongba literature manuscripts36

Ben Cao Gang Mu 本草纲目 (Compendium of Materia Medica) ...200

Records of the Qing's Grand Secretariat239

Golden Lists of the Qing dynasty imperial examination244

Qing dynasty Yangshi Lei archives280

Traditional music sound archives ...502

Colombia

Negros y Esclavos archives ..169

*American colonial music: a sample of its documentary richness** ..188

Croatia

*Tabula Hungariae** ...164

Cuba

'José Martí Pérez' fonds ...366

Original negative of the Noticiero ICAIC Latinoamericano .. 519

Curaçao

*Archives of the Middelburgsche Commercie Compagnie** ...274

*Dutch West India Company (Westindische Compagnie) archives**220

Catecismo corticu pa uso di catolicanan di Curaçao (first catechism written in Papiamentu language)336

Czech Republic

Collection of medieval manuscripts of the Czech Reformation ...112

Collection of 526 prints of university theses from 1637 to 1754 ... 232

Collection of Russian, Ukrainian and Belarusian émigré periodicals 1918–1945 ..442

Denmark

*The Arnamagnæan manuscript collection** 87

MS. GKS 4 2°, vol. I–III, Biblia Latina. Commonly called 'The Hamburg Bible'. ...100

Sound Toll Registers ... 158

El Primer Nueva Corónica y Buen Gobierno 212

Archives of the Danish overseas trading companies248

Linné collection ... 276

The Søren Kierkegaard archives .. 323

Manuscripts and correspondence of Hans Christian Andersen ...340

Dominica

*Registry of Slaves of the British Caribbean 1817–1834** ..326

Dominican Republic

Book for the Baptism of Slaves (1636-1670)228

Documentary heritage on the resistance and struggle for human rights in the Dominican Republic, 1930–1961 .. 457

Egypt

Deeds of sultans and princes ... 65

Persian illustrated and illuminated manuscripts 118

Memory of the Suez Canal .. 352

Estonia

*The Baltic Way – Human chain linking three states in their drive for freedom** ...556

Ethiopia

Treasures from National Archives and Library organizations ..127

Finland

Radziwills' Archives and Niasvizh (Nieśwież) Library collection*.. 130

The A.E. Nordenskiold Collection 364

Fiji
Records of the Indian indentured labourers*...................... 344

France
Bayeux Tapestry ..80

Bibliotheca Corviniana* ... 149

Library of the Cistercian Abbey of Clairvaux at the time of Pierre de Virey (1472) 150

Beatus Rhenanus Library.. 165

Châtelet de Paris banner register from the reign of Francis I (National Archives Y9, France) 184

Original Declaration of the Rights of Man and of the Citizen (1789–1791) ..302

Introduction of the decimal metric system, 1790–1837...306

Lumière films ...398

The Appeal of 18 June 1940* 476

Georgia
Georgian Byzantine manuscripts 62

Germany
Illuminated manuscripts from the Ottonian period produced in the monastery of Reichenau (Lake Constance) ...66

Song of the Nibelungs, a heroic poem from medieval Europe ..94

The 42-line Gutenberg Bible, printed on vellum.................... 146

Bibliotheca Corviniana* ... 149

Universalis cosmographia secundum Ptholomaei traditionem et Americi Vespucii aliorumque Lustrationes*.. 162

Letters from and to Gottfried Wilhelm Leibniz246

The literary estate of Goethe in the Goethe and Schiller Archives.. 285

Kinder- und Hausmärchen (Children's and Household Tales) ...317

Ludwig van Beethoven: Symphony no. 9, D minor, op. 125.. 332

Benz patent of 1886...382

Early cylinder recordings of the world's musical traditions (1893–1952).. 397

Metropolis – Sicherungsstück Nr. 1: Negative of the restored and reconstructed version (2001)454

Construction and fall of the Berlin Wall and the Two-Plus-Four-Treaty of 1990................................520

Ghana
Dutch West India Company (Westindische Compagnie) archives*..220

Guyana
Dutch West India Company (Westindische Compagnie) archives*..220

Records of the Indian indentured labourers*.......................344

Hungary
Bibliotheca Corviniana* ...149

Tabula Hungariae*... 164

Csoma archive of the Library of the Hungarian Academy of Sciences.. 328

János Bolyai: Appendix, Scientiam Spatii absolute veram exhibens.. 348

Kalman Tihanyi's 1926 patent application 'Radioskop'........ 452

Iceland
The Arnamagnæan manuscript collection* 87

India
Rigveda ..26

Saiva manuscripts in Pondicherry40

Laghukālacakratantrarājatikā (Vimalaprabhā) 59

Tarikh-e-Khandan-e-Timuriyah196

Archives of the Dutch East India Company*....................... 214

The IAS Tamil medical manuscript collection 222

Indonesia
La Galigo*...117

Archives of the Dutch East India Company*....................... 214

Iran
Al-Tafhim li Awa'il Sana'at al-Tanjim76

The Deed For Endowment: Rab' i-Rashidi (Rab
i-Rashidi Endowment) .. 114

Collection of Nezami's Panj Ganj............................. 120

'Bayasanghori Shâhnâmeh' (Prince Bayasanghor's
'Book of the Kings') ...137

Administrative documents of Astan-e Quds Razavi
in the Safavid era.. 198

Ireland
The Book of Kells .. 54

Italy
Lucca's historical diocesan archives......................... 52

The Malatesta Novello Library 142

Bibliotheca Corviniana* ... 149

Jamaica
Registry of Slaves of the British Caribbean
1817–1834*..326

Silver men: West Indian labourers at the Panama
Canal*.. 376

Japan
Sakubei Yamamoto collection................................. 418

Kazakhstan
Collection of the manuscripts of Khoja Ahmed Yasawi........186

Audiovisual documents of the international antinuclear
movement 'Nevada-Semipalatinsk'.........................490

Aral Sea archival fonds ... 530

Korea (Republic of)
Printing woodblocks of the Tripitaka Koreana.......................98

Baegun hwasang chorok buljo jikji simche yojeol
(vol. II) .. 122

The Annals of the Joseon dynasty 124

The Hunminjeongum manuscript............................ 141

Uigwe: The royal protocols of the court
of Joseon dynasty... 213

Donguibogam: 'Principles and Practice of Eastern
Medicine' .. 218

Seungjeongwon Ilgi, the diaries of the royal
secretariat .. 227

Ilseongnok: Records of Daily Reflections 286

Human rights documentary heritage, 1980 546

Latvia
Dainu Skapis – Cabinet of folksongs...................... 374

The Baltic Way – Human chain linking three states in
their drive for freedom*.. 556

Lebanon
Commemorative stelae of Nahr el-Kalb, Mount
Lebanon...30

The Phoenician alphabet.. 32

Lithuania
Radziwills' Archives and Niasvizh (Nieśwież) Library
collection*... 130

The Baltic Way – Human chain linking three states in
their drive for freedom*.. 556

Luxembourg
The Family of Man ... 510

Madagascar
Royal archives (1824–1897)...................................... 334

Malaysia
Batu Bersurat, Terengganu (Inscribed Stone of
Terengganu) .. 116

Sejarah Melayu (The Malay Annals)....................... 219

Hikayat Hang Tuah .. 236

Correspondence of the late Sultan of Kedah
(1882–1943)... 385

Mauritius
Records of the French occupation of Mauritius.................... 256

Mexico
Sixteenth to eighteenth century pictographs from 'Maps,
drawings and illustrations' Archives of Mexico 168

Collection of Mexican codices.................................172

Colección de lenguas indígenas174

Collection of the Center of Documentation and
Investigation of the Ashkenazi community in Mexico.......... 179

Codices from the Oaxaca Valley.............................. 183

American colonial music: a sample of its documentary
richness* ...188

Codex Techaloyan de Cuajimalpaz208

Biblioteca Palafoxiana .. 233

Los Olvidados ..494

Mongolia
Lu.'Altan Tobchi': Golden History written in 1651..................240

Mongolian Tanjur 279

Morocco
Kitab al-ibar, wa diwan al-mobtadae wa al-khabar............ 125

Namibia
Letter journals of Hendrik Witbooi....................................408

Netherlands
Library Ets Haim–Livraria Montezinos108

La Galigo* ..117

Archives of the Dutch East India Company* 214

Dutch West India Company (Westindische Compagnie) archives* ..220

Archives of the Middelburgsche Commercie Compagnie* ... 274

Desmet collection 425

Diaries of Anne Frank..478

New Zealand
The Treaty of Waitangi....................................... 356

The 1893 Women's Suffrage Petition..........................394

Nicaragua
National Literacy Crusade 552

Norway
The Leprosy Archives of Bergen308

Henrik Ibsen: A Doll's House........................... 379

Roald Amundsen's South Pole Expedition (1910–1912)..428

Thor Heyerdahl archives .. 461

Pakistan
Jinnah papers (Quaid-i-Azam)............................ 372

Panama
Silver men: West Indian labourers at the Panama Canal*.. 376

Paraguay
The Archives of Terror ...498

Peru
American colonial music: a sample of its documentary richness* ... 188

Philippines
Philippine Paleographs (Hanunoo, Buid, Tagbanua and Pala'wan).. 61

Presidential papers of Manuel L. Quezon 416

José Maceda collection .. 505

Radio broadcast of the Philippine People Power Revolution .. 554

Poland
Codex Suprasliensis*... 71

Radziwills' Archives and Niasvizh (Nieśwież) Library collection* .. 130

Nicolaus Copernicus' masterpiece 'De revolutionibus libri sex'...180

The Confederation of Warsaw of 28th of January 1573 ...194

National Education Commission archives290

The masterpieces of Fryderyk Chopin.......................... 314

Warsaw Ghetto archives (Emanuel Ringelblum archives)..470

Archive of Warsaw Reconstruction Office482

Archives of the Literary Institute in Paris (1946–2000) ..486

Twenty-One demands, Gdańsk, August 1980 549

Portugal
Corpo Cronológico (collection of manuscripts on the Portuguese discoveries)................................... 128

Treaty of Tordesillas*... 156

Letter from Pêro Vaz de Caminha............................. 159

Arquivos dos Dembos / Ndembu archives* 253

First flight across the South Atlantic Ocean in 1922 449

Russian Federation
Codex Suprasliensis*... 71

Ostromir Gospel (1056–1057) 78

Archangel Gospel of 1092 .. 83

Khitrovo Gospel .. 123

Slavonic publications in Cyrillic script of the 15th century .. 126

Radziwills' Archives and Niasvizh (Nieśwież) Library collection .. 130

Tolstoy's personal library and manuscripts, photo and film collection 202

Collection of 18th-century maps of the Russian empire ... 260

Newspaper collections, Russian Federation 264

The Historical Collections (1889–1955) of St Petersburg Phonogram Archives 386

Russian posters of the end of the 19th and early 20th centuries .. 412

Saint Kitts and Nevis
Registry of Slaves of the British Caribbean 1817–1834 ... 326

Saint Lucia
Silver men: West Indian labourers at the Panama Canal ... 376

Sir William Arthur Lewis papers 458

Saudi Arabia
Earliest Islamic (Kufic) inscription 48

Senegal
Fonds of the Afrique occidentale française (AOF) ... 402

Serbia
Miroslav Gospel – manuscript from 1180 90

Nikola Tesla's Archive .. 380

Slovakia
Illuminated codices from the library of the Bratislava Chapter House 84

Bašagic collection of Islamic manuscripts 176

Mining maps and plans of the Main Chamber – Count Office in Banská Štiavnica 230

Slovenia
Codex Suprasliensis .. 71

South Africa
Archives of the Dutch East India Company 214

The Bleek collection .. 329

Criminal Court Case No. 253/1963 (The State versus N. Mandela and Others) 525

Liberation Struggle Living Archive Collection 544

Spain
Santa Fe Capitulations .. 154

Treaty of Tordesillas ... 156

Sri Lanka
Archives of the Dutch East India Company 214

Suriname
Dutch West India Company (Westindische Compagnie) archives .. 220

Archives of the Middelburgsche Commercie Compagnie .. 274

Records of the Indian indentured labourers 344

Sweden
Codex Argenteus – the 'Silver Bible' 42

Stockholm City Planning Committee archives 270

Emanuel Swedenborg collection 272

Alfred Nobel family archives 360

Ingmar Bergman archives 464

Astrid Lindgren archives 474

Switzerland
Jean-Jacques Rousseau, Geneva and Neuchâtel collections ... 269

Tajikistan
The manuscript of Ubayd Zakoni's Kulliyat and Hafez Sherozi's Gazalliyt 110

Tanzania
Collection of Arabic manuscripts and books 266

German records of the National Archives 388

Thailand
The King Ram Khamhaeng inscription 104

Epigraphic archives of Wat Pho 346

Archival documents of King Chulalongkorn's transformation of Siam (1868–1910) 369

Trinidad and Tobago
Registry of Slaves of the British Caribbean 1817–1834 ... 326

Records of the Indian indentured labourers 344

Constantine collection..446

C.L.R. James collection...456

Derek Walcott collection.......................................508

Eric Williams collection 514

Tunisia
Privateering and the international relations of the
Regency of Tunis in the 18th and 19th centuries 258

Turkey
The Hittite cuneiform tablets from Bogazköy.......................24

Kandilli Observatory and Earthquake Research
Institute manuscripts ...70

The works of Ibn Sina in the Süleymaniye
Manuscript Library.. 72

Ukraine
Radziwills' Archives and Niasvizh (Nieśwież) Library
collection*.. 130

Collection of Jewish musical folklore (1912–1947)...............430

United Kingdom
Magna Carta, issued in 1215......................................96

Hereford Mappa Mundi ...102

Dutch West India Company (Westindische Compagnie)
archives*...220

Registry of Slaves of the British Caribbean
1817–1834*..326

Silver men: West Indian labourers at the Panama
Canal*.. 376

Historic ethnographic recordings (1898–1951) at the
British Library...404

The Battle of the Somme...438

The Appeal of 18 June 1940*476

United States of America
Universalis cosmographia secundum Ptholomaei
traditionem et Americi Vespucii aliorumque
Lustrationes*... 162

Dutch West India Company (Westindische Compagnie)
archives*...220

Silver men: West Indian labourers at the Panama
Canal*.. 376

The Wizard of Oz (Victor Fleming, 1939), produced by
Metro-Goldwyn-Mayer...466

John Marshall Ju/'hoan bushman film and video
collection, 1950–2000...500

Landsat Program records: Multispectral Scanner
(MSS) sensors .. 532

Uruguay
Original records of Carlos Gardel – Horacio Loriente
collection (1913–1935)..432

Uzbekistan
Holy Koran Mushaf of Othman50

The collection of the Al-Biruni Institute of Oriental
Studies...60

Venezuela
Colombeia: Generalissimo Francisco de Miranda's
archives ...294

General Archive of the Nation: Writings of The
Liberator Simón Bolívar...320

Collection of Latin American photographs of the
19th century ... 415

Vietnam
Stone stele records of royal examinations of the Le and
Mac dynasties (1442–1779)....................................... 138

Woodblocks of the Nguyễn dynasty................................ 254

Other
Christopher Okigbo Foundation (Africa)
Christopher Okigbo collection................................... 512

International Committee of the Red Cross (ICRC)
Archives of the International Prisoners of War Agency,
1914–1923.. 434

United Nations Office at Geneva (UNOG)
League of Nations archives 1919–1946............................443

United Nations Relief and Works Agency for
Palestine Refugees (UNRWA)
UNRWA photo and film archives of Palestinian
refugees ...492

* Joint Inscriptions between 2 or more countries.

MEMORY OF THE
WORLD DOCUMENTS

ORDERED BY THE DATE THEY WERE RECORDED

◀ BC AD ▶

The Hittite cuneiform tablets from Bogazköy

Inscribed 2001

What is it

Ancient Hittite texts preserved in cuneiform on 25,000 clay tablets.

Why was it inscribed

The Bogazköy archive of cuneiform tablets is the only source of information on the Hittites as well as on the social, political and commercial activities of the area. The archive sheds light not only on that area and period, but also on the history and the civilization of human kind as a whole.

Where is it

Archaeological Museums of Istanbul and Anatolian Civilizations Museum of Ankara, Turkey

Anatolia forms a bridge between Europe and Asia, and the area has been the cradle of many civilizations. The Hittites ruled here for nearly 600 years in the 2nd millennium BC, after moving from the Caucasus. They established a powerful state within a bend of the Kızılırmak river (the ancient Halys) with its capital at Bogazköy. The civilization of the Hittites was advanced in its military achievements, political organization, legislation and the administration of justice. Their military, political, social

▼ Ancient Hittite cuneiform script

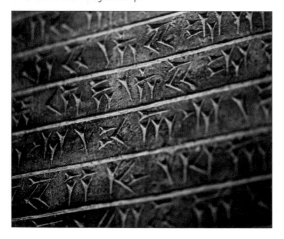

and commercial relations with neighbouring countries were all recorded and kept in archives meticulously.

The state had a federal structure, and the central government was headed by the king who was also the commander of the army, the supreme judicial authority and the chief priest, though he was never actually deified. In fact, the Hittite king, for the first time in the history of the ancient east, possessed no divine attributes.

Excavations from 1906 to 1970 at Bogazköy (ancient Hattusas) uncovered thousands of cuneiform clay tablets in the Great Palace and in the Great Temple. The Bogazköy archive consists of nearly 25,000 cuneiform clay tablets and is the only extant material about the civilization of the Hittites. The tablets are mostly on political, military,

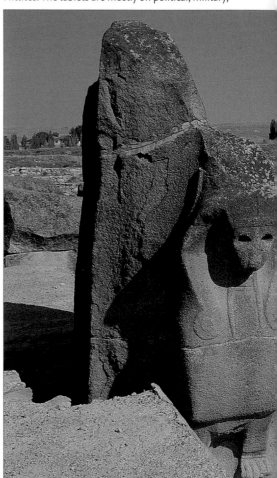

social, commercial, religious and artistic topics relating to the Hittites and the neighbouring nations. The archive also includes sets of tablets on law codes, national and international treaties and correspondence.

The archive includes tablets of the Treaty of Quadesh signed between Hittites and Egypt. This well-known treaty of 'eternal peace' guaranteed harmony and security throughout the area for a considerable length of time. Now a symbol of the movement for peace, the Treaty of Quadesh adorns the walls of the United Nations Building in New York.

The archive includes tablets of many literary works, chiefly of an epic and mythological character; some of the most important of these tell the story of the exploits and quarrels of the gods. The tablets show the existence of eight different languages, illustrating the polyglot nature of the Hittite Empire.

The correspondence and other documents in the archive have a universal importance since they contain important information not only on the Hittite Empire, but also on the political and civil life of other neighbouring states and cities. Most of our knowledge relating to that period of history in Asia Minor and partially in the Arab region comes from the cuneiform tablets found at Bogazköy.

Sphinx Gate of Hattusas, Turkey ▼

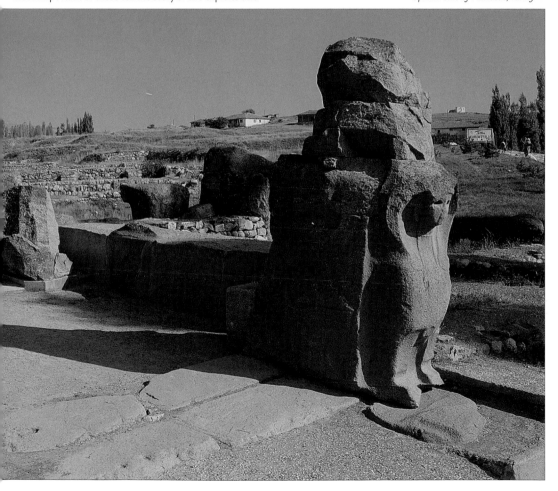

Rigveda

Inscribed 2007

What is it

Thirty manuscripts of the Rigveda, the oldest of the four Vedas which are the Hindu sacred texts of scripture. The Rigveda contains a collection of Sanskrit hymns and prayers and is believed to date to between 1700 BC and 1100 BC.

Why was it inscribed

The Vedas are among the first literary documents in human history but their significance goes beyond their scriptural importance. The Rigveda is considered the source of the culture that spread beyond the subcontinent to South, Southeast and Central Asia.

Where is it

Bhandarkar Oriental Research Institute, Pune, India

The Rigveda is a book of Sanskrit prayers, songs and hymns and is more than 3000 years old. The songs' composers represent the origins of different families which are considered as the ancestors of the Hindus.

The hymns of the Rigveda vary in nature: most are written in praise and petition to different gods, while others are pieces of poetry. Some are connected with sacrificial rituals, and others accompany specific ceremonies, including marriage and funeral rites. Hymns of creation also feature together with beautiful descriptions of nature and considerations of various aspects of human behaviour.

The language in the Rigveda suggests that it is not a single, unitary work but instead is comprised of earlier and later elements. In fact, the manuscripts are believed to be the composition of several generations of poet-priests over a period of centuries. The songs and prayers also belong to different geographical regions, mostly on the

Fragments of older editions of the Rigveda, including one on birch bark ▲ ▶

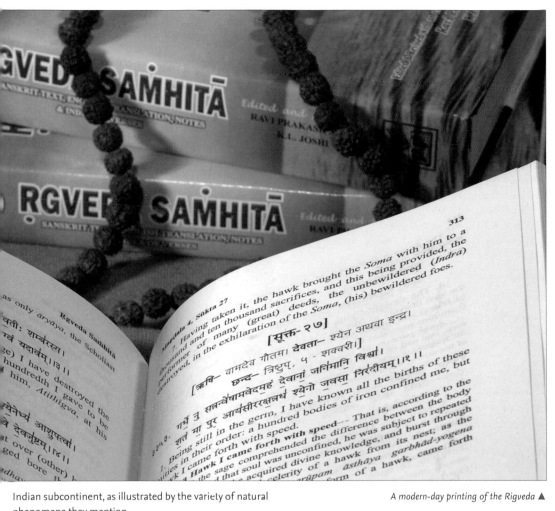

A modern-day printing of the Rigveda ▲

Indian subcontinent, as illustrated by the variety of natural phenomena they mention.

The Vedic culture spread across Central and South Asia and was a significant contributor to the growth and development of Asian civilization. Some scholars also claim the culture extended as far as Europe in prehistoric times. So as well as its place as a sacred text of the Hindus, the Rigveda is considered an important text in studies of comparative religion and mythology, ritual, anthropology, prehistory and poetry.

The Institute holds thirty manuscripts of Rigveda from across India. Of these, twenty-nine are written on paper and one, from Kashmir, is on birch bark. Several of the manuscripts contain the complete intact text of the Rigveda, which is rare. Nevertheless, all are important in the cultural and social heritage of the world. Thirteen manuscripts contain one of the oldest available commentaries on the text, while another five have the Padapatha, the traditional word analysis of the text. These aids have helped greatly in interpreting and understanding the Rigveda.

Papyrus Erzherzog Rainer
Inscribed 2001

What is it
A collection of around 180,000 written objects: papyri, parchment and paper; wooden tablets; ostraka, or pieces of inscribed pottery; cloths; and leather scrolls. The items date from the 15th century BC up to the 16th century AD.

Why was it inscribed
This collection of writing materials and languages is one of the most extensive in the world. Many of the important languages of the ancient world are represented in written form, including Egyptian, from hieroglyphics to Coptic; Greek; Latin; Hebrew and Aramaic; and Arabic. The papyri material covers a wide range of subject matter, from school and legal texts to writings on medicine, war and magic. Together, they allow insights into societies and cultures which have long since disappeared.

Where is it
Austrian National Library, Vienna, Austria

▲ *Erzherzog Rainer, who acquired the collection in 1883.*

The Fayum oasis in Egypt, where the papyri were first found in the 1870s. ▶

The collection was begun by Austrian historian and Orientalist Professor Josef von Karabacek, who was among the first to realise the importance of the papyri found at the Fayum oasis in Egypt in the late 1870s and early '80s. Together with his collaborator Theodor Graf, Professor von Karabacek imported thousands of the finds into Austria. Archduke (or Erzherzog) Rainer, a former prime minister and a member of the Habsburg royal family, bought the collection in 1883.

Material continued to come from Egypt and the collection grew to almost its present size within a few years. In 1899 Professor von Karabacek became head of the Imperial Court Library and that same year the archduke gave his collection as a birthday gift to the Emperor Franz Josef I, requesting that it be placed in the Court Library.

The material in the papyri covers every aspect of life: literature, school texts, magic, religion, the afterlife, legal affairs, financial transactions, military matters, medicine, books and writing. Together, they offer a direct insight into the world as it was known at the time. For example, many of the cities, villages, churches and temples of ancient Egypt are known through these papyri. Byzantine tax receipts form a large part of the records, allowing the reconstruction of aspects of the social and economic history of the Byzantine Empire. Roman military papers reveal aspects of governance in Egypt and beyond. Family archives from various periods also feature in the collection.

Among the most important items are the Greek papyri from the period between the end of Byzantine rule and the start of the Muslim control in Egypt in the 7th century AD. The period was one of upheaval, and the contents of the papyri document this. Other items include the oldest written Arabic text and a receipt, written in both Greek and Arabic, dating from the start of Muslim rule in the country.

The collection's treasures include some unique religious texts of great importance for the documenting of the ancient Egyptian religion, Christianity and Islam. These

include Books of the Dead (including one with gilded pictures), rare New Testament papyri and the oldest-known fragment of the biography of the Prophet Mohammed.

Also among the vast wealth of material are individual special items of particular interest. Included is possibly the only surviving piece of the Library of Alexandria, as well as the oldest-known fragment of an ancient song. The works of many ancient writers and poets are represented here.

Many of the most important languages in the Old World exist in original writing in the collection. Examples include the Egyptian languages in their different forms: hieroglyphics, hieratic, demotic and Coptic, as well as Latin, Hebrew, Aramaic, Syriac and Pehlewi (Middle Persian). Most numerous are the texts in Arabic and Greek, which was the language of the establishment and of administration for almost a millennium from around 300 BC onwards.

The Austrian National Library has a separate Papyrus Museum which features some highlights of the collection and allows an insight into the lives of some of the people who lived in the Nile Valley over a period of 3000 years.

◄ BC AD ►

| 15TH C. | 14TH C. | 13TH C. | 12TH C. | 11TH C. | 10TH C. | | 2ND C. | 1ST C. | 1ST C. | 2ND C. | | 16TH C. | 17TH C. | 18TH C. | 19TH C. | 20TH C. | 21ST C. |

Commemorative stelae of Nahr el-Kalb, Mount Lebanon

Inscribed 2005

What is it

A series of commemorative stelae (carved stone tablets) depicting Lebanese history from the 14th century BC to the present through the inscriptions left by successive armies.

Why was it inscribed

Situated on a strategic north-south road, the stelae, carved with inscriptions in different languages, evoke the history of Lebanon and testify to its relations with the rest of the Middle East and the West.

Where is it

Nahr el-Kalb, Mount Lebanon, Lebanon

▲ *Commemorative stelae have been carved into the hillside since prehistoric times, marking the passage of armies through the dangerous pass of Nahr el-Kalb, near Mount Lebanon. The stele illustrated here commemorates the passage of French troops in 1861 during the rule of Napoleon III.*

This stele marks the passage of French troops under General Gouraud in July 1920, on their way to Damascus. ▶

The commemorative stelae of Nahr el-Kalb, the Lycus or Dog River, on Mount Lebanon are a series of stone tablets depicting Lebanese history from the 14th century BC to the present through the inscriptions left by successive armies: Pharaonic, Assyro-Babylonian, Greek, Roman, Arab, French and British. Situated at a difficult and very steep crossing point on an important north-south road, the stelae were carved into the rocks with inscriptions in different languages. They evoke the history of Lebanon and testify to its relations with the rest of the Middle East and the West.

The hillside where the stelae are carved forms a strategic location, protected by a water course and steep escarpment that commands the coast road which links the south of the country to the north. From the time of the Old Kingdom in Egypt, the road was taken by the Pharaonic armies for two reasons: to ensure easy, rapid access to the timber of the Lebanese cedar (*Cedrus libanus*), a rare and valuable commodity in Egypt; and to block the road to invaders from the north, in particular the Mitanni and the Hittites. The first stele was built by the pharaoh, Ramses II. Likewise, the Assyro-Babylonians, coming from Mesopotamia, planned their incursions to gain free access to the Mediterranean in order to spread out in all directions. Later conquerors, the Greeks, Romans, Arabs, Mameluks, Ottomans, French and British, followed suit, marking their passage with stelae which remain the best evidence of their presence.

The stelae are carved in soft, chalky limestone. In all there are twenty-two stelae, carved in many languages, including Egyptian hieroglyphs, Assyro-Babylonian cuneiform, Greek, Latin, English, French and Arabic. The series of stelae, unique in number and style, are in imminent danger of erosion, on the one hand, and vandalism on the other, making protection and conservation measures a matter of necessity and urgency.

◄ BC AD ►

| 15TH C. | 14TH C. | **13TH C.** | 12TH C. | 11TH C. | 10TH C. | | 2ND C. | 1ST C. | | 1ST C. | 2ND C. | | 16TH C. | 17TH C. | 18TH C. | 19TH C. | 20TH C. | 21ST C. |

The Phoenician alphabet

Inscribed 2005

What is it

The Phoenician alphabet, developed in 13th-century BC
Phoenicia, is a non-pictographic, consonantal alphabet.

Why was it inscribed

The Phoenician alphabet is the writing system that
is regarded as the prototype for all alphabets of the
world today.

Where is it

Stele no. I is in cadastral lot n.35 that falls within the
municipality of Zouk Mosbeh. Stelae nos. II–XXII
are located in plot n.98 that belongs to the Order of
Antonine (Wakf St Joseph – City of Dbayeh)

The Phoenician alphabet was developed in the 13th century
BC in Phoenicia, an area that spanned much of the eastern
shore of the Mediterranean in the region of Canaan, the
zone of the Middle East known as the Fertile Crescent.
Phoenicia was a seafaring nation with trading links
mostly along the southern shores of the Mediterranean,
and by the 13th century BC it was the foremost maritime
power in the region.

Trading and cultural links brought the Phoenicians
into contact with the writing systems used in Egypt and
Mesopotamia, the two major powers of the time. The
Phoenicians used both these alphabets – hieroglyphics
and cuneiforms – but in the 13th century they devised
their own system.

What made the new alphabet so innovative was that it
used the sounds of the contemporary Phoenician dialect
and represented them in letter form. Unlike pictograph-
based writing systems, a phonetic alphabet cut down
on the number of characters needed for expression,
thus simplifying the language and making it easier to
use. Their writing system spread into the western and
eastern worlds.

There were twenty-two letterforms in the Phoenician
alphabet, which was an abjad – that is, all of its letters were
consonants. It is widely seen as the precursor to most

*The sarcophagus of King Ahiram of Byblos bears the oldest example
still extant of the full Phoenician alphabet, from around 1200 BC.* ►

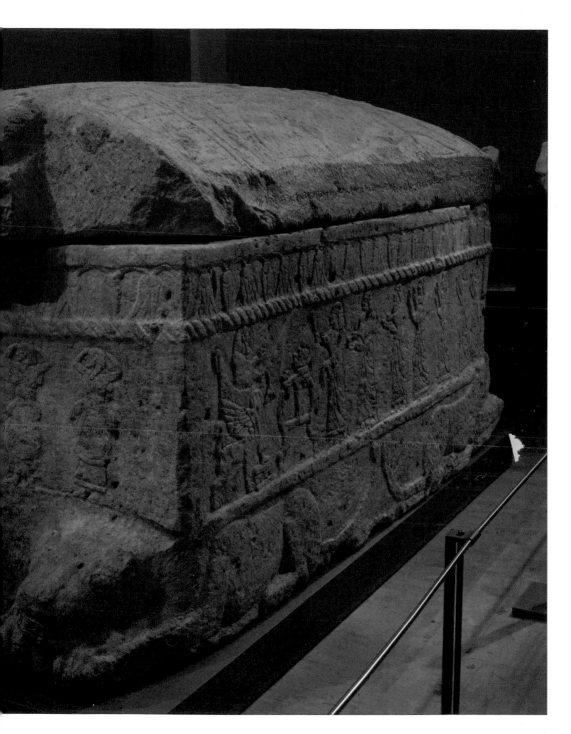

of the major alphabets in use today. As Greece became the economic and cultural powerhouse, so the Phoenicians' alphabet gradually gave way to the Greek; furthermore, some letters were modified to function as vowels. However, traces of the Phoenician alphabet can still be found in the Roman era in the 1st century AD.

The oldest example still extant of the full alphabet dates from around 1200 BC and is engraved on the sarcophagus of King Ahiram of Byblos, a Phoenician city.

▲ Monument to the Phoenician alphabet at the UNESCO World Heritage Site, Byblos, Lebanon.

Huang Di Nei Jing 黄帝内经
(Yellow Emperor's Inner Canon)
Inscribed 2011

What is it
The earliest and most important written work of traditional Chinese medicine. It was compiled over 2200 years ago.

Why was it inscribed
It contains the two basic theories of Chinese medicine, the theories of Yinyang and the Five Elements, and is regarded as the fundamental medical text from which traditional Chinese medicine was systematically recorded, standardized, developed and now applied by and to people of different countries and races.

Where is it
National Library of China, Beijing, China

▲ *The earliest-surviving printed copy of the Yellow Emperor's Inner Canon, dating from 1339, over 1000 years after the text was first written down.*

The *Huang Di Nei Jing* was compiled some 2200 years ago and it laid down the foundation and inspired further development of traditional Chinese medicine, not only in China but also in neighbouring countries and beyond. Based on the theoretical principles of Yinyang, Qi (or life force) and the Five Elements (or phases), it provides a systematic summary of the relationship between physical and mental activities and the pathological changes in the human body, covering internal medicine, surgery, gynaecology, pediatrics and infectious diseases.

The *Huang Di Nei Jing* was the first medical text that departed from the old shamanistic beliefs that disease was caused by demonic influences. It expounds the concept of health with the philosophical thinking of Taoism and Confucianism. It sees diseases as closely related to diet, emotion, lifestyle, environment, age and heredity. Emphasis is placed on the unity of man and nature, and the holistic idea of body and mind. Accordingly, human activities should be in conformity with the regular changes in nature, including climatic changes of the four seasons, alternation of day and night and the cyclic phases of the moon. At the same time, emotions should be adjusted and desires restrained, with ethical considerations given to high moral value, an essential element of self-control. The book discusses the principles and prescribes methods of diagnosis and treatment of diseases. A large number of 'modern' diseases such as malaria, gout, diabetes, coronary heart disease, rheumatic arthritis and cerebrovascular problems are mentioned in the book with detailed analyses and treatment methods.

The book is written in an interlocutory pattern, with the Yellow Emperor (Huang Di) raising questions on medical issues and his sage physicians, Qibo and Leigong answering by explaining medical theories and principles with illustrations of clinical experience and practices. The text is written in lively and yet poetic rhyming language, which demonstrates the rich medical knowledge and refined literary culture in China at the time.

Many scholars believe that the *Huang Di Nei Jing* was not compiled by a single author within a limited period of time; rather, it was the fruit of the joint efforts of many experienced and dedicated physicians over the centuries. The major part of the book was completed with various editions in the Warring States period of Chinese history (475–221 BC) with supplements and revisions made in the Qin dynasty (221–206 BC) and Han dynasty (206 BC–AD 220). The original *Huang Di Nei Jing* had been copied onto bamboo slips, silk scrolls and paper until it was officially published during the 9th and 10th centuries AD. It was further edited by the government-authorized Bureau of Revising Medical Works of the Northern Song dynasty (960–1127). The National Library of China's copy was printed in 1339 by Hu's Gulin Sanctum using woodblock printing and is the earliest and the best-preserved version in existence.

Ancient Naxi Dongba literature manuscripts

Inscribed 2003

What are they

The collection contains 1000 volumes on a variety of subjects dating from c.AD 30 to the Tang dynasty (618–907) in a pictographic script using more than 2000 characters. It is the only surviving script of its type in the world.

Why were they inscribed

These documents represent a unique form of script and written culture which represent an important part of the heritage of mankind.

Where are they

Dongba Culture Research Institute, Lijang county, Yunnan, China

The Naxi people are the descendants of the ancient Qiang tribe, who inhabited the Huang He and Huang Shui valleys in northwest China. After constant nomadic migration, the early Naxi finally settled down in eastern and western areas along the upper reaches of the Jinsha river. Today approximately 300,000 Naxi live at the junction of Yunnan province, Sichuan province and the Tibet autonomous region.

Despite the extremely difficult environmental conditions and the lack of material wealth, the Naxi still managed to create a unique and distinctive ethnic culture. As a consequence of being handed down through a religion whose priests were called 'Dongbas', this ancient culture acquired the name of 'Dongba culture'. Thus, all the pictographic characters, scriptures, ritual dancing, artworks and utensils related to this culture are prefixed by the word 'Dongba'. What is a continual surprise to many people and what makes this culture remarkable is the fact that the Naxi ancestors were able to create a system of writing with more than 2000 characters, using a particular pictographic script to write down their customs and scriptures. The scripts for writing the ancient Dongba literature are of great value for studies of the origin and development of written languages. It holds an irreplaceable position in the history of the development of the written languages, and is more primitive than the inscriptions on bones or tortoise shells

of the Shang dynasty. It is the only surviving script of this type in the world.

The collection records all the aspects of the Dongba culture, ranging from the creation of the world through philosophy, economics, military affairs, culture, astronomy and farming to the social life of the Naxi people, and is an encyclopedia of their ancient society; it also covers every aspect of their religious rituals including praying for blessings, sacrificial offerings for exorcising evils, funerals and divination. The scriptures were written on the tough local paper with bamboo pens and were bound with threads. Written in a unique way and style, all the scripts in Dongba literature look like beautiful paintings. They are also of great value for comparative studies of the techniques of papermaking and binding of literature in ancient times. As they cannot withstand natural ageing and incessant handling, the challenge of how to safeguard this rare and irreproducible heritage is under study. Dongba literature, except for that which is already collected and stored, is on the brink of disappearing, and Dongba culture

itself is becoming dispersed and is slowly dying out as a result of the impact of other powerful cultures. There are only a few masters left who can read the scriptures.

There is insufficient evidence to set accurately the time and place of creation of Naxi ancient literature and the Dongba script. However, it is of great value for studies into the origin of classical Chinese, and quite possibly, as Tibetan Buddhism also had a great influence on the Dongba religion, the origins of ancient Naxi Dongba literature may lie not only in the southwest of China, but also in some of the bordering countries.

◄ *A modern example of the Dongba pictograms used by the Naxi people in Yunnan province in southern China.*

Dongba pictograms used by the Naxi people, the only system of pictograms still in use today. ▼

Mashtots Matenadaran ancient manuscripts collection

Inscribed 1997

What is it

A collection of around 17,000 manuscripts from every sphere of ancient and medieval science and culture in Armenia.

Why was it inscribed

The Matenadaran collection is one of the foremost and most important sets of ancient and medieval manuscripts in the world. The collection covers a broad subject range.

Where is it

Mashtots Institute of Ancient Manuscripts, Yerevan, Armenia

The Matenadaran (which in Armenian means 'manuscript repository') holds a collection of priceless medieval manuscripts that are rare in themselves and are exceptional in the scope of their subject matter. The collection covers religion, history, geography, philosophy, grammar, law, medicine, mathematics and literature, as well as manuscripts in Arabic, Persian, Greek, Syriac, Latin, Ethiopian, Indian and Japanese.

The Matenadaran was founded at Etchmiadzin at the start of the 4th century AD by the first catholicos (the supreme patriarch) of the Armenian Orthodox Church. It was a centre for the preservation of Greek and Syriac manuscripts and, from the 5th century onwards, the main translation centre in Armenia.

Its position in the Caucasus left Armenia vulnerable to invasion and the country suffered repeatedly. By the start of the 18th century, what had been a rich manuscript collection was reduced to a small percentage of its previous size. Greater stability came when Eastern Armenia was incorporated into Russia in the early 19th century and the collection began to grow again. In 1939 the Matenadaran was transferred to Yerevan where research work is still a major activity today. The treasures of Armenian culture, spread around the world, are still being actively sought and donated to the immense collection.

The oldest relics of Armenian literature date back to the 5th and 6th centuries. Only fragments from this period have survived, often as flyleaves to the bindings of manuscripts. Medieval bookbinders often sewed in leaves of parchment of older or no-longer-used manuscripts between the cover and the first page of a book to protect the writing from coming into contact with the binding. Thanks to this practice, specimens of those earlier works have been preserved. Other pages have been found in caves, in ruins or buried in the ground.

The collection contains the work of the church fathers and other Armenian translations from Greek or Syriac of the 5th century AD, the originals of which have disappeared. These include *Six Hundred Questions and Answers about the Book of Genesis* by Philo of Alexandria; a body of works of spiritual revelation by Hermes Trismegistos; writings by Basil of Caesarea; and the *Chronicon* by Eusebius of Caesarea, a vital source for the history of the first three centuries of Christianity.

The oldest binding and miniatures in the Matenadaran date back to the 6th century. The oldest complete manuscript is the Lazarian Gospel, written in AD 887 on parchment, while the oldest extant Armenian paper manuscript is a collection of scientific, historical and philosophical work dating back to AD 981.

St Mesrop Mashtots, after whom the institute and its collection are named, devised the Armenian alphabet in AD 405. ▶

Saiva manuscripts in Pondicherry

Inscribed 2005

What is it

This collection of 11,000 palm-leaf and paper manuscripts in Sanskrit, Tamil and Manipravalam focuses mainly on the religion and worship of the Hindu god Siva in southern India.

Why were they inscribed

It includes the largest collection in the world of manuscripts of texts of the Saiva Siddhanta, a religious tradition whose primary deity is the god Siva, which spread across the Indian subcontinent and beyond, as far as Cambodia, but which, from the 12th century, became restricted to southern India.

Where are they

French Institute of Pondicherry and the École française d'Extrême-Orient, Pondicherry, India

The Sanskrit scriptures of the Saiva Siddhanta were widely spread over the whole of the Indian subcontinent ten centuries ago. The influence of the Saiva Siddhanta can be found in Cambodia and Java and in the ritual traditions of all the Tantric and subsequent theistic traditions in India. After a period of wide-reaching influence, this religious tradition fell into abeyance everywhere but in Tamil-speaking southern India: there is no evidence of adherents of the Saiva Siddhanta outside that area after the 12th century. Surviving post-12th-century ritual treatises, commentaries and other religious literature of the school all appear to have been written in the Tamil-speaking area.

Two large collections of palm-leaf and paper manuscripts of Sanskrit, Tamil and Manipravalam texts are preserved in French research institutions in the south Indian town of Pondicherry. The 1662 palm-leaf bundles at the Pondicherry Centre of the École française d'Extrême-Orient belong to a single collection from the Tirunelveli district in the south of India. More than a third of this material (about 650 bundles) relates to the cult of the Hindu god Visnu and at least sixty of these Vaisnava manuscripts transmit texts that have never been published. The major collection, however, is that of the French Institute of Pondicherry, which includes 8187 palm-leaf bundles and 360 paper codices. The manuscripts have been collected from every area of the Tamil-speaking south of India and the collection contains texts of every branch of pre-colonial Indian learning. Nearly half of the material relates to the worship of the god Siva. The surviving texts, the majority of them unpublished, were originally written from the 6th century to the colonial period.

Although some of the texts are of very great antiquity, these South Indian manuscript copies belong for the most part to the 19th century. Palm-leaf manuscripts kept in South India can perish extremely rapidly and no surviving examples are known to be older than three

centuries. As for the paper manuscripts of the collection, they have tended to be much more regularly consulted, being much easier to read, and the most used are now very fragile.

▲ *An example of a palm-leaf manuscript showing how the text is written on to palm leaves and how the bundles of leaves are joined together.*

Codex Argenteus – the 'Silver Bible'

Inscribed 2011

What is it

The *Codex Argenteus – the 'Silver Bible'* – is a remnant of a liturgical book of the four Gospels written in the Gothic language for Arian Christian Church services in the early 6th century.

Why was it inscribed

The *'Silver Bible'* contains the most comprehensive extant text in the Gothic language and is one of the world's best-known remaining artefacts from Gothic culture. Its historical value lies in its contribution to the spread of Christianity.

Where is it

Uppsala University Library, Uppsala, Sweden

The *Codex Argenteus* is a book for use in religious liturgy that contains the selected portions of the Gospels to be read during church services. The book was written in the early 6th century in northern Italy, probably in the city of Ravenna.

At that time, Ravenna was the capital of the Ostrogothic Kingdom which stretched from modern-day southern France across to Serbia and took in all of Italy. However, in AD 553 the Ostrogoths were defeated after a long and costly war by the forces of the Eastern Roman or Byzantine Empire which was then at almost the greatest extent of its power. As a result, Gothic language and culture largely disappeared.

The *Codex Argenteus* contains the most comprehensive still existing text in the Gothic language. It is part of the 4th-century translation of the Bible from Greek into Gothic by Bishop Wulfila, an Arian preacher who had converted the Germanic tribes and was said to have constructed the

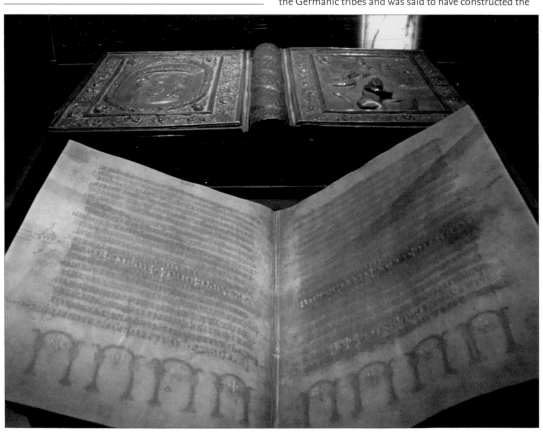

▲ Christ's baptism, depicted on the ceiling
of King Theodoric's Arian Baptistry in Ravenna.

Gothic alphabet specifically for the translation. Wulfila
is also the oldest known non-mythical constructor
of an alphabet.

A beautiful and impressive object in its own right, the
Codex Argenteus was thought to have been made for the
Ostrogoth King Theodoric the Great (AD 454–526) and
intended to be admired in a central place in a church,
probably the Gothic Arian cathedral in Ravenna. The pages
are high-quality coloured vellum inscribed in a decorative
script in silver and gold ink – a degree of ostentation and
decoration that suggests a royal connection.

Today the *Codex Argenteus* is held at Uppsala University
Library. Its whereabouts after the fall of the Ostrogothic
Kingdom were unknown until it emerged in the 17th

century in the Benedictine Abbey of Werden in Essen; from
there, via the royal library in Prague, it arrived in Sweden
as a donation to the university library in 1669. The Codex
was bound in silver by the royal court's goldsmith
in Stockholm.

◀ *Codex Argenteus – the 'Silver Bible'*

Codex Purpureus Beratinus

Inscribed 2005

What is it

Two Gospels found in Berat, Albania, dating from the 6th and 9th centuries.

Why was it inscribed

The two Beratinus codices are masterpieces of religious art and important evidence of the development of Christian thought. They represent one of the most valuable treasures of the Albanian cultural heritage.

Where is it

Albanian National Archives, Tirana, Albania

'Codex Purpureus' refers to manuscripts written in gold or silver lettering on parchment dyed purple, originally restricted for the use of Roman or Byzantine emperors. The Beratinus Codices are two Gospels found in Berat, Albania: 'Beratinus-1' dates from the 6th century, and 'Beratinus-2' from the 9th century.

They are two of the seven 'purple codices' written from the 6th to the 18th centuries that survive today. These are of global importance, illustrating the development of ancient biblical, liturgical and hagiographical literature.

'Beratinus-1' is a 6th-century uncial illuminated manuscript Gospel written in Greek. It is one of the oldest examples of the New Testament and is an important reference point for the development of biblical and liturgical literature throughout the world.

The 'Beratinus-1' manuscript, containing non-standard pre-canonical Gospel passages, has true global importance as it is an indispensable reference point for international research on literary textology. It is also extremely valuable in terms of the history of handwriting and the calligraphic elements of applied figurative art.

The letters and words are not separated from one another (*scriptio continua*). The letters are silver and the initials gold; the manuscript is on parchment. It contains several gold abbreviations, typical of ancient Christianity. It comprises 190 pages.

'Beratinus-1' contains the majority of the texts of the Gospels according to St Mark and St Matthew. It is thought that the other two Gospels probably also existed.

'Beratinus-2' dates back to the 9th century and was found in a church in Berat. The codex contains simple miniatures (Gospel portraits) and comprises 420 pages. The origin of

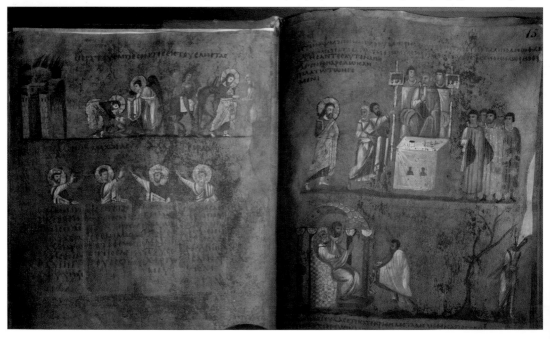

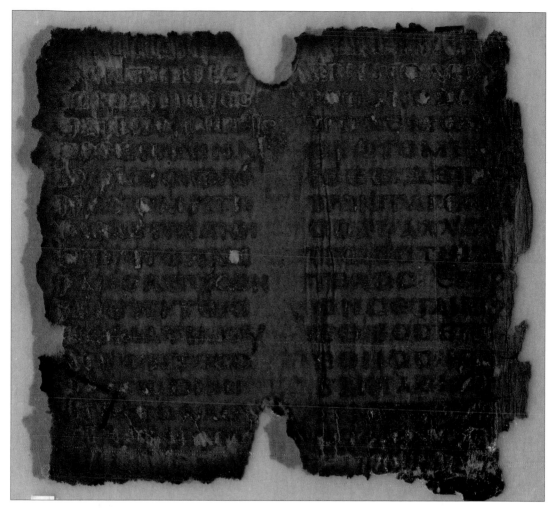

◀ An example of a Codex Purpureus from the Museo Diocesano
di Rossano, Calabria, Italy.

Codex Purpureus Beratinus ▲

this manuscript has been and remains the subject of much debate. It includes all four Gospels. The letters are all gold and the manuscript is on parchment. The text is from the standard text period and includes some semiuncial letters.

This manuscript is an essential landmark in evangelical literature and Christian culture in general. It is a unique record of the development of the world's ancient evangelical and liturgical literature and a model of evangelical writings in minuscules.

In 1967, after a long period during which they were thought to have been lost, the two Beratinus Codices were found and were handed over to the National Archives in 1971. They are of universal importance as examples of the spiritual heritage of nations and as treasures of the global heritage.

Vienna Dioscurides

Inscribed 1997

What is it

A Byzantine illuminated manuscript of *De Materia Medica* by Dioscorides, a Greek physician, pharmacologist and botanist of the 1st century AD. The manuscript was written in the early 6th century and has 491 folios of parchment with more than 400 colour pictures of plants and animals.

Why was it inscribed

The *Vienna Dioscurides* can be considered as the most important pharmaceutical source of the Ancient World. It was used from early medieval times into the early modern period as a dictionary for medical practitioners. It forms the basis of medical herbal therapeutic knowledge and is possibly the most important, enduring and comprehensive work on herbal and other remedies in the West.

The manuscript itself is a masterpiece of the book art from later Classical Antiquity.

Where is it

Austrian National Library, Vienna, Austria

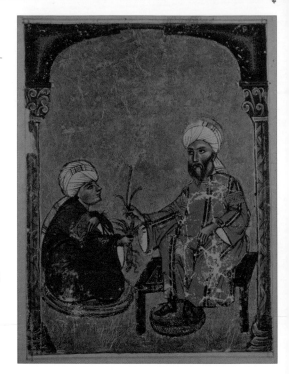

Dioscorides with a student seated at his feet. ▲

The *Vienna Dioscurides* is the oldest and most famous copy of Dioscorides's 1st century AD work, *De Materia Medica*. It was copied in the early 6th century for Juliana Anicia, daughter of Flavius Anicius Olybrius, emperor of the Western Roman Empire, in recognition of her patronage in building a church in Constantinople. This same copy passed through many hands that made annotations in Greek, Arabic, Turkish and Hebrew. In 1519 the Holy Roman Emperor Maximilian II bought the book for the Habsburg Imperial Library.

De Materia Medica was the most important pharmaceutical source of the Ancient World and through medieval times. It was in active use for 1000 years as a pharmacopoeia and reference work for medical practitioners. There are indications that it was first regarded as a luxury copy and later as a medical textbook in daily use in a Constantinople hospital; these changes in use throw some light on social and cultural progress through the centuries. The information it contains also reveals how plant and herbal remedies were used from antiquity through to early modern times.

Written 'on the preparation, properties and testing of drugs', the book lists more than 1000 natural substances and their medicinal properties. Most of these are botanical, although some mineral- and animal-based remedies are also included. There are more than 400 colour illustrations, the vast majority being of plants; each illustrated plant appears on a page facing the description of medicinal properties. Other full-page illustrations in the book feature Anicia and Dioscorides himself, both in an author portrait and seated among seven noted physicians.

The *Vienna Dioscurides* also contains five supplementary texts including Dionysius's *Ornithiaca*, describing more than forty birds, with illustrations.

βᾶτος

Earliest Islamic (Kufic) inscription

Inscribed 2003

What is it

An Arabic inscription, dated 24 Hegira (equivalent to AD 644), engraved on a rock located near al-Ula in the northwest Saudi Arabia.

Why was it inscribed

The inscription, in Kufic script, is the first and oldest dated Arabic inscription in the world and the earliest Islamic inscription.

Where is it

Near al-Ula, Saudi Arabia

This inscription, from the 7th century AD, was carved into a block of red sandstone located south of Qa'a al Muatadil and north of Sharma in northwestern Saudi Arabia. The rock stands on an ancient trade and pilgrimage route that connected the early Islamic city of al-Mabiyat with Madain Saleh, a city known to the Romans as Hegra and which was originally part of the Nabatean kingdom in the 1st century AD, their second city after Petra. By the time the inscription was carved, Madain Saleh was on the pilgrimage route to Mecca further south.

The inscription itself reads: *'Bismallah Ana Zuhair Kataba zaman maout Omar sanat Arba Wa eshrain'*, which translates as, 'In the name of God I Zuhair wrote the date of the death of Omar the year four and twenty (Hegira)'.

The Omar mentioned in the inscription was Omar or Umar bin al-Khattab, the second caliph to rule after the death of the Prophet Mohammed. He is also named in the Sunni Muslim tradition as one of the four rightly guided, or righteous caliphs who succeeded the Prophet. Although he ruled the caliphate for only 10 years from 634 until his death in 644, his military and political prowess brought the vast expansion of Muslim lands, ultimately including the conquest of the Persian Empire.

Omar also established the Muslim calendar. Its start date was taken to be AD 622, the year the Prophet Mohammed moved from Mecca to Medina. Omar was stabbed and mortally wounded in an assassination attempt. He died on the last night of the month of Dul-Hajj of the year 23 Hegira, and was buried next day on the first day of Muharram of the new year 24 Hegira (corresponding to AD 644).

The inscription is in Kufic script, in a style without dots and in a relatively early or crude form of the script. The term 'Kufic' relates to the Muslim city of Kufah which was founded in Mesopotamia (in modern-day southern Iraq) in AD 638, although the script was used in the region

before the city was established and may have taken its name because the style was developed there. Kufic script, which fell into disuse around the 11th or 12th century, was generally used as a display script on metal and stone, on coins and in mural inscriptions and, in this instance, on rock.

Holy Koran Mushaf of Othman
Inscribed 1997

What is it
Known as the Mushaf of Othman, it is the earliest extant written version of the Koran. The manuscript is 250 pages long and is written on animal skins.

Why was it inscribed
One of the world's major and most influential books of religion, the Koran has played a significant role in shaping world history. The Mushaf of Othman is the earliest written version. Compiled in Medina in AD 651, it supersedes all other versions.

Where is it
Muslim Board of Uzbekistan, Tashkent, Uzbekistan

The Koran, which Muslims believe was divinely revealed to the Prophet Mohammed, was transcribed by his followers onto various materials, such as pieces of wood and camel bones. After the Prophet's death, the first caliph to succeed, Abu Bakr (c. AD 573-634) ordered that scribes should record in writing all such verses, or suras. His later successor Othman (c. AD 579-656) ordered that the suras should be compiled into a book with the help of the four best contemporary scholars of the Koran.

In 651 this first, definitive version of the Koran was transcribed at Medina, the Muslim capital and power base, and was known as the Mushaf of Othman. A 'mushaf' is a collection of written pages or book, here of the Koran, and the mushaf was named after the caliph who ordered its creation. This version was declared as a standard, substituting all other versions. The manuscript is written in large black letters in the Arabic Kufic script.

Caliph Othman was assassinated while reading it and the manuscript is believed to be stained with his blood. The succession to the caliphate after the death of the Prophet was a source of conflict among his followers, and Othman's assassination and its repercussions precipitated the schism into the Sunni and Shia denominations of Islam which has divided the Muslim community ever since.

Conflicting accounts explain how the Koran arrived at Uzbekistan. According to one, the book was brought by a relative of Othman during a period of disorder in Medina; while another states that Othman's successor, Ali Ibn Abi Taleb, brought it to Kufah, from where the Uzbekistani leader and warrior Amir Temur brought it as a trophy to Samarkand after a military campaign during the 14th century.

▲ *Mushaf of Othman*

In the 19th century the book went to Russia, but several years after the Russian Revolution of 1917 it was returned to Uzbekistan where it stayed in a museum until the fall of Communism in 1989, when it was handed over to the Muslim Board of Uzbekistan.

The Koran, an acknowledged masterpiece of Arabic literature, contains a code of conduct and correct living. It records the creation of the world, the stages of divine revelation and the place of humanity in the universe and in relation to the Creator.

▲ *The Khazrati Imam complex in Tashkent, where the Holy Koran Mushaf of Othman is kept.*

Lucca's historical diocesan archives

Inscribed 2011

What is it

The extensive archives of the Archdiocese of Lucca, which date back more than thirteen centuries. The inscribed documents date from AD 685 to 1000.

▲ *Parchments from the archives*

Why was it inscribed

Lucca's Historical Diocesan Archives are among the biggest and most ancient archives in the world. Five codices in the collection preserve 13,000 documents dating back to AD 685 and among these, 1800 documents are earlier than AD 1000.

As church and state were intertwined during the Middle Ages, the archives present a unique and valuable resource of the religious, economic, agrarian, civic, cultural, social and political history of a diocese and its community that was at the religious and geographic heart of Europe.

Where is it

Archives of the Archdiocese of Lucca, Lucca, Italy

The Lucca archdiocesan archive is one of the largest archives in the world from the Early Middle Ages.

During the time the archives cover, Lucca, in Tuscany, was ruled by the Lombards and was part of the Carolingian Empire. Its geographical situation placed it at a strategic point in the heart of Europe, along the Via Francigena pilgrimage route which connected Canterbury and Rome.

The wealth of material in the archive dating from the Dark Ages makes the collection exceptional in Western Europe. The documents show the activities of the clerics and laymen who ruled Lucca during this time and their secular as well as religious activities, including relations with the papacy and the imperial powers. Many of the most important characters in early medieval Europe are mentioned in the papers, including Charlemagne, Otto I, king of Italy and later Holy Roman Emperor, and his successors, Otto II and Otto III.

The papers show the changes and evolution of the community and its territory, which were also closely

Volto Santo de Lucca ▲

◄ *Detail of a codex from the archives*

The community's religious and spiritual expression is particularly notable in the edification of churches and the development of the cult of the Holy Face, the town's patron. The Holy Face, or Volto Santo, is a wooden crucifix believed to have been sculpted by Nicodemus, a friend and contemporary of Christ, and brought to Lucca in AD 742. Bound up with religious expression is the city's artistic outflowing, in the wealth of religious buildings, the decoration of its churches and in the production of its silk factory, used to make religious vestments.

related to the growth and development of Italy and Europe through the four centuries.

The history of the local people, their society, economy, culture and other aspects such as demographic patterns can all be traced through the documents. Lucca was a rich community and imperial and papal privileges and provisions, agrarian and commercial contracts, sales, loans and donations are all recorded.

The documents reveal further changes, both through the centuries and in different geographical areas, in practices in handwriting, parchment and miniature preparation and the use of colours and gold in manuscripts.

◄ *Lucca today*

The Book of Kells

Inscribed 2011

What is it

The Book of Kells, dating from around AD 800, contains a copy in Latin of the four Gospels of the life of Jesus Christ, along with ancillary texts. Its fame rests principally on the extent and artistry of its lavish decoration.

Why was it inscribed

The Book of Kells is widely regarded as Ireland's greatest historical treasure, and is one of the most spectacular examples of medieval Christian art in the world.

Where is it

Trinity College Library, Dublin, Ireland

Christianity came to Ireland in the 5th century and spread rapidly. Gospel books and psalters were produced in large numbers from this time. The Book of Kells is the greatest example of a decorated manuscript Gospel book from the 7th to the 9th centuries, the period known as the 'Golden Age' of Irish art.

The Book of Kells is widely believed to date from around AD 800. The principal foundation of the great Irish missionary and scribe St Colum Cille (died 597) was on the small island of Iona, off the west coast of what is now Scotland. Following the sack of the island by Vikings in the year 806, and the killing of sixty-eight of the community, the building of a new and less vulnerable house was begun the next year at Kells in county Meath, about 60 km north-west of Dublin, and completed in 814. It was traditionally believed that the Book of Kells was the work of St Colum Cille himself, a tradition which persisted well into the 19th century. There has been considerable academic debate on whether it was executed in its entirety at Iona or at Kells, or whether it was begun at Iona and completed at Kells; and so whether it was produced before or after 806 or whether, indeed, it was written in Northumbria or even Pictland.

Its lavish and complex decoration differentiates the Book of Kells from other manuscripts of the period. This text is decorated and at the same time elucidated with images of great iconographic subtlety. Important words and phrases are emphasized and the text is enlivened by an endlessly inventive range of decorated initials and interlinear drawings. The greatly decorated pages, upon which the book's celebrity mainly rests, comprise symbols and portraits of the evangelists, introducing the Gospels; portraits of Christ and the Virgin and Child; illustrations of the temptation and the arrest of Christ; and decorations based on initial letters and Christian symbols. No other Gospel manuscript of the period was planned or executed with such an elaborate decorative scheme. Little is known for certain about the circumstances of production of the Book of Kells and we do not know the names of its scribes or artists.

The Book of Kells is a large manuscript now containing 340 folios (680 pages), measuring in the region of 330 x 255 mm. Originally, the leaves probably

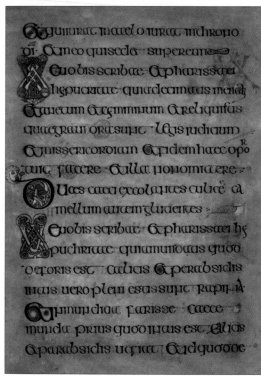

◄ A page from the Gospel of Matthew, showing the wealth of decoration used to enliven a page of text.

A portrait of Christ from the Book of Kells. A cross is placed above Christ's head and he is flanked by angels and by two peacocks standing behind two chalices. ►

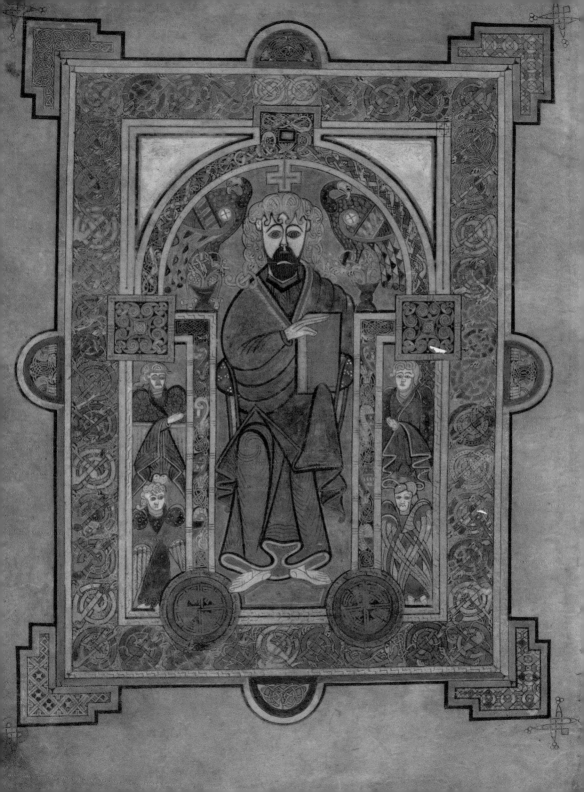

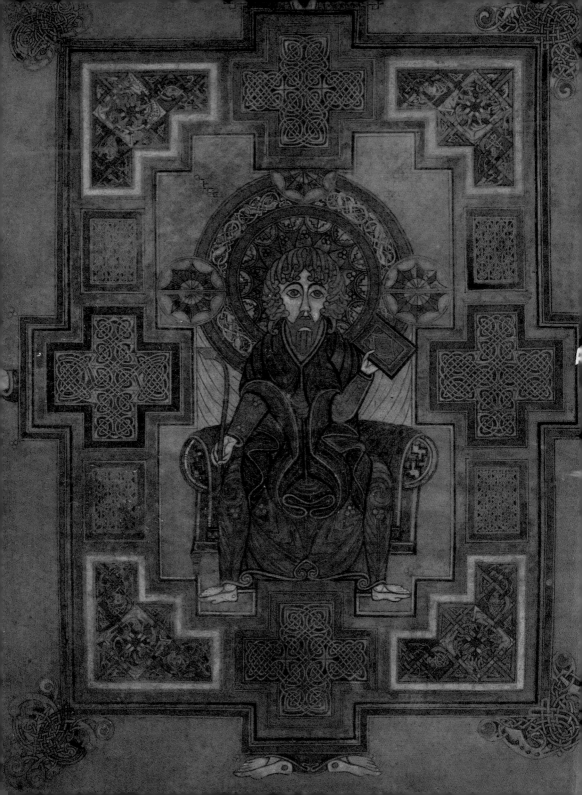

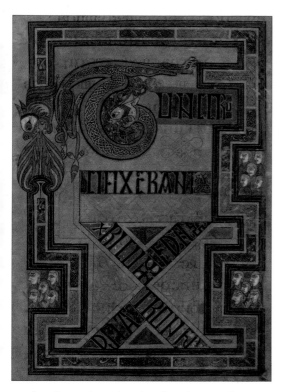

◀ A page from St Matthew's Gospel in the Book of Kells: Tunc crucifixerant Xpi cum eo duos latrones *(Then were crucified with him two thieves)*.

numbered around 370: there have been losses to the beginning and end of the manuscript. Since 1956 it has been housed, for reasons of conservation, in four separately bound volumes, one for each of the Gospels. It is written on calfskin vellum, mostly using iron gall ink, with carbon black, purple, red and yellow inks used on a few pages. The script is best described as insular majuscule. Decoration has been applied in mineral and organic pigments, with the basic palette including red, blue, yellow, green, purple/pink and white, frequently layered or mixed.

For many in Ireland, the Book of Kells is as a reminder both of the Christian faith and of high artistic achievement at an early historical date. In a sense, it has also transcended its primary function as a Christian artefact and has become a symbol of Irish culture worldwide.

◀ An image of St John, shown holding the symbols of a scribe.

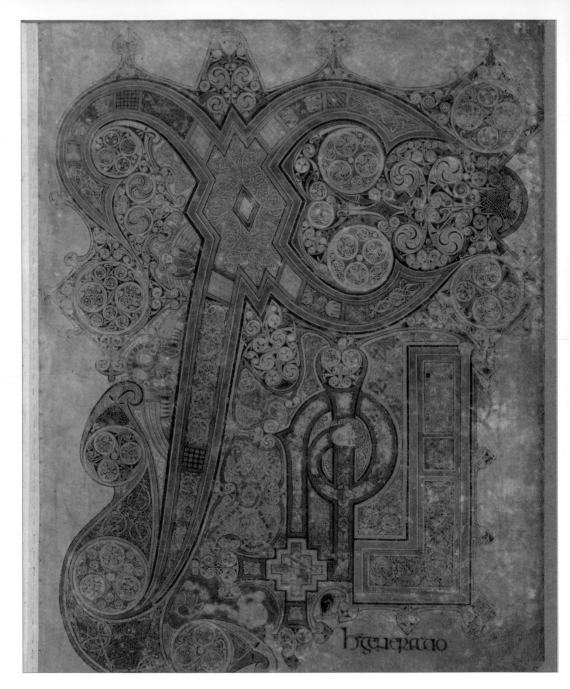

▲ *The Chi-Rho page, so named because the first two letters of Christ's name in Greek were* chi *and* rho, *at the start of Matthew's account of the birth of Christ* (Christi autem generatio).

Laghukālacakratantrarājatikā
(Vimalaprabhā)
Inscribed 2011

What is it
The *Vimalaprabhā* is an exhaustive commentary on the Kālacakra Tantra, one of the most important Tantras in Tibetan Buddhism, which has now spread to other parts of the world. One complete and one incomplete copy of the *Vimalaprabhā* have been registered.

Why were they inscribed
The complete copy of the *Vimalaprabhā* is regarded by scholars of Tibetan Buddhism as the oldest in existence. It is one of the most important Tantras not only in India, but also in Tibetan Buddhism, and it discusses many Indian philosophical concepts.

Where are they
Asiatic Society, Kolkata, India

commenced their studies in Buddhism, abundant literary materials in Nepal were discovered. B.H. Hodgson, an English administrator, ethnologist and a resident at the royal court of Nepal, bequeathed 144 manuscripts to the Asiatic Society in Kolkata with a view to preserving them. Among the manuscripts that have been collected is this unique and complete text of the *Vimalaprabhā*. All other known manuscripts of the *Vimalaprabhā* are incomplete. The complete palm-leaf manuscript was copied in the thirty-ninth year of Harivarman of Bengal (last half of 10th century), which makes this the oldest extant copy of the commentary, transcribed a little over one hundred years after the commentary was composed.

The *Laghukālacakratantrarājatikā* (*Vimalaprabhā*) is the most important commentary on the Kālacakra Tantra, which was delivered by the Buddha at Dhānyakataka in South India. Buddhist Tantric literature is both vast and extensive, and the Kālacakra Tantra is a distinguished paradigm among them. It was on this Tantra that the King Pundarāka, one of the thirty-two kings of Shambhala, composed the great encyclopedic commentary named *Vimalaprabhā* in the 9th century.

In addition to the text of the Tantra, the commentary contains detailed discussions of philosophy, astrology and astronomy. There is also discussion on the lesser known wisdom of svarodaya. Āyurveda occupies an important thematic focus in the Tantra. Measurements of the globe are given which are more detailed than those in the *Abhidharmakosa*, a celebrated 4th-century text authored by Acharya Vasubandhu, which is itself a renowned encyclopedia of information.

There were once a large number of manuscripts of Kālacakra Tantra and its commentaries in India. However, as Buddhism disappeared from India during the 12th and 13th centuries, a large body of Buddhist literature was lost. Many of the literary manuscripts were taken to neighbouring countries and regions such as Nepal and Tibet. In the 19th century, when European scholars

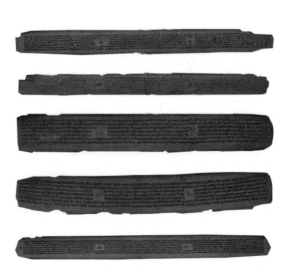

▲ *Pages from the palm-leaf manuscript of the* Laghukālacakratantrarājatikā.

The collection of the Al-Biruni Institute of Oriental Studies

Inscribed 1997

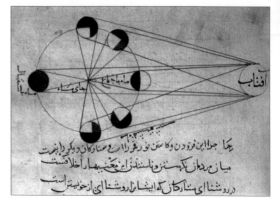

▲ *A diagram showing the phases of the moon from al-Biruni's Tafkhim li Availi Sinaat al-Tandjim ('The Book of Teaching of the Fundamentals of Astrology'). The Collection contains one of the oldest copies of this very important astronomical work.*

What is it

This unique collection of works by the great scholars, poets and thinkers of Central Asia contains many original manuscripts and rare copies of major works on history, literature, philosophy, law, mathematics, the sciences and the fine arts.

Why was it inscribed

These manuscripts are of great significance in the development of Islamic science and culture as well as for the study of the history and culture of the peoples of Central Asia, India, Pakistan, Afghanistan, Iran and the Arab world, and of the political, diplomatic and cultural relations between them.

Where is it

Al-Biruni Institute of Oriental Studies, the Academy of Sciences of the Republic of Uzbekistan, Tashkent, Uzbekistan

The collection of around 18,000 manuscripts is one of the richest depositories of Central Asian manuscripts in the world and reflects the importance of this region at the heart of the cultural exchange that took place along the Silk Road from China to the Mediterranean.

Many of the great medieval scholars, poets and thinkers of Central Asia and the Near and Middle East are represented in this collection. Their work has greatly enriched our spiritual life and contributed to the advancement of science, whether in geography and mathematics (the works of al-Biruni), astronomy (Ulugh Bey's comprehensive *Star Charts*), philosophy (for example in the works of al-Farabi), medicine (Ibn Sina's *Canon*) and in works of great literature (including the writings of Ferdowsi, Rumi and Khayyam). In addition, many works are invaluable for the study of Central Asian history, such as the 10th-century *Takhkiki Viloyat'* and *Bukharo Tarikhi'* by Ibn Jaffar Narshani, which describes the great trading city and Islamic intellectual centre of Bukhara, now in Uzbekistan. A number of historical works relate to the Mughal dynasty including the *Tabakati Akbarshahi'* by

al-Kharavi, dating from 1595, which serves as the main source for the history of India during that period.

The collection as a whole reflects the remarkable flowering of Islamic science and culture during the Middle Ages which was later to exercise a profound influence on Renaissance scholars in Europe. One of the oldest manuscripts (by Ibn Salam) is from AD 837.

Among the rare works in the collection are one of the oldest known copies of al-Biruni's *Tafkhim li Availi Sinaat al-Tandjim* ('The Book of Teaching of the Fundamentals of Astrology'); fragments of poems by Ibn Sina, better known as philosopher and physician, and the only known copy of his book *Salman and Ibsal*; the *Haft Awrang* ('Seven Colours') and other works by Jami in the author's own hand; one of the only three known copies in the world of the *Kitab-e-Sindbad* ('The Book of Sindbad'). Many of the manuscripts contain exceptional examples of calligraphy, while others contain wonderful miniatures and elaborate contemporary bindings.

The collection was started with the founding of the Department of Oriental Studies at the Uzbekistan Public Library in 1870. The collections of the Scientific Research Institute of Samarkand, the Ibn Sina Library of Bukhara, the libraries of the Khans of Khiva and many others were added, and in 1943 the Al-Biruni Institute of Oriental Studies became the home of these collections.

Philippine paleographs
(Hanunoo, Buid, Tagbanua and Pala'wan)
Inscribed 1999

What is it

Four samples of Philippine paleographs dating back to at least the 10th century, in four of the traditional scripts of the islands – Hanunoo, Buid, Tagbanua and Pala'wan.

Why was it inscribed

The paleographs are syllabaries – that is, characters that represent complete syllables – and are the only four surviving scripts out of seventeen once used throughout the Philippines.

Where is it

Various locations, Mindoro province, Philippines; various locations, Palawan province, Philippines; National Museum, Manila, Philippines

Syllabaries are phonetic systems of writing in which symbols represent sets of consonants and vowels, so articulating sounds. The syllabaries of the Philippines were the ancient writing systems of the islands used before the arrival of the Spanish in the 16th century.

The scripts reflect a long period of cultural and social interchange and relationships between peoples located as far apart as India and Southeast Asia, which were related to population movements across the Austronesian family of languages, especially the Malayo-Polynesian branch. In particular, the syllabary has been related to other Sanskrit-derived writing that has been traced to the syllabaries in Sulawesi and Java to the south of the Philippines.

The oldest of the sample paleographs is an inscription in copper plate that bears a date of 850 in the Saka or Indian calendar, equivalent to AD 928; this was discovered in southern Luzon. The script relates to an ancient Malay language although it is similar to other Indonesian paleographs. A second paleograph, dating from the 14th to the 15th centuries and inscribed on a piece of silver associated with Ming dynasty burials, was found in the island of Mindanao. A third from the same period was inscribed on the shoulder of an earthenware pot excavated in the Batangas province on the island of Luzon.

The scripts were also often written on bamboo and palm and banana leaves and were used particularly as a way of sending messages between isolated communities. They were also used in poetic forms, such as the *ambahan* and *urukay* poetry of the Hanunoo and Mindoro Buid respectively. Of the seventeen documented scripts that existed in the Philippines in the 16th century, only four remain in use to this day – those of the Tagbanua and Pala'wan people of Palawan island, and of the Hanunoo and Buid on Mindoro island.

The scripts are expressive of the distinct culture of the islands that is threatened with extinction in the drive for homogeneity and a common global culture expressed not only in the widespread adoption of the Western alphabet but also by modern technology, especially phones and text messaging.

The Hanunoo script is still in use and relative isolation from mainstream society keeps the Buid script alive; both are currently used in *ambahan* poetic works and songs. However, the Tagbanua and Pala'wan scripts are in decline and the National Museum has an active programme to teach the scripts within the communities.

Georgian Byzantine manuscripts

Inscribed 2011

What is it

A collection of 451 Byzantine manuscripts from Georgia, dating from the 10th to the 15th centuries.

Why was it inscribed

The manuscripts are a unique remnant and resource of Georgia and the Eastern Roman Empire, in both content and importance. They help illustrate development of Georgian Byzantine culture and expression over the medieval period.

The content of the manuscripts is in many cases unique, preserving writing lost in Greek and other languages as well as the names and works of Byzantine authors known and unknown. The collection gives a striking overview of Georgian cultural heritage and the literary processes of the Byzantine period.

Where is it

National Centre of Manuscripts, Tbilisi, Georgia

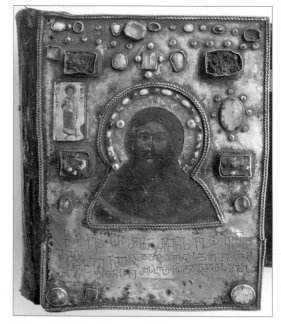

▲ Cover of the 'Alaverdi Four Gospels' (AD 1054)

The 'Berta Four Gospels' (12th century) ▼

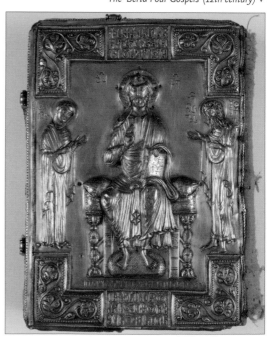

The Eastern Roman Empire was centred on the city of Byzantium, renamed Constantinople in AD 335 when the Emperor Constantine I chose it as his capital. The split between the Eastern and Western Empires came around the end of the 4th century AD when Rome was buckling under internal instability and corruption and waves of attack from various tribes. By contrast, although there were periods of setback, the Eastern Roman Empire – also known as the Byzantine Empire – grew as a first-rank power with strong economic, cultural and religious influences within its lands and beyond.

Georgia's location on the eastern shores of the Black Sea left it in the sphere of influence of the Roman Empire for over a millennium. The country became a client state of Rome when the Romans conquered the Caucasus region. Its conversion to Christianity in the 4th century meant not just geographical and political closeness but also ties to the empire in religion and culture, until its fall to the Ottoman Turks in 1453.

These influences are reflected in the magnificent collection of Georgian Byzantine manuscripts. The 451 works span a period of six centuries, so reflecting the

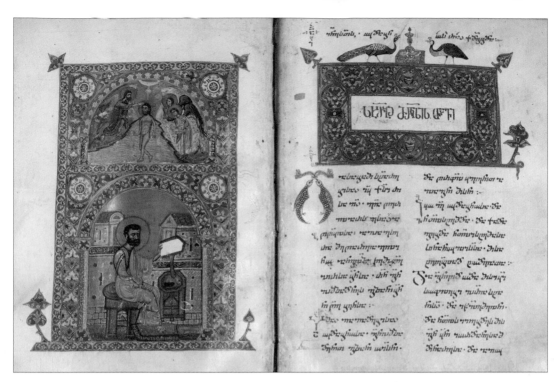

Pages from the 'Vani Four Gospels' (12th-13th centuries)

A page from the 'Gelati Four Gospels' (12th century) ▼

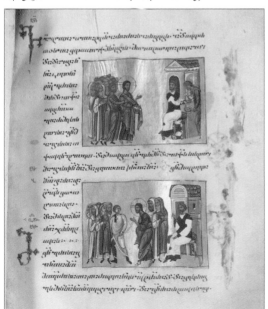

development of Byzantine-influenced Georgian religion and literature both under the empire and after its fall.

Centres of Georgian culture existed across the region and further south into the Holy Land, and the manuscripts were created in all these places. The manufacture of manuscript books called for successive, interconnected processes – producing parchment, rewriting, painting text pages and decoration – and was usually the combined work of several specially trained individuals. Among the most notable centres were monasteries in Georgia itself, in Palestine and on Mount Sinai, in Jerusalem and in Bulgaria, where works were translated from the Greek and original hymnographies and liturgical works were created. The development of the Georgian alphabet and the movement towards cursive script can be traced through the works.

Illustrated manuscripts in the Byzantine style spread to Georgia, where the techniques of illustration were learned. The manuscripts in the collection are lavishly decorated, with detailed illustrations and animal and floral decorative elements characteristic of the Byzantine world. Contemporary painters normally represented space by means of a gold background and *The Gospel from Mokvi*, dated 1300, was actually made on gold.

Most of the work is religious and sacred in nature, ranging from Bible expositions through hymnographies to works of theology and polemics. However, the works of the Byzantine Church fathers are particularly notable: these include texts by John Chrysostom, Gregory of Nazianzus, Basil the Great and Maximus the Confessor.

Much of the collection is unique, containing material not seen anywhere else. Some texts preserve works lost in Greek and other languages; some make references to Byzantine authors whose work is known; others document the life and works of writers previously unknown in the modern era.

In addition to religious and liturgical texts, there are also secular works relating to law, history, literature, astronomy and medicine. Several of the religious works also contain secular passages, such as descriptions of battle scenes in a book of psalms. Some of these texts also contain information that is no longer known or used, and so is only available through written sources such as these. In addition, the terminology they use in relation to financial and administrative systems and aspects of society and culture, is characteristic of the Byzantine era.

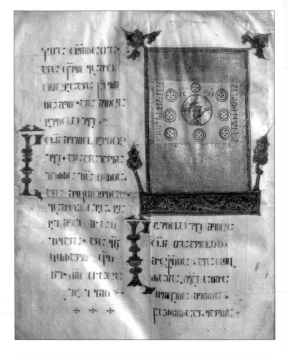

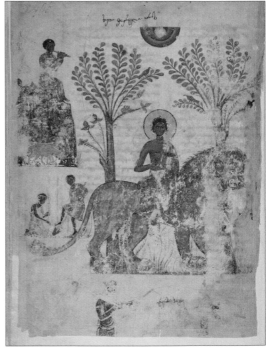

(top) A page from the 'Alaverdi Four Gospels' (AD 1054) ▲

(bottom) 'The Works of Gregory the Theologian' (12th century) ▶

Deeds of sultans and princes

Inscribed 2005

What is it

Four hundred deeds, on paper and parchment scrolls, of the princes and sultans who ruled Egypt for more than 500 years from the Fatimid era in the 10th century to the end of the Mameluke dynasty in 1517.

Why was it inscribed

The deeds in the collection are considered a main source for the history of Egypt and for its relations with other countries with which it had trading, cultural, religious and educational links in the period from AD 970 to 1517.

Where is it

National Library and Archives of Egypt, Cairo, Egypt

The collection is composed of title deeds which record transactions related to selling, buying, endowing and proving ownership of property. As a consequence, they allow an insight into the geography of the region and town plans in the late-medieval and early-modern period through various descriptions of streets, shops, mosques, churches, schools and libraries.

The documents also allow a picture to emerge of society and its levels, divisions and classes; different occupations and their requirements; the types of contemporary industry and the methods of appointing employees, together with wages and living conditions; trade between Egypt and other countries; military organization, ranks and their titles; building industry terms and the prices of land and real estate.

The information in the deeds falls into several categories. Those dealing with historic and architectural monuments contain information on Islamic mosques, Coptic Christian churches, monasteries and graveyards and Roman churches, buildings and walls still extant. Other buildings mentioned in the deeds include schools, hospitals, baths and public fountains; and military monuments such as forts, towers, castles and fences. The deeds are a rich source of detail of Ottoman architecture and ornamental inscription in their depictions of buildings and building materials. Detailed descriptions of contemporary coinage, including weight, shape and value also feature.

Aspects of the deeds that deal with economic matters include endowments, sales, exchanges and gifts. Commonly used weights and measures are recorded as are trade transactions, employees' wages, the prices of various items including land and buildings and the amount of tribute or poll tax that Muslim rulers demanded from their non-Muslim subjects. The language and terminology in the documents also allow Islamic scholars to determine which of the four schools of thought within Islam was prominent at a particular time.

The deeds are written in dotless Arabic on both sides of the paper, in various calligraphic styles. They are written in characteristic legal terminology, recording in detail the subject of the deed, the eligibility of those involved, all witnesses, monies due and the date. The longest of the deeds is 40 metres in length and its width ranges from 34 to 45 centimetres.

Illuminated manuscripts from the Ottonian period produced in the monastery of Reichenau

(Lake Constance)

Inscribed 2003

What are they

A dispersed set of ten manuscripts, dating from c.965 to 1020, produced during the Ottonian period in Germany. The illuminations in the Reichenau manuscripts feature miniatures of the life of Christ and portraits of emperors.

Why were they inscribed

The manuscripts are magnificent examples of Ottonian art and represent the climax of medieval German manuscript illumination. They were written and decorated for the emperor or high representatives of the church at a time when the Reichenau scriptorium flourished.

Where are they

Libraries in Munich, Bamberg, Darmstadt, Trier and Paris, the cathedral treasury at Aachen and the Museo Archeologico Nazionale at Friuli

After the decline of the Carolingian Empire at the end of the 9th century, political consolidation, the renewal

Pages from the Book of the Gospels *of Emperor Otto III.* ▶

of the idea of the Holy Roman Empire under Ottonian rule and the reform of the church all contributed to a period of cultural revival. With sponsorship from the emperor and influential imperial bishops, the great churches of the empire were provided with priceless equipment and choice manuscripts. The intense intellectual, cultural and religious climate inspired artistic masterpieces as demonstrated by these illuminated manuscripts. The illustrations reflect the spirituality of the time, and their ambitions can be inferred from the models on which the new art was based: paintings from Late Antiquity, the Carolingian period and Byzantium. Yet their intention was not imitation, but creative new design.

The ten selected manuscripts were produced in the scriptorium of the Benedictine monastery of Reichenau (Lake Constance) between c.965 and 1020. While three of the manuscripts represent the earlier period, the other manuscripts selected were produced during the high period of the workshop and are the most outstanding examples of the Ottonian art of illumination. The iconographic tradition developed here formed the basis of the medieval Romanesque manuscript illumination.

Their history is closely connected with the coronation church at Aachen and the bishoprics of Bamberg, Cologne

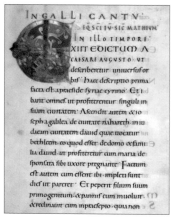 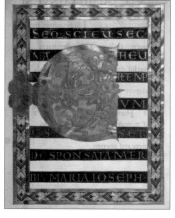 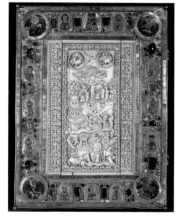

▲ *Pages from the* Book of Pericopes *of Emperor Heinrich II. The illuminated manuscripts created at the Reichenau monastery by Lake Constance in the 10th century are supreme examples of German medieval artistry.*

▲ *The elaborate binding of the* Book of Pericopes *of Emperor Heinrich II containing an ivory panel dominated by Christ's crucifixion.*

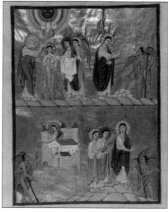
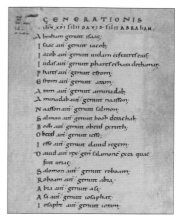

and Trier which received the books for liturgical use. The full-page portrait of Emperor Otto III (983–1002) is the artistic highlight of his *Book of the Gospels*; the miniature has been interpreted as a representation of Otto's political agenda, which was based on the revival of Rome as the centre of the Roman Empire. As the son of the German Emperor Otto II and the Greek princess Theophanu, Otto III embodied the merging of Western and Eastern traditions which are reflected in the manuscript's treatment of classical and Byzantine art. Emperor Heinrich II (1002–1024), who is shown together with his wife in a coronation scene in his *Book of Pericopes*, endowed his newly founded bishopric at Bamberg (1007) with several manuscripts (including the so-called *Bamberg Apocalypse*). The books thus symbolize the view of the ruler as protector of the church who was installed by God himself. By adding the ruler's portrait to the book, both his support of the church and his inclusion into prayer are captured visually.

The manuscripts contain different versions of Jerome's Latin translation of the Gospels, a text at the very centre of Western medieval culture. From the time of its standardization under Charlemagne (768-814) until the Second Vatican Council (1962-65), the Latin Book of Gospels formed an integral part of the Roman Catholic Mass. The full text of the four Gospels is shown in three manuscripts whereas five manuscripts present only those passages from the Gospels which are read during Mass (pericopes) following the order of the Church year. One further manuscript contains three books from the Old Testament and another manuscript, the Psalter, while one of the volumes of pericopes also contains the full text of the Revelation of St John (the Apocalypse). In addition to portraits of the emperors, clerical sponsors and the four evangelists, they contain the earliest examples of a narrative pictorial cycle based on the four Gospels and the most splendid rendering of the apocalypse in Western medieval art.

◀ ▲ *Pages from the* Book of the Gospels *of Emperor Otto III*

The jewel-encrusted binding of the Book of the Gospels *of Emperor Otto III* ▶

Enina Apostolos, Old Bulgarian Cyrillic manuscript (fragment) of the 11th century

Inscribed 2011

What is it

A fragment of thirty-nine parchment folios, forming the oldest extant Slavonic copy of the Acts and Epistles of the New Testament.

Why was it inscribed

The fragments contain one of the oldest forms of Cyrillic script that is evidence of the crucial change in the history of the Slavonian conversion to Christianity. The *Enina Apostolos* has unique historical significance as testimony of the old Cyrillic script, in the region from which it emerged.

Where is it

SS. Cyril and Methodius National Library, Sofia, Bulgaria

The 11th-century *Enina Apostolos* is the most ancient extant Slavonic copy of the Acts and Epistles. Written on parchment, the fragment represents one of the oldest forms of the Cyrillic script. It is important in the history of Slavonic literacy and in particular, of the translations from Greek made by St Cyril and St Methodius and their disciples. The translations were transmitted in East Bulgaria at the end of the 9th century and the beginning of the 10th century.

▲ *SS. Cyril and Methodius National Library, Sofia, Bulgaria*

◀ *St Cyril and St Methodius*

Enina Apostolos is akin to other ancient Old Bulgarian manuscripts, but has several very distinctive features. The script is archaic Cyrillic ustav (uncial), sloping to right and hanging from the ruling line, 3–3.5 mm high. The illumination is represented by two headpieces, of the band- or strip-type, and several initials preceding each reading. Their ornament is prevailingly geometric with early elements of the Slavonic teratological style. A peculiar feature of the decoration is the giant initial on f. 1v, comparable to those in two Glagolitic manuscripts – Codex *Zographensis* and *Codex Marianus*, both datable to the 10th century.

Even though the greatest part of the copy is missing, the extant leaves form a unity, the synaxarion comprising

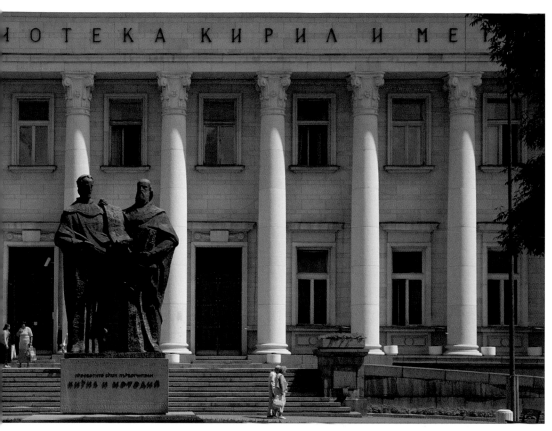

the readings from the Acts and Epistles provided for the services between the thirty-fifth week after Pentecost and Holy Saturday, and the menologion comprising readings for the period between 1 September (the beginning of the indiction) and 3 October, the commemoration of St. Dionysius Areopagites.

The readings supplied with their corresponding liturgical elements: antiphons, prokeimena and alleluia, together with the liturgical indications are a valuable source for the earliest liturgical practices introduced with the conversion of Bulgarians and followed by Bulgarian Church in the epoch of the First Bulgarian Kingdom. The language of *Enina Apostolos* is an ancient example of the phonetic and syntactic features of Old Bulgarian.

From the time of its discovery until today the fragment has proven to be of crucial importance for establishing basic linguistic, textological, orthographic, paleographic, historic and liturgical issues of the Slavonic cultural heritage based on the works of St Cyril and St Methodius.

The text of the Apostolos Lectionary (selected parts or readings from the Acts and Epistles, arranged according to the liturgical calendar) is of great importance as it comprises the basic formulac of Christian dogma. As an inseparable part of the text corpus for the Christianization of Slavs and the performing of Slavonic liturgy in vernacular, the New Testament text preserved in *Enina Apostolos* is a witness of the affiliation of Slav people to Christianity – a crucial change in their history and culture.

Kandilli Observatory and Earthquake Research Institute manuscripts

Inscribed 2001

What are they

Manuscripts on Islamic astronomy, mathematics and astrology and other subjects from the 11th century up to the 20th century.

Why were they inscribed

Astronomy, astrology, mathematics and medicine were core disciplines of Islamic science in the Ottoman Empire and this is one of the finest collections of manuscripts on these subjects in the world.

Where are they

Library of the Kandilli Observatory and Earthquake Research Institute, Bogaziçi University, Istanbul, Turkey

▲ A manuscript from the collection

Medicine, mathematics and astronomy were the core disciplines of Islamic science in the Ottoman Empire and there were many works written on these subjects in Turkish, Arabic and Persian. The Library of the Kandilli Observatory and Earthquake Research Institute contains astronomical, astrological, mathematical, geographical and miscellaneous works dating from the 11th century to the early 20th century. This collection of 1339 works contains a number of unique and rare manuscripts and occupies an important place among other related manuscript collections in the world, especially as its works on astronomy and astrology are crucial not only to scholars of the Ottoman Empire and the Islamic world, but also to Western scholars in the field. The manuscripts in the library were donated to the Institute by the founder and the first director of the observatory, Fatin

Gökmen (also known as Fatin Hoca), who oversaw the start of operations in July 1911. The Kandilli Observatory and Earthquake Research Institute was under the responsibility of the Turkish Ministry of Education until 1982, when it came under Bogaziçi University, Istanbul.

Among the treasures in the Kandilli collection is a calendar in Persian prepared in 1489–90 and presented to Sultan Beyazit whose personal seals are found at the beginning and end of this calendar. Other calendar scrolls are designed by month of the year, with details of the partial and total eclipses of both the sun and moon, and have gilded decorations and calligraphy of great artistic merit. The *rûznâmes* (daily calendars) show the religious festivals and prayer times in the Islamic world. Other significant items in the collection include astronomical tables prepared through the use of Takiyeddîn's works, the translations of Ali Kuscu's *Hulâsatu'l-hey'e* and *Mirkatu's-semâ* and Ulugh Bey's astronomical tables, which overall reflect the cultural and scientific achievements of the Ottoman Empire.

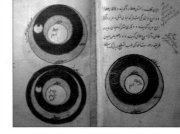
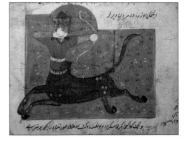

▲ Treasures from the Kandilli collection

Codex Suprasliensis –
Mineia četia, Mart
(The Supraśl Codex – Menology, March)
Inscribed 2007

What is it
The largest and oldest of the few surviving manuscripts written in Old Church Slavonic.

Why was it inscribed
Codex Suprasliensis is the main source for studying Old Church Slavonic. It is also one of the earliest testimonials to the reception of Orthodox Christianity among the Slavs.

Where is it
National and University Library in Ljubljana, Slovenia;
National Library of Russia, St Petersburg, Russia;
National Library, Warsaw, Poland

▲ Codex Suprasliensis

The *Codex Suprasliensis* is a unique manuscript written by a monk named Retko around 1014 in one of the monasteries near Preslav, the old capital of Bulgaria. In 1823 it was discovered by Professor Michał Bobrowski in the library of the Basilian monastery in Supraśl near Białystok, Poland, where it had been brought by monks from Athos, Greece. The item was divided in 1838 and 1839 and is now kept in three libraries: in Warsaw, Ljubljana and St Petersburg.

The codex was written in Old Church Slavonic, using the Cyrillic alphabet in Slavonic majuscule. It consists of 285 (118+16+151) parchment folios. It describes the lives of saints and the teachings of fathers of the church for readings in March (the final fragment of Mineia četia). It is especially valuable for linguists who study Old Slavonic languages because of its age and extent. It does not possess illuminations; its decorations are very modest and consist of ink-painted initials and narrow vignettes. The script is a very beautiful, regular, broad Cyrillic.

Old Church Slavonic was the first literary Slavic language, developed by the 9th-century Byzantine Greek missionaries St Cyril and St Methodius who used it to translate the Bible and other Christian texts into a language that ordinary Slavic peoples could understand. The introduction of a national language to the liturgy

influenced the reception of a religion and had great significance in forming national languages.

The codex is irreplaceable as a testimonial to Orthodox Christianity and Slavdom at the time when Old Slavonic was evolving into national languages (Old Bulgarian, Old Slovenian, Old Polish). Being supranational and supraregional, it is a significant fragment of European and world culture.

The discovery of the codex in the 19th century was important for the rapidly developing field of Slavonic studies and for the strengthening of national consciousness among the Slavs who were subjects of the Austro-Hungarian Empire and the Turkish state (e.g. Bulgarians, Slovenians, Serbs).

The first part of the codex (Ljubljana) consists of sixteen unbound quires (one hundred and eighteen folios) kept in a special acid-free case. The text contains twenty-four lives of saints and twenty-three homilies, separate for Lent and Easter cycles, and one prayer.

The second part of the codex (St Petersburg) consists of two quires (sixteen folios). The text contains Colloquy on Annunciation, assigned to John Chrysostom; Colloquy on Annunciation by John Chrysostom, 25 March; St. Irene's Torment, 26 March; Torment of the St. Iona and St. Varahisi, 29 March.

The third part of the codex (Warsaw) consists of 151 folios. The text contains: six lives of saints, eighteen sermons of John Chrysostom, one sermon of Photius (patriarch of Constantinople) and one sermon of Epiphanius.

The works of Ibn Sina in the Süleymaniye Manuscript Library

Inscribed 2003

What is it

This is the largest collection of manuscript copies, some of them dating back to the 11th century, of the surviving works by Ibn Sina, often known in the West by the Latin name of Avicenna. The manuscripts are unique and some are rendered more precious because of their calligraphic style, illuminations, miniatures, illustrations and bindings.

Why was it inscribed

Ibn Sina, the great physician, scientist and philosopher of Islam during the 11th century made a major contribution to learning and was an important figure in the transfer and mutual contact between Arab and European cultures.

Where is it

Süleymaniye Manuscript Library, Istanbul, Turkey

Ibn Sina (980–1038) was born in Afshana, a village near Bukhara, now in Uzbekistan, and died in Hamadan, now in Iran. He was the most eminent scientist, philosopher, pharmacologist, theorist, poet and politician of his time. He is often known as a physician under the Latin name of Avicenna. He also wrote a large number of books, essays and treatises. Ibn Sina was so famous that he was entitled al-Shaikh al-Rais ('The Chief Teacher') by his compatriots or just 'Shaikh' by his disciples. His works gradually filtered to Europe where they were received with the same enthusiasm. Al-Qanun Fi'l Tıbb ('The Canon of Medicine') is the work that inspired European scholars to call him the Medicorum Principes.

Though there is no dispute about where Ibn Sina was born or where he died, his background is debated. However, according to his own words in Al-Qanun Fi'l Tıbb, it is reasonable to accept him as a Turk from Central Asia. The fact that he wrote mostly in Arabic is due to his desire to abide with the unwritten rule of the era: the language of religion was the language of science since both aimed to be understood universally. Consequently, Latin was used for scholarly works in the Christian World, while Arabic was the common language used by Muslim scholars.

The Süleymaniye Manuscript Library houses perhaps the richest collection of Ibn Sina manuscripts in the world, totalling 263 separate titles (with some multiple copies, reaching a total of nearly 600 volumes). All are manuscripts; some contain illuminations, some have thematic drawings and some have unique gilded bindings. The subjects covered include philosophy, logic, philosophy of religion, mysticism, linguistics, literature, mathematics, physics, chemistry, medicine, politics, geography and astronomy. Most of the works that carry a copy date were written between 1022 and 1728. One of the copies of Al-Shifa ('The Book of Remedy') is believed to have the authorization signature of Ibn Sina himself. This collection also includes his correspondence with the world famous philosopher al-Biruni.

Many of his books, especially the medical encyclopedia, Al Qanun Fi'l Tıbb, were translated into Latin and other Western languages. The 'Canon' was used between 1400 and 1600 as the main medical text in various medical schools in Europe, and by this route, much classical Greek medical knowledge was reintroduced into Europe, having been lost during the Dark Ages. There are fifty-eight copies of the 'Canon' in the collection as well as translations into Ottoman Turkish and Latin. The Latin version carries the date 1510 and includes a picture of a crowned Ibn Sina, between the great Roman and Greek physicians Galen and Hippocrates, which proves the importance given to this great scientist at that time.

A decorated chapter opening of a work by Ibn Sina ▶

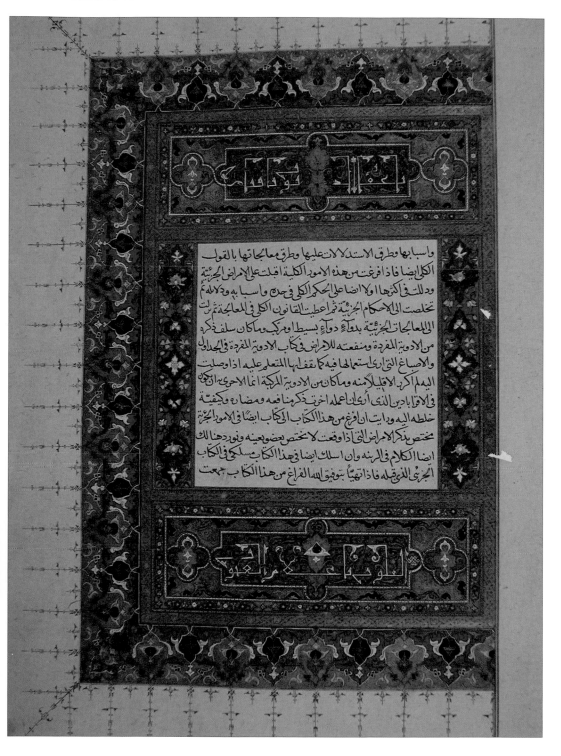

واسبابها وطرق الاستدلال لان عليها وطرق معالجاتها بالقول
الكلي ايضا فاذا فرغت من هذه الامور الكلية اقبلت على الامراض الجزئية
ودللت في اكثرها ولا ايضا على الحكم الكلي في جنس واسبابه ودلالة ثم
تخلصت الى الاحكام الجزئية ثم اعطيت القانون الكلي في المعالجة ثم دللت
المعالجات الجزئية بدواء دواء بسيط ومركب ومكان سلف ذكره
من الادوية المفردة ومنفعته للامراض في كتاب الادوية المفردة في الجداول
والاصناغ التي تستعملها فيه كما يقف عليها المتعلم عليه اذا وصلت
اليه الم اكرر الا قليلا منه ومكان من الادوية المركبة انا الاحرى ان يكون
في الاقرابادين الذي اريد ان اعمله اخبرت بمنافعه ومضاره وكيفية
خلطه اليه ورايت ان افرغ من هذا الكتاب الى كتاب ايضا في الامور الجزئية
مختص بذكر الامراض التي اذا وقعت لا يختص بعضو بعينه ونورد هنالك
ايضا الكلام في الربنه وان اسلك ايضا في هذا الكتاب مسلكي في الكتاب
الجزئي الذي قبله فاذا انتهينا بتوفيق الله الفارغ من هذا الكتاب جمعت

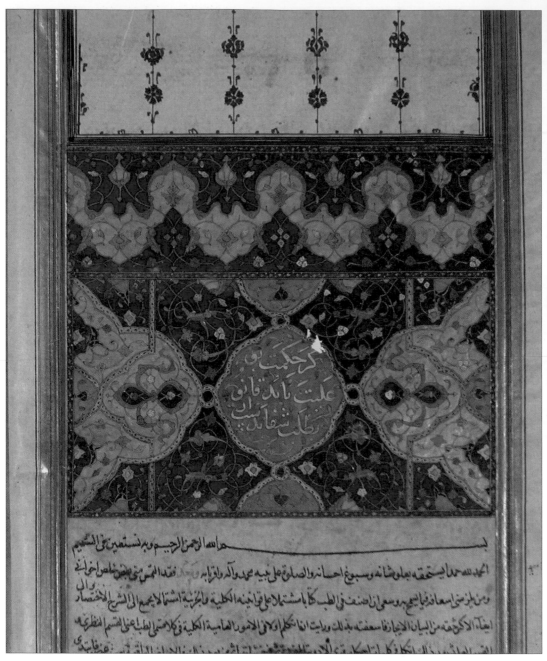

▲ *The first page of a copy of* Al-Qanun

Next page, top left and clockwise: A decorated chapter opening
of a work by Ibn Sina; A gilded binding of an edition of Al-Qanun;
The title page from a copy of Ibn Sina's Al-Qanun, *better known*
to Renaissance Europe as 'Avicenna's Canon', the great medical
textbook; A decorated page from a copy of Al-Qanun ▶

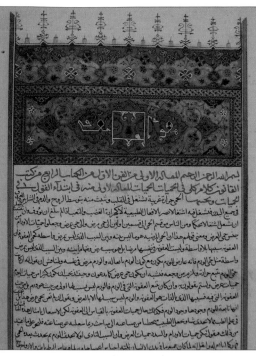

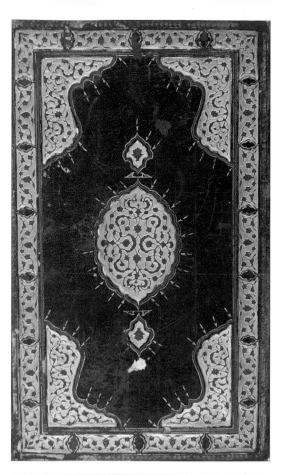

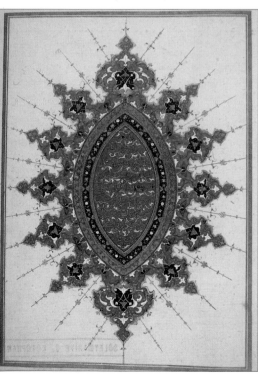

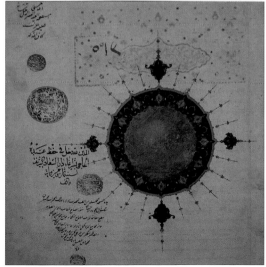

Al-Tafhim li Awa'il Sana'at al-Tanjim ('The Book of Instruction in the Elements of the Art of Astrology')

Inscribed 2011

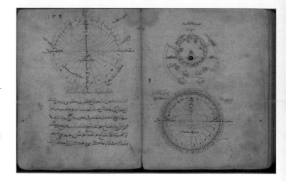

▲ Leaves of the manuscript

Arabian astrolabe, 11th century ▶

What is it

The manuscript, written in Persian in the 11th century, is one of the world's oldest scientific works on mathematics and astrology.

Why was it inscribed

Using precise mathematical calculations, it brought astronomical rigour to traditional astrology and contributed towards the astronomy revolution during the Renaissance.

Where is it

Library of the Islamic Consultative Assembly in Tehran, Iran

Al-Tafhim li Awa'il Sana'at al-Tanjim is a Persian language work by the renowned Iranian scientist, abu-Rayhan al-Biruni (973–1048). It is the oldest Persian text on mathematics and astrology and was written when Iranian scientists and scholars used Arabic to write their scientific works. By composing his book in Persian, al-Biruni contributed to the creation of scientific Persian. He also composed an Arabic version simultaneously.

This book was written at the request of Rayhanah, the daughter of Hussein or Hassan Khwarizmi, in 1029. As a self-study text on astrology for a Persian-speaking girl, it is an important example of the ancient Persian vernacular and offers a wealth of insight into the history, traditions and chronology of Iranian culture of that era.

To aid his readers in their comprehension of a complex subject, al-Biruni begins with the principles of geometry and arithmetic; he then proceeds to astronomy and chronology, and after introducing the use of the astrolabe for astronomical and astrological purposes, he explains the principles of astrology. The book is logically structured into 530 questions and answers. Each new topic starts with a question posed by an imaginary student and ends with an answer by an imaginary professor. It is illustrated with clear and elegant figures in red and black inks and the text is also coloured, with bright red questions and black answers.

The book is a concise compilation of al-Biruni's knowledge of mathematics and astrology and is a treasury of scientific and literary wisdom. At the time it was written, political leaders and ordinary people searched for guidance in their lives and found the systemic links between the stars and human activities useful and believable. It is still cited today as an example of how scientific instruction can be presented in a simple and easy-to-understand way.

Al-Biruni wrote many volumes in Arabic, but this is his only remaining work in Persian. Its historical authenticity, scientific merits and literary significance have made this rare book one of the most famous in the Persian language. It has been reprinted in many formats and translated into English, Italian, German and Russian.

The oldest Arabic manuscript of this book dates back to 1177 and is preserved in Chester Beatty Library in Dublin; this Persian manuscript was transcribed in 1143, less than 100 years after al-Biruni's death.

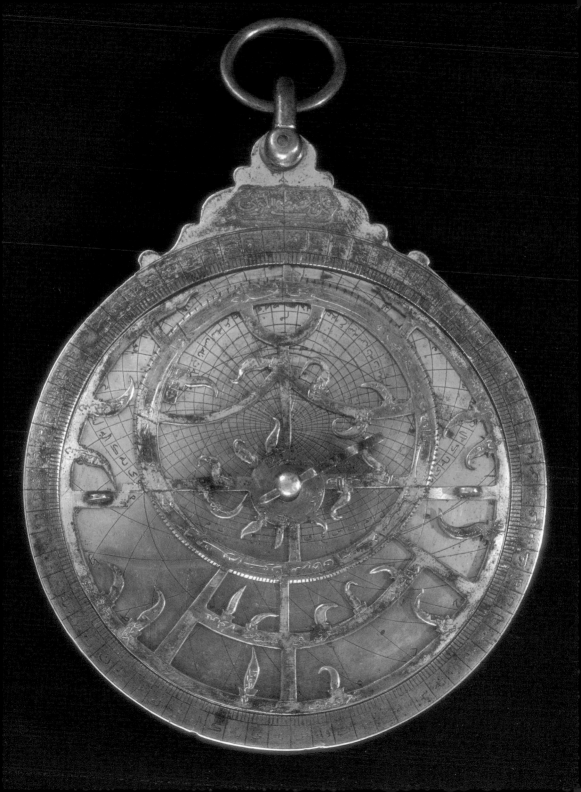

Ostromir Gospel (1056–1057)

Inscribed 2011

What is it

The 11th century Ostromir Gospel, written less than
80 years after Christianity was accepted in Russia.
The manuscript is written in Old Russian using the
Cyrillic alphabet.

Why was it inscribed

Written in 1056–57, the Ostromir Gospel is the world's
oldest-known East Slavonic manuscript. The text
introduced Christianity to previously isolated and pagan
East Slavonic tribes. As an art object, it also represents
the genesis of Russian literature and culture.

Where is it

National Library of Russia, St Petersburg, Russia

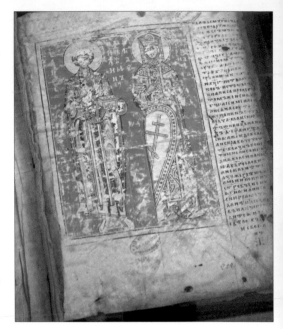

Christianity was adopted in Russia as late as AD 988 and
the Ostromir Gospel was commissioned during its first
century as the official religion. The manuscript was created
between 21 October 1056 and 12 May 1057, according to
an inscription by its scribe, Deacon Grigory, by the order
of Ostromir, the governor of Novgorod, then one of the
richest cities in Russia.

The manuscript is an *aprakos*, that is, a lectionary of the
Gospels as used in Orthodox Catholic Church services,
arranged in weekly order. Unlike Western Church
lectionaries, the works of the evangelists begin with
John rather than Matthew. It was created as a donation
to St Sophia's, the new cathedral of Novgorod, where it
remained for several centuries until its removal to Moscow.
In 1806, it was moved to the then Imperial Public Library,
now the National Library of Russia in St Petersburg.

The Ostromir Gospel is an expression of the dynamic
religious and cultural development in 11th-century Russia,
encompassing the dissemination of Christianity among
the pagan Slavs, the moves towards a unified state of the
Eastern Slavs and the growth of writing. The Gospel is the
oldest known manuscript in the Old Russian language and
is written in the Cyrillic alphabet which was devised in the
10th century. As an early example of how Russian Cyrillic
became the new means of expression of the Christian
religion, the manuscript is centrally important in the

dynamic evolution of the religion, language and culture
of Russia at that time.

More specifically, it expresses the confidence of Russia
in its new religion and its place in the world. Russian
princes had close connections with the leaders of the
Byzantine Empire and European nations further afield,
and the cultural and artistic traditions of those lands were
influential in Russia. The Gospel is the only book of the
10th and 11th centuries that fuses elements of Byzantine
and Western illumination and decoration. It was also
among the last major works produced within the unified
Christian Church – although the Great Schism between
East and West is officially dated at 1054, before the Gospel
was produced, in practical, day-to-day terms the church
carried on as before. The calendar of saints in the Gospel is
drawn from the unified Christian tradition.

*A miniature from the Gospel depicted
on a postage stamp of the former USSR.* ▶

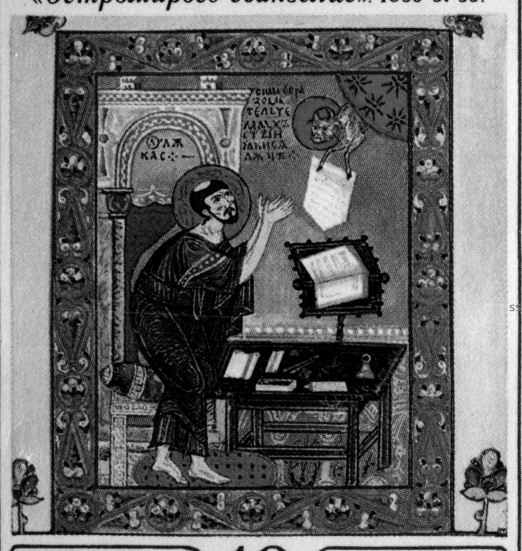

КИРИЛЛ МЕФОДИЙ

«Остромирово евангелие». 1056-57 гг.

ПОЧТА **10**к 1991 СССР

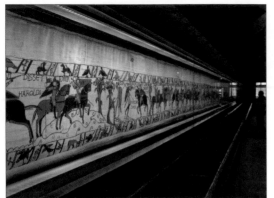

Bayeux Tapestry

Inscribed 2007

What is it

An 11th-century embroidery stitched in wool, linen, hemp and cotton on linen cloth that depicts pictorially and in narrative detail the political background and military events of the start of the Norman Conquest of England in 1066, together with everyday scenes of ordinary life.

Why was it inscribed

The Bayeux Tapestry is a unique artefact of its period, both as a historical document and record, and also as a work of art in its own right.

Where is it

Médiathèque Municipale de Bayeux, Bayeux, France

The Norman Conquest was one of the most significant events in British and European medieval history and the tapestry narrates its early stages in the political and personal events leading up to the military campaign and Battle of Hastings in 1066.

Its images depict, scene by scene and in lively detail, the events between 1064 and 1066 that led up to William, Duke of Normandy's disputed claim to and taking of the English throne. The story is told arguably from a Norman perspective and includes information that appears in no other contemporary source: for example, an oath

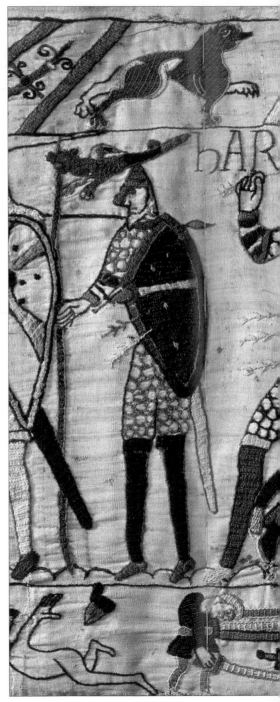

A detail from the tapestry shows what is believed to be King Harold, struck in the eye by an arrow. ▶

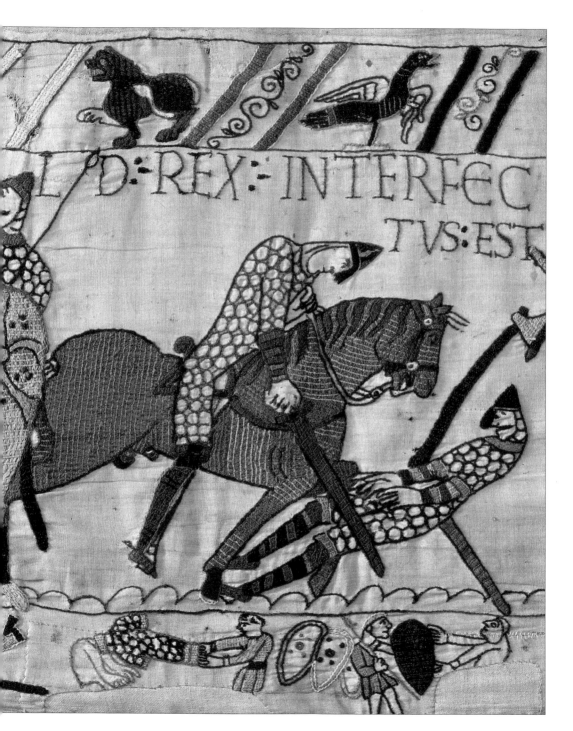

L·D·REX·INTERFEC TVS·EST

▲ *The death of King Edward*

▲ *Border details depict scenes of work.*

of fealty that Harold, Earl of Wessex – later King Harold II of England and William's rival – was said to have sworn to the duke at Bayeux.

The tapestry is unique in size and scope. Works of art celebrating military victories were common but virtually none remain now beyond references in contemporary accounts.

The political and military events of the mid-1060s are related in pictorial chronological narrative. The scenes on the tapestry's main section appear between two narrower upper and lower borders depicting animal, possibly fabulous, and everyday rural scenes. At moments of tension in the main action, the central image overlaps the upper border in a technique that implies energy and movement, while the raised strands of wool create a light-and-shadow effect suggestive of a cartoon technique.

Little is known of the tapestry's origins, but the details of its manufacture offer some clues. It is believed that a cleric skilled in Latin and with a knowledge of illumination techniques designed and oversaw production, ensuring the remarkable consistency of style throughout. The design may have been influenced by the mural cloths of northern Europe – the only other equivalents remaining are fragments from Scandinavia, where the Normans originated. Another possible influence was a similar narrative style used in Anglo-Saxon Bible manuscripts. The tapestry was probably sewn in the south of England. Furthermore there is distinct English influence in its colours and dyes, and in its etymology.

Odo, bishop of Bayeux and William's half-brother, may have commissioned the work for the consecration of Bayeux Cathedral in 1077. The church was the foremost artistic patron in the medieval period, and appropriately for a clerical commission and creation, the tapestry is said to use religious allegory and imagery interwoven with historical record – in this case, the conquest of Judah by Babylon.

◀ *The tapestry on display in Bayeux today.*

Archangel Gospel of 1092

Inscribed 1997

What is it

A Cyrillic manuscript on calfskin parchment written in 1092 of the four Gospels of the New Testament and lectionary in codex or bound-book form.

Why was it inscribed

The Archangel Gospel presents valuable evidence of the state and development of religion, philosophy and culture in Europe and in European Russia at the end of the 11th century.

Where is it

Russian State Library, Moscow, Russia

The existence of the Archangel Gospel was unknown to the world until 1876 when it arrived in Moscow and was there sold by its owner, a farmer from the Archangel or Arkhangelsk region of northern Russia. Beyond these facts, little is known of its origins and provenance although it has been suggested that the book was a product of St George's (Yuriev) Monastery at Novgorod to the south of Archangel.

The manuscript itself contains the four books of the Gospel together with a lectionary – a collected listing of the specific readings appointed for worship on a particular day. The colophon or publishing detail of the manuscript records that two scribes wrote the main parts, although there are shorter, inserted contributions from two other scribes. The Gospel's design is relatively simple and its illustration minimal compared with better known and more highly illustrated and illuminated medieval manuscripts. The relative plainness of the book's appearance perhaps suggests that the copy was intended for everyday use rather than for presentation as a gift to a patron.

Rare and attractive as the Gospel is, its particular value lies in what it reveals about the time and culture from which it came. In 1054 the Great Schism divided the Christian Church along differing theological lines into Eastern Greek and Western Latin wings and the Archangel Gospel is a product of the aftermath of the split.

The Gospel is written in Cyrillic rather than Latin, and as such it is one of the oldest existing Eastern Slavic books in the world. The Cyrillic alphabet was a form that had developed in Russia as recently as the 10th century, so the transcription of the Slavonic language of the Church into Cyrillic makes the book highly valuable for scholars of linguistics. In addition, the handwriting in the manuscript is invaluable to paleographers.

The Gospel is also significant in that it is a codex and is bound in the form of printed books of today. The practice of presenting information in book rather than in scroll form is generally thought to derive from the spread of Christianity, which early adopted the codex form for the Bible. Scrolls continued to be used in Far Eastern culture beyond the end of their use in the West.

Illuminated codices from the library of the Bratislava Chapter House

Inscribed 1997

What is it

A collection of 101 early books, or codices, containing numerous illuminations and illustrations and dating from the 12th to the 16th centuries.

Why was it inscribed

The collection, from the former Chapter House library, is the most wide-ranging, comprehensive, influential and historically and artistically valuable set of medieval manuscript books in Slovakia.

Where is it

Slovak National Archives, Bratislava, Slovakia

The territory of Slovakia has historically been a meeting ground of political and cultural influences from Central, Eastern and Western Europe. The *Bratislava Antiphonaries*, as the codices are known, are among the most important religious documents in Central Europe.

Archival documents reveal that the library of the Bratislava Chapter of canons was created and grew during the 13th century. The Chapter itself was an important institution of the Church in Bratislava with legal and cultural as well as religious responsibilities.

Antiphons are chants sung at certain parts of the Roman Catholic Mass and the *Bratislava Antiphonaries* were in active use in church services for several centuries. This constant use over such a long period put them at the centre of worship in the region and made them one of the foremost religious and spiritual influences of Central Europe.

The illuminations in the antiphonaries are the central resource of information and knowledge of the history of medieval book painting in the Central European area. In addition, they are also among the most important music books of the region and allow an insight into its medieval music culture.

The musical codices of the collection dating from the 15th and 16th centuries are assumed to have been created in the scriptorium at St Martin's Cathedral in Bratislava. The work of several illuminators and scribes, they contain numerous lavish, ornate and colourful illuminations and illustrations and are of central importance in the history of books in Central Europe.

The complete collection is the most wide-ranging and comprehensive set of medieval manuscript books in Slovakia. In 1988 it was acknowledged by the government as one of the cultural monuments of the nation.

St Martin's Cathedral, Bratislava, where the musical codices of the collection are believed to have been created. ▶

Medieval manuscripts on medicine and pharmacy

Inscribed 2005

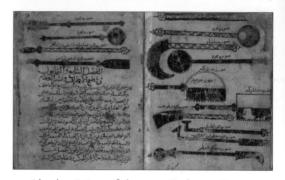

What is it

Three manuscripts from the Institute of Manuscripts of the Azerbaijan National Academy of Sciences (IMANAS), which holds 12,000 manuscripts in total. The manuscripts listed on the Register are three medical texts copied in the 12th, 13th and 18th centuries from earlier originals.

Why was it inscribed

These manuscripts on medicine and pharmacology are rare and valuable. One is a single-existing copy; another is one of the oldest copies in the world; and all were influential in their fields not only in Azerbaijan but also in neighbouring countries around the region.

Where is it

Institute of Manuscripts of the Azerbaijan National Academy of Sciences (IMANAS), Baku, Azerbaijan

The collection as a whole has 363 valuable medieval medical manuscripts: 222 are in Persian, seventy-one in Turkish and seventy in Arabic. The three books listed on the Register are *Zakhirai-Nizamshahi* (Supplies of Nizamshah) by Rustam Jurjani; *Al-Qanun Fi'l Tibb* (Canon of Medicine, The Second Book) by Ibn Sina (Avicenna); and *Al-Makala as-Salasun* (Thirtieth Treatise) by Abu al-Qasim al-Zahravi (Abulcasis).

The first of the works, *Zakhirai-Nizamshahi* by Rustam Jurjani, is not known to be in any other collection in the world. Its date of compilation is uncertain, but the manuscript was copied in the 16th century. The book

provides descriptions of pharmaceutical properties of medicinal herbs, animal substances, minerals and complex medicines. It influenced the development of medicine and pharmacology in Persian-speaking areas and countries.

Al-Qanun (Canon of Medicine, The Second Book) by Ibn Sina (Avicenna), is a famous work in the field of pharmacology and medicine. The second book deals primarily with pharmacology and contains pharmaceutical descriptions of hundreds of natural medicines derived from plants, minerals and animal substances. It was one of the most influential and popular books of medicine in the world and was copied in AD 1143, only 104 years after the author's death. The book was influential in the development of medical sciences in the Muslim world and in the West.

Al-Makala as-Salasum (Thirtieth Treatise) by Abu al-Qasim al-Zahravi (Abulcasis) is an Arabic book of surgery and surgical instruments and is a rare manuscript in world terms. The book contains pictures of approximately 200 medieval surgical instruments used at the time. Zahravi (who died in 1013) is the only medieval author who provides pictures of so many surgical instruments, together with explanation methods of their use. This work influenced the development of surgery in the Muslim East and Europe. This manuscript is the 13th-century copy of the 11th century book.

The Arnamagnæan manuscript collection

Inscribed 2009

What is it
A collection of almost 3000 early Scandinavian manuscripts dating from the 12th century onwards.

Why was it inscribed
The manuscripts and documents in the collection are invaluable sources of information on the history and culture of Scandinavia and by extension, northern Europe, from around 1150 to 1850.

Where is it
Copenhagen, Denmark and Reykjavik, Iceland

Old Norse and Icelandic literary works make up the largest part of the Arnamagnæan Manuscript Collection. Among these, particular treasures are the Icelandic sagas which relate the voyages of the Vikings – usually from Norway – who sailed west to invade, explore and settle in Britain and Ireland, the Faroes and Iceland, and from there, Greenland and North America around AD 1000; and east and south to Russia and as far as the Mediterranean and Byzantium.

Scandinavia, and Iceland in particular, were among the last major areas of Europe to convert to Christianity and the establishment of the new religion can be charted from its official beginnings around AD 1000. The manuscripts reveal a society in transition, from heathendom to Christianity, from an oral culture to literacy, and from localized oligarchy to a more centralized monarchy.

Other manuscripts originated in Norway, Denmark and Sweden. Religious and legal texts are among the most numerous, with translations of chivalric literature from the original French, alongside hagiographies, devotional books and other religious texts. In particular, most of the Danish manuscripts are legal codices; one of these, *Skånske lov* or the *Law of Skaane*, is written in runic script. There are also manuscripts from the continent, in Latin and other

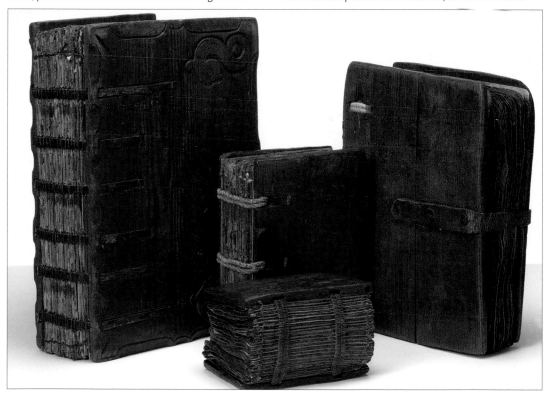

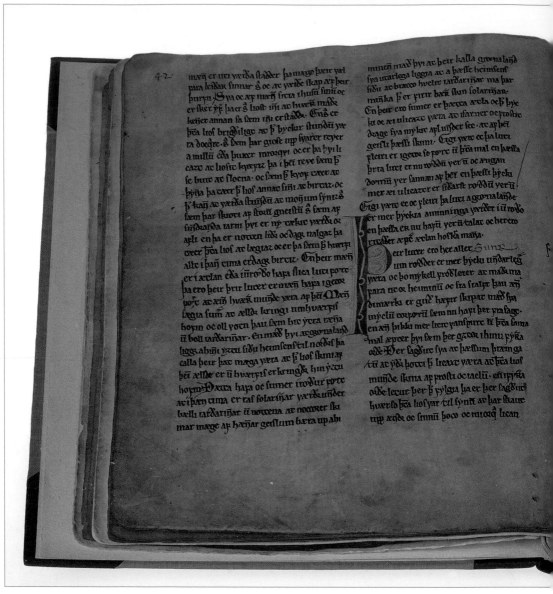

languages, on diverse subjects from a copy of a 6th-century commentary on the Apocalypse to a 15th-century treatise on warfare and the use of cannons.

The works of the collection are central to the study and understanding of Scandinavian language and culture. They are also invaluable as a source of information on the history of mainland Scandinavia and the North American colonies during the Viking expansion. This was a period which shaped both how the region perceives itself and how it is regarded by the rest of the world. They were a source of national inspiration in art and politics, fuelling the movements that led to independence for Norway and Iceland.

The collection was gathered over much of his life by Árni Magnússon (1663–1730), an Icelander and professor of antiquities at the University of Copenhagen (his name in its Latinized form, Arnas Magnæus, gives the collection its name).

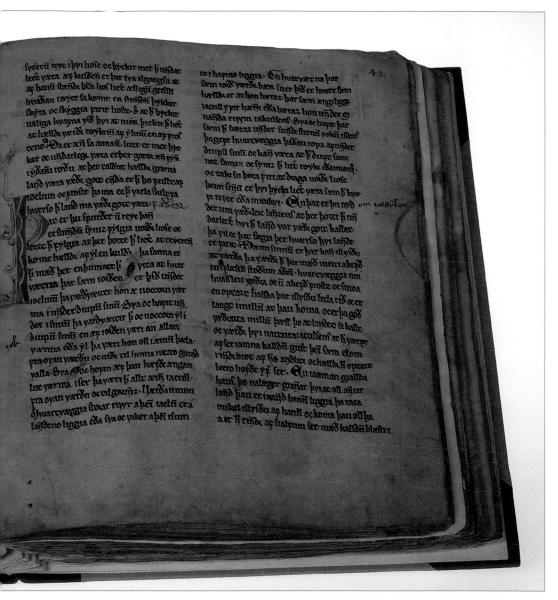

Although Magnússon bequeathed the collection to his university, Icelandic independence from Denmark in 1944 lent weight to an already-existing campaign to have the Icelandic sections of the collection returned to Reykjavik.

As a result, the collection is now divided between the two countries under an arrangement that was itself ground-breaking in setting a precedent for the amicable return of cultural treasures. In a transfer that took 26 years and was completed in 1997, Iceland received 1666 items from the collection together with the Icelandic charters and apographa, or transcripts. Both countries remain joint custodians, working together to secure continued access to the manuscripts and their preservation.

Miroslav Gospel –
manuscript from 1180
Inscribed 2005

What is it
An illuminated manuscript from around AD 1180 and the
product of a fusion of styles from West and East.

Why was it inscribed
The Miroslav Gospel is a unique fusion of styles and
iconography from Italy and Byzantium. Its text combines
the Serbian script with the style of miniature illustrations,
ornamentation and illumination from the West.

Where is it
National Museum, Belgrade, Serbia

The Miroslav Gospel was made around 1180, according
to an inscription in the book itself, for Prince Miroslav
of Hum (an area equating roughly to present-day
Herzegovina), and is assumed to have been used in
the church of St Peter in Bijelo Polje. It is the oldest
surviving Serbian illuminated manuscript.

The manuscript has 181 sheets of parchment and is an
evangelistary – that is, a book containing passages from
the Gospels by the four evangelists, and from which priests
read in church services. The text is arranged according
to the reading plan for the liturgical or church year and is
possibly modelled on the type of evangelistary that was used

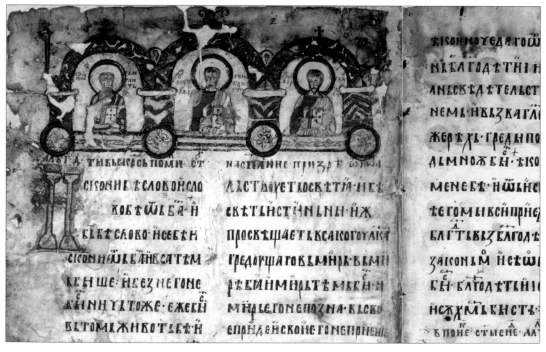

in Hagia Sophia, seat of the patriarch of Constantinople and the central church of the Orthodox Catholic Church. It is illustrated with 296 coloured miniatures decorated with gold; a monk named Gligorije is mentioned in the book as the illuminator of the miniatures.

The Gospel is written in the old Slavic language and proved highly influential in the development of the Cyrillic alphabet whose use spread across the Central and Eastern Balkans in the medieval period.

Serbia's geographic position meant the country was well placed to absorb cultural influences from both East and West, and this too is evident in the Gospel, which used a radical new blend of artistic and decorative styles from Byzantium and Italy. Elaborate initial letters were the main decorative devices in Eastern manuscripts, and miniature illustrations covering the page were rare. However, this style of miniature illustration painting was the preferred method of decoration in the scriptoria of Central Italy. The Miroslav Gospel used both, and this new fusion influenced the development of manuscript illumination in the region into the 15th century.

Art historians have traced mutual Eastern and Western influences in the ornamentation, with Byzantine and Roman influences alongside techniques from Syrian, Bithynian, Coptic and other Western styles.

By the mid-19th century the Gospel was in the library of Hilandar, the Serbian monastery on Mount Athos in Greece. Unusually, a page of the book (folio 166) was taken by a visiting Russian churchman: he took it to St. Petersburg where it is still kept in the National Library of Russia. The rest of the Gospel was given to the Serbian king some years later and its fate was at times precarious during the regional upheavals of the 20th century. After the Second World War it was transferred into the keeping of the Arts Museum, now the National Museum in Belgrade.

Tabula Peutingeriana

Inscribed 2007

What is it

The Tabula Peutingeriana is a unique preserved map of the road system for the *cursus publicus*, the Roman Empire's public transportation system. It consists of eleven segments with the map, written on parchment.

Why was it inscribed

The Tabula Peutingeriana offers insights into the history of administration and economy in the Roman Empire and unique information on the topography and geography of all the provinces and territories under Roman rule.

Where is it

Austrian National Library, Vienna, Austria

is an authentic copy made at the end of the 12th century – in effect, a medieval facsimile in the form of a scroll.

The Tabula Peutingeriana is named after Konrad Peutinger, a German humanist and antiquarian who was responsible for publishing the map in 1591. It stayed in his family, but in 1737 it was bought for the Habsburg Imperial Library (now the Austrian National Library).

The Tabula Peutingeriana is one of only two preserved book scrolls made in the Middle Ages as an imitation of the form used in Antiquity for literary texts (that is, book scroll written on papyrus). The other manuscript, kept in the Biblioteca Apostolica Vaticana, the Vatican Library, is a copy of the text of the Old Testament made in 10th-century Constantinople.

The *cursus publicus* was the public transportation system that stretched across the Roman Empire. It carried government messages and certain goods and allowed travel by government officials. Stations along the way provided lodging, food, vehicles and animals.

The Tabula Peutingeriana maps the road system that the *cursus publicus* used. It covers the complete area of the provinces under Roman rule and the territories conquered by Alexander the Great in the East.

The information on the map is not an accurate geographical description of where the roads lie on the landscape. Instead, rather like modern urban underground maps, the Tabula was a stylized rendering of the structure and network of the *cursus publicus*. This explains why the sea is missing from the map and also its west-east orientation. Cities are denoted by symbols according to their importance.

As the only map of the *cursus publicus*, the Tabula Peutingeriana is of great importance for all studies concerning the administration and economy of the Roman Empire. It also serves as a guide for historians and archaeologists. Much information about the topography and historical geography relating to archaeological sites in Europe, Africa and Asia is only known through the Tabula Peutingeriana.

The original Tabula dates back to the first half of the 5th century and the manuscript inscribed on the Register

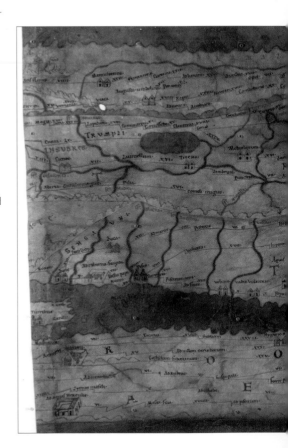

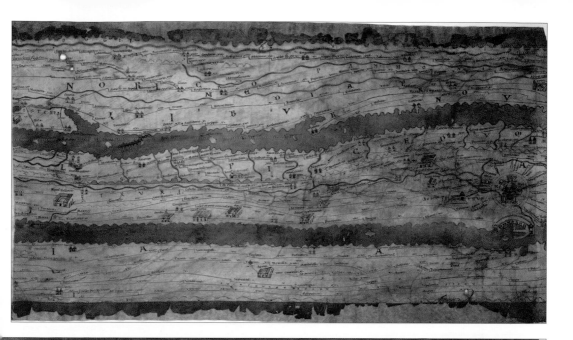

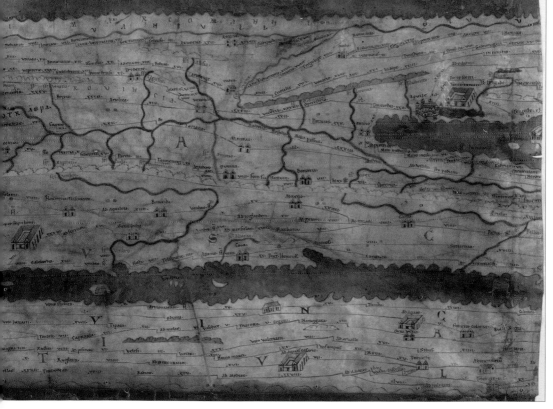

93

Song of the Nibelungs,
a heroic poem from medieval Europe

Inscribed 2009

What is it

The *Nibelungenlied*, or *The Song of the Nibelungs*, is an epic heroic poem written in Middle High German. Based on older oral tradition, it was transcribed around AD 1200. Three separate manuscript copies on vellum are listed.

Why was it inscribed

The *Nibelungenlied* is a rare example of heroic poetry in German literature and is important in world terms, ranking alongside Gilgamesh, the Mahabharata, Beowulf and the Chanson de Roland.

Where is it

Codex A: Bavarian State Library, Munich, Germany;
Codex B: Monastic Library of St Gallen, Switzerland;
Codex C: Regional Library of the State of Baden, Karlsruhe, Germany

The *Nibelungenlied* tells the story of dragon-slayer Siegfried from his childhood and later marriage to Kriemhild, to his murder and the subsequent story of Kriemhild's revenge. It culminates in the extinction of the Burgundians or Nibelungs at the court of the Huns. The story takes place in Central Europe along the Rhine and the Danube, corresponding to modern Germany, Austria, and Hungary; a single episode takes place in Iceland. It dates back to the time of mass migration across Europe in the 5th and 6th centuries AD and is known across the continent.

The roots of the myth lie in the memory of a disastrous defeat of the Eastern German tribe of the Burgundians by the Roman general Aëtius as they advanced from the Rhine to Roman Gaul in around AD 436.

The *Nibelungenlied* was written during the 13th century in the Alemannic or Bavarian language area within the Alps region. It originated in the classical time of Middle German literature and was written in the form of singable stanzas. Its author is unknown, but his patron was Wolfger von Erla, bishop of Passau from 1191 to 1204.

Rediscovered by a new generation in the 18th century, it came to the fore in the 19th as a national epic poem both in numerous illustrations and in the musical dramas of Richard Wagner. It has exerted a wide influence on the history of thought, literature, art and music.

It is known only in the versions that have survived in thirty-seven manuscripts and manuscript fragments from the 13th to the 16th centuries. The three main manuscripts inscribed in the Register are labelled A, B and C. Each one is unique and transmits a different version of the text. They were written within a century of the poem's composition and are the earliest and most important manuscripts of the text.

Codex A preserves the shortest version, probably in anticipation that its readers had some knowledge of the oral text. Codex B, some decades older, contains other Middle High German epic poems besides The *Nibelungenlied*. The oldest codex is C, a revised and expanded version of the text.

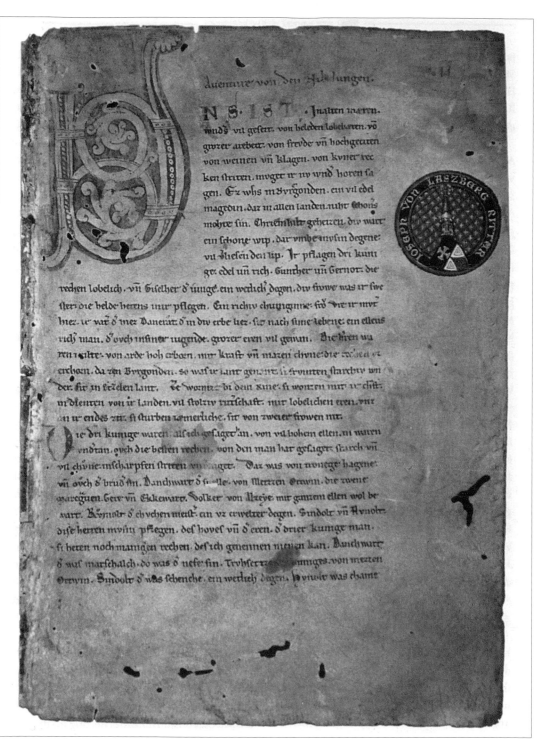

VNS IST. Jn alten maeren.
wnds vil geseit. von heleden lobebaren. võ
grozer arebeit. von freuden vñ hochgeten
von weinen vñ klagen. von kuner rec
ken striten. muget ir nu vñd horen sa
gen. Ez whs in Vrgonden. ein vil edel
magedin. daz in allen landen niht schons
mohte sin. Chriemhilt geheizen. div wart
ein schone wip. dar vmbe muson degene
vil lieseu den lip. Ir pflagen dri kuni
ge edel vñ rich. Gunther vñ Gernot die
rechen lobelich. vñ Giselher d'iunge. ein wetlich degen. div frowe was ir swe
ster die helde hetens in ir pflegen. Ein richiu chuniginne frô. die in muei
hiez. ir vat d'mer Dancrat. d'in div erbe liez. sit nach sine lebene: ein ellens
rich man. d'ovch insiner iugende. grozer eren vil gwan. Die hren wa
ren milte. von arde hoh erboren. mit kraft vñ mazen chune die recken vz
erchorn. da zen Vrgonden. so was ir lant genant sit frouten starchiu wn
der sit in etzelen lant. Ze wormz bi dem rine. si wonten mit ir chraft.
in dienten von ir landen. vil stolziu ritschaft. mit lobelichen eren. vnz
an ir endes zit. si sturben iamerliche. sit von zweier frowen nit.

Die dri kunige waren. als ich gesaget han. von vil hohem ellen. in waren
vndtan. ovch die besten recken. von den man hat gesaget starch vñ
vil chune inscharpfen striten vnverzaget. Daz was von Tronege hagne.
vñ ovch d'bruder sin. Danchwart d'snelle. von Mezzen Ortwin. die zwene
mareguen. Gere vñ Eckewart. Volker von Alzeye mit gantem ellen wol be
wart. Rumolt d'chuchen meist' ein vz erwelter degen. Sindolt vñ Hunolt
dise herren musn pflegen. des hoves vñ d'eren. d'drier kunige man.
si heten noch manigen recken. des ich genennen nieuen kan. Danchwart
d' was marschalch. do was d' nefe sin. Truhsetze der kuniges. von mezzen
Ortwin. Sindolt d' was schenche. ein wetlich degen. so Rumolt was chame

Magna Carta, issued in 1215

Inscribed 2009

What is it

Magna Carta (or Great Charter) is the document
recording the agreement made at Runnymede in 1215
between King John and the English barons, at the
conclusion of a series of political crises of John's reign.

Why was it inscribed

Magna Carta is one of the most celebrated documents
in English history. The charter limited for the first time
royal authority in tax, feudal rights and justice. It also
reasserted the power of customary practice to limit
unjust and arbitrary behaviour by the king. In essence, it
established the principle that the king was not above the
law, but had to rule within it.

Magna Carta has now become a byword and icon
of freedom and democracy with an impact and
influence across the world.

Where is it

British Library, London, UK;
Lincoln Castle, Lincoln, UK;
Salisbury Cathedral Chapter House, Salisbury, UK

The issuing of Magna Carta was one of the most famous
acts in history, but its immediate origins lay not only in
English Common Law but also in the immediate political
context of the period.

John's brother King Richard II, the Lionheart, had lost
some of the family's lands in France and committed his
successor to enormous expense in the attempt to hold
on to Aquitaine and their homelands in Normandy. After
his accession to the English throne in 1199, John's own
military, political and personal shortcomings brought
the almost complete loss of their French possessions by
1204. For the rest of his reign, the recovery of Normandy
remained his primary aim.

For this John needed money, and the dispensation
of royal justice was a key source. Taxes were increased and
privileges and offices within the king's gift were also sold to
raise funds. The heavy financial and judicial burdens of his
policies were felt keenly.

John's political position had been weakened by his six-
year disagreement with the powerful Pope Innocent III
over the succession to the Archbishopric of Canterbury
which had resulted in the king's excommunication and
England's being placed under an interdict disallowing
church services. John's popularity with his God-fearing
subjects – including his barons – declined further. In
theory, the terms of the interdict also absolved the king's
subjects from their allegiance and allowed a Christian ruler
to invade England to take the throne. John's disagreement
with the papacy was settled only weeks before he went into
battle against the French in July 1214.

Despite his success in raising money for his war chest
and re-cementing relations with the pope, John failed in
the decisive battle at Bouvines with the French King Philip
II and was forced to return to England empty-handed with
his barons.

The loss of Normandy and John's attempts to raise more
money opened the floodgates for protest and within
months the king faced a baronial revolt. On the back foot,

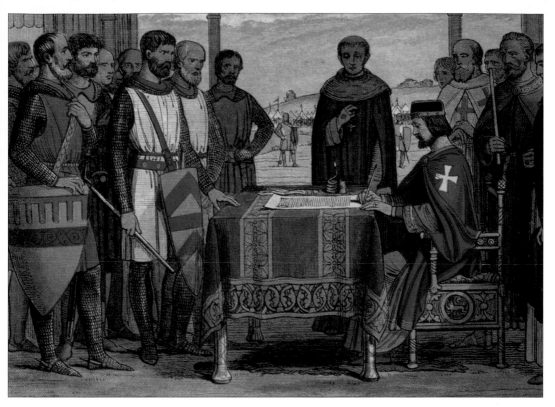

◄ *Inside the Magna Carta Memorial at Runnymede.*

▲ *A later depiction of King John signing Magna Carta at Runnymede before his barons and the archbishop.*

he was forced to meet with the rebels at Runnymede near Windsor in June 1215. Archbishop Langton, the man John had rejected for the vacant see at Canterbury, mediated the peace agreement which was made orally and subsequently written up by royal scribes. Copies were then despatched around the country.

Four copies of the charter as issued in 1215 are listed on the Memory of the World Register. Two are in the British Library although one of these was badly damaged by fire in 1731; nevertheless, this is the only copy to retain a trace of the royal seal. The others are in Lincoln and Salisbury and are assumed to be the copies sent to those towns.

The charter sought to establish boundaries to kingship. Its intent was to limit the king's money-making operations, make his justice more equitable, reform the abuse of his local agents and prevent his acting in an arbitrary fashion against individuals. Although it initially failed to end the conflict between the barons and the king, the subsequent issues of Magna Carta have assured that its long-term effects on English legal and social history have been profound.

However, Magna Carta as it has come to be interpreted reaches far beyond its immediate context of 13th-century England. It was cited in the 17th century as a factor in the Parliamentarians' struggle against King Charles I, in the American colonists' fight for independence from Great Britain in the 18th century and in the subsequent American Constitution and the Bill of Rights. Its renown grew with the spread across the world of the British Empire and it still endures as an icon of hope for those who consider themselves oppressed today.

Printing woodblocks of the Tripitaka Koreana
and miscellaneous Buddhist scriptures

Inscribed 2007

What is it

The Tripitaka Koreana is a Korean collection of the Tripitaka or Buddhist scriptures which were carved onto 81,258 wooden printing blocks in the 13th century. The collection is stored at Haeinsa Monastery in southwest Korea.

Why was it inscribed

The Tripitaka Koreana is the only existing example of a Tripitaka in the form of wooden blocks and the only complete canon of Buddhist scriptures still extant on the Asian mainland. The Tripitaka and the associated scriptures at Haeinsa Monastery are examples of the best printing and publishing techniques of the period.

Where is it

Haeinsa Monastery, South Gyeongsang province, Republic of Korea

The Tripitaka, or *Daejanggyeong* in Korean, refers to the collection of Buddhist scriptures, or Buddhist canon, that relate to discourses with the Buddha, regulations of monastic life and commentaries on the sutras by renowned monks and scholars. The Tripitaka Koreana is the oldest extant complete canon of Buddhist scripture edited, compiled and collated from the various contemporary Tripitakas that did not survive to the present.

After Buddhism was transmitted to East Asia through China and Buddhist scriptures were translated from various Indian and Central Asian languages into classical Chinese (the lingua franca of educated discourse throughout East Asia, including Korea), several countries tried to inscribe them in wooden printing blocks for distribution. However, the Tripitaka Koreana is the only complete canon still extant on the mainland of Asia.

The first edition of the Tripitaka was begun in 1011 and completed in 1087. However, it was destroyed in 1234 during a Mongol invasion. The Goryeo royal dynasty of Korea (AD 918–1392) commissioned the production of another Tripitaka in 1236. According to inscriptions on the blocks, as many as 1800 scribes worked on the job, which was completed in 1251. This edition is the Tripitaka Koreana and from these printing blocks, the monastery continually printed, published and distributed new copies whenever the need arose.

Each of the 81,258 blocks was meticulously prepared and individually inscribed with care and regularity. The blocks are 24.2 cm long, 69.7 cm wide, 3.6 cm thick and weigh about 3.5 kg. They exemplify the pinnacle of East Asian

Haeinsa Monastery ▲

◀ *A monk holds a block of the Tripitaka Koreana.*

woodblock printing techniques and their durability is such that the blocks can still print crisp, complete copies of the Tripitaka, more than 760 years after their creation. All other woodblock Tripitakas have since been destroyed or lost.

The quality of its editing, compilation and collation mean the Tripitaka Koreana is acknowledged as the most accurate of the Tripitakas written in classical Chinese. A standard critical edition for East Asian Buddhist scholarship, it has been widely distributed and used over the ages. Many of the works it contains exist nowhere else in the world.

Also listed on the Register is Haeinsa Monastery's collection of 5987 individual woodblocks of miscellaneous Buddhist scriptures which the monks had commissioned directly to supplement the Tripitaka. These included Buddhist scriptures and precepts, as well as research work in Buddhism, Buddhist history, discourses and narratives by notable Buddhist monk-scholars, and various Buddhist illustrations and iconography.

These wooden printing blocks became a medium through which knowledge could be produced and distributed continuously. As a result, the monastery became a central locus for the traditional practice of knowledge transmission, where Buddhist education and scholastic research could be conducted.

Even today, Haeinsa Monastery carries on this tradition as a centre of Buddhist scholastic study, as the designated Dharma-Jewel Monastery of Korea, responsible for the teaching and transmission of the Dharma which is one of the Three Precious Jewels of Buddhism – the Buddha, the Dharma (his teachings) and the Sangha (the community of monks and nuns).

MS. GKS 4 2°, vol. I–III, Biblia Latina. Commonly called 'The Hamburg Bible', or 'The Bible of Bertoldus'

Inscribed 2011

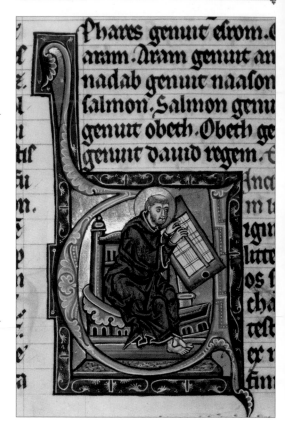

What is it

A richly illuminated Latin Bible in three volumes, made in 1255 for Hamburg Cathedral.

Why was it inscribed

The Hamburg Bible is the work of a group of highly talented clerical craftsmen. The eighty-nine illuminated initial letters in the three volumes illustrate book themes and are unique both as expressions of medieval art and as a source of information on the craft and history of the medieval book.

Where is it

Royal Library, Copenhagen, Denmark

The Hamburg Bible is the most important document for the study of book production and book art in Europe in the 13th century. Not simply a monument of medieval bookmaking, the manuscript is a celebration by its creators of the craft of book production, and a unique expression of the medieval fascination with books.

The manuscript is in three volumes of 242, 230 and 218 leaves respectively, and starts with a full-page initial depicting the Creation at the start of Genesis, to finish with the final Book of the Apocalypse or Revelation. Together the three volumes weigh almost 40 kg.

The Bible was the work of a scribe named Karolus, working at the request of Bertoldus, dean of the Chapter of Hamburg; both are named in a dedication in all three volumes. However, the artist responsible for the eighty-nine illuminated letters is not named. The only clue to his identity is the painting of an illustrator at his desk at the letter A, starting the Book of the Apocalypse.

In addition to its initial letters decorated with Biblical scenes, the Hamburg Bible also contains a sequence illustrating how medieval books were produced, from the production and preparation of parchment to the various steps in the writing process and the painter's work with illumination.

Although the illustration of a monk writing is popular in medieval books, depictions of other parts of the manuscript production process are rare. The sequence in the Hamburg Bible illustrates the process in more detail and with greater artistic skill than any other medieval book. Its images are commonly used to illustrate medieval bookmaking.

The nineteen scenes depicting the creation of the book are spread through all three volumes, although most are gathered in volume three. Most depict either St Jerome, who translated the Bible into Latin, and St Paul; St Timothy, St Peter and the four evangelists also feature.

The three volumes belonged to Hamburg Cathedral until 1784, when they were bought at auction by the Royal Library in Copenhagen.

tabulatori nunt. e
talem quingenti
porte eoz tres. P
a ser una. porta
cuitum decem et
ciuitatis ex illa
plicat ezechiel ppha
presbiteri in dam

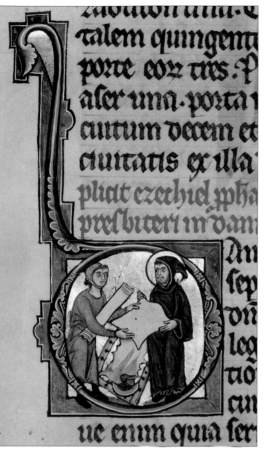

ue enim quia ser

pietum criminati

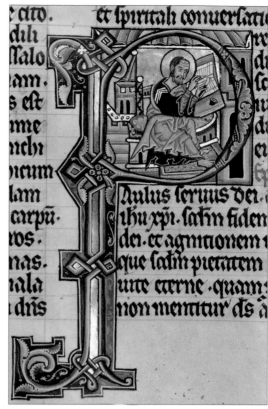

e cito.
dili
ssalo
iam.
s est
me
nchi
rieum
iam
carpū.
ros.
nas.
nala
on
a dīis

et spiritali conuersatio

aulus seruus dei
thu xpi. satin fiden
den. et agnitionem
que satin pietatem
unte eterne. quam
non mentitur ds

Expliat daniel

Osee commati

Hereford Mappa Mundi

Inscribed 2007

What is it

A medieval map of the world on one sheet of vellum and featuring about 500 illustrations. Produced in England at either Lincoln or Hereford, the map is thought to have been made between c. 1290 and 1310.

Why was it inscribed

The Hereford Mappa Mundi is the only complete example of a large medieval world map intended for public display. The presentation of its information, in the form of a visual map-based encyclopedia, gives a crucial insight not only into medieval cartography but also into contemporary spirituality and the medieval worldview.

Where is it

Hereford Cathedral Library, Hereford, UK

The Hereford Mappa Mundi is the largest and most detailed surviving of the medieval genre of maps known as 'mappae mundi' and the most famous of its kind still in existence. 'Mappa mundi' was a term used in medieval times for a map of the world, 'mappa' meaning 'cloth'.

Just as modern maps reflect our worldview, so did the cartography of medieval times. Unlike maps today, mappae mundi did not attempt an accurate representation of the physical landscape; rather, they showed the world as it was perceived and understood. Like other aspects of learning and education of the time, maps were intended as a spiritual tool and displayed the faith and devotion that were an integral part of the way contemporary people interpreted the world and their place in it.

The deeply spiritual and religious worldview of the medieval mind, expressed in the map interprets the world and everything in it as subject to God and part of an eternal order, with humans destined for death and judgement. The map depicts the earth as a circle, with Jerusalem, the place of Christ's crucifixion, death and resurrection, at its centre, marked with the cross of Calvary. Outside the boundary of the world Christ sits in judgement at the top with the letters 'm o r s' (Latin for 'death') around the outside. Angels welcome the saved and turn away the unrepentant.

Within the circle of the world, physical features, places, scripture, mythology and imagination blend in a compendium of knowledge. Facts on history, flora and fauna, real and fictional races of people of unknown lands and tales from classical times feature alongside religious and Biblical content.

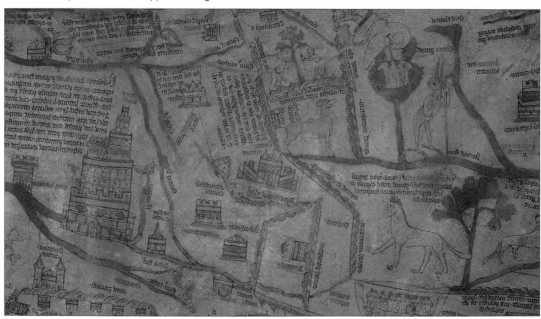

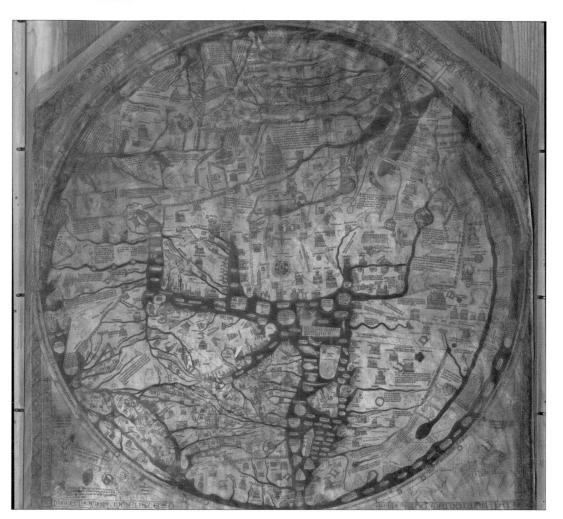

Five hundred drawings illustrate these themes, including around 420 depictions of towns and cities, outlined by walls and towers; fifteen illustrations of events from the Bible; thirty-three pictures of plants, animals, birds and fish; thirty-two illustrations of peoples of the earth; and eight images from classical mythology. Seas and rivers are coloured blue or green, with the exception of the Red Sea which is red, while the writing is black with red and gold embellishments. Hereford is depicted by a drawing of its cathedral. The author's name, 'Richard of Haldingham or Lafford', is inscribed on the map.

According to another inscription on the map, it was based on a description of the world from the works of Orosius (c. AD 375), a student of St Augustine at Hippo. In addition to his spiritual, Biblical and theological knowledge, Orosius had studied the works of classic Roman authors, including Caesar, Livy and Tacitus. The Mappa Mundi is based on the synthesis of this learning.

The Mappa Mundi was not intended for use as a geographical tool, but was probably displayed in a wooden frame for educational reasons. The map was one of the latest of its genre: later large-scale medieval maps, for example the Catalan World Map of c.1375, differ from mappae mundi in that they are based on the portolan charts drawn up by sailors and consequently depict coastlines more accurately.

The King Ram Khamhaeng inscription

Inscribed 2003

What is it

A siltstone from the royal palace grounds of the old city of Sukhothai. Its four sides bear the oldest known inscription in the Thai language in Sukhothai scripts which celebrates the achievements of King Ram Khamhaeng (1279–98).

Why was it inscribed

This inscription's significance comes from the light it throws on the reign of King Khamhaeng from a Thai perspective and on the use of the Thai script. It is evocative of its time and place in the context of Southeast Asia and China which form an important strand of world history.

Where is it

National Museum, Bangkok, Thailand

The King Ram Khamhaeng inscription of 1292 records the invention of Thai language script that is the foundation

the script's versatility and its ability to convey verbal expression into written words. It is generally agreed that Thai scripts were first adapted from Pallava scripts in the 9th century. They were then broken into two branches: one was associated with Mon and the other with Khmer scripts. Sukhothai writing combined the two lines. The Ram Khamhaeng inscription is the earliest linguistic evidence of this development. As the writing system continued to evolve after the 13th century, the inscription is best considered as a prototype of the Thai script that was later continuously modified.

The content of the inscription can be divided into three parts. The first part from line 1 to line 18 describes the personal background and heroic deeds of King Ram Khamhaeng from his birth to his accession to the throne. Although direct inheritance was the main principle for the legitimate assumption of power, King Ram Khamhaeng added that filial piety and bravery were his personal virtues (hence the name 'khamhaeng' meaning brave). The personal pronoun 'I' is used throughout. The second part from line 18 on the first side to line 8 on the fourth side describes the various aspects of Sukhothai city in

▲ The King Ram Khamhaeng inscription as displayed in the National Museum, Bangkok. ▶

◀ The National Museum, Bangkok, Thailand.

of the modern script used in Thailand by 60 million people. Its detailed description of the 13th-century Thai state of Sukhothai also reflects universal values shared by many states in the world today. Those values include good governance, the rule of law, economic freedom and religious morality through the practice of Buddhism.

Carved in siltstone, the inscription stands nearly 115 cm high with four sides, each about 36 cm wide, and is topped by a quadrilateral pyramid. The first and second sides have thirty-five lines of inscription and the third and fourth sides, twenty-seven lines. The inscription is a rare piece of historical evidence of King Ram Khamhaeng's invention of the script for the Thai language. The long inscription successfully describes both facts and values to demonstrate

▲ *The inscription on the fourth side of the stone, showing clearly the Thai script that was used*

▲ The National Museum, Bangkok, Thailand.

detail – physical, political, religious and social. The detailed description suggests an idyllic place, perhaps to match the vision of an ideal state and society, and is a globally rare source of urban history for that period. The third part from line 8 to the last line 27 on the fourth side glorifies the king as the inventor of the Thai script and the ruler of an extensive kingdom. The inscription maintains that his rule was based on justice (*dharma*) and the rule of law for all, which he urged his people to follow. He was generous and merciful, as well as responsive and accessible to his citizens. The absence of the first pronoun in the last two parts has given rise to the speculation that they were composed by the king's successors.

The King Ram Khamhaeng inscription was discovered in 1833 by Prince Mongkut of Siam, later King Chomklao or Rama IV, in the old city of Sukhothai during his visit there while he was in the Buddhist monkhood, and it was brought to Bangkok. After many moves within Bangkok, the King Ram Khamhaeng inscription was placed in the Siwamokhaphiman Hall which is now part of the National Museum. It was put on display as a part of the Sukhothai exhibits where it still stands today.

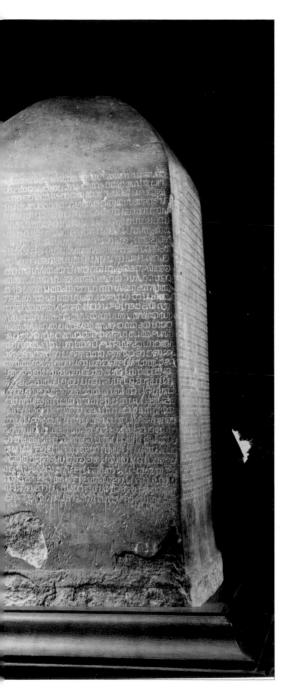

▲ The first side of the King Ram Khamhaeng Inscription.

Library Ets Haim – Livraria Montezinos

Inscribed 2003

What is it

The entire collection of Ets Haim Library – Livraria Montezinos, comprising approximately 500 manuscripts and around 30,000 printed works in 20,000 volumes.

Why was it inscribed

The collections allow an understanding of the unique combination of Jewish religious and secular education provided by the Portuguese-Jewish Community in Amsterdam from 1616 until the Second World War.

They also reflect the cultural and social history of a Jewish community that contributed substantially to the rise of the Dutch Republic and the New World in the age of mercantilism.

Where is it

Portuguese-Jewish Seminary Ets Haim, Amsterdam, the Netherlands

The Ets Haim (Tree of Life) Academy has been internationally renowned since the Dutch Golden Age. Its rich collections of manuscripts, books, sheet music and graphic materials reflect the institute's influence until the early 20th century and the international ties it maintained.

The collections of the Library Ets Haim – Livraria Montezinos comprise 500 manuscripts dating from 1282 onwards and 30,000 printed works, the earliest from 1484; around 65 percent are in Hebrew. The printed books include six Hebrew incunabula (books printed before 1501), four hundred Hebrew unique works, approximately 400 unique and rare Spanish and Portuguese works and 750 ephemera. Ets Haim also has approximately 250 prints and sheet music for children's and men's choirs.

The collections are a unique and irreplaceable example of Sephardic Jewish heritage. The culture of the Sephardic Jews, who originated in the Iberian Peninsula, was characterized by open exchange with their environment – integration without assimilation. Continuing this tradition, the curriculum of Ets Haim combined a thorough Jewish education in combination with an excellent knowledge of literature, philosophy, rhetoric and science. In training its students for leadership positions in international

Sephardic communities, the institute made important contributions to societies in which several religions coexisted peacefully. In addition, Sephardic Jews, based in this location since 1675, were central to the rise and prosperity of the Dutch Republic and mercantilism in the Golden Age.

The collections reflect the 17th-century humanist ideal, documenting all fields of human knowledge, science and activities. Many editions are available of all Jewish standard works: editions of the Bible, exegetic, hermeneutic, homiletic, legal and didactic works, and there are also various Christian publications. History, language and literature, rhetoric, calligraphy,

lexicography, medicine, mysticism and economics are all represented.

The vast liturgical collection comprises virtually all Jewish prayer books printed in the Netherlands. In addition to Hebrew and Aramaic books, the library contains works in Latin, Greek, Dutch, Spanish, Portuguese, French, German, English, Yiddish and other languages. The collection represents the history of the output of Jewish book printing from Eastern Europe to the Americas and from Portugal via the Levant to Cochin.

In 1889 the then librarian David Montezinos donated his valuable personal collection to the library and

The Portuguese Synagogue in Amsterdam, home to the library. ▲

since then it has been known as Ets Haim Library – Livraria Montezinos.

Since the monumental complex of the Portuguese Synagogue was built in Amsterdam in 1675, the library has been located there almost continuously, with the exception of its confiscation for some years by Germany during the Second World War.

The manuscript of Ubayd Zakoni's Kulliyat and Hafez Sherozi's Gazalliyt (XIV century)

Inscribed 2003

What is it

A unique manuscript featuring the works of two famous Tajik-Persian poets.

Why was it inscribed

This rare and unique manuscript is a notable example of classic Tajik-Persian literature and oriental culture in general.

Where is it

Institute of the Written Heritage of the Academy of Sciences, Tajikistan

Ubayd Zakoni was a Persian poet and satirist of the 14th century. His work is noted for its satire and obscene verses, many of which contain homosexual allusions that have often been censored. Originally from the city of Qazvin, he studied in Shiraz, where he became one of the most accomplished men of letters of his time and a court poet for Shah Abu Ishaq. Also present in Shiraz was the young Hafez Sherozi.

Hafez Sherozi was a Persian lyric poet whose collected works are often found in the homes of Persian speakers in Iran and Afghanistan. His poems are frequently learnt by heart and used as proverbs and sayings. Hafez was acclaimed throughout the Islamic world during his lifetime, with other Persian poets imitating his work, and offered patronage from Baghdad to India. Today, he is the most popular poet in Iran and most libraries in India, Pakistan and Iran contain his works. Much later, the work of Hafez would leave a mark on such Western writers as Thoreau, Goethe and Ralph Waldo Emerson – the latter referring to him as 'a poet's poet'.

This unique joint manuscript consists of two parts: the complete works ('Kulliyat') of Ubayd Zakoni and Hafez's work *Gazalliyt*. This is the most ancient version of this manuscript and the only one of its kind. It was re-written in 1405 only thirty-five years after the death of Ubayd Zakoni and nine years after the death of Hafez Sherozi. The manuscript has a unique design with Hafez's poems inscribed around Ubayd Zakoni's text.

The Tajiks are one of the ancient native populations of Central Asia and Afghanistan who, over thousands of years, created a rich literary and spiritual culture. Notable writers and scientists from this civilisation include Avicenna, Ferdowsi, Rumi and Omar Khayyam. This rare manuscript is a notable example of classic Tajik-Persian literature and oriental culture in general.

The region these poets lived and worked in has historically been a place of social meeting and intellectual interaction between East and West. The national cultural and spiritual heritage of Tajik-Persian literature has had a wide influence on world history and literature. From the 18th century, Western writers began to discover many Tajik-Persian masterpieces and they featured in several famous works, including Goethe's *West–Eastern Divan*, Hugo's *Eastern Motives*, Montesquieu's *Persian Letters*, Heine's *Poet Firdausi* and Esenin's *Persian Motives* among others.

◀ *Calligraphy of a poem by Hafez*

Illustration of a country meal, from a Hafez manuscript on the subject of love. ▶

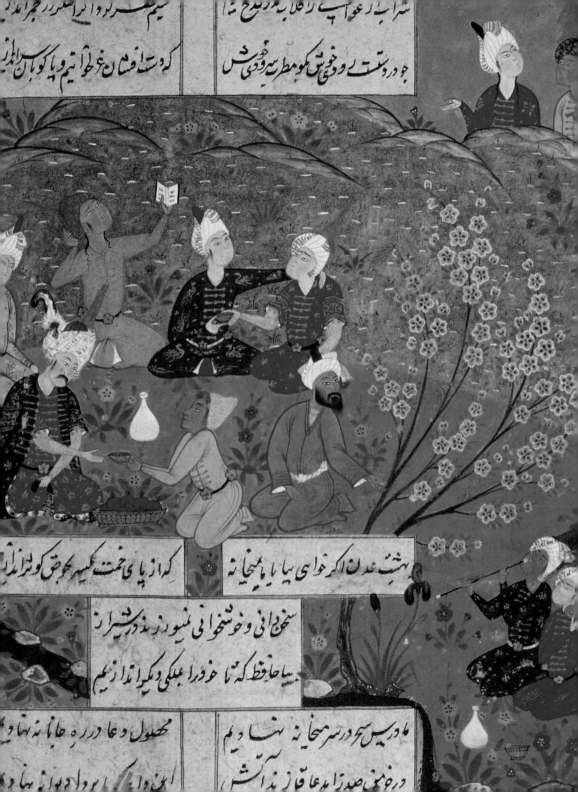

Collection of medieval manuscripts of the Czech Reformation

Inscribed 2007

What is it

The collection of Czech manuscripts relating to what became the Hussite movement for religious reform and its offshoot Christian denomination, the Unity of Brethren.

Why was it inscribed

The collection represents a movement which in retrospect can be said to have anticipated and influenced the Reformation that took place in Germany and Switzerland and spread across Europe in the 16th century.

Where is it

National Library of the Czech Republic, Prague, Czech Republic

Among the most important documents in the collection are the works of Jan Hus himself. Hus was a supporter of Wycliffe, whose work he translated, and was also influenced by the ideas of von Waldhausen. He became one of the most prominent figures among those agitating for reform and set an example that was followed by many younger, reform-minded priests in the Czech lands. Many of his most important works are represented in original form and in copies made later by his contemporaries and students.

After Hus was executed in 1415, civil unrest brought the Czech lands to the brink of civil war. Hus's followers split into various factions, one of which was the Unity of Brethren (Unitas Fratrum); the collection also contains documents relating to this denomination. Still in existence today, it is the oldest Czech Protestant church.

All the documents in the collection relate to reforming ideas that influenced or originated in the Czech Church from the late-medieval period into the early-modern era. Manuscripts relating to reform movements within the Church are far less common than printed material, and extensive manuscript collections such as this one, even less so. The collection is also distinct in that it is held in or close to its place of origin. Although the collection, containing the works of various authors, lacks a uniformity of theme, its time-span allows an overview of the development of Czech and other European ideas of reform over a long period.

Many of the manuscripts in the collection are either originals or direct copies of originals, and are often unique. They comprise a wide variety of material, ranging from transcriptions of tracts and sermons by Czech priests and lay preachers to some of the polemical works of English priest John Wycliffe, a noted critic of clerical immorality and vocal advocate of reform in the Church in the 14th century. The collection also contains works by German priest Konrad von Waldhausen, who lived and preached in Prague in the 1360s and whose ideas influenced Czech clergyman Jan Hus (c. 1369–1415).

A depiction of Czech cleric Jan Hus being led to his execution in 1415. ▶

National Library of the Czech Republic, Prague, where the manuscripts are housed. ▼

Jn ak vnd wger der voß
schmacht den man schmek-
en macht Wan der Cardin-
al pangratius hett ain roß

kam darnach fürt man
äsſten gentzlichen was
da lag Jn den fün.

The Deed For Endowment: Rab' i-Rashidi (Rab i-Rashidi Endowment) 13th-century manuscript

Inscribed 2007

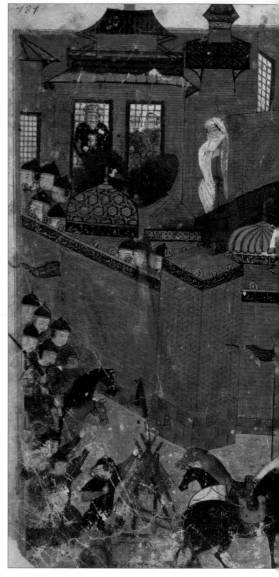

What is it

The deed of endowment of the Rab' i-Rashidi in the city of Tabriz. The Rab' i-Rashidi was a noted and multi-faceted academic complex which undertook many educational, charitable and industrial functions.

Why was it inscribed

The high value of the many endowed properties and the famous reputation of the Rab' i-Rashidi gives the manuscript great importance. The institution of the *waqf*, or endowment, is a central pillar of Islamic society and this deed therefore provides an important record of political and economic administration in Central Asia at a time of great dynamism and change.

Where is it

Tabriz Central Library, Tabriz, Iran

Seven centuries ago, the city of Tabriz was the flourishing capital of the Mongol Ilkhanid dynasty (c. 1260–1353) and a regional intellectual and cultural hub, ruled by Il-Khan Mahmud Ghazan (1295–1304). Ghazan Khan's *wazir*, or lord chancellor, was Khajeh Rashid al-Din Fazlollah Hamadani. A doctor, mathematician and author of a history of the Persian language, he founded an academic complex known as the Rab' i-Rashidi, or Suburb of Rashid, on the outskirts of Tabriz.

The Rab' i-Rashidi contained a paper mill, library, teaching hospital, orphanage, caravanserai, textile factory, teachers' training college and seminary, and attracted students and thinkers from as far away as China. The purpose of this endowment, or *waqf*, was to ensure that as many of the scientific treatises written by the *wazir* Rashid al-Din, or which fell into his possession, could be copied.

The endowment details the justification for the complex, its management system and the administration and budget of the endowed properties which included land in present-day Afghanistan, Asia Minor, Azerbaijan, Georgia, Iraq and Syria as well as in Iran. The endowment manuscript is 382 pages long, of which the first 290 pages were written by Rashid al-Din himself, with the city governor and two scribes completing the rest.

Historical records show that five copies of the original manuscript were made under the supervision of Rashid al-Din. Four were either destroyed or were used to improve the current manuscript, which is therefore the only extant copy of the deed.

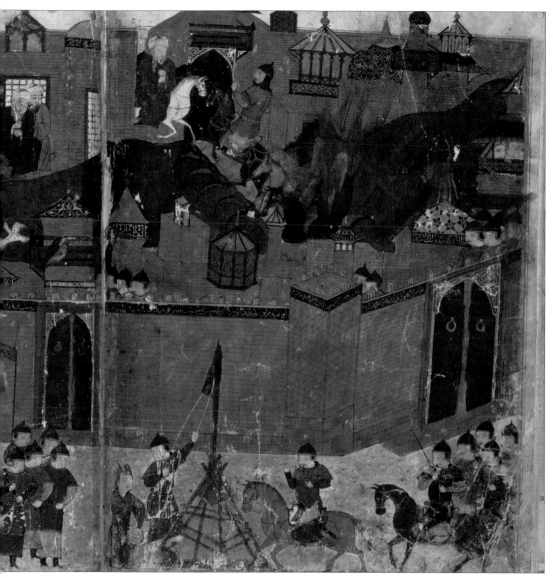

Tabriz under the Mongol Ilkhanids became a centre of book production and manuscript illustration. The significance and high status of the deed of endowment was reflected in the costly materials, including Chinese paper and gold, used in its creation; its cover page is elaborately designed with gilded calligraphy.

▲ *Mongols storming and capturing Baghdad in 1258, from the 'Jami al-Tawarikh' by Rashid al-Din.*

Batu Bersurat, Terengganu
(Inscribed Stone of Terengganu)
Inscribed 2009

What is it
The Inscribed Stone of Terengganu provides the earliest evidence of Jawi writing (Malay written in an Arabic script) in the Muslim world of Southeast Asia.

Why was it inscribed
The Stone is a testimony to the spread of Islam, offering an insight to the life of the people of the era and depicting the growing Islamic culture reflected in religious laws.

Where is it
Terengganu State Museum, Kuala Terengganu, Malaysia

With the arrival of Islam in Southeast Asia in the 10th or 11th century, an Islamic way of living based on the teachings of the Koran and the Hadith (practices of the Prophet) became widespread, and with this, the use of the Jawi script. It heralded a new age of literacy, when converts to the new faith gradually replaced the previous Hindu-derived script with Jawi, as a way of expressing their new belief. As a testimony to the spread of Islam that emanated from the Middle East, the Inscribed Stone offers more than just a glimpse of the life of the people of the era. This historical artefact also depicts the growing Islamic culture reflected in a set of religious laws. A feature of this historic movement was the growth of maritime commerce that centred around Kuala Berang, the place where the Batu Bersurat was found in 1887 and whose significance was recognized in 1902. The Inscribed Stone alludes to regional trade that flourished in the course of Islamization, with its trading patterns and the related movement of peoples.

While the Islamization of Terengganu (a state on the east coast of the Malay Peninsula) was pursued effectively, it did not put an end to the old way of life. The Batu Bersurat bears witness to a new way of thinking that did not jeopardize the previous way of life unnecessarily – indeed, the Inscribed Stone also contained a number of Sanskrit terms, a memorial to Southeast Asia's Hindu past.

The Stone is 89 cm in height, 53 cm in width at the top, and weighs 214.8 kg. All of its four sides have inscriptions in Malay written in the Jawi script, and dated AH 702 (1303).

▼ The front of the Stone of Terengganu, with the Jawi script going horizontally across its face.

One side of the Inscribed Stone of Terengganu, ▲ with the Jawi script running vertically.

The promulgation of Islamic laws established Islam as the state religion of Terengganu, the first recorded state in the Malay Peninsula to do so, and defined a new way of life for the people. The first side records this recognition of Islam as the state religion, while the other sides record commandments and regulations.

The Inscribed Stone of Terengganu has assumed additional importance, especially in the context of understanding the political and social history of Southeast Asia, and the transformation of the religious and economic life of its people associated with trade and commerce of the era. The presence of traders from various Asian regions illustrates not only the variety of cultures that interacted in the area, but also the migratory patterns of the time.

This translation of the text on the front of the Stone establishes its great significance:

Behold the Prophet of God and his apostles.
Praise the God Almighty for giving us Islam.
With Islam, truth revealed to all Thy creatures.
On this land the religion of the Holy Prophet shall prevail.
The Holy Prophet, the upholder of truth in Thy kingdom.
Hear ye kings, these messages.
Messages from the Almighty, ye doubt not.
Goodwill, with thee fellow men, saith the Almighty.
Be it known, the land of Terengganu, the first to receive message of Islam.
On the noon on Friday in the month of Rejab whilst the sun was in the north by religious reckoning.
Seven hundred and two years after the demise of the Holy Prophet.

La Galigo

Inscribed 2011

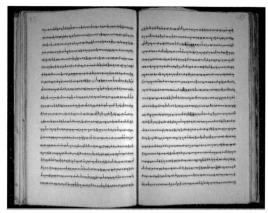

What is it

Two manuscript copies of *La Galigo*, a poetic text in a Bugis dialect of South Sulawesi in Southeast Asia and dating from around the 14th century. One copy is in South Sulawesi in Indonesia and the other is in the Netherlands.

Why was it inscribed

At an estimated 6000 folio pages long, *La Galigo*, also known as *Sureq Galigo*, may be the longest work of literature in the world. A mythological epic, the work has its origins in oral tradition and its language is considered beautiful and difficult.

Where is it

Museum La Galigo, Makassar, Indonesia;
Leiden University Library, Leiden, the Netherlands

The two copies of *La Galigo* listed on the Register are not the only extant manuscripts of the work: many others are in public and private collections, but the work itself is so long that no single manuscript contains the entire text. Instead, the work is contained in many manuscripts and all the known copies are fragments – some extensive, others much smaller – but the copies in Museum La Galigo in Indonesia and at Leiden University Library in the Netherlands are exceptionally important.

The Sulawesian manuscript, at 217 pages in length, narrates one complete episode in the text. The Dutch manuscript is 2851 pages long and comprises the first third of the story; this version is the largest continuous and consistent fragment of the text in the world. Both were probably transcribed in the 19th century.

La Galigo is a poetic text generally set in a strict, five-syllable metre using a particular branch of the Bugis dialect. Its origins lay in oral tradition and it was thought to have first been recorded in writing around the 14th century, when the indigenous Bugis script developed. Its story is a mythological epic centred in Luwuq, the kingdom regarded as the cradle of Bugis culture, and relates the coming of the gods to Earth and their adventures there over six generations.

The main barriers to the study and understanding of the work are the disappearing knowledge of Bugis in both written and spoken forms. The first systematic study of *La Galigo* was the work of B.F. Matthes, a missionary who, like many of his colleagues, learned the local language of the region in which he taught and preached. He also published a Bugis–Dutch dictionary which remains an important source both for the language and its use in *La Galigo*.

Difficulties with the language, and the fragmented and incomplete nature of the manuscripts mean that, although the text is of a high literary quality, it remains less studied than other epic poems. However, *La Galigo* still remains part of the culture and identity of the Bugis people who have named public roads and buildings after the story and its protagonists.

Persian illustrated and illuminated manuscripts

Inscribed 2007

◀ 'The king of Egypt with his entourage welcoming Zulaykha on her arrival to Egypt': an illustration from a 1533 text in this Egyptian collection of Persian manuscripts.

Battle scene, from 1553 Persian manuscript by Shah Mahmud al Nishapury. ▶

What are they

A collection of seventy-one Persian manuscripts each containing (on average) 100 miniature paintings in exquisite and vibrant colours, produced in art centres and royal ateliers in Asia Minor, Central Asia, Persia and India over a span of almost 500 years.

Why were they inscribed

The collection is a treasure trove of the 'art of copying', a widespread activity for distributing iconography and information, and is of great importance for its authentic copies of Persian illustrated and illuminated manuscripts from different royal ateliers. It is culturally significant for the evolution of art schools and ateliers in the Islamic world.

Where are they

National Library and Archives of Egypt, Cairo, Egypt

This unique collection of Persian illustrated and illuminated manuscripts from different royal ateliers comprises seventy-one rare illustrated and illuminated Persian manuscripts that highlight the development of royal ateliers from the 14th century to the 19th century. The collection is unique as it tells the history of Persian Islamic miniature painting, the development of Persian calligraphic script styles and the art of single folios and album compilation (*muraqqa'*). The collection was produced at renowned art centres and royal ateliers that flourished in a vast geographical region: from Baghdad and the Mosul area to Central Asia (Samarkand and Bukhara), to Iran and Afghanistan (Herat, Shiraz and Isfahan) and to the Indian Subcontinent. All of these geographical areas considered the Persian language as the literate and refined language to be used by the elite. The collection includes miniature paintings from the Mosul and Baghdad School which was devastated by the Mongol invasion in 1258, from the Timurid school which flourished in 1368 under Shah Timur, in Iran, Turkistan and Khurasan, and from the Safavid dynasty (1502–1736) as well as from the Mughal Empire of India (15th–18th centuries). Among the rare manuscripts are

a copy of *Khalila wa Dimna* (which includes 112 miniatures) inscribed in the 12th century by Abu al Muzafar Bahramshah of Ghaznah, a *Shâhnâmeh* of Ferdowsi (with 166 miniatures) inscribed and illustrated by Mani during the 15th century and a copy of the *Bustan* of Sa'adi al-Shirazi inscribed by Sultan Ali al Katib in 1488 and illustrated by the renowned Behzad who proudly signed and dated his miniatures to 1489.

The collection comprises epic poems (*shâhnâmeh*), love poems (quintets and rhyming couplets), mystic poems (Sufi) and religious aphorisms and wise sayings. The manuscripts are illuminated by geometric frontispieces, opening medallions, gold rulings and illuminated end pages. They are further illustrated with exquisite, colourful and vibrant miniature paintings. The miniatures range from royal gatherings in famous courts, depictions of hunting and themes of festivities, anthologies of the lover and beloved, as in Majnun and Layla (Nezami's *Khamsah*), astronomical images, images of wise men, plants and animals.

The collection includes anthologies inscribed by some of the most renowned calligraphers of the 16th, 17th and 18th centuries in the region and dedicated to the shahs and leaders of key dynasties. It fills an important gap in history and in the relationship between calligraphers and ateliers. The miniatures are important to the development of Islamic miniature paintings; names found in this collection such as Mani and Behzad are rarely found in other collections around the world.

The collection is of great significance; the manuscripts and the *muraqqa'* albums recollect the history of the region, the history of calligraphy and miniature paintings and the relationship between the artist and the royal ateliers. It is irreplaceable because these items are the joint work of ateliers, where painters, calligraphers, illuminators,

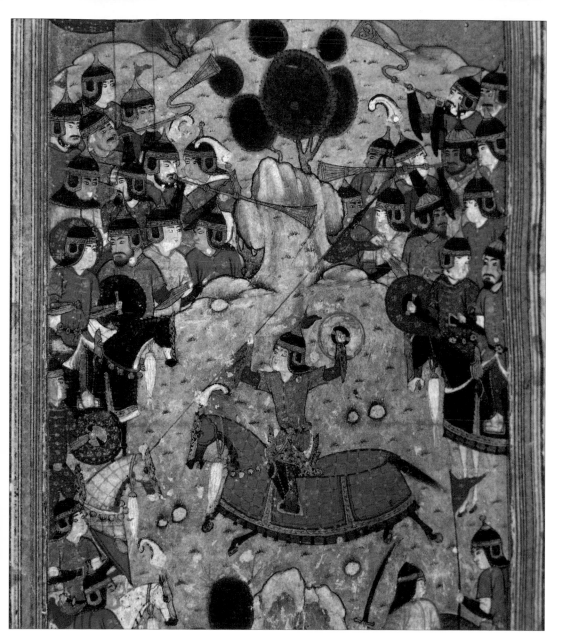

paper makers and cover producers jointly worked for years to produce a single text. While the collection ranges from the 14th to the 19th centuries, much of the content of the *muraqqa'* manuscripts was compiled before this. The copying of famous stories of kings in the *shâhnâmeh* or famous poems of Sa'adi and Nezami by famous scribes safeguarded the original manuscripts from destruction or disappearance. The collection illuminates the different styles of the royal ateliers, as guided and dictated by outstanding calligraphers and painters, and the taste of the Mosul, the Timurids, the Safavids, the Shaybanids and the Mughal empires.

Collection of Nezami's Panj Ganj

Inscribed 2011

▲ *Pages from the manuscripts*

What is it

Five separate manuscript copies of *Panj Ganj*, a collection of five versified stories in Persian, attributed to the medieval Persian poet Nezami Ganjavi and gathered together in one volume.

Why was it inscribed

Also known as *Khamseh*, the work is a renowned masterpiece of Persian literature. Its style proved hugely influential, providing a model for later versified storytellers to follow as well as inspiration for Persian artists.

Where is it

Sepahsalar Library, Sepahsalar School, Tehran, Iran; Golestan Palace, Tehran, Iran; National Museum of Iran, Tehran, Iran; Malek National Library and Museum, Tehran, Iran; Central Library and document centre of the University of Tehran, Tehran, Iran

Panj Ganj means 'Five Treasures', a reference to the five separate tales within the collection, all of which are derived from recognized narratives in Persian literature. The collection is believed to be the work of Nezami Ganjavi (1133–1222) who lived at a time when the narrative poetry form in Persia was at its height. The five stories take the form of long poems versified in rhyming couplets (*mathnavi* in Persian) and retell the most famous and popular romantic stories from Persia.

The first of the five stories is *Makhzan al-Asrar (Treasury of Secrets)*. It has 2263 couplets and 20 essays, each telling a single story expressive of the poet's inner state and the importance of the acquisition of self-knowledge. *Khosrow and Shirin* has 6512 couplets relating one of the best-known Persian love stories – the story of Khosrow Parviz, the Sasanid king of Iran, and Shirin, an Armenian princess. *Layli and Majnoon*, written in AD 1188 after *Khosrow and Shirin*, relates a story of unhappy love over 4718 couplets.

The section acknowledged as the finest in *Panj Ganj* is *Haft Paykar (Seven Bodies)*, a poem in 5136 couplets recounting the story of a Sasanid king, Bahram Goor, together with seven stories that seven princesses narrated for the king in seven palaces. Finally, *Eskandar Nameh (The Tale of Alexander)* tells the story of Alexander the Great and his wars, with philosophical reflections and advice in two parts comprising 10,500 couplets.

The work was written during the rule of the Saljuqid dynasty, noted for their patronage of the arts and particularly of poetry, literature and language. Although written around 850 years ago, the poems remain easily comprehensible and enduringly popular with modern-day Persian speakers. *Panj Ganj* remains a masterpiece of its genre and is enduringly influential. The work has also been translated into the major European and Asian languages.

Many manuscripts of the tales exist, but the five listed are exceptional for several reasons, including the quality of the artistry, the quality of the calligraphy, associations with royal libraries and a dated inscription of the year 1318 on one, making it the oldest known version.

An image of the author Nezami from an Azerbaijani banknote ▶

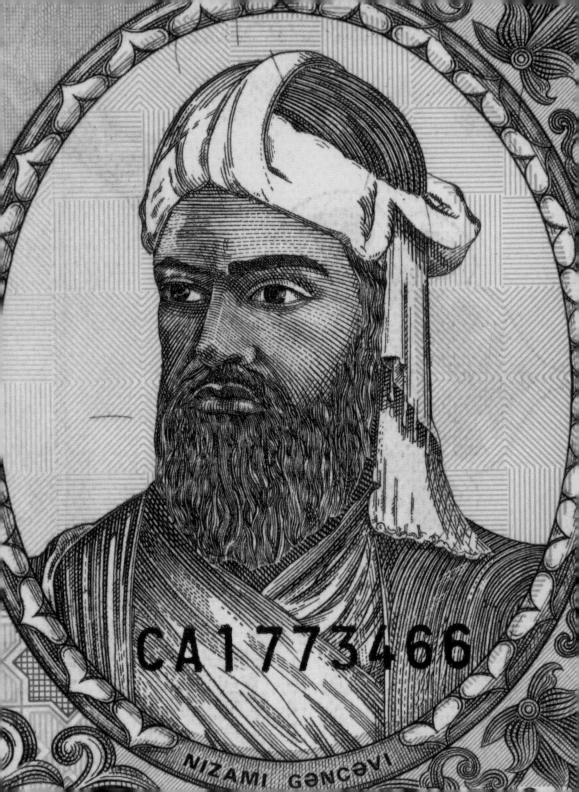

CA1773466

NIZAMI GƏNCƏVI

Baegun hwasang chorok buljo jikji simche yojeol (vol. II) –
The second volume of 'The Anthology of Great Buddhist Priests' Zen Teachings'
Inscribed 2001

What is it
The second of two volumes of a Korean book containing the essentials of Zen Buddhist teaching and dating from the 14th century.

Why was it inscribed
Buljo jikji simche yojeol, or simply *Jikji*, was printed in 1377 and is an anthology of Zen Buddhist teachings. It is the oldest extant book in the world to be printed with movable metal type.

Where is it
Bibliothèque Nationale de France, Paris, France

Buljo jikji simche yojeol means 'Anthology of Great Buddhist Priests' Zen Teachings' and its compilation was the work of Baegun, a Buddhist priest in Korea. Its contents represented the teachings of his master, Seogok Cheonggong, a master of Zen or Buddhist meditation which aimed at achieving enlightenment.

Buddhism was a Korean national religion under the long-lasting Goryeo dynasty which ruled the country from AD 918 to 1392. Towards the end of this period however, the religion became corrupted by secularism. Baegun worked to correct this decay and his compilation, written in 1372 when he was 75 years old, was intended as a continuation of his life's work, disseminating the essential ideas of Zen to his hundreds of students and beyond.

Jikji contains Buddhist texts in verse, song, chant, scripture, letters and poems drawn from the works of 145 priests and monks from Korea, India and China. It originally contained thirty-nine chapters, although the first chapter is now missing. The book was the second part of a two-volume set and the first volume has not been found.

Printed in July 1377 at Heungdeok-sa temple in Cheongju, the volume is the world's oldest known book to be printed using movable type, an advance that stands as one of the single most significant in the dissemination of knowledge and information. It predates Johannes Gutenberg's famous Bible – which was printed in the early 1450s – by over 70 years. Old Korean books contain references to some even earlier metal-type printings, but *Jikji* is the only known one still extant. The place and date of its publication are printed on the book's final leaf together with the names of two of Baegun's student priests, Seokcan and Daldam, and a Buddhist nun Myodeok who all helped with the printing.

Although *Jikji* is Korean, the book is currently kept at the Bibliothèque Nationale, the National Library in Paris. By 1887 it was part of the collection of a member of staff at the French Embassy in Seoul and from there passed into the hands of Henri Vever, a collector of classic books. After his death it was donated to the French National Library.

Khitrovo Gospel

Inscribed 1997

What is it

A Russian illuminated Gospel manuscript of the four Gospels of the New Testament, dating from the late Middle Ages.

Why was it inscribed

The Khitrovo Gospel is an important and unique part of religious and cultural expression of the Russian and Slavonic peoples. The Gospel illustrates the development of Russian book-writing schools and literature and the dissemination of the church Slavonic language.

Where is it

Russian State Library, Moscow, Russia

Written on parchment, the Khitrovo Gospel manuscript is 300 pages long. In total, it contains eight full-page miniatures – one of each of the four Evangelists and one each of their symbols (angel, lion, bull and eagle). It was the first time the symbols were depicted on their own in a Russian book, and the Gospel is widely known for these eight paintings, by Andrei Rublyov and his students.

Rublyov was thought to have been trained by the Greek painter Theophanes, a master in the Byzantine style, and was considered the foremost Russian painter of religious icons of his day. Rublyov was a monk in the Troitse-Sergieva Lavra (Holy Trinity Monastery) near Moscow, where the Gospel was believed to have been created. In addition to his work with miniatures, he was also famed for his icons and fresco work. Many of the other pages of the Gospel are also lavishly decorated, and the initial letters are painted in colour and gold.

The Khitrovo Gospel takes its name from Bogdan Matveevich Khitrovo, a Russian aristocrat who obtained the manuscript from Tsar Feodor III in 1677; Khitrovo later bequeathed the manuscript again to the Troitse-Sergieva Lavra. The manuscript remained there until 1920 when the monastery was closed by the new Communist government in the wake of the Russian Revolution. The Gospel has been part of the Russian State Library since then.

Annals of the Joseon dynasty

Inscribed 1997

What is it

This collection covers more than 470 years of the history of the Joeson dynasty, from the reign of King Taejo (1392–98), the founder, to the reign of King Cheoljong (1849–63).

Why was it inscribed

The *Annals of the Joseon dynasty* are among the most detailed and comprehensive dynastic historical records in the world, and cover the rule of a dynasty that had significant impact on Korean society.

Where are they

Kyujanggak Institute for Korean Studies, Seoul National University and National Archives of Korea, History Archives, Busan, Republic of Korea

In the Joseon dynasty, the concept of history as a mirror, or exemplar, for government heightened the interest of the state in the compilation of histories. The tradition of preparing a history of each reign began with the *Annals of King Taejo*, completed in 1413. This tradition was continued throughout the dynasty, giving us the basic record known collectively as the *Annals of the Joseon Dynasty, Joseon Wangjo Sillok*.

The *Annals of the Joseon dynasty* cover more than 470 years to the reign of King Cheoljong (1849–63). With the kings as the central figures, the annals are daily records of the history and culture of the Joseon dynasty, covering politics, military affairs, diplomatic relations with China and Japan, the social system, law, economics, industry, transportation, communications, customary arts, crafts

and religion. The annals of a given king were definitively compiled only when his successor ordered it. The materials were collected from official records, the most important being *Sacho* (Draft History) and *Shijonggi* (Daily Records). The main authors of the Draft History attended every national conference and kept records of the details of national affairs under discussion between the king and his officials. Sometimes they made character sketches of people who had done good or evil deeds. The Daily Records were placed in the custody of the Office for Annals Compilation (*Chunchugwan*). Nobody – not even the king was allowed to read the Draft History and the Daily Records except historiographers. Any historiographer who disclosed the contents of the annals was severely punished as a felon. The annals were printed and then preserved in the historical archives under rigorous management, and to ensure their safety, copies were placed in historical archives in different parts of the country. There are a total of 2077 books in the *Annals of the Joseon dynasty*.

These annals record historical facts about twenty-five kings, including information about their officials and their other subjects. Three of these kings were outstanding: King Taejo, who founded the dynasty after overcoming the Goryeo dynasty, King Sejong the Great, who invented the Korean alphabet, *hang-gul*, and devoted himself to the development of science, and King Jeongjo, who established the Kyujanggak, the royal library, which stimulated literature and arts. The annals for the first three reigns were in manuscript form in excellent calligraphy. Thereafter, they were printed using movable bronze and wooden type with the best quality paper and bindings. Every volume of the annals is a model of the Korean culture and technology of its time.

◀ *Chapter 3 of The* Annals of King Jeongjong, *as reprinted in 1606.*

◀ *The book covers from the annals of three kings, Sunjo (1838), Heonjong (1851) and Cheoljong (1865).*

Kitab al-ibar, wa diwan al-mobtadae wa al-khabar

Inscribed 2011

What is it

The fifth volume of *Kitab al-ibar*, a major work on the history of social organization and on the history of Arab Muslim countries.

Why was it inscribed

The book's author, Ibn Khaldoun, is regarded as the father of sociology and cultural history. This volume was donated by him to the library of al-Quaraouiyine University in Fez, where it still remains.

Where is it

Library of al-Quaraouiyine University, Fez, Morocco

This particular manuscript is the fifth volume of seven of one of the most important treatises on history, written by Ibn Khaldoun in the late 14th century. This complete manuscript is about social and political history and contains profound reflections on the logic of the emergence, constitution and decay of states. It is considered as a pioneering work in sociology, as a treatise of political philosophy and a major work of history in general and of the Arab Muslim countries in particular. Its full title can be translated as *The Book of Exemplaries* (or *Admonitions* or *Precepts*) and the *Collection of Origins and Information respecting the History of the Arabs, Foreigners and Berbers and Others who possess Great Power*. It is sometimes referred to as *The Universal History*.

The first volume, the *Muqaddimah* (the *Prolegomena*), is the most renowned volume, in which Ibn Khaldoun develops his thoughts on social organization through the study of nomadism, urbanization and the rise and fall of rulers and dynasties. Volumes II–V cover the history of mankind up to the time of Ibn Khaldoun, while Volumes VI and VII cover the history of the Berbers of the Maghreb.

Ibn Khaldoun (Abu Zayd 'Abd al-Rahman ibn Muhammad ibn Khaldoun al-Hadhrami, 1332–1406) was born in Tunis and served a number of rulers in North Africa and Granada, finally settling in Cairo, where he was a teacher, judge and political adviser. In 1396 he gave instructions that a copy of Volume V of *Kitab al-ibar* be made for the library of al-Quaraouiyine University in Fez,

▲ *The fifth volume of Ibn Khaldoun's* Kitab al-ibar, *a major historical work, which the author donated to the library of al-Quaraouiyine University in Fez in 1396.*

and the dedication mentions that students should benefit from consulting and copying it, but that it may not be borrowed for more than a month at a time. The university was established in the late 9th century, while the library was founded in 1349 and is one of the oldest libraries in Morocco. This unique volume remains there to this day.

Slavonic publications in Cyrillic script of the 15th century

Inscribed 1997

What is it

A collection of sixty-three exceptionally rare and early books printed in the Cyrillic script.

Why was it inscribed

This collection is of international significance and is of great importance to the cultural heritage of Slavonic nations. They represent the earliest books printed in Cyrillic, dating from the late 15th century.

Where is it

Russian State Library, Department of Rare Books, Moscow, Russia

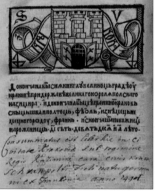

◀ ▲ *Pages from the earliest known printed book in Cyrillic, an Oktoih (Book of Psalms), printed in Krakow in 1491.*

This collection of early printed books in Cyrillic is the result of more than 50 years of research work by the specialists of the Russian State Library, who located and verified the authenticity of these rare books. The majority of the books are held in Russia, but others are scattered in libraries in many countries such as Ukraine, Belarus, Bulgaria, Serbia, Montenegro, Romania, France, UK, USA, Croatia, Slovenia, the Czech Republic and Greece – and have never been seen altogether. The exceptional rarity of these publications and their fragility brought on by their age has necessitated limited access to them and has spurred on the project to have all of them available in digital form so that they can be widely studied. Another goal of selecting this collection is, in essence, the creation of a new cultural resource – a united digital collection of early printed books in Cyrillic which far surpasses the collection in any single library in the world.

These books are an important part of the cultural heritage of Slavic nations. The books predate those produced by the traditionally recognized father of Russian book printing, Ivan Federov (c.1510–83), by 70 years and mark an important landmark in the early period of book printing. The collection includes the first book printed in Cyrillic, the *Oktoih*, a liturgical book of the Orthodox Church, printed in Krakow in 1491. These Slavonic publications in Cyrillic script have exerted appreciable influence on the development of the Slavonic nations and helped Slavic peoples to reaffirm their national literary languages and to produce books with a cultural identity that is different from the early printed books of western Europe.

Treasures from National Archives and Library organizations

Inscribed 1997

What are they

These treasures are a small selection of rare Ethiopian manuscripts and include religious texts of the 14th and 15th centuries; royal correspondence to European monarchs; the first printed Ethiopian publication (1513); and manuscripts from the 18th to the 20th century, relating Ethiopian history.

Why were they inscribed

Ethiopia has rare, precious and priceless manuscripts mainly written in the Geez language in the form of verse and prose which reflect its indigenous civilization.

Where are they

National Archives and Library, Addis Ababa, Ethiopia

It is estimated that there are some 500,000 historical manuscripts in Ethiopia. Aware of their historical, religious, philosophical, artistic and socio-cultural values, the Ethiopian National Archives and Library has been collecting manuscripts for scholastic research and preservation for future generations. A few highlights of their manuscript collection are included in this inscription and are detailed below.

The manuscript of the Fourth Gospel was written on vellum in the Geez language in the 14th century. The first forty-five pages of the book are filled with painted images, particularly of Jesus Christ, his followers, saints and angels. *The Homily of the Passion of our Lord and Services for Passion Week* was written on vellum in the Geez language in the 15th century. The writing is bold and neat, and the text is bound with wooden boards covered with stamped leather. The manuscript of St Paul's Gospel was written on vellum in the Geez language in the 15th century. It includes a painted picture of St Paul and his followers. The manuscript of *Henock* was written on vellum in the Geez language in the 15th century. The writing is fine and neat and there are marginal notes on each page. The *Psalterium Davidis* was written by Johannes Potken in the Geez language with an introduction in German and was printed in Rome in 1513. It is considered to be the first printed publication in Ethiopian history. The manuscript of Anaphora was written on vellum in the Geez language in the 17th century. There is musical notation over most of the text and it has marginal notes and designs. From the 19th century *The Letter from King Tewdros to Queen Victoria of Britain*, the *Letter from King Menelik II to Tsar Nicolas II of Russia* and the *Letter from King Sahleselassie of Shoa to the Queen Victoria of Britain* deal with the relations, not always cordial, between Ethiopia, Britain and Russia. The manuscript *Fetha Negest (Nomocanon)* was written on vellum in the Geez language in the 19th century. The manuscript of the *History of Menelik II* was written on paper in the Amharic language in the 19th century. It has marginal notes and designs, is illuminated and contains musical notation. The manuscript of the *Tarike Negest (History of Kings)* was written on vellum in the Geez and Amharic languages in the 20th century.

Corpo Cronológico
(collection of manuscripts on the Portuguese discoveries)
Inscribed 2007

What is it

A collection of more than 80,000 public manuscript documents, mostly from the 15th and 16th centuries, which chronicle the voyages of the Portuguese explorers and the people and lands they discovered.

Why was it inscribed

The enormous breadth of this truly unique collection offers a direct view into the Age of Discovery, recording the first mutual impressions and interaction between people from previously unknown lands, and the development of influences between disparate civilizations over the course of the 15th and 16th centuries.

The documents chart the growth of Portugal's vast empire, which ultimately spanned the globe, from its beginnings in the voyages of exploration.

Where is it

Arquivo Nacional da Torre do Tombo, Lisbon, Portugal

The Portuguese were in the vanguard in the Age of Discovery and it would be difficult to overstate their contribution to the expansion of knowledge and to changing human perception of the world. Although the Corpo Cronológico is Portuguese in origin, the information in the papers is almost uniquely of worldwide interest in that the navigators and explorers recorded

details of other civilizations and new-found lands where few other contemporary written records existed.

The sources in the Corpo Cronológico follow the routes taken by the Portuguese ships across the Atlantic in search of the Orient and around the coasts and kingdoms of Africa.

Included in the African material are descriptions of the voyages, accounts of meetings between the Africans and the Portuguese, information on African kingdoms, the search for the legendary Prester John and descriptions of the gifts offered to local leaders.

Military affairs including the capture and building of fortifications are reported and there is information on trade, trafficking in slaves, ivory, gold, sugar, cotton and textiles as well as details of English trade in the area. The settlement and integration of incomers is documented as are the mechanics of converting the Africans to Christianity, while other papers record the administration of the growing Portuguese interests in the area.

The material dealing with Asia in the Corpo is more extensive still, charting the growth and administration of the far-flung Portuguese Empire, of matters of diplomacy and peace and trade treaties. Militarily, the documents deal with the conquest and occupation

◀ *Instituto dos Arquivos Nacionais*

Documents from the collection ▶

as 'captaincies', while others describe attacks by the French and the Dutch, and defensive measures to deal with them. Religious matters, particularly the role of the Jesuits in the area, receive attention, as does trade, particularly the slave trade.

Other documents in the collection dealt with matters closer to home in politics and diplomacy. Notable among these from the 16th century is material dealing with the continued expansion of the Ottoman Empire, the Siege of Vienna and the threat posed to Europe by the ferocious Ottoman Turkish forces.

The collection was held in Lisbon and was first systematically catalogued after the devastating earthquake that struck the city in 1755. The Guarda-Mor da Torre do Tombo – effectively head of the royal archives – organized the division of the collection into three parts, arranged according to chronological criteria, to which it owes its name. The collection of manuscript documents, written in cursive script on parchment and paper, was then described for the first time.

of territories, while trade relations were governed by the Casa da India which administered the royal monopoly of trade and shipping in the east. Trade was in pepper, cinnamon and other spices, and the Portuguese were involved in a fierce rivalry with the Dutch and the English. Information was gathered on China, and on conflicts with the Turks in many places.

The spread of Christianity is chronicled with records of conversions, church and convent building and the establishment of pious organizations and institutions. The explorers and navigators, including famous names like Vasco da Gama, are named on decrees, edicts and other grants from the Portuguese crown.

Documents relating to the New World, especially Latin America, are dominated by the affairs of Brazil, by far the largest of the Portuguese colonies. Papers deal with the division of the country into administrative divisions known

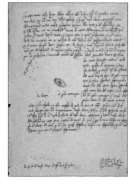

Radziwills' Archives and Niasvizh (Nieśwież) Library collection

Inscribed 2009

What is it

The collection was assembled from the 15th century to the 20th century by members of the Radziwill family, one of the most prominent aristocratic families of the Grand Duchy of Lithuania and the Polish Lithuanian Commonwealth.

Why were they inscribed

Members of the family often occupied the highest state posts and later played an important role in the history of Prussia, the Russian Empire and the Polish Republic. The Radziwills' Archives became the official archives of the Grand Duchy of Lithuania and contain both state records and treaties alongside private family correspondence.

Where are they

National Historical Archives of Belarus, Central Science Library of the National Academy of Sciences of Belarus, National Library of Belarus and Presidential Library of the Republic of Belarus, Minsk, Belarus; National Library of Finland, Helsinki, Finland; State Historical Archives of Lithuania, Vilnius, Lithuania; Central Archives of Historical Records in Warsaw, Poland; Library of the Russian Academy of Sciences, St Petersburg and Science Library of Moscow State University, Moscow, Russia; Central State Historical Archives of Ukraine, Kiev, Ukraine

The Radziwills' Archives and Library Collection was created by members of the Radziwill family who owned, as their principal estate, Niasvizh, now in Belarus. The Radziwills were a dynasty of major landlords and statesmen, whose members often occupied the highest state posts in the Grand Duchy of Lithuania and the Polish Lithuanian Commonwealth and later played an important role in the history of Prussia, the Russian Empire and the Polish Republic. During all this time the Radziwills continued to preserve their family identity and realized the importance of the historical and cultural treasures they amassed showing much concern about their preservation. The estate's land holdings and architectural buildings were nationalized by the Soviet authorities in 1939 and its

collections were dispersed among archives, libraries and museums in several countries.

The archives in the Radziwills' collection, originally established at Niasvizh in the 1570s, include one of the largest collections of documents on the history of Central and Eastern Europe and have survived almost entirely intact. Containing nearly 70,000 documents, it includes, for example, the records of Polish-Lithuanian unions, and treaties between

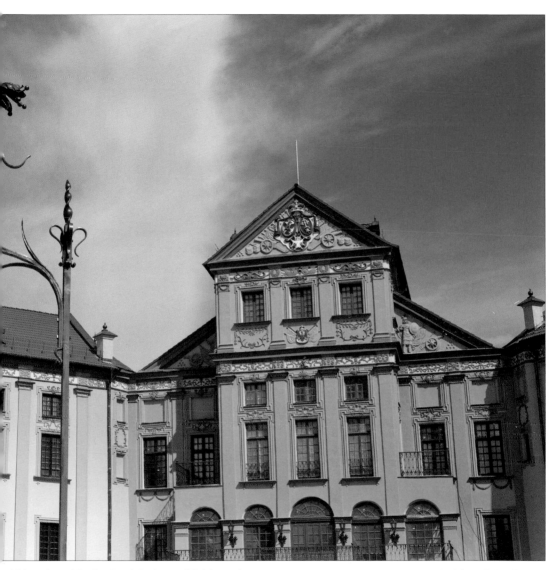

Niasvizh Castle in Belarus. ▲

Lithuania and Ruthenian dukedoms of Psków and Novgorod. One of the Radziwills was an addressee of the first letter from the New World – from New Amsterdam (now New York) in 1659. The records are in Old Belarusian, Russian, Latin, Polish, German, English, French, Italian and other languages. As members of the family occupied the highest state positions and took part in various diplomatic events they had access to state and international information, which was accumulated in their archives. The Radziwills were related to many aristocratic families in Europe, and the archives were constantly expanded with new records on political history and international relations acquired through marriage.

As owners of many huge estates in Belarus, Lithuania and Poland, the Radziwills were obliged to deal with

Antonin bei Ostrowo im Gros-Herzogthum Posen
Jagdschloß S^r Durchlaucht des Herrn Fürsten Anton Radzivill

Biblioteka
Zamku Nieswieskiego

▲ The hunting lodge of Prince Antoni Radziwill, friend and
benefactor of Fryderyk Chopin. The wooden building, at
Antonin near Poznan in Poland, was designed by the prominent
German architect Karl Friedrich Schinkel in 1822-4.

◄ Some of the ex-libris bookplates used
by members of the Radziwill family.

factories and industrial enterprises. The archives also
contain extensive information on the history of daily
life, including personal diaries and memoirs, and,
as cultural benefactors and authors of literary and
musical works, on the history of culture in Central
and Eastern Europe.

Among the early printed books in the Niasvizh library
are unique incunabula dating from the 15th century,
illustrated and illuminated herbaria, atlases and

much business concerning their property, which
generated numerous financial records. These provide
valuable information on the history of towns and
villages, and on the development of handicrafts,

▲ Herbarius Maguntiae impressus, a compilation
of herbal information from classical and
Arabic sources published in Mainz around 1484
.

▲ Statut Regni Poloniae by Joahn Herbort
published in Krakow, 1567.

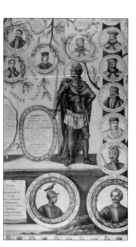

Part of the genealogical tree of the
Krasinsksis, a noble Polish family. ▶

albums of engravings. Many *ex-libris* bookplates are
works of art in themselves. The library also contains a
number of manuscripts, especially genealogical records
embellished with coloured coats of arms and magnificent
images of family trees. Extremely rare works include
parchment charters, papal bulls and indulgences, early
prints and manuscripts, plans and sketches executed by
prominent architects, printed music and libretti dating
from the 18th century.

In recent years experts in all the countries that
acquired parts of the collection have discussed the
idea of its virtual reconstruction in a single information
resource, covering all parts of the collection and
accessible to the world's scholarly community and
the general public.

▲ An *ex-libris* bookplate used by Geronim Radziwill.

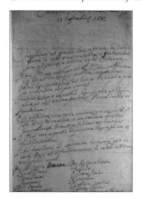

▲ Instruction by Jan III Sobieski
concerning the upbringing
of his sons.

▲ An inventory of the Radziwill
estate of Lachwa in 1672.

Collection of Gothic architectural drawings

Inscribed 2005

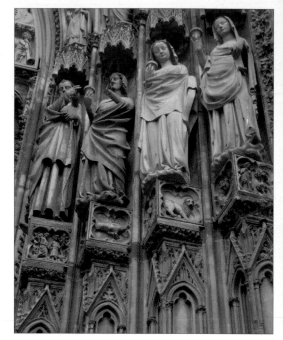

▲ *Gothic sculpture on Strasbourg Cathedral.*

What is it

A unique collection of 425 drawings that are indispensable for the study of buildings of the Gothic period. These drawings date from 1400 to 1550 and are among the world's oldest surviving architectural drawings.

Why was it inscribed

These architectural drawings bear testimony to the epoch in European history when major construction projects began to be undertaken on the basis of the advance planning of every detail.

Where is it

Academy of Fine Arts Vienna, Vienna, Austria

St Stephen's Cathedral in Vienna, one of the many Gothic buildings featured in this collection of architectural drawings. ▶

The architecture of the Gothic period (c.1150–1550) belongs to one of the most significant manifestations of European culture. With 425 drawings (representing over 85 percent of all architectural drawings from this period), this collection is of central importance for the study of Gothic architecture and is not confined to the national architectural heritage of a single country. The genre of architectural drawings on paper or parchment came into being only in the Gothic period, but as nearly all the Gothic architectural drawings in France and England are lost, those in the Viennese collection are the only major collection before the 16th century that document the emergence and development of a planning mechanism without which modern architecture would have been impossible.

With material related to cathedrals in Vienna (Austria), Prague (Czech Republic), Regensburg, Ulm and Augsburg (Germany) and Strasbourg (France), the collection demonstrates the close interrelation and exchange that existed in the late Middle Ages between cathedral lodges of masons. Since important single drawings were exchanged between different places, it shows how a consistency and internationality of style could develop and contribute to an emerging common European architectural language.

A large portion of the drawings is attributable to some of the most outstanding architects of the Middle Ages,

including Jodocus Dotzinger (Strasbourg) and Laurenz Spenning (Vienna), who organized the first conference of architects and stonemasons held in 1459 in Regensburg. The bulk of the drawings is devoted to ecclesiastical architecture in all its variations. The more spectacular drawings show the ground plans or the elevations of Gothic cathedrals, notably tower projects of unsurpassed height that attracted most interest at that time. Others deal with Gothic designs for specific parts of buildings such as window tracery, vaults, galleries and furnishings, while by far the largest number of the drawings shows details of many kinds, including geometrical devices of a more theoretical nature, demonstrating the high level of mathematical knowledge available. The rediscovery of these drawings in the 19th century also had an important impact on the development of the Neogothic architecture that dominated the Western world in that period.

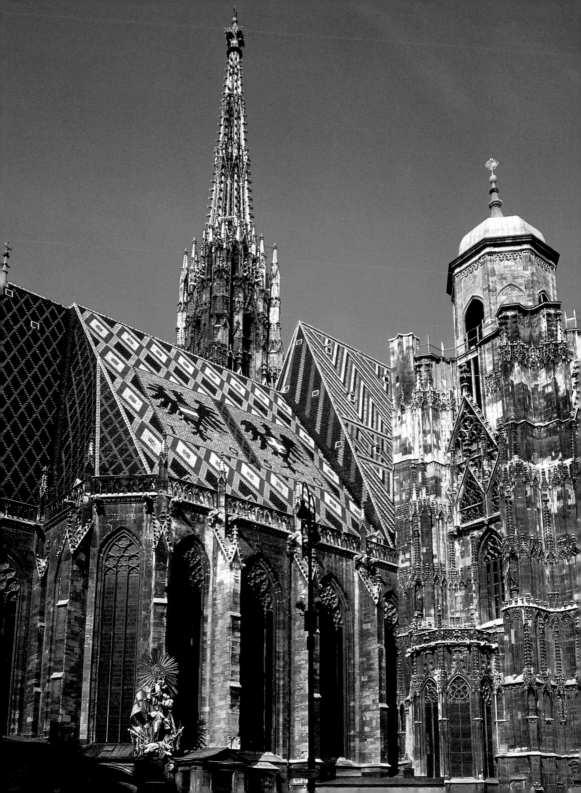

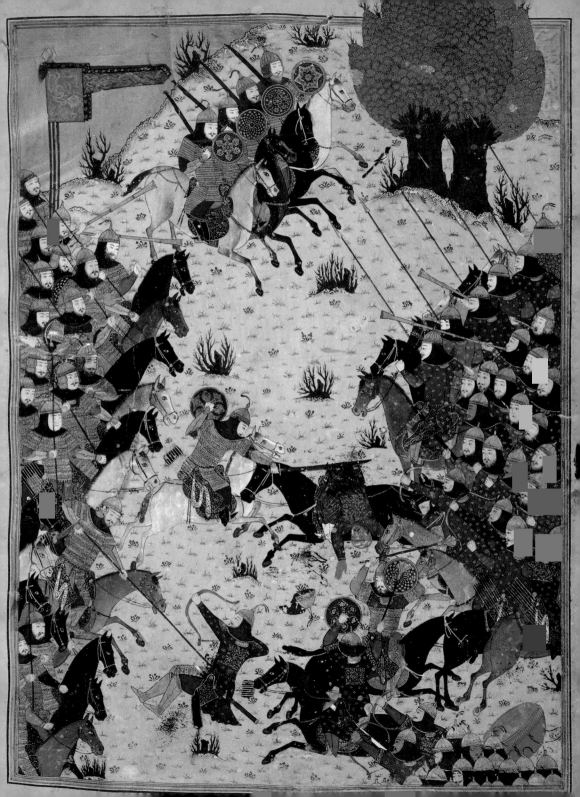

'Bayasanghori Shâhnâmeh'
(Prince Bayasanghor's 'Book of the Kings')
Inscribed 2007

What is it
Prince Bayasanghor's Book of the Kings, the *Shâhnâmeh*, is regarded as the crown jewel of Persian literature and is cherished by all Iranians as well as Farsi-speaking societies of Afghanistan, Tajikistan and Central Asia, a language group that comprises over 65 million people.

Why was it inscribed
The *Shâhnâmeh* represents the quintessence of aesthetic and literary values of the elite rulers of the Timurid Renaissance who dominated Central and Western Asia in the 15th century.

Where is it
Imperial Library, Golestan Palace, Tehran, Iran

Ferdowsi was a prominent figure in Iranian poetry and the nationalist poet of the Persian Empire. He was born in the Iranian city of Tous in 941 and died in 1020, 10 years after he finished his major epic work, the *Shâhnâmeh* (Book of the Kings). This is one of the classics of the Persian-speaking world and is on a par with *The Iliad* and *The Aeneid* of Greco-Romano culture. Ferdowsi was commissioned by Sultan Mahmud of Ghazni in Afghanistan to transcribe traditional Persian legends into an epic poem. He spent thirty-five years on the *Shâhnâmeh* and completed it in 1010, when he was about 70 years old. An important feature of this work is that, although Arabic was the main language of science and literature at that time, Ferdowsi used only Persian and therefore helped to revive and maintain this important world language.

The work became an important text throughout Central and Western Asia, India and the former Ottoman Empire. It has been copied countless times and three of these copies could be said to have universal value: the *Demotte Shâhnâmeh* made in the early 1300s for the Il-Khanid patron, Giyath al-Din; the 16th-century *Houghton Shâhnâmeh* commissioned for the founder of the Safavid dynasty, Shah Isma'il and commonly named after his son, Tahmasp; and the *Bayasanghori Shâhnâmeh*, which was made in 1430 for Prince Bayasanghor (1399–1433), the grandson of the great Central Asian leader Timur (1336–1405). Only the *Bayasanghori Shâhnâmeh* has survived, while the two other versions were broken up by the collectors after whom they were named.

The *Shâhnâmeh* contains about 60,000 rhyming couplets, making it more than seven times the length of Homer's *Iliad*. The poem progresses through Persian legend to historic times, from the first legendary Persian kings to the reigns of the Sassanid kings, the introduction of Islam to Persia and the death of Yazdegerd III in 651. Just like epic poems across the world, the *Shâhnâmeh* served an overtly political function of legitimizing ruling dynasties and it soon became a favourite subject for royal commissions. Hundreds of copies of the poem were produced, but few attained the status of masterpieces and of those that did, even fewer survived the depredations of Western collectors.

When commissioning this magnificent manuscript in 1426, Prince Bayasanghor also commanded that an account of the life of Ferdowsi and of the composition of the epic be added to the original text. The master calligrapher Ja'far Al-Tabrizi took the charge of copying the book, which was finished on 30 January 1430. Its production symbolizes the melting pot of cultures that became the great empires of West and Central Asia. Mongol rule facilitated contacts between Persia and China, and the influence of Chinese painting is easily recognizable in the twenty-two full-page miniatures. The manuscript remained in royal hands, passing from the Timurids to the Safavids in the 16th century and the Afshars two hundred years later. The *Bayasanghori Shâhnâmeh* was kept in a private sub-division (*andarun*) of the Imperial Library accessible only to the family and close friends of the shah. It is still in the Imperial Library of the Golestan Palace in Tehran.

◀ *A dazzling 15th-century illustration from the Bayasanghori Shâhnâmeh showing the battle between the army of Iran led by Key-Khosrow and the army of Turan, under the command of Afrasiyab.*

Stone stele records of royal examinations of the Le and Mac dynasties (1442–1779)

Inscribed 2011

What is it

Eighty-two stone stelae, dating from the 15th to the 18th centuries, at the Van Mieu-Quoc Tu Giam historical site. They record the names of doctoral laureates of the royal examinations at The Temple of Confucius, the National University.

Why was it inscribed

The stelae are a monument to the influence and importance of Confucianism in Vietnamese royalty, government and society, especially from the 15th to the 18th centuries. They are also works of art in their own right.

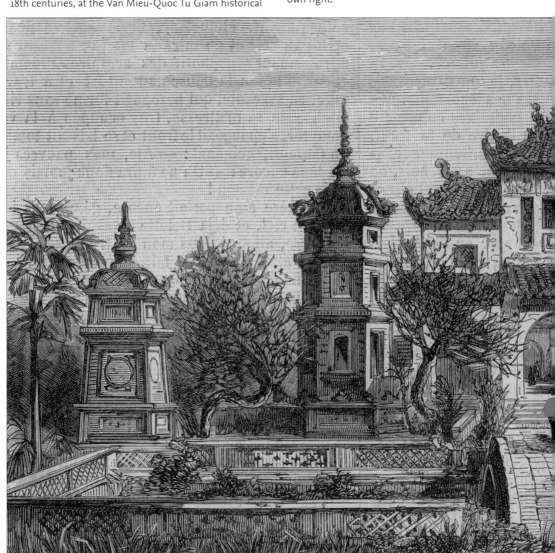

138 Stone stele records of royal examinations of the Le and Mac dynasties (1442–1779)

Where is it

Van Mieu-Quoc Tu Giam Scientific and Cultural Activities Center, Hanoi, Vietnam

Van Mieu-Quoc Tu Giam, where the stelae are located, was established as a place of learning in the 11th century and dedicated to the philosopher Confucius (551–479 BC) and Confucian education; it also functioned as the first national university of Vietnam.

Confucianism was adopted by the Vietnamese royal dynasties who made it the foundation for building the state and governing the country. Van Mieu-Quoc Tu Giam trained administrators and bureaucrats, or mandarins, for work in government. Through the centuries, the

A 19th-century engraving of the Temple of Confucius in Hanoi. ▼

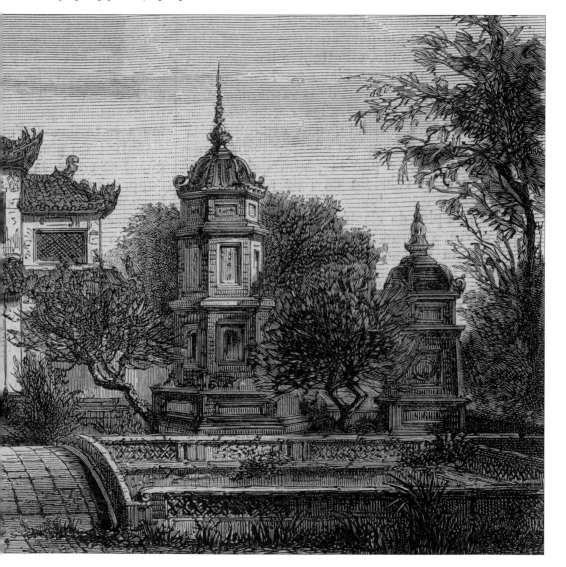

139

institution produced thousands of doctoral laureates who passed through the system of royal examinations.

The stone stelae at the Van Mieu-Quoc Tu Giam site record the names of those who successfully passed the royal exams under the Le and Mac dynasties from the 15th to the 18th centuries. Vietnam was in the sphere of Chinese influence and the erection of stone stelae as records of royal examinations in Vietnam followed the same tradition in China.

The exams were held every three years and the first

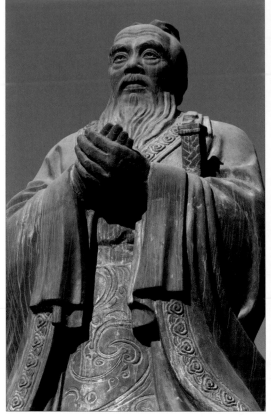

▲ *Statue of Confucius*

examination to select doctoral laureates was held in 1442. Honouring of candidates by recording their successes in stone was intended to encourage others to emulate their achievements and Chinese inscriptions on the stelae record the laureates in royal examinations held between 1442 and 1779.

Other details on the inscriptions include the date, names and official posts of the inscription compilers, revisers, calligraphers and engravers. Each period left its own mark on the stelae in terms of design, decorative pattern, their bases and the Chinese characters used, preserving each stela's originality and preventing attempts to produce

replicas. It is thought that there were ninety-one stele originally, although only eighty-two have survived to date.

The largest stele is 2.07 m high and 1.3 m wide, and the smallest 1.1 m high and 0.7 m wide. Each stele slab rests on its base of a carved stone turtle (representing longevity).

Many of those listed became famous figures in Vietnamese history, making contributions to culture, education, the military, the economy and diplomacy in the country, as well as holding offices at the royal court.

As well as their importance in Vietnamese history and culture, the designs and ornamental patterns are unique works of art from the centuries they cover.

The Hunminjeongum manuscript

Inscribed 1997

What is it

This book, published in 1446, contains the Korean alphabet *Hunminjeongum* (now called *hang-gul*), newly created by King Sejong and explanations by scholars on how to use the alphabet.

Why was it inscribed

After the creation of *Hunminjeongum*, the Korean people had an alphabet with which they could directly write down their distinctive national language. Consequently their culture began to develop at a new level.

Where is it

Kansong Art Museum, Seoul, Republic of Korea

▲ *A page from the main text of* Hunminjeongeum. *It explains each of the twenty-eight letters of the Korean alphabet that were created in this book: seventeen consonants and eleven vowels. Of the twenty-eight original letters, four fell into disuse naturally and the remaining twenty-four are still used today.*

▲ *A page of explanation of how the Korean alphabet works, from the Commentaries that form part of the Haerye edition of* Hunminjeongeum.

Prior to the publication of the *Hunminjeongum*, there had been no written Korean alphabet. Instead Chinese characters had been used since the beginning of the Christian era, and by the middle of the 15th century there were many scholarly and literary works composed in classical written Chinese. However, Chinese characters were not suitable for writing Korean, a language quite different from Chinese. A system for using Chinese characters to represent the Korean language, called *yidu*, was used for the everyday paperwork of the bureaucracy and the people, but it did not provide a perfect representation of the Korean language.

Therefore, after studying the methods of writing in neighbouring countries, King Sejong (1418–50), the fourth king of the Joseon dynasty, with the assistance of scholars of the Hall of Worthies, invented the twenty-eight alphabetic letters (seventeen consonants and eleven vowels) of the *Hunminjeongum*, which both allowed a perfect representation of spoken Korean and were easy to learn. Sejong had scholars write commentaries with examples of the new writing system, and compiled them with his own simple explanation of the new script in a book with the same name as the alphabet itself and his own explanation of it, *Hunminjeongum* ('Proper Sounds to Instruct the People').

The *Hunminjeongum* was created as a phonemic writing system, where written syllables correspond exactly with spoken syllables (modern *hang-gul* no longer maintains this direct relationship). The letters of syllables are written together in blocks approximately the same size and shape as the monosyllabic Chinese characters they often appear with in so-called mixed script.

Published in the ninth lunar month of 1446, *Hunminjeongum* is printed from woodblocks carved in a refined and elegant style. It is made of thirty-three leaves, printed on both sides, and is 32.2 cm high and 20 cm high. The main text comprises four leaves and the Commentaries twenty-nine leaves. This book used Sejong's original font, with all strokes of uniform thickness. This rectangular font became more cursive from the mid-15th century. This style harmonized well with the cursive Chinese characters. This is the only surviving example of the *Hunminjeongum* with its commentaries and is often referred to as the Haerye Edition of *Hunminjeongum*. It was thought to have been lost around 1504 and was only rediscovered in 1940. The discovery of these commentaries answered many questions about the creation of this alphabet that had been previously debated.

The Malatesta Novello Library

Inscribed 2005

What is it

This library contains manuscripts on philosophy and
theology as well as classical and scientific books. The
collection is kept in its original building in the town
of Cesena, and is one of the oldest public libraries
in Europe.

Why was it inscribed

The collection is a unique example of a humanistic
library of the Renaissance, a time when the dominance
of Christian writing and teaching was giving way to
more secular considerations. It is a rare example of a
complete, beautifully preserved collection from the mid-
15th century, just before the advent of printing in Europe.

Where is it

Malatesta Novello Library, Cesena, Italy

The Malatesta Novello Library (Biblioteca Malatestiana)
was the last library dating from immediately before the
invention of printing and embodies the very concept of a

humanist library. The architectural design by Matteo Nuti
is innovative, but the focus and essence of the library are
the books themselves. Besides the great works of medieval
culture, Malatesta Novello, the Lord of Cesena, collected
the fruits of the classical Latin, Greek, Hebrew and Arab
traditions so that he could create a library worthy of a
Renaissance prince, and comparable to those in Florence,
Milan, Ferrara and Rome.

The library, built in the Convent of St Francis, consists of
343 codices of different provenances and eras. To establish
this collection, Malatesta Novello added 126 codices,
produced by his own scriptorium between 1450 and 1465

◀ *The entrance to the Malatesta Novello Library, built in the mid-
15th century in Cesena, Italy.*

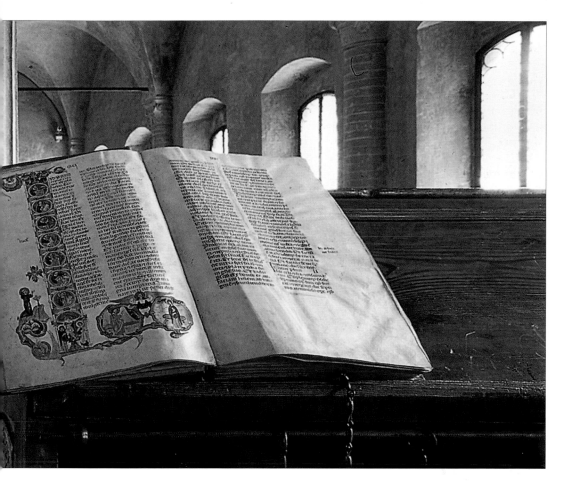

in a uniform style, to the codices owned by the convent and to the bequest of manuscripts from Giovanni di Marco, his personal physician. Their bindings conferred a uniform appearance on the corpus of the Cesena manuscripts, all of which are still linked by their original 15th-century chains to the same reading benches.

The variety of genres demonstrates the founder's desire to establish a universal collection for public use. The collection only included volumes in Latin, Greek and Hebrew. However, the library's catalogue is not confined to the most illustrious examples of classical literature but is enriched by ancient treatises on science and technology, ranging from geographers to mathematicians, doctors, students of agriculture and the authors of naturalist encyclopedias. There are also translations of the major

▲ *A book open on a reading desk, showing the chain that secures the book.*

An example of the illuminated manuscripts held in the Malatesta Novello Library ▼

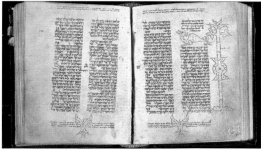

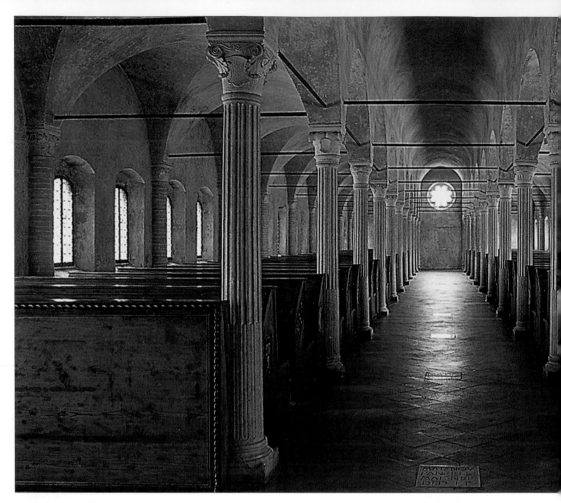

scientific, medical, philosophical and mathematical works of the Arab world, including works by Ibn Sina (Avicenna) and Ibn Rushd (Averroes). In addition there are texts of Christian thought (Bibles and biblical commentaries) and many of the works of the church fathers, among whom St. Augustine, St Jerome and St John Chrysostom stand out by their importance and fame. The present arrangement of the manuscripts still reflects the original order: the codices, five per bench, are divided by subject with, on the right, as a rule, the sacred writings, the church fathers, Bible commentaries and theological works; on the left are legal, classical and historical texts, contemporary writings and Hebrew manuscripts.

The manuscript collection in the Biblioteca Malatestiana has remained intact over the centuries as the result of a series of special measures and

precautions. Malatesta Novello entrusted his library to the Commune of Cesena, rather than to the Franciscans or to his descendants. He introduced strict regular controls, which were exercised even during his lifetime by the town magistrates, who drew up reports that can be found in the records of the commune's proceedings. As a result, the library survived unharmed both the end of the Malatesti domination of Cesena and during other eventful periods of history that elsewhere caused the dispersal and loss of famous aristocratic and monastic libraries.

The world significance of the Biblioteca Malatestiana was strengthened by the decision to open the collection to the public under the supervision of the communal authorities. Since March 2002 there has been general access to this heritage via the *Catalogo Aperto dei Manoscritti*

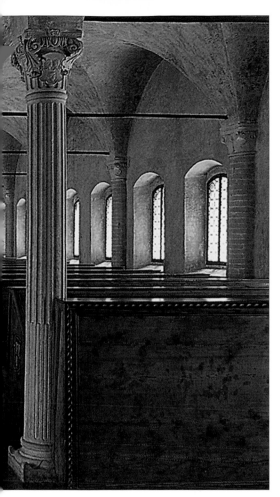

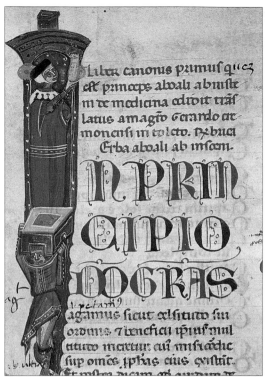

▲ *The simplicity of the inside of the Malatesta Novello Library showing the reading benches to which the books in the library were chained.*

Examples of the illuminated manuscripts held in the Malatesta Novello Library. ▶

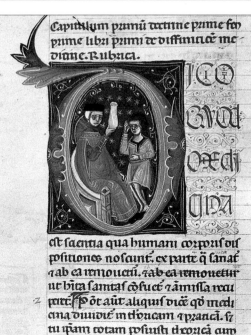

Malatestiana, which can be viewed online on the library's web page. In addition to the large and steadily increasing number of digital images, the *Catalogo Aperto* provides bibliographies, codicological descriptions, a discussion forum and specific texts that supplement knowledge of individual manuscripts.

The 42-line Gutenberg Bible, printed on vellum, and its contemporary documentary background

Inscribed 2001

What is it

The Gutenberg Bible, completed around 1456, is probably the first European printed book using movable type. It was the work of Johannes Gutenberg of Mainz, in Germany.

Why was it inscribed

From Mainz, the location of Gutenberg's printing office, the new technology of book printing spread all over Europe and the world, radically and completely changing book production and the dissemination of information and ideas.

Where is it

State and University Library of Lower Saxony, Goettingen, Germany

The invention of printing with movable letters took place independently in Asia (Korea) and Europe (Germany). In Europe Johannes Gutenberg's achievement was revolutionary for culture and society. In the mid-15th century, in his printing office in Mainz, he developed techniques for the production of movable metal type by using a hand mould, the setting of the text in type and the printing of the text using a printing press. Taking the stylistic and formal characteristics of the hand-produced books of his time, Gutenberg managed to invent a technology that allowed for an almost perfect reproduction of books in a much faster and easier way.

The Gutenberg Bible has 1282 pages, the text pages having two columns of type, each of forty-two lines. It is thought that approximately 180 copies were printed, forty on vellum, 140 on paper. For this, 100,000 types had to be cast. At times, up to twelve printers worked on six presses. Besides typesetters, the project also employed assistants responsible for dyeing, inserting the sheets, etc. It took three years to print the 180 Bibles, a period in which a copyist would have completed one Bible. Each printed copy was then embellished with hand-drawn illustrations and decorations. Printing was completed around 1456. Of the copies printed on vellum, only four complete copies still survive, at Goettingen, Paris, London and Washington, DC. A further fifteen complete copies printed on paper survive in Austria (one copy), France (one copy), Germany (two copies), Portugal (one copy), United Kingdom (six copies) and the USA (four copies). In addition thirty incomplete copies exist.

A hand-written comment on the margin of the Goettingen copy of the Bible indicates that this copy originally belonged to a monastery which was probably located in Calenberg-Goettingen, a part of the Guelph territory. From 1587, the Bible was in the possession of Duke Julius of Brunswick. The Bible then came into possession of the University Library at Helmstedt together with the older Wolfenbuettel Library. The Helmstedt Library was dissolved in 1812 – at the time of the Kingdom of Westphalia – and from there the Bible found its way to Goettingen. In Goettingen that same year, the Paulinerkirche had just been renovated for use as a library room by adding an additional floor. It is in this newly renovated historical hall that the Bible is presented to an interested public. All 1282 pages can also be freely viewed online at www.gutenbergdigital.de.

The illumination in the Goettingen copy is modelled on a contemporary 15th-century source which is also part of the collections of the State and University Library at Goettingen. This manuscript, the Goettingen Model Book, is a painting book for the drawing of leaves, initials and patterned backgrounds in different colour combinations; even the composition of the colours is described in detail. The book decorations described in this manuscript can be found in the Goettingen copy of the Bible. The Model Book describes how the colours are mixed, in what sequence they should be applied and what the finished pattern should look like.

Besides the Gutenberg Bible and the Goettingen Model Book, the Library owns the only surviving contemporary document that gives evidence of Gutenberg's invention: the Notarial Instrument of Ulrich Helmasperger of 1455. This is a legal account of the disputed business relations between Gutenberg and Johannes Fust and of Gutenberg's invention, the so-called 'Work of the Books'. Goettingen alone holds three such interconnected and outstanding documents which focus on the invention of printing.

The Goettingen copy of the Gutenburg Bible is one of only four printed on vellum to have survived. After the pages were printed, elaborate decorations were added, marrying together the revolutionary use of movable type with the traditional skills of medieval illumination. ▶

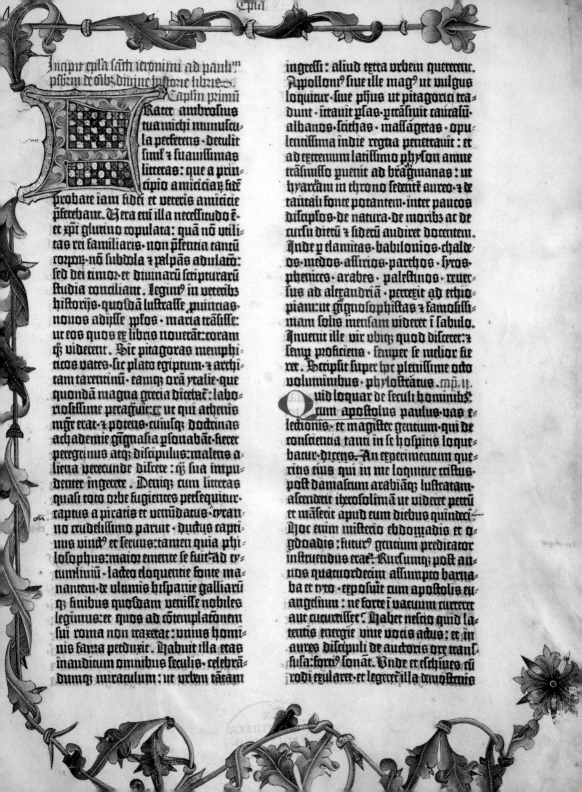

Incipit epla scti iemnimi ad paulin'
pstbitem de oibz dimine hystorie libris.

Caplm primu

Rater ambrosius
tua michi munuscu-
la perferens · detulit
simul z suauissimas
litteras : que a prin-
cipio amiciciaz · side
probate iam sidei et veteris amicicie
pferebant. Uera eni illa necessitudo e
et xpi glutino copulata · qua no vtili-
tas rei familiaris · non psentia tantu
corpoz · no subdola z palpas adulatio :
sed dei timor · et diuinaru scripturaru
studia conciliant. legim' in veteribz
historiis · quosda lustrasse puincias ·
nouos adiisse pplos · maria transisse ·
ut eos quos ex libris nouerat : coram
qz viderent. Sic pitagoras memphi-
ticos vates · sic plato egiptum · z archi-
tam tarentinu · eamqz ora ytalie · que
quonda magna grecia dicebat : labo-
riosissime peragrauit : et ut qui athenis
mgr erat · z potens : cuiusqz doctrinas
achademie gignasia psonabat : sieret
peregrinus atqz discipulus : malens a-
liena verecunde discere : qz sua impu-
denter ingerere. Deniqz cum litteras
quasi toto orbe fugientes persequitur ·
raptus a piratis et venundatus · tyran-
no crudelissimo paruit · ductus capti-
uus vinct' et seruus : tamen quia phi-
losophus : maior emente se suit · Ad ty-
tum liuiu · lacteo eloquentie fonte ma-
nantem · de vltimis hispanie galliaru-
qz sinibus quosdam venisse nobiles
legimus : et quos ad cotemplatonem
sui roma non traxerat : vnius homi-
nis fama perduxit. Habuit illa etas
inauditum omnibus seculis · celebra-
dumqz miraculum : ut vrbem tanta

ingressi : aliud extra vrbem quererent.
Apolloni' siue ille mag' ut vulgus
loquitur · siue phus ut pitagorici tra-
dunt · itrauit plas · ptransiuit raucasu-
albanos · scithas · massagetas · opu-
lentissima indie regna penetrauit : et
ad extremum latissimo physon amne
transmisso puenit ad bragmanas : ut
hyarcam in throno sedente aureo · z de
tantali fonte potantem · inter paucos
discipulos · de natura · de moribz ac de
cursu dieru z sideru audiret docentem.
Inde p elamitas · babilonios · chalde-
os · medos · assirios · parthos · syros ·
phenices · arabes · palestinos · reuer-
sus ad alexandria · perrexit ad ethio-
piam : ut gignosophistas z famosissi-
mam solis mensam videret i sabulo.
Inuenit ille vir vbiqz quod disceret : z
semp proficiens · semper se melior sie-
ret. Scripsit super hoc plenissime octo
voluminibus · phylostratus. cap. ii.

Quid loquar de seculi hominibz :
cum apostolus paulus · vas e-
lectionis · et magister gentium · qui de
conscientia tanti in se hospitis loque-
batur · dicens. An experimentum que-
ritis eius qui in me loquitur cristus ·
post damascum arabiaqz lustratam
ascenderit iherosolima ut videret petru
et maserit apud eum diebus quindeci.
Hoc enim misterio ebdomadis et og-
doadis : futur' gentium predicator
instruendus erat. Rursumqz post an-
nos quatuordecim assumpto barna-
ba et tyto · exposuit cum apostolis eu-
angelium : ne forte i vacuum curreret
aut cucurrisset. Habet nescio quid la-
tentis energie viue vocis actus : et in
aures discipuli de auctoris ore trans-
fusa : forti' sonat. Vnde et eschines cu
rodi exularet · et legeret illa demosthenis

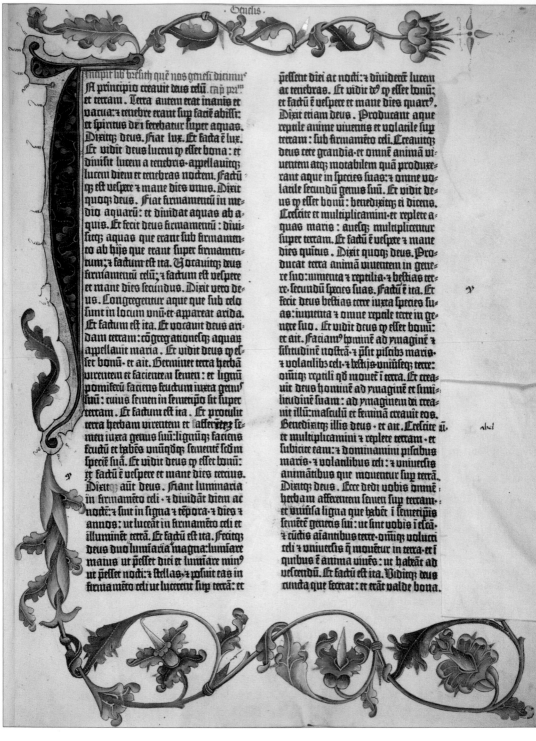

148 The 42-line Gutenberg Bible, printed on vellum

Bibliotheca Corviniana

Inscribed 2005

What is it

The Bibliotheca Corviniana collection was the one of the greatest collection of books in Europe in the Renaissance period and contains works written for Matthias Corvinus, king of Hungary (1458–90) and copies of the most important works known at that time.

Why was it inscribed

The collection is an outstanding representation of Renaissance culture of the late 15th century, covering both literature and the contemporary state of understanding in such subjects as philosophy, theology, history, law, literature, geography, natural sciences, medicine and architecture.

Where is it

National Szechenyi Library, Hungary; Austrian National Library, Austria; Biblioteca Medicea Laurenziana, Italy; Herzog August Bibliothek Wolfenbüttel, Germany; Bibliothèque Nationale de France, France; Bayerische Staatsbibliothek München, Germany; Koninklijke Bibliotheek Van Belgie, Belgium

The Bibliotheca Corviniana was regarded in its time as the second most important library in Europe after the Vatican Library. It was created by Matthias Corvinus, king of Hungary (1458–90), and was housed in his royal palace in Buda. The collection reflected the aspirations of an ideal humanist education of the period and contained Greek and Latin authors discovered by humanists; the Bible and works by ecclesiastics, medieval theologians and scholars; and also writings of contemporary humanists. The humanists' favourite subjects included literature, history, philosophy, theology, rhetoric, military science, medicine, architecture and astronomy, which were represented by volumes written in Latin, Greek, Arabic and Hungarian. The collection also contained early examples of printed books. This classic Renaissance library used to consist of around 2000 volumes. However, after the Ottoman conquest of Hungary in 1526, many of the volumes in the collection were lost. Today, 216 volumes from the collection are known and they are scattered all over the world: fifty-three remain in various libraries in Hungary, forty-nine are in Italian libraries, thirty-nine are in the Austrian National Library and others can be found in France, Germany, United Kingdom, Turkey and the USA. A digital version of the Bibliotheca Corviniana is being created so that all the surviving volumes from this remarkable library can be viewed together in spite of the scattered nature of the collection today.

Matthias Corvinus and his Italian wife, Queen Beatrix, offered excellent working and intellectual conditions to the most outstanding humanists of the late 15th century at the Hungarian court, and many outstanding humanists were connected with the library – for instance Regiomontanus, the leading astronomer of his time, was in charge of the Greek codices. The Bibliotheca Corviniana influenced Hungarian, Central and Western European culture. The diplomats, scientists, authors and artists who visited the royal court transmitted their impressions of the collection to Vienna, Krakow, Prague and throughout Europe. The influence on Czech culture was notable, because Matthias was its king and there were many Czechs working at the Buda court.

The Corviniana texts most often show the characteristic style of Renaissance art, the all'antica, but some contain Gothic-style illuminations. Among the most beautiful examples of the all'antica style is Thomas Aquinas's commentary on De coelo et mundo Aristotelis, Aristotle's text that outlines his cosmographic system. This text is decorated with panels of typical Renaissance decorations. Another example is Johannes Michael Nagonius's panegyric, Ad Divum Wladislaum Regem pronostichon et panegyrichon. A more historic approach to illustration is seen in the collection's edition of Dante's La Divina Commedia. The collection also is renowned for the excellent quality of miniatures; for example, the Matthias Graduale contains eighty colour miniatures prepared by French artists who worked at the court of King Matthias in Buda.

Library of the Cistercian Abbey of Clairvaux at the time of Pierre de Virey (1472)

Inscribed 2009

What is it

The manuscript collection of Clairvaux Abbey, one of the most important libraries in the world in the 15th century, as it was catalogued in 1472.

Why was it inscribed

The Clairvaux collection superbly represents the monastic library at the time when abbeys were the beacons of education and scholarship in Christendom. It also illustrates the particular influence of the Cistercian order in the fostering of intellectual, religious and artistic debate and learning.

Where is it

Médiathèque de l'Agglomération Troyenne, Troyes, France; Bibliothèque Interuniversitaire de Montpellier, Montpellier, France; Bibliothèque Nationale de France, Paris, France; Bibliothèque Municipale de Laon, Laon, France; Bibliothèque Sainte Geneviève, Paris, France; Bibliothèque Centrale, Université de Mons, Mons, Belgium; British Library, London, UK; National Széchényi Library, Budapest, Hungary; Biblioteca Medicea Laurenziana, Florence, Italy

Clairvaux was a daughter abbey of Cîteaux, the mother-house of the powerful Cistercian order, and was founded in 1115 by St Bernard. A charismatic figure of international importance, Bernard was one of the foremost intellectuals of the 12th century and the founder of the abbey's library.

From the start he and his successors encouraged the library's growth. The abbey's scriptorium produced most of its own manuscripts – resulting in a uniquely coherent collection – but donations also came from outside. The reputation of the Cistercian order and Clairvaux in particular was high and drew wealthy benefactors; and the abbey's links with its Collège St Bernard at the University of Paris, where many Cistercians were trained, also boosted its holdings.

The collection covers all disciplines of medieval knowledge. Spirituality and religious thought are most numerous, represented in Bibles, theology, liturgical books, rules of the order and teachings of the church fathers; other fields include law, medicine, history, philosophy, literature, science, mathematics and medicine. Taken as a whole, the collection reflects the development of scholarship from the 12th to the 15th centuries, not only within the monastic sphere but also, through its college in Paris, within the growing university environment.

Bernard's influence extended not only over the size and scope of the manuscript collection but also its aesthetics. Purity and simplicity were at the heart of his spiritual philosophy and this led to the development of Clairvaux's monochrome style. The use of gold was forbidden and pages were almost without adornment, resulting in a simplicity striking by contrast with the more familiar styles of ornamentation and illumination characteristic of medieval manuscripts.

By the time the catalogue of Clairvaux's collection was compiled in 1472 under Abbot Pierre de Virey, the library's holdings stretched to 1790 books; of these, 1115 survive together with three copies of the catalogue itself. This catalogue forms the main record of the collection. An outstanding example of librarianship, it provides an inventory and management system for the library, identifying and assigning a catalogue number to each book. It also illustrates the classification of books according to the categories of medieval scholarship.

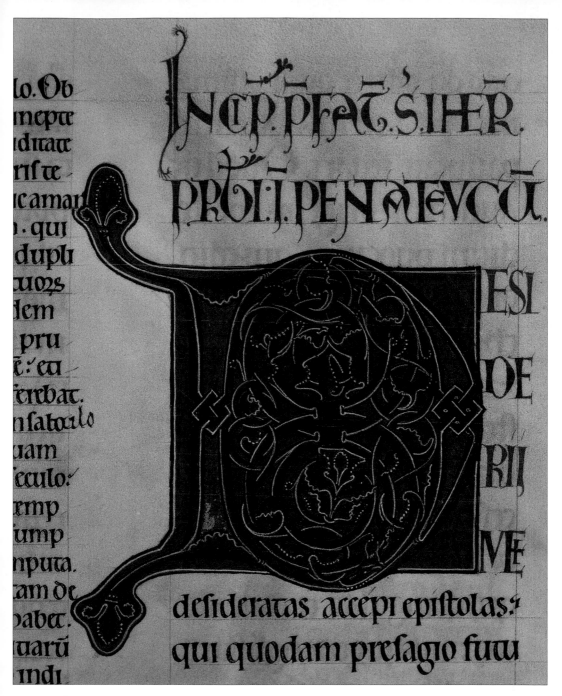

INCP. PFAT. S. IHER

PROL. I. PENTATEVCŪ.

desideratas accepi epistolas;
qui quodam presagio futu

▲ *Lettering from a 12th-century Bible produced at Clairvaux*

Regẽ magnũ dũm venite adoremꝰ, Oꝝ venite,
Dñicis diebz poſt feſtũ epĥie Inuitatoriũ ·

Adoremꝰ dũm ꝗ fecit nos, Oꝝ venite aũ Seruite ·

Eatus vir qui
non abijt in
conſilio impiorũ et in
via pꝯcõꝝ nõ ſtetit : ⁊ ĩ
cathedra peſtilẽtie nõ ſe-
dit Sed ĩ lege dñi vo-
lũtas eiꝰ : et in lege eius meditabit̃ die ac
nocte Et erit tanᵹᵹ lignũ qd plãtatũ eſt
ſecꝰ dcurſus aꝗã : qd fructũ ſuũ dabit in
ꝯꝛe ſuo Et foliũ eiꝰ nõ defluet : ⁊ õia ꝗcũᵹ
faciet pſperabũt̃ Nõ ſic impij nõ ſic : ſed
tanᵹᵹ puluis quẽ ꝓicit ventus a facie ꞇꝛe
Ideo nõ reſurgũt impij in iudicio : neᵹᵹ
pꝯcõres in ꝯſilio iuſtoꝝ · Quĩ nouit dñs
viã iuſtoꝝ : ⁊ iter impioꝝ ꝑibit Oꝝ a Oꝝ

Mainz Psalter at the Austrian National Library

Inscribed 2011

▲ *A medieval printing press*

What is it
Printed in 1457, the Mainz Psalter was the second major book in the West to be printed with movable type.

Why was it inscribed
The Mainz Psalter is almost as important as the Gutenberg Bible in its impact on the development of printing and was ground-breaking in its own right in several respects. The book is a landmark in the transition of Western culture from medieval times to the modern era, especially in cultural, media and technological terms.

Where is it
Austrian National Library, Vienna, Austria

Although the Gutenberg Bible is more famous as the first major book printed in the West using movable metal type, the Mainz Psalter was actually the first book to be printed and produced completely by mechanical means. Gutenberg's Bible remained his only printed book, but the methods used to produce the Psalter opened the way for further development and improvements in printing, mechanizing book illustration and integrating the production process into the company's business plans, that brought success on a longer-term basis.

Information in the colophon states that the whole book was produced by printing, including the decoration which until then would have been added by illuminators. Consequently, the Psalter is also the first book to be printed in more than one colour. In his printed version of the Bible, Gutenberg had left gaps in the text, such as with initial letters, which illustrators later filled in by hand. The printers of the Mainz Psalter solved the problem of how to print in movable type using more than one colour, and the book is printed in three – black, red and blue – on vellum.

This was also the first time a printed book carried a colophon stating the work's title, date of publication and printer, so using the colophon as a means of advertising for further commissions and business.

The printers were Peter Schöffer and Johannes Fust who had worked with Johannes Gutenberg but parted from him in a disagreement. They completed their first edition of the Mainz Psalter on 14 August 1457, after Gutenberg's Bible.

There are two variants of the Mainz Psalter, one of 143 sheets and the other of 175, and only ten copies in the world of the combined variants surviving today. All are printed on vellum. The copy in the Austrian National Library is the only complete version of the larger edition and the only one in which the colophon contains the combined coat of arms of the Fust and Schöffer Press that was subsequently used in many of the company's printed products. This copy was part of the Habsburgs' royal library and was never used in liturgy, so it remains in excellent condition.

◀ *Sample page from the Psalter*

Santa Fe Capitulations

Inscribed 2009

What is it

The Santa Fe Capitulations was the agreement
Christopher Columbus signed with King Ferdinand II
of Aragon and Queen Isabella I of Castile in Santa Fe
de la Vega on 17 April 1492. The document laid out the
conditions under which Columbus would undertake
his voyage later that year which led to his discovery of
the Americas. The subsequent Spanish exploration and
conquest of the American territories were based on it.

Why was it inscribed

The Capitulations is the starting point of Spanish
presence in the Americas. Seen in retrospect, the
document marked the end of the period of the Middle
Ages and heralded Spanish colonization of the New
World. It opened the way to territorial expansion initially
for Spain, and a new social, economic and religious
context for the Iberian Peninsula and for Europe as
a whole.

Where is it

Archive of the Crown of Aragon, Barcelona, Spain

The Santa Fe Capitulations is the document signed by the
Catholic Monarchs of Spain, establishing the grounds of
the agreement between them and Christopher Columbus
for his voyage west in 1492.

Columbus's idea was to reach the Indies by a
southwesterly route. Under the terms of the agreement,
Columbus received permission to find 'pearls, precious
stones, gold, silver, spices' – products that would be found
in the East Indies, for which he would be searching. He was
allowed 10 percent of what he obtained on the journey and
the right to an eighth of the profits from corresponding
trade transactions.

The Capitulations presumed the existence of lands in the
Atlantic Ocean and in essence, grant licences to Columbus
if his enterprise is successful. He received titles, including
Admiral of the Ocean and Viceroy and Governor-General
of all the islands and land he would discover.

The document's form followed the pattern already set in
the organization of the exploration and colonization of the
Canary Islands and in the relations established between
the Portuguese Crown and its explorers. Naturally,
the enormity of what would follow from Columbus's
discoveries across the Atlantic was unsuspected, and the
document's significance could hardly be guessed at by
any of those involved.

The monarchs signed the Capitulations and Columbus
would have received a copy. Then the document, the letters
of recommendation and the credentials or safe-conduct
were prepared, drawn up, issued and registered by the
secretary of the chancery. The royal chancery copied and

classified all documents relating to the Crown of Aragon
for deposit in the royal archive. In fact, this document is
the only record of Christopher Columbus to be found in
the Catalan-Aragonian Chancery. The Capitulations were
overlooked in the archive until their rediscovery in 1862.

The Archive of the Crown of Aragon, where the document
is still held, was founded in 1318, making it one of the
oldest archive institutions in the world. It has existed
without interruption to modern times.

▲ *Statues of Christopher Columbus, King Ferdinand II of Aragon
and Queen Isabella I of Castile in the gardens of the Alcazar
in Andalucia, Spain.*

Treaty of Tordesillas

Inscribed 2007

What is it

The agreement signed by the monarchs of Portugal and Spain to divide between them the newly discovered lands of the New World.

Why was it inscribed

The treaty marked officially the start of the Portuguese and Spanish presence on the American continent, and established their zones of jurisdiction there and in the lands beyond.

Where is it

Arquivo Nacional da Torre do Tombo, Lisbon, Portugal; Archivo General de Indias, Seville, Spain

The Treaty of Tordesillas was signed on 7 June 1494 between King John II of Portugal and the Spanish Catholic Monarchs King Ferdinand II of Aragon and Queen Isabella I of Castile. Under its terms, the world was divided into two zones of demarcation along a meridian running pole to pole at a point 370 leagues west of the Cape Verde Islands. Portugal was allowed to claim everything to the east of the zone and Spain everything to the west.

The treaty was prompted by Christopher Columbus's return from the New World the previous year. Portugal had been one of the foremost maritime powers in the 15th century and the Portuguese suspected that Columbus's discoveries lay within their zone of influence as agreed under the Treaty of Alcáçovas of 1479–80: that treaty had given Portugal exclusive rights to navigate, discover and trade in the Atlantic south of the Canary Islands.

In 1493 talks began between the Castilian and Portuguese crowns, with the pope weighing in on the Spanish side. Complex diplomatic negotiations between ambassadors and barristers from both kingdoms concluded with the Treaty of Tordesillas, signed at the small town of that name near the Spanish border with Portugal.

In the years that followed the treaty, the Portuguese and Spanish discoveries resulted in Iberian hegemony over a large part of the world's surface and their sovereignty over the Atlantic Ocean led to the discovery of new sea routes, giving access to other lands. The empires both nations built up after 1494 were largely on either side of the line of demarcation, which lay roughly 1770 km west of the Cape Verde Islands, or 46° 37 ′ W.

For Spain, it allowed the conquest of the Americas; for Portugal, new lands in Africa and Asia to the south and east brought them access to the valuable spice trade. Crucially, the line of demarcation fell across the American continent at what would become Brazil.

The repercussions of the treaty would be felt up to the 18th century when questions about borders between the Portuguese and Spanish colonies in South America led to the modification of the demarcation line. This change set the Brazilian borders much further to the west and signified the revocation of the treaty.

 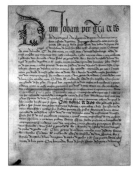

▲ *The Portuguese royal seal and the treaty*

King John II of Portugal ▶

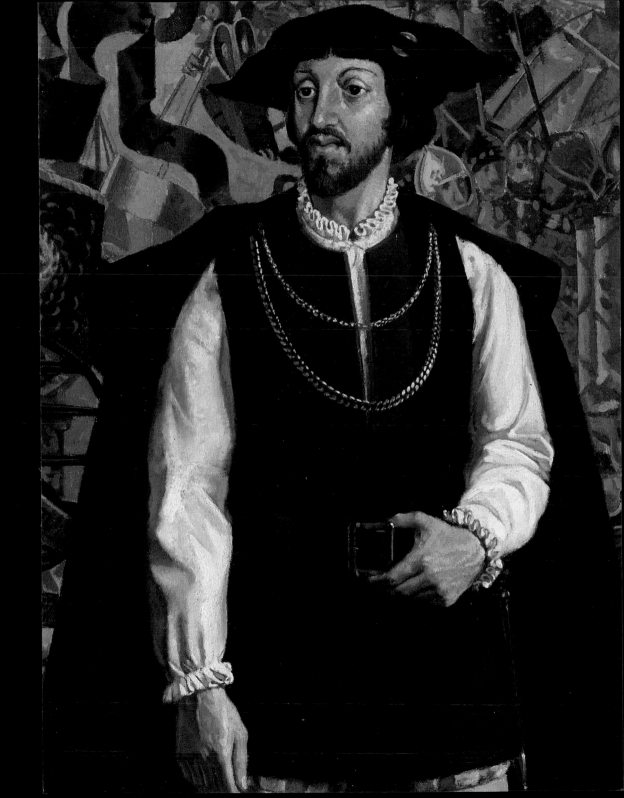

Sound Toll Registers

Inscribed 2007

What is it

The Sound Toll Registers provide detailed information about every single ship and cargo that entered and left the Baltic Sea through the Danish straits. It was introduced in the 15th century and the series runs until the abolition of the Sound Toll in 1857.

Why was it inscribed

The Registers contain unique information on international trade and are a valuable source of research for the study of economic history, trade and commerce in the centuries they cover, not just in Denmark but also in its neighbours and their trading partners.

Where is it

Danish National Archives, Copenhagen, Denmark

▲ The Sound Toll Register for 1734 shows that a total of 448 Dutch ships sailed into the Sound that year.

The Sound Toll was a tax levied on every ship that sailed to and from the Baltic Sea through the narrow Sound (Øresund) between Denmark and Sweden. The strait is 4 km wide at its narrowest point and controlled access from the Baltic to the seas beyond. The Danes retained military control of both sides of the Sound until 1658.

In 1429 Eric of Pomerania, king of Norway, Sweden and Denmark, introduced tolls on non-Danish shipping using the Sound. Ships were obliged to stop to pay the toll at Helsingør at the narrowest point of the Sound. Those that refused to stop could be fired on and sunk by the Danish fortresses that overlooked the Sound – from Helsingborg on the east side and Helsingør on the west.

Tolls were also collected at the Great Belt and Little Belt seaways to the west of Lolland, but the Sound provided the most direct route and the highest revenue. The Sound Toll was the major source of income for the Danish Crown but remained a cause of friction with many of the Baltic nations, particularly Sweden.

The Sound Toll Registers (Øresundstoldregnskaber) logged every ship and shipmaster that passed through the Sound, with an increasing amount of detail being gathered in successive centuries, such as the nature of the ship's cargo. The cataloguing of this information, which included a ship's port of origin and destination, gives a detailed insight into trade in northern Europe during the period the

registers cover. In total, around 1.8 million passages were logged in the registers.

The inscribed registers date from 1497 and annual volumes are intermittent thereafter until 1557, when an unbroken run begins through to 1857. There are more than 500 volumes in total.

By the 19th century and the expansion of free trade, the tolls were increasingly considered restrictive. In 1857, the Copenhagen Convention came into effect between Denmark and other nations, abolishing all tolls on the Sound. Denmark received a one-off payment in return for waiving the Sound Toll.

Letter from Pêro Vaz de Caminha

Inscribed 2005

What is it

Sent from Porto Seguro, Island of Vera Cruz, Brazil, 1 May 1500, the letter from Pêro Vaz de Caminha to Manuel I, king of Portugal, is the first document that describes the land and people of what later became Brazil. The letter is handwritten over 14 folios.

Why was it inscribed

Written at the very moment of first contact with the New World, the letter is a central document from the Age of Discovery and a landmark in Portuguese, Brazilian and world history. It is rich in detail and contains shrewd observations of the territory, people and culture unknown in Europe up to that time.

Where is it

Arquivo Nacional da Torre do Tombo, Lisbon, Portugal

In 1500 an expedition of thirteen ships under the command of Pedro Álvares Cabral set out from Portugal to establish trade relations with India in the wake of Vasco da Gama's successful explorations. The expedition sailed west where it reached what the Portuguese named Terra de Vera Cruz (Brazil).

Pêro Vaz de Caminha was a clerk who had been commissioned to provide eyewitness accounts of the fleet's findings, so he was one of three chosen to go on a preliminary exploration of the new territory. He began his letter on 24 April, two days after the Portuguese reached land, and finished it on 1 May for despatch on one of the vessels returning to Lisbon to take the news to the king.

His letter gives an account of the physical geography during their short coastal exploration as they came to land: a high, rounded elevation (Monte Pascoal, or Easter Mount, as the Portuguese had reached Terra de Vera Cruz in the Easter season), with lower mountains to the south, bare countryside and tall trees.

He identified animal species and birds, including the Atlantic petrel, doves and parrots; marine species (shrimp and clam); and plants (fern, thistle, palm and yam) and their uses. He also described the climate.

Perhaps the most interesting parts of the letter are Caminha's observations of the local people the Portuguese explorers met. He relates their tentative approaches to the Portuguese and the mutual curiosity of the explorers and the locals.

Caminha describes their peaceful behaviour, their houses, food and clothes, adornments and necklaces, their tools such as bows, arrows and axes and the fact that they neither kept domestic animals nor ploughed the land. He relates how the Portuguese and the locals communicated through gestures, laying down their bows and arrows and exchanging objects – bows, necklaces and plumages for berets, hats, shirts and boars' teeth. Their language he found barbarous, but he admired the people's innocent primitivism and ingenuity.

Caminha also describes the celebration of Mass and the elevation of the cross with the arms and emblems of the king of Portugal in recognition and thanksgiving of the taking of Terra de Vera Cruz.

Archives Insolvente Boedelskamer Antwerpen

Inscribed 2009

What is it

A rich collection of over 150 archives of private companies and traders that went bankrupt in the 16th, 17th and 18th centuries in Antwerp.

Why was it inscribed

The archives, connected to one city and – via family networks – to the world, are a unique collection of documents that contribute to an understanding and analysis of international relations and interactions in the Early Modern Period (1500–1800).

Where is it

Municipal Archives, Antwerp, Belgium

In the 16th century, the city of Antwerp was one of the most important centres of the world economy, a very rapidly growing and vibrant metropolis that based its wealth on international trade, banking and communication. After this golden age for the Spanish Netherlands and after Amsterdam and other Dutch cities had taken over the central role of Antwerp in the world economy in the 17th century, Antwerp remained an important international hub, in particular in the luxury-goods trade.

In this international context, a very special institution was developed in Antwerp. In order to protect the interests of creditors or clients, the Antwerp municipal council ordered that from 1518 onwards all papers, correspondence, archives and possessions of 'insolvent' or bankrupt persons or firms had to be confiscated immediately and placed in the charge of the *Amman*, a court official of the city. This resulted in more than 150 archives of companies, firms and traders being confiscated and guarded in the town hall of Antwerp. Due to the nature of this procedure, a series of snapshots of economic, social and cultural life in the 16th, 17th and 18th centuries is contained within the Insolvente Boedelskamer (Chamber of Insolvent Estates). Documents and information can be found about dozens of prominent Antwerp firms with branches in Austria, Germany (the Holy Roman Empire), Spain, Italy and France, with worldwide trade relations, for instance with China and Brazil. The detailed information about products exchanged in Europe and through intercontinental trade offers important information. The archives allow the study of techniques of book-keeping, different kinds of trade, insurance and many other topics.

Complete archives of firms in the 16th, 17th and 18th centuries are very rare. This procedure of confiscating the whole documentary collection of families and firms during their active life yielded very rich and diverse material that sheds light on political, religious, artistic and social evolution of Antwerp during this period. It provides

very detailed information on key individuals originating from or working in many countries in and outside Europe and provides an insight into their daily life, thanks to the many family letters held in the archives.

▲ Former guild houses in the Grote Markt (town square) of Antwerp. The records of guild merchants who went bankrupt have been preserved and provide a unique record of business and daily life in Antwerp between 1500 and 1800.

Universalis cosmographia secundum Ptholomaei traditionem et Americi Vespucii aliorumque Lustrationes

Inscribed 2005

What is it

A 1507 map of the world which depicts a separate western hemisphere and the Pacific Ocean, and on which the name 'America' is used for the New World. It is also the first printed world wall map.

Why was it inscribed

This was the first map, either printed or manuscript, to incorporate the new information from the Spanish and Portuguese expeditions of the late 15th and early 16th centuries.

The map revolutionized the European understanding of the earth which had focused on the existence of a three-continent world, and led to a new way of understanding its geography.

The map-maker also decided to name the new world 'America' in honour of Italian explorer and cartographer Amerigo Vespucci, a decision which had lasting influence.

Where is it

Library of Congress, Washington, DC, USA

The 1507 world map by German map-maker Martin Waldseemüller is the first map to depict correctly the European discoveries in the New World and represents the earliest understanding of the shape and position of the earth's continental landmasses.

The map was prepared in the Gymnasium Vosagense in St Dié-des-Vosges in France with the help of a team of scholars assembled to synthesize the new geographic data from the discoveries in the New World and Africa in the late 15th and early 16th centuries.

Its representation of the earth was a departure from the accepted European perception which was built on Ptolemy's long-accepted idea of a three-part world comprising Europe, Asia and Africa. Waldseemüller

built on the Ptolemaic tradition, integrating the recent discoveries by the Portuguese and the Spanish and merging the new information with the medieval knowledge.

Waldseemüller's map used the most up-to-date and detailed information about Africa gleaned from the recent expeditions of the Portuguese navigators. It depicted two oceans separating Europe from Asia to the west, and a large and separate western hemisphere.

Accompanying the map was Waldseemüller's text *Cosmographiae Introductio cum quibusdam Geometriae ac astronomiae principiis ad eam rem necessariis* in which the large world map was referenced as well as a set of gores

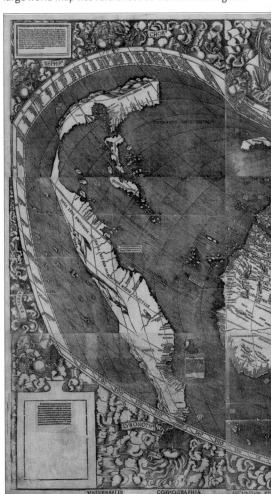

for a small globe. Through the map, and the book, Waldseemüller recognized the contribution of Amerigo Vespucci in the understanding of the New World as a separate continent.

Vespucci had sailed on several of the Portuguese voyages that explored the coast of the New World between 1499 and 1502 and found that it extended much further south than had previously been realized. He was credited for the discovery that the new land was not part of Asia but was a separate landmass. In recognition of this understanding, Waldseemüller christened the New World 'America' after Vespucci. With that designation on the map, the use of the name America was applied and gradually accepted to describe the Western Hemisphere.

The map provided a relatively accurate depiction of the geography of the world and influenced subsequent representations of the earth and of America.

Martin Waldseemüller's map of the world, including America ▼

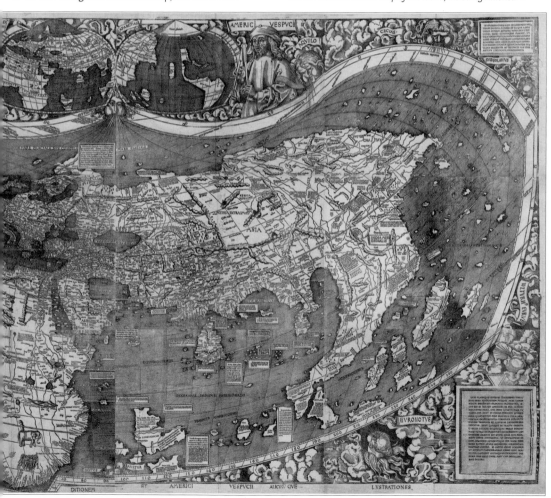

Tabula Hungariae

Inscribed 2007

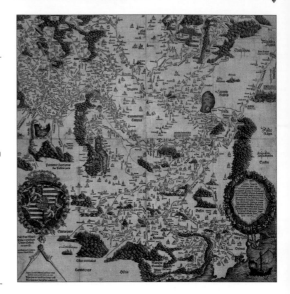

What is it

A 16th-century map of the Carpathian basin.

Why was it inscribed

This unique map depicts in detail the territory and settlements that now fall within the boundaries of a number of European nations; and a geopolitical situation that no longer exists. It is unique and irreplaceable, and has considerable significance for its form, style and aesthetic qualities. Its accuracy and detailed nature have made it a key tool in current environmental mapping in the 21st century.

Where is it

National Széchényi Library, Budapest, Hungary

This document is a map representing faithfully and in great detail the structure of settlements that could be found on the territory of the Hungarian Kingdom (corresponding to the territory of modern Hungary, Slovakia and including parts of modern Austria, Ukraine, Romania, Serbia/Montenegro, Croatia and Slovenia). Many settlements disappeared during the Turkish wars of the 16th century fought there, making this representation particularly important.

For several centuries, researchers and other interested persons had only an indirect knowledge of this document. It reappeared in public in the 1880s, when the collector Sándor Apponyi acquired it. He later offered it (in 1924) to the National Library, which included it in its collection of rare and historical works.

As is clear from the title, the Tabula Hungariae was a collective work. The Hungarian Lazarus Secretarius made the surveys on which the map was based (with assistance from Jacob Ziegler) and probably supplied a draft of the map; Apian's mentor Tanstetter (Collimitus), an accomplished cartographer, put it into proper shape and completed it by adding data of his own and a scale; and Cuspinianus published the map or authorized the funds for it and dedicated it to the king. He also contributed some place names, mainly taken from classical sources.

The Lazarus/Ziegler/Tanstetter/Cuspinianus/Apian map of Hungary was the first one made of the Carpathian basin

and was copied and adapted in numerous later maps. Among these are the maps by Augustin Hirschvogel (1552), Wolfgang Lazius (1556) and that published anonymously by Vavasore in Venice.

It has outstanding aesthetic and stylistic value due to the combined application of woodcutting techniques and use of movable characters in printing. The style is particularly attractive and unique thanks to the skills of Peter Apian. His son, Philipp Apian prepared a map of Bavaria in the same way in the 16th century.

The map is also a good example of the way in which a general view of a complete kingdom's administration could be shown at the end of the medieval period. The reproduction of such maps by printing differed substantially from the techniques applied in reproducing other kinds of graphical works, due to the need of presenting place names in a readable way. The difficulties related to this task were overcome by Peter Apian when he developed stereotype printing. With this technique the textual components, in particular the place names, were castled in lead and put at the appropriate place in form of small plates. This allowed the cartographer to create a very elegant and readable style of map.

Beatus Rhenanus Library
Inscribed 2011

What is it
The library and collected correspondence
of French humanist scholar Beatus Rhenanus
(1485–1547), comprising 1686 documents,
including 1287 printed works.

Why was it inscribed
The library is unique in that it was the working
collection of a single individual and contains several
books of which no other copies exist. The books' authors
come from a wide spectrum, reflecting the expansion
of ideas that grew out of the Renaissance and also
the intellectual and religious ferment that consumed
Europe in the 16th century. Despite its uniqueness and
irreplaceability, the library is still famously housed in the
home town of its former owner.

▲ *A wood engraving of Beatus Rhenanus*

Where is it
Bibliothèque Humaniste, Sélestat, France.

Beatus Rhenanus was an Alsatian of German origin
and a teacher, scholar, historian, publisher, writer and
translator who lived and worked in Paris, Strasbourg,
Basle and Sélestat, his home in childhood and later
life. By inclination he was a humanist and his library,
collected over the course of his life, gives a glimpse of the
Renaissance period, its explosion of intellectual and artistic
pursuit and its propagation of classic works from antiquity
through the medium of the printing press.

The humanist movement grew out of the Italian
Renaissance and its new attitudes to education and culture
expanded from the 14th century onwards. Humanism
rejected the more formalized learning structures
of medieval scholasticism and its classical training
through logic with rhetoric and grammar, in favour of the
education of the whole person by means of the liberal arts,
notably history, poetry and moral philosophy alongside
rhetoric and grammar. However, its influence spread far
beyond the educational and into every area of intellectual
and artistic concern.

This spread is reflected in the vast range of subject areas
Rhenanus's books cover, including theology, religious
controversy, philosophy, history, politics, morals, law,

medicine, grammar, education, geography, science in
antiquity, rhetoric, languages, technology, information,
mathematics and astronomy. Most of the works are
in Latin, the universal intellectual language of the day,
with some Greek and Hebrew as well as more modern
vernacular volumes in German, Italian and French.

During his time as a student Rhenanus worked in
a printer's office and in later life put his experience to
good use, disseminating through the new medium
ancient literary and historic texts of which he had
acquired copies through his Europe-wide book-buying
network. His collecting and publishing work ensured
the survival of these texts and helped disseminate the
writings of authors such as Seneca, Tacitus and Pliny the
Elder. He also published and collected the work of his
contemporaries and fellow humanists, including Thomas
More and Desiderius Erasmus, probably the most famous
humanist of his day. Erasmus was also a personal friend
and Rhenanus edited his works for publication and wrote
his biography.

After Rhenanus's death, the Latin school where he was
educated in Sélestat received his library. Famous even
among contemporaries, it is now virtually unique as the
libraries of his contemporaries, including Erasmus, were
broken up after their owners' deaths.

(overleaf) The Humanist Library in Sélestat ▶

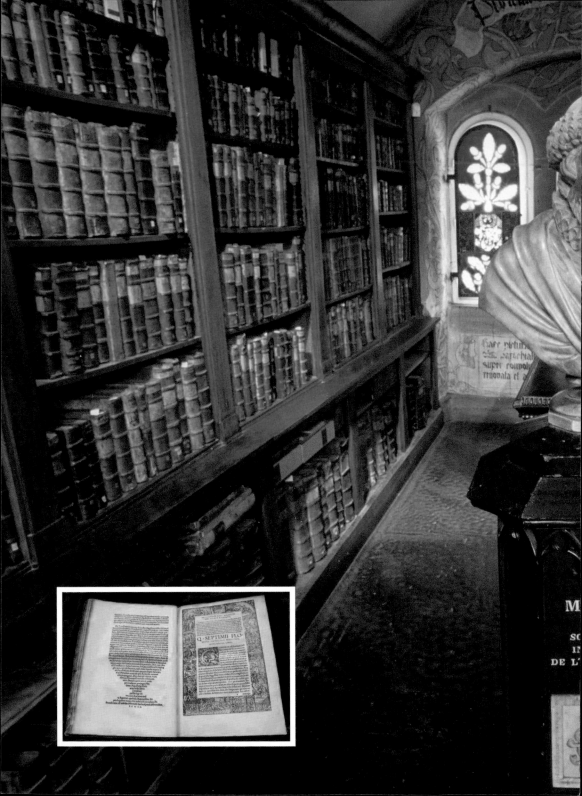

Sixteenth to eighteenth century pictographs from the 'Maps, drawings and illustrations' of the National Archives of Mexico

Inscribed 2011

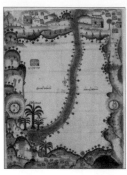

What are they

A collection of maps, documents, drawings and illustrations from the 16th to the 18th centuries that contain data characterized by the use of pre-Hispanic graphic style and symbolism.

Why were they inscribed

Their importance lies in being the main written evidence that carried on the tradition of painting, testimonial and narrative of pre-Hispanic times. Their originality reflects the enormous creative power of the Indian peoples against colonialism.

Where are they

Archivo General de la Nación, Mexico City, Mexico

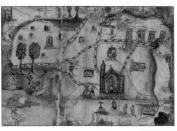

▲ ▶ *A selection of the extraordinary collection of Mexican pictographs that show the adaptation of traditional forms of Aztec illustration and mapping to meet the needs of the new Spanish rulers.*

The 323 maps, drawings and illustrations in this collection date from after the Spanish conquest of Mexico under Hernán Cortés between 1519 and 1521, but they still show a 'distinctly Indian style or Indian influence'. They include representations and pre-Hispanic glyphs that are evidence of enormous wealth, deep symbolism and meaning and continue to be the subject of comprehensive study. These documents constitute a rich and original culture that provide graphic evidence to help understand the pre-Hispanic cultures in Central America and the permanence of their legacy during and after Spanish colonization. In that sense they constitute the historical memory that survived European settlement in America and left a legacy of multi-ethnicity in Mexico.

Among the documents in the collection are traditional illustrated codices and genealogies from the 16th and 17th centuries, which include drawings of human figures, both of traditional pre-Hispanic peoples and of the new Spanish settlers, with the illustrators trying to adapt their style to reproduce Spanish clothing. There are many maps and town plans in the collection. Some are quick sketches to identify the general location of particular places while others are detailed coloured drawings, many produced to establish land ownership. Nearly all of them feature decorations which show the influence of pre-Hispanic illustration styles and clearly differentiate them from European maps of the time. The collection also includes tax documents and Inquisition documents – the Holy Office of the Inquisition was established at the formation of New Spain in 1522 and Indians were subject to it for a short period up to 1542; some of its cases relating to polygamy and idolatry featured graphic material of pre-Hispanic origin and these rare cases are included in the collection.

The original documents are very fragile, having been prepared on a variety of materials, including cotton paper, cloth and other natural fibres made into paper and use inks and natural dyes that are sensitive to light. There is a continuing programme to make digital images available through the National Archives website of these outstanding pictographs so that their beauty and great intrinsic value can be more widely appreciated.

Negros y Esclavos archives

Inscribed 2005

What is it

A collection of original documents detailing the development of the slave trade in the city of Cartagena in the Spanish colony of New Granada (now Colombia).

Why was it inscribed

These unique archives provide evidence of all aspects of slavery in the New World: the maltreatment of slaves, their sale and marketing, their role in daily domestic work, their work in the mines and on the large estates, their protests, and, finally, their rebellion.

Where is it

Archivo General de la Nación, Bogota, Colombia

The archive contains extensive and very wide-ranging records of the development of the African slave trade in the New Granada territory (the country now known as the Republic of Colombia). The collection is composed of fifty-five files, equivalent to approximately 55,000 sheets of paper, which refer not only to the history of Colombia, but also that of Ecuador, Panama and Venezuela.

New slaves were sent to the different Spanish colonies in South America from the port of Cartagena, which therefore documented information about slaves and their treatment. Regrettably, most documents produced in Cartagena during that period – the 16th to 18th centuries – have disappeared. This archive is one of only two in the world that preserve information on the slave trade in this area.

The trade began from the start of European occupation of American territory. The trade and sale of slaves were

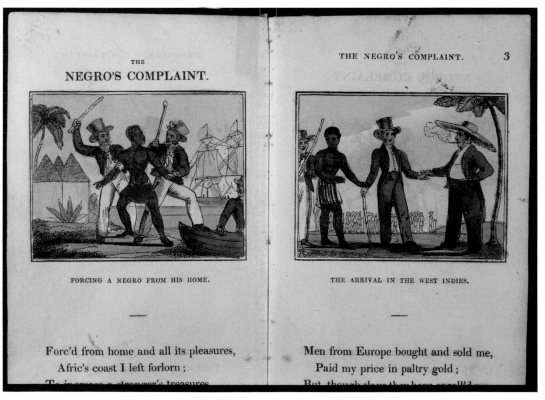

▲ Illustration of an African forced into slavery, from 'The Negro's Complaint', an 1826 poem.

carried out through the *asiento* contract, formalized between the Spanish Crown and the contractor. These documents provide evidence of the maltreatment of slaves; their protests; their sale and marketing; their role in daily domestic work; their work in the mines and on the large estates, and finally of their rebellion.

The price paid for a slave depended on his age and physical fitness for work. Between 150 and 250 pesos were paid for a slave between 16 and 18 years at the beginning of the 18th century. During this same period, a house made of wood and straw cost 900 pesos in Santafé.

The value of a slave was determined by a procedure known as the *palmeo*. The slave was measured with a strip of wood and the price would drop if the slave was ill, had lost teeth or had spots. Afterwards, the skin would be branded with a hot iron – the *marquilla* – on the chest (with the 'R' of the Real Crown) and on the back with the initials of the respective owner. Some slaves were branded on their faces.

The role of the slaves in the colony was not limited to work in the mines or the plantations. Slaves also performed diverse domestic chores such as the manufacture of handmade goods and activities relating to transportation. At least 250,000 African slaves were introduced into New Granada during the 300-year period.

The documents 'Negros y Esclavos' of the ancient Spanish colonies in America are today one of the most important archives of their type in the world. The preservation and study of evidence relating to the route of the African slaves to the American continent is a flourishing field. It has become very important to preserve the history of slavery and to understand the role it played in the creation of nations throughout four centuries.

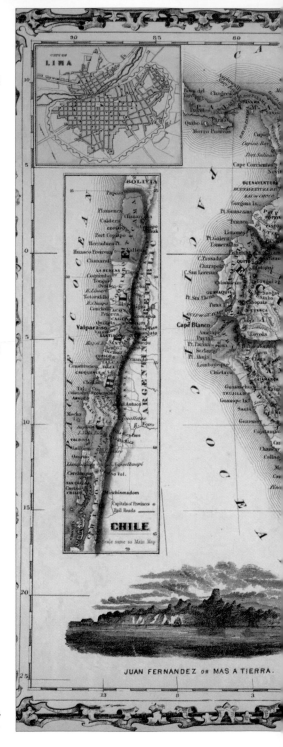

Map of Venezuela, New Granada, Ecuador,
Peru, Bolivia, Chile & Guyana in 1862. ▶

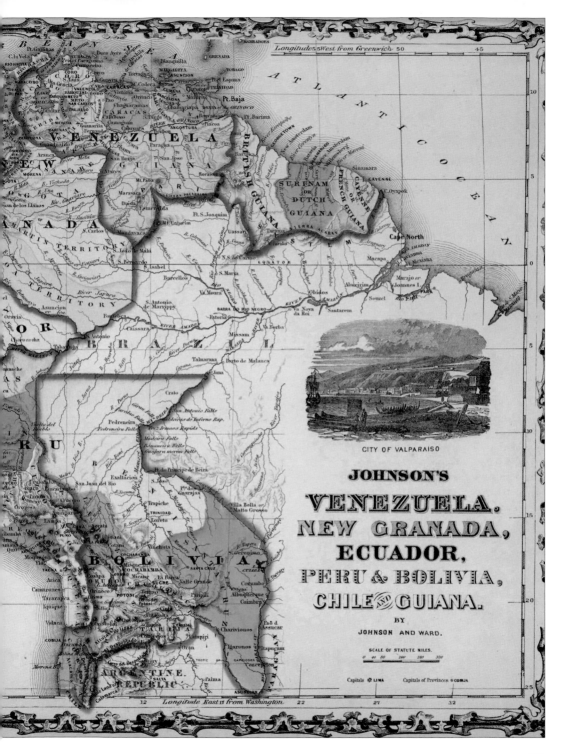

CITY OF VALPARAISO

JOHNSON'S
VENEZUELA,
NEW GRANADA,
ECUADOR,
PERU & BOLIVIA,
CHILE and GUIANA.

BY

JOHNSON AND WARD.

SCALE OF STATUTE MILES.

Capitals ⭐ LIMA Capitals of Provinces ◉ COBIJA

Collection of Mexican codices

Inscribed 1997

What is it
The collection comprises one pre-Hispanic codex, ninety-two colonial originals and sixty-eight period facsimiles from original sources of pre-Colonial Mesoamerica.

Why was it inscribed
These pictorial documents or codices are the only surviving examples of the pre-Hispanic reading and writing system peculiar to the cultures of Mesoamerica. They constitute the only original sources of the early relations between the native peoples and the Spanish incomers.

Where is it
Biblioteca Nacional de Antropología e Historia del INAH, Mexico City, Mexico

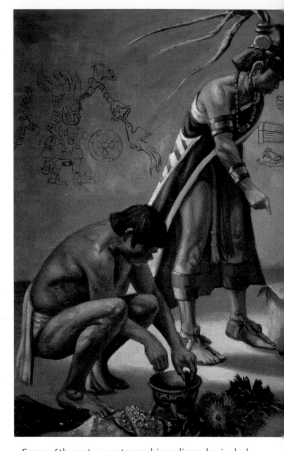

The *Colección de Códices Originales Mexicanos* is a set of 161 documents which together comprise the writings of the native cultures that existed in Mesoamerica before the arrival of the Spanish from the late-15th century onwards.

The codices offer insights into the social, economic, political, religious and cultural organization of the pre-Hispanic peoples. They also reveal how two such different cultures as the Mesoamerican and the Spanish came to terms with one another; the fate of the human groups involved in the processes of conquest and colonization; and how the relationship between the two developed from one of domination to a different type of relationship based on coalition.

The pre-Hispanic books use an iconographic writing system developed by scribes known as *tlacuilos*, although the system and images used make the codices difficult documents to interpret and decode. Some of the individual pictorial manuscripts cover a wide range of subjects, so definitive classification of the titles in the collection is challenging. However, broad thematic groups can be outlined.

There are various types of historical material: genealogical, which gives detailed information on important pre-Hispanic figures and aristocratic dynasties; annals and chronicles from the 16th century; and ritual–calendric which detail not only calendars but also religious, mythical and historical matters, also from the 16th century.

Some 16th-century cartographic codices also include historical and genealogical information, while others are simply maps. The partial map of the Aztec capital Tenochtitlan outlines urban planning, land ownership and land census information. Genealogical documents from colonial times were drawn up to defend inheritance rights in lawsuits, and these date from the 16th through to the early 18th centuries. Other documents relate to land ownership and there are lists of taxes that were payable both before and after the Spanish conquest.

The *Chilam Balam* books from the 18th century contain historic, calendric, botanical and medical information, almanacs and prophesies, and are written in the Mayan language of Yucatán. Earlier religious books from the 16th century which were used in converting and teaching the local people Christianity include catechisms and a prayer book. Botanical and medical documents dating

paper, tanned animal hides (usually deerskin) and cloth made on indigenous looms, parchment, European paper, and oils on canvas and bristolboard.

The codices come from several regions in Mexico. Most are from Mexico City itself, the State of Mexico and Oaxaca, but others are from Guerrero, Hidalgo, Morelos, Michoacán, Puebla, Tlaxcala, Veracruz and Yucatán, while the origins of some remain unknown.

from the mid-16th century were prompted by the desire of the Spanish to learn about local plants and treatments and detail contemporary plant and herbal remedies.

Although some of the codices which may be later copies of pre-Hispanic documents – such as the Tax Register and the Pilgrimage Strip – are now considered to be originals, most of the pictorial testimonies in the collection date from the 16th century and therefore preserve the iconographic forms and conventions of the Mesoamerican pictorial tradition.

Some of these codices were bound in book form, as European codices were, while others were constructed of long, folded strips of paper, bark, hide and other material. The variety of their formats includes folding-screen books, canvases, maps and plans, books and framed oil painting. The codices are on a variety of media – mostly on fig-bark paper, although also used are agave (maguey)

Colección de lenguas indígenas

Inscribed 2007

What is it

A collection of 166 books comprising 128 titles which are either written in, or are studies of, indigenous Amerindian languages from the 16th to the 19th centuries.

Why was it inscribed

Amerindian societies relied on oral traditions supplemented by pictographs as their means of transmitting information; consequently there are few records of the languages of Central America before the area came under Spanish rule from the early 16th century onwards. The span of the collection's publication dates also reveals the development of those languages as they encountered the Castilian spoken and imposed by the new Spanish establishment.

Where is it

Biblioteca Pública del Estado de Jalisco, Jalisco, Mexico

The *Colección de Lenguas Indígenas* ('Collection of Indigenous Languages') represents the first systematic study ever undertaken by incomers and colonizers of the languages of the people in their new territorial holdings. They allow access to seventeen of the native languages of Mesoamerica from the Early Modern period onwards, recording their vocabulary, grammar, phonetic renderings of words and accents and notes of their use in everyday speech. Some of the languages are now extinct while others which are still spoken today – for example Nahuatl – are represented here in earlier or classical form.

The books were largely written to serve European clerics in their dealings with local people. Various religious orders – Franciscans, Jesuits and Dominicans – divided between them geographical responsibility for the territory's conversion, while ordinary clergy ministered to the people. As a result, the titles in the collection tend to fall into two categories: those with strictly linguistic information; and those detailing the means of communicating and explaining Christianity in the native languages. In addition to books of grammar and bilingual dictionaries, the collection contains catechisms, confessional books, books of doctrine and sermons, and books of instruction for teaching people how to read.

Local people acted as translators and intermediaries with the Europeans, and the books were printed locally in the viceroyalty of New Spain.

The collection officially came into government possession in 1859 after Mexico's republican government, whose forces had two years previously executed the country's Emperor Maximilian, and seized all Church property in Mexico with the sole exception of churches. The monasteries were dissolved and their holdings – buildings, lands and possessions – seized. Many monastic library collections were lost in the ensuing culling and pillaging.

This listed collection came from seven monasteries in western Mexico. Some of the books in the collection are very rare, with few other known examples in publicly accessible collections. However, it is not complete as it was initially received: some titles seem to have disappeared while others were incorporated from the date of the earliest inventory in 1873.

Tzapotla, Chalchiuchtli, Cioapipilti and Tlaculteutl, the ancient gods of the Mexicans. ▶

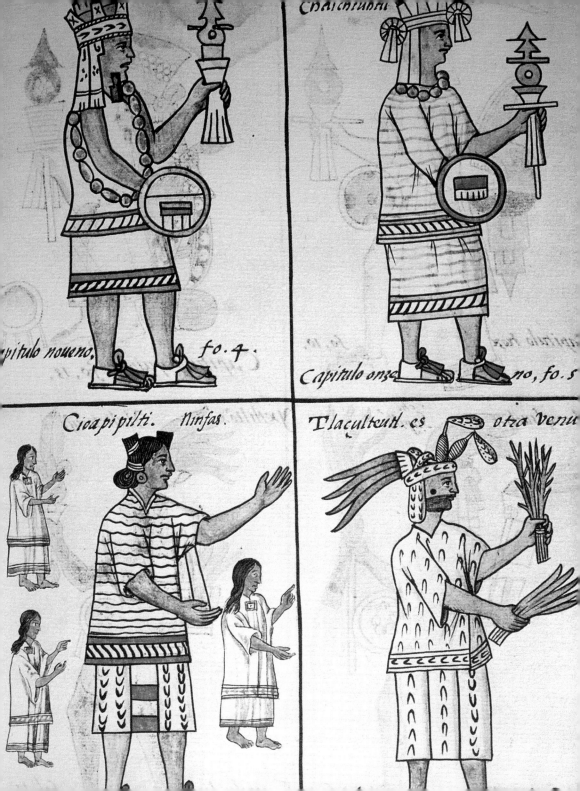

Chalchiuhtli

Capitulo noueno.　fo. 4.

Capitulo onze no, fo. 5.

Cioapipilti. Ninfas.

Tlaçulteutl. es otra Venus

Bašagić collection of Islamic manuscripts

Inscribed 1997

What is it
A collection of Bosnian literary and scientific works.

Why was it inscribed
After the destruction of the National Library of Sarajevo, Bašagić's manuscripts became the most significant and comprehensive, and in some cases the sole, record of Bosnian Muslim literature from the 16th to the 19th centuries.

Where is it
University Library, Bratislava, Slovak Republic

Dr Safvet beg Bašagić was a Bosnian writer, poet, academic and curator who played a leading role in the early-20th-century renaissance in Bosnian Muslim culture. Born in Nevesinje in 1870, he received his doctorate from the University of Vienna where he studied Arabic and Persian. He then taught Oriental languages at the University of Zagreb and was curator of the Archaeological Museum in Sarajevo from 1919 to 1927.

He co-founded the cultural magazine *Gajret*, and was elected President of the Bosnian council in 1910.

After inheriting an extensive book collection from his father, Bašagić spent 30 years adding to it rare texts from across the former Ottoman empire and transforming it into the single most important literary archive of Bosnian culture. In 1924 he sold his collection of manuscripts and printed books to the University Library in Bratislava.

The Bašagić Collection includes 284 volumes of manuscripts and 589 individual works: 393 Arabic, 117 Turkish and eighty-eight Persian. Together these represent the most comprehensive record of Bosnia's written heritage from the 16th to the 19th centuries. There are famous works of Bosnian Muslim literature (both prose and poetry) and many influential scientific texts (in subjects as diverse as theology, law, history, philosophy and Islamic mysticism). Many of the books by Bosnian scholars are unique and there are several rare works of worldwide importance by Islamic authors from other countries, including a complete manuscript by Al-Farabi and the largest collection of four-lined verses by Omar Khayyam.

As well as documenting the changing culture and history of Bosnia, the collection offers valuable insights into Turkish State administration and the religious situation in Bosnia between the 16th and the 19th centuries.

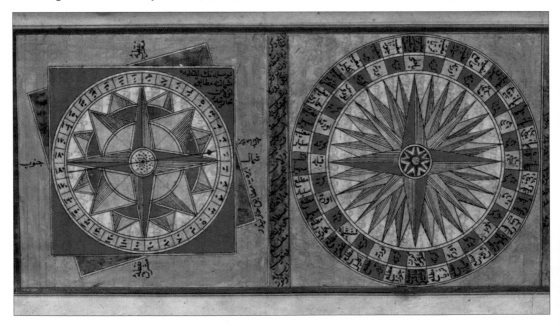

◀ *Illustration from the Bašagić collection*

Bratislava, home of the Bašagić collection ▲

(overleaf) A manuscript page from Bašagić collection ▶

Fighting during the war in the former Yugoslavia in the 1990s destroyed many treasures of Bosnian culture and literature. The National Library in Sarajevo was nearly completely burnt out and several other libraries were also damaged. This has made the Bašagić Collection even more valuable: it is the most complete existing record of Bosnian Muslim culture.

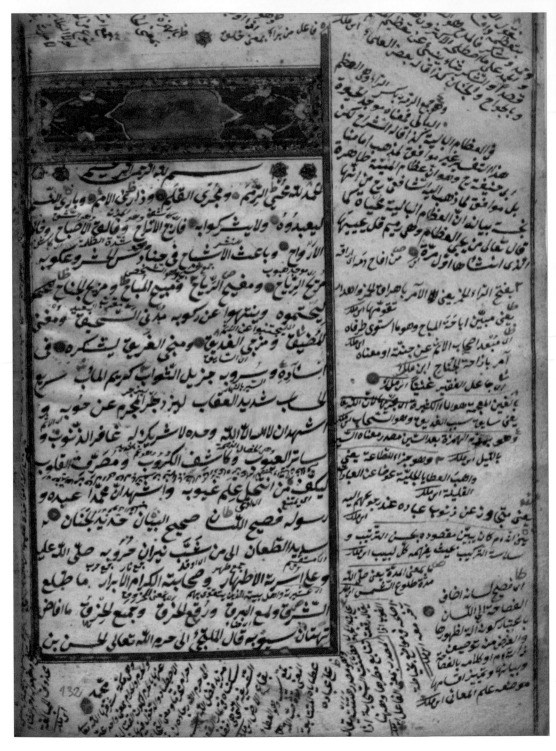

Collection of the Center of Documentation and Investigation of the Ashkenazi community in Mexico
(16th to 20th centuries)

Inscribed 2009

◀ *Illustration from* Fonen und Blunt *('Flags and Blood') by Jacobo Glantz, 1936.*

What is it

A collection of books, manuscripts and other historical items in different languages from the Ashkenazi Jewish Community of Mexico.

Why was it inscribed

It is a unique heritage of Ashkenazi culture in Mexico and a testament to the extraordinary historic saga that brought it from Europe. It is the memory of a cultural minority that was persecuted in Europe but found survival in the Americas.

Where is it

Comunidad Ashkenazí de México, Lomas de Chapultepec, Mexico City, Mexico

The Center of Documentation and Investigation of the Ashkenazi Community of Mexico preserves and disseminates the Ashkenazi culture, which nearly disappeared during the Nazi era in Germany between 1933 and 1945. It also safeguards the historic memory of the Jewish minority in Mexico that arrived from Central and Eastern Europe.

The collection consists of 16,000 volumes, mostly in Yiddish and Hebrew, but also in Polish, Lithuanian, Hungarian, Russian and other languages relating to Ashkenazi culture.

From the end of the 19th century the Jews of Central and Eastern Europe decided to emigrate towards America to find better living conditions, resulting in large groups of Jews cutting their ties to the lands in which they had developed a way of life, a language (Yiddish) and a manner of being: the Ashkenazi.

In the first two decades of the last century, many Jews coming from countries such as Russia, Poland, Romania, Czechoslovakia, Hungary, Austria, Germany and France settled in Mexico. To retain their identity and continuity for later generations, they founded the Nidjei Israel (1922), a community very similar in its functions to what they had left behind in Europe.

Their former life was ended forever by the pogroms unleashed at the dawn of the 20th century, by the First World War and the Bolshevik Revolution, and by the rise of Nazism in Germany in the 1930s.

When the religious and cultural centres finally disappeared during the Holocaust, the responsibility for preserving the Ashkenazi culture fell on the shoulders of Latin American communities.

In 1945, thousands of books that had been confiscated by the Nazis were rescued by the Allies near Offenbach in Germany. Returning them to their original libraries was impossible, so it was decided to contact the established Jewish communities in Latin America. The Ashkenazi community in Mexico received 1000 of those books, which became the starting point for a new collection of Ashkenazi and wider Jewish culture in Mexico.

The CDICA now has more than 16,000 volumes dating from the 16th to the 20th centuries, the greater part of them written in Yiddish and Hebrew, and a few in other languages including Polish, Lithuanian, Hungarian and Russian. It also has all the manuscripts from the Ashkenazi institutions in Mexico. The books focus mainly on the humanities, Jewish studies and cultural history.

The collection is unique for two main reasons: the first, because it is the only one of its kind in Mexico and the second, because of the extraordinary historic saga that brought it from Europe.

Nicolaus Copernicus' masterpiece 'De revolutionibus libri sex'

Inscribed 1999

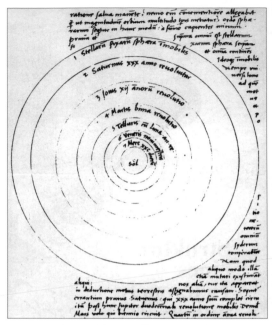

What is it

The manuscript, in six books (*libri sex*), of *De revolutionibus* was written by Copernicus around 1520. In this work he presented his theory that the planets moved round the Sun.

Why was it inscribed

His theory revolutionized our understanding of the world and became the foundation of many branches of science.

Where is it

Jagiellonian Library, Jagiellonian University, Krakow, Poland

▲ *Copernicus's original diagram of his astronomical system, with the Sun at the centre of our universe.*

Nicolaus Copernicus ▶

Nicolaus Copernicus (Mikolaj Kopernik, 1473–1543), who studied at the University of Krakow and at several Italian universities, is considered to be one of the fathers of the Renaissance. He was not only a scholar and researcher but also a humanist, philologist, doctor and a pioneer in the practical study of economics. From 1512, apart from a short period, he lived in Frombork (Frauenburg) in northern Poland.

His theory proposed that the planets orbited around the Sun in almost circular orbits (the heliocentric theory) and became one of the greatest achievements in the history of natural science. He also proposed that the Earth moves in three directions: around its axis (explaining the existence of day and night); around the Sun on an annual basis (the most interesting from the mathematical point of view) and the movement of the axis of the earth (which explains the phenomenon of precession). These new ideas replaced the fictitious and complex models of spheres thought to be located above the stars which existed in Earth-centred (geocentric) astronomy. He carried out an analysis of all the consequences that the refutation of the geocentric theory would have and proved that all astronomical phenomena which could be observed were in accordance with the new theory. Apart from its importance for the development of natural science, the new theory also exerted great

influence on the worldwide outlook which questioned the anthropocentric theory of the universe.

His student, the astronomer Rheticus (Jerzy Joachim Retyk, 1514–74), only persuaded Copernicus to publish his work 20 years after he wrote this text, and the final proofs of *De revolutionibus orbium coelestrium* reached him from the printers in Nuremberg on his death bed on 24 May 1543.

After Copernicus' death, his manuscript from 1520, together with all his papers and books were taken over by his friend Tiedemann Giese (1480–1550) who was the bishop of Chelmno (Kulm) at the time. Even though Giese bequeathed his library to the Warmia Chapter, the manuscript remained in the collection of Rheticus. After his death it passed through a number of collectors, ending up at the National Museum in Prague in 1945. In 1956 the government of Czechoslovakia gave it to the government of Poland, and it was transferred to the Library at Jagiellonian University where Copernicus had studied.

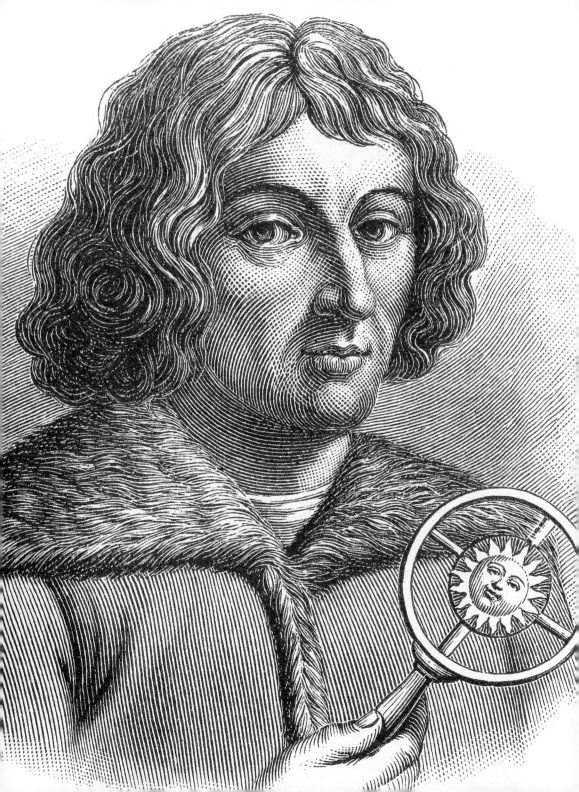

Codices from the Oaxaca Valley

Inscribed 1997

What is it

Three codices from 1529 recording Spanish Crown grants of the title of Marquisate of the Oaxaca Valley of Mexico and land in the area to the soldier and explorer Hernán Cortés (1485–1547).

Why was it inscribed

The codices and dossiers are rare examples of the written pre-Hispanic culture of Mexico which was largely lost or destroyed after the Spanish conquest of the region.

Where is it

Archivo General de la Nación, Mexico City, Mexico

Charles V, Holy Roman emperor and king of Castile, awarded the title of Marquis of the Oaxaca Valley and gave extensive grants of land to the conquistador Hernán Cortés in recognition of his services to the Spanish Crown.

Cortés was an energetic and prolific explorer and soldier who had first set foot in the Americas on the island of Hispaniola as an 18-year-old in 1504. He took an active part in the Spanish conquests of both Hispaniola and Cuba, working his way up through the local political administration and acquiring increasing wealth through land and slaves. His military campaign in Mexico from 1518 to 1521 resulted in the defeat of the Aztec empire and saw him rewarded with the position of governor of Mexico.

The grants of some of the richest areas of land in what was now called New Spain, were made on 6 July 1529 and were recorded in the codices, which detail the extent of Cortés's new holdings and its forms of administration.

Although the codices deal with the business of the new culture of the Spanish incomers, they were drawn up by local scribes and reveal a form of expression which is different from that of European culture. The indigenous scribes (*tlacuilos*) who drafted the three documents used their own writing system and wrote on agave (maguey) paper. These documents have allowed the expression of the indigenous culture to be preserved, as adaptation to Spanish practice led to the abandonment of native forms of expression, and most pre-Hispanic original documents were destroyed.

The codices are accompanied by other documents drafted by the descendants of Hernán Cortés regarding land ownership and the payment and collection of taxes. Some of these relate directly to local people: in one area, detailing the onerous tribute and taxation the locals were obliged to pay Martín Cortés, Hernán's son and the second marquis; and another listing Mayan Indians with the names of their chiefs and taxpayers. These documents were drafted in the indigenous Nahuatl language.

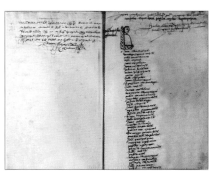
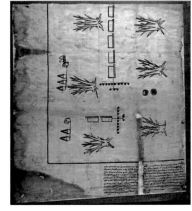
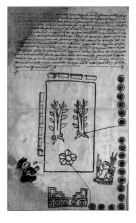

Pages from the codices ▲ ▶

◀ *Hernán Cortés, First Marquis of the Oaxaca Valley*

Châtelet de Paris banner register from the reign of Francis I

(National Archives Y9, France)

Inscribed 2011

▲ *The Archives Nationales in Paris*

What is it

The Châtelet banners series dealt with the registration and publication of French legislative texts of which the Y9 register is the third volume. Covering the period from 1515 to 1546, it covers the reign of the dynamic French Renaissance King Francis I.

Why was it inscribed

The register shows in detail the extraordinary legislative, administrative and legal output of Francis I, most notably his decree of 1537 requiring printers and booksellers to deposit a copy of their work in his royal library (and later, other state institutions). Other countries later followed the French example in the establishment of the legal deposit system which helped safeguard the preservation of knowledge.

Where is it

Archives Nationales, Paris, France

Like many of his royal contemporaries, Francis I was influenced by the ideas of the Italian Renaissance. A man of great energy, he was a renowned patron of the arts and learning who transformed the cultural life of France during the course of his reign.

Francis undertook a large-scale building programme, constructing several châteaux, all lavishly decorated, including Fontainebleau and the Louvre. His patronage brought Leonardo da Vinci to France for the artist's final years, together with many of his paintings, including the *Mona Lisa*. The art collection Francis gathered became the foundation for the French royal art collection, which is now housed at the Louvre. As a Renaissance prince, he also dabbled in warfare – in which he was less successful – and encouraged overseas exploration, most notably in Quebec. He established the royal library, made French the official language in place of Latin and set up a requirement for a registry of births, marriages and deaths in every parish.

King Francis I of France ▶

The energetic output of administrative initiatives during Francis's reign was recorded in the Châtelet de Paris banners. These registers, dating from 1416 onwards, recorded official administrative decrees and statues considered worthy of publication. Among the most famous of these initiatives was the king's 1537 decree introducing the legal requirement for a copy of each book to be deposited in the royal library. The printing of books was less than 100 years old and France was the first country to introduce this now commonplace practice, which ensured the conservation in a single place of every written and printed work produced in France.

The creation of a central repository went beyond Francis's renowned patronage of the arts. The Catholic Francis was keen to control the spread of the new Protestant ideas. As no work could be sold until a copy had been deposited in the royal library, the content of published work could be scrutinized for heretical ideas and controlled more closely. The concept of legal deposit, by which authors would eventually be able to register and date their work, was also an important stage in the development of copyright.

Collection of the manuscripts of Khoja Ahmed Yasawi

Inscribed 2003

What is it

This is a collection of manuscripts in the medieval Turkic language of the writings of Khoja Ahmed Yasawi, one of the most revered Islamic religious figures of Central Asia, and of one of his disciples, Suleiman Bakyrgani.

Why was it inscribed

The texts had great influence upon the development of the spiritual culture of the ancient Turks and promoted the development of the Turkic language and literature that had an impact upon the wider Islamic world.

Where is it

National Library of the Republic of Kazakhstan, Almaty, Kazakhstan

The National Library of the Republic of Kazakhstan holds a unique collection of the earliest known manuscripts of the works of Khoja Ahmed Yasawi (died 1166–67), one of the most revered Islamic religious figures of Central Asia, and of his follower, Suleiman Bakyrgani. All the manuscripts are in the medieval Turkic language, Chagatai, and together comprise about 1400 pages. The works of Yasawi had a great influence on the spiritual culture of the Turks, then powerful in Eurasia and the Islamic world. By writing in the Turkic language, despite the customary practice of writing in Arabic or Farsi, Yasawi and Bakyrgani promoted the development and expansion of Turkic Chagatai as a literary language.

Khoja Ahmed Yasawi lived most of his life in Yasi (the city now called Turkestan, one of the four most important surviving Silk Road cities, with Khiva, Bukhara and Samarkand). He was buried there with great honours, his grave becoming a place of pilgrimage and worship for Muslims throughout Central Asia and the wider Muslim world. The domed mausoleum later erected over his grave (1389–1405) is a masterpiece of medieval Islamic architecture and the greatest surviving monument

in Kazakhstan. By the 16th century Yasi was referred to throughout the region and beyond as a second Mecca and became the focus of the Sufist discipline known as the 'study of truth' which occupied the principal place in the philosophical studies of Yasawi.

The manuscripts in this collection represent the key monuments of medieval Turkic literature, and date back to the 16th and 17th centuries. The collection contains unique and very important data on the history, culture,

The great mausoleum of Khoja Ahmed Yasawi, built at the end of the 14th century, in Yasi (now Turkestan), one of the great architectural treasures of Kazakhstan. ▶

literature and ethnography of the Turkic nations and peoples within the context of the whole Turkic civilization. The influence of Yasawi and Bakyrgani served as a means of spreading Islam throughout the Turkic peoples in Turkestan, Khorasan, the Caucasus, Iran, Anatolia, Crimea, the Balkans and Desht-i-Kipchak (all of which encompass the region of modern Kazakhstan and parts of western China and Uzbekistan).

American colonial music:
a sample of its documentary richness
Inscribed 2007

What is it

Collections of music, including choir books, polyphonic books, music papers, codices and manuscripts from Bolivia, Colombia, Mexico and Peru dating from the 16th to the 18th centuries.

Why was it inscribed

The collections, from a wide range of sources, influences, backgrounds and musicians, comprise important roots of music in the American continent. They illustrate how the contributions and fusion of indigenous, European and African influences evolved into a new culture and musical heritage.

Where is it

Archivo y Biblioteca Nacionales de Bolivia, Sucre, Bolivia; Archivo de la Catedral de Bogotá, Bogotá, Colombia; Archivo Histórico de la Arquidiócesis de Oaxaca, Oaxaca, Mexico; Biblioteca Nacional del Perú, Lima, Peru

The American colonial music collections span three centuries of the musical history of Hispanic America during the Colonial era. They reflect its many aspects and influences and include religious and lay music, cultural and popular, vocal, instrumental, Renaissance, Baroque and classical. The collection comes from the many areas where music would have been heard in American colonial society – cathedrals, convents, schools, aristocratic houses, theatres, public spaces and places of entertainment, including the *corrales de comedias*, the public playhouses of contemporary Spanish popular culture. Together they represent an aspect of the new culture that grew from the cross-fertilization of indigenous, European and African roots in this part of the American continent.

Sacred and religious music features prominently and includes the polyphonic pieces that comprise much of a *libro de coro* (choir book) by Gutierre Fernández Hidalgo. Dated 1584, the book is one of the earliest South American choir books (from Colombia) and reflects the musical repertoire used in the conversion of the continent in the 16th century. The *Cancionero Musical de Gaspar Fernandes* is another volume of polyphonic compositions, this time

from the early 17th century. Said to be the only book that synthesizes the change from Renaissance to Baroque in the Hispanic empire, the *Cancionero* also charts the course colonial music followed between the 16th and 17th centuries, and displays influences of European, indigenous and African origin. Many of the compositions are in the vernacular, with some Latin and also secular pieces.

The growth in popularity in the 17th century of *villancicos* is also represented. These devotionals were sung in the vernacular and used in religious liturgy in the Hispanic American tradition. Early forms appear in Fernandes's *Cancionero Musical*, and there are versions from later in the century by Juan de Araujo and Antonio Durán de la Mota for voice or instruments. Both chapel masters, they composed noted *villancicos* based on the work of the Mexican nun Sor Juana Inés de la Cruz, the most famous woman poet in the territory of New Spain.

Another specific treasure is *La Púrpura de la Rosa*, the only example of dramatic music from the region in the 17th-century Hispanic Baroque style. Premiered in Lima in 1701, it is the earliest opera composed and performed in the Americas. Its importance is such that in 2001, during the tricentennial commemoration of its composition, Peru's National Congress declared it 'Patrimonio Cultural de la Nación', an official part of Peruvian cultural heritage.

Sor Juana Inés de la Cruz whose work inspired some of the music. ▶

Business archives of the Officina Plantiniana

Inscribed 2001

▲ A book printed by the Officina Plantiniana.

ABCDEFGHIJKL
MNOPQRSTUVW
XYZabcdefghijklmn
opqrstuvwxyz&0123
456789ÆÁÂÄÀÅ
ÇÉÊÈËÍÎÏÑŒÓÔ
ÒÖØÚÛÙÜÝæáâ
äàåçéêèëfiflíîïñœóô
òöøßúûùüyᵢ£¥ƒ$¢
□™©®@ªº†‡§¶*!¡?¿.
,;:'"‹›«»„…‚‹‹‹000()[]{}
|/_\•‾ˆ˜¯#%‰
=−+<>—¬^/·

This typeface, originally designed by Christophe Plantin ▲ in 16th-century Antwerp, continues to be much used today.

What is it

The Officina Plantiniana was perhaps the most important printing and publishing house in Belgium. Their business archives provide incredible detail on all aspects of 300 years of book history.

Why was it inscribed

The importance of the archives lies not only in their content but also in the effect of the business in spreading printed documents and printing culture in Europe and among Latin, Spanish and Portuguese Americans.

Where is it

Museum Plantin-Moretus, Antwerp, Belgium

The Officina Plantiniana was founded in 1555 by Christophe Plantin who, in one of the most turbulent periods of Western history, succeeded in making himself the greatest typographer of his day. With the establishment of the Officina Plantiniana, Antwerp consolidated its role, for more than half a century, as one of the most important typographical centres in Europe, together with Venice and Paris. The rise and the heyday of the Officina in the 16th and 17th centuries coincided with an era in which scholars from the Low Countries – present-day Belgium and the Netherlands – were able to play an extremely important part in the development of Western thought. The history of the Officina Plantiniana is therefore more than an account of the fortunes of a large capitalist enterprise: it also reflects and is part of the great cultural currents of the West. The Officina expanded into the largest printing and publishing house of the time: the first example of a capitalistic industrial enterprise in the typographical sector whose production, thanks to an especially well developed distribution network, reached as far as North Africa, America and the East. Since Plantin held the monopoly for printing religious works for the Spanish home and colonial market, the archives contain detailed figures of publications meant for the Christianization of the Spanish colonies. The Officina continued in business until 1876, run by Plantin's descendants, the Moretuses.

The archives reflect the activity of the Officina Plantiniana in all its aspects for the period from around 1555 to the second half of the 19th century (the start of the industrial revolution in printing). They provide information on the printing and book-trade history, on economic and socio-economic history and on humanism and the Counter Reformation. The archives also provide first-hand information on the fields of science (cartography and mapmaking, botany, medicine), philosophy, humanism and art. Beside information on printing techniques and everything associated with the mechanics of printing, the archives record the management of the Officina Plantiniana as an industrial printing and publishing house. An important number of documents provide essential information on working conditions in the Officina Plantiniana, its social organization and the position of women (for example, the 'complaint books' with the different causes of dissatisfaction of its employees, and nine volumes on the 'Chapel', a pre-industrial form of union or guild).

Documentary fonds of Royal Audiencia Court of La Plata (RALP)

Inscribed 2011

What is it

Documentation covering 264 years of the administrative, judicial and governmental functions of what is now Bolivia.

Why was it inscribed

The RALP is a valuable record of Spanish colonialism, with its mixture of economic exploitation and Christian evangelism. In particular, it contains the history of silver mining in Potosí, a UNESCO World Heritage site and the centre of silver mining from the 16th to the 19th centuries an activity that fuelled the pre-industrial global economy. Silver became the lifeblood of the Spanish empire and a global economy that stretched from Europe to Asia.

Where is it

National Archive of Bolivia, Sucre, Bolivia

The Royal Audiencia Court of La Plata (RALP) was a legislative body set up by the Spanish crown in Charcas in 1561 to manage the local colonial territory. This was a huge area, which at its peak included what is now Bolivia, Paraguay, Uruguay, northern Argentina and Peru to the south of Cuzco. RALP functioned for 264 years until the creation of the Republic of Bolivia in 1825.

This documentary resource spans the period between 1561 and 1825 covering civil wars, rebellions and the incredible development of the silver mines of Potosí. The reserves of silver here were extremely rich: at least 41,000 metric tons of pure silver were mined from Potosí from 1556 to 1783. Of this, 8200 metric tons went directly to the Spanish monarchy.

The exploitation of this resource led to the creation of an extensive economic network that, from its base in South America, made its influence felt throughout the known world. Silver from Potosí was exported to the Iberian Peninsula, crossed Europe and continued on to the Oriental and Asian markets. The documentation of the

Silver miner, Potosí, Bolivia ▼

RALP thus illustrates the genesis of the globalization of the silver trade in the 16th and 17th centuries.

The archives from RALP deal with economic, military, ecclesiastical, cultural and social issues within its huge territorial and administrative jurisdiction.

The documents relate, among other things the legal system of the Indies and the supplementary application of Castilian law; the exportation of silver to Spain; the importation of European goods; the transformation of monetary wealth into commercial capital; the transfer of capital to commerce and agriculture; the adoption of indigenous technological knowledge; the development of new mining technology; and the adaptation of the indigenous obligatory system of labour, the *mita*, to capital accumulation. Also illustrated are the transformation of the pre-European tribute to the Inca and local deities into a tithe system established by the European conquerors; the responsibilities and privileges of the Inca aristocracy as regards the functioning of the *mita* system; the application and later decline of the obligatory paid-work regime in the mines; the labour of African slaves in the Royal Mint House; the establishments of networks for the circulation, interchange and consumption of goods among regions; the creation of mining, commercial and industrial societies; the creation of transport networks employing Andean animals such as the llama and the alpaca; norms for the acquisition, exploitation and sale of mining properties; technological limitations for refining complex silver ores containing other metals and non-metals; the role in development of the local economic, political, social and other trends in the entire jurisdiction of the RALP.

This documentation is of huge relevance to the present-day territories of Argentina, Paraguay, Chile and Peru, as well as Bolivia. It also provides a fascinating historical account of crucial factors in the development and funding of the Spanish empire.

Cerro Rico - the 'richest hill on earth' – Potosí, Bolivia ▶

The Confederation of Warsaw of 28th of January 1573: religious tolerance guaranteed

Inscribed 2003

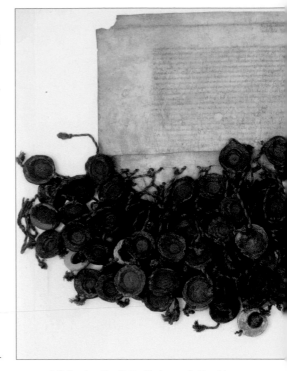

What is it

This document is the earliest formal declaration of religious tolerance in Europe. It was supported by some 200 individuals who appended their seals to the parchment, a personal commitment of the nobility to guaranteeing religious tolerance and securing the unity of the state.

Why was it inscribed

It is a unique testimony of democratic compromise granting religious tolerance to the Polish nobility as part of a consensual pact to maintain social order and preserve the union of Poland and Lithuania. It had an influence on events in a number of other European countries.

Where is it

Central Archives of Historical Records in Warsaw, Poland

King Sigismund II Augustus (1548–72) ruled the states of Poland and the Grand Duchy of Lithuania, which covered not just Lithuania, but also Latvia and Belarus and parts of Estonia, Ukraine and Russia and was the largest state in Europe. He died childless on 7 July 1572 and, in advance of his death, he created, through the Union of Lublin of 1569, the Polish Lithuanian Commonwealth, joining together the Kingdom of Poland and the Grand Duchy of Lithuania. The Union of Lublin provided for the election of a new monarch, but the end of the male line of the Jagiellon dynasty, after nearly 100 years, took place when the reform of the political system was still incomplete. What made matters worse was the fact that there were no legal measures which would enable the state to function effectively during the interregnum when there was no king. It was feared that separatist trends might prevail, especially in Lithuania, and that the integrity of union of Poland and Lithuania might be threatened. There also existed a threat of two rulers being elected and the election of an unsuitable candidate might have brought about the destruction of religious stability in the country, prompting a religious civil war. The concerns were very real, following the St Bartholomew's Day Massacre on 24 August 1572 in Paris, when French Protestants were murdered on the orders of the French king, followed by many massacres throughout France.

To prevent a political crisis the nobility gathered in Warsaw for the General Confederation of Warsaw. The Confederation created a legal basis for a new political system and at the same time secured the unity of the state which had been inhabited for generations by communities from different ethnic backgrounds (Poles, Lithuanians, Russians, Germans, Georgians and Jews) and of different denominations. Religious life in late 16th-century Poland, situated between Orthodox Moscow, Muslim Turkey and Western Europe torn by religious conflicts between Catholics and Protestants, was of an exceptional character. This country had become what Cardinal Hozjusz, the Papal Legate to Poland, called 'a place of shelter for heretics', where the most radical Christian religious sects, trying to escape persecution elsewhere, sought refuge. The Anabaptists (Dutch Mennonites) and Anti-trinitarians (Arians) enjoyed peace and freedom such as they could not have in any other

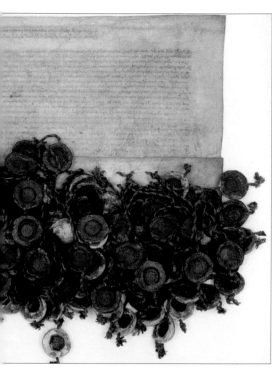

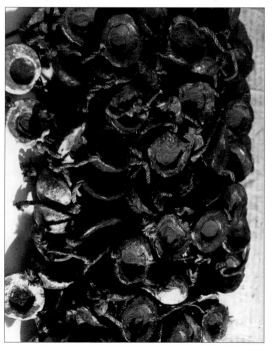

◄ The original document of the Confederation of Warsaw agreed on 28 January 1573. Over 200 seals, mainly representing noble Polish families, are attached to the parchment. The Convention is the earliest example in Europe of a commitment to religious tolerance.

Some of the 200 seals attached to the Convention of Warsaw. ▼

country. All religious sects in Poland enjoyed tolerance as this was the king's will. The Confederation officially legalized this situation.

The General Convention of Warsaw was approved on 28 January 1573 and introduced the rule of peaceful coexistence for nobles of all denominations, guaranteeing equal access to state offices regardless of denomination, which confirmed the equality of all the members of this social class; freedom to worship and spread one's religion; the right to organize synods (representative Church meetings), which guaranteed freedom of assembly; and the right to print theological treatises, which guaranteed the freedom of publishing. The Convention also obliged citizens to abide by all decisions taken in a representative body and to maintain the existing legal order.

The document was handwritten on parchment and attached to it were over 200 seals. Most of them are private seals imprinted by the representatives of noble families as well as by the representatives of the Catholic Church. They constituted a visible proof of a personal commitment on behalf of the nobles to establish fundamental freedoms for their class.

Tarikh-e-Khandan-e-Timuriyah

Inscribed 2011

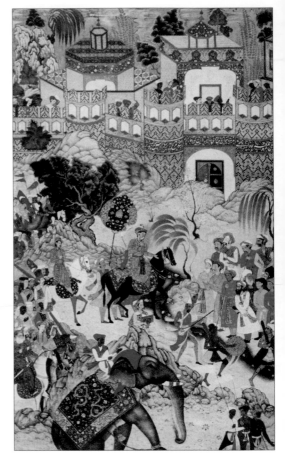

What is it

Authenticated as having been created for the Mughal emperor Akbar in the 16th century, this manuscript is one of the finest examples of the work of skilled scribes and painters from both India and Persia.

Why was it inscribed

The extent of Timurid and Mughal rule, both geographically and across the centuries, attests to the world significance of these dynasties. There is no other illustrated historical work on these two dynasties preserved within India that matches the richness of *Tarikh-e-Khandan-e-Timuriyah*.

Where is it

Khuda Bakhsh Oriental Public Library, Patna, India

The *Tarikh-e-Khandan-e-Timuriyah* is the only extant copy of a richly illustrated manuscript which deals with the history of Timur and his descendants in Iran and India, including the Mughal rulers Babur, Humayun and Akbar. The exploits of Timur in the 14th century were well known beyond Central Asia and in Europe, where he was known as 'Tamerlane' or 'Tamburlaine'. The manuscript was compiled in the twenty-second regnal year of Akbar (1577–78). The original title of the work is not given in the text; but an endorsement, by one of its former owners, mentions the title as *Tarikh-e-Khandan-e-Timuriya*, descriptive of its contents, a history of the family of Timur, the great Central Asian ruler and conqueror. It appears that the text was written primarily to provide basic reference material to Abul Fazl who was then compiling the official history of Akbar's reign – the *Akbar Namah*, which includes a history of Akbar's ancestors. Commonly, this text is also referred to as *Timur Namah*.

The authorship and calligraphy of *Tarikh-e-Khandan-e-Timuriyah* is ascribed to numerous court historians and scribes, since it is a collective work, typical of most Mughal illustrated manuscripts. Attesting to its authenticity and status as a royal copy, a brief note at the beginning of the manuscript, by Emperor Shah Jahan, in his own hand, states that this history was written during the time of 'Shah Baba', the name by which Emperor Shah Jahan

affectionately called his grandfather, Akbar. There are also several notes and seals of Mughal nobles, testifying to its authenticity. Unfortunately, it is incomplete at its start, so that the introduction begins abruptly while it ends suddenly with the events of the second campaign in Gujarat in Akbar's nineteenth regnal year, three years before the manuscript was completed.

The manuscript is remarkable for the number and splendour of its illuminations, all representing the delicate and highly refined style that was the trademark of the important artists of the imperial atelier under Akbar's patronage. Some of the miniatures contain the names of the painters. A total of fifty-one artists including the leading masters of the time are mentioned. In most cases, more than one artist has worked on some of the 133 paintings contained in the manuscript. Sieges and

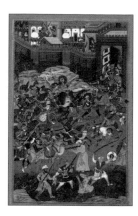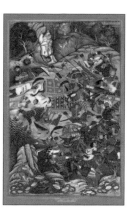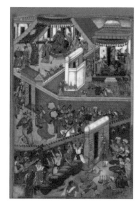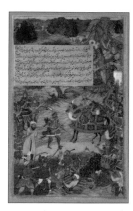

◄ The Tarikh-e-Khandan-e-Timuriyah *was thought to have been prepared to help Abul Fazl to write his history of Akbar's reign, the Akbar Namah. This work, too, was lavishly illustrated, as seen in this example of Akbar riding on a black horse and about to enter Surat.*

▲ *Four pages from the* Tarikh-e-Khandan-e-Timuriyah, *including two battle scenes, one of Mughal forces storming a fort, and one of presents being brought to court.*

battles comprise the principal themes of the paintings, as might be expected of a chronicle of generations of conquerors and rulers. The manuscript is written in beautiful bold calligraphy, within coloured and gold-ruled borders. The paper is of an excellent quality, of a sharp cream colour and with a slight ivory gloss.

Administrative documents of Astan-e Quds Razavi in the Safavid era

Inscribed 2009

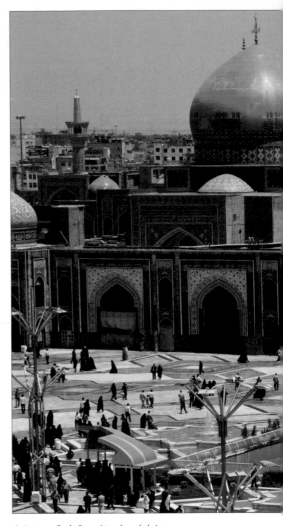

▲ Astan-e Quds Razavi tomb and shrine of Shi'ite Imam Reza Mashhad.

What is it

A collection of documents dating from 1589 to 1735 recording and relating to daily life and governance across a wide area of the Middle East that includes modern-day Iran and Afghanistan.

Why was it inscribed

The collection provides an insight into everyday administrative, economic, agricultural, social and religious life, especially in the city of Mashhad, under the powerful Safavid house which ruled Iran and the Persian empire from 1501 to 1736.

Where is it

Astan-e Quds Razavi Library, Mashhad, Iran

There are 69,000 pages of documents in the collection which forms part of the archives of Astan-e Quds Razavi, a large and wide-ranging religious and charitable institution based in the Islamic holy city of Mashhad in Khorasan province. Today Astan-e Quds Razavi is one of the biggest charitable institutions in the world and in the time frame the documents cover, the *motevalli*, or head of the institution, was a direct deputy of the Safavid kings with powers that extended into all areas of government. As a consequence, the reach of Astan-e Quds Razavi into all sections of society was extensive and the collection of documents reflects this.

▲ Pages from the documents

Although the archives of Astan-e Quds Razavi cover centuries of Persian and Iranian history and derive from several ruling houses, documents from the Safavid era are rare. This collection dates from after the start of the Safivids era, when a large increase in endowments drove Astan-e Quds Razavi to evolve its function from a purely charitable and religious organization into a much larger-scale concern with an administrative reach across society so all-encompassing that it even paid the army wages on

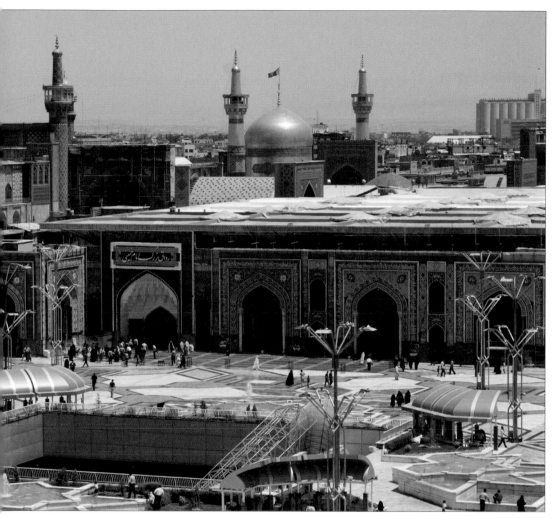

behalf of the king. As a consequence, the collection throws light not only on life and society from the 16th to the 18th centuries but also on Astan-e Quds Razavi itself.

The changes that Safavid society experienced over a century and a half are discernable through the papers. The documents illustrate the concerns of the people and the society as a whole, the common cultural viewpoints and difficulties and the financial and administrative systems that grew up to deal with them.

The papers can be grouped into several classifications. On the most basic level of the history of society, the papers illustrate the people's speech, dress codes, eating habits,

medical concerns and illnesses, professions, occupations and levels of income. The status of religion, societal economic relationships and the role of women are all revealed, as are different social levels and living standards. In addition to this, everyday administrative concerns ranging from types of endowments and payment to the organisation, to natural disasters – floods, earthquakes and droughts – show the workings of the society and its mindset.

Ben Cao Gang Mu 本草纲目
(Compendium of Materia Medica)
Inscribed 2011

What is it
Ben Cao Gang Mu or 'Compendium of Materia Medica' is a comprehensive pharmacopedia, textbook and encyclopedia of traditional Chinese medicine written in the 16th century.

Why was it inscribed
The compendium is regarded as the foundation of herbal medicine. It illustrates the pharmaceutical progress and achievements of China up to the 16th century and was the forerunner of modern pharmacological studies.

Where is it
Library of the China Academy of Chinese Medical Sciences, Beijing, China

Ben Cao Gang Mu is a multi-volume work which recorded and summarized traditional medicinal knowledge before the 16th century. The book lists, analyzes and describes plants, animals, minerals and other objects believed to have medicinal and pharmacological properties.

The author was Shanghai physician Li Shi-zhen (1518–93) who took 27 years to complete his work. He described each drug with its name and explanation, processing method, flavour and taste, known cure, observation notes and prescriptions. Contraindications and drugs recommended for various specific uses are also listed.

The content of Li's work goes beyond pharmacology to cover related topics including botany, zoology, mineralogy, physics, astronomy, chemistry, metallurgy, geology and meteorology. British biologist Charles Darwin called the book an 'ancient Chinese encyclopedia'.

Ben Cao Gang Mu was the first work of its kind and drew from texts written as far back as several centuries BC and from places as far-flung as Persia, India and the Mediterranean. Many of the sources Li used have since been lost or destroyed, leaving his *Compendium* as the only record of many of them. He built on the content in these works, correcting mistakes regarding the nature of medicinal substances and the causes of various illnesses, and supplementing them with new advances.

The book is a fifty-two-volume compilation with the edition listed on the Register being the one carved and

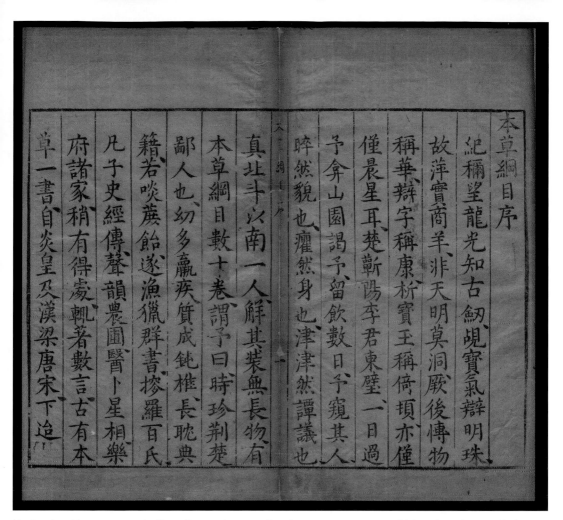

本草綱目序

草一書自炎皇及漢梁唐宋下逮
府諸家稍有得處輒著數言古有本
凡子史經傳聲韻農圃醫卜星相樂
籍若啖蔗飴遂漁獵群書摉羅百氏
鄙人也幼多羸疾質成鈍椎長耽典
本草綱目數十卷謂予曰時珍荆楚
真北斗以南一人解其裝無長物有
晬然貌也癯然身也津津然譚議也
予拿山園謁予留飲數日予窺其人
僅晨星耳楚蘄陽李君東璧一日過
稱華辯字稱康衒寶王稱倚頓亦僅
故萍實商羊非天明莫洞厳後博物
紀稱望龍光知古劔覘寶氣辯明珠

block-printed in 1593. It was the first edition to be printed in this way and all subsequent versions produced in China and internationally are based on this one. Volumes are arranged by medicinal source: for example, several volumes deal with vegetables, others with grasses, animals with scale and animals with shell. One volume also deals with different human body parts which can be used as medicine. A contents list takes up one volume while two are books of illustrations. In addition to its invaluable content matter, the book's stylized design and detailed illustrations are beautiful.

The first draft was published in 1578 when China's Ming dynasty (1368–1644) was at its height. The dynasty's hegemony was so powerful that, through its reach, the influence of the *Compendium* extended over the Far East region, notably into Japan and Korea. A Polish scientist, Jesuit missionary and explorer also took the book back to Europe in the 17th century, translating it into Latin and enabling its spread across the world.

◀ *Statue of the author, Li Shi-zhen*

Tolstoy's personal library and manuscripts, photo and film collection

Inscribed 2011

What is it

Leo Tolstoy's library and collection of manuscripts, photos, letters and other personal documents.

Why was it inscribed

The significance of Tolstoy is globally acknowledged. This collection of manuscripts includes Tolstoy's most important and famous works, notes on his personal life and his extensive correspondence with admirers and critics.

Where is it

Leo Tolstoy State Museum, Moscow, Russia; State Museum-Estate of Leo Tolstoy, Yasnaya Polyana, Russia

Leo Tolstoy was one of the greatest intellectuals of his time and his personal library is a unique collection of 22,000 books and periodicals in forty languages.

◀ *The study in Leo Tolstoy's house in Moscow, Russia.*

The Tolstoy House at Yasnaya Polyana, Russia. ▲

It is one of the largest writer's libraries in the world and was created by three generations of the Volkonsky-Tolstoy families: by his grandfather Prince Nikolai Volkonsky, and his parents Maria and Nikolai Tolstoy, and by Tolstoy himself who collected the greater part of the library.

His collection of manuscripts, photos and films is a unique literary and historical archive. It includes the manuscripts of the writer's works, diaries and notebooks, his correspondence, annotated document and social activity, publications of his literary works, memoirs, censor cases, works on Leo Tolstoy by his family members and close friends and documents related to his ancestors. Also present are the books that surrounded and inspired him.

The manuscripts of Tolstoy's own works start with literary compositions from when he was seven years old and finish with his last article 'A Radical Remedy'. The collection includes the manuscripts of *War and Peace*, *Anna Karenina*, *The Resurrection*, *The Childhood*, *The Adolescence*,

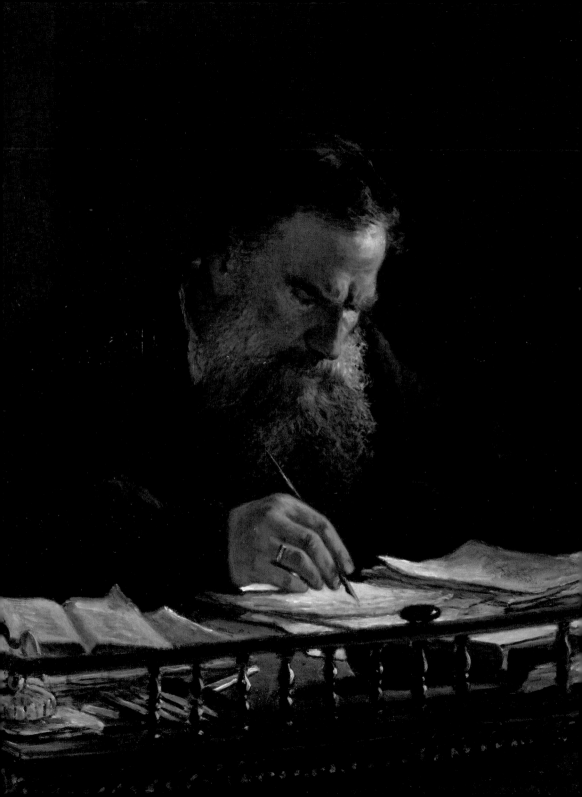

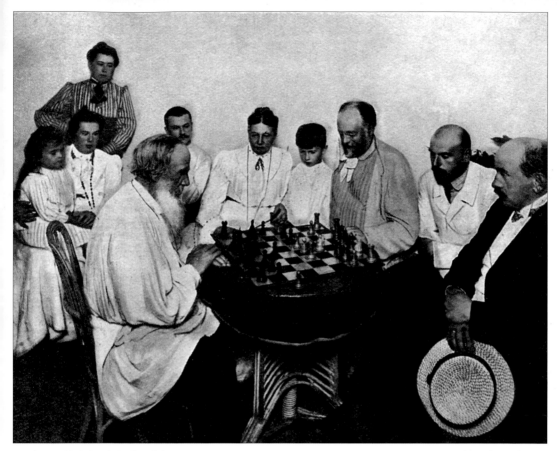

◄ *Tolstoy at his desk, painting by Nikolay Ge.*

Leo Tolstoy playing chess. ▲

The Youth, and the dramas *The Power of Darkness* and
A Living Corpse.

The documents preserved date from the end of the
16th century to the beginning of the 20th century.
Among the books and periodicals there are many
editions signed by famous contemporaries of Tolstoy
including A.M. Gorki, Bernard Shaw, Romain Rolland,
John Galsworthy, Björnstjerne Björnson, William Stead
and many others. Some books show Tolstoy's skills as
a translator: he did his pencilled translations on the
pages themselves. There are many documents created
by Tolstoy's disciples and literary critics.

The collection of photos and films contains over
25,000 items. It is a monumental visual testimony
to the life of the writer and his close friends and family.
It is also a fascinating record of Russian landscapes of the
time; the views of Moscow and other places add to a
feeling of being near the writer.

The significance of Leo Tolstoy's collection of manuscripts,
photos and films library is immense: it is a part of Tolstoy's,
Russia's and the world's literary heritage and a source
of inspiration for many generations of scholars.

Jesuits of America

Inscribed 2003

What is it

A collection of 128,000 sheets which comprise the documentary cultural heritage of the Society of Jesus, or Jesuits, in the 17th and 18th centuries in Latin America.

Why was it inscribed

The Society of Jesus was among the most important players in building the new culture and society in Central and South America under the Spanish imperial rule, and this is the only collection that records that work and activity.

Where is it

Archivo Nacional de Chile, Santiago, Chile

The Society of Jesus was founded in Rome in 1540 as a religious order of priests living under the rule of their founder, St Ignatius Loyola. By the end of the decade they had opened their first college for the training of priests, drawing their teaching philosophy from both scholasticism, the traditional, medieval educational training, and the newer, humanist-based teaching that had emerged from the Italian Renaissance.

From the beginning, the priests of the Society were trained to serve and undertake missionary and charitable work anywhere in the world and education was a central part of this. As a result, they were committed to convert the people of the new Spanish territory in the Americas from the 16th century onwards.

In fact, the achievements of the Society in America went far beyond its pastoral work and its contribution was crucial to the religious, social, political and economic development of the continent. Priests explored territories and drew up maps and charts, learnt local languages and compiled grammars, and wrote histories and catechisms. The Society also accumulated property that gave them economic self-sufficiency and financed their spiritual work.

In 1767 the Society was suppressed in the Catholic countries of Europe and their overseas territories. Its priests found themselves banished from their missions and places of work, and they were expelled from South America.

The profitable consequence of the suppression for the Spanish Crown was that it seized all the Society's possessions. The Crown set up the Board of Administration of Jesuitical Temporalities to take an inventory of the goods and properties of the Society in each place where it had settled and the documents they produced comprise this collection.

Taken as a whole, the collection provides an overview of the way the Jesuits worked in American society and the contribution they made to it at a critical point in its development. The documents have been ordered into six distinct thematic categories.

The Occupation Series contains inventories and property appraisal of schools, details of country estates, data on indigenous populations and numbers of slaves. The Application Series details how the property was to be divided up, for example, sent to Spain or used in the colonies. The Private Series deals with the political, economic, social and jurisdictional implications of the expulsion caused by the sale of estates and other possessions.

The Decision Series comprises minutes of the meetings of the Board of Temporalities; the Accounts Series details financial transactions including expenditure and income; and the Missions Series deals with the conversion of the native people.

But the Crown proved unable to administer the Society's organization as well as it had done. The administration and accountancy, artisan workshops, pharmacies, schools and other activities of the Jesuits' system had been run coherently and with economic and financial efficiency. The Board of Temporalities could neither undertake nor administer all these aspects, so denying the Crown one of its objectives in the expulsion – to take the profits that the Society's holdings had given their former owners.

Between 1801 and 1815, the Society was restored first by the papacy, then by the countries from which it had been expelled. Governments requested their educational and teaching prowess, but did not return their former buildings, nor did they resume their previous missionary work nor their artisan, agricultural or trading activities. Even their liturgical objects, church furnishings and libraries, dispersed among other religious orders, were never returned.

Iglesia de Nuestra Señora de Gracia,
a wooden church built by the Jesuits in Chile. ▶

Codex Techaloyan de Cuajimalpaz

Inscribed 1997

What is it

An illustrated manuscript with texts written in Nahuatl depicting indigenous life under Spanish rule in 17th century Mexico.

Why was it inscribed

The document is one of the few examples of the writings of a pre-Hispanic culture to have survived to the present day.

Where is it

Archivo General de la Nación, Mexico City, Mexico

The Techaloyan de Cuajimalpaz codex describes how indigenous communities were established in various places in the valley of Mexico City. It also contains a survey of the land, a regional map, historical and economic data, a census and a description of the local ecology.

Even after the conquest, the indigenous peoples bore witness to the survival and lasting nature of the cultural elements reflected in these codices (indigenous documents). They were also effective tools for communicating with the new dominant culture.

The manuscript is structured around a series of images with accompanying text written in the local language Nahuatl. The inscribed document also includes a Spanish translation. The subject matter is framed in a way that would make sense to the local population: the illustrations relate directly to the lands belonging to a village. The map shows man-made boundaries and villages in the hills and also fertile areas where agave plants grow.

To modern eyes, the illustrations and descriptions therefore provide a fascinating insight into the everyday activities taking place during a period of cultural assimilation. Illustrations show the Spanish conquerors arriving in the area; where they all met; and how they were baptized and buried. The manuscript thus functions as a social commentary, giving the indigenous people a history that helps them visualize the impact of the Spanish conquest: for example, it shows where the new lords took control of the irrigated land that had once belonged to the native people.

The document was drafted by indigenous scribes (*tlacuilos*) using their own writing system on vegetable bark. It provides us with Christian and traditional names, natural and artificial boundaries, the population and the customs prevalent in that area of Mexico.

The manuscript's importance lies in the fact that documents such as these have preserved the testimony of indigenous culture, as the vast majority of the pre-Hispanic originals were destroyed. Conversion to Christianity and adaptation to Spanish customs led to the destruction of the vast majority of the forms of expression of these societies. This makes the Techaloyan de Cuajimalpaz codex a unique testimony to this ancient culture.

Documentary heritage of enslaved peoples of the Caribbean

Inscribed 2003

What is it

A collection of antique legal documents, plantation ledgers, estate inventories, rare books and original prints and paintings, relating to the lives of enslaved people.

Why was it inscribed

The documentary heritage of enslaved peoples of the Caribbean is a unique collection that reflects the life of slaves in the Caribbean. The system established in Barbados became a model for plantations in other countries including the United States of America.

Where is it

Barbados Museum and Historical Society, Shilstone Memorial Library, St Michael, Barbados

▲ Freed Slave statue by Karl Broodhagen.

The Barbados Museum and Historical Society's collection of Caribbean slavery heritage constitutes a unique corpus of documentary evidence on the lives of enslaved Caribbean people throughout the 17th to the 19th centuries.

These archives record one of the darkest periods in human history: the legalized and institutionalized enslavement of people on a global scale. They also document a defining moment in the development of the modern world: the shift from an agrarian to an industrialized society.

The economically successful system of slave labour and ownership that was perfected on Barbados was then exported to other colonies such as Antigua, Jamaica, South Carolina, Guyana, Trinidad and Suriname. The slave laws of Barbados became the template against which most of the other slave laws in the West Indies – and the continental United States – were based.

The museum's collection comprises several categories of material. Letters relating to affairs of plantation life provide insight into the attitudes and belief systems of slave owners, how they treated their slaves, and other

▲ Travel licence for a slave man named William.

▲ Certificate of compensation.

▲ Letter from a governor requesting the pardon of two slaves.

▲ *Traditional slave hut, Barbados*

Owner's house, colonial sugar plantation, Barbados ▶

everyday master/slave interactions. Estate Plans show drawings of plantations and how these properties were allocated. They provide information on estate ownership, relationship between master and enslaved, allocation of lands and size of estates. Plantation Accounts provide an informative background to the nature of the plantation enterprise, which was at the centre of the slave system. Deeds and Wills illustrate how enslaved peoples were seen and treated as property. Individuals were transferred or loaned to friends and family members, sold to settle debts and given as gifts. Government Records underscore the legislative framework created to ensure the prosperity and security of a plantation society built upon the labour of an enslaved people. There are also Church, Military and Legislative Records, Bills of Sale, Slave Registers and a varied collection of general publications.

Together these documentary resources chart the transformation of Barbados from a small, isolated frontier settlement from the first decades of the 17th century to its zenith, as the island's flourishing economy made

it the richest jewel in England's crown. Within the first two decades of settlement the island's economy was inextricably intertwined with the growth of sugar and slavery, a system of labour that defined the region for more than two centuries, and which still resonates through national and regional sensibilities today.

The collection provides invaluable source material for scholars studying the history of Barbados. These records could also help to recover the lost heritage of millions of people.

El Primer Nueva Corónica y Buen Gobierno

Inscribed 2007

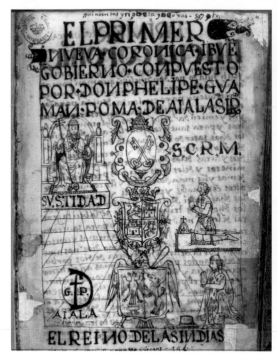

▲ Title page of the manuscript

What is it

A 1200-page autograph manuscript written in Spanish with Quechua words and phrases and including 400 full-page line drawings, of Andean Indian life before and after the Spanish conquest in the 1530s.

Why was it inscribed

The manuscript is the only one extant conveying an Andean Indian viewpoint on pre-conquest Andean history and Inca rule, the Spanish conquest and early Spanish colonial rule.

Where is it

Royal Library, Copenhagen, Denmark

El Primer Nueva Corónica y Buen Gobierno or 'The First New Chronicle and Good Government' (it is assumed that the writer misspelled the word '*crónica*') was written by Felipe Guaman Poma de Ayala, a Peruvian nobleman born shortly after the Spanish conquest of Peru in 1532. Although the manuscript is unsigned, Guaman Poma has been identified as its author from other documents and manuscripts.

As one of the first generation born under Spanish rule, Guaman Poma was in a unique position to assess the strengths and weaknesses of both pre-conquest indigenous society and the new practices the Spanish colonizers brought in government, language, religion and culture.

Guaman Poma is believed to have worked as a translator for Spanish clerics in Peru, but in 1600 he was banished from his lands after losing them and his title in a series of unsuccessful lawsuits. His banishment is thought to have precipitated his travels around the country and, as a result, the *Corónica* which is thought to have been written between 1600 and 1615. The manuscript is in the form of an appeal to King Philip III of Spain.

Guaman Poma gave an account of ancient Inca history and claimed the land was given to the Peruvians by God. He had seen at first hand abuses perpetrated by Spanish incomers and urged Philip to reform the administration of Peru by appointing local people, claiming the Incas'

government was more benevolent. In essence, his vision was intended to combine the best of the two systems.

Like his European contemporaries, he regarded the king as divinely appointed and did not question his rule. His ideal vision for Peru included Christianity and the technical superiority of the Spanish within a context of Inca culture and society. This Inca-Spanish synthesis was also reflected in his own Quechua and Spanish name.

The Danes came into possession of the manuscript in the 1660s, less than 50 years after it was written. It is assumed to have been presented to the Danish King Frederic III by a Danish ambassador to the Spanish court who was himself a book collector. The manuscript was rediscovered in the Royal Library in 1908 and has now been transcribed and scanned with its own website where the illustrations and relevant resources can also be viewed.

Uigwe: The royal protocols of the court of Joseon dynasty

Inscribed 2007

What is it

Uigwe is a collection of royal protocols that reflects the beliefs, life and rituals of the Joseon dynasty through detailed accounts of its ceremonies including the language, dress, music, art, architecture, dance, sports and food involved.

Why was it inscribed

Uigwe showed how Confucian rituals were performed and evolved over the course of 300 years and are of importance as no other Confucian monarchy in East Asia has such records. Uigwe is also a good source for the reconstruction of Joseon period buildings, as well as other masterpieces of intangible heritage.

Where is it

Kyujanggak Institute for Korean Studies, Seoul National University and Jangseogak Archives, Academy of Korean Studies, Bundang, Republic of Korea

Uigwe is a collection of royal protocols of the Joseon dynasty (1392–1910) that both records and prescribes through prose and illustration the major ceremonies and rites of the royal family. The unique value of Uigwe is that it records so many details of different aspects of the life of the royal family. It documents the procedures, protocols, formalities and requirements needed to conduct important ceremonies such as weddings, funerals, ceremonies honouring the dead, banquets, receiving foreign missions and various cultural activities of the royal family. It also includes details on the construction of royal buildings and tombs.

Each Uigwe provides a detailed description of a particular ceremony, from preparations and procedures to the award-giving at the end of the function, and includes the expenses and implements needed, so that later generations could refer to it as a guide in performing the ceremony the same way. Immediately after the ceremony, an Uigwe would be compiled and published by a *dogam*, an independent temporary government office, created to deal with national matters of the greatest importance, such as the funeral of a king or palace construction. In general,

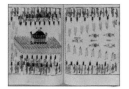

▲ A funeral procession recorded in the Myeongseong Hwanghu Gukjang Dogam Uigwe, the manual for the state funeral of Empress Myeongseong Hwanghu (1873–95).

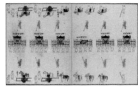

▲ A royal procession recorded in an Uigwe.

five to nine copies were made of each Uigwe including one for the king, one each for the four national archives located in different parts of the country, and one for Yejo (the office of protocol).

Categorized by time and theme, the surviving books (3430 of which are covered by this registration) date from the 17th century to the start of the 20th century. This long time span makes it possible to record the changes that took place over time in royal ceremonies and compare them with other East Asian monarchies. The pictorial records illustrate the rituals and ceremonies of the time with great sophistication and vividness. For example, the documentary painting of King Jeongjo's visit to the royal tomb of his father is composed of several scenes and is 15.4 metres long; its creation required the cooperation of court painters and officials.

The Joseon dynasty existed at a time when Confucianism flourished in East Asia and especially in Korea. Confucian rituals penetrated deep into Korean society as a system of practical ethics. It was Uigwe that expressed the ideals of Confucianism and showed how Confucian rituals were performed and evolved over the course of 300 years.

Archives of the Dutch East India Company

Inscribed 2003

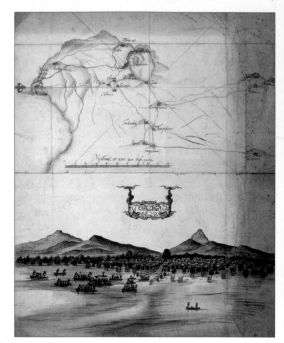

What are they

The archives of the Dutch East India Company (Verenigde Oostindische Compagnie), the largest of the early modern European trading companies operating in Asia, are the most extensive source on Asian and African local, political and trade history during the 17th and 18th centuries.

Why were they inscribed

They are of outstanding importance in studying the development of the coastal regions of Africa and Asia. The growth of countries such as South Africa, India, Sri Lanka and Indonesia can only be researched by recourse to the archives.

Where are they

National Archives, The Hague, the Netherlands; repositories in Cape Town, South Africa; Chennai, India; Colombo, Sri Lanka; and Jakarta, Indonesia

▲ *Minahassa, on the Indonesian island of Sulawesi, in 1679, as recorded by Dutch traders.*

The VOC was a Dutch trading company founded by merchants from port towns such as Amsterdam, Rotterdam and Middelburg. It was formed in 1602 when the States-General of the United Provinces, the highest authority of the Republic of the Netherlands, persuaded several competing Dutch spice-trading firms to incorporate into a single trading company. It had the States-General's authority in the trade zone between South Africa and Japan to conduct trade, erect fortifications, appoint governors, keep a standing army and conclude treaties in its name. Statistically, the VOC eclipsed all of its rivals in the Asian trade. Between 1602 and 1796, the VOC sent almost a million Europeans to work in the Asia trade on 4785 ships, and netted for their efforts more than 2.5 million tonnes of Asian trade goods.

The VOC enjoyed huge profits from its spice monopoly through most of the 17th century. In the last quarter of that century European demand shifted to textiles, coffee and tea, commodities over which the VOC did not and could not exercise a monopoly. Thus, VOC revenues came increasingly from tolls, taxes and tributes collected through an expanding colonial administration over its

territorial holdings in Africa and Asia. Crippled by a debt of almost one hundred million guilders and reeling from the Fourth Anglo-Dutch War and French control over the Netherlands, the VOC was liquidated at the end of the 18th century.

The VOC's presence in Africa and Asia resulted not only in warehouses packed with spices, textiles, porcelain and silk, but also in shiploads of documents. Most of the papers found in VOC archives were produced by locally stationed company officials, but much was also produced by those with whom they dealt with: kings and noblemen, traders and middlemen, shippers and harbour masters. Data on political, economic, cultural, religious and social circumstances over a broad area circulated between hundreds of VOC officials and dozens of establishments around the world and the administrative centres in the Netherlands and at Batavia (now Jakarta) in the Dutch East Indies (now Indonesia). Moreover, when exploring Africa and Asia, VOC officials described and made drawings of numerous 'discoveries', including the now-extinct dodo. The VOC archives include thousands

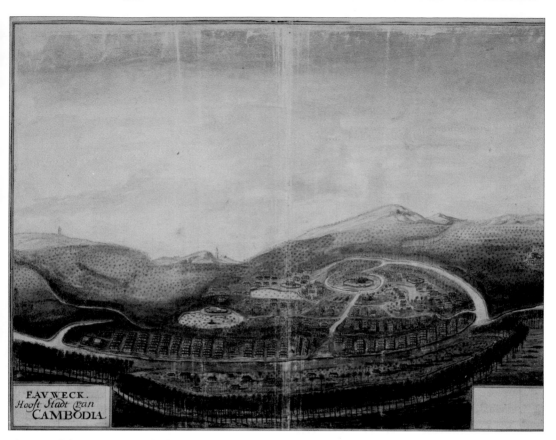

EAVWECK.
Hooft Stadt van
CAMBODIA.

of maps and drawings. Frequently, these pictures are the first representations ever made of the people, houses, landscape, flora or fauna of these regions. About twenty-five million pages of VOC records have survived in repositories in Jakarta, Colombo, Chennai, Cape Town and The Hague.

The contents range from carved inscriptions in stone, manuscripts on palm leaf and bark and printed court chronicles to trade correspondence, travel reports and the records of civic administrations. The VOC archives not only richly supplement valuable regional sources, but they also contain general information on Monsoon Asia and Southern Africa as a whole, providing the data necessary to draw a broad comparative picture from region to region, and from village to village. When analyzed with skill and training, the VOC archives offer a wealth of new and valuable knowledge on Asian and African societies in the 17th and 18th centuries.

▲ *An early 18th-century aerial view of Eauweck (now Khum Peam Lvek), the main Dutch settlement in Cambodia, first established in 1620.*

(following page) A panoramic view of the bay of Nagasaki in August 1823, showing some Dutch merchant ships. Nagasaki was the main port in Japan that traded with European countries. ▶

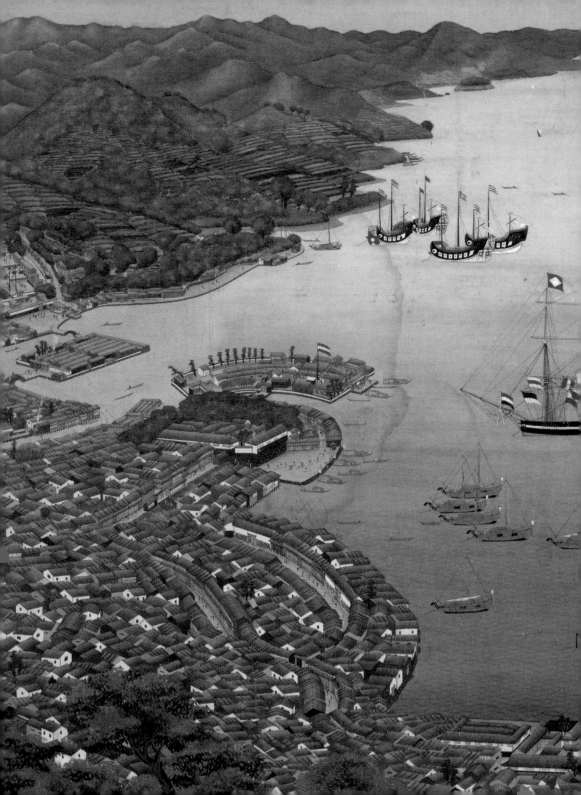

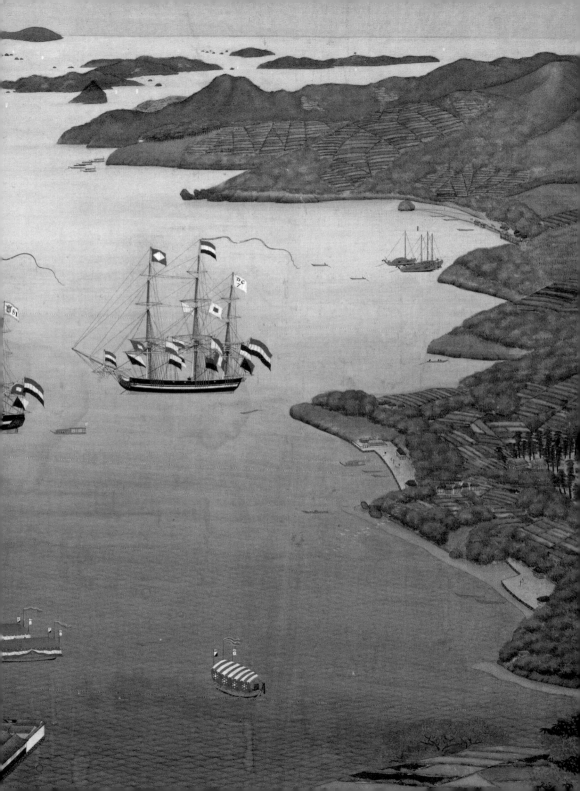

Donguibogam: 'Principles and Practice of Eastern Medicine'

Inscribed 2009

What is it

A twenty-five-volume encyclopedic reference work of contemporary medical knowledge and treatments compiled in Korea in 1613.

Why was it inscribed

The *Donguibogam* synthesized 2000 years of traditional medical knowledge and clinical experience not only from Korea but also from China, and was influential in Japan and China and beyond. It posited the notion of right living as preventative medicine.

Where is it

National Library of Korea, Seoul, Republic of Korea

The *Donguibogam* was edited and compiled by the royal physician Heo Jun on the instruction of King Seonjo. The work was intended for a wide distribution, to maintain the health of the king's subjects. The king's interest in his people's health has led some commentators to view the work as an early form of public-health policy. Begun in 1596, it was completed in the reign of Seonjo's successor, King Gwanghaegun, in 1610.

The version handwritten by Heo Jun and presented to the new king no longer exists but the first print version, based upon the original, is virtually identical to it. The work, in twenty-five original volumes, has been reprinted more than forty times in Korea and abroad, but only two full sets of the first print issue remain. The book was set using movable wooden type.

Two volumes are taken up by tables of contents and the rest of the work is arranged into five chapters: *Naegyeong* (Overview of the Inner Body); Oehyeong (External Appearance); *Japbyeong* (Various Diseases); *Tang-aek* (Liquid Medications); and Acupuncture. Its approach to medicine was three-pronged: holistic, socio-medical – that is, seeing society as having a part to play in human health and disease – and preventative.

The layout of the information in The *Donguibogam* was unique. The reasons for medical conditions appeared alongside symptoms, diagnosis, acupuncture and the Asian medical practice of moxibustion. In its emphasis on the Yangsaeng principle of correct living, it brought the concept of disease prevention into the area of clinical medicine. Taoist, Confucian and Buddhist beliefs are each reflected within the work, although all share a common assumption that human and nature are inseparably and organically related.

Suggested treatments covered all classes of people – expensive prescriptions for the wealthier, and simpler remedies or acupuncture for the poorer sections of society. The book allows a direct insight into contemporary diseases and their treatments. In addition to the specific diseases examined in *Japbyeong*, the third chapter, there are also sections on pediatrics and gynaecology.

Specific sources were cited throughout and as several of these have since been lost, The *Donguibogam* remains the sole surviving record.

Sejarah Melayu (The Malay Annals)
Inscribed 2001

What is it
The Malay Annals are the only available account of the history of the Malay sultanate, based at Melaka, in the 15th and early 16th centuries, when it was an important trading port between Europe and China.

Why was it inscribed
They cover the origins, evolution and demise of this great Malay maritime empire, with its unique system of government, administration and politics, and are regarded as the finest historical literary work in the Malay language of its period.

Where is it
Institute of Language and Literature, Kuala Lumpur, Malaysia

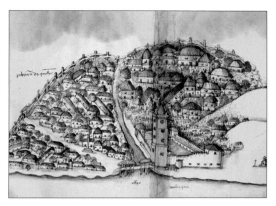

▲ A view of Melaka made by the Portuguese historian Gaspar Correia around 1512, a year after the Portuguese had invaded the city of Melaka, bringing to a close the golden age of the Melaka Sultanate, the subject of the Malay Annals.

The Malay Annals were written in 1612 and give a romanticized history of the Malay sultanate and Melaka (Malacca) from start of the 15th century to the early 16th century. This copy, written in Jawi script, is the oldest handwritten copy in Malaysia.

The Annals are prefaced by a celebration of the greatness of Allah, the Prophet and his companions. They begin with a genealogical account of the first Sultan of Melaka who is said to be descended from Raja Iskandar Zulkarnain (Alexander the Great). The Annals cover the founding of Melaka and its rise to power; its relationship with neighbouring kingdoms and distant countries; the advent of Islam and its spread in Melaka and the region as a whole; the origin of the Cham community in Melaka; the history of the royalty in the region including battles won or lost, marriage ties and diplomatic relationships; the administrative hierarchy that ruled Melaka, the greatness of its rulers and administrators, including Tun Mutahir, the most famous prime minister of Melaka, and Hang Tuah, the great Malay legendary hero. The Annals conclude with the account of Melaka's defeat by the Portuguese forces in 1515, resulting not only in the downfall of Melaka, but also in the eventual re-emergence of the Malay sultanate in other parts of the country, including Johor and Pahang.

The Malay Annals have had a great influence on the history, culture and development of the Malay civilization, which had to confront major cultural transformation through the centuries on the road to becoming the modern nation of Malaysia. Throughout the 15th and 16th centuries, Melaka was identified with two dominant influences, the Malay Hindu and the Malay Islamic cultures. Melaka's rapid growth at that time was assisted by its cosmopolitan population of merchants from India, China, Arabia, Portugal and other nations of the world who contributed to the social, economic and political evolution of the Malay sultanate.

Melaka exerted a strong influence in the area of politics and administration. The concept of sovereignty (daulat) as applied to the absolute powers wielded by the monarchy was clearly understood and applied. The Annals also defined the positions of responsibility occupied by the rulers and administrators within an established hierarchy. The customary ceremonial practices of the court were formalized and still constitute the basis for the official ceremonies and protocols observed today in the royal courts of the various Malaysian states.

Dutch West India Company (Westindische Compagnie) archives

Inscribed 2011

What are they

The archives of the Dutch West India Company cover its activities in West Africa and the Americas including commerce and the slave trade, colonization, warfare, diplomacy, plantation cultures and daily life. The archives contain unique information for the history of Brazil, Curaçao, Ghana, Guyana, the Netherlands, Suriname and the USA.

Why were they inscribed

The company introduced the triangular trade in slaves, linking Europe, Africa and the Americas with far-reaching consequences that still resound today. In many instances there is no other written information available for that period.

Where are they

Archives in the Netherlands, Brazil, Curaçao, Ghana, Guyana, Suriname, UK and USA

The Westindische Compagnie or Dutch West India Company (DWIC) was a Dutch trading company, modelled on the VOC (Vernigde Oostindische Compagnie) or Dutch East India Company (see page 214). In 1621 it was granted a charter for the 'right on shipping and trade' and a monopoly of trade and navigation, conquest and commerce in the Western hemisphere by the States-General of the United Province of the Netherlands. The company was created to eliminate trade competition in the West Indies, particularly against the Spanish and Portuguese, and to gain a share in the African slave trade. Therefore the DWIC was authorized to make alliances with the local rulers in West Africa, America and the Pacific islands east of New Guinea; to build fortresses, maintain troops, garrisons and fleets. The area where the company operated was West Africa and the Americas (including the Pacific Ocean).

In the 1620s and 1630s, many trading posts or colonies were established along the American Atlantic coast. New Netherlands, which included New Amsterdam, covered parts of present-day New York, Connecticut, Delaware and New Jersey. Other settlements were established on Curaçao, several other Caribbean islands, Suriname and Guyana. In 1630, the colony of New Holland (Recife) was formed, taking over Portuguese possessions in Brazil. In Africa, posts were established on the Gold Coast (now Ghana) and briefly in Angola.

Facing bankruptcy in 1674, the DWIC was reorganized as a slave-trading enterprise with profitable side activities in trading products such as gold. It introduced the triangular trade, which linked manufacturing communities in Europe, slave procuring communities of Africa and plantation communities of the Americas in an increasingly profitable circuit of trade and production. The company, which also administered its African and American overseas territories and fortresses, was abolished in 1791.

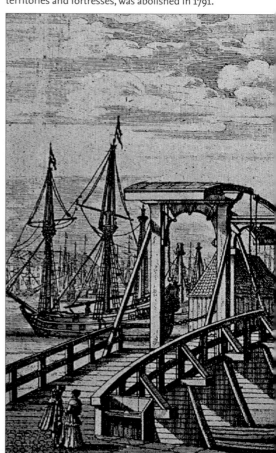

The archives include records of the Dutch Board of Directors, including resolutions, general accounts, lists of personnel, pay and records of the Colonial Board. The administration of the trading posts includes records of the resolutions of the local director and his council, daily reports, reports about the exploration of the region, financial records, correspondence, treaties with local rulers, reports about the trade and the products needed in the region. They contain abundant cultural, religious, social, political and economic information as well as geographical, geological and agricultural information. In addition, dozens of other types of documents were created and they reflect the life and history of the people in the region of the many DWIC trading posts.

The warehouse of the Dutch West India Company in Amsterdam, built in 1642 ▼

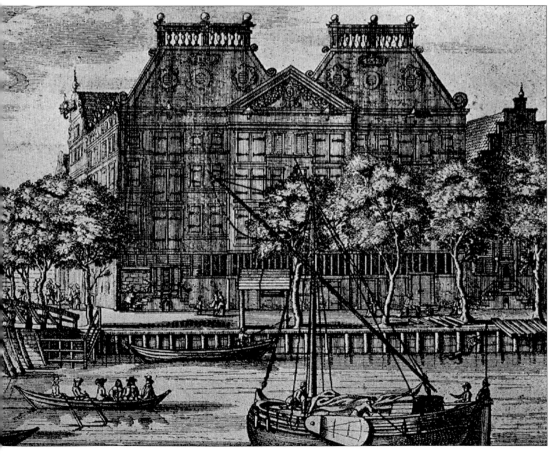

The IAS Tamil medical manuscript collection

Inscribed 1997

What is it

More than 500 medical manuscripts, written on palm leaves and mostly Tamil in origin, which reflect the ancient system of medicine practiced by the yogis.

Why was it inscribed

The manuscript collection contains the essentials of the collected pharmacological and medical knowledge and experience of the Tamil culture, recorded on rare and fragile media.

Where is it

Institute of Asian Studies, Chennai, India

The manuscripts of the Institute of Asian Studies (IAS) inscribed on the Register are largely of Tamil origin and written on palm leaves. Tamil, together with Sanskrit, is one of the two classical languages of India and the manuscripts are a record of the contemporary knowledge of the practice of medicine in Tamil culture.

Palm leaves were used as writing material in India for over two millennia. The leaves were dried, smoothed and smoke-treated, then inscribed by calligraphers in a way that did not damage the leaf. Substances were applied to highlight contrast between the leaf page and the written text. Palm leaves had the benefit of longevity over several hundred years in the tropical climate before they had to be replaced. However, with the abandonment of this way of recording information, existing manuscripts are not being replaced.

Traditional Indian medical practices were based on Siddha and Ayurvedic medical systems and were practiced by yogi practitioners. These ancient systems, together with Indian traditional Unani medicine, are based on elemental, holistic and natural practices, and are believed to be thousands of years old, with Siddha being practiced up to 10,000 years ago.

The manuscripts themselves examine the nature and symptoms of diseases, together with methods of cure, and the preparation of medicines following the Siddha and Ayurvedic systems. They explain the methods of obtaining medicines from herbs, herbal roots, leaves, flowers, barks and fruits. The proportions of the ingredients as well as the specific processes for creating the medicines are explained in detail.

By far the greatest number of manuscripts deal with the preparation of medicines, including powders and pastes, to cure specific diseases, although more than fifty of the texts relate to cure through medicine and *mantiram*, or mantric devotional chanting. Some manuscripts deal specifically with illnesses in women and children, and thirty-five are on alchemy. Many of the most famous yogi doctors are represented in the collection.

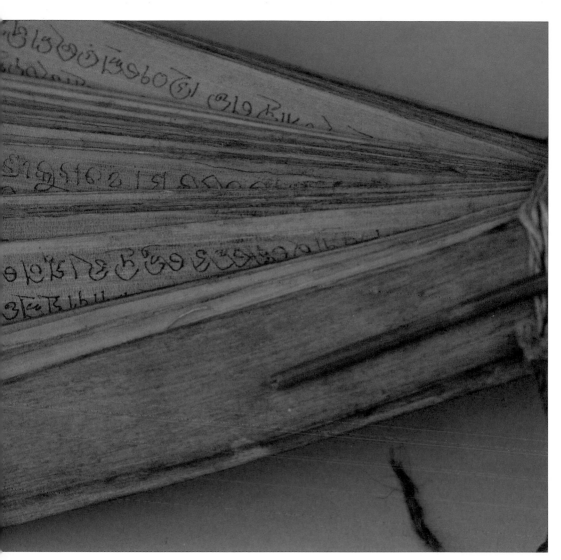
▲ *Antique palm leaf manuscripts*

Quebec Seminary collection, 1623–1800 (17th–19th centuries)

Inscribed 2007

What is it

The archives of the Quebec Seminary, founded in 1663 to train priests to convert and minister to the indigenous people of Quebec, a diocese which then covered most of North America. The collection dates from 1623 to 1800.

Why was it inscribed

Quebec Seminary was central to the birth and development of Quebec and Canada. Its documents form an irreplaceable part of Canadian and North American history and culture and are particularly valuable as a source for the study of North American colonial history. They offer a window into the exchanges between the Old and New Worlds and into Quebec's central role in that process of cross-fertilization.

Where is it

Musée Canadien des Civilisations, Quebec, Canada

Quebec Seminary was founded in 1663 and its records show the dynamic processes of migration and the introduction, influence and continuity of French culture and Catholic spirituality in North America. They also reveal their interaction both with indigenous cultures and with other cultures of European origin.

The seminary archives and library were established early on and contain in particular documents produced or received during the French regime (1534–1763) and the first decades of the British regime (1763–1867). They also include a part of the library of the Jesuit College, the first institution of higher education founded in North America (1653–1765).

As the archive is extensive, the documents chosen for inclusion on the Register are those most representative and significant for the development of the French colony of New France, Quebec City, Quebec and Canadian society as a whole. The dates of these documents represent the beginnings of the New World for the French in 1623 up to the ending of French hegemony and the British takeover in 1800.

They fall naturally into several thematic series. Some relate to the foundation of the seminary and its administration and account books, its properties and rights. Its spiritual and pastoral duties and related administration are included, as are manuscripts from

Quebec Seminary ▶

within the seminary itself – handwritten course notes, dictionaries, catechisms and Amerindian chants. The map collection shows the extent of exploration and settlement throughout the continent. There are also files of correspondence with famous and notable people, such as popes, French kings and ministers and the founders of New France.

This collection bears witness to the European powers' Age of Discovery and particularly to the colonization of the New World and the continual growth of spiritual, societal and commercial exchanges between Europe and North America.

The documents show a vast range of the conceivable elements of colonization and the building of a new society.

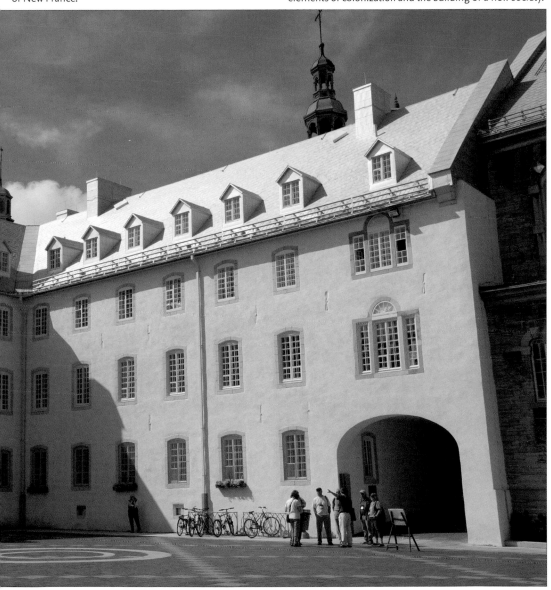

▲ *The monument of Bishop François de Laval, founder of the seminary*

They record migratory flows from Europe to America and to the population growth of their descendants, and the migrations in their turn of Amerindian societies as they were pushed back and shrank in size.

Most notably from the collection's maps and drawings emerges the distinctive settlement patterns of the French, their exploitation of natural resources and creation of fortified centres, in particular Quebec. There are also vivid and unmatched accounts of voyages of discovery and evangelization and in particular descriptions of places and landscapes before their colonization.

The documents provide a detailed record of the everyday life of the inhabitants both in peace and in wartime and show the transition from an unstable society based on fur trading to a stable, increasingly self-sufficient one as new techniques were developed for exploiting natural resources.

The records show the rigorous spiritual and academic training of the Catholic priests as the seminary adapted to North American cultures and to the expansionist designs of French culture; and, later, how both clergy and lay people adapted to the new economic, political and religious order that grew out of Britain's conquest of New France in 1763. The documents also are a fresh source of information on the repercussions of the American Revolution in 1776.

Also revealed is the influence exercised by the seminary's founder, Monsignor François de Laval (1623–1708), the first Catholic bishop of Quebec, who was beatified in 1980.

The collection is virtually unique in that its contents were produced continuously, without a break, and it is still held and managed in the place where it originated.

Seungjeongwon Ilgi,
the diaries of the royal secretariat
Inscribed 2001

What are they
These *Diaries* contain historic records and state secrets of the Joseon dynasty from the 17th century to the early 20th century; those from the late 19th century and the early 20th century show how Western influence opened the door of the closed dynasty.

Why were they inscribed
In addition to the detailed account of the methods of government used by the Joseon Dynasty, the *Diaries* recount the impact of Western civilization on traditional Korea and the reflections and reactions of Korean society and their representatives to that impact.

▲ *A few of the 3243 surviving volumes of the diaries of the Royal Secretariat of the Joseon Dynasty in Korea.*

Where are they
Kyujanggak Institute for Korean Studies, Seoul National University, Seoul, Republic of Korea

The Seungjeongwon, the Royal Secretariat of the Joseon dynasty (1392–1910), was responsible for keeping *Seungjeongwon Ilgi, the Diaries of the Royal Secretariat*, a detailed record of the daily events and official schedules of the court, from the Joseon dynasty's first king, Taejo, to its twenty-seventh and last, Sunjong. However, only 3243 diaries have survived, containing detailed information on 288 years of the Joseon dynasty, from 12 March 1623 (the first year of the sixteenth king, Injo, to 29 August 1910 (the fourth year of the twenty-seventh king, Sunjong), the year of the Japanese annexation of Korea.

All records were written daily in chronological order. The details of the main text are written in the order of the daily tasks of the Seungjeongwon, including the king's *gyeongyeon* (discussions with scholars on the Confucian and other Chinese classics), the Seungjeongwon's personnel affairs, reports from different ministries and the king's commands. As *gyeongyeon* became the means through which the king could impart his aims for education and his political opinions, they were recorded in detail, including the time and place, a list of those in attendance, and the subjects of discussion. Monthly records were usually compiled into one diary, but sometimes into more than

one. The king's appointments, including *gyeongyeon*, meetings with court functionaries, administrative acts and affairs in the queen's inner palace, were listed in the preface to a monthly diary.

The Joseon dynasty's royal secretaries and scribes attended all state meetings with civil and military officials at which important decisions were made, and recorded the proceedings and included classified information about politics, economics, society, diplomacy and the military. As a result, *Seungjeongwon Ilgi* contains many state secrets of the Joseon dynasty and provides indispensable primary data for the study of Korean history. Its historic value is even greater than that of the *Annals of the Joseon Dynasty* (see page 124). The *Diaries* written in the late-19th century and the early-20th century show how Western influence reached the closed Joseon dynasty. Those written after the Political Reform of 1894 record Japan's intervention in domestic affairs. They include the compulsory agreement requested of the Joseon king and other secret court deals.

Book for the Baptism of Slaves (1636–1670)

Inscribed 2009

What is it
A handwritten record of slaves from the Dominican Republic.

Why was it inscribed
It is a historic and unique first-hand source of information about the form, character and development of American slavery.

Where is it
Ciudad Colonial, Santo Domingo, Dominican Republic

It was on the Caribbean island of Hispaniola that Christopher Columbus first landed after crossing the Atlantic in 1492. His brother Bartholomew established the city of Santo Domingo four years later and this became the first seat of Spanish colonial rule in the New World. It was the launch pad for much of the exploration and conquest of the New World and, as such, its history is inextricably linked with that of the slave trade.

The first African slaves arrived on the island in 1493, although it was not until the 1520s that the slave trade was officially organized, first with a system of individual licenses and later using the facilities of the Portuguese trade system. The slave population increased rapidly as the sugar industry grew and the plantation system became established in the New World.

The Book for the Baptism of Slaves (Libro de Bautismos de Esclavos) covers a period more than a century after the trade was established (1636–1670). This parish document offers a fascinating window into a time when economic pressures shifted the country from a slave society to a society with slaves, profoundly influencing all levels of Dominican society, including the Church. Given its antiquity and uniqueness (it is the only one in Dominican ecclesiastical history), it is a vital source of information on the form, character and development of slavery in the Americas, particularly in the Dominican Republic. After 1670 the baptism books of Santo Domingo unified the records of slaves and free people on the island.

The book contains seventy-eight double pages with 794 handwritten records of baptisms. Two of them are collective ceremonies of almost thirty slave children from 1655, and there are also eighty-three confirmation records from 1659.

The text is notable for the simplicity of its writing, which paints a vivid picture of life in Santo Domingo for the slaves, but also for the families, ordinary citizens and church officials who were slave owners during the

17th century. It also gives a remarkable insight into how the development of the well-entrenched social strata of the island in the 19th century came to be defined and developed.

*The cathedral in Ciudad Colonial,
Santo Domingo, Dominican Republic.* ▼

Mining maps and plans of the Main Chamber – Count Office in Banská Štiavnica

Inscribed 2007

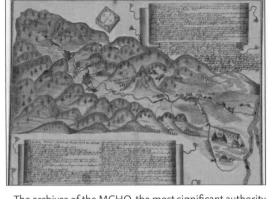

What are they

Almost 20,000 maps and plans from the 17th century to the beginning of the 20th relating to mining in the territory of the former Austro-Hungarian empire. These complement the surviving mining works in Banská Štiavnica and its surroundings, which have been inscribed on the UNESCO World Heritage List since 1993.

Why were they inscribed

These irreplaceable documents are important for the history of mining and metallurgy at the global level, especially for the development of mining cartography and surveying instrumentation.

Where are they

State Central Mining Archives, Banská Štiavnica, Slovakia

Banská Štiavnica, now in Slovakia, has long been an important mining town and a centre for the administration of the industry, most significantly through the Main Chamber – Count Office (MCHO). In 1762 the Mining and Forestry Academy, the first world's mining university, was established here by Empress Maria Theresa. New, more efficient mining methods and technical devices were created and, in 1786, an international scientific association for mining development was founded in the town. The surviving mining works were inscribed on the UNESCO World Heritage List in 1993.

The archives of the MCHO, the most significant authority for mining, metallurgy and minting in the Hungarian part of the Austro-Hungarian empire, contain a collection of almost 20,000 items from the 17th century up to the early years of the 20th century. The maps and plans display underground mining works as well as above-ground structures in the mining regions of Slovakia, Hungary, Transylvania and Slovenia. Some of the maps display mining works and other technical facilities, including a unique system of water reservoirs in Banská Štiavnica and its surroundings. The collection of maps also contains examples of new patterns for drawing mining maps and construction plans designed in the 19th century by Gabriel Svaiczer and Anton Péch of the MCHO. The work of mining surveyors was carried out according to these patterns both in the Austro-Hungarian empire and Germany. New methods developed in Banská Štiavnica were implemented in many other countries by the thousands of students from throughout Europe who studied at the Mining Academy from 1764 to 1918 and took their new skills back to their own countries.

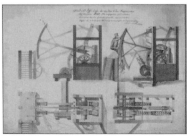
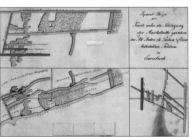
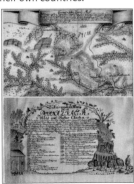

▲ A plan of shafts designed by court watch-maker Artz for the Spitaler Gallery, Lhotka, 1770.

▲ Part of mining works in the Vyhne region, using the new mapping techniques developed in the mid-19th century in Banská Štiavnica.

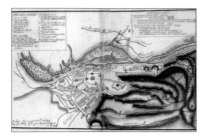

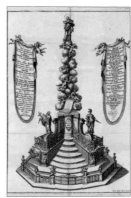

▲ A plan of Bratislava and its surroundings, 1766.

▲ A shaft plan of the Juraj Gallery in Banská
Belá designed by J. Schitko, 1832.

◄ A map of forests near Prešov, showing water
transport to a factory producing salt, 1728.

A plan of a dramatic sculpture built in Košice, 1722. ▶

The oldest original mining map is of the Horná Bíberová Gallery, dating from 1641, which displays mining works and technical equipment of the main mining enterprise in Banská Štiavnica. Another remarkable map of this enterprise dates back to 1695. A map of mining works in Nová Baňa from 1631 has been preserved in a copy from 1776. Several maps come from the 17th century but the largest number are from the late 18th century and the beginning of the 19th century. At that time, mining techniques developed in the Slovak mining regions were leading the world.

The vast majority of MCHO maps and plans in Banská Štiavnica are in manuscript form. They reflect both the artistic style of their time and advances in technical measurement. In addition to the precise specialized documentation of mining works or equipment, they also depict the work of miners and smelters, the technical equipment in mines, the work and tools of mining surveyors, the design of mining towns and even the clothes worn by miners. The maps from the last half of the 18th century and beginning of the 19th century are distinguished by the high quality of their additional decorations and frequently include supplementary drawings on the maps. The later 19th-century maps drop the decoration and additional drawings and concentrate on recording the technical details of the mining works, their location and the surrounding geological conditions, based on the design principles developed by the MCHO. Other mapping variations include layer-segmented maps based on geological horizons and maps where ore veins are marked with ore grit. Some plans were completed with cut-out and glued images of equipment to enable better visualization of the mining chambers. A number of records and documents register mining activities and new methods of creating mining maps up until the fall of the Austro-Hungarian empire and the establishment of Czechoslovakia in 1918.

◄ An extract of an above-ground map displaying the
surroundings of copper ore mines in Dognacka, Romania,
with a list of explanatory notes, 1753.

Collection of 526 prints of university theses from 1637 to 1754

Inscribed 2011

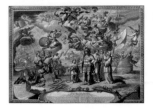
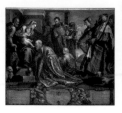

▲ *Celebration of Leopold with the heir to the throne.*

Adoration of the Magi. ▲

What is it

A collection of university theses, spanning more than a century, that are engraved in the baroque style and printed in a large format.

Why was it inscribed

Apart from its exceptional artistic value, the Prague collection comprehensively covers the golden era of the theses' use in the university environment, offering a unique insight into European scholarship and the university environment of the period.

Where is it

National Library of the Czech Republic, Prague, Czech Republic

The 526 university theses are very large poster-like individual sheets, which were published to announce a public university disputation. They are high-baroque in style and are printed on paper using the copperplate, steel engraving or mezzotint technique.

The artistic design of the theses was often done by renowned painters (the leading Czech baroque painter, Karel Škréta for example) and would be an original design or reproduction of a work by a European master (Rubens, Van Dyck, Raphael). The text was written in Latin and included the actual theses to be defended with the names of the defending student, chairman of the disputation and patron, and the date and place of the disputation.

While the textual component of this important historical source adds to what we know about the nature of university philosophical studies and the official university ceremonies in the 17th and 18th centuries, the visual component significantly enriches and deepens our understanding of the highly sophisticated baroque iconography and baroque graphic art.

Although used by European universities from the first half of the 16th century, they enjoyed greatest popularity during the 17th and 18th century, largely thanks to the

Jesuit order, which played an important role in spreading baroque culture in Europe and other areas of the world.

Because of their artistic and material value, the university theses were regarded as precious objects even at the time of their origin, and first collections of them date back to that period. What makes the Prague collection unique is not only its size and good condition, but that they are related to a single institution, the Faculty of Philosophy and the Arts of Prague University, and that they are still kept at the place of their origin, the historical building of the Clementinum, a former Prague Jesuit college and the present seat of the National Library of the Czech Republic.

Covering the period from 1637 to 1754, a time when graphic theses were most popular and widely used, the collection maps the gradual changes of their appearance: the length of the time it almost uninterruptedly spans makes it something of a chronicle of baroque iconography. The Prague collection of prints is thus unique on a world scale since its volume, compactness and link to a single institution make it an ideal model material from which to draw conclusions concerning the history of other 17th- and 18th-century educational institutions. It thus significantly contributes to our knowledge of the university environment in the given period. Of incomparable value from the viewpoint of both cultural and art history, the collection is also an important source of information on the content of philosophical studies at universities closely linked to the Society of Jesus. It also enables us to get a more specific idea of the contemporary university ceremonies.

Biblioteca Palafoxiana

Inscribed 2005

What is it

A colonial library with more than 42,000 volumes of historical documents.

Why was it inscribed

It is the first public library in the Americas and has remained in its original building for more than three centuries. It has an important collection of incunabula.

Where is it

Puebla, Mexico

The Biblioteca Palafoxiana, founded in 1646 by Bishop Juan de Palafox y Mendoza, was the first public library in the Americas. Bishop Palafox bequeathed his personal library of 5000 volumes with the stipulation that the library would be open to members of the public wishing to study and not just clergy and seminarians as was typical at the time.

The library grew from a European intellectual and cultural heritage, and it faithfully conserves this tradition. It is also an integral part of the New World society that developed around it, forming a unique academic bridge between two continents.

Biblioteca Palafoxiana ▼

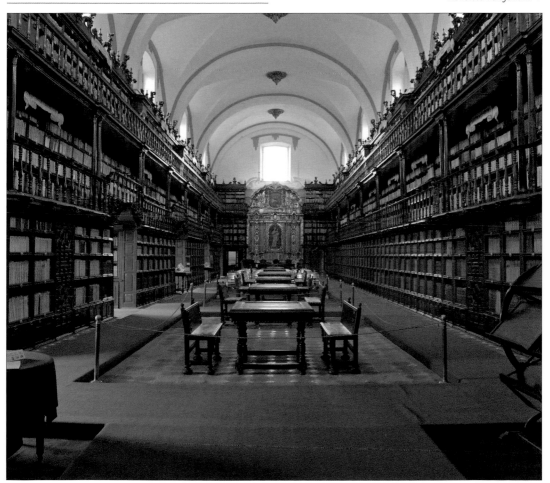

It has been located in the same building in the seminary of the Antiguo Colegio de San Juan (also founded by Palafox) since its inception in 1646. The main vault was built later, in 1773. Its beautiful bookcases feature ayacahuite, wild sunflower and cedar woods and are a testament to the cabinetmaker's art.

The Biblioteca Palafoxiana is the only extant colonial library in Mexico. The library was arranged in its current format in the late 19th century and now holds more than 42,000 books and unique manuscripts. Among the most important books are nine incunabula (printed books from before 1501) of which the oldest is the *History* of Herodotus, printed in 1473. There is also an important bibliographical collection dating from 1473 to 1821.

In the bibliographical collection the integration of the development of European and American thought can be appreciated with clarity through the organization of subjects into those of European medieval or classical themes and those from the American continent. As a colonial work built on an ancient European foundation, the Biblioteca Palafoxiana represents a model of modern cultural development in the Americas.

After the library was damaged in a 1999 earthquake, it underwent a comprehensive process of restoration and cataloguing. It successfully reopened in April 2005.

The library's founding spirit of 'reading for all' continues to thrive today. The 'Palafoxiana mobile' is a popular service that takes books to economically excluded communities, which are often difficult to reach. This is a cultural lifeline for many people in remote areas, particularly children.

Entrance to Biblioteca Palafoxiana ▶

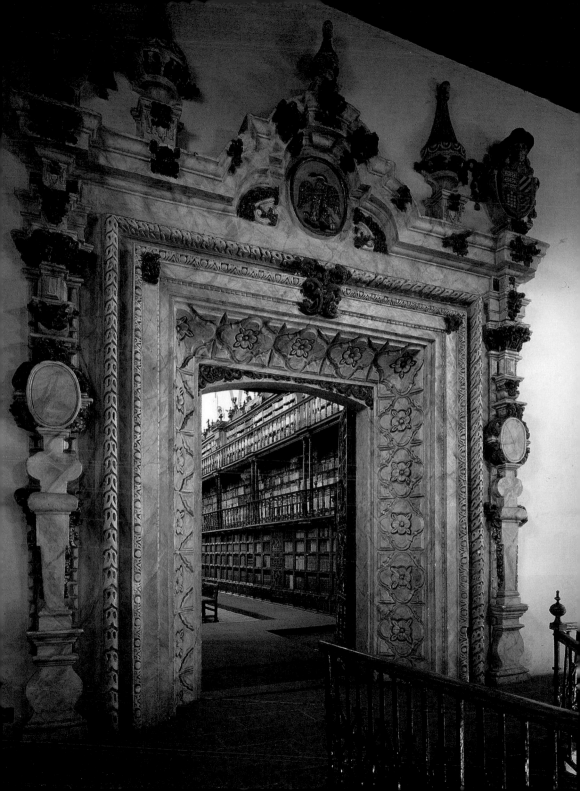

Hikayat Hang Tuah

Inscribed 2001

What is it

The *Hikayat Hang Tuah* is a Malay literary classic and describes the world of palace life and customs during the Melaka (Malacca) sultanate along with the internal life of the legendary Hang Tuah, 'the man who must be both servant and warrior'.

Why was it inscribed

The *Hikayat Hang Tuah* describes the behaviour of the ideal Malay subject, Hang Tuah, who dedicates his life to serving his ruler. The relationship established between Hang Tuah and his sultan presented a model for Malay rulers and subjects.

Where is it

National Library of Malaysia, Kuala Lumpur, Malaysia

The *Hikayat Hang Tuah* was written to boost the morale of the Malays by retelling the territorial, diplomatic and political achievements of the Melaka sultanate, and it caught the imagination of generations of Malays in Southeast Asia.

The historical time-span covered by the text is from the beginning of the Melaka sultanate in the early 15th century until the Dutch invasion in 1641. Hang Tuah's many exploits demonstrating the greatness of his sultan are symbolic, but at the same time are described with sufficient realism to make them credible and enthralling. Stories from folklore and legends have also been incorporated, not just as literary ornamentation, for they form an integral part of the *Hikayat*. Hang Tuah's superhuman life span is matched by the distances he covers in his many voyages. His exploits span the then-known world as he travels to China, Sumatra, Java, Thailand, India, the Middle East and Constantinople on missions for the sultan of Melaka. His missions abroad were varied. Expansion of trade relations and political ties with the countries were the main objective whilst spreading the influence of Melaka and its sultanate. His loyalty to his ruler extended even to persuading a Chinese princess to accept his ruler's proposal of marriage, which resulted in a prolonged cordial relationship between China and Melaka. He travelled as far as Turkey to purchase guns and ammunition in order to fortify Melaka against the possible Portuguese aggression. Hang Tuah's relationship with his temporal ruler is balanced by his relationships with a series of holy people from whom he gains spiritual knowledge. By the end of the *Hikayat* he is referred to as *wali Allah*, a saint. His power to save and protect is so strong that Malays see him as linked with their well-being as a people and he is considered to be immortal. The epic testifies that he did not die in 1641, but retired to the interior of the country where he still lives with the Batiq people, always ready to come to their rescue whenever he is needed.

To this day the author of the *Hikayat* remains unknown. The National Library of Malaysia has two manuscripts of *Hikayat Hang Tuah*. The manuscripts were written in Jawi (Malay written in an Arabic script) about 200 years ago on old European paper. Both are beautifully decorated with illuminations of floral designs in red, yellow, blue and green covering the whole page, leaving a diamond-shaped space for the text.

The great Malaysian folk hero, Hang Tuah, from a bas-relief panel in Melaka, the setting for his many exploits. ▶

Adam Schall

Adamo Schall. Adan Schall.

C Devrist del E. Monnin sc.

Records of the Qing's Grand Secretariat – 'Infiltration of Western Culture in China'

Inscribed 1999

What are they

These archives relate to the activities of Western priests in 17th-century China and are contained in the Confidential Records of the Qing's Grand Secretariat; only twenty-four of the original records remain.

Why were they inscribed

They provide a detailed first-hand account of the infiltration of Western culture in China through the activities of Catholic Jesuit priests, and the resulting clash between Western and Eastern culture that shaped relations between China and the West.

Where are they

First Historical Archives of China, Beijing, China

These archives relate to the activities of Western Catholic priests in China in the 17th century and form part of the Confidential Records of the Qing's Grand Secretariat. They consist of memorials to the throne that were submitted by government agencies and senior officials and were created and maintained according to administrative security regulations. They are written in Manchu, the official language of the Qing dynasty (1644–1911), and are in the original form and style of ancient Chinese records.

The Catholic mission to China began when the Jesuit priests, Matteo Ricci and Michele Ruggieri, travelled to Gwangzhou in southern China in 1583. Ricci was allowed to travel to Beijing in 1601 and had an audience with the Ming Emperor Wanli. He remained in Beijing until his death in 1610, having established a reputation as a scientist and a man of literature. The Jesuit mission reached its peak of influence in the middle of the 17th century; the Confidential Records reveal the living conditions and experiences of the Western priests at that time and support the fact that Catholicism was popular not only among the

people, but that it also permeated high society and even the Palace. It deeply influenced the history of the relations between China and the West. The teaching and use of developments in science and technology by the Western priests made a great impact on 17th-century China.

Subsequently this golden age underwent a rapid decline, which resulted in the 'Case of Priest Tang Ruowang' (Johann Adam Schall von Bell) which is transcribed in its entirety in the Confidential Records. As a German Jesuit, he arrived in China in 1619, where he lived for 40 years. When the Qing dynasty began in 1640 he was appointed Director of the Imperial Board of Astronomy by the Qing emperor and worked in the palace for 20 years. He was regularly promoted and was even appointed Director of State Protocol and enjoyed a very high reputation in China. However, the divergence of the two cultures ultimately created a sharp conflict and the Confidential Records provide original evidence for this dramatic historical event. The 'Case of Priest Tang Ruowang' concerned the Western and Chinese astronomers' divergent views on the details of the Chinese calendar. Tang Ruowang suffered a great deal in his later years, and was eventually sentenced to death, though he was reprieved in 1665 and died in Beijing in the following year. The infiltration of Western culture in China in the 17th century effectively ended after the death of another prominent Jesuit astronomer priest, Ferdinand Verbiest, in 1688.

◀ The German Jesuit priest and astronomer Tang Ruowang (Johann Adam Schall von Bell), whose activities played an important role in this selection from the Confidential Records of the Qing's Grand Secretariat.

Lu.'Altan Tobchi':
Golden History written in 1651
Inscribed 2011

What is it

This manuscript tells the story of Mongol history including the rise of Genghis Khan and the growth of the Mongol empire and it contains the oldest record in Mongolian of *The Secret History of the Mongols*, the oldest account of the origins of the Mongols.

Why is it inscribed

The only surviving handwritten manuscript in Mongolian vertical script, the *Altan Tobchi*, dating from 1651, remains the most reliable historical source on Mongol history, and its relevance extends to all countries that once were part of the Mongol empire.

Where is it

National Library of Mongolia, Ulaanbaatar, Mongolia

The *Altan Tobchi* recounts the genealogy of the early Mongol khans and the life and deeds of Genghis Khan, founder of the unified Mongol state and prime initiator of the Mongol empire, which became the world's largest continuous land empire. It also paints a vivid picture of the nomadic Mongol way of life and provides rich source material for an understanding of Mongol society in the 13th–17th centuries. The text reveals the philosophical outlook, language, religion, culture, customs and traditions of nomadic Mongol people. It displays a remarkably accurate knowledge of the geography of Mongolia itself and also includes information on foreign countries, towns, lakes, rivers, mountains and people that can still be recognized and identified today. It also contains rich information about life and culture of the nations of Central Asia – the Uigur, Kirghyz, Turkish, Tajik and Uzbek peoples and people of Russia and China. Mongol nomadic culture undoubtedly influenced societies across Asia and into Europe and, in turn, absorbed influences from both East and West in a true interchange of human values.

This manuscript presents the history of Mongolia and neighbouring countries from Genghis (Chinggis) Khan to Ligden Khan (13th–17th centuries). It was written with a bamboo pen on muutuu paper in black ink in Mongolian vertical script. The greatest achievement of its author, Lubsandanzan, was that he restored old Mongolian historiographic traditions, successfully using sources of the 13th century, particularly *The Secret History of the Mongols*. Scholars have shown that 233 of the 282 paragraphs of *The Secret History* are incorporated into the *Altan Tobchi*.

The *Secret History of the Mongols* is an epic account of the story of Mongol origins, the rise of Genghis Khan, the unification of the Mongol tribes and the beginning of Mongol empire. On the 750th anniversary of the appearance of *The Secret History of the Mongols*, UNESCO honoured the work by citing it as a 'great monument of eastern history and literature, unique in history by its rich literary language and artistic aesthetics'. Unfortunately no original version written in Mongolian characters has survived to the present day. Chinese bibliophiles of the 14th century transcribed *The Secret History* into Chinese characters and made verbatim and abridged translations. The *Altan Tobchi* also contains additional information about Mongolia, Central Asia and China in the 12th and 13th centuries which are not present in *The Secret History*.

Genghis Khan sitting on his throne, with two of his sons, Ogadei and Jochi, as imagined in a Persian manuscript. The Altan Tobchi recounts the history of the Mongol empire created by Genghis Khan and is central to the understanding of Mongolian history. ▶

The Atlas Blaeu–Van der Hem

Inscribed 2003

What is it

With more than 2400 maps, prints and drawings, the forty-six-volume *Atlas Blaeu–Van der Hem* offers a pictorial encyclopedia of 17th-century knowledge ranging from geography and topography to warfare and politics.

Why was it inscribed

Representing the entire surface of the Earth, the *Atlas Blaeu–Van der Hem* is often considered the most beautiful and most remarkable atlas ever composed. It has been influential in determining the movements of European traders and explorers.

Where is it

Austrian National Library, Vienna, Austria

The lawyer Laurens van der Hem (1621–78) of Amsterdam used the largest and most expensive book published in the 17th century, Joan Blaeu's eleven-volume *Atlas Maior*, which contained 593 maps, as the base for an even more ambitious, forty-six-volume collection of over 2400 maps, charts, townscapes, architectural prints, portraits and diagrams, most of them luxuriously painted by well-known artists.

The atlas, compiled from 1662 to 1678, represents the cartographic heritage of the Golden Age of Dutch history when the development of overseas trade greatly influenced Dutch and European cultural life and led to changes in the global economy. The Netherlands, as one of the major trading nations successfully involved in the struggle for overseas domination, developed into the centre for the production of maps and atlases. Topographical knowledge was valuable and therefore often kept secret. As one of the few private individuals in possession of a portion of confidential cartographic material, van der Hem imparted this information in one of the most impressive additions to his atlas: the four volumes of manuscript maps and topographical drawings of East Asian regions that were originally made for the Dutch East India Company (VOC) (see page 214), and sometimes known as 'Secret Atlas of the Dutch East India Company'.

The atlas contains not only the best printed maps and charts of the day, but also a great number of unique hand-drawn pictures. The atlas is unique in terms of the lavish colour added to the copperplate printed maps and other images. In contrast to the usual colour then used by publishing houses, the engravings of the *Atlas Blaeu–Van der Hem* were enhanced with sumptuous colour and gold-leaf by one of the best colourists of the day, Dirck Jansz van Santen.

Unchanged since its compilation and bought by the Imperial Library (now the Austrian National Library) in 1736, the *Atlas Blaeu–Van der Hem* contains invaluable information, not only in the fields of geography and topography, but also in archaeology, architecture,

Joan Blaeu's map of Africa from the Atlas Maior, *showing the very elaborate style of mapping that he created.* ▶

▼ *A Blaeu map of Asia*

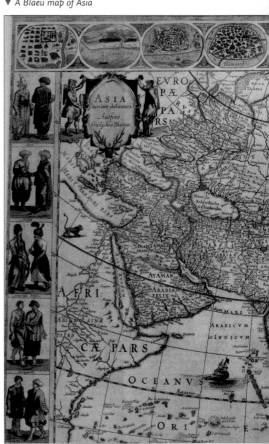

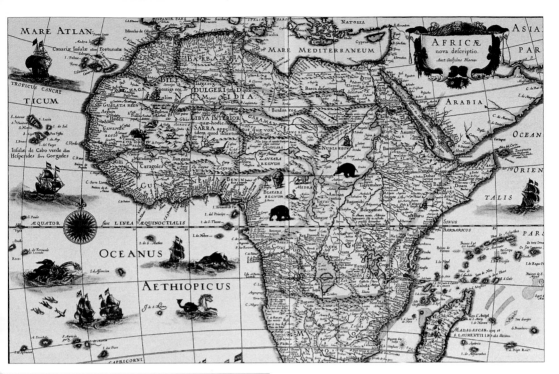

sculpture, ethnography, folklore, heraldry, navigation, fortifications and warfare. It also contains portraits of famous people, technological inventions, public works and many other aspects of 17th-century history and culture.

Golden Lists of the Qing dynasty imperial examination
Inscribed 2005

What is it
The Golden Lists are the name of candidates, written in Chinese and Manchu on sheets of yellow paper, who passed the Palace Examination, the final stage of civil-service recruitment, during the Qing dynasty.

Why was it inscribed
China's feudal examination system had international impact and influenced recruitment systems in other countries in Asia and Europe. All documents have high calligraphic value, and are pieces of art in their own right.

Where is it
First Historical Archives of China, Beijing, China

The examination system for recruitment into the civil service reached its zenith in the Qing dynasty (1644–1911) having developed over many centuries since the Sui dynasty (581–618). Under the Qing, the regularly scheduled civil service examination was the only way for scholars to seek official positions. The sequence of the examination includes District Examination, Provincial Examination, Metropolitan Examination and the Palace Examination, which was held in the Hall of Preserving Harmony in the Imperial Palace in Beijing. This examination was prepared and presided over by the emperor in person. The Golden Lists are the names of the successful candidates, in three categories, and were written on sheets of yellow paper. There are two types of Golden Lists. The small one was submitted to the emperor, and the large one placed outside the Chang'an gates at the entrance to the Imperial Palace. The names of many prominent historical figures can be found on the lists.

The large Golden List is 150–220 cm long and 80–90 cm wide. It was written in both Chinese and Manchu in Chinese ink and stamped with the emperor's seal. The Manchu language was written from left to right, while the Chinese was written from right to left. The two languages meet in the middle of the paper by date and the word 'list', written in both Manchu and Chinese characters. The paper starts with an Imperial Command and follows with the names of those who passed in the three categories. The emperor's seal is put over the dates in both languages and also the junction of the paper edge. For easy hanging, there are cords on the upper edge of the paper every metre. The small Golden List is 100 cm long and 35 cm wide. It has the same form as the large list but without the emperor's seal. There are over 200 pieces of small and large Golden Lists in the archives dating from the sixth year of Emperor Kangxi (1667) to the twenty-ninth year of Emperor Guangxu (1903).

The civil-service-recruitment examination dates back more than 1300 years and has had international impact, being copied in Japan, Korea and Vietnam. Ambassadors to the emperor from Europe introduced adaptations of the examination system in several countries in Europe. It has influenced subsequently civil service systems in many colonies and successor states.

▲ *The Hall of Preserving Harmony in the Imperial Palace, Beijing, where candidates took the Palace Examination, the final exam to enter the highest level of the civil service. The Golden Lists recorded all those who passed.*

Letters from and to Gottfried Wilhelm Leibniz within the collection of manuscript papers of Gottfried Wilhelm Leibniz

Inscribed 2007

What is it

The extensive correspondence, stretching over half a century, of Gottfried Wilhelm Leibniz, one of the greatest 17th-century thinkers. He corresponded with individuals all over the world covering a wide range of scientific and scholarly topics.

Why was it inscribed

The letters to and from Leibniz reflect the development of scholarship and science in his era. Its size, versatility and completeness, allied with the prestige of Leibniz in his era, makes his correspondence unique and of world significance.

Where is it

Gottfried Wilhelm Leibniz Library – Lower Saxony State Library, Hannover, Germany

If the modern scientific world looks back to its origins, it meets Gottfried Wilhelm Leibniz (1646–1716) – the mathematician, natural scientist, engineer, logician, philosopher, jurist, science organizer and perhaps the last universalist. It is Leibniz's correspondence (about 15,000 letters from and to about 1100 correspondents) that reveals the wide range of topics he worked on. The letters written by Leibniz (about 40 percent of all the letters in the collection) are mainly drafts in his own hand. The letters actually dispatched were mainly written by amanuenses or copying clerks and then signed by Leibniz. This correspondence provides an invaluable insight into the extent to which Leibniz influenced the thought of the scientific world of his time. He established a global network of correspondents, even as far as China, and thus exchanged letters with the most eminent scientists and scholars of his day.

Being accepted as the most prominent scientist and scholar of his time, Leibniz was looked upon by his contemporaries as an expert, arbiter, scientific advocate and referee in matters of science and scholarship. His correspondence thus reflects contemporary knowledge on any topic, be it in Leibniz's discussions of his own works, the discussions of the work of others, or his aspiration to academic positions. Leibniz's correspondence today sets him as one of the first to establish what is nowadays called the scientific and scholarly community.

The letters of Leibniz also discuss contemporary issues. Their scope ranges from statements on the regal election in Poland, legal opinions on the Hanoverian electorate and the succession to the British throne, statements on the subject of reunion of the Christian denominations, intellectual pan-European unity including Russia and even extends to a thorough examination of China and the thoughts of Confucius. He encouraged religious toleration between Christian denominations and was open-minded in his approach to other cultures. Intellectual debate through letters was an essential part of Leibniz's life and his proficiency in languages enabled this discussion to take place with scientists and intellectuals around the world. His correspondence was mostly written in Latin and French, but sometimes also in German, and occasionally in English, Italian and Dutch.

The Gottfried Wilhelm Leibniz Library and its predecessor institutions have owned the manuscript papers and letters since Leibniz's death in 1716. In 1895 the librarian, Eduard Bodemann, published a catalogue of the Leibniz's manuscripts and in 1889 a catalogue of Leibniz's correspondence that scholars and scientists have studied from that time on.

Gottfried Wilhelm Leibniz, the great German mathematician, polymath and correspondent. ▶

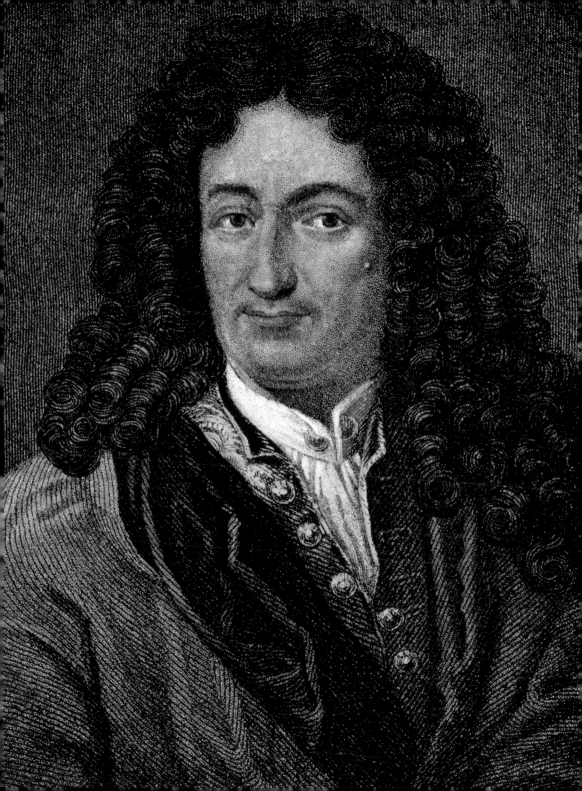

Archives of the Danish overseas trading companies

Inscribed 1997

What are they

The archives of the Danish overseas trading companies that operated in India, West Africa and the West Indies over a period of 150 years.

Why were they inscribed

The archives record in meticulous detail the administration of these small and ultimately unsuccessful trading companies and the process of colonization that accompanied their activities.

Where are they

Danish National Archives, Copenhagen, Denmark

The archives cover the Danish East India Company (1670–1730), the Danish Asiatic Company (1730–1827), the Danish West India and Guinea Company (1671–1755), the Danish Guinea Company (1765–78) and the Danish West India Trading Company (1778–1816). The archives are composed of around 4000 protocols and bundles and includes royal charters, copybooks, letters, instructions, accounts, files on employees, ship's logs and maps. They are housed in the Danish National Archives (the Rigsarkivet) next to Christiansborg Palace in the centre of Copenhagen.

The Danish East India Company was formed in 1616 with a grant of the monopoly of trade between Denmark and Asia. It established a base at Tranquebar (now Tharangambadi) in Tamil Nadu, India, but it did not thrive. It was re-established in 1670 only to be liquidated in 1729 and succeeded by the Danish Asiatic Company, which was granted a 40-year monopoly in trade east of the Cape of Good Hope. As well as Tranquebar, it established itself at Serampore, in West Bengal, and on the Nicobar Islands. In 1777 the Danish state took over the administration of these colonies, while the company continued to trade in India and the Far East until its final demise in 1843–45, at which point the remaining colonies were also sold to the British.

The Danish West India and Guinea Company, formed in 1671, was developed to take part in the slave trade. The company established bases along the Gold Coast (now

part of Ghana, but at the time referred to as Guinea), with the greatest presence being at Fort Christiansborg (now known as Osu Castle and the official seat of the President of Ghana). In the West Indies, the islands of St Thomas, St Croix and St Jan (St John) were colonized and sugar plantations were developed, dependent upon slave labour. Denmark was the first country to ban slave trading through a Royal Decree issued on 16 March 1792; this came into force ten years later on 1 January 1803. Slavery itself was not abolished in the Danish West Indies until 1848. Denmark sold its Gold Coast colonies to the British in 1850 and its West Indian colonies in 1917 to the USA (they are now known as the US Virgin Islands). The

trading archives include records about the establishment of these colonies that later became the responsibility of the Danish state.

▲ *The trading post of Tranquebar, the Indian base of the Danish East India Company, as illustrated in the log of the frigate* Count Laurving *on its voyage in 1725–27.*

Fort Dansborg at Tranquebar (now Tharangambadi) in Tamil Nadu, southern India, established as the base of the Danish East India Company in 1620. ▼

Hudson's Bay Company archival records

Inscribed 2007

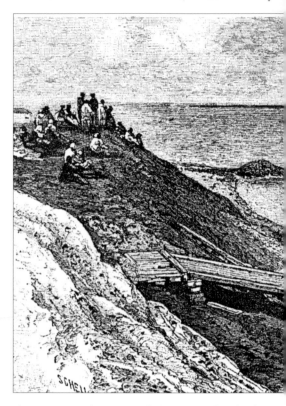

What is it

The archives of the Hudson's Bay Company from 1670, when the company received a royal charter to trade in Rupert's Land, the huge drainage basin of Hudson Bay in North America, to 1920, the 250th anniversary of the company's founding.

Why was it inscribed

The oldest company in Canada and one of the oldest in the world, the Hudson's Bay Company was enormously successful with a reach spanning vast areas of the western hemisphere. Its extensive and meticulously kept archives are a rich source of information on its activities in commerce and trading, in the exploration and administration of its vast holdings, in mapping and research and in every aspect of running an organization that operated across 40 percent of modern-day Canada and over two continents.

Where is it

Archives of Manitoba, Winnipeg, Canada

Many great merchant expeditions set out in the last four centuries from the shores of these Islands and materially altered the history of the lands to which they sailed. Of these, none was more prominent than the Hudson's Bay Company.
 Sir Winston Churchill (1874–1965)

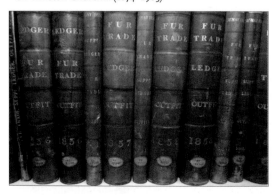

▲ *Company ledgers*

The Governor and Company of Adventurers of England trading into Hudson's Bay is the full name of the organization established in London on 2 May 1670 by royal charter of King Charles II. The charter gave the company full ownership and control of the huge area of the Hudson Bay drainage basin. The area was renamed Rupert's Land after Prince Rupert of the Palatinate, Charles's cousin and the company's first governor.

The archives of the Hudson's Bay Company over the following 250 years show it involved not only the history of the fur trade for which it was established, but also in the exploration of North America, in the expansion of the newly established Dominion of Canada to whom it ceded its territory in 1870, and in its development of its widespread business interests – including retail, wholesale, property and natural resources – in the 20th century.

In its cross-Atlantic trade links with London and thereby to the world, the Hudson's Bay Company was a pioneer of the modern international and global economy. It added

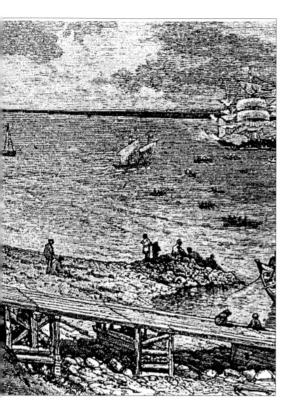

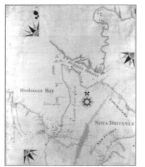

▲ Map of Hudson's Bay

Preserving the archives today ▲

▲ Hudson's Bay Company loading point at York Factory, Manitoba, on the southwest shore of the bay. Ships sailed from here for England, loaded with furs.

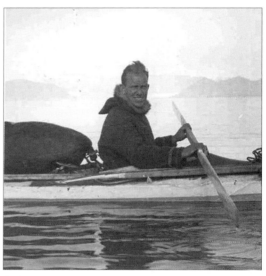

Rev. Canon John Turner in his kayak ▶

to the repository of world knowledge through exploration, mapping and research. It changed living conditions and opened up new avenues for trade and income for the indigenous people of northern North America, and its archives are a central source for their written history and also for land claims in law.

The company operated not only as a commercial enterprise controlling the North American fur trade but also as a *de facto* government in many areas of the continent before large-scale settlement. Its trappers and traders provided the first contact with local indigenous people. The network of its trading posts and agencies covered the continent from Newfoundland to Vancouver Island and north from the St Lawrence to the Arctic. At its

furthest extent, its operations stretched to Alaska, Hawaii, Russia and possibly even as far south as Texas.

The company's records were gathered from remote trading posts dotted across the North American wilderness and taken across lakes and rivers, through mountain passes and over endless prairies to York Factory on the shores of Hudson Bay for transportation to London. Given the difficulty of collecting the records and the extremes of weather and sailing conditions to which they were exposed, their survival is extraordinary.

In fact, the archives are a meticulous record of the daily commercial activities of the company. The vast span of its business is also evident, ranging from records of decisions taken by administrators in London or Montreal, clerks at isolated trading posts, and sea captains and explorers.

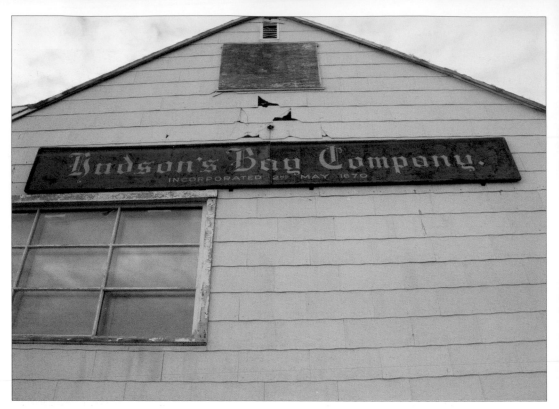

Besides daily records, there are such diverse items as medical journals, ships' logs, census records, scientific data, vocabularies of indigenous languages, records of hunting practices, advertising art, maps, paintings, drawings, photographs and audio and film recordings. The earliest item in the archives is a minute book from 1671 and in total the documents stretch for more than 3000 linear metres.

The company is still in existence, most prominently now in The Bay department stores, so its archives remain open. However, the records of its first 300 years were transferred from London to Canada in 1974 and gifted to Manitoba in 1994.

Historic Hudson's Bay Company building on Baffin Island ▲

Arquivos dos Dembos / Ndembu archives

Inscribed 2011

What are they

These archives consist of some 1160 manuscript items from the late 17th century to the early 20th century and record the long and different relationships among the Ndembu peoples of northern Angola and with the colonial Portuguese.

Why were they inscribed

The Ndembu archives are uniquely valuable to scholarship in history, anthropology and linguistics as they record the transformation of an essentially oral southern African culture through the assimilation of the Portuguese language.

Where are they

Arquivo Nacional de Angola, Luanda, Angola and Arquivo Histórico Ultramarino, Lisbon, Portugal

▲ *Examples of letters from the late 18th and 19th centuries from the Ndembu archives. These letters, written in Portuguese, provide evidence of the interactions between the Portuguese colonial officials and the Ndembu people in northern Angola. One of these letters mentions the installation of a military barracks.*

These documents establish and reflect diverse relations between the Portuguese colonial authorities of Angola, including the governor in Luanda, and African chiefs, and between them and the king of Kongo. The archives are composed of originals, copies and drafts of official and some private letters, wills, lists of products, receipts, bills of exchange, certificates, vassalage acts, orders, prayers, votive offerings, judicial cases and spelling books. Several documents are certified with wax seals and seals on paper either by Ndembu or Portuguese authorities.

The Ndembu archives bear witness to the long and different relationships among African peoples and Europeans. The archives are of great value because of the long period they cover and because they were all created in one area, the Ndembu (or Dembos) region in northern Angola. They record variations within African communities, their internal relations and their connections with Portuguese colonial authorities and individuals. Subjects covered include population movements, slave trading, commercial relations, changes in social and political hierarchies, religious practices, and the teaching of written Portuguese by Ndembu people. In addition, these archives have a special linguistic value, as the records use Portuguese and mainly Kimbundu words and expressions in documents created both by the Ndembu and the Portuguese. In addition there are echoes of Kikongo and some Latin expressions appear too.

The manuscripts were created and kept by Ndembu chiefs in the north of Angola. The documents were collected in Angola, in 1934, by Antonio Almeida, a medical doctor and physical anthropologist, during a study mission to the Ndembu area. They are now in the Arquivo Histórico Ultramarino (Overseas Historical Archive) in Lisbon. The Arquivo Nacional de Angola has one codex of 184 written folios comprising the register of letters from the colonial authorities to Ndembu chiefs, dating from 1798 to 1854. Due to its contents it is possible to understand that there was a fluent exchange of correspondence between the colonial authorities and Angolan chiefs. Unfortunately, the letters of these Ndembu chiefs have not been found in the colonial archives.

Woodblocks of the Nguyễn dynasty

Inscribed 2009

What is it

A collection of 34,555 plates of woodblock from the Nguyễn dynasty (1802–1945) which record a range of material, particularly official and government literature and dynastic history as well as classic and historical books.

Why was it inscribed

Woodblocks are relatively rare and especially valuable in Vietnam and the collection contains material of historical importance. It is also technically and artistically valuable for what it reveals about the development of woodblock carving and printing.

Where is it

State Records and Archives Department of Vietnam, Hanoi, Vietnam.

The woodblocks were used to print books in the period of the Nguyễn dynasty. The dynasty was prominent intermittently in Vietnam between the 16th and 20th centuries, ultimately coming to an end in 1945.

The woodblocks were carved into Chinese or Chinese-transcribed Vietnamese lettering, reversed out for printing onto paper. Illustrations of pictures and maps were also carved. This was the main means of printing books in Vietnam for centuries. These blocks were made between 1697 and 1945.

The woodblocks represented one stage of the process of printing in Vietnam at the time. Imperial records contain the instructions to carve the woodblocks for printing; the blocks were carved out; and the books were printed. Consequently, the carved woodblocks form a unique record of the books that were printed at the time.

The Nguyễn dynasty set up a methodical administrative system and the emperors enacted a variety of legal documents which were used as important bases to govern the kingdom. They keenly promoted book printing in a range of subjects: articles of law, royal and noble biographies, politics, foreign affairs and diplomacy, religion, culture and education, histories and literature. As books could only be carved by order of the emperor, the woodblocks were considered a national treasure.

The blocks are thought to be carved from the wood of the pear, apple, thi and nha dong trees – all woods which retain the shape of the carvings. The blocks themselves are works of art and testimony to the skills of the carvers who created them.

Many of the items preserved on the woodblocks are rare, including the *History of the Unification of Great Vietnam*, the *Royal Annals of Great Vietnam* and poems and works of literature written by emperors including Minh Mang (1791–1841), Thieu Tri (1807–47) and Tu Duc (1829–83).

Once used to preserve information and communicate it to the Vietnamese people, they now provide a valuable source of information on Vietnamese history and culture for historians and researchers. The progress of woodcarving and printing techniques can also be followed through the blocks.

At the tomb of Emperor Thieu Tri whose writings are among those recorded in the woodblocks. The tomb is a UNESCO World Heritage Site. ▶

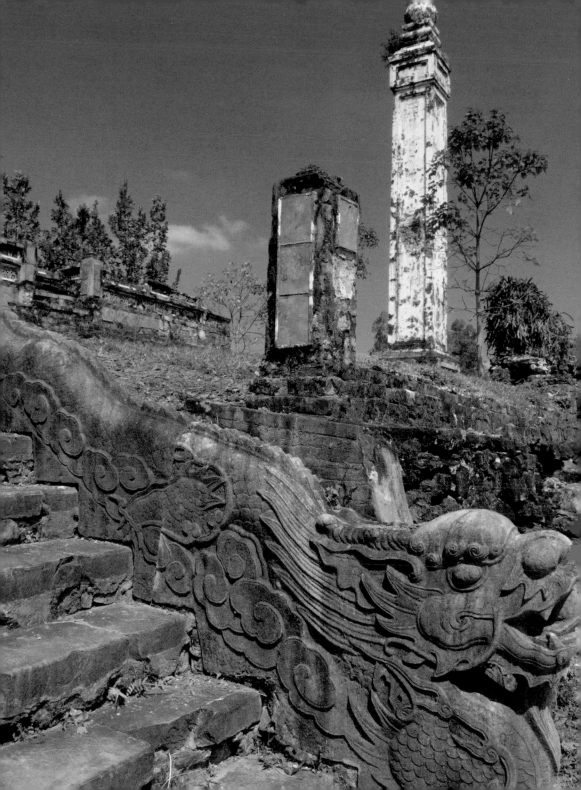

Records of the French occupation of Mauritius

Inscribed 1997

What are they

A series of records of the French occupation of Mauritius, then known as Isle de France, from the late 17th century to the early 19th century, and of the early English period from 1810.

Why were they inscribed

These records document the colonial administration of Mauritius by the French and British and provide detailed information on the practice of slavery up to its abolition in 1835.

Where are they

Mauritius Archives, Petite Rivière, Mauritius

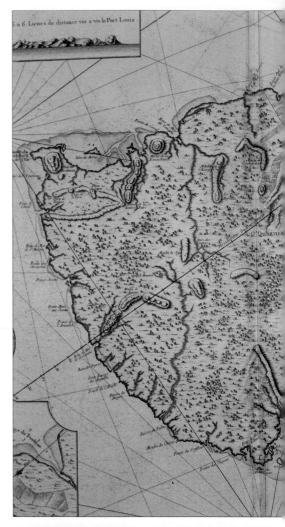

These records provide a picture of the European colonial conquests and settlements in Mauritius and the Indian Ocean from the late 17th century to the early 19th century. They include information on the French settlements on Isle de France and Bourbon, and on other islands of the Indian Ocean, Port of Africa and Asia, and documents relating to the East India Company, navigation, pirates and corsairs, and naval activity in the Indian Ocean. Most significantly they also contain details about the slave trade, including treatment of slaves, the struggle for the abolition of slavery and the compensation paid to owners after abolition.

Among the oldest documents in the archive is the *Acte de Prise de Possession*, the formal start to French occupation in 1715, following the departure in 1710 of the Dutch, who had established sugar plantations here. The French developed sugar plantations further, and brought in more slaves from East Africa and Madagascar as labour. Some of the documents in the archive recall the island's role in the slave trade – the 1723 *Code Noir* relating to slaves on Isle de France and Bourbon; the registers, from 1772 to 1775, that were used to record the daily catch of escaped 'black fugitives' (*noirs fugitifs*); and also the registers covering the period 1776–92 that recorded acts of freedom granted to slaves.

Liberation certificate of a slave and her seven children issued by the British Government after they took control of Mauritius. ▶

Mauritius either as domestic servants or permanently transferred, returns on the number of slaves transferred from Mauritius to its dependencies, returns of the number of marriages legally solemnized between slaves and returns on the number and names of slaves levied upon or sold for taxes.

The Mauritius Archives is the custodian of most of the administrative records dating back as far as 1715. The successive governments of the country from 1715 to date have shown their interest in the preservation of these records.

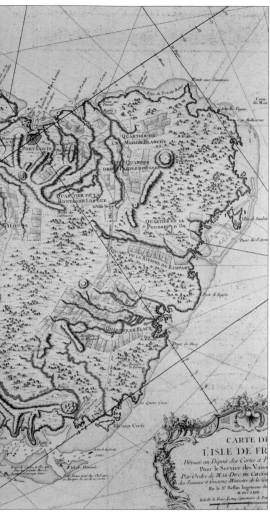

▲ Map of Isle de France (Mauritius), from the 1763 Atlas maritime by the French cartographer Jacques-Nicolas Bellin.

◄ The daily register recording the capture of black fugitives in every district of Mauritius.

In 1810, during the Napoleonic Wars, the French surrendered to a British invasion force. The archives continue to record the use of slaves on Mauritius under British rule until slavery was abolished in 1835 and include weekly reports of the distribution of government slaves, returns showing the number of slaves imported into

Privateering and the international relations of the Regency of Tunis in the 18th and 19th centuries

Inscribed 2011

What are they

A wide range of documents relating to the diplomatic activities of the Regency of Tunis and to all aspects of privateering, including detailed lists of European captives, their social and ethnic origins in their home countries and their life during captivity.

Why were they inscribed

Privateering was closely linked to international relations and played an important part in the political and strategic balance in the region. These unique archives document the nature and practice of privateering from an Islamic point of view and serve as a major resource for researchers of genealogy, pre-colonial history, the Islamic world and international relations.

Where are they

National Archives of Tunisia, Tunis, Tunisia

▲ The passport of Mahmoud Jallouli who was sent on a mission to Malta for the purchase of weapons for the Bey of Tunis, March 1813. The text of the passport is in Italian, with a note in Arabic at the bottom.

▲ List of Christian captives drawn up by Mariano Stinca, himself a captive from Naples, who worked for Hammuda Pasha Bey of Tunis. Such lists are of great value to those researching family histories.

A view of Tunis around 1788, at the height of the Regency of Tunis, from Thomas Bankes's New System of Geography. ▶

In North Africa a new maritime trading network took shape during the 16th century, after the great discoveries of the Americas and the Cape of Good Hope, which enabled the emerging European powers to circumvent the trading posts of the Middle East and reach the Indies directly. This new situation prompted the corsairs of the Levant, specifically the two Ottoman corsairs Aruj and Khayr al-Din Barbarossa, to migrate to the western Mediterranean where Spain conducted its trade with the kingdoms of Italy. The states on the Barbary Coast of North Africa accorded certain privileges to these Ottoman corsairs, and the new ruling caste on the Barbary Coast discovered a valuable new resource in the adventurers, volunteers and renegades captured by the corsairs, some of whom succeeded in occupying the highest state positions. The privateering that resulted, unlike piracy, was legal and seen by countries that endorsed it as a source of revenue. It was regarded as legitimate to seize the cargoes of merchant ships together with their crews, who were taken captive and only regained their freedom in exchange for considerable ransoms.

During the 17th and 18th centuries, privateering was the pillar of the economy of the states of North Africa, especially under the regime of the Deys in Tunis. The peak period of privateering in the Regency of Tunis was during the reign of Hammuda Pasha (1782–1814), when Tunis enjoyed social and economic success and played an extremely important role internationally, particularly in relation to the belligerents in the Mediterranean at the time of the French Revolution and the Napoleonic Wars (France, Britain and the USA). However, privateering was responsible for the misfortune of its victims. The most capable captives were chosen to join the court or hold important government posts. Others, lacking such skills, were much less fortunate, being assigned to arduous tasks such as hard labour in prisons and construction sites, while female captives were often assigned to the harems.

There are a wide range of documents, in Arabic, Turkish, French, Italian and English, in the archive, including accounting documents tied to the financing of privateering operations, which cover the sailors' spending, their food provisions, weapons, munitions and all equipment supplied by shipowners. These registers also detail the

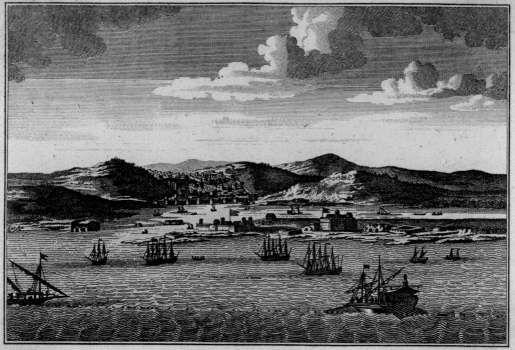

View of the CITY *of* TUNIS *the* CAPITAL *of that* KINGDOM *on the* COAST *of* BARBARY .

value and nature of the prizes and, for captives, listing their names, their ethnic origins, their 'qualifications' to serve the state, ransom amounts and those responsible for the exchange (often European consuls). State registers record information on the financing of commercial state transactions and contain data related to the spoils of privateering and their reinjection into the local or international economy, and information about spending on weapons, cannons and munitions. Hospitality registers list amounts spent hosting foreign dignitaries, including the number of guests, their nationalities, professions, the reasons for their visits and the assignments of emissaries, diplomats or admirals who chose to take on supplies in Tunisia. Other registers contain copies of every international treaty signed between the Regency of Tunis and European countries, in which articles dealing with privateering are omnipresent. In addition there are files, classified by country, which contain correspondence and treaties signed, while navy files provide information about the activities of Tunisia's navy and the support it provided to the Ottoman navy by taking part in conflicts or providing logistical assistance. They are a source of information about the types of weapons and ships, and the ethnic and social origins of Tunisian navy crews at the time.

Collection of 18th-century maps of the Russian empire

Inscribed 1997

What are they
Maps and town plans that record the growth of the Russian empire in the 18th century.

Why were they inscribed
These maps provide physical representations of the dramatic changes in the size of the Russian empire.

Where are they
Russian State Library, Moscow, Russia

From the late 16th century, Russian fur traders travelled east into Siberia, finally reaching the Pacific coast in 1639. A network of forts soon established control over the whole of Siberia. In the 18th century, Russia expanded to the west along the Baltic coast and into Belarus and south to Crimea and then reaching Georgia at the start of the 19th century. Landmarks in this expansion included the establishment of St Petersburg, on the Baltic coast, by Peter the Great in 1703, the conquest of much of the northern coast of the Black Sea and the establishment of Odessa in 1794 by Catherine the Great. These changes gave Russia direct access to the Baltic and the Black Sea and stimulated Russian trade with northern Europe and with Mediterranean countries.

These great territorial expansions prompted many geographical explorations and related cartographic work that greatly broadened knowledge not only of the interior of the country but also of the northern coast of Asia, the Far East, the Pacific coast and across the Bering Strait to Alaska. The maps in this collection recorded and formalized this new empire. To accompany these major maps there is a collection of hand-drawn and printed town maps dating from the second half of the 18th century to the beginning of the 19th century. These maps are of great value in recording the growth of urban settlements throughout Russia and provide invaluable information on the economic growth of the Russian

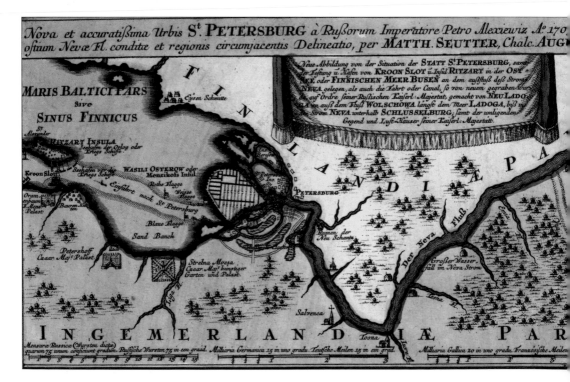

empire and the development of the Russian language through its use in naming buildings, streets, settlements and physical features.

These rare cartographic works of the 18th century are either hand-drawn or printed maps and atlases. Hand-drawn maps and atlases are preserved as single copies, while printed maps and atlases have survived in libraries and archives of Russia either in one or several copies. This collection started with the foundation of the Russian State Library in 1862 and has been continually added to over the years.

The partition of Poland in 1772 required new maps to record the growing Russian empire. In this allegory, Catherine the Great, the Holy Roman Emperor Joseph II and Frederick the Great of Prussia are seen consulting a map of Poland. ▶

(below and overleaf) A map of St Petersburg prepared in the mid-18th century in Amsterdam, believed to be based on the original plans of Peter the Great. ▼ ▶

ue ū: accurate Abbildung der von dem großen Ruß. Kaiſer Petro Alexiewiz A.º 1703. an dem Außfl. deß Neva oms erbaueten Statt S.ᵗ PETERSBURG, ſamt d. umligend. gegend heraußgegeb. von M. SEUTTER.

LADOGA LACUS

NOTTEBURG, jetz SCHLÜSSELBURG

West — Nord — Ost
Sud

Tschernot

Kiwoda

Liwoda

Lugowa

Doubino

Insula Linouw

NOVO GARDIÆ

MAGNÆ DUCAT-US

PARS

Labona

Natia

Ladoga Nova Neu-Ladoga

Krinitza

Wolschowa

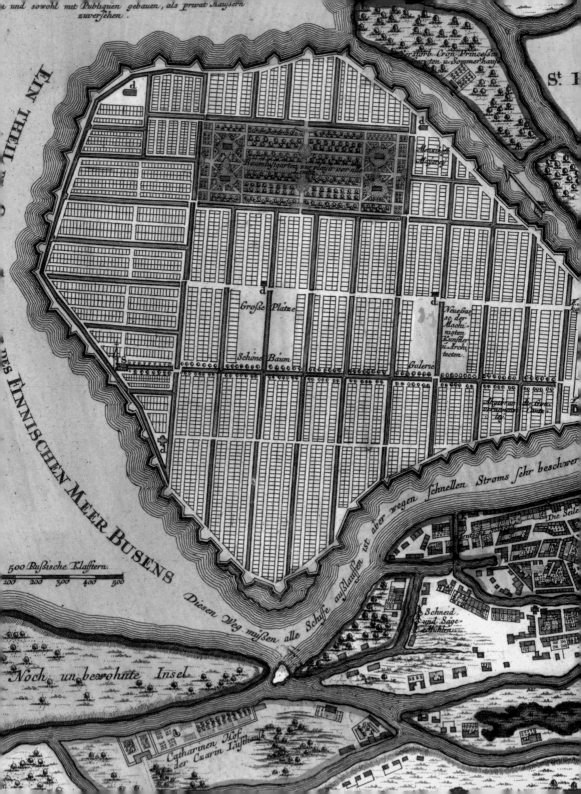

und sowohl mit Publiquen gebauen, als privat Kaysern
zuversehen.

St. I

EIN THEIL

DES FINNISCHEN MEER BUSENS

Verstarb Crön Princessin
ten u Sommerhauss

Alexander
Magazey

Baumhstgarten

Grosse Platze

Schöne Baum

Neue basse der Mecha nisten Kunstler u Arch tecten

Galerie

Academ wennsten sis

500 Russische Klaffern
100 200 300 400 500

Diesen Weg meissen alle Schiffe ausslauffen ist aber wegen schnellen Stroms sehr beschwer

Noch un bewohnte Insel

Schneid und Sage Mühlen

Catharinen Hof der Czarin Lusthaus

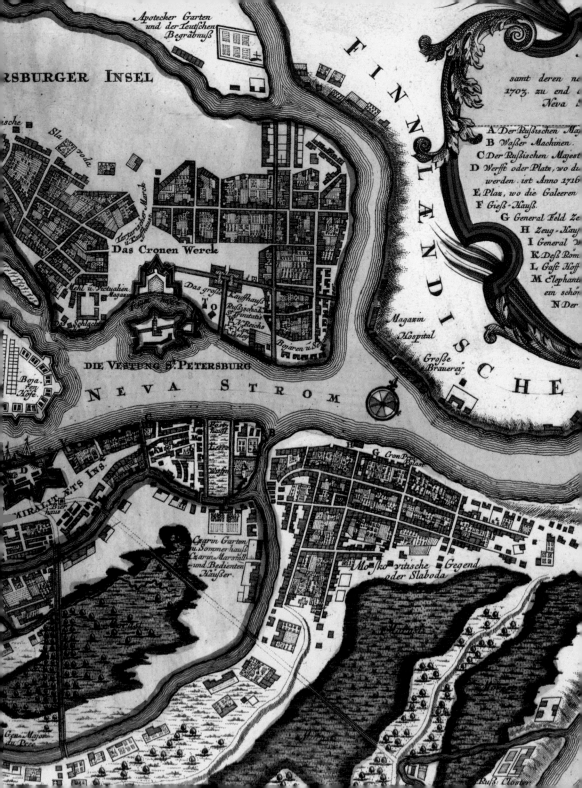

Apotecker Garten
und der Teutschen
Begräbnuß

...RSBURGER INSEL

FINNLANDISCHE

samt deren ne...
1703. zu end ...
Neva ...

A Der Rußischen May...
B Waßer Machinen...
C Der Rußischen Majest...
D Werfft oder Platz, wo du...
 werden ist Anno 1716...
E Plaz, wo die Galeeren...
F Gieß-Hauß.
G General Feld Ze...
H Zeug-Kay...
I General ...
K Deß Rom...
L Gast Hoff...
M Elephant...
 ein schö...
N Der ...

Sla...boda

Tartarischer Marck
Tartarisches Kauffhauß

Das Cronen Werck

Mehl u. Victualien
Magazin

Das große
Kauffhauß
Rußisches
St Trinitatis
T...
Reichs
Cantzley

Bojaren u. Se...

DIE VESTUNG St. PETERSBURG

Boja...
en
Hofe

NEVA STROM

Magazin
Hospital

Große
Brauerey

ADMIRALITÄTS INS.

Bier
hauß

Bier
hauß

Czarin Garten
zu Sommerhauß
Czarin Marstall
und Bedienten
Häuser.

G Cron Printz...

Mosko-vitische Gegend
oder Slaboda

Ruß: Closter...

Newspaper collections, Russian Federation

Inscribed 1997

What is it

A newspaper collection from four of the most important periods in Russian history, from the start of the 18th century to 1945.

Why was it inscribed

This collection provides documentary sources for studies of the history of the Russian State and its worldwide influence.

Where is it

Russian State Library, Moscow, Russia

The newspaper is one of the prime documentary sources that narrates both the development and making of the Russian State. This collection contains newspapers from four crucial periods in Russian history. The first two periods mark the transition from feudalism to the young, just-nascent capitalism. This is shown, firstly, in newspapers dating from the reforms of Peter I (Peter the Great), who ruled from 1682 to 1725 and who turned the country towards the West, and secondly in the collection of district and provincial newspapers (including literary gazettes) published from the 1820s to the 1860s, the period of the Enlightenment which concluded with the abolition of serfdom in 1861. The third part of the collection contains newspapers from Russia's revolutionary period, starting with the unsuccessful revolution of 1905 and concluding with the October 1917 Revolution. The fourth part of the collection covers the period of the Great Patriotic War (1941–45), when Russia, at huge cost, resisted the attacks

of Nazi Germany. The newspapers from the 20th century are like chronicles recounting the history of the state which has immensely influenced both the country and the whole world.

The collection was selected based on more than 50 years of research work of specialists of the Russian State Library whose assessment took into consideration international resonance and users' interests.

Since its foundation in 1862, the Russian State Library has had a policy of free access to national documentary heritage (the newspapers) for every citizen of the country and for visitors. While still holding the formal right of access to the collection, a large part of the population has been unable to enjoy them because the newspapers cannot leave Moscow due to their brittleness. The state of the newspapers from the second half of the 19th century (1860–99), from 1917 to 1926, and from the war years of 1943–45 is extremely fragile and they are undergoing complicated restoration and conservation processes. All are now listed on the Russian State Library Digital Catalogue. The complete newspaper collection of the library now contains over 671,000 items.

This collection includes papers from the Russian revolutionary period from 1905 to 1917, a time that included the launch of Pravda, *the paper of the Bolsheviks. This is the front page of the first issue, published on 22 April 1912 in St Petersburg.* ▶

Printed images from the collection that date back to the reforms of Peter the Great at the start of the 18th century. ▼

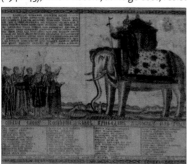

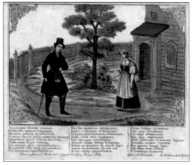

ПРАВДА

ЕЖЕДНЕВНАЯ РАБОЧАЯ ГАЗЕТА.

Годъ изданія первый.

№ 1. Воскресенье, 22 апрѣля 1912 г. ЦѢНА 2 коп.

Отъ редакціи.

Наши цѣли.

На граня.

Collection of Arabic manuscripts and books

Inscribed 2003

What is it

More than 800 books and manuscripts, with some material over 300 years old, providing insight on various aspects of Islam, Arabic literature and rhetoric and the history of Zanzibar and Eastern Africa.

Why was it inscribed

This collection includes exceptional and invaluable documents in Arabic and Swahili for the study of the social and cultural heritage of Zanzibar and the Eastern African region.

Where is it

Zanzibar National Archives, Zanzibar, Tanzania

In the 19th century Zanzibar was an important commercial empire and the centre of administration for the whole of East Africa. It also developed as a seat of learning and a centre of Swahili culture, a fountainhead of Swahili language and Islam, from which the language and the religion were disseminated over a vast region of middle of Africa.

In this context, records were created by institutions and individuals over a period of many years. Most of these have been systematically collected and preserved in the Zanzibar National Archives. The Archives are therefore the oldest and richest in the East African region and include Arabic manuscripts that cover not only the history of Zanzibar but also the neighbouring countries. There are two main categories of Arabic manuscripts: those which are purely religious and those which are secular in orientation. There is also an unpublished list of the sultans' Arabic correspondence as well as Arabic correspondence from the German Records collection in the Tanzania National Archives in Dar es Salaam.

The Arabic manuscripts are of great interest to those who study the various aspects of Islam, culture and history in eastern Africa. There are manuscripts on Islamic sharia and theology, the interpretation of the Koran and the Prophet Mohammad's Hadiths, Arabic literature, language and grammar, medicine and diseases (including treatments, local medicines and witchcraft), astronomy, navigation,

Sufism, slavery, divination, diaries, memoirs and local Arabic publications.

The collection is a unique source depicting the rich cultural heritage of Swahili civilization (from Mozambique to Mogadishu) based on interaction between African and Indian Ocean peoples with complex and overlapping economic, social and cultural networks. There are also a number of rare early editions of printed books from Zanzibar and other presses.

As literary and cultural documents, the manuscripts play a significant role in the study of the social and cultural heritage of Zanzibar and the region. In addition, the manuscripts include good examples of the art of calligraphy and artistic embellishment, drawing attention to the existence of a class of artistic calligraphers and copyists.

The Arab influence in Zanzibar is made manifest in this detail of a carved door in Stone Town, Zanzibar. ▶

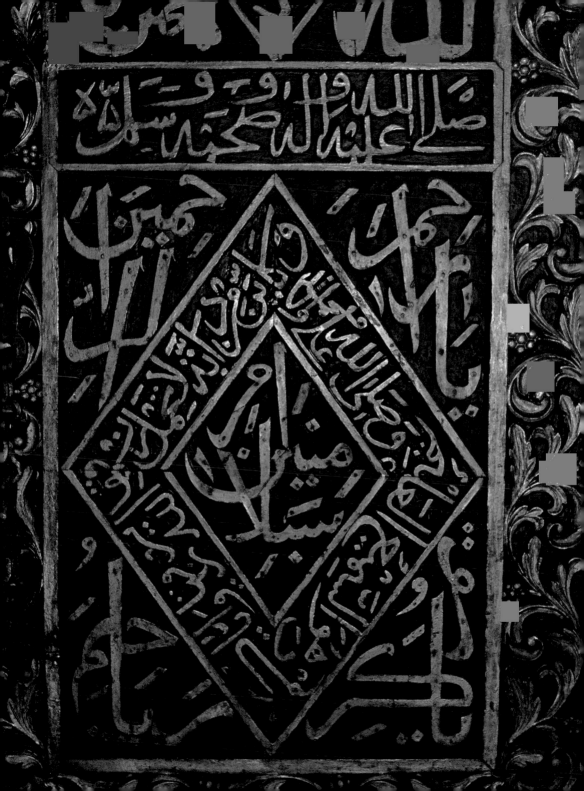

Jean-Jacques Rousseau, Geneva and Neuchâtel collections

Inscribed 2011

What are they

These collections consist of very important manuscripts, a unique collection of prints and portraits, extremely rare printed books and a mass of critical works.

Why were they inscribed

Jean-Jacques Rousseau is one of Europe's greatest philosophers. He has influenced philosophy, political thought, man's relationship with nature and children's education.

Where are they

Bibliothèque de Genève, Bibliothèque publique et universitaire de Neuchâtel, Société Jean-Jacques Rousseau and Association Jean-Jacques Rousseau Neuchâtel, Switzerland

Jean-Jacques Rousseau was born in Geneva in 1712 and died in Neuchâtel in 1778 (at Ermenonville, on the estate of the Marquis de Girardin). During his lifetime, he moved from one place to another and one country to another without establishing any real roots. Geneva and Neuchâtel were, nevertheless, of particular importance to him even if his relations with them were occasionally ambivalent. He maintained special ties with a number of important figures there, who were to accumulate collections of records immediately associated with him. These sets of records have made their way into public and private institutions – the Bibliothèque de Genève, the Neuchâtel Public and University Library, the Jean-Jacques Rousseau Society of Geneva and the Jean-Jacques Rousseau Association in Neuchâtel – to constitute remarkably extensive collections of the main manuscripts of Rousseau's major works, his extensive correspondence, all his printed works from first editions to unauthorized editions and the countless pirated editions, key iconographic documents, archives and critical literature.

The influence of Jean-Jacques Rousseau's thought and work is universal, because it has affected virtually all fields of knowledge: *Emile, or On Education* paved the way for modern education; *The Social Contract*, together with the works of Montesquieu, underpins the democratic systems on which many contemporary societies are based; the *Essay on the Origin of Languages* encourages both musical and ethnological reflection; *Julie, or The New Eloise* crystallized the focus on women since the mid-18th century and pioneered a new style of novel writing; the *Confessions* and the *Dialogues* offer a form of introspection of which autobiographical writing, modern psychology and analytic self-observation are the direct successors; and, lastly, the *Reveries of the Solitary Walker* raises, among other subjects, the question of our relationship to nature.

He opened up important new lines of thought that were to play a considerable part in social and political upheavals from the 18th century to the present day. Far from being confined to French-speaking Switzerland or even French-speaking Europe, his thoughts and writings very quickly transcended all borders to become universal: German Romanticism invoked Rousseau; the United States Constitution derived its founding principles from the text of *The Social Contract*; and modern teaching draws on Rousseau. He very clearly pointed to the hollowness of any revelation not supported, or confirmed, by a free examination of one's conscience.

◀ *Jean-Jacques Rousseau collecting plants in Ermenonville. He was a keen botanist and part of his herbaria (collection of preserved plants) is held nearby in the collections at Neuchâtel.*

Stockholm City Planning Committee archives

Inscribed 2011

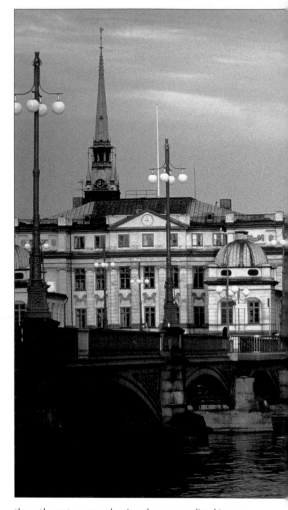

What is it

A collection of over two and a half million architectural drawings and plans in the Stockholm Planning Archives. The material covers the whole city and its public and private buildings and structures for all social and economic classes from 1713 to 1978.

Why was it inscribed

Stockholm is one of the most important capitals in northern Europe and the documents cover the period from the early 18th century when it grew from a population of around 50,000 to over one million at the end of the 20th century. Few other cities have such a centralized, long-running and comprehensive set of architectural plans.

Where is it

Stockholm City Archives, Stockholm, Sweden

Architectural plans and drawings are normally kept in the offices of individual firms and a centralized planning archive such as Stockholm's is unusual, especially over such a long period. Although the archive contains drawings from as early as 1713, the collection expanded after 1736 when a government ordinance stated that an architectural drawing or a copy – usually involving a new building or changes to an existing one – should be placed in the city archive. Royal and state-owned buildings are archived separately in the national archives.

The time period and scope of the archive allows the study of Stockholm's development and expansion, not just in terms of its buildings but also of its social, economic and commercial history. In addition, the archive's completeness – with records of almost all plans for buildings for almost three centuries – allows the study and investigation of the architectural, social and economic issues of city building and planning.

The plans of the archive allow a clearer picture of the ideas that drove different ages, people and social groups over three centuries. It is also possible to trace historical and political developments in society through the drawings. For example, the plans for cheap housing in the 17th century reveal a city where many lived in poor conditions, a seeming contrast with the perception of Sweden's golden age in culture, trade and commerce at the time.

In the 19th century, industrialization and economic growth prompted migration into the city and buildings were required for housing. Architecture flourished as a profession and the use of space changed to reflect new social trends: so, for example, dwellings for the middle classes were designed with different male and female spheres. Centralized planning and government intervention characterize development in the 20th century, even down to the minutest details of apartment buildings.

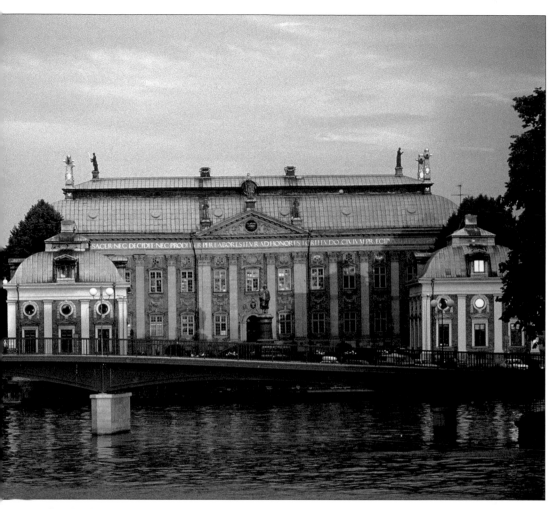

Most of the buildings depicted on the drawings and plans no longer exist and have been replaced with others. The archive allows Stockholm a memory of its former self. Of the archive's 2.5 million drawings, originals are on paper in black and white or colour, and there are copies and reproductions on paper and other materials. Much of the collection is also accessible through the archive's database and this task remains ongoing.

▲ *Stockholm Old Town*

Emanuel Swedenborg collection

Inscribed 2005

What is it

The collected papers, books, manuscripts and letters of the Swedish scientist and mystic Emanuel Swedenborg (1688–1772), dating from the 18th century.

Why was it inscribed

The Emanuel Swedenborg collection is one of the largest existing collections of 18th-century manuscripts and reflects not just the progression and development of Swedenborg's own ideas and interests from science to metaphysics, but also the ideas and influence of the Enlightenment or Age of Reason in the fields of science and theology. The collection is also one of the few to have inspired the founding of a new Christian church.

Where is it

Center for History of Science, The Royal Swedish Academy of Sciences, Stockholm, Sweden

The collection numbers approximately 140 items extending to 20,000 pages and covers more than 50 years of Swedenborg's working life, from his earlier career as a successful scientist, technician and assessor in the College of Mines, through to his later life and ideas after his Damascene-style religious experience and related series of spiritual revelations.

His work was erudite and wide-ranging and covered mathematics, metallurgy, chemistry and geometry, anatomy and physiology, physics and even astrophysics, proposing theories that were ground-breaking in several of his subject areas.

But it is for his religious writings that Swedenborg is best known. After an apparent spiritual experience in 1745, Swedenborg claimed that he was instructed to spend the remainder of his years interpreting and explaining every verse of the Bible under divine guidance. The revelations he presumably received formed the basis of his work and thought from then on through to his death in 1772. His theological ideas also grew out of these revelations.

Much of his work was devoted to interpreting and revealing the spiritual meaning, or correspondence, that underlay Scripture. This was a departure from contemporary mainstream belief that, for example, the Creation story in Genesis was literal truth. His books were published in England and the Netherlands where greater freedom of expression existed than in his native country.

Swedenborg's theories have parallels in Neo-Platonism and they influenced other noted thinkers such as Immanuel Kant, Ralph Waldo Emerson, William Blake and Carl Jung. His ideas also led after his death to the founding of a new Christian church. Originally called Swedenborgianism, it still exists today, most notably in Britain and the USA, and is known as The New Church.

The veneration in which Swedenborg's followers held his writings and papers led to their reproduction around 1870 using the newly devised process of photolithography, the first time the technique had been used on a large scale. Some of the Swedenborg societies and churches continue to translate and publish his writings today.

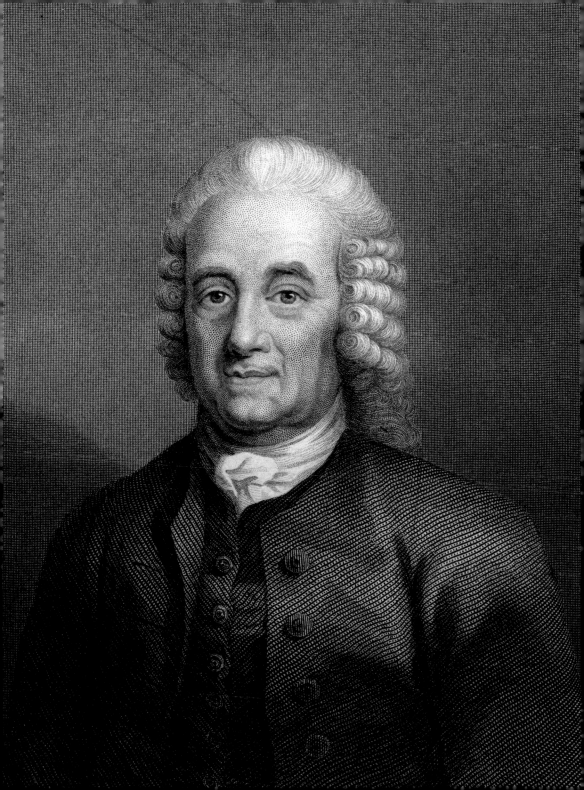

Archives of the Middelburgsche Commercie Compagnie

Inscribed 2011

What is it

This archive is a well-preserved and eloquent monument to the victims of the transatlantic slave trade and is more complete and richer in details than those of other slave-trade companies.

Why was it inscribed

These archives offer a unique and global perspective on the slave trade in the 18th century from Middelburg, in the Netherlands, to West Africa and then across the Atlantic.

Where is it

Zeeland Archive, Middelburg, the Netherlands

In the 18th century, the province of Zeeland and the city of Middelburg in particular became the most important centre of the slave trade in the Dutch Republic due to the decline of the Dutch West India Company (see page 220) following its loss of the charter for the Atlantic slave trade in 1720. The comprehensive archive of the Middelburgsche Commercie Compagnie (MCC) makes it possible to explore crucial aspects of the daily life of the slave traders as well of their human cargo. This collection is richer in details than those of other slave trade companies and contains a very wide variety of sources, including account books, journals, contracts, correspondence, auction proclamations and maps. The documents of the MCC are not only of unique value for the Netherlands, but also for Curaçao and Suriname because they cast light on their colonization and on the role that slavery and the transatlantic slave trade played.

The documents record all the voyages between 1730 and 1807 to Curaçao and Suriname, giving an overview of how many enslaved Africans were brought from Angola and the coast of Guinea; the price paid for those enslaved, both sold at auction and by private sale; the merchandise sold in Western Africa and the products brought back from the colonies to Middelburg. They provide an insight into the daily life on board the slave ships, the death toll per ship, the resistance on the ships, and the attitude of the slave captains concerning the people they carried, in particular through letters and journals.

One of the goals of UNESCO, in particular through the project 'Breaking the Silence', is to increase awareness of the causes and consequences of the transatlantic slave trade, in particular through educational projects. The MCC documents, because of their detailed recording of the slave trade, are an excellent tool as they explain how and why such an inhuman trade was conducted. The spotlight is put on the universal value of these documents.

The Stadhuis (town hall) of Middelburg, the home town of the Middelburgsche Commercie Compagnie, an 18th-century Dutch slave-trading company. ▶

Linné collection

Inscribed 1997

What is it

A collection of books and correspondence by and about Carl von Linné (Carl Linnaeus) and his pupils. His pioneering work in devising a system of naming plants and animals is covered in detail in material in the collection.

Why was it inscribed

Carl von Linné provided methods of botanical and zoological nomenclature and description which remain the basis for naming all living organisms to this day. This collection is one of the most important collections in the world relating to the work of Linné.

Where is it

Royal Library, Copenhagen, Denmark

point for botanical names is *Species Plantarum* of 1753 and for zoological names is the 10th edition of *Systema Naturæ* of 1758.

The Linné collection now in the Royal Library at Copenhagen contains significant works by and on Linné, while other important collections are held in London, Uppsala and Pittsburgh (the Linnean Society in London holds his personal library and collections). The Linné collection was formed by merging the collection of a private Danish book collector and the collection of the Danish National Library of Science and Medicine and is now kept in the Royal Library. The collection comprises a total of around 5000 items. In addition to Linné's own works it includes biographies, correspondence, a large quantity of reprints, a few letters and some pictures. His students at Uppsala who became naturalists are also represented in a special section.

Carl von Linné (Carl Linnaeus) was born in 1707 in Småland in Sweden, the son of a clergyman. He coined his own surname Linné (or Linnaeus), which referred to the large linden (or linn) tree at the family home. He studied medicine at Lund and Uppsala and in 1732 made a journey to Lapland. He lived in Holland from 1735 to 1738, and then returned to Sweden, practising medicine until he became professor of medicine and botany at Uppsala University in 1741, a position he retained until his death in 1778.

His fame rests on his great mission to classify, record and name all living organisms in a rational and logical system. He created the binomial system of scientific nomenclature that continues to be used today. Using a form of botanical Latin that he devised, the names of all organisms were made up of two parts, the genus name which contained organisms of similar characteristics, and the species name, which defined a unique organism: thus *Homo* (the genus) *sapiens* (the species). To place these organisms in context, he also classified the whole of nature so that, for example, he divided the animal kingdom into major divisions – *Mammalia* (mammals), *Aves* (birds), *Amphibia* (amphibians and reptiles), *Pisces* (fish), *Insecta* (including crustaceans) and *Vermes* (including molluscs). The first edition of Linnaeus' main work, *Systema Naturæ*, was published in 1735. He followed this with further books and new editions. Today the internationally recognized starting

Linné's great contribution to science was in providing a system of classification for all living things. He classified plants on the basis of their reproductive parts, as illustrated here by Georg Ehret in 1736. ▶

▲ *An illustration from* Hortus Cliffortianus, *written by Carl von Linné and illustrated by Georg Ehret, which classified the garden plants in the country estate of a wealthy Amsterdam merchant, George Clifford. It was an early work of botanical classification and was published in Amsterdam in 1738.*

Mongolian Tanjur

Inscribed 2011

What is it

The Mongolian *Tanjur* is a Mongolian-language collection of over 3425 Buddhist commentaries and treatises (as opposed to the *Kanjur* which contains the Buddha's own words).

Why was it inscribed

It is the only complete Mongolian-language version in existence and has survived wars and also religious persecution under Stalin in 1937–39, a feat regarded by Mongolians as a miracle. This reinforces its spiritual value to Mongolian Buddhists in Mongolia and elsewhere.

Where is it

National Library of Mongolia, Ulaanbaatar, Mongolia

Tanjur is a Tibetan word meaning 'treatise'. The Mongolian *Tanjur* is a large collection of over 3425 Buddhist works on the so-called 'ten great and small sciences' (philosophy, technology, logic, medicine, philology, astrology, model dance, poetics, Abhidharma or psychology, and composition) created by Indian and Tibetan scientists and panditas. These had a huge effect on the development of Mongolian literature and many branches of science. It is recognized as the largest sutra in the world.

The *Tanjur* was translated from Tibetan into Mongolian under the supervision of Janjaa Rolbiidorj and Shireet Luvsandambiinyam and was printed, using the old Mongolian vertical script format and Mongolian red dust ink, in Beijing between 1742 and 1749. To print the 226 volumes and 107,839 pages of the Mongolian *Tanjur* required, among other raw materials, thick Chinese muutuu paper and 2161 ounces of silver. The completed work was wrapped in yellow fabric and pressed by two wooden frames with sandalwood book covers. The cost of this single copy was then equivalent to the cost of 4000 sheep.

Works included in the *Tanjur* had been translated into Tibetan since the 9th century and Mongolians were translating and studying the works of *Tanjur* from the beginning of the 14th century. The translation of the whole *Tanjur* began in 1724 when a khan's decree was issued for the translation of the *Tanjur*. Under the decree, 135 Mongolian, Tibetan and Manchurian translators, teachers, print workers and Buddhist scientists as well as 163 copyists were gathered from all corners of Mongolia. In the course of translation of such a large number of works, the language knowledge, translation skills and methods of Mongolian translators greatly improved. The translation of the *Tanjur* played a significant role in developing the classic Mongolian language as a literary language. A Tibetan–Mongolian dictionary was published in 1748, influenced by the work on the *Tanjur*, which served as a theoretical guide for translators and, moreover, greatly contributed to the translation of Mongolian of the Middle Ages.

Qing dynasty Yangshi Lei archives

Inscribed 2007

What are they

A rich and invaluable collection of over 20,000 architectural and engineering documents, models, and drawings made by the Lei family, who were architects for the Qing dynasty (1644–1911) over seven generations.

Why were they inscribed

They provide unparalleled insight into Chinese architectural history, traditional architectural planning, engineering and principles of design, and attest to the impact of Chinese architecture on world architectural history.

Where are they

National Library of China, First Historical Archives of China and the Palace Museum, Beijing, China

The Qing dynasty Yangshi Lei archives refers to the collections of architectural drawings and models made by the Lei family and other relevant documents. Dozens of members of the Lei family over seven generations, from the end of the 17th century to the beginning of the 20th century, acted as architects for the Qing court. They were responsible for architectural design, as well as the design of interiors and furnishings, for the greatest imperial buildings of the Qing dynasty (1644–1911) and were honorifically known as the 'Yangshi Lei'. Today, more than 20,000 documents relating to Yangshi Lei family remain. They are chiefly housed in the National Library of China, the First Historical Archives of China and the Palace Museum. The surviving documents range in date from the middle of the 18th century to the beginning of the 20th century, and cover imperial architecture in the cities of Beijing and Tianjin and the provinces of Hebei, Liaoning and Shanxi.

Among the buildings the Lei family designed, constructed and maintained were the Forbidden City, the Altar of Heaven, the Beijing Summer Palace, the Chengde Mountain Palace and the Eastern and Western Qing Mausoleums, all now UNESCO World Heritage sites. Some of these buildings were completely the work of the Leis, and some underwent some redesign, but all of them encapsulate generations of great Chinese craftsmanship with the Leis as central figures. For one architectural family to have had their hands in so many masterpieces is an unparalleled phenomenon in the history of world architecture.

An architectural drawing of the Zun Zhaomu mausoleum at Digong in the Yangshi Lei Archives ▶

In the same way one would research a writer or an artist, one needs reliable, first-hand sources to research an architect, and the archives are the only such source in the case of the Lei family. They cover architectural surveys, designs and plans for construction and decoration, relating to cities, palaces, gardens, altars, mausoleums, official residences, factories and schools. There are various materials, including land surveys, architectural sketches, construction plans and drawings of the floorplans, elevations, sections and decorations, as well as models and notes on construction progress. There are also written records on construction plans, engineering notes and even some imperial and official orders.

The documents in the Qing Yangshi Lei Archives consist almost solely of ink-brush and charcoal drawings and writing on traditional Chinese hand-made paper.

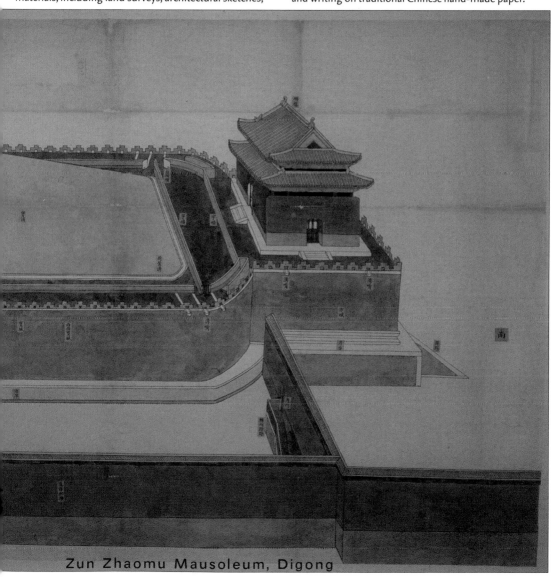

Zun Zhaomu Mausoleum, Digong

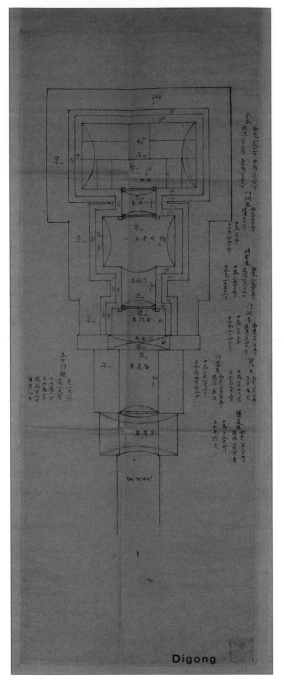

Digong

▲ *An example of an architectural plan in the Yangshi Lei Archives.*

The documents reveal the entire process by which structures were built, from selection of sites through construction and maintenance. Documentation of such scale, completeness and systematization is very rare in the world. Qing-era structures that have been preserved to this day are the best examples of Qing architecture and the archives show the entire process by which locations were selected, plans were drawn up and repeatedly altered, and how construction was finally carried out. No other resource is available to provide this historical information as well as information on lost classical structures like the Yuanming Yuan, the Old Summer Palace outside Beijing, destroyed by British and French soldiers in 1860.

Most of the archives concern extant structures, providing unparalleled insight into Chinese architectural history, traditional architectural planning, engineering and principles of design, as well as incomparable resources in helping with restoration projects. At the same time, they provide further insights into understanding of Qing society, economics, culture, aesthetics and philosophies.

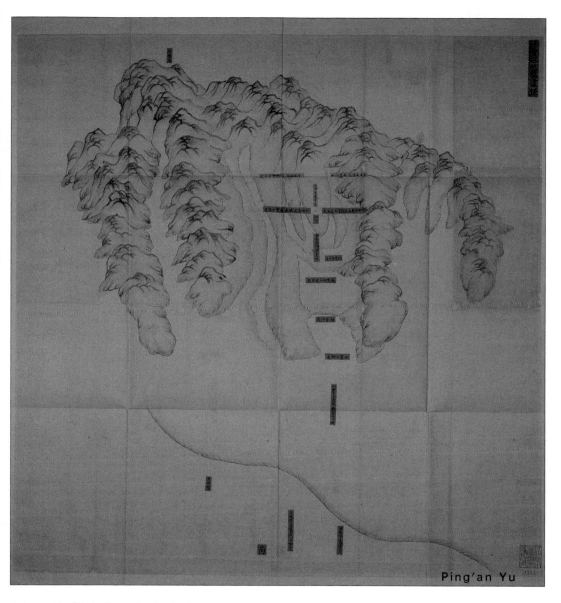

Ping'an Yu

▲ *An example of the landscape planning drawings in the Yangshi Lei Archives.*

The literary estate of Goethe in the Goethe and Schiller Archives

Inscribed 2001

What is it

A collection of Goethe's manuscripts, correspondence, diaries, scientific works and other historical documents.

Why was it inscribed

In its unity, completeness and range of holdings, this collection not only represents a unique record of the creative work of Goethe, but also reflects in Goethe's works the whole Classical Period in Germany.

Where is it

Goethe and Schiller Archives (GSA), Weimar, Germany

Johann Wolfgang von Goethe (1749–1832) is the best-known German writer and poet, but he was also a noted artist, biologist, theoretical physicist and polymath. The literary estate of Goethe is the most important holding of the Goethe and Schiller Archives (GSA) in Weimar. The collection includes the most important of his creative works and includes manuscripts from all periods of Goethe's life.

The bulk of today's holdings were established by Goethe's efforts during the second half of his life to create an archive of his written works. The main part of the holdings consists of the poet's own collection of manuscripts, including most of Goethe's poems, plays, novels and stories, his autobiographical works and theoretical writings on different subjects of art and literature. The collection contains 87 percent of all known manuscripts of Goethe's poems. Furthermore, the archives have subsequently added Goethe autographs from manuscript auctions and private collections.

The estate of Goethe also includes his scientific writings, his diaries, letters, personal and business files. Goethe's scientific writings reflect the wide range of his interest in natural sciences. He investigated the function of light and colours, the morphology of plants and was also interested in anatomy, zoology, mineralogy, meteorology, geology, the general fund of knowledge and the methods of science. The scientific records in the estate document Goethe's contribution to the extension of knowledge in different fields during his lifetime.

Goethe's diaries make up almost 10 percent of the whole estate since Goethe wrote them over a period of 57 years of his life. The diaries recall the topics of everyday life that prevailed in Goethe's time and reflect the wide range of Goethe's thinking.

Furthermore, the archives contain a collection of more than 20,000 manuscripts of letters written by Goethe, to more than 1400 different correspondents, including drafts and copies. To complete the collection of letters a total of more than 21,000 letters to Goethe from about 3500 different correspondents have survived. Goethe could count Friedrich Schiller, Alexander and Wilhelm von Humboldt, Karl Friedrich Zelter, Thomas Carlyle and Charlotte von Stein among his correspondents.

In addition, the other parts of the estate including his personal and business files and his collections of autographs and sources of music are of great interest for our understanding of human life in the 18th and 19th centuries. In general, the collection reflects the myriad subjects to which Goethe devoted himself throughout his lifetime, including literary, scientific, philosophical, political and aesthetic issues.

◀ *Statue of Goethe in Goethovo Namesti (Square), Marianske Lazne, Czech Republic.*

Ilseongnok: Records of Daily Reflections

Inscribed 2011

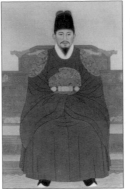

What is it

Ilseongnok originated in the personal diaries of King Jeongjo, from before his accession to the throne in 1776. After his accession, it was transformed into an official daily journal of state affairs and continued until 1910.

Why was it inscribed

The *Ilseongnok* provides a fully documented picture of the operations of an Asian dynasty at a time of social and geopolitical transition into the modern era.

Where is it

Kyujanggak Institute for Korean Studies (KIKS) at Seoul National University, Seoul, Republic of Korea

▲ *King Jeongjo (1776–1800) of Korea, who started the 'Records of Daily Reflections'.*

A few of the 2329 volumes of Ilseongnok *('Records of Daily Reflections'), the official daily journal of state affairs kept by the Joseon dynasty in Korea from the late 18th century until 1910.* ▲ ▶

Ilseongnok, literally 'The Records of Daily Reflections', originated in the diaries kept by King Jeongjo (1776–1800), twenty-second monarch of the Joseon dynasty (1392–1910), from the days before his accession to the throne. In these diaries, he reflected on his everyday life and academic progress. Once he acceded to the throne, King Jeongjo had officials of Kyujanggak, the royal library, keep daily records and obtain his approval for the content, transforming *Ilseongnok* from the personal diary of the monarch to an official daily journal of state affairs. As such, it continued to be compiled until the fall of the dynasty in 1910. The complete set comprises 2329 volumes.

Ilseongnok is unique in terms of the reasons for its compilation, the style and format of writing, and the content. Historical records compiled in the pre-modern period usually dealt with past events while *Ilseongnok* was a contemporary record and its compilation was politically motivated for use as a reference for the king in ruling the nation. *Ilseongnok* describes events in an orderly manner and is accompanied by explanatory notes for quick and easy reference. It also displays originality in content, much of which is hard to find in any other historical documents from the Joseon era, such as procedures for state ceremonial rites, reports by provincial government officials, lists of convicts and investigation records by the State Tribunal (*Uigeumbu*) and the Ministry

of Justice (*Hyeongjo*), petitions by the common people and subsequent measures taken, reports by secret censors, diplomacy-related documents and envoys' reports and even daily weather reports related to farming.

The compilation is not merely the historical record of state affairs but it also has significance in world history because of its detailed descriptions of political, cultural, scientific and technological exchanges between the East and West from the 18th century to the early 20th century. The *Ilseongnok* contains specific records on how science and technology, initially filtered through China, was propagated and developed in Korea. With Western imperialistic expansion into the region in the 19th century, *Ilseongnok* gives a detailed portrayal of this process and clashes that ensued.

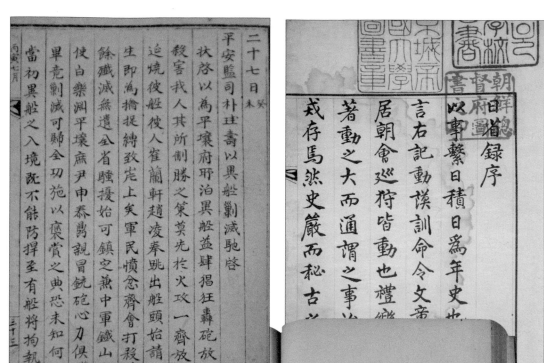

日省錄序

戎存馬然史嚴而秘古之
著動之大而通謂之事也
居朝會巡狩皆動也禮樂
言右記動謨訓命令文帝
以事繫日積日爲年史也

二十七日（乙未）

平安監司朴建壽以異艦剿滅馳啓

狀啓以爲平壤府邪泊異艦益肆猖狂轟砲放銃
殺害我人其所剿勝之策莫先於火攻一齊放火
延燒彼艇彼人崔蘭軒趙凌奉跳出艇頭始謀救
生即爲搶捉縛致岸上矢軍民憤怨齊會打殺其
餘殲滅無遺全省驅擾始可鎮定熟中軍鐵山府
使白樂淵平壤庶尹申泰鼎親冒銃砲心力俱殫
早竟剿滅可賜全切施以褒賞之典恐未知何如
當初異艦之入境既不能防捍至有艇將拘執之

丙寅七月　三十三

命枝正堂上不必逐日仕進
因實錄屬進不進草子教以此枝正就
畢云枝正堂上如無日下綸摩之事不必逐日仕
進或因向來飭教無事赴衙則徒有空往空來之
歎以此意令史局知悉

刑曹以金聲玉擊錚四啓

該曹啓言再昨日動駕時德山居金應斗爲名人梅以
情以爲丁酉戊戌兩年京居金應斗爲名人梅以
宮監以掘浦作畓事與同行十餘人來索食價爲
一百五十兩而終不備給云矣金應斗之爲捕宮

差誣誑愚民之狀極爲駭駭押送該道監營使之
一一徵給金聲玉則以如此瑣屑之事肆軍黨螫聞
原情勿施依受教請勘虞兔之教以克軍分揀
夾狀收贖而追來宮差之弊又欲復起于若此則
卽梜以後一副當規模惟在絕私遵保民産六字
符而飭禁捎弛則無論真宮差假宮差假復踵前醫
之弊安保其必無也德山事特一蹻跎之乱联誠
宮宮任捉致嚴問捧供以聞此微又無論此事俊
事如有宮差作弊之事誠地方官卽報巡營自巡
營亦卽狀聞如是申飭而外邑或又搪置則是豈

辛丑閏五月

The Endeavour journal of James Cook

Inscribed 2001

Cook's journal ▶

What is it

The journal of Lieutenant James Cook describing his first exploration in the Pacific on HMS *Endeavour* in 1768–71.

Why was it inscribed

James Cook is among the great navigators and explorers of the world and the journal is one of the few substantial manuscripts in his own hand. Cook circumnavigated New Zealand, charted the east coast of Australia and explored Tahiti and the Society Islands in the South Pacific. His discoveries and his journal were believed to have opened the way for British colonization of Australia in the decades that followed.

Where is it

National Library of Australia, Canberra, Australia

James Cook, then a lieutenant in the Royal Navy, was commander of a joint Royal Navy and Royal Society expedition that set out from England to explore the South Pacific in 1768. Its aims were two-fold: to observe the transit of Venus across the Sun in 1769 – observations which helped determine other distances in the solar system – and to find the *Terra Australis Incognita*, the unknown southern land, already assumed by Europeans to exist. Cook had already proved himself skilful in mapping and cartography during service in North America in the 1850s and '60s. His voyage in the southern hemisphere, from August 1768 to July 1771, lasted almost three years.

The expedition sailed southwest across the Atlantic, stopping at Rio de Janeiro before rounding Cape Horn to reach Tahiti in April 1769. There the crew observed the transit of Venus before sailing west to search for the southern continent. With the help of a Tahitian mariner, Cook reached New Zealand in October 1769, mapping it with few errors.

From there he set course west on 31 March 1770 in search of the continent and with little knowledge of what lay ahead of him. In fact, the ship's crew sighted the southeastern coast of Australia on what is now recognized, allowing for time differences, to be 20 April 1770. From

what the explorers named Point Hicks, the *Endeavour* sailed north up the east coast of Australia before finally dropping anchor on 29 April at a place Cook later called Botany Bay after the botanical specimens the ship's scientists collected there. The crew made their first contact with local people there.

The *Endeavour* was badly damaged on the Great Barrier Reef as she sailed north, requiring repairs lasting more than six weeks. During the enforced stopover they encountered more aboriginal people and the scientists collected more botanical specimens. Once through the Torres Strait to the north, Cook landed on Possession Island and claimed for the British Crown the coastline he had just navigated. The expedition lost several members to tropical and other diseases in the East Indies before finally sailing for England via the Cape of Good Hope.

Cook's journal covers the entire voyage, although one page is missing. While the journals of several other members of the *Endeavour* party have survived, Cook's is considered preeminent as it records the experiences and reflections of the expedition leader, a man who was one of the world's great explorers in his own right. Furthermore this journal is the founding document of the National Library of Australia.

Cook's journal deals directly or indirectly with many aspects of his voyage: life on board a Royal Navy vessel in the 18th century; the relations between Cook, his officers, the crew, the scientists and the artists on the expedition; the exploration of the South Pacific; experiments with navigational instruments; the precise charting of immense coastlines; astronomical observations; and observations of the topography, flora, fauna and possible resources of the countries explored.

In addition to assessments of the land and sea, the journal is also one of the earliest written records of the indigenous peoples of Polynesia, New Zealand and eastern Australia and records relations with them and observations of their physiognomies, economies, social systems, customs and religions.

This replica of the HMS Endeavour was launched in 1994. ▶

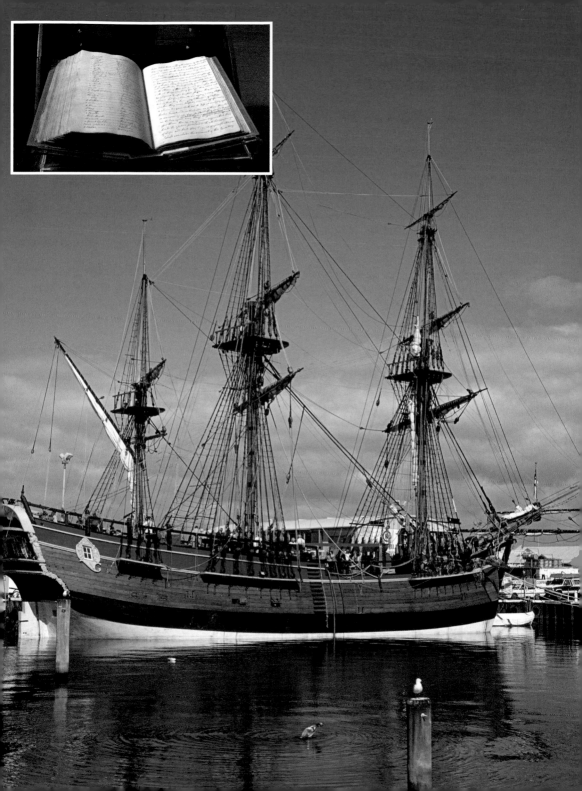

National Education Commission archives

Inscribed 2007

Jagiellonian University, Krakow, which was supervised by the Commission. ▶

What is it

A collection of manuscripts, journal extracts, printed papers, maps, directives and curricula that were created from 1773 to 1794.

Why was it inscribed

The Polish National Education Commission was the first Ministry of Education in the world, and introduced the first comprehensive, democratic public-school system open to all social classes, and to women. It is of global significance for its early adoption and propagation of the progressive and democratic values of the 18th-century European Enlightenment.

Where is it

Polish Academy of Arts and Sciences, Krakow, Poland

The National Education Commission (NEC) reform was carried at a groundbreaking time of social and political change in 18th century Europe and the wider world. It was an era of major scientific discoveries, especially in natural sciences, and economic transformations that would lead to the birth of capitalism. Social revolutions changed countries from medieval structures with dynastic and authoritarian political systems to new national states. The NEC reform anticipated these changes, becoming the first educational reform to implement a curriculum of new knowledge about nature and man.

The Commission was an institution established by the Sejm (Parliament) on the initiative of the King of Poland, Stanisław August Poniatowski. It combined the features of an administrative body with some juridical powers and its members were drawn from all strata of society: there were two bishops and eight laypersons, nobles, scientists, intellectuals and the king.

The educational curriculum covered natural sciences, mathematics and philosophy and was prepared for all the social classes and for all teaching levels – tertiary, secondary and parochial schools. This had a decisive impact on the education of peasants who were still legally dependent on their overlords. It also covered education and schools for women, which was revolutionary

at the time. The curriculum used new textbooks and was supervised by inspectors according to the formulated guidelines.

The archives show the framework on which the reforms were built. They contain manuscripts, guidelines for inspectors, plans for study reforms, journal extracts, entitlements to teach, buildings inventories, receipts, maps, directives and curricula created in the period 1773–94. The records depict all aspects of the implemented reform: the concept, methods of completion, the organizational system and resources used.

The inventive reforms of the NEC were reflected in the slogan 'Education is public interest'. The concept was introduced consistently throughout the country and it had decisive social and political impacts, sowing the seeds of the Polish national identity. The successful completion of such a systematic educational programme has no equivalent in the political history or reformatory efforts of previous times.

Although the archival records have suffered severe damage, in particular during the Second World War, the nominated collection symbolizes the historical significance of the National Education Commission.

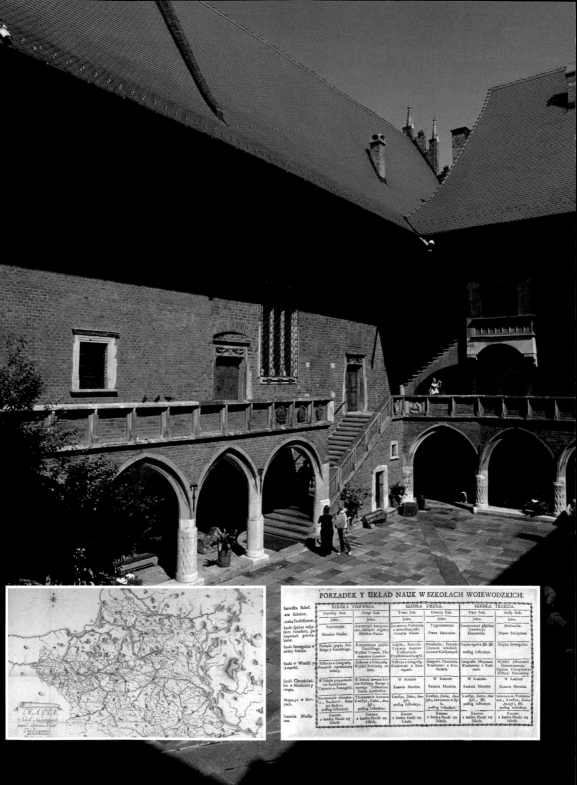

Documentary heritage of the Viceroyalty of the Río de la Plata

Inscribed 1997

▲ *Documents from the collection*

What is it

The documentary archive of the Spanish Viceroyalty of the Río de la Plata which was established in 1776 and lasted until 1810.

Why was it inscribed

The documentary archive covers the political and administrative history of the last Spanish viceroyalty in South America against a background of decline in the Spanish overseas empire.

Where is it

Archivo General de la Nación, Buenos Aires, Argentina

Viceroyalties were the administrative territories through which Spain governed its extensive and far-flung empire. The viceroyalities of New Spain and Peru were responsible for vast areas of land in South America and beyond, but growing pressures on the administration in the 18th century, and especially encroachment from Portugal and Great Britain, forced the creation of two new viceroyalties: New Granada, in 1717, and the Río de la Plata in 1776. This was the last viceroyalty Spain established in South America.

The capital of the new viceroyalty was in Buenos Aires and its extensive lands took in the areas that comprise modern-day Argentina, Uruguay, Paraguay, Bolivia and a part of Peru. The documentation for the viceroyalty covers the administration of government, justice, defence, economics and religion from the 17th century when the Spanish established their foothold on to the first decade of the 19th century.

A separate part of the archive relates to trade and shipping. Documents on the ports of Buenos Aires and Montevideo allow an insight into the viceroyalty's political and commercial relations with other American countries, with Europe and with Africa. This included the registration of ships, ship arrivals, cargoes, crews and passage and departure to foreign ports. Shipping officials also supervised the slave trade.

Papers relating to the slave trade are also spread through other parts of the archives, including censuses, legal records, registers and account books. As a whole, they cover the processing of slaves from the time they were brought in, through their taxation, sale and distribution. The history and development of the trade can be followed through the documents up to the end of the viceroyalty. Slaves were brought into the Río de la Plata until 1812, when the post-independence government banned their import.

The administration and practice of enforced indigenous labour was dealt with at the level of governorship, of which there were eight in the viceroyalty. The Laws of the Indies, the corpus of Spanish Crown laws for the regulation of its imperial possessions, prohibited enslavement of the native peoples; nevertheless as the papers show, various categories of enforced labour existed. The viceroyalty experienced a large-scale rebellion by indigenous people in the early 1780s.

The inscription includes colonial documentary collections from the republics of Uruguay, Paraguay and Bolivia as well as from Puno, a district in Peru. ▶

siendo testigo guillermo Joan residente en esta ciudad

[firmas]

En la ciudad de la trinidad a diez dias del mes de
abril de mill y seiscientos y quatro años ante el dho
alcalde y estando presente el dho licenciado ant.º xo y
rillo se rematron en pregon ocho piezas de esclavos
quatro hembras y quatro varones de la dha armazon
por voz de maestre Jaques y uvo differentes posturas
y augustin ramirez los que en ducientos y treinta p.º
cada pieça machos y hembras los quales pagara luego
de contado y se pregono la dha postura e no pareçio
quien pujase aunque se hizieron muchas diligencias y
apercibimientos Lo qual visto de conçentim.to del dho
D.º ant.º rosillo en el dho nombre que estava presente el
dho pregonero apercibir remate diziendo dos ci y
entos y treinta p.º dan por cada pieça de esclavo
a la una a las dos a la terçera quien que no ay
quien puje ni ay quien de mas que buena pro le hagi y
endo tres veces prottesada y assi quedaron re-
matadas las dhas ocho pieças de esclavos en el dho
augustin ramirez a ducientos y treinta p.º cada
uno y el dho D.º ant.º rosillo en el dho nombre
y el dho alcalde que assistio a esta moneda ouieran
por fecho el dho remate y lo aprovaron y el
dho augustin ramiñes que estava presente
le acepto y llevo en su poder los dhos esclavos

Colombeia: Generalissimo Francisco de Miranda's archives

Inscribed 2007

What is it

The sixty-three unique and irreplaceable volumes of documents, manuscripts, prints and maps of Generalissimo Francisco de Miranda (1750–1816) that were organized by Miranda himself.

Why was it inscribed

The archives portray Miranda's role in notable historical events including the American War of Independence; Tsarist Russia in the era of Catherine the Great; the French Revolution; and the initial struggle for independence of the Spanish American colonies.

Where is it

Archivo General de la Nación, Caracas, Venezuela

Francisco de Miranda was born and brought up in Caracas. He was an officer in the Spanish Army during the Spanish-Moroccan war (1774–75) and at the siege of Pensacola, in American Florida during the American War of Independence (1781); he was authorized by Catherine the Great in 1787 to wear the uniform of a Russian army officer; and he played a key role as Commander-in-Chief of the French Armies of the North, under General Charles

Dumouriez (1792), in defence of the French Revolution during the war against the Prussian-Austrian coalition.

His passion for freedom governed his life. From 1790 he tenaciously promoted Latin America's independence. He presented his project before the British government, travelled to revolutionary France seeking cooperation for his undertaking and promoted his project among politicians of the burgeoning American democracy. Simultaneously, he wrote constitutions, prepared invasion plans, wrote proclamations, promoted meetings and raised funds, all for one purpose: the independence of the territories of Latin America. In 1811, he was appointed Land and Sea Commander-in-Chief of the Venezuelan Confederation and led the initial independence campaign

▲ *A map of Greece, published in Paris in 1780, from the Miranda archives.*

▲ *A map of New York, published in May 1804, from the Miranda archives.*

against the Spanish rule. However, he was unsuccessful and was taken into custody by the Spanish in 1812 and then spent the last four years of his life in prison in Cadiz, Spain.

Don Francisco de Miranda was one of the most important chronicle writers of his time and he committed himself to preserving the traces of an era of profound change. He travelled all over Europe, Asia Minor and the Atlantic coast of the United States of America, the result of which was a vast account of personal observations on different topics and an outstanding compilation of documents and personal letters to and from important personalities of the time. His archives cover the final years of the 18th century and

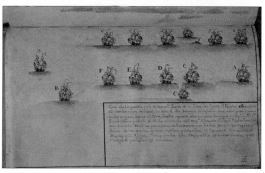

▲ A detail from Miranda's illustration of a battle at sea.

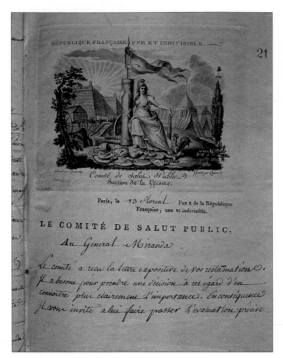

▲ A note to Miranda from the Committee of Public Safety, War Section, headed by a wonderful engraving symbolizing the French Republic.

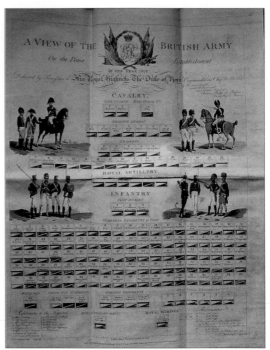

▲ An interesting item in the collection for a former French general, 'A view of the British Army Establishment on the Peace in the year 1803', a peace which was short-lived.

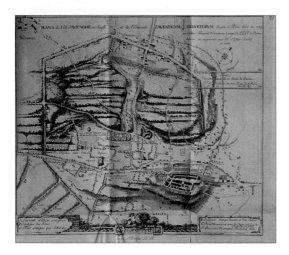

▲ A map of Avenghe (now Avenches) in Switzerland and of the ruins of Aventicum, the capital of Roman Switzerland (Helvetica), produced in 1786, from the Miranda archive.

beginning of the 19th century, and are linked directly to events of great historical significance: the independence of the United States of America and the decisive Franco-Spanish participation in the conflict; the political life of Tsarist Russia in the era of the Empress Catherine the Great; the French Revolution and wars to defend it; and, last but not least, the initial struggle towards independence in the Spanish American colonies. He kept a wide variety of documents and records which illustrated his efforts to attract world attention to his cause of independence for Spanish America from Spain. He organized and saved personal and official letters, complete judicial records, notes, and even revolutionary and military music scores (including an original score of the *Marseillaise*) which today constitute a fundamental primary source to understanding these processes of world importance.

The archives of Generalissimo Francisco de Miranda comprise different types of documents, manuscripts,

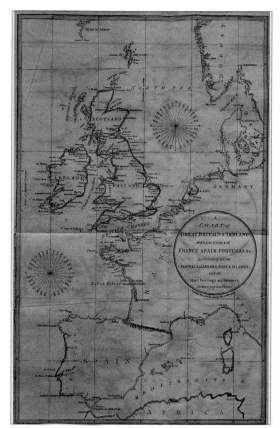

▲ 'A chart of Great Britain and Ireland with the coasts of France, Spain and Portugal exhibiting all the Channels, Harbors, Bays Islands with bearings and exact distances' published by John Stockdale of Piccadilly, London in 1798, from the Miranda archive.

▲ A fascinating example of the wealth of the Miranda Archives, a menu of the food and wine offered by M. Savard, Restaurateur.

letters, prints and maps. Miranda himself organized it in 1805. It includes sixty-three volumes, divided into three sections: travels (twenty-six volumes), the French Revolution (eighteen volumes) and negotiation (nineteen volumes). A few days before he was detained by the Spanish in 1812, he sent all the boxes that contained this documentation to Curaçao (a British colony at the time). Soon after, the documents were sent to Great Britain, where they stayed until Venezuela acquired them in 1926.

The Convict Records of Australia

Inscribed 2007

What is it

The records of the forced emigration or transportation to Australia of around 165,000 people convicted of crime in Britain. This practice of the British penal system lasted 80 years, from 1788 to 1868.

Why was it inscribed

The Australian convict records document a period in the 18th and 19th centuries of state-organized forced migration as a means of combating and punishing criminal activity. The transportees were largely of a lower social group that was rarely officially documented at this time. It is estimated that the convicts were the ancestors of around one third of Australia's current population.

Where is it

State Records Office of New South Wales, Kingswood, Australia; Archives Office of Tasmania, Hobart, Tasmania, Australia; State Records Office of Western Australia, Perth, Australia

The British settlement of Australia progressed through the establishment of individual colonies. New South Wales was the first colony established, in 1788, and Van Diemen's Land, later Tasmania, was settled in 1803, as a part of New South Wales until 1825. The Swan River Colony, later Western Australia, was initially free but labour shortages forced the colony to accept convicts in 1850. In addition to these colonies, the remote Norfolk Island was settled as a penal settlement in 1824. Convicts provided the labour needed to break new ground and establish the colonies as self-supporting. They were assigned to work as servants for free settlers where possible, otherwise being housed in barracks.

The bureaucracy of transportation was kept on an individual colony level. The records for each colony do not generally cover the full time span of the policy of transportation; instead, different record categories cover different time periods. Indents reveal each transportee's name, age, birthplace, home town,

Convicts sentenced to hard labour ▶

Nº 9 SKETCHES OF AUST

*The above represents ...
years since, it consisted of carr...
pounds a piece, the distance th...*

Produced for Associated Pu...

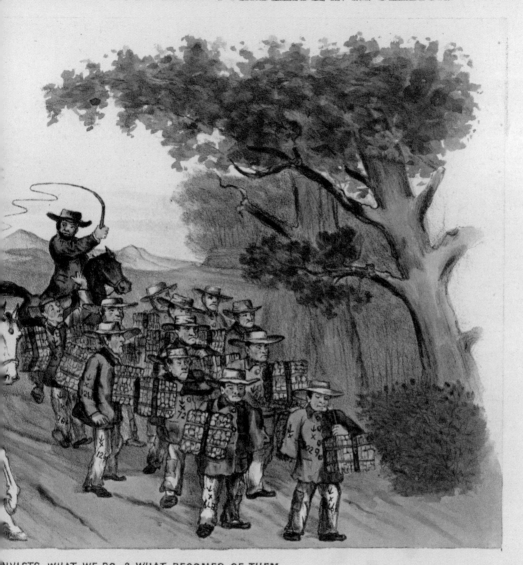

...NVICTS WHAT WE DO & WHAT BECOMES OF THEM.

*...bor gang in Tasmania, performing a species of work which used to be imposed on them, some
...es of shingles or wooden tiles.– They each man carried two of them weighing twenty eight
...walk generally averaged about thirty miles daily.– This inhuman labor is now abolished*

...Mills Limited by N. J. Field & Co. Pty. Ltd. with kind permission of The National Library of Australia, Canberra

Printed on Burnie Glopaque Wove. 1970

trial details and sentence. Medical records list illnesses, hospital admissions and individual patient records. Conditional and absolute pardons were listed, as were convict marriage applications and deaths. Records were kept of certificates of freedom and tickets of leave which allowed a form of parole within the colony. Re-offending and convictions within Australia were recorded. In Van Diemen's Land, registers listed descriptions of the convicts' physical appearances and their conduct. There are also general administration and financial management records both within Australia and with Britain.

Although they were created and logged with bureaucratic impersonality, the convict records are often deeply personal. The records allow access to the life experience of transported men and women by modern historians and family descendants, in ways unparalleled in other mass migrations. The detailed physical descriptions provide a rare view of a broad segment of the British and Irish population of the time and is an invaluable resource for a wide range of demographic, medical and other research.

Picture of a Convict: The Story of Susan Courtney

The Convict Indent recorded prisoner details and one of the entries from the 1820s is transcribed below. It relates to a Londoner called Susan Courtney who was transported to New South Wales colony.

Grenada 3rd (1825) Anderson Master

No. 19

Name – Susan Courtney alias Elizabeth Jones

Trade or calling – Nursery maid. Escaped from the Colony in the Emerald 1823

Tried Where/When – from VDL about 2½ years ago came in the Friendship husband John Peck lived at Nottingham; London Septr 16 came more than 14 years since

Sentence – Life

Age – 32

Native place – London

Height – 5 Feet 2½ Inches

Colour of Eyes – Hazel

Hair – light brown

Complexion – fresh

Remarks – Well

To whom assigned –

The story of Susan Courtney:

'Susan Courtney was originally tried and convicted for forgery on 16 April 1817 at Middlesex and sentenced to 14 years transportation. She arrived in Sydney on the Friendship in January 1818. She was then sent with other prisoners on the Duke of Wellington to Van Diemen's Land. There she married John Peck and subsequently managed to escape back to England.

Perhaps unwisely, Susan returned to her old haunts, and was recognised in the street by William Nicols 'one of the conductors of the Bow Street Night Patrol'. She was apprehended (despite giving the false name of Elizabeth Jones), and was tried on 10 September 1823 for returning from transportation, and found guilty. She was re-transported to New South Wales on the Grenada in 1825 with a life sentence.

Susan Courtney continued to cause problems for the authorities. On 13 June 1826 she was sentenced to the Female Factory for 3 months for being at large without

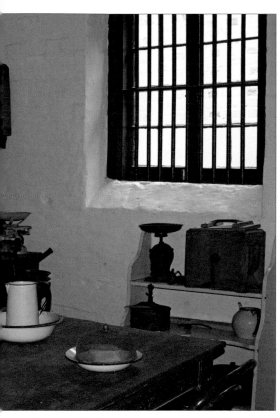

◀ *A former prison, now a museum reconstructing prison life.*

legal authority. In 1827 she appears on a list of prisoners who recently escaped from the Female Factory. By 1833 she appears to have been sentenced to further time in the Female Factory as there is a letter in the Colonial Secretary's Correspondence from her husband, John Peck, praying for her release CSIL 33/4733 [4/2191.5], Reel 2196.

Whether by guile or good fortune, Susan managed to obtain her freedom somewhat earlier than she should have. In early June 1831 she obtained a Certificate of Freedom as Susan Courtney per 'Friendship'. Granting her a certificate of freedom was a major administrative error on the part of the authorities, as the life sentence imposed in 1823 should have superseded the original 14 year term, and she should have remained a convict for many years beyond 1831.'

Original Declaration of the Rights of Man and of the Citizen (1789–1791)

Inscribed 2003

What is it

The first version of the 1789 *Declaration of the Rights of Man and of the Citizen*, which was finalized by the National Assembly in Paris during the summer of 1789, related documents and the 1791 Declaration.

Why was it inscribed

The *Declaration*, together with its supporting papers, are fundamental documents in the evolution of democracy and respect for human rights around the world.

Where is it

Centre Historique des Archives Nationales, Paris, France

This inscription covers a collection of documents connected to the proclamation of the *Declaration of the Rights of Man and of the Citizen* and its entry into law. The symbolic and political importance of the *Declaration* and the historical context in which it was drafted can be fully appreciated only if these documents are considered together.

A comparison of all the existing versions of the *Declaration* shows that there are six different versions, dating from the beginning of the discussion stage to the promulgation of the Constitution in 1791 and not, as historians and folk memory still seem to suggest, just one single text. However, only two versions meet the criteria for legal validity. Both these versions were adopted by

The original draft of the 1791 Constitution, preceded by the text of the Declaration of the Rights of Man and of the Citizen, signed first by the President and secretaries of the National Assembly on 3 September 1791, and then by the King on 14 September 1791. ▼ ▶

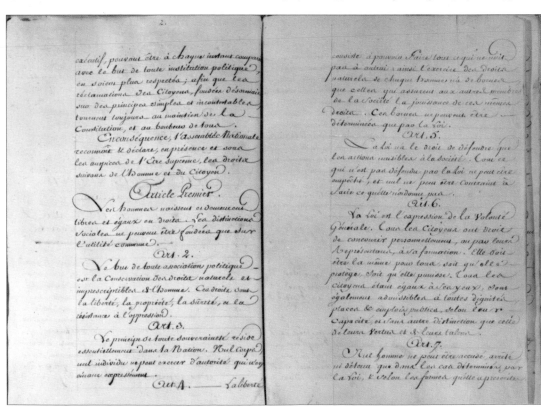

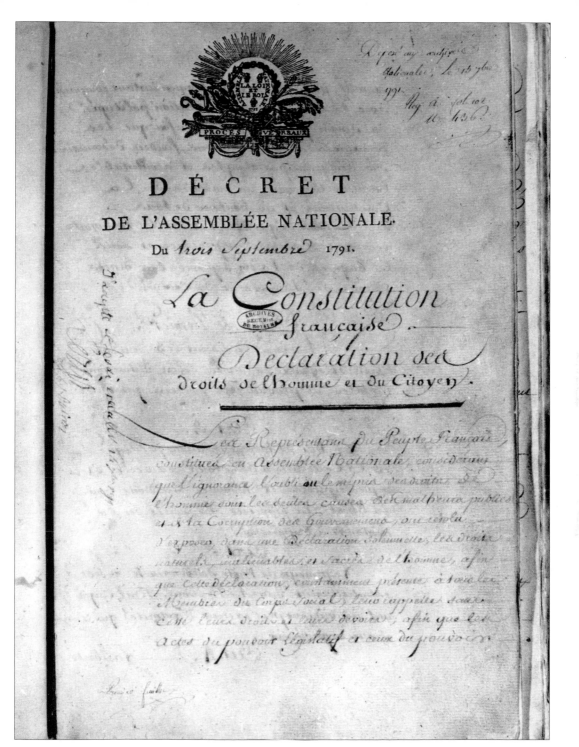

DÉCRET

DE L'ASSEMBLÉE NATIONALE.

Du *trois Septembre* 1791.

La Constitution française.

Déclaration des droits de l'homme et du Citoyen.

Les Représentans du Peuple Français, constitués en Assemblée Nationale, considérant que l'ignorance, l'oubli ou le mépris des droits de l'homme sont les seules causes des malheurs publics et de la corruption des Gouvernemens, ont résolu d'exposer, dans une Déclaration solemnelle, les droits naturels, inaliénables, et sacrés de l'homme, afin que cette déclaration, constamment présente à tous les Membres du corps social, leur rappelle sans cesse leurs droits et leurs devoirs; afin que les actes du pouvoir législatif et ceux du pouvoir

the National Assembly, received royal approval, were promulgated by letters patent or law and, finally, were officially published. The first version corresponds to the 1789 *Declaration*; the second is the 1791 *Declaration*. The collection includes the handwritten text of the *Declaration of the Rights of Man*, taken from the minutes of the National Assembly, checked against the original on 30 September 1789 by the serving President, Jean-Joseph Mounier, and the six secretaries, and tabled for a vote by the National Assembly on 2 October 1789; and a signed note by Louis XVI approving the aforementioned text: *'I hereby fully accept the articles of the Constitution and Declaration of the Rights of Man presented to me by the National Assembly. 5 October 1789. Louis.'*

The *Declaration* represents, on its own, the legacy of the French Revolution and sums up its principles and ideals. It was originally a French text, but from the time of its promulgation it was aimed at all humanity, irrespective of cultural, religious, political and other differences. It established respect for the human person as an inviolable and fundamental principle. The *Declaration* has a universal value extending beyond cultural, religious, political, ethnic, economic and social differences, and it thereby establishes the inalienable rights and duties of every human being and has had a major influence on human history. It is one of the foundations of international law and formed the basis of the United Nations Declaration of 1948.

les cas déterminés par la Loi.

Art. 12.

La Garantie des droits de l'Homme et du Citoyen nécessite une force publique : cette force est donc instituée pour l'avantage de tous, et non pour l'utilité particulière de ceux auxquels elle est confiée.

Art. 13.

Pour l'entretien de la force publique, et pour les dépenses d'administration, une contribution commune est indispensable : elle doit être également répartie entre tous les citoyens, en raison de leurs facultés.

Art. 14.

Tous les Citoyens ont le droit de constater par eux-mêmes ou par leurs Représentants, la nécessité de la Contribution publique, de la consentir librement, d'en suivre l'emploi, et d'en déterminer la quotité, l'assiete, le recouvrement et la durée.

Art. 15.

La Société a le droit de demander compte à tout agent public de son administration.

Art. 16.

Toute Société dans laquelle la garantie des droits n'est pas assurée, ni la séparation des pouvoirs déterminée, n'a point de Constitution.

Troisieme

Introduction of the decimal metric system, 1790–1837

Inscribed 2005

What is it

Nine items dating from 1790 to 1837, which were central to the introduction and adoption of the decimal metric system in France.

Why was it inscribed

The decimal metric system devised and adopted in France after the revolution of 1789 provided the basis of today's international measurement system. It has since spread across the world to become the standard official system of measurement in most countries and has been applied in almost every area.

Where is it

Archives Nationales, Paris, France

The decimal metric system emerged out of the drive for centralization and uniformity that characterized the French political establishment during the country's revolutionary period from 1789 onwards. The inspirations for this drive were the ideas that came out of the 18th-century intellectual movement of the Enlightenment and its emphasis on the supremacy of reason.

A central part of the ideas of the Enlightenment was the reform of society. The new decimal metric system was one part of a manifesto intended to overthrow or remodel the social systems that existed in France up to the revolution. The attempted reforms were ambitious and all-encompassing and took in areas as diverse as timekeeping and the calendar, measurement, taxation and the currency and the systems of law and government. The reformers also attempted to end the monarchy, the titled aristocracy and religious practice and worship.

These post-revolutionary reforms had varying degrees of success although in many cases the changes they brought to both institutions and individual life in France were profound. The new decimal metric system would eventually prove to be one of the more enduring reforms.

Before its introduction, there was no agreed principle for calculating weights and measures in France: it was estimated that one foot, for example, was measured at twenty different lengths across the country. In 1790 the pragmatic politician Talleyrand, who was at that point the bishop of Autun, proposed the adoption of a new system of measurement that was at once universal, invariable, reproducible and verifiable everywhere and at all times.

In 1791 it was decided that the measure of one quarter of the earth's meridian should be used as a natural, universal unit. Under economic and military pressures, the measurement first adopted in 1793 was one ten-millionth of the distance from the North Pole to the Equator, a distance equal to 3 feet 11 lines and 44 hundredths of a line as measured by the Académie des Sciences (the French Academy of Sciences).

A standard metre measurement was built in platinum as it was less susceptible to shifts in temperature than other metals. A platinum weight was also made for a standard kilogram measurement, a gram being based on the weight and thermodynamic properties of water – one gram was defined as the mass of one cubic centimetre of water at its temperature of maximum density.

The new measures were officially approved in 1799 but were not uniformly popular in France and even Napoleon once banned the system. They finally became compulsory in 1840. Over the following centuries, the decimal metric systems have been adopted for official use in virtually all areas of activity in line with the International Organization for Standardization (ISO).

Nine documents and items are considered central to the introduction of the decimal metric system in France. The first five, from 1790 to 1795, are documents: the Bishop of Autun's initial proposal of weights and measures reform to the National Assembly; the law, approved by King Louis XVI, relating to the method of establishing the standards; a National Convention decree establishing a standard; the measurements themselves based on the measured length of the earth's meridian; and the National Convention decree to establish the new system.

Two of the items, both dating from 1799, are the metre length and kilogram weight made in platinum and deemed to be the standard. A certificate of registration for both with the National Archives exists for the same year. Finally, a handwritten law from 1837, signed by King Louis Philippe, made the new metric system compulsory in France from 1 January 1840.

Talleyrand, then bishop of Autun, proposed the adoption of a new system of measurement after the revolution in France. ▶

The Leprosy Archives of Bergen

Inscribed 2001

What is it

Administrative, medical and financial records relating to leprosy from three hospitals in Bergen.

Why was it inscribed

The Leprosy Archives of Bergen comprise the only archive worldwide on the existence and eradication of leprosy. The holdings document the breakthrough of the scientific understanding and description of leprosy on a world basis.

Where is it

City Archives and Regional State Archives of Bergen, Bergen, Norway

Leprosy, or Hansen's Disease, has always been a problem of the poor and is still a scourge in some parts of the world. Although mostly restricted to developing countries now, it was an everyday part of European life for centuries.

Bergen harbour, Norway ▲

◄ *Waterfront, Bryggen, Bergen, Norway*

At the end of the 18th century, leprosy was a particular health problem in Norway, Iceland and England. During the 1830s, the number of lepers in these countries rose rapidly, an increase attributed to frequent visits of sailors who had travelled widely. This led to an increase in medical research into the condition, and the disease became a political issue. Norway appointed a medical superintendent for leprosy in 1854 and established a national register for lepers in 1856, the first national patient register in the world.

Bergen became the scientific centre of the efforts to cure leprosy, through the work of Dr Danielsen and Dr Armauer Hansen, who discovered *Mycobacterium leprae*, the causative agent of leprosy, in 1873. This was the first bacterium to be identified as causing disease in humans.

Most of the documents in the archive are examples of hospital records as they have evolved over a period of 300 years, covering documentation of leprosy patients' care, leprosy research as well as the development of health policies and the roles of health authorities. These comprise administrative records (including inspections reports, journals, letters, inventories of instruments), medical records (including patients' journals, patient registers, autopsy reports) and financial records.

Also of interest are the many medical illustrations, from the Atlas of Leprosy and other places. The illustrations were made by well-known Norwegian artists such as Johan Ludvig Losting, and are pieces of art as well as scientific documents.

The experience of the Norwegian fight against the disease is still of great significance for the work against leprosy worldwide. The Leprosy Registry was computerised in the 1970s and comprises 8231 patients' records. Since it represents the only source of data so far that documents, from an epidemiological point of view, the decline and disappearance of leprosy in a country, its files have been and are still used for important epidemiological research.

Today leprosy is practically non-existent in Europe, and although there are still 10–15 million lepers in the rest of the world the number of new cases is decelerating. The documentary heritage from this turning point of the fight against one of the world's most dreadful diseases is still internationally sought after.

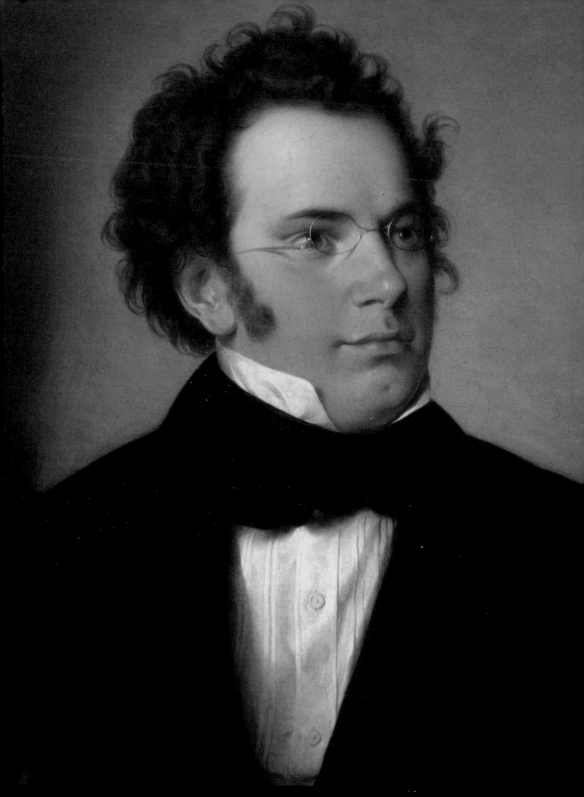

The Vienna City Library Schubert collection

Inscribed 2001

What is it
Original manuscripts by the composer and letters and writings by his contemporaries.

Why was it inscribed
The collection is the world's most substantial body of autograph music manuscripts by Schubert and a nearly complete collection of first editions of the works of one of the world's best known composers.

Where is it
Vienna City Library, Vienna, Austria

Franz Schubert (1797–1828) is one of the greatest and best loved composers of all times and his music is played all over the world. Schubert's creative output, although rooted in the ideals of classical music, marks the beginning of the Romantic era in music. His significance is also shown in the vast amount of literature, both scholarly and popular, dealing with his personality and creative output. More than with many other composers, Schubert's autograph music manuscripts lay the foundation for establishing a reasonably accurate picture of his career.

Schubert's autograph music manuscripts give a fascinating insight into his method of composition: he usually composed his works entirely in his mind before taking down even a first draft. Subsequent corrections and alterations dealt solely with details, never with the general outline of the composition. This method was used only by

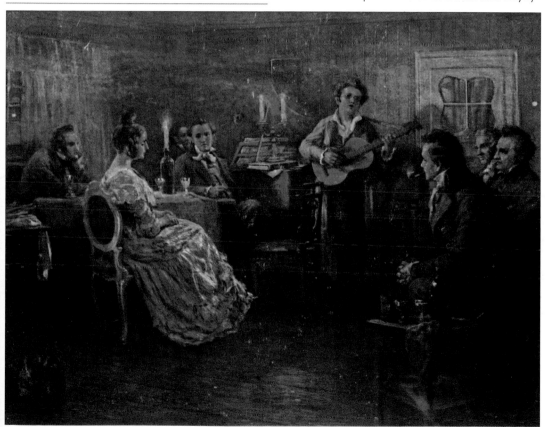

◄ Franz Peter Schubert

▲ Franz Schubert playing to friends at a Schubertiade.

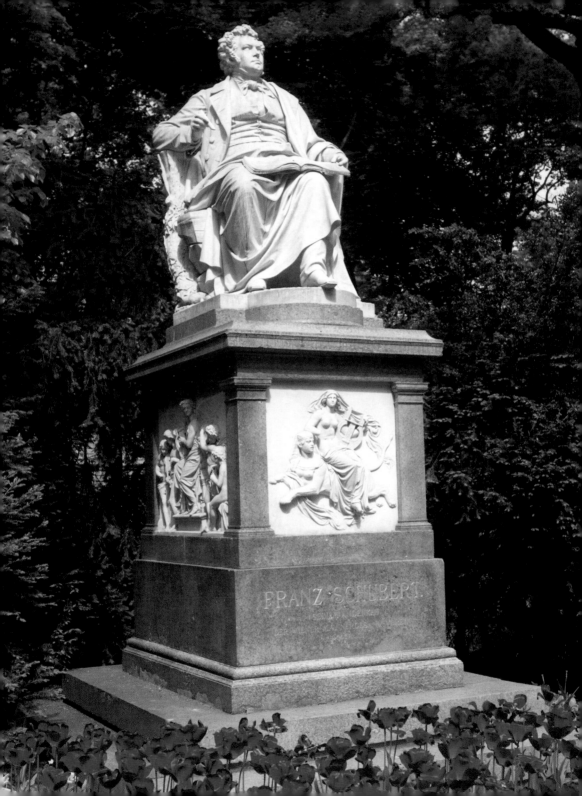

a few other composers, who are rated among the world's most brilliant, like Mozart or Shostakovich.

As the bulk of his output was published and publicly performed only after his death, the evidence established by the manuscripts as to the time of origin of Schubert's works is of special importance. The development of certain musical genres and forms, like the *lied* or the sonata form, has been strongly determined, if not re-defined, by Schubert's contribution.

Schubert's circle of friends, an important factor of both his career and his private life, was unique in music history. Among his contemporaries were great men of literature, art and Viennese life in general. From this circle evolved the Schubertiads: a forum which not only promoted the performance of Schubert's compositions, but also, in spite of a pervasive atmosphere of political oppression, created opportunities for open-minded discussions which transcended the fine arts.

A bequest from the art patron Nicolaus Dumba in 1900 led to the foundation of the Music Collection of the Vienna City Library with Dumba's Schubert collection as its centrepiece. The collection has been systematically enlarged and is today the world's largest collection of Schubertiana.

The Vienna City Library's Schubert collection comprises about 340 autograph music manuscripts, first editions of nearly all of Schubert's works, numerous later editions and manuscript copies by other hands, several autograph letters and other writings and various further documents referring to Schubert (in particular writings by members of his circle of friends), accompanied by a large collection of international literature on Schubert.

The Vienna City Library's Schubert collection is often consulted by musicologists from all over the world. Items from the collection have been regularly demanded as show pieces for exhibitions and for several of Schubert's compositions the collection provides the only source material available.

◄ *Franz Schubert Memorial in Stadtpark, Vienna.*

The masterpieces of Fryderyk Chopin

Inscribed 1999

What is it

A collection of original musical autographs, copies of Chopin's works, letters and notebooks.

Why was it inscribed

Chopin's originality, uniqueness and worldwide popularity make him one of the world's most prominent and influential musicians, and this collection is a unique archive of his works.

Where is it

National Library, Warsaw, Poland

Fryderyk Chopin (1810–49) was a composer and virtuoso pianist of French-Polish parentage. He is considered one of the great masters of Romantic music and is often grouped with Bach, Mozart and Beethoven as an original composer of universal influence.

Chopin's works had a huge influence in 19th-century music and Romanticism still plays an important part in modern culture. Romanticism in music is characterized by the use of a large number of instruments, a rich sound and the rejection of rigid rules, as well as by the presence of lyrical, folk and poetic elements. Even though Chopin helped create the Romantic movement, his music had a very individual character that is distinct form his predecessors and followers.

In his compositions Chopin combined elements of Polish culture with universal ones in a very sophisticated way, appealing to people from different continents and cultural backgrounds. Beyond Europe, he also made a name for himself in Asia (especially in Japan and Korea) and in both Americas.

The Chopin Museum of the Fryderyk Chopin Society in Warsaw (known until 1950 as the Fryderyk Chopin Institute) began collecting Chopin's autographs in 1935. The first thirty-page set of his writings was bought from Ludwika Ciechomska, the great-granddaughter of the composer's sister Ludwika Jldrzejewska. The autography included a trio in G minor opus 8, and together with the other 127 original writings, it constitutes a priceless collection.

More autographs soon followed until, when the Second World War broke out, the collection was moved to Canada. It was returned to the National Library in Poland in 1959. The Fryderyk Chopin Institute once again began gathering autographs written by Chopin; this was not an easy task as he had lived outside Poland for almost 19 years. However, between 1953 and 1967 the Fryderyk Chopin Society received as gifts, borrowed or bought a total of forty items.

Forty-six autographs of Fryderyk Chopin were bought with the museum's own financial resources in the years from 1955 to 1992. The biggest collection of Chopin's

original writings (seventeen items in all) was bequeathed to the Fryderyk Chopin Society by Arthur Rubinstein in 1977.

The works of Fryderyk Chopin now comprise autographs, authorized copies of his works, letters, notes and corrections written on works, notebooks, details of his piano method and congratulatory scrolls. As a whole, this collection paints a unique and rich picture of the life and work of one of history's most original musical talents.

▲ *Rooms used by Fryderyk Chopin, Royal Carthusian Monastery, Mallorca.*

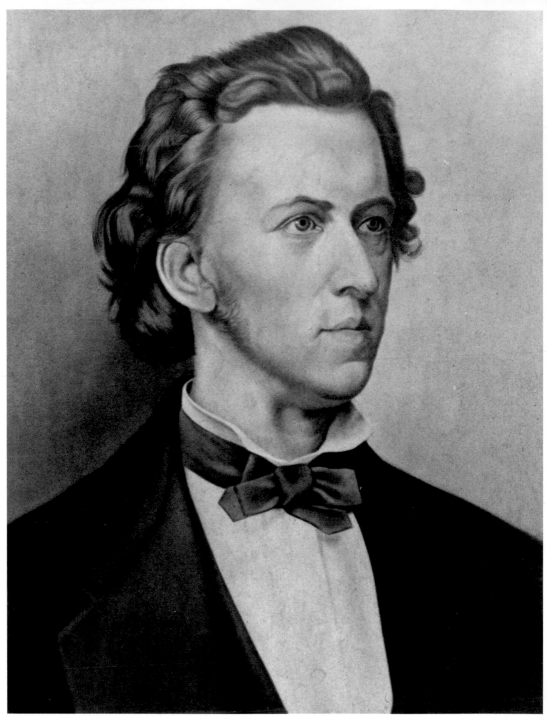

▲ *Fryderyk Chopin*

316 The masterpieces of Fryderyk Chopin

Kinder- und Hausmärchen
(Children's and Household Tales)
Inscribed 2005

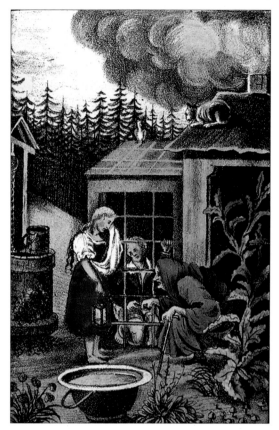

What is it

The annotated reference copies written by the Brothers Grimm, with supplements and notes, of their fairy tales, *Kinder- und Hausmärchen (Children's and Household Tales)*, together with other associated handwritten materials.

Why was it inscribed

The *Kinder- und Hausmärchen* have had an extraordinary and lasting influence on the arts, literature, music, theatre and film which has endured into digitized media.

The *Kassel Handexemplare* (annotated reference copies) of the *Kinder- und Hausmärchen* are the most significant preserved historical source for the origins and effect of the Grimms' fairy tales.

Where is it

Museum of the Brothers Grimm, Kassel, Germany

The *Kinder- und Hausmärchen* (or *KHM*), first published in 1812, is second only to the Luther Bible as the best known and most widely distributed book of German culture. It includes some of the most famous stories in the world, including *Little Red Riding Hood*, *Sleeping Beauty* and *Cinderella*.

The authors were brothers Jacob (1785–1863) and Wilhelm (1786–1859) Grimm, philologists and scholars who were interested in written texts and languages, and in the history of popular culture. They were also fairy-tale collectors and they completed the first compilation and scientific documentation of fairy tales drawn from

▲ *Illustration from one of the Grimms' most famous tales,* Hansel and Gretel.

European and Oriental tradition. Their work was not only hugely popular, it also set a standard for the systematic collection and documentation of popular folk tales.

The Grimms always noted the context in terms of society, history and culture, of each fairy-tale tradition. Their sources and references extended far beyond Germany to embrace popular oral and written narrative material from many countries and cultures. Although the stories as reworked by the Grimms were rooted in and expressed the German Romanticism of their period, they created a lasting and influential collection which resonated beyond their time and place. *KHM* has been translated into 160 languages and has sold many millions of copies around the world in the two centuries since its publication.

▲ Kinder- und Hausmärchen

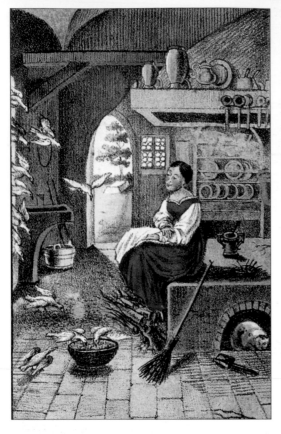
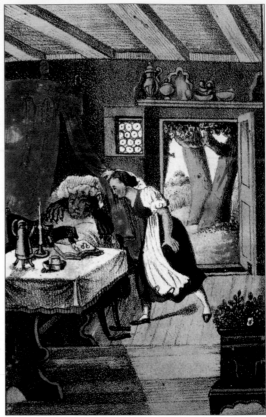

▲ *Illustrations from* Cinderella *and* Little Red Riding Hood

Jacob and Wilhelm Grimm ▶

The special language and poetic quality of the fairy-tale text was a particular factor in their success. Wilhelm Grimm edited and re-edited from one edition to the next, heightening the stories' romantic, stylized narrative tone; this too endures to the present day as the definitive style for fairy-tale narration.

Several parts of the Grimms' archive are listed on the Register. Their own *Kassel Handexemplare* (annotated reference copies) are the authoritative sources for the work, especially for the first two editions in 1812–15 and 1819–22. These comprise handwritten notes, commentaries and lengthier supplements for 201 fairy tales and ten children's legends. Also listed is the *Ölenberger Märchenhandschrift* or Ölenberg Fairy Tale Manuscript with around sixty texts which they prepared in 1810 for a friend, and around thirty individual fairy-tale manuscripts and other source documents, some of which are fragments.

General Archive of the Nation:
Writings of The Liberator Simón Bolívar
Inscribed 1997

▲ A hand-written note signed by the Liberator, Simón Bolívar

A 19th-century engraving of Simón Bolívar ▶

What is it
The archive contains more than 82,000 original documents relating to the Liberator, Simón Bolívar, including manuscripts and printed materials signed by him.

Why was it inscribed
Bolívar's writings constitute a political, social and military record of immense value to South American history. The importance of his actions is immeasurable and his political thought and vision of the future are incomparable.

Where is it
Archivo General de la Nación, Caracas, Venezuela

Simón Bolívar (1783–1830) was born into a wealthy family in Caracas. Both his parents had died before his ninth birthday, and, after a period of private tutoring and military training, he travelled to Spain in 1799 and spent most of the next eight years in Europe, before returning to Caracas. Over the next 20 years he instigated and oversaw the struggles for independence from Spain in the countries which are now the Republics of Venezuela, Colombia, Ecuador and Peru, and gained the nickname 'The Liberator' (El Libertador).

The early 19th century was a time of great philosophical and political changes, stimulated by the American and French Revolutions, and it saw introduction of new policies that were to transform South America. Throughout 20 years of ceaseless activity, Bolívar studied contemporary South American society and its history and looked to the future in a never-ending quest for rules which could serve as a guide for his actions. He was both a man of action and a great thinker and his political and military actions dominated the history of Latin America, from the Caribbean to the Andes on the Pacific Coast.

The work of Simón Bolívar is of universal significance as his writings constitute a political, social and military record which are of key importance in understanding historical events in Bolivia, Peru, Ecuador, Colombia, Panama and

Venezuela. He also wrote about Cuba, Puerto Rico, Santo Domingo (now the Dominican Republic) and Costa Rica.

The archive contains more than 82,000 original documents including: family and personal letters; deeds; decrees; orders; proclamations; speeches; war dispatches; military appointments; and newspapers and other publications. The Archive of Pedro Briceño Méndez held the documents from 1813 to 1818 and was subsequently transferred to the National History Academy in 1915. Documentation corresponding to the period from 1819 to 1830 was kept by General Daniel O'Leary, Bolívar's aide-de-camp (who did not carry out Bolívar's deathbed instructions to burn them). The remainder was kept by Juan de Francisco Martín who transferred his archive to his nephew in Paris, and which was subsequently bought by the Venezuelan government and added to the Archive of the Liberator.

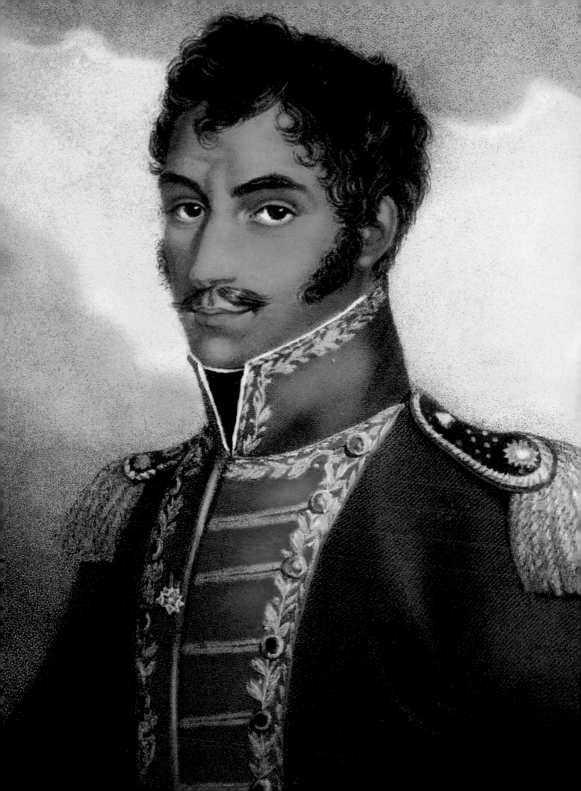

The Søren Kierkegaard archives

Inscribed 1997

▲ *Bronze statue of Søren Kierkegaard, Copenhagen*

What is it
A collection of the manuscripts and personal papers of the philosopher Søren Kierkegaard.

Why was it inscribed
Kierkegaard's existential philosophy and religious writings have influenced thinkers for over 150 years. This archive is a unique collection of his original works and personal materials.

Where is it
Royal Library, Copenhagen, Denmark

Søren Kierkegaard (1813–55) was a hugely influential Danish philosopher, theologian and religious author. He was a critic of idealist intellectuals and philosophers of his time, such as Georg Wilhelm Friedrich Hegel, Friedrich Wilhelm Joseph Schelling and Karl Wilhelm Friedrich Schlegel. He was also critical of the state and practice of Christianity, primarily that of the Church of Denmark. He is widely considered to be the first existentialist philosopher.

Kierkegaard devoted much of his philosophical work to the issue of how one lives as a 'single individual', giving priority to concrete human reality over abstract thinking, and highlighting the importance of personal choice and commitment. Many 20th-century philosophers, both theistic and atheistic, and theologians drew concepts from Kierkegaard, including the notions of angst, despair and the importance of the individual. His fame as a philosopher grew tremendously in the 1930s, in large part because the ascendant existentialist movement pointed to him as a precursor. Philosophers and theologians influenced by Kierkegaard include Karl Barth, Simone de Beauvoir, Niels Bohr, Albert Camus, Martin Heidegger, Gabriel Marcel and Jean-Paul Sartre.

Kierkegaard was both typical and atypical for his time. He has had a substantial impact on Danish culture in general and on theological matters in particular, as an author and as an extraordinary personality. His writings are not only marked by stringent and original thinking, but also by an unusually rich and effective literary style. As a thinker he was far ahead of his time. As a human being he was in many respects deeply rooted in it.

The Kierkegaard archives are among the most complete and comprehensive set of documents left by any author. They include original manuscripts, papers, discourses, correspondence, and other personal papers, which relate to all aspects of Kierkegaard's life and writings. Together they are of the utmost importance for the study of Kierkegaard and his era. Almost all the papers in the Kierkegaard Archives have been written by Kierkegaard, and are therefore unique.

The Royal Library was founded in 1653 and holds Denmark's largest collection of literary and artistic archives. The Kierkegaard archives are part of a wider Memory of the World heritage held by the National Library.

◄ *Søren Aabye Kierkegaard*

Final document of the Congress of Vienna

Inscribed 1997

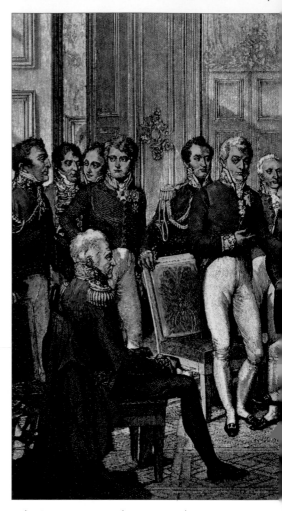

What is it

The final settlement, printed in book form, of the Congress of Vienna, the international assembly that met in 1814–15 to reorder the map of Europe in the wake of the French Revolutionary and Napoleonic Wars (1792–1815).

Why was it inscribed

The Congress of Vienna marked the first occasion when national powers met to settle events on a continent-wide scale. An event of primary importance in 19th-century diplomatic history, it resulted in the most wide-ranging treaty seen until that date and helped maintain peace in Europe for decades.

Where is it

Austrian State Archives, Vienna, Austria

The French Revolution of 1789 and its aftermath sparked a protracted series of conflicts between France and other European powers as France sought initially to protect the ideals of the revolution and later to spread them. What became known as the French Revolutionary Wars and the Napoleonic Wars together lasted from 1792 to 1815.

France and Great Britain were the main combatants but virtually all the continental nations were involved at some point as, to a lesser extent, were their overseas colonies and America. By the time the Emperor Napoleon was defeated and forced to abdicate in 1814, former French client and puppet states spanned Europe from the borders of Portugal to the borders of Russia. In April 1814 the Treaty of Fontainebleau ended the wars and in September the Congress of Vienna met to settle the peace.

The Congress is notable because it transcended the bounds of national culture and had a major influence on not only European but also world history. It decided upon a new political settlement for Europe which determined the political system for over half a century and whose impact in some aspects is still discernible. It provided the conditions for a long period of peace in Europe and redefined the political relations between the major European powers.

The Congress convened in Vienna with many European monarchs and heads of state in attendance, and for its duration the city became the centre of international diplomacy. It was organized and to an extent dominated by Prince Klemens Wenzel von Metternich (1773–1859), later the Austrian Chancellor.

The final settlement redrew national boundaries and set the seal on the new political order in Europe. It contained more than 100 articles and annexes and tackled a series of international issues, including the regulation of international naval traffic. The neutrality of Switzerland was also prepared by the Congress and remains one of its lasting contributions to the political geography of Europe.

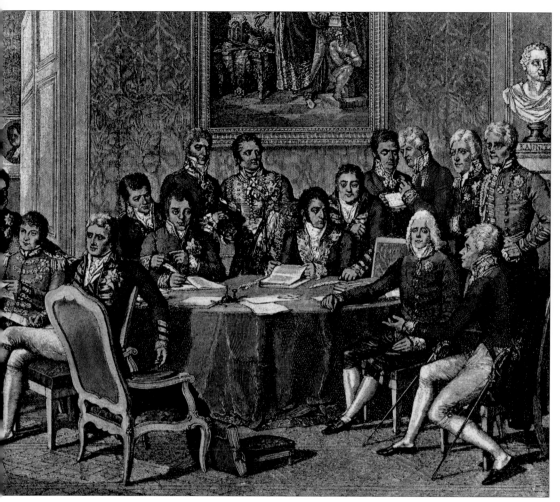

The eight signatory powers – Austria, France, Great Britain, Portugal, Prussia, Russia, Spain and Sweden – each received a copy of the final complete document. It comprises 220 folios in a red, plush velvet binding, bearing ornamental gilded clasps in the form of the coats of arms of the eight powers.

▲ *Statesmen and diplomats at the Congress of Vienna*

Registry of Slaves of the British Caribbean 1817–1834

Inscribed 2009 (2011 Bermuda)

◄ Slave register, St Kitts

Jolly Harbour, Antigua ►

What is it
Records of slave populations of British Caribbean islands, with information related to slaves' age, colour, sex, place of origin and work performed.

Why was it inscribed
The enslaved people who are recorded in these registers are the ancestors of the vast majority of Afro-Caribbean people making these documents of immense social significance. They are also evidence of the inequalities of the plantation societies and of the valuation of human life on mere economic grounds.

Where is it
The National Archives of The Bahamas, Belize, Bermuda, Dominica, Jamaica, St Kitts, Trinidad and Tobago, and the UK

Enslaved Africans made up the great majority of transatlantic migrants who were forcibly removed to the Americas from the time of Columbus's first voyages in the 15th century until the 19th century. Estimates suggest that between eleven million and fifteen million ethnic Africans, mainly from West Africa and the Congo, disembarked in the New World. The transatlantic slave trade, originating in Africa and ending in the Caribbean and the Americas, remains a sensitive subject for several reasons, including issues of race, morality, ethics, identity, underdevelopment and reparations.

Europeans defended the trade mainly for its role in providing renewable plantation labour and stimulating economic growth, best manifested in the phenomenal expansion of mercantilist Britain. By the 18th century the trade had become the 'most advantageous and most abundant source of wealth' to participating European nations; which indubitably accounts for its longevity and resilience against the forces of abolition.

In 1807 the transatlantic trade in enslaved Africans to the British West Indies was legally terminated by Britain. Nonetheless, inter-colonial slave trading remained legal until 1811. In an effort to monitor more closely the state of the enslaved populations, slave registers were first established in Trinidad and in Saint Lucia in 1813 and 1815 respectively, by legislation originating from the British Government. The other West Indian colonies were urged by the British Government to introduce similar slave registers, and the majority including Antigua, Barbados, Berbice, Dominica, Demerara Essequibo, Grenada, Jamaica, Montserrat, Nevis, St Kitts and St Vincent were compiled between 1816 and 1817. The Virgin Islands and Tobago established theirs in 1818 and 1819 respectively.

However, Bermuda and The Bahamas did not establish their registries until 1821 and 1822, and the Cayman Islands (then a dependency of Jamaica) and Honduras did not make any returns until 1834.

In 1819, the British Government established a central slave registry in London that was intended to record all sales, inheritance, transfer or inter-colonial movement of enslaved persons. Furthermore, in 1821, governors of West Indian colonies were required to send copies and indexes of the local registers to London. Under the terms of the Abolition of Slavery Act 1833, slavery was abolished in most British possessions on 1 August 1834 and the slave registers were used by the local authorities to determine who were to be apprenticed labourers. In addition the Slave Compensation Commissioners established legal ownership and undertook final evaluations for compensation purposes.

The majority of slave registers were set up as scheduled by local colonial legislation; hence, a fair degree of variability in formatting and data collected exists across the registers. Nevertheless, in spite of

such variability and the local colonial peculiarity of
these records, they collectively comprise an invaluable
set of archives for the study and understanding of one
of the world's slavery systems, and provide the basis for
international comparability.

Csoma archive of the Library of the Hungarian Academy of Sciences

Inscribed 2009

What is it

Csoma was the first European to interpret the cultural heritage of the Tibetan people. He compiled the first Tibetan-English dictionary of scientific value together with a grammar of the Tibetan language. The archive includes his collection of Tibetan manuscripts and his correspondence.

Why was it inscribed

The archive is a prime source for Buddhist and Tibetan studies. It is a unique testimony of Tibetan monastic knowledge at the beginning of the 19th century and includes the first books written for use by a Westerner to explain Tibetan religion, science and culture in a simple style.

Where is it

Oriental Collection of the Library of the Hungarian Academy of Sciences, Budapest, Hungary

▲ One of the 'Alexander books', a compendium of medicine and chronology written by one of the lamas at the Zangla monastery, Sangyee Phuntsok, for Csoma between June 1823 and October 1824.

Another of the 'Alexander ▲ books', a compendium of Tibetan grammar and poetry also written by Sangyee Phuntsok, for Csoma between June 1823 and October 1824.

Kőrösi Csoma Sándor or, as he signed his name in English, Alexander Csoma de Kőrös (c.1784–1842) was among the Hungarian scholars who went to the East to find the cradle of his nation, assumed to be somewhere in Central Asia. He became the first European to study the social and cultural context of Tibetan people, and especially Buddhist monks who, at the beginning of the 19th century, lived in a secluded society. In 1834 he published in Kolkata (Calcutta) two ground-breaking books, *Dictionary, English and Tibetan*, the first such dictionary of scientific value, and *A Grammar of the Tibetan Language in English*.

The Csoma archive is home to the four so-called 'Alexander books' which are summary outlines of various fields of Tibetan literature and scholarship, compiled at his explicit request probably by Csoma's teachers, the lamas at the Zangla monastery in Ladakh, now in northern India. Their value resides in their uniqueness, having been composed as single copies personally for Csoma. The archive also contains thirty-two Tibetan block prints and manuscripts copied or purchased by Csoma, his correspondence (nearly 250 letters), the Csoma-related collection of his first biographer, Theodore Duka (1825–1908) and contemporary and modern documents related to Csoma's life and work.

The archive is a prime source for an understanding of the basic concepts of Buddhism, summarized on the basis of the sutras revealed by Buddha and of the sacred writings on monastic discipline occurring at a very early phase of the history of Buddhism. They treat every aspect of Tibetan knowledge: cosmology, cosmography, medicine, grammar, philosophy, history, metrics, etc.

The 'Alexander books' and the Tibetan woodblock prints and manuscripts were donated in 1839 by Csoma to the secretary of the Asiatic Society of Bengal, S.C. Malan, to whom he taught the Tibetan language at that time. When Duka, the biographer of Csoma, visited Malan in London in 1883, he was given these treasures and in 1885 he donated them and his own Csoma collection to the Hungarian Academy of Sciences.

The Bleek collection

Inscribed 1997

What is it

Notebooks, lexicons, sketchbooks, photographs, family records, biographical information and correspondence by the Bleek Family on the San people.

Why was it inscribed

The material provides an invaluable and unique insight into the language, life, religion, mythology, folklore and stories of a now-extinct African people.

Where is it

University of Cape Town, the National Library, and Iziko South African Museum, South Africa

The Bleek collection consists of papers of German linguist Dr W.H.I. Bleek (1827–75), his sister-in-law Lucy Lloyd (1834–1914), his daughter Dorothea Bleek (1873–1948) and G.W. Stow (1822–82) relating to their researches into the San (Bushman) language and folklore, as well as albums of photographs.

The society of the semi-nomadic |xam had existed for hundreds of years. They were responsible for some of the world's finest rock art, but otherwise had a very simple material culture. The culture collapsed owing to the intrusion of the new inhabitants who brought with them diseases and undertook active measures to eradicate them.

The |xam language was a Khoisan click language. The bar symbol in the name '|xam' represents a dental click like the English interjection 'tsk, tsk!' used to express pity or shame. The 'x' represents the ch sound of Scottish

▲ *Petroglyphs at least 3000 years old, Twyfelfontein, Namibia.*

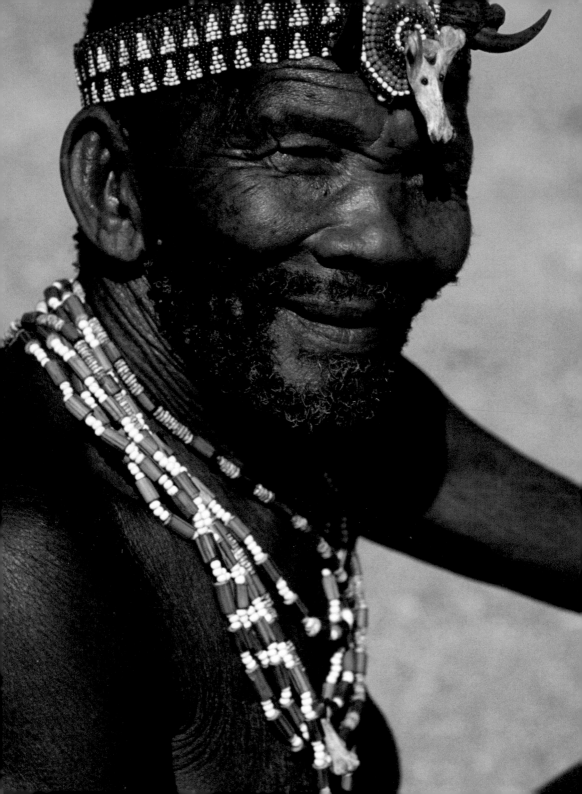

'loch'. Bleek developed a phonetic script for transcribing the characteristic clicks and sounds of the |xam language which is used by linguists to this day. Although some of the material was published by Lucy Lloyd and Dorothea Bleek, a great deal remains unpublished.

The largest and most important part of the collection consists of the notebooks in which Bleek and Lloyd recorded the language and mythology of the |xam. These notebooks comprise over 12,000 pages. In them were written |xam words or narrative, with the English translation. They served as a 'Rosetta Stone' that has enabled scholars to decipher the meaning of southern African rock art. Thanks to insights gained from the South African material, advances have been made in the study of Australian and European rock art.

The collection also includes lexicons, Bleek family records, biographical information and correspondence with the family and colleagues in many parts of the world. The material provides an invaluable and unique insight into the language, life, religion, mythology, folklore and stories of this late-Stone Age people.

The documentation about their language, life and mythology was gathered at the crucial moment of disintegration of this culture in the mid-to-late 19th century. Studies of other hunter-gatherer societies done elsewhere were undertaken later, when those societies were already drastically transformed by colonial expansion. The collection of this data was done fairly early, so it represents a unique, authentic early glimpse into the consciousness of hunter-gatherer societies.

These collections shed light on a unique religious system, a unique consciousness, a unique system of representation, all of which are now extinct, and this is almost the sole resource for knowledge of these systems of thought. They provide the only means of hearing one of the most fascinating 'lost voices' of humanity.

◄ *San Bushman, Namibia*

Ludwig van Beethoven:
Symphony no. 9, D minor, op. 125
Inscribed 2001

What is it
The autograph score, leaves and historic records
of Beethoven's Symphony no. 9, D minor, op 125.

Why was it inscribed
The composition is among the most important
symphonies of the 19th century, with an influence that
spans the 20th century to the present day. It was the last
symphony Beethoven completed and is counted among
his finest works. The poem *An die Freude* ('Ode to Joy')
is sung in the final movement and was the first
instrumental symphony composed with human voices.

Where is it
Staatsbibliothek zu Berlin, Berlin, Germany;
Beethoven-Haus, Bonn, Germany;
Deutsches Rundfunkarchiv, Frankfurt, Germany

The ninth symphony of Ludwig van Beethoven (1770–1827)
is one of the most famous music compositions in the
world and is considered by many to be among the finest
pieces of music ever written. Beethoven completed the
work in 1824 and since its first performance its influence
has been long-lasting and extensive.

It was the first instrumental symphony composed
with human voices. Friedrich Schiller's *An die Freude*
('Ode to Joy'), written in the 18th century, is a hymn of
praise to God and a celebration of humanity and is set
in the symphony's fourth and final movement.

Although well known and appreciated around the
world, the symphony has particular resonance in
the German consciousness. West Germany (Federal
Republic of Germany) and East Germany (German
Democratic Republic) fielded a unified team in the
Olympic competitions between 1956 and 1964 and used
the first stanza of the final movement as their anthem.
The symphony was played in celebration of the Fall of the
Berlin Wall in 1989 and the reunification of East and West
Germany. Across Eastern Europe as a whole it became an
anthem of celebration of the ending of Communism.

Other countries and organizations used the final
movement as their own anthem with different lyrics,
and the work is often played in orchestral performances on
New Year's Eve.

Beethoven's original manuscript is held in two separate
institutions in Germany – the Staatsbibliothek zu Berlin has
all except two leaves which are in the Beethoven-Haus in
Bonn. The two repositories also have two other autograph
manuscripts which are single parts for certain instruments:
contrabassoon, used in the fourth movement, and
trombone, used in the second and fourth movements only.

Some of the most important performances of this work
comprise the third element of the listing, making a living
musical memory of the symphony. Although it would

be impossible to note every performance, six notable performances dating from 1922 to 1979 are considered among the best and are listed in an archive that remains open for additions from across the world, now and in the future.

Together the three parts are listed in the Memory of the World register.

▲ Beethoven's manuscript

Royal archives (1824–1897)

Inscribed 2009

What is it

The collection comprises the royal archives, old journals, registers of *Sakaizambohitra* (village officials) and registry office documents from the 19th-century Kingdom of Madagascar.

Why were they inscribed

These archives record key elements in the foundation of Madagascar's identity, including the exercise of the royal authority, the end of absolute monarchy and the rise to power of the common people, its external relations, particularly with Western colonial powers, and social and economic progress.

Where are they

National Archives, Antananarivo, Madagascar

The 19th century was a watershed in Madagascar's history, being the starting point for a number of changes associated with the Kingdom of Madagascar and the country's entry into the modern era. For the first time, with the creation of the Kingdom of Madagascar, a single authority ruled over the whole of the territory. Over time the power of the monarchy started to decline and the crown became increasingly symbolic, while its prerogatives were gradually taken over by the powerful Hova clan, represented by the prime minister, who held full executive authority. On the cultural level, the century witnessed the introduction of the Latin alphabet to write down the Malagasy language, the spread of Christianity, the emergence of the professions and the growth of Western-style education.

In the 19th century, Madagascar, in the southwest of the Indian Ocean, held an important position in the geopolitical competition between the great powers. This eventually resulted in its annexation by France in 1896 after the French, under General Duchesne, invaded in 1895. The royal archives contain written documents that were recovered by General Duchesne, and include the archives of high-ranking figures in the Kingdom of Madagascar.

The royal archives cover the period from 1824 to 1896 and recount events from the adoption of the Latin alphabet by King Radama I to the proclamation of the Law of Annexation by France in 1896. The archives include information and personal accounts of social and economic change and progress, the evolution of thought and morality, political power and its application, local administration, as recorded in the registers of *Sakaizambohitra* (village officials), relations with religious missions and with international partners. They provide information on the history of families, their genealogy, their way of life and standard of living and their property. The royal archives are original manuscript documents in the form of paper, loose sheets, books and registers, together with some photographs. The faded ink is illegible in many cases. The language used in the documents is mostly Malagasy, while French, English, Italian and German is also used. The archives' historical importance has grown since a destructive fire at the royal residences (*Anatirova*) in 1995 made the archives one of the few reminders of the past.

Queen Ranavalona III, the last monarch of Madagascar, ruled from 1883 until the French occupation of the island in 1896. The Royal archives contain much information on her reign. ▶

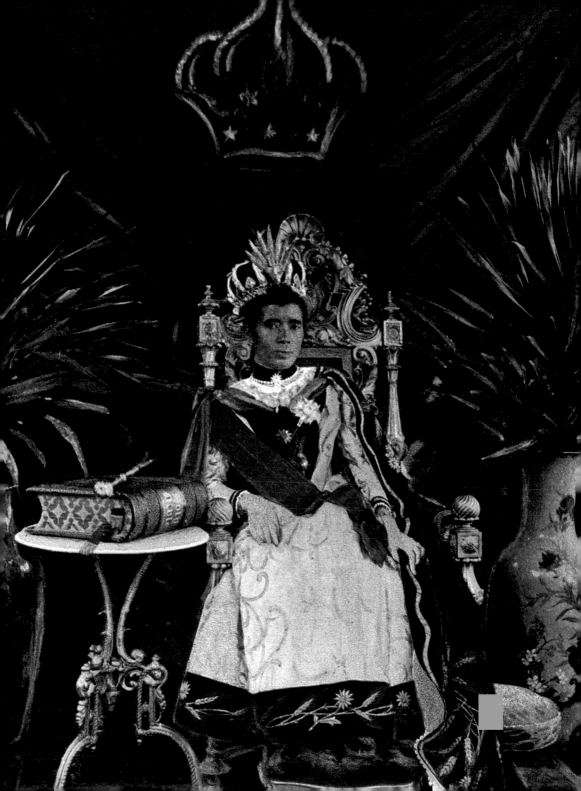

Catecismo corticu pa uso di catolicanan di Curaçao
(first catechism written in Papiamentu language)
Inscribed 2009

What is it

The earliest surviving edition, dating from 1827, of a catechism written in the Papiamentu language of the islands of the former Netherlands Antilles.

Why was it inscribed

Papiamentu is a Creole that evolved in the islands from the 16th century. The catechism, for use by local people, is the first known book to be written and published in Papiamentu and its publication denoted a turning point in its transition and status from an oral to a written, literary language.

Where is it

National Archives, Willemstad, Curaçao

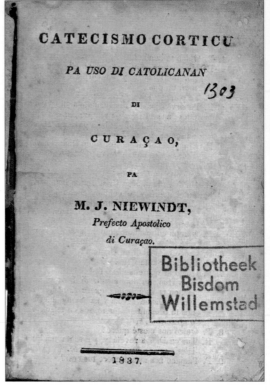

▲ *Title page of the catechism*

Monsignor Niewindt, translator of the catechism into Papiamentu ▶

Catecismo corticu pa uso di catolicanan di Curaçao or 'Short Catechism' to be used by the Catholics of Curaçao, was the first book to be published in Papiamentu and has proved to be of central importance in the survival and evolution of the language in the Dutch Caribbean islands.

Curaçao is the largest of the Leeward Antilles off the northern coast of Venezuela and the most populous of the six island areas of the former Netherlands Antilles. The islands came under the control of the Dutch West India Company in the 17th century and were colonies at the time the catechism was written. Dutch missionaries came to convert the islands to Christianity and one of these, Monsignor Martinus Joannes Niewindt, who was to serve in the islands for 36 years, was the translator of the catechism, which is a book of instruction in the principles of religion. The catechism was a product of the Catholic press on the islands in the early 19th century, when Papiamentu began appearing in print for the first time – an important turning point in the language's recognition.

Papiamentu fuses several tongues, including Dutch and Venezuelan Spanish with input from indigenous Arawaks and Sephardic Jewish refugees from Europe. The language,

reflecting the mixed backgrounds of the people, is part of the cultural identity of Aruba, Bonaire and Curaçao, known as the ABC islands. It finally gained recognition as an official language in 2007; this remained the case on the islands after the dissolution of the Netherlands Antilles in 2010. Today there are almost a quarter of a million Papiamentu speakers in the islands and others in the diaspora community in the Netherlands.

The catechism played a central role in the continued existence and progress of Papiamentu. It was one of the books that helped keep the language alive in the late colonial period (1850–1950s) in the face of official attempts to marginalize it. Once published, the catechism's existence encouraged the printing and distribution of other books in the language, and Arubans, Bonaireans

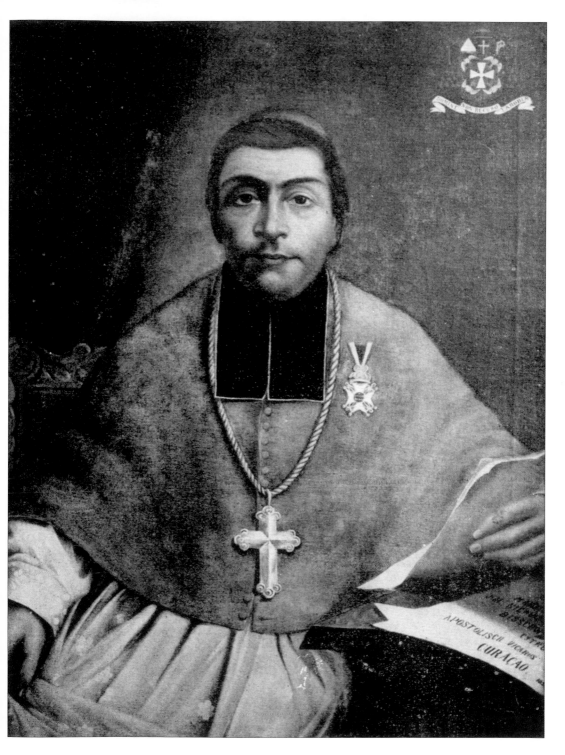

APOSTOLISCH VICARIUS
CURAÇAO.

337

99. P. Quico nueve mandamiento ta taha nos ?
R. Tur deseo pa cos dishonesto.
100. P. Quico ultimo mandamiento ta taha ?
R. Deseá di cogé cos di otre hende.
101. P. Quantu mandamiento di santaIglesia tin?
R. Principalmentu é Cinco: 1. Guarda dia di domingo y dia di fiesta. 2. Oir misa é dia nan. 3. Ayuna dianan, cu Iglesia ta manda. 4. Confesa su picarnan alomenos un vez na aña. 5. Ricibi Santu Eucaristia tempu di Cuaresma o di pascua di resurreccion.
102. P. Nos mesté guarda é mandamiento nan ?
R. Si, asina més com ley di Dios, pasobra Jesu Cristo a manda nos di obedecé na Iglesia.
103. P. Com nos mesté oir misa ?
R. Cu muchu atencion y respectu.
104. P. Quico ta panifica cu atencion ?
R. Cu nos ta poné tur nos sentir y cordamentu ariba es cu Padre ta haci na altar.
105. P. Com nos mesté monstrá nos respectu ?
R. Cu nos alma y cu nos curpa.
106. P. Quico tercero mandamiento di Iglesia ta manda ?
R. Ayuna.
107. P. Quico quarto mandamiento di Iglesia ta manda nos ?
R. Confesá nos picar alomenos un vez na aña.
108. P. Quende mesté confesa ?

R. Tur Cristian cu tin mas cu Siete aña.
109. P. Quico traser mandamientu di Iglesia ta manda nos ?
R. Ricibi Santu Comunion tempu di cuaresima, ó di pascua di resureccion.
110. P. Quico ta un Sacramentu ?
R. Un siñal di un gracia invisible, cu Jesu Cristo a institui pa nos éterna salvacion.
111. P. Quantu Sacramentu tin ?
R. Siete: 1. Bautismo. 2. Confirmacion. 3. Eucharistia. 4. Penitencia. 5. Extrema Uncion. 6. Orden sacerdotal. 7. Matrimonio.
112. P. Quico ta gracia ?
R. Un fabor ó dunamentu di Dios pa nos éterna Salvacion, mas cu nos no á merecé.
113. P. Que Sacramentu nos no por ricibi mas cu un vez den nos vida ?
R. E tres: Bautismo, Confirmacion y orden Sacerdotál.
114. P. Qual Sacramentu nos tin di mas mester ?
R. Bautismo, pasobra ningun hende no por salvá sin Bautismo.
115. P. Pa quico ?
R. Pasobra tur hende ta manchár cu picar original, cu nos á erf di nos promer tata Adam.
116. P. Quico ta Bautismo ?
R. Un Sacramentu cu ta instituir di nos Señor Jesu Cristo, na cual pa lavamen-

Questions and answers on the Catholic faith, in Papiamentu ▲

◀ Cover of the catechism

and Curaçaoans used it to teach one another how to read and write in Papiamentu.

It also remains an important symbol in the survival of the language and culture of the people as the islands developed and moved forward from the constraints of the colonial era. However, its importance is not restricted to history and symbol: it is a living work still used by the Catholic population of the islands today.

The former Netherlands Antilles. ▲

Manuscripts and correspondence of Hans Christian Andersen

Inscribed 1997

What are they

Manuscripts, printed works, illustrations, papercuts and letters from and to Hans Christian Andersen comprise the most significant collection of his writings in the world.

Why were they inscribed

Hans Christian Andersen's reputation as a story teller remains unrivalled and this collection contains the essential sources for researching and editing critical editions of his work.

Where are they

Royal Library, Copenhagen, Denmark

Hans Christian Andersen (1805–75) was born in humble circumstances in Odense. He trained first as a singer and actor, but success then came to him as a writer and his worldwide fame rests upon his fairy tales, many of which he developed out of Danish folk tales. However, the range of his work was far wider, for he wrote novels, plays and, reflecting one of his enthusiasms, travel books. He was also engrossed by music, theatre and the visual arts, showing particular talent for pencil and pen-and-ink drawings and for his speciality, complex papercuts. He had learnt the skill from his father and used it to great effect, frequently entertaining children with his creations (around 1000 have survived and there are many examples in the Royal Library collection). The Hans Christian Andersen collection is based around three major acquisitions of the Library. The Collin manuscript collection was donated in 1905. In 1954 the Holger Laage Petersen collection was donated. This contains 4500 volumes of Hans Christian Andersen's printed works and works about him, some of his manuscripts and items connected with the writer. In 1969

A watercolour by the Danish painter Otto Svend for The Wild Swans by Hans Christian Andersen. Svend won the Hans Christian Andersen Award for Illustration, the most prestigious prize for children's book illustrators, in 1978. ▶

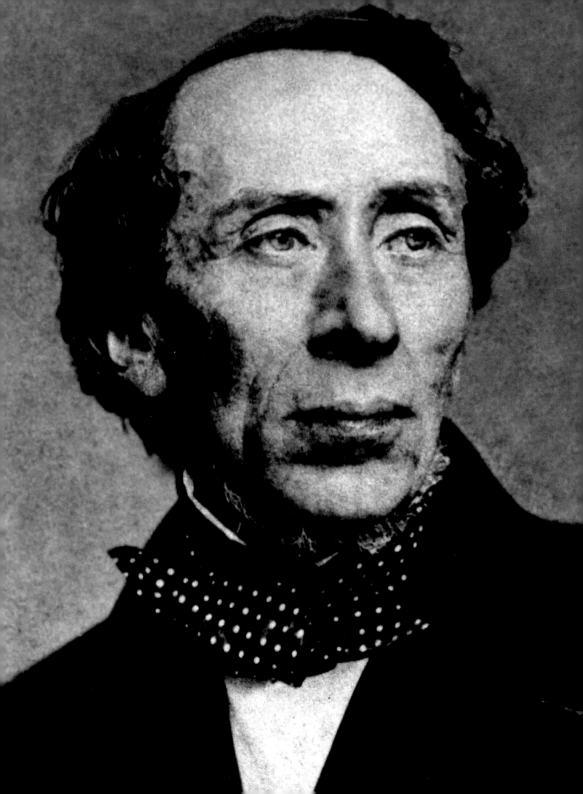

the Arne Portman collection was purchased. It comprises books by and about Hans Christian Andersen, including some directly connected with the writer, manuscripts, papercuts, letters and music.

The Hans Christian Andersen collections comprise the largest accumulation of his manuscripts in the world, forming the essential resource for the research and the critical editions of his writings. Of the fairy tales alone, the collection contains 216 manuscripts and manuscript fragments relating to around 150 stories. The collection reflects the aesthetic and social way of life of the author and his time and the contemporary importance of his writings in Denmark and in the rest of Europe.

About 60 per cent of the manuscripts and letters need continuous conservation and minor repair, but the collection has never been exposed to serious damage. The manuscripts are kept in safe-deposit stacks, with controlled temperature and humidity. Use of the material from the collections is only allowed in secured reading-room areas.

▲ An illustration by Helen Stratton from the story Elfin Mount in a book of Hans Christian Andersen's fairy tales published around 1930.

◀ Hans Christian Andersen, photographed in 1865

Records of the Indian indentured labourers

Inscribed 2011

What is it

Colonial records of Indian labourers in Fiji, Guyana, Suriname, and Trinidad and Tobago.

Why was it inscribed

The documents offer a unique perspective of colonialism as a major phenomenon in the unfurling of world history.

Where is it

National Archives of Fiji, National Archives of Guyana, National Archives of Suriname, National Archives of Trinidad and Tobago

At the peak of colonialism in the early 19th century, slavery was finally abolished. However, colonial administrators were hard-pressed to find alternative cheap labour to meet the demands of maintaining their empires, particularly the vast sugar plantations on the many island colonies.

To meet this demand for labour they turned to the Indian subcontinent. The recruitment process was often hasty and unorthodox, targeting the populations of poverty-stricken Indian provinces. Given that many people were landless, affected by food shortages and unemployment, they were easily lured and deceived about the work on offer. They were hustled aboard the waiting ships, unprepared for the long and arduous sea journey.

The Indian indentured immigration was first accounted for in the 1830s and over a period of roughly 100 years 1,194,957 Indians were relocated to nineteen colonies. These records are the only documents for ancestral and lineage research for the numerous descendants of those Indian labourers.

The arrival of large groups of Indian labourers in the receiving colonies had immense repercussions, many of which are still being felt today. This mass movement of labour was meticulously recorded by former colonial powers and stored in the archives of many receiving colonies around the world.

The Indian diaspora to these nations had an enormous impact on the local economy, the politics and the socio-cultural makeup of the colonies. The indentured descendants have gone on to create new livelihoods and expanded their horizons beyond the colonies, with some taking their place in the world as renowned sportsmen, politicians, dignitaries and professionals. Their stories are compelling and demand the equal attention of the international community through the preservation and accessibility of their documentary heritage.

The descendants of the indentured labourers have become an integral part of the former colonies that received them; the records pertaining to their forebears are of irreplaceable social, cultural and historical significance. The personal information contained within the records is the only source for genealogy search for the descendants of the labourers.

The legacy of indentured labour against the backdrop of colonialism and the concept of Empire are vigorously debated in learning institutions the world over.

◀ Emigration pass, Trinidad, 1870

Farquharson's Journal

Inscribed 2009

What is it

The handwritten journal of a cotton-plantation owner in the Bahamas covering the two-year period from 1 January 1831 to 31 December 1832.

Why was it inscribed

Farquharson's Journal chronicles the day-to-day events on cotton-producing Prospect Hill Plantation on Watlings Island and was written by the owner Charles Farquharson who, unusually, lived on the plantation itself. It is the only surviving handwritten account in the Bahamas, the wider Caribbean and as far as is known, the world, of slave and plantation life on a non-sugar plantation.

Where is it

Bahamas National Archives, Nassau, Bahamas

Prospect Hill Plantation on Watlings Island grew cotton rather than the more usual Caribbean crops of sugar and coffee, and in 1803 Scottish-born Charles Farquharson, a Loyalist from the recently independent United States of America, obtained a land grant there for an estate originally of 200 acres. Watlings Island, now known as San Salvador, is a small island in the Bahamas archipelago and was noted as the first landfall in the New World of Christopher Columbus, who landed there on 12 October 1492.

Crop production on the Bahamas was less successful than on the other Caribbean islands of Jamaica, Barbados and Antigua, and the cotton production that had supplied trade with England was already well into decline by the time Farquharson wrote his journal.

Farquharson's record is the only surviving journal of slave and plantation life in the Bahamas. Slavery was abolished in virtually the whole of the British empire in 1834, so the journal allows a glimpse into conditions that were about to end in this part of the world. Farquharson's spelling is sometimes rendered phonetically and his language and descriptions are clear and concise throughout.

His journal records the day-to-day work of the slaves on the plantation, which was less labour-intensive than a sugar plantation. Duties included planting, harvesting and processing cotton and other crops, including corn, peas and beans; ground-clearing and maintenance work on walls, buildings and roads; and more general tasks of carrying produce, wood and luggage, and of raking salt, which was also produced on the island. The journal also describes entertainments of the slaves, such as dancing during their Christmas holidays.

Farquharson's writing reveals also his own attitude towards the slaves, whom he describes as 'the people' and 'the hands' – similar to terms used, it has been noted, to refer to labourers on an English farm. He expected them to work continually but not through illness or bad weather and was reluctant to use corporal punishment. He accepted the need for protest and negotiation but did not tolerate violent resistance and open rebellion; one leader of such a revolt on the plantation was punished, sent to Nassau and later sold.

Epigraphic archives of Wat Pho

Inscribed 2011

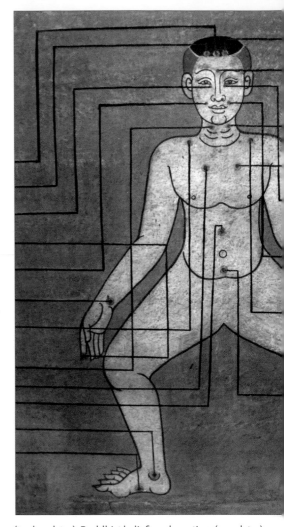

What is it

The 1431 inscriptions erected by King Rama III on the walls of the Wat Pho Temple in Bangkok cover a wide range of subjects including traditional knowledge, Buddhism, medicine, massage, morality and literary texts that now attract interest from a worldwide audience.

Why was it inscribed

The inscriptions comprise Buddhist texts, selections from the Hindu *Ramayana* and the Persian *Shâhnâmeh*. In addition the inscriptions provide unique details of the techniques of Thai massage and holistic healing methods that have been adopted globally, testifying to cross-cultural exchanges.

Where is it

Wat Pho Temple, Bangkok, Thailand

Wat Pho is second only to the Temple of the Emerald Buddha in terms of importance in Thailand. Situated south of and close to the Grand Palace in Bangkok, it was probably built in the 17th century in the Ayutthaya period. It underwent major restoration in 1795 during the reign of King Rama I (King Phra Phutthayotfa, 1782–1809) who established the new dynasty in Bangkok, and it was regarded as the monarch's temple. During King Rama III's reign (King Nangklao, 1824–51) in 1831–41, the temple's grounds were expanded and the buildings were decorated with Chinese ceramic tiles, mural paintings, stone sculptures, wood carvings and mother-of-pearl inlaid works. The king also commissioned the inscribing of texts on various subjects on stone plates in different sizes ranging from 32 cm by 14 cm to 200 cm by 110 cm. The marble, limestone and slate plates were placed on the exterior and interior walls, windows, posts or wooden beams of twenty-five buildings. Most of the 1431 inscriptions that survive are legible and in good physical condition.

The subject matter of the inscriptions varies, covering history, government, literature, Buddhism, herbal medicine, physical therapy, ethnology and morality. They represent a cherished corpus of wisdom that includes a history of Wat Pho's construction and restoration

(twelve plates), Buddhist beliefs and practices (310 plates), literature (including 152 plates retelling the Hindu *Ramayana* and nine from the Persian *Shâhnâmeh*), general knowledge on political geography and cultural diversity (124 plates), moral teachings (sixty-five plates), royal customs (thirty-six plates) and health, medicines and massage (608 plates). Indeed, nearly half of the existing inscriptions contain medical and massage or Thai yoga texts composed by royal physicians. The temple is recognized by many health experts as a world centre for the teaching and practising of Thai healing techniques that are sometimes known as 'Thai massage'.

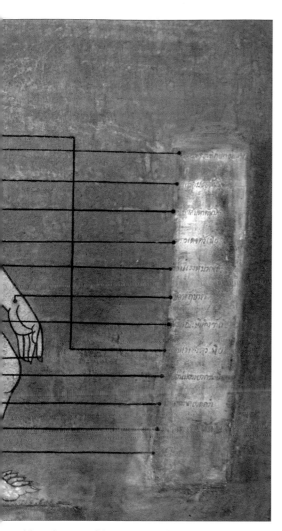

◄ *Acupressure points shown on one of the stone inscriptions at the Wat Pho Temple in Bangkok.*

Although many of the texts were already available elsewhere in traditional books and palm-leaf manuscripts, by putting them together in one place, King Rama III actually turned the temple into an open-air public library where visitors can browse at their leisure. The early 19th century saw the beginning of Western colonial and cultural expansion into Asia. The Wat Pho archives represent the best of existing local Asian and Thai knowledge about Buddhism and the world as viewed from the cosmopolitan city of Bangkok at that time, compiled to provide a match to new Western knowledge.

János Bolyai: Appendix, Scientiam Spatii absolute veram exhibens
Maros-Vásárhelyini, 1832

Inscribed 2009

What is it

The *Appendix* contains the description of János Bolyai's revolutionary discovery of non-Euclidean and the more general absolute geometry, derived from the solution to an ancient Greek mathematical problem in connection with parallel lines.

Why was it inscribed

Bolyai's non-Euclidean geometry changed thinking about geometry, led to the development of modern mathematics and paved the way for modern physical theories of the 20th century. The *Appendix* records one of the most significant mathematical discoveries of the 19th century.

Where is it

Library of the Hungarian Academy of Sciences, Budapest, Hungary

János Bolyai (1802–60) received his mathematical education from his father, Farkas Bolyai, also a world-famous mathematician, professor at the Reformed (Church) College of Marosvásárhely, Transylvania. János first reported his discovery in a letter written to his father on 3 November 1823, when, as an army engineer, he was assigned to the Directorate of Fortification of Temesvár, Transylvania. At about the same time as Bolyai published his results, the Russian mathematician N.I. Lobachevskii also published similar results, so the discovery of non-Euclidean geometry is attributed to both of them. However, absolute geometry is Bolyai's sole discovery.

The *Appendix, Scientiam Spatii absolute veram exhibens* ('Appendix, explaining the absolutely true science of space') is the primary document of the epoch-making discovery of János Bolyai. For over 2000 years many of the best mathematicians tried to prove Euclid's parallel postulate (or axiom). János Bolyai created entirely new settings for the problem by inventing absolute (or neutral) geometry that is independent of parallelism. He also showed that

no proof was possible and, by assuming all the axioms for absolute geometry and replacing the axiom of parallelism by its negation, obtained another geometry of equal standing to Euclidean geometry. This discovery stimulated not only the creation of new space concepts vital for modern physics but, by the dissemination of the axiomatic method, the evolution of modern mathematical thinking.

János Bolyai's work appeared as a short appendix to Farkas Bolyai's monumental two-volume book *Tentamen* (Maros-Vásárhelyini, 1832–33), which summarized the mathematical knowledge of the time. The *Appendix* appeared in the first volume in 1832 but was also published as a preprint in 1831. The *Appendix* was written in Latin, in a concise, elegant and rigorous style. The text is divided into forty-three sections and two major parts may be distinguished in its contents. The first part is about absolute geometry, the second about non-Euclidean (hyperbolic) geometry. This copy of the *Appendix* belonged to János Bolyai and contains his handwritten notes and diagrams.

Johan Bolyai. **Anmerkung.**

[handwritten German text by János Bolyai, largely illegible cursive]

...

Zur ... mit Vega ... rbs 2. ... "Kritik ... von Jos. Joy. ... Hoffmann. ... 1807 ...

Appendix,
Scientiam Spatii

absolute veram exhibens;
a veritate aut falsitate Axiomatis XI. Euclidei (a priori haud unquam decidenda) independentem; adjecta ad casum falsitatis quadratura circuli geometrica.

Auctore

Johanne Bolyai de Bolya,
Geometrarum in Exercitu
Caesareo Regio Austriaco
Castrensium Capitaneo.

Agropoli sive Maros-Vásárhelyini.
Typis Collegii Reformatorum per
Josephum et Simeonem Kali de Felső-Vist.
1832.

Bestimmung und

Handschrift von Johan Bolyai

▲ In this copy of the Appendix, the printed title page is missing, and is replaced by a handwritten title page in Farkas Bolyai's hand, while the Anmerkung (or Note) is written by János Bolyai.

◀ A sheet of white paper, containing the diagrams for the Appendix, drawn by János Bolyai in Indian ink, as well as his corrections (e.g. Fig. 13) and an additional (Fig. 23) in pencil (which were included in the printed work).

Brahms collection

Inscribed 2005

What is it

The estate of Johannes Brahms, including scores, musical sketches and drafts, his correspondence, his music and literary library, portraits and photographs, and music autographs of other composers.

Why was it inscribed

Brahms is one of the most important representatives of Western classical music. This collection is both a unique record of his creativity and a document of the music, musical life, literature, and social and cultural history of the second half of the 19th century.

Where is it

Gesellschaft der Musikfreunde, Vienna, Austria

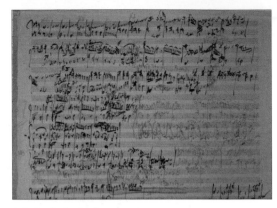

▲ *Brahms's sketches from op. 121*

Johannes Brahms (1833–97) ranks amongst the most famous composers in the history of Western music and is one of the leading musicians of the Romantic period. He has remained one of the most performed composers in international concert life, virtually on a par with Mozart and Beethoven.

The core of the Brahms collection is the Estate of Johannes Brahms, bequeathed by him to the Archives of the Gesellschaft der Musikfreunde in Vienna so that it would survive as a unified whole. This has been expanded with additional materials closely related to the personality and artistic creativity of Johannes Brahms.

In a nutshell, the scope of the collection can be summarised as follows: Brahms's music autographs; the complete collection of Brahms's 'Handexemplare' (Brahms's printed copies of his own works); all correspondence addressed to Brahms; correspondence sent by Brahms; all the music autographs of other composers once in Brahms's possession; the complete collection of books and music as left behind by Brahms; and bequests of his friends.

No composer of the Classical or Romantic period has dedicated his estate totally to an archive, thus enabling it to build up a special collection through further acquisitions. What makes this collection so unique and special is that it focuses on a leading personality, covering a key period of European music, literature and social life. Its scope and completeness permit deep insights into the creativity of a major composer.

The collection documents Brahms's life and works as a whole, his wide interest in the history of art and music, in literature and politics – in other words, it also documents his time and his environment. It is one of the most important sources for cultural history in general and the music history of Vienna in the second half of the 19th century.

Brahms's personal contacts with important and world-famous composers and musician colleagues – such as Robert Schumann and Richard Wagner – also affords these composers pride of place in the Brahms collection.

The Brahms collection is of a high degree of completeness. Autographs (music and correspondence) that do not form part of it are scattered, missing or presumed lost. It is a major holding of the Gesellschaft der Musikfreunde in Vienna, one of the five largest music libraries in the world.

Brahms statue, Vienna, Austria ▶

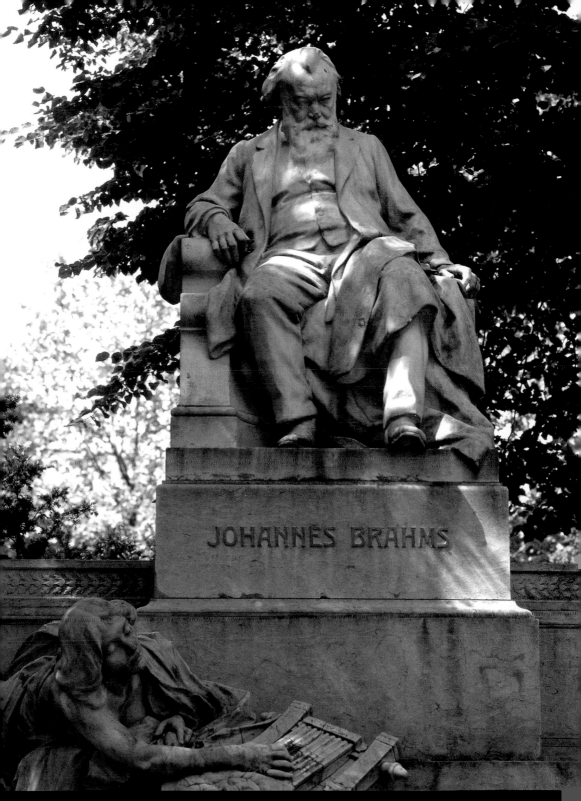

JOHANNES BRAHMS

Memory of the Suez Canal

Inscribed 1997

What is it

The Memory of the Suez Canal is the record of the canal and its history, purpose and significance.

Why was it inscribed

The Suez Canal is one of the most important waterways in the world, connecting East and West and affecting the history of the world over the last 150 years.

Where is it

Centre des Archives du Monde du Travail (CAMT), Roubaix, France; Archives Nationales, Paris, France; Bibliothèque de l'Arsenal, Paris, France; Suez Canal Authority, Ismailia, Egypt; Bibliothèque de l'Institut du Monde Arabe (IMA), Paris, France; Bibliothèque Nationale de France, Paris, France; Bibliothèque Forney, Paris, France; Institut National de l'Audiovisuel (INA), Paris, France

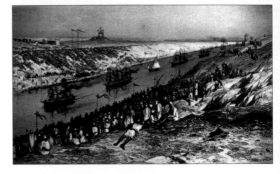

▲ *Ships sailing through the new canal*

Documents, manuscripts and images comprise the memory of the Suez Canal. Its building and inauguration, its nationalization and the consequences span over a century of recent history. Those involved in the canal's story come not only from contemporary engineering, maritime and commercial circles but also include some of the foremost political and military figures of their day.

INAUGURATION DU CANAL DE SUEZ

VOYAGE
DES SOUVERAINS

The items relating to the memory of the Suez Canal are spread through several repositories, notably those listed above, and date back some years before the canal's opening in 1869. Archives up to 1956 are with the records of the Compagnie Universelle du Canal Maritime de Suez, now stored at the CAMT in Paris. From 1956 onwards, documents are archived with the Suez Canal Authority in Egypt. In addition to the official documents, rare books and manuscripts are stored in different libraries.

The Suez Canal connects the Mediterranean and the Red Sea over the Isthmus of Suez, offering an alternative route between Europe and East Africa and Asia to sailing around the Cape of Good Hope. At 164 km long when it opened in 1869, it now measures 193.3 km and is the longest canal in the world. It runs from Port Said on the Mediterranean coast to the Gulf of Suez at the head of the Red Sea. Canals had linked the Red Sea and the River Nile in ancient times, but a waterway connecting the two seas had long been considered unfeasible.

In 1854 French engineer and diplomat Ferdinand de Lesseps succeeded in interesting the Egyptian authorities in his idea to bypass perceived problems and build the canal. La Compagnie Universelle du Canal Maritime de Suez (Universal Company of the Maritime Suez Canal) was set up in 1858 to build and operate the canal for 99 years, after which it would pass into Egyptian government ownership; de Lesseps was its first president.

Building was fraught with financial problems, political conflict and labour difficulties. Although France was the majority shareholder in the canal company, Britain maintained a close interest throughout its first hundred

▲ *Souvenir brochure of the inauguration*

President Nasser of Egypt ▶

▲ A ship sunk in the canal during the Suez Crisis of 1956

years, suspicious of perceived threats to its maritime supremacy and colonial interests. However, the canal was opened on 17 November 1869 and under the terms of the Convention of Constantinople in 1888, it was officially open to vessels of any nation without discrimination, in peace and war, under British protection.

The British occupied Egypt from 1882 onwards and maintained joint control with Egypt over the Suez Canal Zone (the canal and its surrounding areas), nominally until 1961. However, President Nasser of Egypt nationalized the canal in 1956, taking it into full Egyptian ownership and precipitating what became known as the Suez Crisis, which involved not only Egypt but the major political and military powers of the day – the USA, the USSR (Soviet Union), Britain, France and Israel. The three smaller powers together invaded Egypt to secure the Canal Zone.

However, the crisis took place in a tense international atmosphere at the height of the Cold War between the Communist Soviet Union and the West and its outcome had long-term repercussions.

Although pressure from the USA forced the three smaller powers into a climb-down, the Soviet Union also threatened to launch nuclear strikes against them – the start of a pattern of sabre-rattling and brinkmanship from the Communist state that led to heightened international tension which continued for several years. Egypt and Israel were drawn in the following decades into two more wars, in which they were supplied by the Soviet Union and the USA in a bloody vicarious Cold War conflict. The freedom of movement of Britain and France, previously major powers, was now exposed as greatly limited without superpower backing.

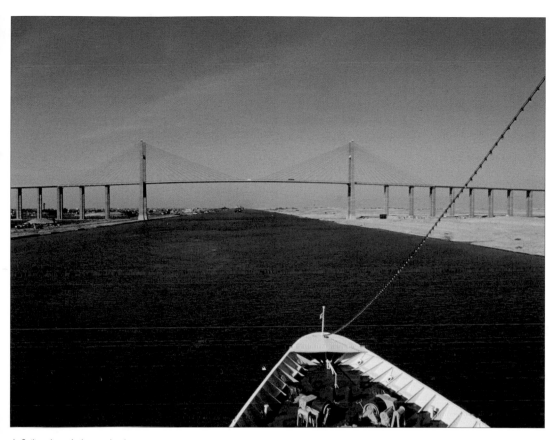

▲ *Sailing through the canal today*

The canal was closed twice during the Egyptian–Israeli conflicts, finally being reopened in 1975; it has remained open since. Currently the canal is being deepened and widened, with improvements to anchorages, to allow a doubling of its capacity. Plans for improvement are continually being updated.

The Treaty of Waitangi

Inscribed 1997

What is it

The treaty signed by British government representatives
and New Zealand Māori chiefs on 6 February 1840.
It established the principles by which the British and
Māori agreed to build the nation of New Zealand.

Why was it inscribed

The Treaty of Waitangi is the founding document
of the New Zealand nation.
It was also considered a radical departure in relations
between indigenous people and the incoming or
centralized power.

Where is it

Archives New Zealand, Wellington, New Zealand

On 6 February 1840 the Treaty of Waitangi was signed
in the Bay of Islands on New Zealand's North Island. In
essence, the treaty agreed the broad terms under which
the British and Māori would move forward in building
and governing the nation.

In the English version of the treaty, Māori ceded
sovereignty of New Zealand to Britain and gave the British
Crown the right to buy lands they wished to sell. By return
Māori received a guarantee of full ownership of their lands,
forests and fishing, and the status and protection of British
subjects. The English and Māori versions of the treaty were
intended to be the same but the versions have been subject
to varying interpretations.

The British were keen to sign the treaty at this stage.
With other foreign powers interested in New Zealand and
large numbers of settlers coming in, the British authorities
wanted to assert their control over the country. Captain
William Hobson was appointed as consul with instructions
to negotiate for sovereignty and the establishment of a
British colony.

Captain Hobson, together with several English
residents, signed along with forty-five Māori chiefs. The
treaty was then taken to obtain more Māori signatures. In
addition, seven other copies were sent around the country,
including to the South Island, for more signatures.
Between February and September 1840, around fifty
signing meetings took place and in the end, around 540

Māori chiefs signed the document. Of these, all but thirty-
nine signed a Māori-language copy of the treaty.

The treaty was unique in promising protection of
indigenous resources and possessions in the face of
colonization, and gave British citizenship to the
indigenous people. The British used the document as
the source from which they derived their authority.

After the signing, Captain Hobson – by then Lieutenant-
Governor – proclaimed Britain's sovereignty over New
Zealand. Although at that time considered a part of the
New South Wales colony, New Zealand became a Crown
colony in its own right by May 1841.

In New Zealand, the anniversary of the signing of the
Treaty of Waitangi on 6 February is now a public holiday
as Waitangi Day.

▲ The signing of the treaty

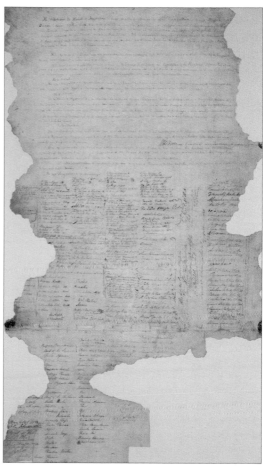

A copy of the treaty today ▲

The Emperor's collection:
foreign and Brazilian photography in the 19th century

Inscribed 2003

What is it
The collection of 21,742 photographs that belonged to the Emperor of Brazil, Dom Pedro II (1825–91).

Why was it inscribed
A unique collection of 19th-century photographs, it was assembled by one person throughout his life and is the largest collection of photographs in Latin America. It includes works by the first photographers in the world. The collection is an accurate portrait of the 19th century, reflecting the customs and the intellectual and industrial developments at the time it was put together.

Where is it
Fundação Biblioteca Nacional, Rio de Janeiro, Brazil

In 1839, the invention was announced of the daguerreotype, the first commercially viable and reliable means of producing a photographic image. The Emperor Dom Pedro II was just 14 years old and in 1840, having seen a demonstration of the process, he acquired daguerreotype equipment. He was the first Brazilian to make a photograph, and the first monarch anywhere in the world to do so.

This proved the start of a lifelong interest in photography. At home and through agents abroad, he bought and acquired items that interested him. He gathered photographs while on travels throughout his empire and abroad to North America, Europe, Russia, Turkey, the Holy Land, the Middle East and Africa. All the photographs collected on these travels give the collection an international interest. Annotations made on the photos are sometimes in the emperor's hand.

The emperor's collection of photographs includes the work of some of the most famous photographers in the world of their day. The new photographic techniques were used for different uses including documentation, representation and expression, in different types and formats, and the collection reflects all of these. In its comprehensive cover of the first half-century of photography, the collection is unique and irreplaceable.

Daguerreotype camera ▲

▼ *Emperor Dom Pedro II and his family visiting Egypt*

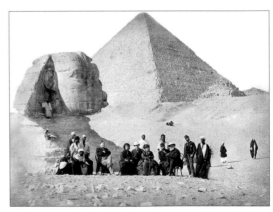

Dom Pedro was a patron of knowledge, learning and the arts, with a wide-ranging and keen interest in many subjects and the collection reflects this. The wealth of themes and subjects covered in the photographs is immense so that alongside photographs of family members, courtiers and everyday events, there are images recording every aspect of 19th-century life: agriculture, archaeology, architecture and town planning, the performing arts, the visual arts, astronomy, biology, botany, education, engineering, war, immigration, medicine and public health, physiology, ethnography and the European nobility of the time. As a patron of knowledge, learning and the arts, he often made personal contact with scientists, writers and artists, using them as a means of adding to his collections. The work of over 50 years resulted in a genuine contribution to the study of 19th-century customs and life in several parts of the world.

Named the Thereza Christina Maria Collection after the emperor's wife, it was bequeathed to the National Library on Dom Pedro's death in 1891.

Alfred Nobel family archives

Inscribed 2007

What are they

Documents, photographs, drawings and paintings comprising the Nobel Family Archive and Alfred Nobel's archive which document their industrial and commercial activities. Alfred Nobel's will is included among the papers.

Why were they inscribed

These archives depict the use of new inventions, the international expansion of industrial enterprises and the industrialization of modern warfare. Alfred Nobel's papers in particular reflect his creativity and also highlight his philanthropic use of the family fortune.

Where are they

Regional Archives in Lund, Lund; National Archives, Stockholm, Sweden

The Nobel Family Archive (*Nobelska arkivet*) in the Regional Archives in Lund mainly originates from the industrial enterprises of Alfred Nobel's father, Immanuel Nobel, of his brothers Robert Nobel and Ludvig Nobel Sr, as well as of his nephew, Ludvig Nobel Jr, during the period c.1840–1900. The main part of the archive is related to the family's industrial and commercial activities in Imperial Russia, particularly the production of land and sea mines intended for the Russian armed forces and the family's petroleum plants at Baku. Of special interest is a series of handpainted descriptions of the use of mines from c.1850 and a series of photographs of the industrial establishment at Baku from c.1880–90. The records thus reflect the enterprising traditions and inventiveness of the Nobel family, which provide an important background to Alfred Nobel's life as an inventor, international industrialist and benefactor of world importance.

Alfred Nobel's archive (*Alfred Nobels arkiv*) at the National Archives in Stockholm mainly consists of copy books, manuscripts, letters and correspondence, documents concerning laboratories, patents, lawsuits and disputes, factories, banks and stockbrokers, and information on particular inventions and products. In addition there are papers concerning Alfred Nobel's properties, his accounts, a collection of prints as well as some drawings and photographs. His day-to-day work as a talented inventor and industrialist is recorded in his copy books and correspondence: he was always busy, travelling, negotiating, carrying on lawsuits, etc. His papers give evidence of an inexhaustible creativity and energy resulting in new ideas and projects and his professional role is fully documented in his archives. The private side of his life, though the time left for this was limited, is documented as well. It appears in his correspondence on questions of war and peace with Bertha von Suttner as well as in his exchange of letters with his friend Sofie Hess. Among his literary files is the famous but abstruse drama *Nemesis*. Finally, there is his will, which established the Nobel Foundation, whose annual prizes ensure that, more than 100 years after his death in 1896, he will never be forgotten as a great benefactor.

Alfred Nobel, the great Swedish industrialist and philanthropist, photographed around 1890. When he died a few years later, he directed that most of his fortune be used to establish the Nobel Foundation which awards the annual Nobel Prizes for outstanding work in physics, chemistry, physiology or medicine, literature, peace and, more recently, economics. ▶

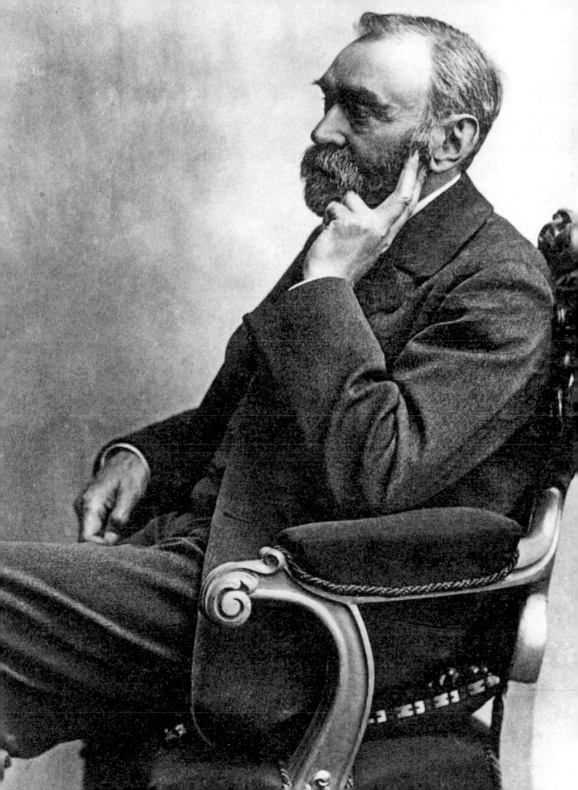

Colonial archives, Benin

Inscribed 1997

What is it

These archives mainly date from the colonial period, primarily for Benin (formerly Dahomey) in West Africa, and record the political activity of European (especially French) colonizers and the response of the indigenous peoples.

Why was it inscribed

The documents record the meeting between colonizers and colonized, between Western and African cultures which caused major political, social and cultural upheavals.

Where is it

Directorate of National Archives, Porto-Novo, Benin

The contacts between Africa and Europe reach back to before the 17th century. These contacts intensified in the mid-19th century as a result of a policy of colonial expansion and subjugation of the indigenous black peoples. The kingdom of Dahomey finally, at the end of the 19th century, became a French colony. Resistance to the colonial occupation was long and fierce, one example being the powerful kingdom of Abomey which constituted an indomitable obstacle to French colonization. King Behanzin led desperate resistance from 1890 to 1893. The local rulers were subsequently vanquished and their territories annexed and turned into colonies. This conflict between white invaders and rebelling indigenous populations of Dahomey and of neighbouring colonies (the German colony of Togo, the British colony of Nigeria and the French colonies of Niger and Upper Volta) is recounted in the richly informative documents contained in these archives. Once the era of conquest had ended, there were detailed internationally negotiated readjustments of the frontiers between the competing French, British and German colonies.

The bitterness of the resistance to the colonial power was affirmed with greatest conviction and intensity in Dahomey, the cradle of certain forms of anti-colonial struggle that subsequently awoke nationalist impulses in other territories under the colonial yoke. Everything regarding the life and work of the earliest champions of resistance, such as Louis Hunkanrin, is conserved in these archives.

The periodic political reports of the governor and local administrators make up the largest part (70 percent) of the archives, mainly because they were obliged to produce regular reports on events taking place in their districts. The archives also include documents relating to the life and work of kings and local chiefs, and to the state of mind and outlook of the indigenous populations, including their reactions to the colonial experience. It contains important data on the spread of Christianity and Islam, on Islam and colonial policy, on the evolution of traditional religions confronted with imported faiths and on relations between the colonial administration and religious leaders. Most of the texts are written by hand, in a very careful calligraphic style with elegant downstrokes and upstrokes. The clarity of the writing guarantees the readability of the information conserved.

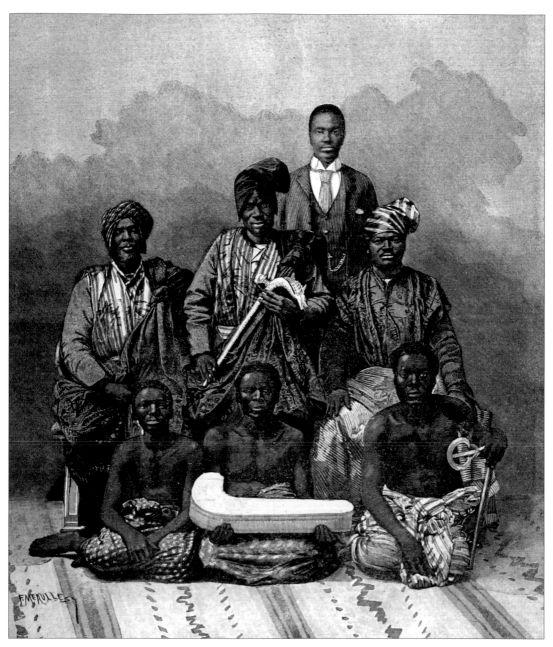

▲ *King Behanzin in Paris with some of his companions after his defeat in Dahomey by the French, whose colonial rule of the area is documented in these archives.*

The A.E. Nordenskiöld Collection

Inscribed 2011

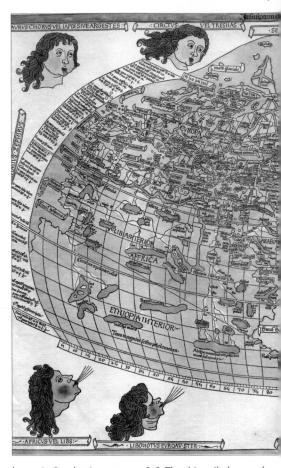

What is it

The collection gathered by Adolf Erik Nordenskiöld of more than 24,000 maps and thousands of volumes of cartographic material – old printed atlases, geographical works and travel literature.

Why was it inscribed

The extensive collection of maps covers the known world from antiquity to modern times. Nordenskiöld was a systematic collector and much of the material is very rare.

Where is it

National Library of Finland, Helsinki, Finland

The maps and cartographic material in the collection were gathered over more than 30 years by Adolf Erik Nordenskiöld (1832–1901). In addition to cartography, he was famed for his Arctic explorations and was a veteran of ten other explorations in the later 19th century.

The period was a golden age of Swedish Arctic exploration and Nordenskiöld was at the forefront. Although born in Helsinki, he lived and worked in Sweden for most of his adult life. As a trained geologist and mineralogist, he valued the potential scientific benefits offered by the exploration of new territories and always included scientists in his crews.

Nordenskiöld's most famous and notable voyage was around the Northeast Passage which he was first to navigate successfully. His journey in the SS *Vega*, a whaler,

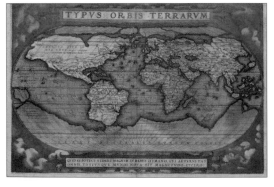

began in Sweden in summer 1878. The ship sailed around Asia and Europe in a clockwise direction via the Arctic Ocean – where it was icebound for almost 10 months – the Bering Strait, the China seas, the Indian Ocean and north again through the Suez Canal to arrive back in Sweden the following summer. The *Vega* was the first ship to circumnavigate the Eurasia landmass.

As an explorer, Nordenskiöld developed an interest in maps and especially in historical cartography in which he made important contributions. The collection of old maps and associated material he gathered was important in its own right and as the basis for his two books of historical cartography.

His collection contains about 5000 volumes covering the expansion of the known world from antiquity to modern times together with innovations in the history

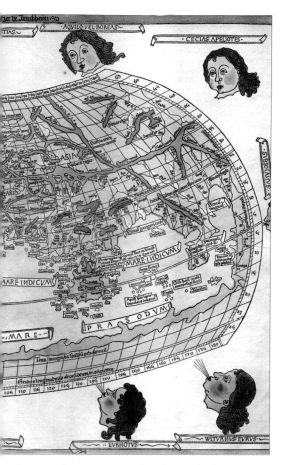

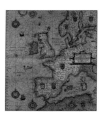

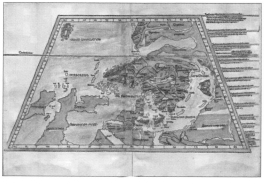

◀ *One of the oldest printed cartographic maps
of maritime Europe (1586).*

of cartography, navigation and seafaring. The discovery
of the New World in the 15th and 16th centuries
is extensively charted, and the Nordic regions are
exhaustively covered in geographic and cartographic
literature. The collection shows the influence of the
exploration of new regions in commerce, navigation
technology and political power from ancient to modern
times and reveals throughout mankind's search for
innovations and new discoveries.

The collection formed the basis of his *Facsimile Atlas*
of 1889. The work reproduced the most important maps
of the 15th and 16th centuries and included maps by
Ptolemy, the earliest maps made of the New World and
maps from atlases of the period. In *Periplus*, published in
1897, he charted the history of early cartography and the

charts mariners used in medieval times, covering not only
portolan charts but also *mappae mundi* and regional maps.

His extensive collection was bequeathed to the university
library of Helsinki, the city of his birth, after his death in
1901. The maps and associated material take up 400 metres
of shelving.

'José Martí Pérez' fonds

Inscribed 2005

What is it

The collection includes 2435 documents covering the literary, journalistic, revolutionary, diplomatic, biographical and personal work of or about José Martí. Some were collected to support the personal papers and place the work of Martí in perspective and illustrate his life.

Why was it inscribed

José Martí was an author and social activist whose influence has had an enduring influence on Latin American culture. The Cuban national hero is also synonymous with the bid for Cuban independence from Spain.

Where is it

Centro de Estudios Martianos, Havana, Cuba

José Martí (1853–95) left a rich cultural legacy in many fields. As a thinker and a politician, he led the way in literary creation and social action. However, his influence extends far beyond literary and artistic spheres: he helped to define the modern Latin American cultural identity.

As a writer, José Martí is one of the masters of universal literature. In his relatively short life he produced a written corpus in prose and verse that formed one of the most powerful foundations of modern literature in the Spanish language.

Like Charles Baudelaire, Arthur Rimbaud or Walt Whitman in their respective tongues, he was one of the fathers of literary modernity in the Spanish-speaking world. He undertook a renewal of the Spanish language and applied techniques that were similar to those used by Parnassians and symbolists to his prose and poetry. His language, syntax and use of adjectives showed a radical novelty, and he put in practice many modern poetical resources. His conviction that 'there will be no Spanish American literature until there is a Spanish America' filled the pages of the main newspapers of Latin America, turning him into the first Cuban figure to attain wide fame in the region.

Plaza José Martí, Cienfuegos, Cuba ▶

▲ *Statue of José Martí, Cienfuegos, Cuba*

His literature helped Cuban and Latin American culture to flourish in a period of vibrant creativity. Together with the praise of the great personalities of culture, science, industry and politics, he gives us portraits of his time and an even more penetrating study of the social restlessness of the final years of the 19th century.

His texts have been translated to several languages because of their literary value and their theses on the spirit of America in favour of a humanism seen from the universe of the poor of this Earth.

As a witness and decisive player in the international relations of his time, Martí's documents are extremely valuable. His writings succeed in showing the diplomatic, political and economic manoeuvres of the inventors of Pan Americanism – an instrument of the groups of power in the United States of America – in the construction of that country as a world power.

The collection shows the importance of the study and conservation of this documentation as an invaluable artistic and historical legacy and as an inseparable component of a new model of sustainable development. It contains 1821 manuscripts by José Martí and 415 documents on Martí or related to him. The collection also includes correspondence, notably with his family.

Archival documents of King Chulalongkorn's transformation of Siam (1868–1910)

Inscribed 2009

What is it

The official and private correspondence and memoranda between King Chulalongkorn and his ministers, memoranda between officials, reports of meetings and drafts of royal decrees and proclamations that took place during his reign.

Why was it inscribed

The documents record the transformation of a traditional state and society into a modern one in the late 19th century, when Thailand (formerly Siam) was the only country in Southeast Asia not to fall under colonial rule.

Where is it

National Archives of Thailand and National Library of Thailand, Bangkok, Thailand

▲ *The lake pavilion at the Summer Palace of Bang Pa-In, built by King Chulalongkorn*

Present-day Thailand is in many aspects a legacy of the policies and practices carried out by King Chulalongkorn the Great (1868–1910). These include the setting up of a national bureaucracy, a centralized government with territorial integrity and sovereignty, professional armed forces and police, an independent judiciary with a modern legal code and diplomatic relations with foreign powers. The documents are also the records of social policies such as the successful legal emancipation of slaves by peaceful means, the abolition of gambling, the establishment of a public school system and the reform of the Buddhist Sangha (the Buddhist monastic system), as well as the promotion of agricultural production, the market economy and financial and fiscal institutions. The documents were either handwritten texts on local papers made from the mulberry and *khoi* trees, or typed on imported papers. They are the basic source of information on the revolutionary measures adopted, the reasons for them, the strategies, the process of execution and the outcomes.

The documents of King Chulalongkorn's reign are the most detailed and well-written records of all in the Thai bureaucracy. The documents were written in simple and straightforward style, though certain precise terminologies were required for some legal documents such as the laws on slavery abolition, or new scientific terms such as 'electricity', 'telegraphy' and 'postal service'. The documents set the standards of official writing and Thai prose. The documents in the National Archive were formerly kept at the Royal Secretariat Department and are divided into thirteen categories according to the new ministries set up by the king: Defence, Agriculture, Finance, Foreign Affairs, Capital City, Interior, Justice, Public Works, Royal Seals, Palace, Education, Royal Secretariat and Miscellaneous. There is also a set of 367 bound volumes that cover such subjects as judicial verdicts, agreements, petitions and reports from the provinces. There are altogether nearly 50,000 subjects by entries. The National Library's collection consists of 'black books' made from *khoi* trees that were transferred from the Royal Palace and contain around 2900 items. The complete archive reflects the successful struggle for survival by a traditional state in face of modern arms and technology in the age of Western imperialism.

Arnold Schönberg estate

Inscribed 2011

What is it

The complete collection of composer Arnold Schönberg's manuscripts, books, photographs, recordings and other personal documents.

Why was it inscribed

The Arnold Schönberg estate forms one of the most extensive 20th-century music legacies of a single composer, who was widely acknowledged as one of the most influential and innovative composers.

Where is it

Arnold Schönberg Center, Vienna, Austria

Arnold Schönberg (1874–1951) was a pioneering composer, painter, teacher and theoretician, and one of the most prominent artistic figures in 20th-century culture.

Schönberg was a leading figure in the rapid development of music and the arts in Vienna, at a time when Vienna was regarded the musical capital of Europe. He was considered the father of the 'Viennese School' which explored atonality and was a hugely influential teacher of many eminent European and American composers, including Alban Berg, Anton Webern, Hanns Eisler, Nikos Skalkottas, Roberto Gerhard and John Cage. He taught in Berlin between 1925 and 1933 – a time of intense creative experimentation – and later worked in Los Angeles, where many key figures from European Arts had found exile.

Schönberg's innovations in atonality were a major landmark in 20th-century musical thought. In the 1920s he developed the twelve-tone technique, a widely influential compositional method of manipulating an ordered series of all twelve notes in the chromatic scale. Many of Schönberg's practices, including the formalization of compositional method, and his habit of openly inviting audiences to think analytically, are echoed in avant-garde musical thought throughout the 20th century.

Although Arnold Schönberg emigrated from Europe in 1933, he was able to keep his work, correspondence and other elements of his estate together. When he died, his estate consisted of a huge amount of music manuscripts, text manuscripts, his complete library, photographs and other documents. This collection was kept entire and

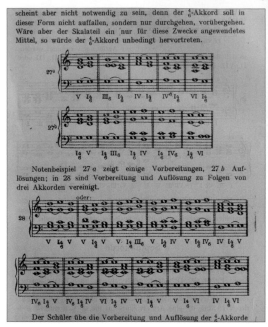

▲ *Page from the* Theory on Harmony *by Arnold Schönberg.*

Arnold Schönberg ▶

nothing has been added since, making it a uniquely comprehensive testament to the work, life and legend of a European composer.

His writings, apart from his compositions, are valuable documents for the musical, intellectual and cultural history of the first half of the 20th century, as well as for exile studies, and thus for contemporary history. They are evidence of the multifaceted interests of an eminent artistic personality, and also address questions of aesthetics, Jewish affairs, politics and religion.

Schönberg worked, socialized and exchanged ideas with some of the most important intellectuals, composers and other artists of his era, including Albert Einstein, Wassily Kandinsky, Thomas Mann, Karl Kraus, Gustav Mahler and Richard Strauss. The estate attests to half a century of cultural and intellectual history in Europe and the United States.

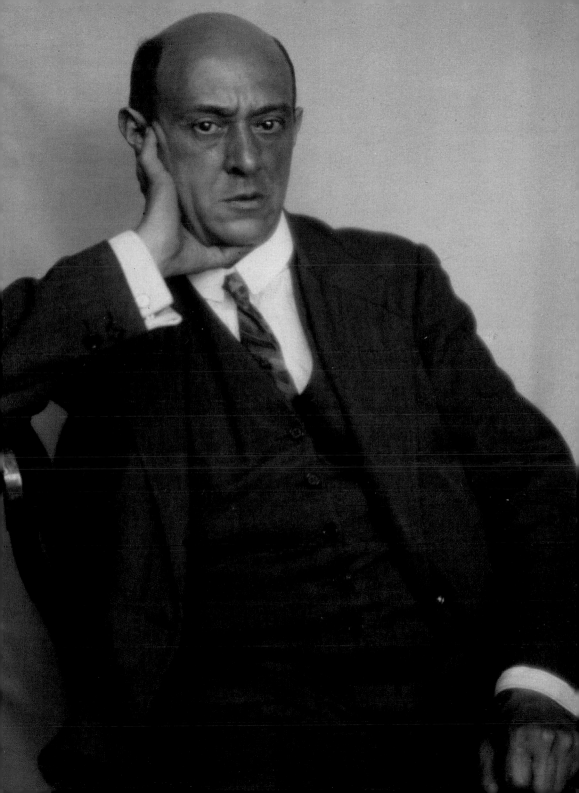

Jinnah papers (Quaid-i-Azam)
Inscribed 1999

What are they
The personal and political papers of Mohammad Ali Jinnah, the founder of Pakistan; the collection also includes Jinnah's published writings, photographs and maps.

Why were they inscribed
This collection reflects a period of tumultuous change and the struggle for independence in South Asia, as seen by one of its major figures, that resulted in the birth of Pakistan and the partition of India.

Where are they
National Archives of Pakistan, Islamabad, Pakistan

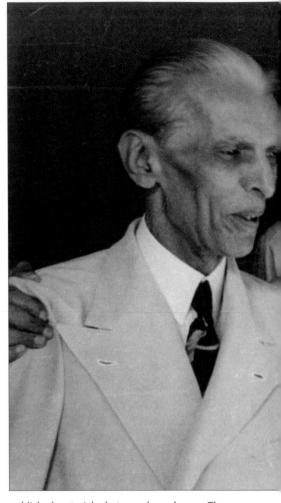

Mohammad Ali Jinnah (1876–1948) was born and educated in Karachi and trained as a barrister in London, returning to Mumbai to establish a legal practice in 1896. Popularly called *Quaid-i-Azam* ('Great Leader'), he was the founding father of Pakistan, of which, in 1947, he became the first governor-general, leading the new country until his death a year later. The collection of his papers covers the period from 1876 to 1948 and is of world significance as it reflects a period of momentous change in South Asia, culminating in the emergence of the two independent states of India and Pakistan. The collection is an important source for the study of the Muslim freedom movement in South Asia and of the political and personal life of Jinnah. It unfolds not only the various facets of his life and career but also the stages in the growth of the Muslim freedom movement and the development of the All-India Muslim League from a mere political faction into a great political party parallel to the Indian National Congress. The All-India Muslim League was created in 1906 to protect the rights of Indian Muslims. Jinnah joined in 1913, having left the Indian National Congress, and became its president in 1916. These papers contain records of the extraordinary qualities of his political leadership which enabled him to wrest the then largest Muslim state in the world, Pakistan, from colonial British rule amid strong opposition from the British and the Hindus.

The papers fall into five main categories: personal papers, political papers (the bulk of the collection), published material, photographs and maps. The personal papers relate to financial, social and medical questions. The political papers consist of reports, speeches, interviews and correspondence with Indian and 650 international leaders. They cover a wide range of subjects including the 'Transfer of Power' which led to the partition of India. Published material is mainly in the form of newspaper clippings, pamphlets, reports and books on subjects ranging from politics and education to sport and health. The 3000 photographs in the collection cover almost 50 years of Jinnah's private and public life. The small map section illustrates the physical features, administrative boundaries and demographic distribution

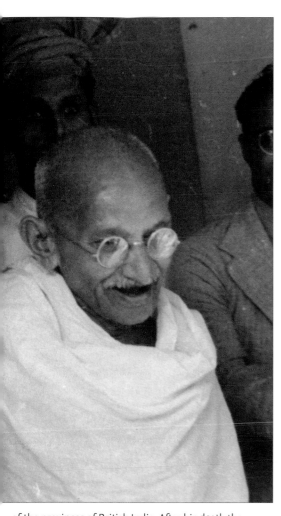

◄ Mohammad Ali Jinnah with Mahatma Gandhi in Bombay (now Mumbai), 9 September 1944. Three years later India and Pakistan were established as independent states.

of the provinces of British India. After his death the collection was kept by his sister and then, in 1967, it was taken over by the government and became part of the National Archives in 1973.

Dainu Skapis – Cabinet of folksongs

Inscribed 2001

What is it

The texts of nearly 218,000 Latvian folk songs in a wooden cabinet.

Why was it inscribed

This collection represents a detailed view of pre-Christian pagan life in Latvia and beyond, which cannot be found anywhere else. It documents folk culture, language, history, lifestyle and worldview.

Where is it

Archives of Latvian Folklore, Riga, Latvia

Dainu Skapis ('Cabinet of folksongs') is the physical archive and transcribed manuscripts of a huge collection of Latvian folk songs. This was edited and compiled by the noted Latvian scholar Krisjanis Barons from 1878 to 1915.

Since antiquity, folk singing has been a part of traditional societies, including that of the Latvian common people. Customs changed only slowly, and so did the songs, acquiring new layers, changing interpretations with the course of time, but always preserving the deeper roots. Not until the 19th century did any changes pose a threat to this tradition. Awareness of these changes and a growing appreciation of the cultural and historical value of ethnic antiquities led to a search for and a preservation of folklore in the 19th century.

A massive effort was launched to collate Latvian folk songs, spearheaded by Barons and carried out by Latvians themselves. This not only gathered nearly 218,000 song texts to be classified and later published in eight volumes, but also helped develop the growing sense of Latvian national identity. To this day it remains a source of collective self-confidence and inspiration for the Latvian people, revealing their rich cultural heritage that had not been previously recorded, yet had endured through centuries by oral transmission.

The source material for each of the printed songs was sent in to Barons by thousands of singers and other correspondents. The original manuscripts were copied by re-writing them and then cut into the required format. With the originals and copies there are now over

▲ Krisjanis Barons

Sample song texts ▲

374 Dainu Skapis – Cabinet of folksongs

350,000 paper slips of 3 cm by 11 cm with handwritten song texts often amended with Barons's annotations. As well as song texts, Dainu Skapis also contains data on traditions, customs, game descriptions, magic spells, proverbs and riddles.

These are all stored in a specially built cabinet with seventy drawers, each containing twenty sections to hold the texts, and three more drawers of additional written material. This 'treasure chest' was originally made in 1880 as Barons's day-to-day filing space, but has now become a cultural icon. For more than 60 years it has been housed at the Archives of Latvian Folklore in Riga where the songs are part of a wider folklore manuscript collection. Dainu Skapis has come to symbolise Latvianness and the Golden Age of Latvian tribes in the distant past.

Silver men: West Indian labourers at the Panama Canal

Inscribed 2011

What is it

This collection includes many official records, photographs, stamps and bank accounts that document and explain the role of West Indian labourers in the construction of the Panama Canal and its global impact.

Why was it inscribed

These documents record one of the most significant voluntary movements of people in the post-emancipation period after 1838. The scale of the emigration led colonial governments to control and mitigate this phenomenon, the scale of which had the potential to further erode the power of the British empire.

Where are they

Barbados Department of Archives and Barbados Museum and Historical Society, Barbados; Jamaica Archives and Records Department, Jamaica; Museo del Canal Interoceánico de Panamá, Republic of Panama; Saint Lucia National Archives; National Archives and Registration, Archives II, USA; George A. Smathers Library, University of Florida, USA; National Archives and a private collection, UK

▲ *Families often came with the West Indian labourers who worked on the Panama Canal. Some made a living hawking food and other goods within the West Indian community.*

A picture of those who oversaw the building of the Panama Canal. West Indian labourers made up an important part of the workforce who built the canal. ▼

The migration to the Isthmus of Panama of more than 50,000 West Indian labourers, followed by their wives, girlfriends, sons and daughters started in 1881 with the French attempt to construct a Level Canal, and lasted until 1914, with the triumphant inauguration of the Lock's Canal by the USA. This mass migration made it necessary for the West Indian colonial authorities to administer those emigrating to Panama to work under contract for the construction of the Panama Canal. This encouraged the creation of registers such as Emigrants' Registers, Official Gazettes, Governors' Reports and Police Reports, all of which documented and recorded the movement of thousands of people migrating out of the region and, significantly, out of colonial legal and political control.

The vested interests of the West Indian plantocracy who wished to maintain an assured labour pool was threatened by this mass out-migration. At the same time the colonial governments of the region had an

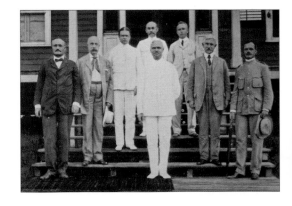

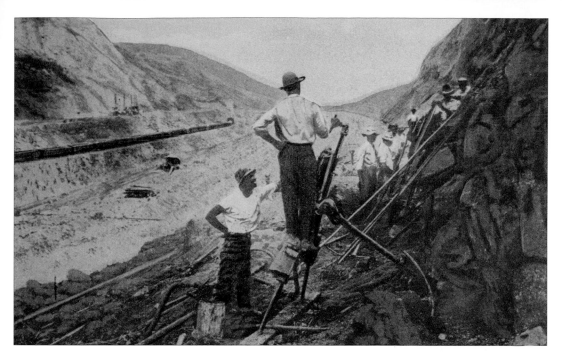

▲ *West Indian labourers working on the Panama Canal, operating drilling machinery in preparation for a rock blast: one of the postcards in this collection.*

interest in appearing benevolent towards plantation workers by creating a legislative framework in which their rights and working environment were optimized. These laws and regulations sought to control the exodus of a labour force over which they had strict control, and which was now being disrupted by this migration. This mass emigration out of the British empire and their relocation to Panama was witnessed and intimately recorded in papers which highlight the daily lives and working conditions which tens of thousands of West Indians had to endure in Panama. The heritage that captures all of this movement is contained in the Colonial Secretary's Office Records, Central Government Department Records of Panama and various statutory bodies' records which reported on their settlement, status and condition.

For the many thousands of West Indians who made new lives in Panama from the middle of the 19th century to opening of the canal, this voluntary separation from home and family represented the unimaginable promise of economic improvement. Depositors' Ledgers of the Barbados Savings Bank, from 1853 to 1918, record the financial transactions of tens of thousands of people who were depositing 'Panama Money', which represented a new-found economic freedom directly related to the West Indian Panama experience. Philatelic and photographic documents offer evidence of the burgeoning exchange of communications between Panama and the West Indies during the first few decades of the 20th century – indeed the Canal Zone had its own stamps as a strategy to make it easier for workers to stay in touch with their relatives. Additionally, the images archived in various media are invaluable as records of the entire process of the excavation and construction of the Panama Canal, and the lives of those who participated in it.

The records of the Isthmian Canal Commission that document the success of the American canal project also relate to the earlier French attempt in the late 19th century and the early records of the Panama Railway Company from the mid-19th century, all of which were catalysts for the introduction of West Indian labour to the Isthmus of Panama.

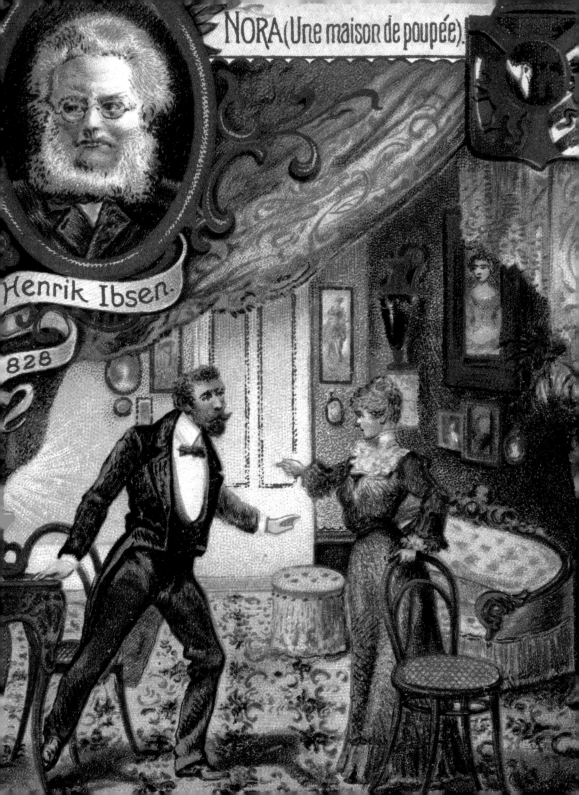

NORA (Une maison de poupée).

Henrik Ibsen.

828

Henrik Ibsen: A Doll's House

Inscribed 2001

What is it

The original manuscript of the play *A Doll's House*.

Why was it inscribed

This is the only autograph manuscript of *A Doll's House*, a play that has had global impact both as an innovative dramatic work and as a groundbreaking work on women's rights.

Where is it

National Library of Norway, Oslo, Norway

Few plays have had the global impact on social norms and conditions as Henrik Ibsen's *A Doll's House*. First produced in 1879, the play had an immediate, shock effect, at times to the point of upheaval. Regarded as a serious attack on social stability, it quickly made the playwright world-famous.

The play revolutionized contemporary Western drama, both formally and thematically. In the 20th century, the effect of the play spread to include Asia and the Third World, where its form became symbolic of a modern Western drama and its content reflected values such as human rights and existential freedom. It was widely staged throughout the world, and is still regularly performed.

In *A Doll's House* Henrik Ibsen portrayed his main female character, Nora Helmer, as a dependent woman who is searching for the freedom to develop as an adult in her own right. The story is that of the individual in opposition to the majority, to society's oppressive authority.

More than anyone, Ibsen gave theatrical art a new vitality by bringing into European bourgeois drama an ethical gravity, a psychological depth and a social significance that the theatre had not seen since the days of William Shakespeare. His realistic contemporary drama was a continuation of the European tradition of tragic plays. In these works he portrays middle class people whose routines are suddenly upset as they are confronted with a deep crisis in their lives. They have been blindly following a way of life leading to the troubles and are themselves responsible for the crisis. Looking back on their lives, they are forced to confront themselves.

The first known draft of the play is entitled *Notes on the Tragedy of the Present Age* (Rome, 19 October 1878). The draft material gives direct access to the playwright's work processes. The reader can clearly follow the development of Ibsen's artistic imagination and the sharpening of ideological content. In the manuscripts, Ibsen expresses his revolutionary ideas more directly than in the finished work, which for artistic reasons is rendered more ambiguous. The manuscripts include all material known to exist from the creation and first printing of the play. The notes, drafts and papers for Henrik Ibsen's *A Doll's House* are the most detailed and interesting manuscript material from the hand of this great playwright.

A Doll's House is an exceptional achievement. In spite of Nora's uncertain future prospects – confronting the problems of a divorced woman without means in the 19th-century society – she has served and serves as a symbol throughout the world for women fighting for liberation and equality.

◀ *French advertisement (c.1900)*
 showing a scene from A Doll's House

Nikola Tesla's archive

Inscribed 2003

What is it

A unique collection of Nikola Tesla's manuscripts, photographs, scientific and patent documentation for many devices including electric motors and fluorescent lighting.

Why was it inscribed

The work of Nikola Tesla has had a major impact on modern life while Tesla himself has remained relatively unknown. The collection is a unique insight into the work of a key engineer of the early 20th century.

Where is it

Nikola Tesla Museum, Belgrade, Serbia

Nikola Tesla (1856–1943), an ethnic Serb, was born in Smijan (now in Croatia), and after study in Graz, Prague and Belgrade, he moved to Paris in 1882 and to the USA in 1884. As an inventor and scientist, he was a pioneer in alternating current (AC) electricity, the cornerstone of modern electricity generation, and of the long-distance transmission and use of electrical power. Tesla's asynchronous electric motor, 'the draught horse of industry', provides 95 percent of the world's electric motive power for driving machinery. It is estimated that 60 percent of total world energy is used in driving these motors. The majority of household motors are also asynchronous.

In addition to the electric motor, he was known as the inventor of the Tesla coil – a high-frequency transformer, which is an essential part of all contemporary HF devices. He was the first to research other effects produced by his currents, such as the possibility of induction heating, ozone production and effects on the human organism. The plasma production technique that he invented was the pioneering work in the field, which only recently became remarkably important for the production of computer chips. The remote control was one of his inventions developed towards the end of the 19th century. He was also the inventor of the system of selective radio reception, later known as the 'spread spectrum technique'. He discovered the principle of the logical 'i' circuit without which contemporary computers would be impossible and worked on phosphorescent and fluorescent light. In his honour, the magnetic induction unit (tesla) of the SI system is named after him.

During his lifetime, Tesla received much recognition from many universities and institutions. Nikola Tesla belonged to that breed of independent inventors who were responsible for many of the most progressive ideas of those times. He was, as a thinker and creator of inventions, far ahead of his time. His inventions belong to the end of 19th and beginning of 20th centuries, but are still in use without new solutions in sight.

The collection documents the most important era in the development of the modern world, which, thanks to Tesla's work, made easy energy production and distribution possible. After Tesla's death in 1943 in New York, his possessions and personal archive (including patent documentation, scientific papers and technical drawings) were shipped to Belgrade, where a small Memorial Museum was established.

Nikola Tesla, photographed in the early 1880s, before he left Europe for the USA and before his great success as an inventor of many of the electrical devices upon which we still depend. ▶

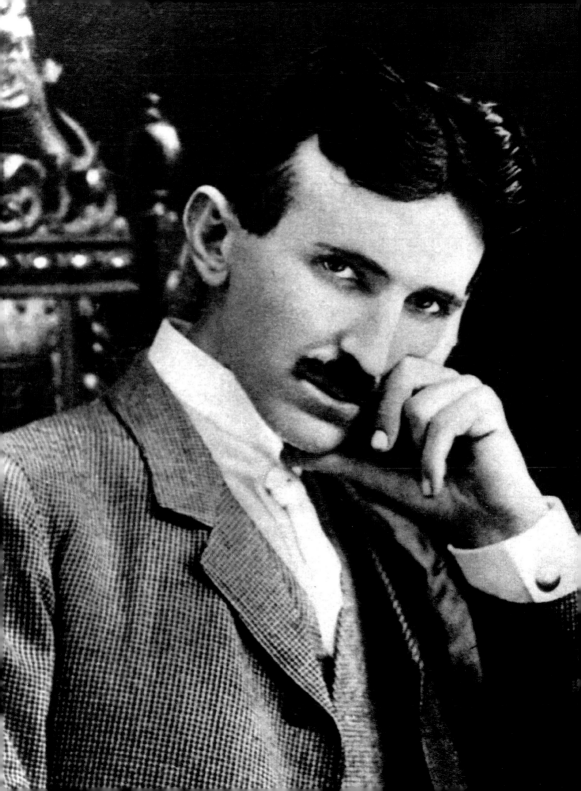

Benz patent of 1886
(Patent DRP 37435 'Vehicle with gas engine operation')

Inscribed 2011

What is it

Carl Benz's unique and irreplaceable patent of 1886 for a 'vehicle with gas engine operation' is the world's first patent for an automobile.

Why was it inscribed

It symbolizes the emergence of individual powered mobility and is the origin of today's automobile society.

Where is it

Daimler AG Collection, Archive and Collection, Stuttgart, Germany

The automobile is unquestionably of great global economic and cultural importance. Its origins lie in southwest Germany with the inventors Gottlieb Daimler and Wilhelm Maybach in Stuttgart and Carl Benz in Mannheim. The work of Carl Benz is particularly significant. The unique feature of his innovation was the idea of developing and building the motor carriage and engine together. From the heavy and slow-running

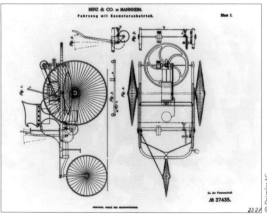

▲ The illustration from the Benz patent showing Carl Benz's design for his three-wheeled Motorwagen, the first practical automobile.

The Benz Patent Motorwagen is shown at the Mercedes-Benz Museum Stuttgart, Germany. ▶

© Daimler AG

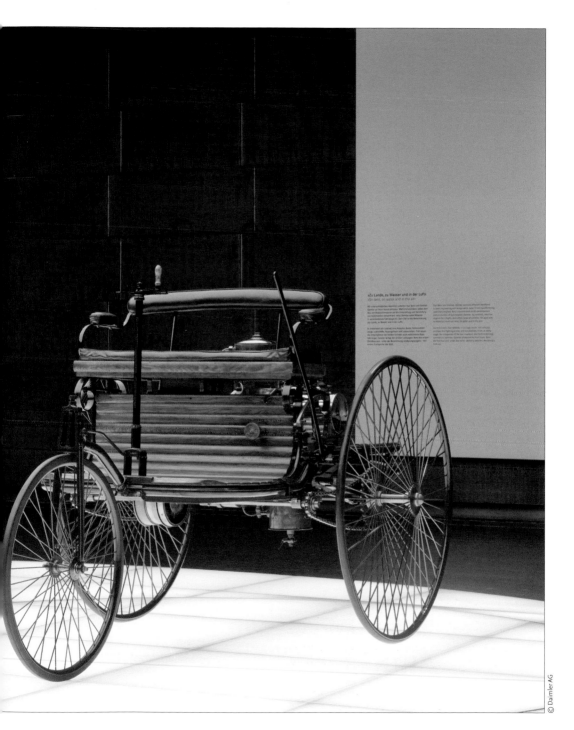

383

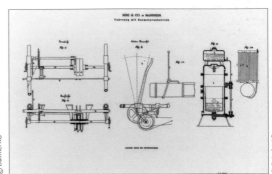

▲ *Carl Benz's patent application of 1886 for his* Motorwagen.

▲ *Various components of Carl Benz's* Motorwagen, *taken from his 1886 patent application.*

stationary combustion engine, a lighter gasoline motor more suitable for mobile applications was developed in his workshops. This, along with a chassis based on the lightweight construction of bicycles and carriages, led to a new device, the *Motorwagen*.

Central to the early history of individual mobility based on motor vehicles is a basic patent, namely, Patent DRP 37435 'Vehicle with gas engine operation' submitted by Carl Benz and dated 29 January 1886. The patent claims which are set down refer to a self-propelled vehicle for the conveyance of 'one to four persons' with a 'small gasoline engine of whatever type' which obtains its gasoline 'from an apparatus carried on board in which gasoline derived from ligroin or other volatile substances is produced'. This patent, therefore, may be seen as the basis for the invention of the automobile with an internal combustion engine running on liquid fuel. Inscribed with it are a number of rare historical documents, such as formal requests to drive on public roads in Mannheim with the *Motorwagen*.

The original certificate issued to the patentee does not exist and the original documentation that supported the application was destroyed when the Imperial Patent Office (*Reichspatentamt*) was burned in the Second World War. There is only one original printed copy known to exist today and, with a high degree of certainty, it can be said that this copy was in the possession of either Carl Benz or the company Benz & Cie.; it is now kept in the company archive of Daimler AG. The ideas documented in the patent can be considered as the technical groundwork for individual motor transport, one of the most influential inventions of the 19th century, that led to today's 'automobile society'.

Correspondence of the late Sultan of Kedah (1882–1943)

Inscribed 2011

What is it

The surviving official documents of the Kedah sultanate record the effect of growing European influence in the Malay Peninsula. They cover social change, economics, politics, foreign relations, education, religion and customs.

Why was it inscribed

This is the only surviving primary source material in Arabic and Malay script of a Malay sultanate from this period. It is doubly significant in that the materials come from a place where very few written documents survive primarily because of the region's strong oral-history tradition and tropical climate.

Where is it

National Archives of Malaysia, Kedah/Perlis State Branch, Alor Setar, Kedah, Malaysia

These unique records constitute the only available evidence of a Malay sultanate prior to the advent of Western-style colonialism. Kedah is in northwest Malaysia, bordering Thailand, and its sultanate is one of the longest surviving monarchies in the world. Its records provide invaluable historical evidence of the precarious life of a state in transition between Siamese overlordship and the British intervention in the Malay Peninsula in the late 19th century.

Originating from the Royal Palace, the highest seat of administration in the state of Kedah, the records reflect the unified authority wielded by the Palace in all matters relating to Kedah state administration. The Palace traditionally had total influence on all aspects of the life of the people. Its influence, however was seen to be waning by this time, as it was no longer able to control the destiny of the state on account of the need to submit to foreign powers far superior in might.

The archives, which are bound in fourteen volumes, comprise 2951 copies of original letters which are penned in Jawi (Malay written in an Arabic script). They consist of official records and correspondence from the Kedah Royal Palace. These manuscripts date back to 1882 to the reign of Sultan Abdul Hamid Halim Shah, the twenty-fifth Sultan of Kedah, corresponding to the years that Wan Mat Saman served as Prime Minister. The collection includes letters written to the King of Siam, the governors of Siamese states as well as the British Residents in Penang, Singapore, Perak and Selangor. Together, the collection provides the only written historical evidence on the history of Kedah under both Siamese and British rule. The archives also include the Royal Diary, agreements, proceedings of the State Council, reports, state budgets, royal household expenditure, letters of application and approval, and various other matters.

The letters, written in Malay, embody all that is most beautiful in Malay culture, civilization and language and offer a glimpse of the complex social and political structure of the Malay society. The language used shows the relative rank of the correspondents and the diplomatic importance of the missive.

The Historical Collections (1889–1955) of St Petersburg Phonogram Archives

Inscribed 2001

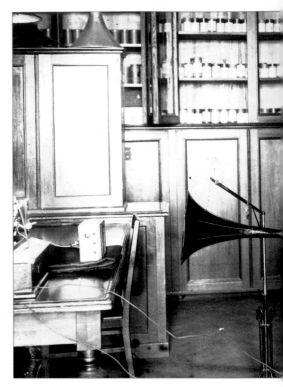

What is it

The Historical Collections of the Phonogram Archive of the Institute of Russian Literature, a corpus of over 35,000 historical recordings in the field of ethnomusicology, ethnolinguistics and philology. Dating from 1889 to 1955, the collections amount to over 500 hours of recorded sound material.

Why was it inscribed

Many of the recordings are the oldest of their kind and some are unique. As a whole, they represent orally transmitted cultures, languages and rites which have since undergone substantial changes or have even been lost altogether.

Where is it

Institute of Russian Literature, St Petersburg, Russia

The Historical Collections of the St Petersburg Phonogram Archive were gathered in many regions of Europe and Asia and represent many of the people and ethnic groupings of the Tsarist Russian empire and later, the USSR (Soviet Union). An encyclopedia of Russian ethnology, the recordings also exemplify beyond a regional and national context, the many types of traditional culture

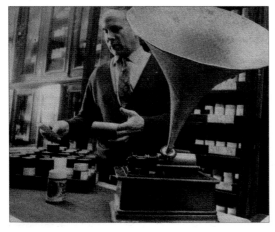

which have been changed irrevocably by the developments of the 20th century.

Most of the recordings made before 1930 are the earliest of their kind, so allowing a deeper insight into the history of their respective cultures, languages and musical styles. A high proportion of the items date from before 1910, the earliest period of recording with a phonograph in the field. The 20th century wrought fundamental changes in the traditional rituals and form of folklore singing, so that contemporary recordings are simplified modern equivalents of the originals.

Many nationalities were recorded for the collection whose significance therefore goes beyond a single culture. Recordings were made not only in Russia, but also its zones of influence and neighbouring regions; the source area spanned from Serbia, Slovenia and Croatia on the shores of the Adriatic to the Aleutian Islands in the Bering Sea, taking in Arkhangelsk (Archangel) and Siberia.

◀ *Storing the wax cylinders* *The recording equipment in use* ▶

Recordings were also made of smaller religious sects who separated from the Russian Orthodox Church, such as the Old Believers, the Molokans and the Doukhobors. Different religious and ethnic groups, including Hassidic Jews and German colonists in Russia, were also recorded, and the extensive folklore collections of peoples in Siberia and the Far East are considered particularly important. The material in the collections is a source for any potential reconstruction and revival of such declining cultures.

The original recordings were made on wax cylinders or gramophone disks. The collection was built up through the efforts of researchers and staff members in the field and of organizations and collectors who donated or deposited their own material. Now the Historical Collections consist of about 10,000 wax cylinders, more than 400 wax disks and more than fifty lacquer disks.

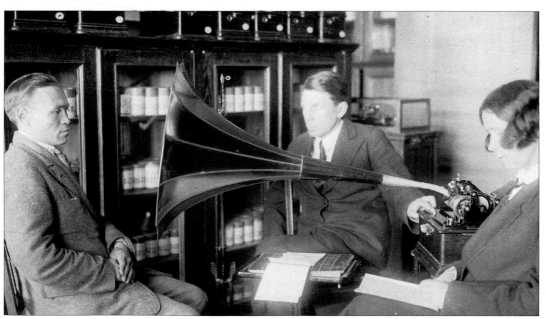

German records of the National Archives

Inscribed 1997

What is it

The German records concern particularly the establishment in the late 19th century of German East Africa (now the countries of Tanzania, Rwanda and Burundi).

Why was it inscribed

The records show the situation in East Africa during the 'Scramble for Africa' in the late 19th century when European powers were dividing Africa among themselves, events which can be understood by referring to these documents.

Where is it

Tanzania National Archives, Dar es Salaam, Tanzania

The European powers partitioned Africa among themselves with such haste that the process has been called the 'Scramble for Africa'. Never in the history of Africa had so many changes occurred with such speed as between 1880 and 1935. By 1914, with the exception of Ethiopia and Liberia, the whole of Africa had been subjected to the rule of the European powers. During this period, Africa, which once was regarded as a 'dark hell', was partitioned, conquered and occupied effectively by the industrialized nations of Europe.

The German records under the custody of the Tanzania National Archives show that German efforts to find colonies in East Africa began in 1884. In September of that year, Dr Carl Peters, one of the founders of the German Colonization Society (*Gesellschaft für deutsche Kolonisation*) and his friends Juhvke, Pfeil and Otto, set out on a voyage to East Africa to look for colonies. In November 1884, they managed to conclude a number of now historically famous so-called 'treaties' with the local chiefs of Usagara, Nguru, Uzigua and Ukami. After the signing of these treaties, Carl Peters hurried back to Germany to report his achievements. This was followed, on 25 February 1885, by the German Imperial government's declaration of the emperor's sovereignty and protection over the territories contained in the treaties. The administration of the territories was handed over to the newly formed German East Africa Company (*Deutsch-Ostafrikanische Gesellschaft*).

The administrative activities of the German East Africa Company in the territories were closely supervised by the German Imperial government, which appointed its representative for East Africa in 1887. Meanwhile, the Germans and the British negotiated an agreement to end the reign of the sultan of Zanzibar on parts of the mainland Tanganyika. An agreement was reached on 25 September 1890, whereby the Sultan of Zanzibar, Seyyid Barghash, permanently gave up his possessions on the mainland against a payment of £200,000. The German Imperial government took over direct control of the colony's administration on 1 April 1891. After the defeat of Germany in the First World War (1914–18), the former German East Africa (Tanganyika, Rwanda and Burundi) was divided, with the Belgians occupying Rwanda and Burundi, while the British took over Tanganyika, with the borders established in a peace treaty with Germany signed on 10 January 1920. The archives also hold information on the activities of Nazi sympathizers and organizers in the years leading up to the Second World War.

The Azania Front Lutheran Church in Dar es Salaam, built in 1898 by German missionaries, 14 years after German colonization of East Africa began. ▶

(following page) A letter of manumission (the granting of freedom) of a former female slave issued by the Imperial Government of German East Africa in 1911. ▶

Kaiserliches Gouvernement
von
Deutsch-Ostafrika.

Freibrief Nr. 251.

1. Name des Freigekauften: *Nyaluwega*
2. Geburtsort: *Ussi*
3. Geschlecht: *weiblich*
4. Alter: *ca 30 Jahre*
5. Personenstand: *-*
6. Wohnsitz: *Tabora*
7. Beschäftigung: *-*
8. Hörige bisher de*s Mussi Swaga*

zu *Tabora*

hat heute durch *Freikauf*

ihr Freiheit erhalten, worüber ih~ auf Grund der Verordnung vom 1. September 1891 der gegenwärtige Freibrief gebührenlos ausgestellt worden ist.

Tabora, den *21 August* 19 *11*.

D*er* Kaiserliche Bezirksamt*mann*

Manifesto of the Queensland Labour Party to the people of Queensland
(dated 9 September 1892)

Inscribed 2009

▲ Charles Seymour Thomas Glassey ▲

What is it
A political manifesto of the Queensland Labour Party in Australia from 1892.

Why was it inscribed
The manifesto is regarded as a formative document of the Labour (now spelled 'Labor') Party in both Queensland and Australia and as a factor in the election of the first socialist government in the world, the short-lived Anderson Dawson administration in Queensland in December 1899. As such, it has world significance in the history of the labour movement.

Where is it
State Library of Queensland, Brisbane, Australia

The Manifesto of the Queensland Labour Party was the product of a period of political and social upheaval in Queensland. The collapse of the Maritime Strike and the Queensland Shearers' Strike in 1890 and '91 had been setbacks for the Australian labour movement which precipitated a new approach: rather than simply taking industrial action, it now also turned its attention to the electoral arena and parliamentary representation.

This venture by a labour movement into parliamentary politics was not a purely Australian phenomenon. Britain, New Zealand, Canada and the US were facing similar social and economic upheaval and labour movements in other countries were moving in a similar direction.

However, the Australian labour movement was at the forefront. The manifesto was among the first documents to tackle parliamentary representation of labour seriously and in practical terms and as a surviving document from the period, it is rare if not unique. In this respect, its significance is important not only for the history of the labour movement in Queensland and Australia but across the wider world.

The manifesto was also one of the planks upon which the Queensland and Australian labour movement

developed and was a central document in the formation of the Australian Labour Party.

The document itself listed the party's grievances against the political and economic establishment of the day and advocated the protection of jobs; however, it was not revolutionary or communist in its aims.

Its author was Charles Seymour (1853–1924) who was prominent in the Queensland labour movement and its signatory was Thomas Glassey, an Irish-born former coal miner and president of the Labour Party in Queensland. Glassey had previous experience in electioneering: before his arrival in Australia, he helped in the election to Parliament of Thomas Burt, one of the first working-class MPs.

Anderson Dawson's seven-day Labour administration in Queensland in December 1899 was the first ever Labour government in the world. Five years later, J.C. Watson's minority administration in the Federal Parliament became the first national Labour government.

◄ The front page
of the manifesto

(following page) Parliament
House in Brisbane
in the late 19th century ►

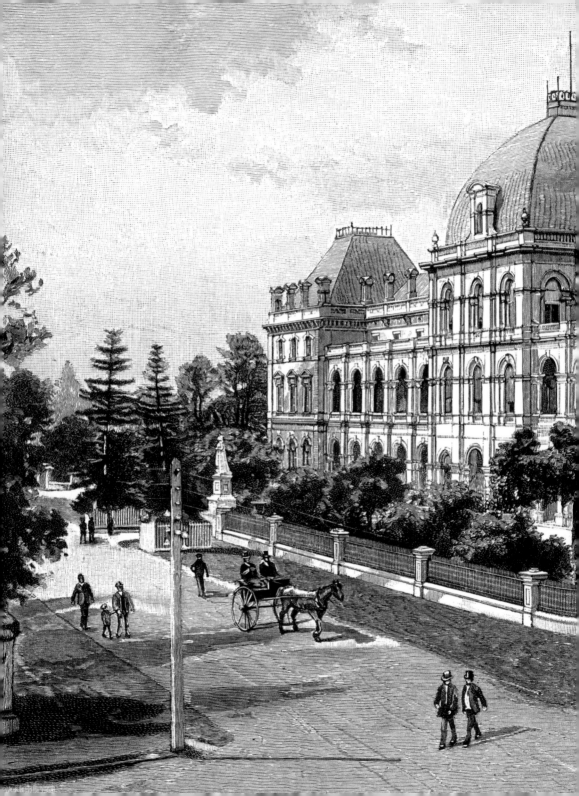

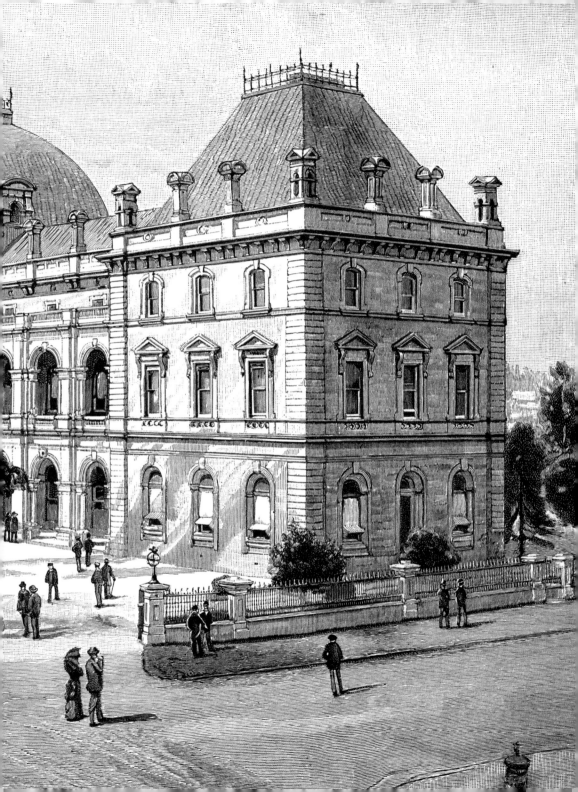

The 1893 Women's Suffrage Petition

Inscribed 1997

What is it

A petition of 1893, addressed to the New Zealand Parliament and signed by almost one quarter of the female adult population, calling for universal female suffrage or voting rights.

Why was it inscribed

New Zealand was the first self-governing nation where women were legally entitled to vote; the petition was a factor in and symbol of this advance.

Where is it

Archives New Zealand, Wellington, New Zealand

The movement for universal suffrage was one that crossed national boundaries in the West, particularly in the 19th and 20th centuries. In many countries, men had benefitted from the gradual relaxation of rules requiring that all voters be property owners, although full democracy for them was still some way distant: for example, full adult male suffrage did not come into effect in Britain until 1918.

In New Zealand, all men over 21 years old were legally entitled to vote from 1879 and the general election of 1881 was the first full democratic election for male voters. Women remained excluded from parliamentary elections although they had made progress in other areas: those who were rate payers could vote in local-body elections from 1873 and four years later, adult women could vote in and stand for elections to school committees and education boards.

The late 1870s through to the early '90s saw several attempts in Parliament to extend the vote to women, many of these failing narrowly as the lower House of Representatives passed the measures, but the upper, more conservative Legislative Council blocked them.

The woman recognized as the driving force behind the petition of 1893 and the ultimately successful campaign was Kate Sheppard, founder in 1885 of the New Zealand Women's Christian Temperance Union. Humanitarianism and a strong sense of natural justice underpinned her ideas; in addition, her favoured causes of temperance and the welfare of women and children were matters she believed could be advanced through women's suffrage and representation in Parliament.

Several petitions had been presented unsuccessfully to the Houses of Parliament from the early 1880s. The Women's Christian Temperance Union organized this already-existing support for votes for women through their branch and public meetings and newspaper letters. In 1892 the Union submitted to Parliament a petition of 20,000 signatures. Although it was ultimately unsuccessful, another petition was planned for the following year.

Petition sheets were circulated throughout New Zealand and when filled were glued together. In all, 546 sheets were stuck end-to-end into a roll 274 m long. Kate Sheppard's signature is on the first sheet. A handwritten note on the reverse of the first sheet states that the petition had 25,519 signatures when it was presented to the House of Representatives in 1893, although the actual number of signatures on the surviving petition is 23,853. The petition was the largest one of its kind to date in New Zealand or any Western country.

This time, the Electoral Bill passed both Houses of Parliament and received royal assent from Governor Glasgow on 19 September 1893. Women were allowed to vote on the same terms as men, which made New Zealand the first country in the world to take this step to equal voting rights.

Although separated by a hemisphere from contemporary social events in Britain and America, the New Zealand supporters of women's suffrage – popularly termed 'suffragettes' – were aware of being part of a movement

◀ K.W. Sheppard's signature, first sheet

Picture of Kate Sheppard on a New Zealand $10 note ▶

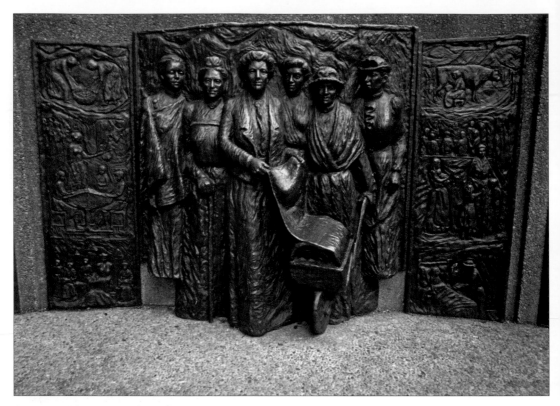

that spanned the world. Suffragettes in Australia, Britain and America hailed the passing of the vote in New Zealand.

It has been suggested that New Zealand was more open to voting reform because, as a new country, it was less constrained by entrenched attitudes. Only in three more countries would women receive the right to vote before the First World War – Australia in 1902, Finland in 1906 and Norway in 1913. In New Zealand, women remained ineligible to stand for election to the House of Representatives until 1919.

The Kate Sheppard Memorial in Christchurch ▲

Early cylinder recordings of the world's musical traditions (1893–1952) in the Berlin Phonogramm-Archiv

Inscribed 1999

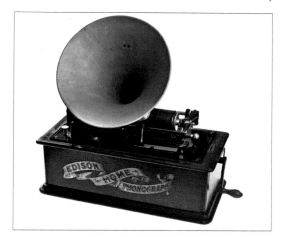

What is it

The oldest sound documents of traditional music of the world from 1893 to 1952. The collection comprises 15,185 phonograph cylinders or mechanical characters.

Why was it inscribed

The collection is of historic, worldwide and cross-cultural significance and is an invaluable source for the study and the history of music.

Where is it

Ethnologisches Museum, Berlin, Germany

The Phonogramm-Archiv is a centre of source materials and reference for musicological and cultural studies. It was formed in 1900 with the recordings on an Edison phonograph of a group of Thai musicians performing in Berlin; this proved to be the start of a pattern of recordings of other touring musicians giving performances in the city.

Field recordings began coming into the Phonogramm-Archiv in 1902 after expeditions to Turkey by the director of the Ethnographical Museum, and to East Africa (now Tanzania) by a German linguist. The archive later received cylinders recorded even before 1900, made with the Kwakiutl in the Pacific northwest in 1893 and the Torres Straits in 1898.

Subsequently, the travellers going abroad – geographers, linguists, ethnographers, doctors, missionaries, colonial officers and others – were supplied by the archive with an Edison phonograph and cylinders for recording music in the field. Their collections, combined with archive's musicological analysis and interpretation, led to its growth into a major centre of comparative musicology.

In addition, technical advances saw the archive become a main centre for the copying of cylinders, and collectors and institutions from other countries sent their collections to Berlin for copying. By 1933, around 10,000 original recordings were archived. Overall, 35.5 percent of the collection comes from Africa, 11.7 percent from America,

25.7 percent from Asia, 11.4 percent from Australia and Oceania and 15.5 percent from Europe.

Before the end of the Second World War all the recordings were evacuated. Many cylinders went west but others, together with other parts of the archive, were sent to Silesia. The Russians took them from there to Leningrad although most, but not all, were sent to East Berlin in 1959. Cooperation at a personal level across the Berlin Wall in the 1960s quietly allowed the shipping of 4000 cylinders to West Berlin and their copying and return, until the Communist authorities found out and locked up the entire collection.

After the fall of Communism and the Wall, the whole collection was returned to the Phonogramm-Archiv Berlin, reuniting it after 47 years.

The archives are a potential source for extinct music cultures, and of religious and traditional beliefs of people before their conversion to Christianity – as, for example, with Indian people in Argentina in 1905–06. Materials from the archives have already been referenced as a basis for a planned revival of obsolete performances, such as the court music of Fumban in Cameroon or of Buganda in Uganda. Accompanying documents give details of the content, including technical details of the recordings, the performers, their instruments and the cultural context; some also have photographs.

Lumière films

Inscribed 2005

What is it

All the 1405 original negative and positive films still in existence, which were produced at the factory of brothers Louis and Auguste Lumière.

Why was it inscribed

The Lumière brothers were among the world's first filmmakers and their films were the first example of a phenomenon that has now spread across the world – the public showing of film. Now an accepted part of modern culture, it was sparked by works of the Lumière cameramen of the late 19th and early 20th centuries.

The films themselves provide a unique and accessible record of the people, places and customs of the times.

Where is it

Archives françaises du film, Bois-d'Arcy, France

The invention which made possible the widespread dissemination of the Lumière films was their patented *cinématographe* – a camera, developer and film projector combined within one device. They made their first film using the *cinématographe* in 1894: *La Sortie des Usines Lumière à Lyon (Workers Leaving the Lumière Factory in Lyon)*. The 46-second film was among several they showed publicly the following year.

The Lumière films are on average between 15 and 17 metres in length and each contains approximately 800 photograms. A particular characteristic of the films is the round perforation in the bottom third of the image; these perforations were a means of spooling the film through the camera.

Although most of the Lumière films are static shots from a single angle, the cameramen's inventiveness was such that they devised the earliest cinematographic effects, escaping the shackles imposed by the static shot in creating the first travelling platforms, panoramic shots, zoom, editing by stopping the camera and special effects.

More than two-thirds of the Lumière films were made between 1896 and 1900. The films show a range of spectacles and commonplace events: military manoeuvres and parades, everyday scenes of busy streets and markets and official events and ceremonies. The films provide the earliest cinematographic footage of leading personalities, such as presidents and monarchs, some of whom died at the start of the 20th century – these included Queen Victoria, King Humbert I of Italy and President Félix Faure of France.

Some of the subject matter is fiction, either comical or historical, and there are films of circus and music-hall entertainment, and the Lumière family themselves. A few

◄ Louis Lumière

(overleaf) Wall painting mural showing the entrance of the Lumière Brothers cinematography shop in Lyon, France. ▶

Indo-China and Japan. They also went to the United States, Mexico, Canada and Australia.

They were the first to capture visually the lifestyles, customs and traditions of people in distant lands. In Western countries, the films capture the people's ways of life before the advent of cars into towns and cities. In most countries the cameramen visited, the Lumière films were the first films ever made and shown.

In all, 1423 films were made at the Lumière factory. The whereabouts of eighteen of these are unknown and the collection currently comprises 1405. This is an exceptionally high survival rate for films of this era, as almost 80 percent of silent films have been lost. Although they are recorded on fragile cellulose nitrate film, almost all the films in the collection have survived because the Lumières kept them in optimal conditions of preservation. The Archives françaises du film is the custodian of the collection which is still owned by the Lumière family.

of the films depict the world of work, either in industry or agriculture. The Lumières initiated the important genres of documentary and fiction in films.

The Lumière films were made initially in and around Lyon and La Ciotat, then in Paris and the French provinces, followed by Italy, Switzerland, Germany, England and Spain. The cameramen subsequently visited Sweden, Russia and Turkey, the Middle East, Egypt and North Africa. Finally, they went to film in the French provinces in

CINEMATO

Séance
ouverte

LA
Photographie
ANIMÉE

RAPHE

LES SEANCES
ont Lieu
tous les Jours

de 2ʰ à Minuit
ET LES
Dimanches et Fêtes
de 10ʰ à Minuit

CITÉ
DE LA CRÉATION

Fonds of the Afrique occidentale française (AOF)

Inscribed 1997

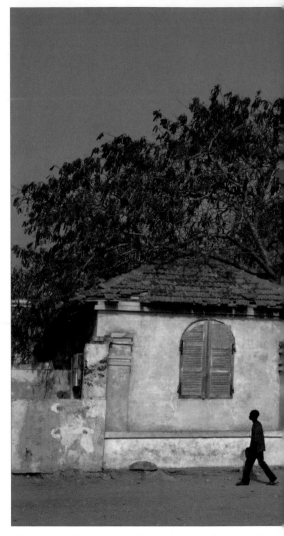

What is it

A series of nineteen archival fonds covering all aspects of the administration of French West Africa from 1895 through to the end of the French colonial period in 1959, when the AOF was replaced by nine independent countries.

Why was it inscribed

The archives exemplify the power struggles between the former colonial powers in West Africa and the consequences for economic expansion, partition and the displacement of peoples. The AOF was a first attempt at African integration.

Where is it

Archives du Sénégal, Dakar, Senegal

The archives of French West Africa (*Afrique occidentale française*, AOF) cover the period 1895–1959. They occupy an important place in the archival heritage conserved at the Archives du Sénégal. They include significant documentation on art and on a number of Islamic brotherhoods such as Mouridism and Tidjanism, as well as on Catholicism in French West Africa. Among the nineteen series of archival fonds included in the AOF holdings, some are of such importance as to have a bearing on world history. This is particularly true of the G series (politics and general administration), which deals primarily with Muslim affairs and brotherhoods. The O series deals with education, one of the consequences of which was the establishment of French-speaking African states that now play a major role in the French-speaking world. The K series deals with slavery, including valuable information on the island of Gorée, a symbol of slavery, and now a UNESCO World Heritage site.

On 16 June 1895 a decree established the government and laid down the territorial composition of AOF, which included eight territories (plus Togo, which was placed under French mandate in 1919). The eight constituent territories were Senegal, Mauritania, Sudan (present-day Mali), Niger, Guinea, Côte d'Ivoire, Dahomey (present-day Benin) and Upper Volta (present-day Burkina Faso). Pierre Messmer, the last Governor-General, returned to France in 1959. The member states of the Franco-African community that he left behind obtained their sovereignty in 1960, with the exception of Guinea which had become independent in 1958.

The establishment of the archives on 1 July 1913 clearly encouraged the preservation of the AOF holdings. They are relatively well conserved, despite many transfers and changes of custody within Dakar, the capital of French West Africa from 1902. François Maurel (Director, 1958–76) was instrumental in maintaining the AOF holdings

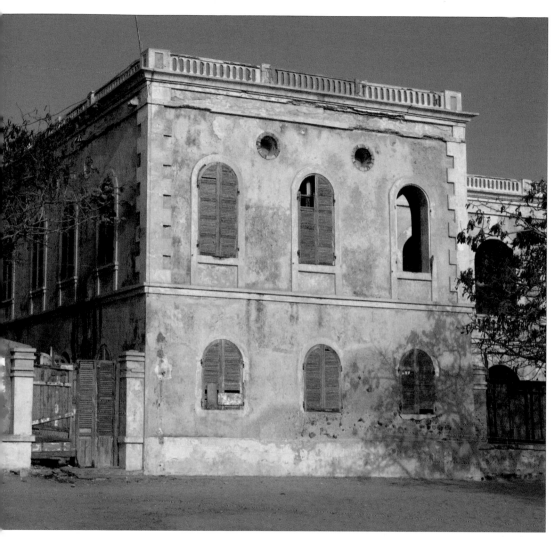

in Dakar, while France repatriated the archives from other areas over which it had sovereignty prior to their independence.

▲ *The house of the former French governor of the island of Gorée in Senegal, once an important centre of the slave trade, and from 1895, part of French West Africa (Afrique occidentale française).*

Historic ethnographic recordings (1898–1951) at the British Library

Inscribed 2011

What is it

The British Library's Historic Ethnographic Recordings collection, comprising field recordings made by linguists and musicologists of orally transmitted cultures from around the world.

Why was it inscribed

The recordings capture the fruits of a period of true linguistic and cultural diversity, from before the more homogeneous global society of today. Done in the field, the recordings are pure and uninterpreted and capture unique regional languages and music, many of which are either under threat or are extinct. The recordings are the work of scholars who were at the forefront of their respective fields.

Where is it

British Library, London, UK

The British Library Historic Ethnographic Recordings collection is one of the largest of its kind in the world. Wax cylinders, which could be both recorded and played on a phonograph, are the commonest medium. Most of the recordings date from the early period of recording technology, before radio or any other broadcast medium could adulterate regional culture and experience. Consequently, the material in the collection is truly irreplaceable.

All the items in the collection are unique examples of the language, music and other cultural practices of their respective areas. In many instances the recordings capture languages and practices that have since changed fundamentally or have disappeared completely. They were often also the first recordings ever made of particular groups and cultures: for example, those from the Cambridge 1898 expedition to the Torres Strait Islands between Australia and Papua New Guinea, were the first British-made ethnographic recordings anywhere and also the first recordings to be made in the islands.

Similarly, recordings made in Uganda in 1901 were the first undertaken in sub-Saharan Africa.

In addition to its linguistic and musical riches, the recordings illustrate a hitherto undocumented complexity of expression and belief among the people and communities; this is particularly the case in non-literate cultures. Many of the places, people and cultures featured in the collection were, and still are, under-represented in an international context.

The recordings have proved valuable not just to researchers but also to the present-day descendants of those recorded. This was proved in a legal case over disputed territory successfully brought by a Torres Strait islander against the Australian government: the recordings in the collection provided key evidence in the case.

Sound recording became a central tool in studying social anthropology and ethnography, and the collection marks its emergence. Sir James Frazer, acknowledged as a founding figure in the field of social anthropology, gathered together a large number of the recordings. Frazer was the author of the fifteen-volume work of social anthropology, *The Golden Bough*.

Taken as a whole, the collection represents not just its subjects but also the research interests of its collectors, so forming a spoken and aural representation of the British empire during this time period.

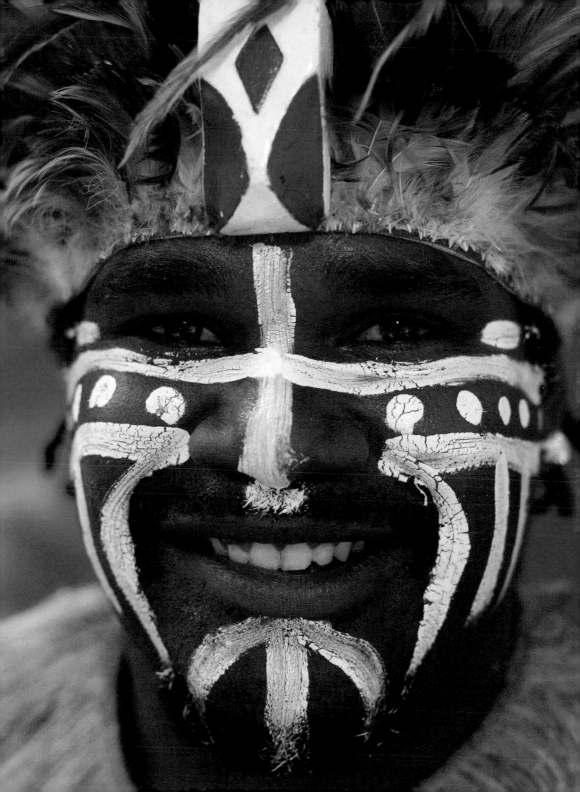

The historical collections (1899–1950) of the Vienna Phonogrammarchiv

Inscribed 1999

What is it

A multi-disciplinary sound archive that records, promotes recording and collects acoustical primary source material for research purposes.

Why was it inscribed

The Vienna Phonogrammarchiv was the first sound archive in the world and the worldwide coverage of the recordings reflects stages of orally transmitted cultures before the impact of Western civilization, some of which have become extinct since the time of recording, or have at least substantially changed.

Where is it

Austrian Academy of Sciences, Vienna, Austria

The Vienna Phonogrammarchiv was founded in 1899 by members of the Imperial Academy of Sciences. It was deliberately founded as an archive with the aim of exploiting the newly available technologies for the systematic recording and safeguarding of acoustic sources without disciplinary or regional restrictions. This foundation marked the beginning of the first sound archive (also the first audiovisual archive) in the world with a unique repository of historical and cultural recordings.

During more than 100 years of existence, the Phonogrammarchiv's collections have grown to more than 50,000 recorded items, amounting to approximately 7000 hours of material. The Phonogrammarchiv is a collection with a varied and broad scope, which safeguards a considerable part of the worldwide heritage of orally transmitted cultures.

When the Vienna Phonogrammarchiv was founded sound recording in anthropological fieldwork was complicated and technically demanding and would

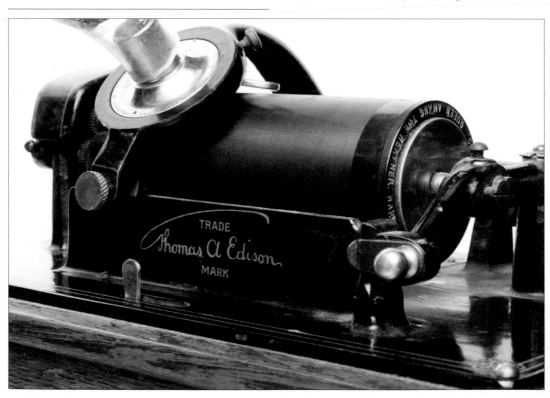

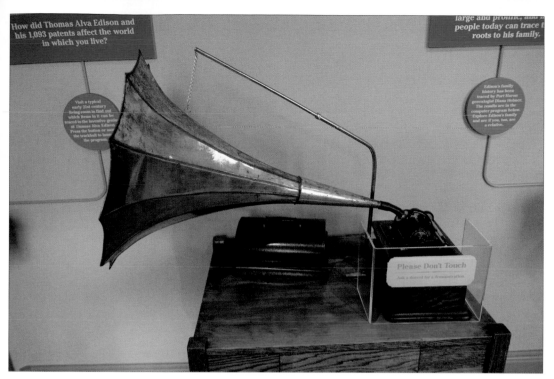

▲ *Early Edison phonograph*

remain so until the introduction of portable magnetic recorders in the mid 1950s.

The Viennese historical holdings contain more than 4000 recordings which, together with the historical collections of the Berlin Phonogramm-Archiv (see page 397), constitute one of the few early collections of phonographic field recordings. Many of these recordings are the oldest of their kind, several are unique and have been sources for extensive and renowned publications.

Central to the archive's rationale was the idea of proper documentation and 'eternal' stability of the recordings. In order to achieve this the 'Wiener Archivphonograph' was constructed. The original recordings were made on 15 cm wax disks (instead of the usual cylinder), employing the groove format and modulation used by the Edison cylinder recording system (vertical cut, 'hill and dale', 100 grooves per inch). This enabled the easy production of copper matrices as permanent negatives by a galvanoplastic process, which prevented the deterioration of the recorded materials by frequent playback, a problem most other early recorded sound collections suffer from.

The Wiener Archivphonograph was used in the field until 1931; in the studio, however, it was replaced by the gramophone in 1927. Since 1950 magnetic recording was used. Over 90 percent of the collection is of an ethnolinguistical and ethnomusicological nature. A small portion, however, is devoted to environmental and wildlife recordings.

◀ *Thomas Edison's wax cylinder phonograph*

Letter journals of Hendrik Witbooi

Inscribed 2005

What are they

The official archive of Witbooi, an African leader in Namibia towards the end of the 19th century, who resisted German colonialism by attempting to forge a united African front.

Why were they inscribed

They offer a rare example of an African perception of, and response to, encroaching colonialism, provide insights into the differences between African and European legal concepts, and show the importance of written records at a time when racism denied or belittled African contributions to world culture.

Where are they

National Archives of Namibia, Windhoek, Namibia

The letter journals of Hendrik Witbooi (c.1835–1905) consist of four (or possibly more) books into which Witbooi and his scribes entered in-coming and out-going

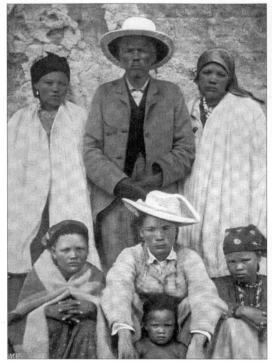

▲ *Hendrik Witbooi with members of his family.*

diplomatic and administrative correspondence, treaties and proclamations, written in Cape Dutch, the *lingua franca* of diplomatic correspondence in 19th-century Namibia. The correspondence is prosaic and businesslike, but at times it attains a poetic and visionary quality, which draws both on biblical language (from the Dutch Bible translation) and on African folklore. Three volumes are in the National Archives of Namibia. Fragments from a fourth volume are in a private collection in Munich, but no other fragments have yet been identified.

Hendrik Witbooi (traditional name !Nanseb /Gabemab) is a key figure in Namibian history. He was born into a traditional leadership position among the /Khowesin, a Khoikhoi community in Namibia. Between 1884 and 1894, he resisted German advances and aimed at gaining colonial control over Namibia, by attempting to forge

◄ *Examples of material taken from Witbooi's letter journals, written in Cape Dutch, the language much used in late-19th-century Namibia.* ▶

Gibeon den 19 Maart 1902.

Lieve Kapt Hendrik Witbooi
en onderkapt Sam. Izaak!

!Nam gaosakho! ||nãu gye gye ra,
Brand tsî ǀnigukha ra ||aub !na
||ẽigu ǂana !kei se i !Kaiga ǂgan
!Kaisa, ogye gge !kho-am kho hãs tsî
!kho-am ǂama kho hãs tõina a ǀu.
ogye gye hoaraga aore khoegye sakho
digye ra ǀkhama kho, ǂa ǂoǂ !kho-
am re ||na ra ǂganhe !Kaiga, tsî
||aub !na hã !kaii hoaragaë gye
ǂoǂ ǂa ||Kaba ǀhũi daba ||ãma tu
re, ǀnai gye gye ǂãu hãse ra mũ,
!gãise gu ǀhũga ra mũ ǂun ǂa,
matigaseï nese ǀnai !gomba gye,
tsî nî !aru-ǀũ !gomba gye !Kaisa.
ẽ ||nai khaekha ||na !ũnikha kho
ga hui ǂgao hã io, ǀnî !kaii ||aub
!auga hãï ǂa goba kha. Eïǂama
phem gye ||kadi go si ǂgao hã i, ǂabe
phem gye ||kha ǂama hã, Magistraa
Salomoni di gamagu gye ǀase ǂ kũ-
ǂgoaësa tu ha, tsî ||kha ||aeb ai Krabe
haof ǂa !huis !oa go ũhe, tsî Petru
tsî Abeli tsũgu di gamagu ...

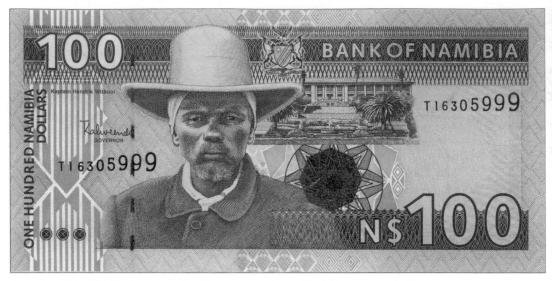

▲ *A portrait of Hendrik Witbooi appears on Namibian banknotes, acknowledging his importance in the history of the struggle for an independent Namibia.*

a united front against the conclusion of 'protection treaties'. He was forced by German military strength to give in, but rose against German rule during the war of anti-colonial resistance (1904–08), and died in combat in 1905. His insights into the nature of colonialism, about the fundamental difference between conflict with African competitors and with European invaders, his attempts at formulating African legal concepts and the visionary and poetic power of some of his texts are the qualities that set his letters apart and above the bulk of contemporary and earlier African texts of the same genre.

This set of manuscripts not only offers a unique first-hand view into the internal administration and external politics of a small African state and its response to colonialism, but also demonstrates the awareness of an outstanding leader about issues of sovereignty. The texts include probably the first written formulation of the concept of Pan-Africanism: '*This part of Africa is the realm of us Red chiefs. If danger threatens one of us which he feels he cannot meet on his own, then he can call on a brother or brothers among the Red chiefs, saying: Come, brothers, let us together oppose this danger which threatens to invade our Africa, for we are one in colour and custom, and this Africa is ours. For the fact that we various Red chiefs occupy our various realms and home grounds is but a lesser division of the one Africa.*'

n ik heb weder de wachter van Damaras gekregen, en die
heeft weder tot my gezeg, ik moet toch omdraaijen, want de
Damaras is zeer kwaad, maar ik heb gezeg, ik zal gaan, zoo
ben ik gegaan, en gekomen op de werf van de Damaras
op 1 Hoabe-tsaus, en in de zelfde tyd zyn de mannen van
de hoofden vermoord geworden, en toen komt die boodschap
in dien zelfden tyd op die werf van de Damaras, waar
ik ben, toen hebben deze Damaras ook besloten, om
my hier te vermoorden, zoo hebben zy al myne paarden
en geweers zelfs genomen, en my gezeg, dat ik van
dag hier zal sterven; maar, geliefde Leeraar! ik heb
weder die dag de almagtigheid van onzen grooten God
gezien, onuitsprekelyk, wonderbaar heeft de Heere my
uitgeholpen, met myne drie mannen, toen de Damaras
nu opgestaan hebben, en ons omsingelen, om ons nu
te dooden, toen hebben zy een ding gedaan, wat zy
zelven niet weten, in plaats, dat zy meenen, dat
zy my dooden, hebben zy my zelfs vry gelaten, en
my een meri gegeven, en gezeg, ik moet haastelyk
huistoegaan, zoo ben ik huistoe gegaan, en toen ik
tusschen de poort van de groot bergen ǁKhanigukha
uitgekomen is, toen heb ik daar die drie merkwaardige
woorden ontvangen, door een stem, die tot my spreek
op den 23 Augustus 1880.

1. Het is volbrag.
2. De weg is opengedaan.
3. Ik geef U een zware opdraag.

Op deze drie woorden is de heele werk aangeknap
en begonnen geworden, maar toen was het nog
niet openbaar voor de mensen, ik alleen heeft

Russian posters of the end of the 19th and early 20th centuries

Inscribed 1997

What is it

A collection of Russian posters from the second half of the 19th and the early 20th centuries.

Why was it inscribed

The largest single collection of Russian posters in the world, these are considered of central importance in the study of Russian art, culture and history of the period.

Where is it

Russian State Library, Moscow, Russia

The collection of posters in the Russian State Library is part of the library's graphic collection and is a central resource for the study of Russian art, culture and history. The collection was begun in the mid 19th century when Count N.P. Rumyantsev, the Russian chancellor, gifted his collection of books, manuscripts and other materials to the state; this compendium formed the basis of the Russian State Library. In subsequent years, the library also acquired posters by legal deposit, by purchase and by bequest.

The later 19th century was a period of growth in poster art across Europe as a whole, thanks to developments in chromolithography and colour printing. The poster was an art form in Russia since that time, so the library's collection covers the genre from its beginnings.

With their origins in placards and shop signs, posters were used in Russia as a way of advertising business, services and announcements. However, during the first Russian revolution in 1905, posters and other graphic art forms became campaigning vehicles, expressing the immediacy of contemporary political ideas.

The First World War brought a new subject matter in 1914, with advertisements for the sale of war bonds. But the February Revolution of 1917 was a catalyst for an explosion of artistic output and the work of the poster artists, with their ability quickly to capture and display fast-moving ideas and events, became a main means of expressing the central political, social and artistic questions of the day.

Political campaigning with posters was seized on by the new Bolshevik revolutionary government which was fighting a civil war that lasted for three years. The Russian Telegraph Agency (Rosta) was the government's news agency from 1918 to 1935. Between 1919 and 1921, Rosta's own poster department began producing posters known as 'Rosta Windows', initially for display in the shop windows of Moscow, although they later spread to other centres. These provided a government slant on current affairs and demonized and satirized the Bolsheviks' opponents. The Rosta Windows drew on the popular Russian graphic art form of the *lubok*, with powerful coloured illustrations overshadowing the text.

The period after the civil war once more brought a change in poster material as the government recognized its value as a vehicle for communication and propaganda.

◀ *Russian posters from the late 19th and early 20th centuries.* ▼ ▶

1) ОРУЖИЕ АНТАНТЫ—ДЕНЬГИ 2) БЕЛОГВАРДЕЙЦЕВ ОРУЖИЕ—
ЛОЖЬ

3) МЕНЬШЕВИКОВ ОРУЖИЕ—4) ПРАВДА.
В СПИНУ НОЖ

5) ГЛАЗА ОТКРЫТЫЕ 6) И РУЖЬЯ—ВОТ КОММУНИ-
СТОВ ОРУЖИЕ.

РОСТА. № 132

ПОМНИ О, ДНЕ КРАСНОЙ КАЗАРМЫ

1) МЫ ДОБИЛИ РУССКИХ БЕЛОГВАРДЕЙЦЕВ. ЭТОГО МАЛО:

2) ЕЩЕ ЖИВЕТ ЧУДОВИЩЕ МИРОВОГО КАПИТАЛА,

3) ЗНАЧИТ НУЖНА ЕЩЕ АРМИЯ КРАСНАЯ,

4) ЗНАЧИТ и ПОМОГАТЬ ЕЙ НУЖНО- ДЕЛО ЯСНОЕ.

▲ *Russian poster used in propaganda*

Collection of Latin American photographs of the 19th century

Inscribed 1997

What is it

A collection of 8000 items featuring a variety of subjects, all depicting life in 19th-century Latin America.

Why was it inscribed

This is the most comprehensive historical collection of 19th-century Latin American photography extant anywhere in the American continent. It depicts a wide range of human environments and habitats and photographic genres; is drawn from every country in South America and the Caribbean; and is taken using most of the photographic techniques current in the 19th century. In all, it provides a visual history of the development of the region.

Where is it

Audio-visual Archive of Venezuela, National Library of Venezuela, Caracas, Venezuela

The 19th century was a period of immense political and administrative change in Latin America, with the collapse of the Spanish and Portuguese empires which had been the dominant presence in the region for three centuries and the separation into new countries, often federal republics, which themselves fell prey to internal instability and dictatorship as the century progressed.

Some of these historic events are recorded in the collection of Latin American photographs. They are also complemented by photographs recording the everyday lives of people of all classes, ages and nationalities, a breadth of subject matter which gives the collection a comprehensive quality. The photographs record progress, technological change and community.

Taken in cities, towns and countryside, they feature busy ports, rural life and landscapes, well-known personalities and the lives of ordinary people. The collection's portraits reveal significant differences in attitudes, styles and forms of interaction between different social classes. Some of the economic activity was shot not only for recording purposes but also for advertising. More recognisable subjects include presidential visits, natural disasters and images of war.

Most of the photographic techniques used in the 19th century are represented in the collection – daguerreotypes, ambrotypes, tintypes, platinotypes, salt paper, bromide paper, gelatin paper and collodion processes. However, the most frequently used technique is albumen printing, the cheapest and easiest method of photographic reproduction and the most commonly used in the second half of the century. The standard formats of photograph are represented, in visiting cards that were normally used for photographs, cabinet prints and negative plates.

The main part of the collection was in private hands in New York in the 1980s. The publicity surrounding the photographs drew the attention of an interested buyer in the Paul Getty Museum in California. However, their efforts to keep and expand the collection led the Venezuelan National Library to transfer it to their Audio-visual Archive. As a result, several South American collectors also donated their own collections to the National Library.

Presidential papers of Manuel L. Quezon

Inscribed 2011

What are they

The papers document the life of Manuel Quezon, the president of the Philippines, who was involved in all stages of his country's struggle for independence from the USA, and then from Japanese invasion.

Why were they inscribed

The papers provide comprehensive and irreplaceable source materials on great-power relations in the region at that time. The Philippines provided an important model internationally for countries emerging from colonial rule.

Where are they

National Library of the Philippines, Manila; University of the Philippines and Senate of the Philippines, Quezon City, Philippines; and Bentley Historical Library, University of Michigan, Ann Arbor, USA

Manuel Luis Quezon (1878–1944) was one of the most prominent Filipino leaders, unequalled in his involvement in Philippine affairs from 1899 until his death, the period covered by the American colonial period and the Japanese occupation in the Second World War. Quezon served as an anti-American guerrilla officer (1899–1901) during the Philippine-American War. He was co-founder of the *Partido Independista Inmediatista* (1906), which became the *Partido Nacionalista* (1907), the dominant political party in the Philippines until 1935, with a platform of immediate, absolute and complete independence from the USA. He served as Resident Commissioner of the Philippines in the US Congress (1909–16). Returning to the Philippines, he became the First President of the Senate of the Philippine Legislature (1916–35) and then was elected First President of the Commonwealth of the Philippines. During the Second World War, after the surrender of the USAFFE (United States Armed Forces in the Far East, consisting of American and Filipino military) to the Japanese military forces in 1942, Quezon continued

as President of the Commonwealth Government-in-exile in Washington, DC until his death in 1944.

This collection is of greatest importance for the wide range of Quezon's correspondence and for the documentation of the events and politics involved in the long history of the Philippine independence movement conducted both in the Philippines and in the USA. Quezon corresponded widely, both with political figures in the USA and with many prominent leaders within the Philippines. He travelled to many foreign countries and met many nationalist leaders who found the Philippine example worthy of emulation, the Philippines being the first country in Asia to launch a nationalist revolution against its colonial rulers – first Spain (1896–98), then the USA in the Philippine-American War (1899–1902).

The collection contains cables, memos, transcripts of press conferences, press clippings, public documents, and letters and speeches. About 40 percent of the material is in Spanish, a small number in Tagalog (he was instrumental in promoting Tagalog as the national language of the Philippines) and other Philippine languages, and the rest in English.

President Manuel Quezon, photographed in the USA in 1942, where he led a government in exile after the Japanese invasion of the Philippines. ▶

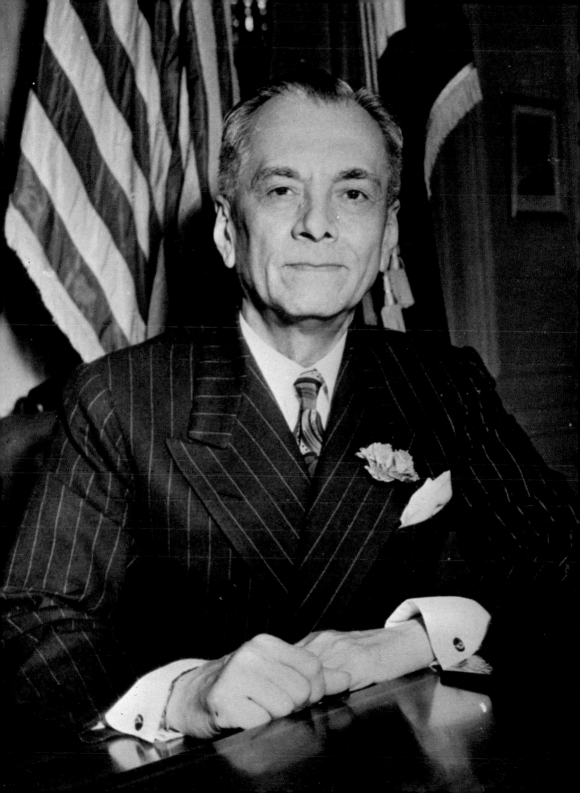

Sakubei Yamamoto collection

Inscribed 2011

What is it

This collection of paintings and diaries is a unique historical source on the coal-mining industry in Japan as seen from the perspective of one worker, Sakubei Yamamoto, who was also a talented visual observer.

Why were they inscribed

His factual accounts in words and pictures represent a memory of Japan's industrialization that had ramifications for the region and the world. The collection shows the impact of Western technologies when transferred to a traditional Eastern culture, an issue of continuing global significance.

Where are they

Tagawa City Coal Mining Historical Museum and Fukuoka Prefectural University, Tagawa, Japan

Coal mining was an essential part of the rapid emergence of industry in Japan from 1850 onwards, when the country was opened up to the Western world. Japan is unusual, if not unique, among non-Western nations in undertaking this industrial transformation on its own terms, without being colonized and without substantial foreign investment. The rapid expansion of coal mining demanded a much increased workforce, and miners during the period recorded by Sakubei Yamamoto included former rural workers, both men and women and their children, tradesmen, ex-convicts and foreign labourers.

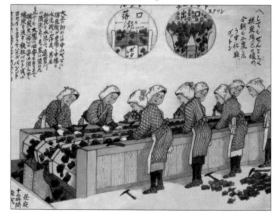

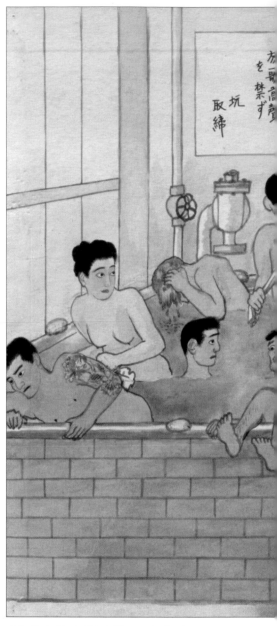

◄ *An illustration by Sakubei Yamamoto showing women sorting coal. The belt moved at walking speed and the women worked twelve-hour shifts.*

418 Sakubei Yamamoto collection

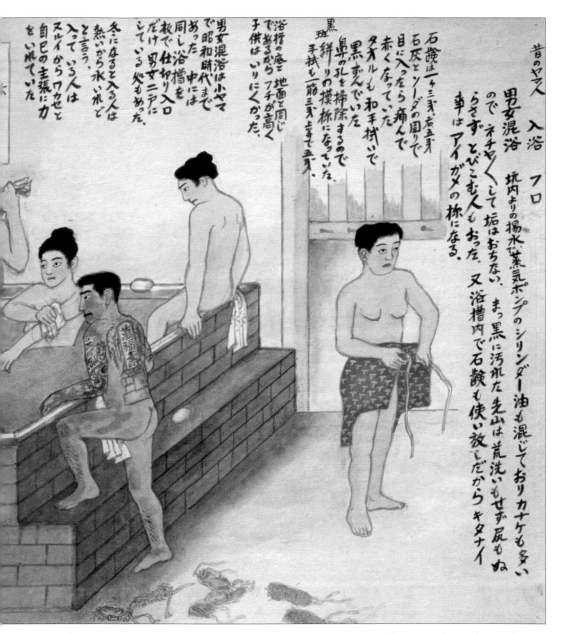

昔のヤマ人　入浴　フロ

男女混浴　坑内よりの揚水で蒸気ポンプのシリンダー油も混じておりカナケも多いのでネチャくして垢はおちない。まっ黒に汚れた先山は荒洗いもせず尻もぬらさず とびこむ人もおった。又浴槽内で石鹸も使い放しだからキタナイ車はアイガメの様になる。

黒斑　黒紺りの撲搽になっていた手拭も一筋二筋三舛まで黒ずんでいた鼻の孔を掃除するので手拭も一筋二筋三舛まで黒身。

石鹸は一ヶ三舛名五舛石灰とソーダの固りで目に入ったら痛んで赤くなっていたタオルも和手拭で黒ずんでいた。

浴槽の底は地面と同じであるからフチが高く同し浴槽を枚で仕切り入口だけ男女二ケにしている処もあった。子供はいりにくかった。

男女混浴は小ヤマで昭和時代まであった。中には同し浴槽を

冬になると入る人は熱いから水いれと言う、入って、いる人はスルイからワカセと自己の主張に力をいれていた

▲ The miners' bath. Yamamoto wrote on this picture 'There was no separate bath for men and women. They bathed together. The bathtub was filled with water pumped from the pit. The water was not pure; it usually contained metallic minerals from cylinder oil from the steam pump. Polluted water became "sticky" and it was hard to wash their bodies clean. Some Sakiyama (hewers, the people who dug the coal) would jump in the hot water without even rinsing themselves (centre of the image). Since the people used soap freely, the hot water in bathtub was dirty and coloured black.'

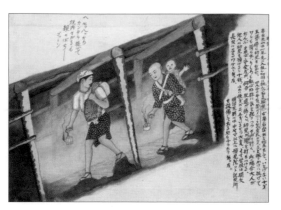
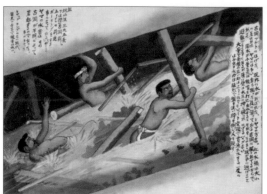

▲ *A selection of illustrations by Sakubei Yamamoto showing the working lives of Japanese miners in the early 20th century. The third picture shows a boatman who has lost his job ferrying coal across the river, replaced by the steam train behind him. Many boatmen became minors.*

Sakubei Yamamoto (1892–1984) lived with his family at the coal mines of the Chikuho region in Kyushu from the age of seven, was apprenticed to a pickaxe smith at a mine in 1904 when he was twelve, and worked variously as a mine blacksmith and miner until the age of sixty-three in 1955. He then became a security guard at a mine and started painting his memories, drawing information from his diaries. Sakubei Yamamoto had little formal education, but from the age of twenty-one in 1913 he began keeping notebooks and diaries in which he recorded events.

The Sakubei collection combines naive art with text, informed by his diaries written at the time of the events being depicted. It is highly unusual in a Japanese context as a private record created by a working man, whereas the dominant records of the period are official government and business papers. The Sakubei paintings have a rawness and immediacy that is totally missing from the official record, and the collection is an authentic personal view of the living and working conditions of male and female miners in Japan during its rise to world prominence as an economic power in the first half of the 20th century.

The paintings are evocative of the harsh and dangerous conditions in which miners worked and of the changes in

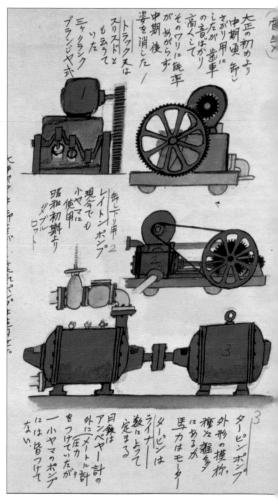

Yamamoto's drawing of some of the machinery used in coal mines. ▶

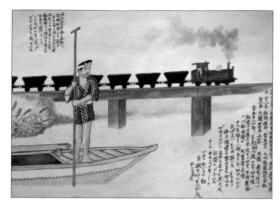

mining technology, as seen from a miner's perspective. They depict labour disputes, changing working practices, the differing attitudes of management and labour, and foreign labour issues; and reflect the many changes in the coal mining industry in the first half of the 20th century. They also show the daily life and pastimes of miners' families and their response to industrialization. Because of the rapid development of the Japanese mining industry, the vast majority of miners came from other backgrounds and the customs, traditions and superstitions they brought with them to the mines are portrayed as well.

The paintings give an immediacy to understanding the impact of industrialization on those who worked in the mines, something which is not usually present in the written word, and not represented at all in official records. In conjunction with the diaries, they reflect a period of enormous change, presenting graphically memories and records from the turn of the century to after the Second World War. Japan's experience is a microcosm of the fundamental changes in social and cultural conditions that working class labour experienced in many non-Western countries when industries developed based on Western technologies. The Sakubei paintings are a startling, rare and authentic representation of that experience and time.

The Story of the Kelly Gang (1906)

Inscribed 2007

What is it

The first full-length narrative feature film produced anywhere in the world, telling the story of the famous Australian bushranger Ned Kelly (1855–80) and his gang.

Why was it inscribed

The Story of the Kelly Gang heralds the emergence of the feature-film format, giving it profound significance in cinema history. On a national scale, it symbolizes both the birth of the Australian film industry and the emergence of an Australian identity.

Where is it

National Film and Sound Archive, Canberra, Australia

▲ *The gang reads the proclamation.*

The Story of the Kelly Gang, directed by Charles Tait in 1906, is a seminal work in the history of feature-film making, as it is believed to be the first feature-length fiction film ever made. Actively promoted as the longest film made to that date, it presented the first true feature story in more than 60 minutes of screen time.

The film had its first showing on 26 December 1906 and was enthusiastically received by the first generation of cinemagoers. It illustrated the potential for detailed storytelling in cinematic form and its creation influenced both cinema production worldwide and also the network of individuals who were to become the creative film-makers of the 20th century.

It was a popular success in Australia, New Zealand and Great Britain and heralded the 20th century's fascination with cinema as a narrative vehicle.

Its purely Australian theme of bushranging also had an enormous impact in Australia, where the attitude to bushrangers could range from disapproval to admiration.

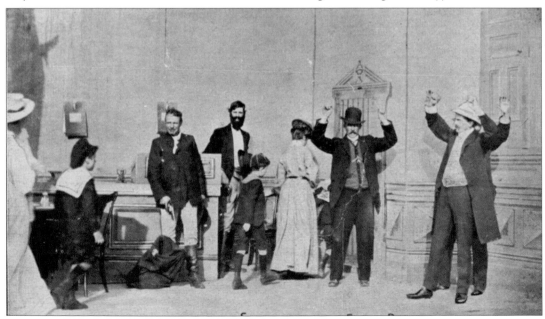

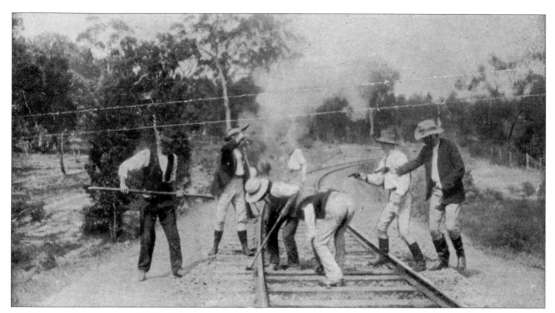

Pulling up the line at Glenrowan. ▲

It led to more than twenty such films being produced in the silent era with more still being made up to the present. More unusually, it also created censorship problems, as its heroic and glamourized images of the bushrangers led to concerns for law and order and resulted in government bans on both this film and other, later films with a bushranging theme. Internationally, the Western theme and the emergence of many gang-based genres at that time reflect a similar thematic approach.

It was thought that *The Story of the Kelly Gang*, like so many other productions on cellulose nitrate, had been lost. However, from the 1970s onwards, fragments of the film began to turn up, sometimes in odd circumstances – in a purchased film collection, in a house clearance, on a rubbish tip in Melbourne and at the National Film and Television Archive in Britain. Although the film remains incomplete, almost 17 minutes have been recovered and digitally restored, comprising around 25 percent of its estimated original length. Other material from the date of the film's release includes its original poster and promotional booklet.

▼ *Sticking up Younghusband's Station.*

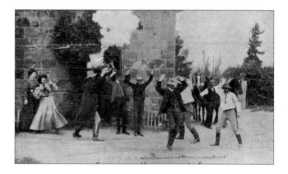

◄ *Sticking up the Euroa Bank.*

Cinema PARISIEN

MODERN

Bioscoop-Theater

Nieuwendijk 69, - AMSTERDAM.

Elken dag van 2 tot 12 Zondags vanaf 12 uur

DOORLOOPENDE

Bioscoop-Voorstellingen

zonder oponthoud;

op welk uur men ook komt, ziet men altijd het

geheele PROGRAMMA.

Iederen Vrijdag nieuwe beelden.

Directeur JEAN DESMET.

Electrische Drukkerij „DE KROON" Rokin 55, Amsterdam.

Desmet collection

Inscribed 2011

What is it

A collection of over 900 films on 35 mm cellulose nitrate, related original posters and publicity publications, company administrative records, and international correspondence with film-producing companies worldwide and film exhibitors in the Netherlands, between 1907 and 1916.

Why was it inscribed

The Desmet collection is important both in film history and as a socio-historical record of one of the most important decades in modern history.

Where is it

EYE Film Instituut Nederland, Amsterdam, the Netherlands

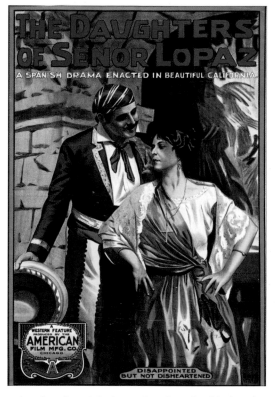

Jean Desmet (1875–1956) was a businessman with contacts not only with many film-trading companies around the world, but also with the local Dutch market of film exhibitors.

Desmet's film-distribution company operated when the film industry was in relative infancy and he experienced the major changes in the business's early years: from travelling shows to permanent cinemas in cities and the sudden flourishing of film distribution towards the end of the decade. He witnessed changes in organization within the film-distribution industry and in the way cinema was viewed by the public, the move from short films to longer films, and the growth from a 'cinema of attractions' to a narrative cinema. By the time he wound up his distribution company, the cinema industry had grown from infancy to maturity.

The 1910s were years of enormous upheaval: this was the decade of the First World War and the associated societal flux; technological and scientific advances; and the Russian Revolution. The cinema was at the centre of these developments.

Most of the films in the collection are fiction, but there are also almost 150 non-fiction films recording historic events, travelogues of city centres, tourist attractions and architectural monuments. All the films have the intertitles which indicate projection prints for show, rather than the original negatives. As well as black-and-white stock, many of the films are hand-coloured, either in their country of origin or locally by the distributors. Many of the film prints are lost in their countries of origin, and there are many others of which the copies in the collection are the sole ones presumed extant. When Jean Desmet was in the industry, distributors had to buy film prints outright, rather than temporary licences as now. Consequently he, like many distributors, built up a collection over time.

The collection also contains stills, film posters and other publicity materials. Similar archive material from the time is rare, and the Desmet collection is noted for its comprehensive and complete nature.

However, the collection's strength is not in the presence of masterpieces of cinema but rather that it gives a representation of daily cinema programming: the everyday and unremarkable documents and films that seem marginal become valuable within the setting of such a comprehensive collection.

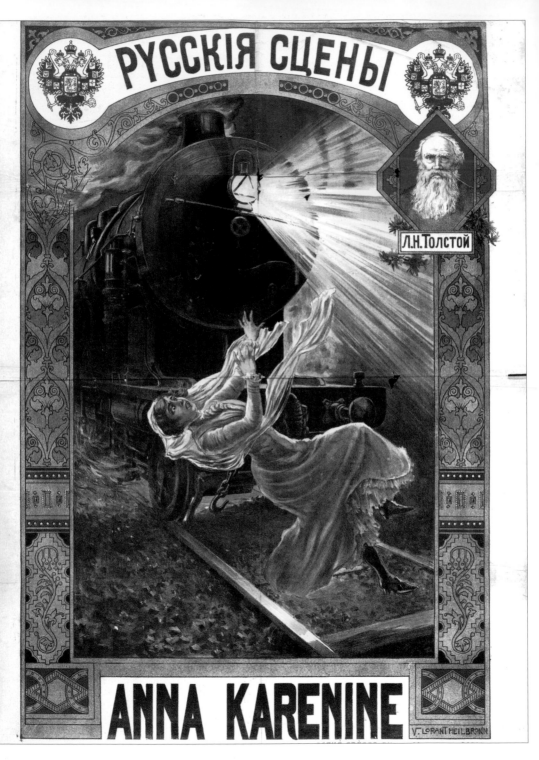

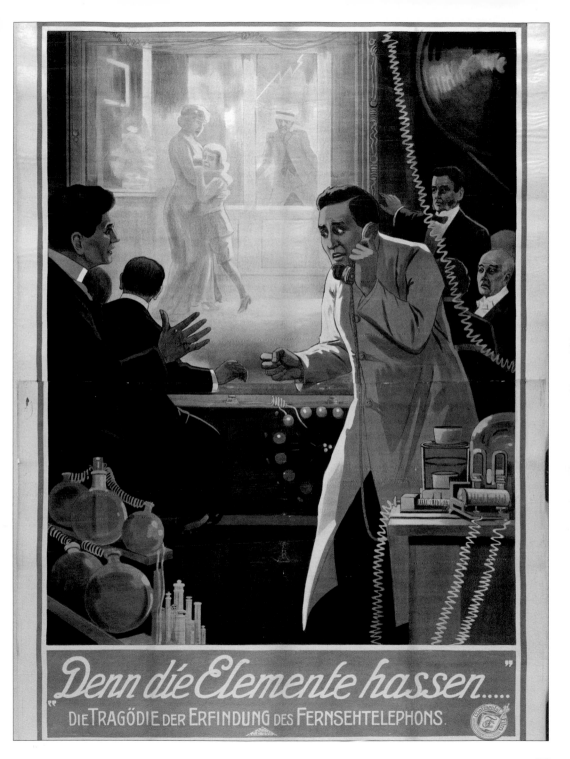

Roald Amundsen's South Pole Expedition (1910–1912)

Inscribed 2005

What is it

The original film of Roald Amundsen's successful expedition to reach the South Pole, filmed between 1910 and 1912. The film is in seven sections.

Why was it inscribed

The Arctic and Antarctic Polar regions were long regarded as the final frontiers for mankind to conquer. Amundsen's successful expedition to the Antarctic was first and foremost an immense achievement and a personal triumph. In the process, he made valuable contributions to aspects of polar research and heightened consciousness of the polar areas.

Where is it

Norwegian Film Institute, Oslo and National Library of Norway, Mo i Rana, Norway

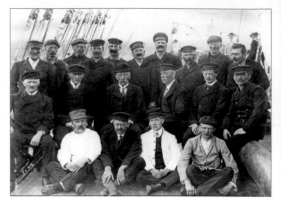

▲ Amundsen and his crew on the deck of the Fram after their successful voyage.

Norwegian Roald Amundsen (1872–1928) and his four-man team made the first-ever successful journey to the South Pole, reaching their destination on 14 December 1911. The film record of his achievement was made between 1910 and 1912 as it followed his team on a journey that could have as easily ended in tragedy as in success.

Amundsen was an experienced adventurer and explorer with a special knowledge of the polar regions: he had previously sailed in the Antarctic and had been the first explorer successfully to navigate the Northwest Passage on a three-year expedition that ended in 1906.

Planning was crucial to Amundsen's success as an explorer. He had already proved himself a master of expedition planning and improvization on his Northwest Passage trip. Now the Antarctic presented a huge logistical challenge with extreme climate conditions, arduous navigation, unknown areas, hidden crevasses and difficulties with food supplies, communication and travel. He studied the experiences and descriptions of previous Antarctic explorers, including Carsten Brochgrevink, Ernest Shackleton and Captain Robert Scott, and decided on a route never taken before.

Amundsen set off from Oslo (then Christiania) on 3 June 1910 in the steamer Fram, two days after the British

Antarctic Expedition, led by Captain Scott, sailed from London on the Terra Nova. The Norwegian expedition was planned to head for the North Pole, but once at sea, Amundsen announced to the crew and the wider world that his goal was actually the South Pole.

The Antarctic at that time was, as the name of Scott's ship suggested, a new land, and almost completely unknown. The British team of explorers and scientists planned to spend several months on the ice, reaching the South Pole and researching and documenting the continent.

By contrast, Amundsen's intention was simply to reach the pole and he and his team gathered little research on their trip. They arrived at Antarctica on 14 January 1911 and reached the pole exactly 11 months later on 14 December 1911. Amundsen's dash for the pole is still regarded as one of the most daring and best-executed dog-sled trips ever and proved that it was possible to reach the heart of Antarctica with relative ease, as long as one was prepared to the smallest detail. The final conquest of Antarctica heralded an almost complete mapping of the land and sea areas of the world.

The exploration of the globe is part of the common history of humanity, involving individual and personal drive and courage, and mutual cooperation across boundaries and nationalities. The film of Amundsen's expedition, almost within living memory and knowable through a familiar modern medium, depicts one of the last great chapters of this exploration.

The unique film material documents this historic achievement, made outside the borders of the civilized

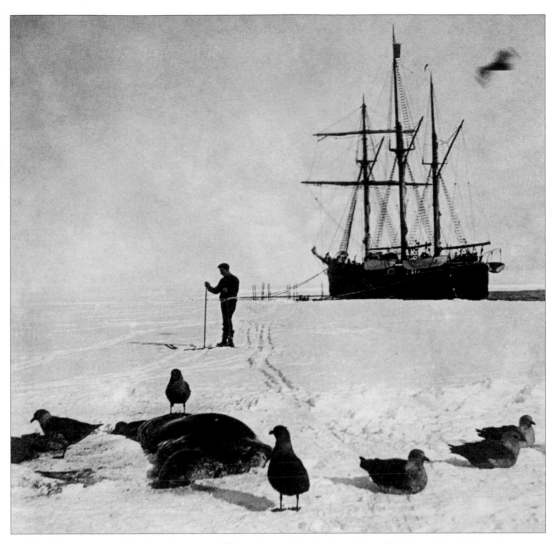

world and in an extreme climatic environment. Although incomplete, the material comprises original sequences filmed between 1910 and 1912. It is the only known film documentation of the expedition and one of the earliest films to have been made in this part of the world.

The achievement was not just a personal one but was also a national triumph for Norway, historically a nation of seafarers and explorers. Amundsen's success boosted national identity, character and sense of belief in the nation which had achieved independence from Sweden only a few years before. Norway has continued at the forefront of geographical and scientific exploration of the polar regions.

▲ *On the Antarctic ice with the* Fram *in the background.*

Collection of Jewish musical folklore (1912–1947)

Inscribed 2005

What is it

A collection of Jewish folk music from Ukraine and Belarus, recorded between 1912 and 1947, on more than 1017 Edison wax cylinders.

Why was it inscribed

This collection recording the art and traditions of early-20th-century Ashkenazi Jews has no direct equivalent in the world, in both its content and its recording character. The unique culture which the cylinders record has now almost vanished.

Edison wax cylinders, played on a phonograph, were in use in the 1880s and were one of the earliest commercially viable means of recording and playing sound.

Where is it

Vernadsky National Library of Ukraine, Kiev, Ukraine

The Jewish musical folklore collection comprises more than 1017 wax cylinders each containing between two and seven minutes of music. The recordings were made in Jewish areas of Ukraine and Belarus in an area known as the Pale of Settlement outside which few Jews in the pre-revolutionary Russian empire were allowed to live. There are virtually no Jewish communities in the area today.

The music which the recordings capture expresses the life of the Jewish people in an area of financial hardship but with a strong and rich religious and spiritual life which finds expression in wordless chants, songs and synagogue liturgies, instrumental performances, examples of *klezmer* music and lesser-known folklore genres, such as Jewish folk musical performances (*purimshpils*).

The recordings feature voices of eminent Jewish actors Solomon Mikhoels, Benjamin Zuskin and Lela Romm, and famous writers such as Jehieskil Dobrushin and Notke Lurie. There are instrumental pieces by violinist and composer Leo Pulver who was also director of the Jewish instrumental ensemble. Also recorded is the noted writer Sholem Aleichem (whose stories of Tevye the milkman were produced for stage and film in *Fiddler on the Roof*).

The collection was the work of a team of ethnographers and folklore researchers who undertook expeditions over several decades in the first half of the 20th century. The idea of ethnographic expeditions to record the culture of the people, originated with Jewish folklorist and writer S. An-sky (1863–1920). In 1912 and 1913, under the auspices of the St. Petersburg Jewish Historical and Ethnographic Society, An-sky set out with fellow researchers, musicians and artists to explore and ethnographically examine areas within the Pale of Settlement, then bring together and classify the enormous and invaluable amounts of data they collected.

After the Russian Revolution of 1917 and especially in the '20s and '30s, the opportunity arose for more expeditions,

this time in conjunction with the Museum of Jewish Culture in Kiev, due to the efforts of the prominent folklorist Moisei Beregovsky. The final recording in the collection was made in 1947. Two years later the Institute was closed down, its staff arrested and the archive confiscated.

Since the fall of the Soviet empire, the collection has become available once more, this time at the Judaic Department of the Vernadsky National Library of Ukraine. The wax cylinders on which the recordings were made are still in a perfect state of preservation today.

Original records of Carlos Gardel –
Horacio Loriente collection (1913–1935)
Inscribed 2003

What is it
A collection of original records produced between 1913 and 1935.

Why was it inscribed
Tango music has had an influence throughout the world and Carlos Gardel was one of the greatest exponents of the genre. This collection of Gardel's recordings is one of the most complete and is irreplaceable.

Where is it
Archivo General de la Nación, Montevideo, Uruguay

▲ *Carlos Gardel mural, Buenos Aires.*

▼ *Tango dancers*

Carlos Gardel was a Latin American singer, songwriter and actor who became one of the most famous figures in the history of tango. Gardel was renowned for the unerring musicality of his baritone voice and the dramatic phrasing of his lyrics, which made miniature masterpieces of his hundreds of three-minute tango recordings.

His most remarkable achievement was the tango-song, performed with his unique singing style and destined to serve as an example for the majority of singers who subsequently devoted themselves to this musical genre. His unique voice gave credibility to this type of music, which, as a dance, was considered scandalous in its early days because the two dancers moved in a way that was then viewed as indecent.

The Horacio Loriente collection contains a total of nearly 800 recordings by Gardel, produced by a variety of record companies. It comprises records produced in Uruguay, Argentina, Spain and France. Virtually all of the records were purchased, while others were donated or obtained through exchanges by the collector himself.

The records include examples of all the genres and styles that made up Gardel's repertoire and cover his whole artistic career: from his early days as a singer of native music to more complex productions. The musical accompaniment to these recordings varies greatly: guitars (solos, duets and quartets); piano, violin and guitars; and orchestras with different conductors.

The perfectly preserved state of the collection offers an excellent record of Carlos Gardel's unique voice, with its highly unusual nuances. Gardel's voice, in his own lifetime, appealed to people both from humble backgrounds (who felt they were portrayed in his songs and recognized him as 'one of them') and from the higher social classes who, following his successes in Paris and Barcelona, welcomed him into their elite salons and clubs.

His reputation spread even further with the coming of the sound revolution in film. Gardel was one of the pioneers of musical pictures in Latin America, and because of Spanish-language co-productions in France and the USA, his fame as a singer and actor spread all over the world.

Following Gardel's success in Europe and the USA, tango academies were opened in Paris, Buenos Aires and Montevideo during his lifetime. Today they exist all over the world: throughout the Latin American continent, in almost every European country and in places as far away as Japan and Hawaii. More than 60 years after his death and 90 years after his earliest recordings were made, Gardel and his music are still popular around the globe.

Archives of the International Prisoners of War Agency, 1914–1923

Inscribed 2007

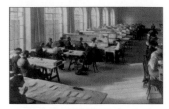

◀ Working on
the records

Henry Dunant,
co-founder of the
International Committee
of the Red Cross. ▶

What is it

The archives of the International Prisoners of War Agency (IPWA) from its establishment at the start of the First World War in 1914 until 1923.

Why was it inscribed

The extensive records of the IPWA, ranging from government-level correspondence to improve the lot of prisoners of war (PoWs) to efforts to repatriate and reunite PoWs with their families, allow a glimpse of the individual, human cost of the Great War.

Where is it

International Red Cross and Red Crescent Museum, Geneva, Switzerland

Created by the International Commission of the Red Cross (ICRC) in August 1914 three weeks after the outbreak of war, the main work of the IPWA was twofold: firstly, it offered combatant governments legal interpretation of the already existing conventions on the protection and humanitarian treatment of PoWs; and secondly, it worked with individuals to re-establish links between families separated by the conflict, especially PoWs and refugees. This work was the first of its kind ever undertaken on such a scale.

The IPWA was a vast organization, employing 1200 at its largest extent, to deal with the unprecedented effects of the war which by 1918 involved 44 countries and their colonies along with several civilian populations. More than sixty-five million men fought in the conflict and of these nine million died and seven million were taken prisoner. Geneva, where the IPWA was based, became a hub for millions of items of post that were forwarded across Europe and the world, and even a meeting point for the repatriation of French and German prisoners while the war was going on.

The archives fall into three main categories. The first are the records of the IPWA managing body and largely deal with the treatment of prisoners, recording their place of captivity, internment in neutral states and repatriation of sick and injured soldiers. These records include national-level correspondence, dealings with other humanitarian organizations, prison-camp-visit reports and press cuttings.

The second group of records deal with medical staff, showing efforts to secure the repatriation of captured medics, and with civilians caught up in the war, including efforts to secure their welfare. A particular concern was the status of civilians living within the borders of enemy countries who could find themselves interred, living under occupation or forced to become refugees.

The third category of records chronicle the fate of PoWs and the missing; these include individually named files created after requests for information from their families. In total, these files comprise seven million index cards dealing with the cases of two million people of widely differing nationalities, ages and backgrounds and range from the notable, including a French captain, Charles de Gaulle, to the unknown. Together, the records comprise a unique, extensive and moving testimony to the human suffering wrought in the Great War and to the attempts to relieve it.

◀ Copy of a document
relating to one
combatant.

(overleaf) German PoWs
in France. ▶

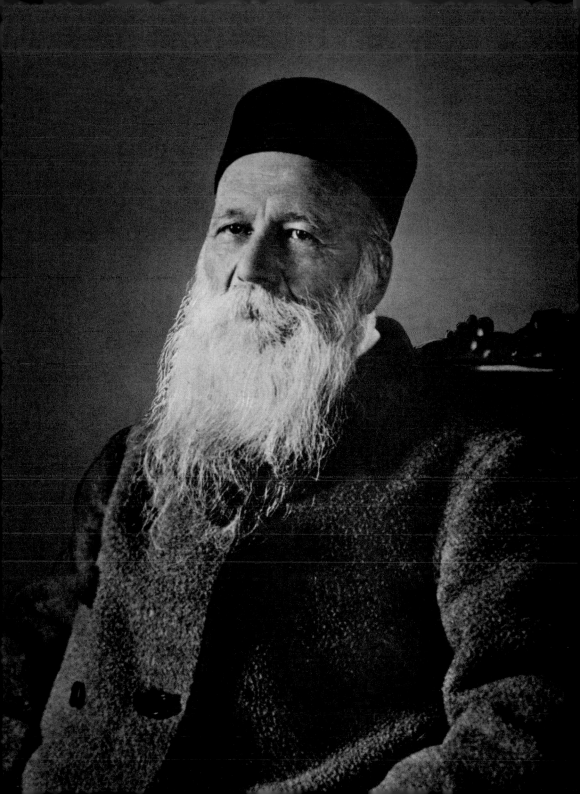

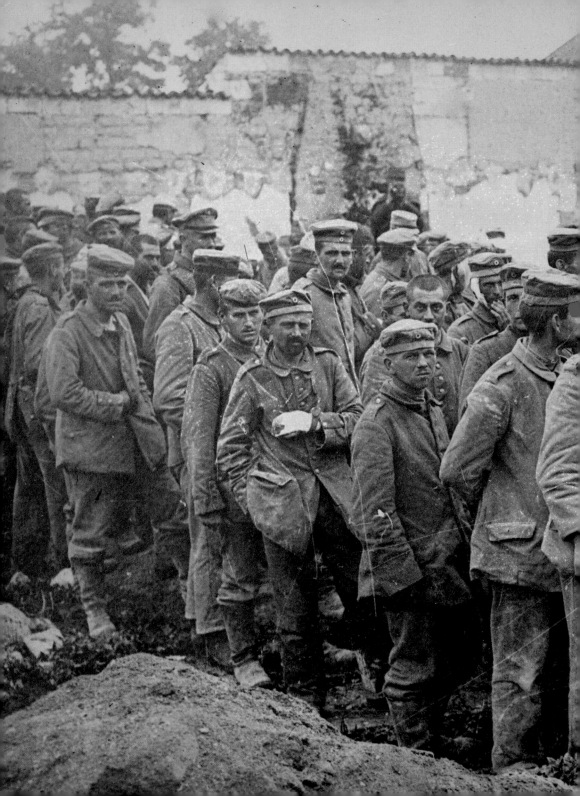

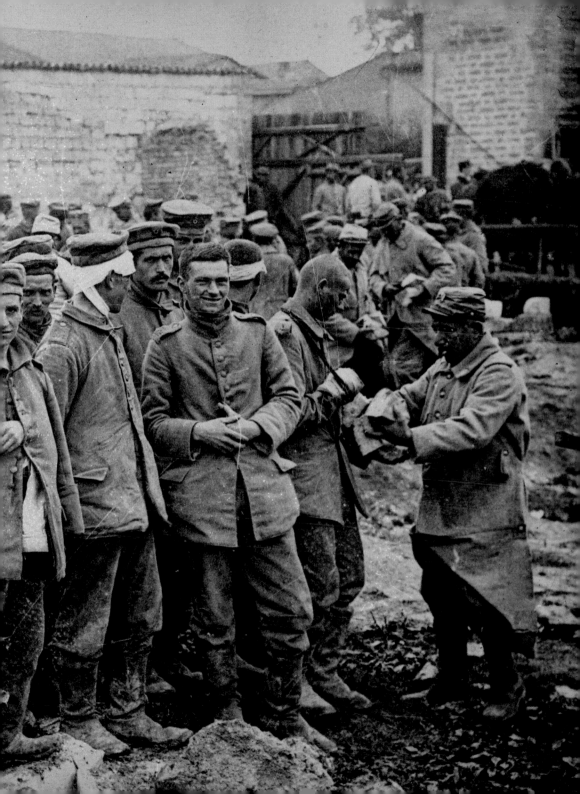

The Battle of the Somme

Inscribed 2005

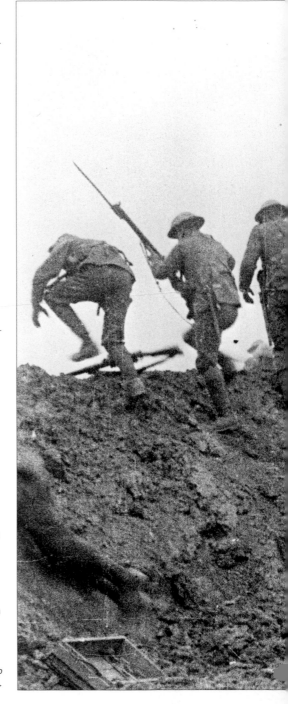

What is it

A black-and-white silent 35 mm film in five reels with a
running time of approximately 70 minutes showing the
British army preparations for the Battle of the Somme in
1916 and the battle's early stages.

Why was it inscribed

The film is the first feature-length documentary film
record of combat, a genre in which its importance
has been defining and long-lasting. It established the
importance of film in wartime propaganda.
On its general release, the film allowed home audiences
to share the soldiers' experiences for the first time,
so cementing the experience of Total War that the
First World War (1914–18) engendered on a then-
unprecedented scale.

Where is it

Imperial War Museum, London, UK

The Battle of the Somme, filmed over several weeks
in northern France in the summer of 1916 by
cinematographers of the British War Office, heralded a
revolutionary departure in warfare, in propaganda and in
the still relatively new medium of moving film. The film's
approach to depicting combat became a standard which
was adopted in other films of warfare of the Second World
War and later.

One of the earliest and most famous documentary
films, it was intended to raise morale on the home front,
and in this it was a great success: an estimated twenty
million people saw it in cinemas in the first six weeks of its
release. It brought the war to popular awareness not just in
Britain and the Empire but also in neutral countries, such
as America. It was also used as a morale booster among
Britain's allies, including Russia, and stimulated counter-
propaganda film making in Germany.

The film sparked contemporary debate over the inclusion
of staged material in documentary film in terms that are
still familiar now. Its value was recognized immediately

*Still from the film of soldiers going over the top
on the first day of the battle.* ▶

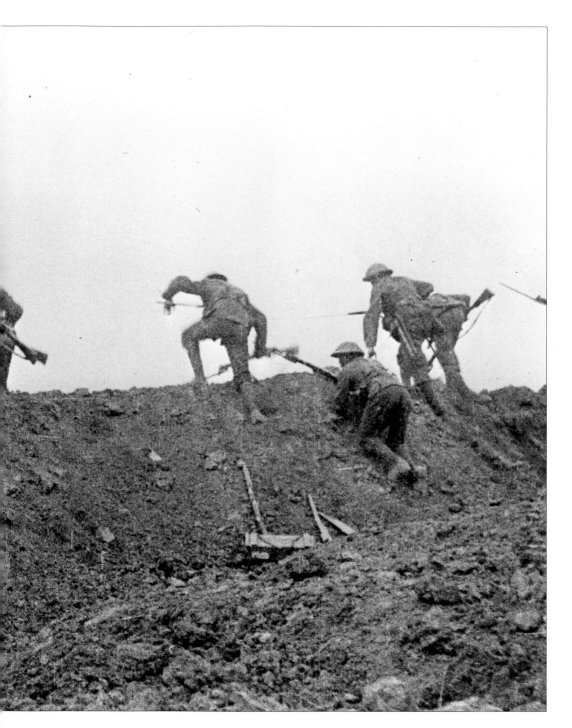

on its release and it was deposited with the Imperial War Museum on the museum's establishment in 1920, one of the earliest films to be so archived.

However, alongside its value as a historical document on film is its importance in human and social history. The British army was largely a volunteer force, many of them 'pals' regiments with strong links to their local areas, and troops from Britain and Ireland fought alongside those from the dominions, including Canada, Newfoundland, Australia, New Zealand and other countries of the Empire, including India; historians have claimed most families in Britain and large numbers overseas were affected directly by the battle. Against this background, the power of its imagery was such that the film shaped and defined the picture of trench warfare, and by extension the First World War, in popular imagination not only in Britain but across the world.

It has also seared the particular experience of the Battle of the Somme into the collective and cultural memory of Britain and the now-Commonwealth countries. The battle still holds the record for the largest number of British losses on one day (more than 58,000 on the first day) and as one of the bloodiest military operations in history, with more than a million dead over its course.

The film recorded front-line conditions for fighting men for the first time and the destruction visited on the French landscape, so raising questions on the morality of depicting the reality of warfare and death, and of trespassing on bereavement. The writer Arthur Conan Doyle, who himself would lose his son in the war, wrote to *The Times* on the subject on 4 September 1916: 'The film is a monument to their devotion. The theatre is filled constantly with the relatives of the men portrayed, and I do not think they feel there is any desecration in the performance'.

Within weeks of being shot, the film was being shown in the open air to troops in France still fighting in the battle, which lasted from 1 July to 18 November. One British officer admired it, declaring that though it lost something from the absence of sound, he could hear the real thing booming some distance away as he watched.

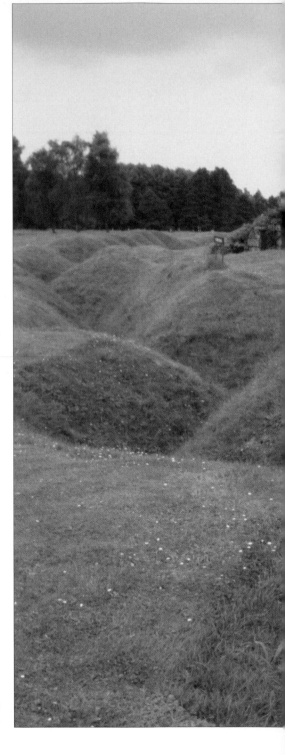

Preserved trenches at the Newfoundland memorial on the Somme battlefield. ▶

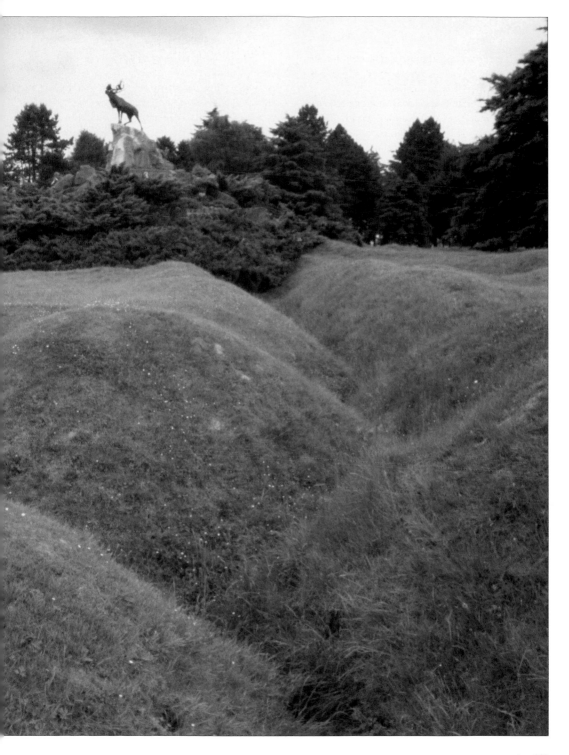

Collection of Russian, Ukrainian and Belarusian émigré periodicals 1918–1945

Inscribed 2007

What is it

A collection of émigré periodicals from the period 1918-45, held by the Slavonic Library in Prague.

Why was it inscribed

The collection is a unique heritage of world importance documenting one of the great chapters of the political development of the 20th century.

Where is it

Slavonic Library, Prague, Czech Republic

This collection of Russian, Ukrainian and Belarusian émigré periodicals (newspapers and journals) preserved by the Slavonic Library is unique set of materials from the interwar period. It represents the heritage of the first wave of Russian emigrants who, following their departure from Bolshevik Russia, settled all over the globe.

The size of this emigration and the scale of its activities led to a specific cultural phenomenon called 'Russia outside Russia'. A new émigré culture was established, separated from its original roots on the territory of the Russian empire, yet preserving for long years the original traditions and cultural values. This culture developed as a mirror of the Soviet culture – parallel with it but without the limits imposed on the Soviet cultural elite.

The collection dates from 1918–45. The large emigration wave from the Bolshevik-occupied territories of Russia started in 1918, while 1945 marks the decline in emigration, due to geopolitical changes in Central and Eastern Europe. Many of the emigrants returned (mostly involuntarily) to the Soviet Union, many of them left Europe and settled in several centres particularly in the United States, Canada and Australia. The decline was also caused by the first large generation shift in the ranks of the diaspora. Many of the second-generation emigrants were losing contact with their roots so that they no longer identified with the traditions of their ancestors. The period 1918–1945 represents the golden era of the first wave of the Russian, Ukrainian and Belarusian emigration and this period correspondingly represents the bulk of the collection.

The émigré periodicals collection described consists in total of approximately 2000 journals and several thousand newspapers. The journals and newspapers belong topically to the fields of politics, culture and humanities.

The collection of Russian, Ukrainian and Belarusian émigré periodicals preserved by the Slavonic Library consists of two main parts. The first part comes directly from the Slavonic Library, which was established in 1924 as the library of the Czechoslovak Ministry of Foreign Affairs. The second, larger part of the collection was established as a result of the activity of the Russian Foreign Historical Archives (RZIA).

The location of the collection in Prague is highly symbolic. Prague, together with Berlin and Paris, was one of the main centres of the interwar life of the diaspora. Only in Prague, however, there was substantial support for émigré activities in the framework of the governmental programme of Russian Aid Action.

The Russian, Ukrainian and Belarusian emigration represents a recognized contribution to world culture and science. A great number of writers, musicians, painters, designers, politicians, academics in both humanities and exact sciences came from its ranks. There can be no doubt about their principal contribution to the advancement of human knowledge and enrichment of the world culture. Many aspects of their professional and private lives can be studied only through the collection of the Slavonic Library. The collection offers researchers the richest and most comprehensive source for study of their achievements and cultural tradition, which is reflected in the strong interest of the scientific community in the collection.

League of Nations archives 1919–1946

Inscribed 2009

What are they

These archives are a unique source of information about the League of Nations (1919-46) and its activities. The collections contain textual records, documents, conventions, ratifications and other diplomatic instruments covering the activities of the League of Nations and its commissions.

Why were they inscribed

The archives bear testimony to the will to create the world's first intergovernmental organization for peace and cooperation, which led to a fundamental change towards an 'institutionalization' of international relations.

Where are they

Library of the United Nations Office, Geneva, Switzerland

▲ *The League of Nations Slavery Convention of 1926, open at the page showing its ratification by Liberia.*

▲ *A specimen of the Nansen Passport for refugees, devised by Fridtjof Nansen, the Norwegian Arctic explorer, scientist and the League of Nations High Commissioner for Russian Refugees, to give refugees some legal protection.*

The League of Nations was conceived in 1919 during the aftermath of the tragedies and suffering caused by the First World War. The victorious states responded to the catastrophe with the establishment of an organization designed 'to promote international cooperation and to achieve peace and security' based on open, just and honourable relations between nations. The Covenant of the League of Nations, which constitutes the first part of the Treaty of Versailles, established the mandates of the world's first intergovernmental organization dedicated to peace.

During the 1920s, the League of Nations enjoyed some remarkable successes by resolving disputes between member states and increasing economic and technical cooperation. In the field of humanitarian assistance, the League had particular success in aiding the return of prisoners-of-war and providing a legal framework for refugees which allowed them to start rebuilding their lives. The increasing economic strife and militant nationalism which characterized the 1930s led not only to the breakup of cooperation between states but also to conflicts which could not be resolved. The League of Nations was unable to prevent these conflicts from erupting into the Second World War and thus it became obsolete, finally being dissolved in 1946. Its legacy is clearly seen in the structure and functions of the United Nations, whose specialized agencies are largely founded on the work initiated by the League of Nations.

The archives of the League of Nations include documents received or produced by the League Secretariat and organized by a central Registry, and Commission files which are records of League agencies concerning, for example, the Financial Reconstruction of Austria and Hungary. The collection of conventions, ratifications and other diplomatic instruments includes documents of important legal value with signatures of heads of states and official seals. The Refugees Mixed Archives Group contains documents from the Geneva headquarters and external offices concerning humanitarian relief, logistics, employment and financial assistance, petitions and legal protection. It includes the inspirational work of Fridtjof Nansen, a Norwegian scientist, Arctic explorer and politician who was appointed League of Nations High Commissioner for Prisoners of War in 1920. Within two years, he arranged for approximately 450,000 ex-prisoners of war from twenty-six countries to be returned to their homes. He played an instrumental role in organizing emergency relief to famine victims in Russia in 1921–23 and, starting in 1922, he also dealt with the problem of refugees from Asia Minor. One of his greatest achievements was the introduction of a system of legal protection for refugees, which was realized by the 'Nansen Passport'. This legal document was eventually recognized by fifty-two governments.

These unique archives attest to the efforts of diplomats, officials and the first international civil servants to promote cooperation between nations and guarantee peace and security. The subjects and themes portrayed in the archives include collective security, peaceful settlement of disputes through conciliation, arbitration and adjudication, disarmament, minorities in Europe and the Near East, supervising mandates over colonies and other territories and the beginnings of a project for the European Union. In addition, the League dealt with refugees, health, social issues, such as slavery, drug control and traffic in women and children, intellectual cooperation and world economy and trade, including financial assistance to member states. They give us an insight into the first experiment of collective security and have already provided its successor organization, the United Nations, with lessons learned.

Palais des Nations, in Geneva, Switzerland is the former headquarters of the League of Nations, and is now used by the United Nations. ▶

Constantine collection

Inscribed 2011

What is it

The collection is a comprehensive compilation of Learie Constantine's correspondence, books, newspaper articles, manuscripts, photographs and ephemeral material.

Why was it inscribed

The collection documents Lord Constantine's work for human rights, British race relations and Commonwealth immigration to Britain, as well his study of the political history of Trinidad and Tobago and his career as one of the world's greatest cricketers.

Where is it

Heritage Library Division of the National Library and Information System Authority, Port of Spain, Trinidad and Tobago

Learie Constantine (1901–71) was not only one of the best cricketers of his time, he was a human rights advocate in his later public life and used the popularity he had gained as a sportsman to successfully promote the improvement of race relations. Constantine made his mark in the only way a poor West Indian male of his time could do, by playing cricket with ability and character. He went on to argue the rights of black people with the effect that only a man who had won public affection through sports could have done in Britain at that period.

▲ Sir Learie Constantine in 1968 at his installation as Rector of the University of St Andrews in Scotland.

▲ Learie Constantine practising a cricket shot.

Constantine has been described as a legend in his time. He emerged from the obscurity of a slave ancestry and a small cocoa plantation to become one of the greatest cricketers of his generation. By the age of twenty-seven he had become a valuable member of the Trinidad and Tobago and West Indies cricket teams and recognized as a master of the game. After 1928, he lived in England where he played at the Nelson Cricket Club. It was there that he launched his professional career, becoming the highest-paid cricketer in the world at that time and paving the way for the West Indian cricketers to play in the United Kingdom after the Second World War. During the Second World War, Lord Constantine was responsible for the West Indian Technicians Volunteer Scheme, ensuring the smooth absorption of people of colour, who had been invited to rebuild Britain as part of the war effort.

He was a Pan Africanist, Head of the League of Coloured Peoples, a politician, diplomat, broadcaster, journalist, lecturer and a respected author. He was the first person of African descent to become a member of the British House of Lords, as Baron Constantine of Maraval, in Trinidad and Tobago, and of Nelson, in the County Palatine of Lancaster. He was also a member of the UK

▲ Learie Constantine at a benefit match for the great Gloucestershire and England bowler, Tom Goddard.

Learie Constantine was Britain's first black life peer in Britain's House of Lords. Formally known as Baron Constantine of Maraval, in Trinidad and Tobago, and of Nelson, in the County Palatine of Lancaster, he is shown here on 26 March 1969, the day he took his seat in the Upper Chamber. ▶

▲ *Learie Constantine and his wife with the first prime minister of an independent Trinidad and Tobago, Dr Eric Williams.*

Race Relations Board and the UK Sports Council, and was Governor of the British Broadcasting Corporation (BBC).

The collection represents all the material that was taken from Lord Constantine's study at his home in England at the time of his death. It includes personal and business correspondence, photographs, manuscripts, hand-written notes of meetings and important events, typescripts of speeches, interviews, transcripts and postcards. It also contains books written by and about Lord Constantine, books on cricket and other subjects, newsletters, periodicals and newspapers from 1948 to 1971 from his personal library. There are approximately 5000 photographs in the Constantine collection depicting his social and public life as a cricketer and coach, diplomat, peer, official overseas visits and other noteworthy events. Of particular significance are several photographs that depict the art of cricket. Constantine details each element of cricket including holding the ball, positioning of the body, catching and batting.

The collection is an excellent source material for the study of the history of cricket in the West Indies, England and the Commonwealth and the role of cricket as an agent of social mobility. It also highlights the theme of immigration from the Commonwealth in the 1950s and 1960s, focusing on India and the West Indies. The collection presents an excellent window into race relations and the treatment of immigrants in Britain in this critical aspect of British history.

First flight across the South Atlantic Ocean in 1922

Inscribed 2011

What is it

Two reports by the pilots of the first flight over the South Atlantic Ocean, from Lisbon to Rio de Janeiro, which was not only a major achievement in aviation but also a milestone in the relations between Europe and Latin America.

Why was it inscribed

This flight was a landmark in air navigation history. It can also be placed in the long Portuguese tradition of explorers and explorations to other continents, initiated by Henry the Navigator in the mid-15th century.

Where is it

Arquivo Histórico da Marinha, Lisbon, Portugal

▲ *Pages from the original report prepared by Coutinho and Cabral, describing their epic flight across the South Atlantic from Lisbon to Rio de Janeiro in 1922.*

This unique document, which includes thirty-eight photographs, is made up of two reports, one by Captain Gago Coutinho and the other by Captain Sacadura Cabral. In 1922 they made the first flight across the South Atlantic Ocean, by floatplane (a type of seaplane where conventional undercarriage is replaced by floats) from Lisbon (Portugal) to Rio de Janeiro (Brazil). The flight also marked the use of a sextant (especially designed by Coutinho with an artificial horizon) in air navigation for the very first time. This showed that precision navigation could be performed on an aircraft in flight. Furthermore, the flight cemented the relations between Portugal and Brazil and involved Spain and Cape Verde, as the floatplane touched all these territories, making it possible to say that three continents were joined by two men in one floatplane, in a mission that changed aeronautical navigation and helped shrink the world.

Soon after the first flight had been made across the North Atlantic Ocean in 1919 and following a visit to Lisbon of the President of Brazil, Captain Cabral proposed a project to attempt the first flight by air over the South Atlantic Ocean, linking the two nations of Portugal and Brazil. This project was welcomed by Portuguese government, and Captain Cabral was immediately commissioned to start the preparations for this epic adventure. Cabral invited Captain Coutinho to help him in this venture and to perform the role of navigator.

The journey began at Lisbon on 30 March 1922 in a floatplane (Fairey F III-D Mark II), specially designed for this flight, equipped with a Rolls-Royce engine and having the call sign, Lusitânia. The first leg took them to Las Palmas. A further ten legs brought them to Rio de Janeiro on 17 June 1922. Although they had taken more than two months to cross South Atlantic Ocean, their flight time was only 62 hours and 26 minutes; they had flown 8383 nautical miles.

(following page) A statue at Belém near Lisbon in Portugal that commemorates the first flight across the South Atlantic undertaken by Captain Gago Coutinho and Captain Sacadura Cabral in 1922. ▶

Kalman Tihanyi's 1926 patent application 'Radioskop'

Inscribed 2001

What is it

The Hungarian patent application of 1926, filed under the name 'Radioskop', contains the first description by Tihanyi of his television system.

Why was it inscribed

This patent contains the fundamental principles of the first practical television system featuring a fully electronic transmitting and receiving devices. This invention made possible the technical realization and industrial mass-production of television, creating a new medium of communication that has had immense impact on global society.

Where is it

National Archives of Hungary, Budapest, Hungary

Kalman Tihanyi (1887–1947) was born in Uzberg, then in Hungary and now in Slovakia, and studied electrical engineering and physics at Bratislava and Budapest. His ideas were fundamental to the development of television and the collection of manuscripts and drawings at the Hungarian National Archives comprises the most

▲ The first page of Kalman Tihanyi's patent application of 20 March 1926 for his 'Radioskop', the precursor of today's television system.

◀ (left and opposite page) Some of the diagrams from Tihanyi's detailed patent application for a practical television system, covering both the transmission and receiving of television signals.

complete record of Tihanyi's first patent application for television (which he entitled 'Radioskop') in 1926. This Hungarian application – due to bureaucratic delays – was never issued, and was consequently never published. Although an awareness of its filing has always existed, it is only recently that its features have been discussed in greater detail. It predates his better-known French and British patents of 1928.

The history of television's development reaches back into the last quarter of the 19th century. Initial work concentrated on electro-mechanical systems which were developed out of the ideas presented in Paul Nipkow's

1884 patent application for an 'Electrical Telescope', which in turn offered a practical solution to scanning an image line by line so that it could be transmitted. This mechanical approach, used both in transmitters and receivers, led to the first practical television sets – it was this system that John Logie Baird, for example, used to build his television system which he demonstrated in 1926. Although most work focused on the electro-mechanical system, ideas for a completely electronic system were also being considered, making use of the recently invented cathode ray tube. The ideas were most clearly laid out in the proposal of A.A. Campbell Swinton, who published his first brief outline in 1908, and a detailed description of his cathode ray transmitter and receiver in 1911.

However, Swinton knew that there were many practical problems to be solved to make his ideas work. Tihanyi sought to find a comprehensive solution. He spent nearly nine years up to 1926 on work to develop the ideas laid out in his two Hungarian patent applications – the second being a forty-three page description accompanied by seven sheets of drawings containing fifty-five diagrams.

He saw the future of television in the cathode ray tube as both transmitter and receiver, and introduced nearly all of the key solutions that would make television using a cathode ray tube a viable instrument. The first commercial television using this system was produced in the 1930s and the electro-mechanical system was consigned to history. The use of cathode ray tubes in televisions, based on Tihanyi's ideas, continued until the advent of flat-screen televisions at the start of the 21st century (a development that Tihanyi had predicted in a groundbreaking paper in 1936).

Metropolis – Sicherungsstück Nr. 1: Negative of the restored and reconstructed version (2001)

Inscribed 2001

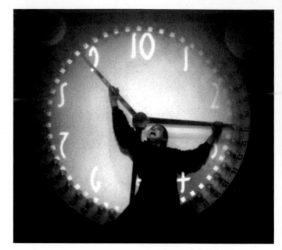

What is it

A reconstructed version of the original cut of Fritz Lang's movie *Metropolis*, first shown in 1927.

Why was it inscribed

A genuine classic not only of German silent film but of world film, *Metropolis* premiered in Berlin in January 1927 but was edited almost immediately afterwards. This is a reconstructed version made of fragments that have been found and is as close to the original as possible.

Where is it

Friedrich Wilhelm Murnau Foundation, Wiesbaden, Germany

First screened in 1927, *Metropolis* is a unique part of the culture of both German film and of the Weimar Republic that produced it. *Metropolis* is a classic also of Expressionist cinema, in which filmmakers used distorted imagery and fantasy, rather than objective physical reality, to express subjective emotions and reactions.

The film presents a futuristic dystopian urban society in a state of conflict. Several meanings have been attributed to the story which has been described variously as a Communist, Capitalist or Christian allegory; the Nazi Party were reputed to be fascinated with the film.

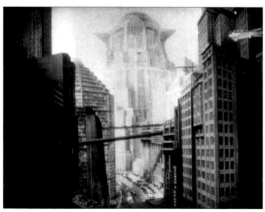

Director Fritz Lang wrote the story with his wife, screenwriter Thea von Harbou. New York was a visual inspiration for the cityscape of *Metropolis*, and Art Deco influenced its look and design. Technical innovations drove new techniques in special effects: for example, the Schüfftan process used mirrors to project the appearance of gigantic buildings in miniature sets.

Fritz Lang filmed *Metropolis* in Potsdam's Babelsberg Film Studios between 1925 and 1926. The production proved costly, taking a year and a half and using 35,000 extras, and the expense left its makers, Universum Film AG (UFA), in financial difficulties. Its length of 4189 metres of film and running time of 153 minutes were considered too long for American release and it was cut and re-edited, changing the story, adding new captions and shortening it to 3100 metres. In Germany, four months after the film's premiere, UFA decided to release the edited-down American version, with only slight changes. This version was the one which was exported to cinemas around the world.

The restored version from 2001, which is listed in the Register, lasts 147 minutes and is 3341 metres long. Missing scenes from recently discovered copies were incorporated, captions were added, the film was restored using new techniques and the new version is believed to be as close to Lang's original vision as was possible to discern in 2001. This new, director's cut premiered at the Berlin Film Festival the same year.

The imagery of *Metropolis* has proved enduring in cinema and popular imagination. It has been cited as

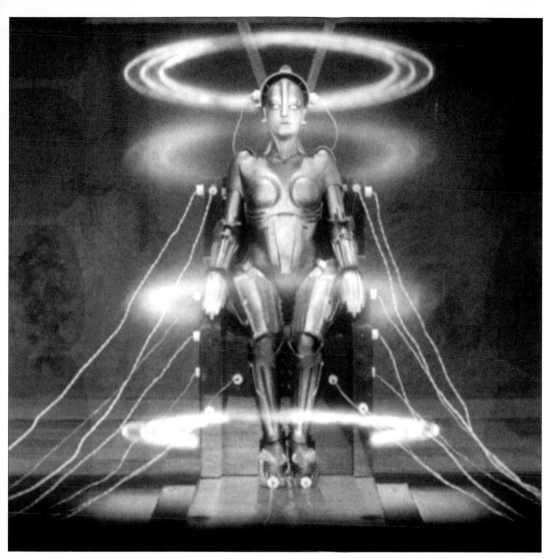

an influence in the imagery of Film Noir especially in
the 1930s, '40s and '50s, and its portrayal of towering
skyscrapers and mechanized transport and city life has also
influenced other science-fiction urban dystopias, such as
Blade Runner. As a commercial venture, *Metropolis* also
illustrates the ongoing difficulty in reconciling artistic
ambition and commercial success.

C.L.R. James collection

Inscribed 2005

What is it

The C.L.R. James collection consists of original documents including correspondence, manuscripts, pamphlets and the personal and literary papers of Cyril Lionel Robert James (1901–89).

Why was it inscribed

C.L.R. James was a leading Caribbean writer whose reputation and influence were global. The collection opens a window to world affairs at a particularly important time in contemporary history.

Where is it

University of the West Indies at St Augustine, Trinidad and Tobago

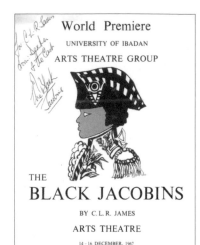

World Premiere

UNIVERSITY OF IBADAN

ARTS THEATRE GROUP

THE

BLACK JACOBINS

BY C.L.R. JAMES

ARTS THEATRE

14 - 16 DECEMBER, 1967

◀ *The programme for the world premiere of C.L.R. James's play* The Black Jacobins, *in Ibadan, Nigeria, sent to the author by the cast and now in the C.L.R. James Collection.*

Cyril Lionel Robert (C.L.R.) James was born in Tunapuna, Trinidad, in the West Indies and became one of the foremost intellectuals of the 20th century. He was self-taught, having left full-time education after secondary school and having never attended university. He left Trinidad for Britain in 1932 to be a cricket correspondent and writer – his first play, *Toussaint L'Ouverture*, on the Haitian Revolution, was staged in 1936. Two years later his influential book, *The Black Jacobins: Toussaint L'Ouverture and the San Domingo Revolution*, developed the themes in the play and became a landmark in the study of Caribbean history. In the same year, he went to the USA, where he became deeply involved in the communist movement. In 1939 he went to Mexico to see Trotsky and was active as a theoretician of the Trotskyite wing of American communism. James eventually fell victim to the anti-communist hysteria that swept the USA and in 1952, he was imprisoned on Ellis Island, New York, and was forced to leave the country in the following year. Following a five-year residence in Britain, James returned to his native Trinidad and Tobago in 1958, invited back by Dr Eric Williams and his political party, the People's National Movement. James edited the party's newspaper, *The Nation*, and emerged as the main ideologue and leftist thinker of the party during its most radical phase (1958–60). He also served as secretary of the West Indian Federal Labour Party and was one of the architects of the short-lived West Indies Federation. Throughout his life, James was a strong advocate of Pan-Africanism. He was an associate of Kwame Nkrumah, the first Prime Minister and the President of Ghana, a prominent supporter of the anti-apartheid struggle in the 1970s and 1980s and was extremely influential amongst leftist African-American intellectuals. From 1965 he mostly lived in the USA and the UK, and he died in London in 1989.

James was also a renowned writer on cricket, and *Beyond a Boundary*, published in 1963, which is a meditation on cricket, partly an autobiography and a brilliant description of Trinidad and Tobago's colonial society, remains a classic.

The collection includes correspondence, manuscripts (hand-written and typescripts) of works by James as well as manuscripts which other authors sent to James for his scrutiny, pamphlets, typescripts of speeches and interviews, lecture and course outlines, notebooks, flyers, newspaper clippings, videotapes and audio-cassettes, together with around 1500 books which formed his working library. The collection largely covers the four decades after World War II, dominated by the Cold War, when the advance of Marxism was a central preoccupation in James' life and writings, and the ending of European colonization, particularly in the former British West Indies, became a reality.

Documentary heritage on the resistance and struggle for human rights in the Dominican Republic, 1930–1961

Inscribed 2009

What is it

An archive of documents, publications, photographs, films, newspaper files, letters, testimonies and official records of the state terrorism of the Trujillo regime.

Why was it inscribed

The collection contains records of the atrocities of the regime and evidence of the Dominican resistance movement and struggles for democracy, freedom and respect for human rights.

Where is it

Memorial Museum of Dominican Resistance, Santo Domingo, Dominican Republic

From 1930 to 1961, the Dominican Republic endured one of the most oppressive regimes in Latin American: the Rafael L. Trujillo dictatorship. Thousands of Dominicans and foreigners were imprisoned, tortured and killed in a systematic culture of oppression. Trujillo personally ordered the genocide of more than 10,000 Haitian residents of the Dominican Republic. His government extended its policy of State terrorism beyond national borders, conducting assassinations overseas.

The archives contain documents, publications, photographs, films, newspaper files, letters, records of organizations of exiles, records of imprisonments, photographs of torture, testimonies of extrajudicial firing squads, autopsy reports on remains exhumed from mass graves, testimonies of military and civilian witnesses as well as registries of mass graves and burial sites.

The files also include descriptions published in the national press after the end of the tyranny, with statements from victims who had been tortured or unlawfully imprisoned, with photos of prisoners and people who had disappeared or been murdered. Many of these items attest to the complicity of the communications media, which was totally controlled by the regime and gave distorted accounts of many crimes.

Together they constitute irrefutable evidence of a system of mass repression, unlawful arrests, torture, political and racial extermination, gender discrimination and the forced disappearance of persons. The archives also bear witness to the actions of resistance, the struggle for truth, justice and respect for human rights during this period of contemporary history.

Making this body of documents accessible and informing younger generations about what happened restores a personal and collective right, fosters a policy of historic memory over a conspiracy of silence and oblivion, raises the conscience of young people and strengthens knowledge of Dominican national history.

In short, this heritage constitutes a valuable educational tool and is a legacy for the formation of new generations and for building a culture of peace based on tolerance, non-discrimination and respect for human rights. It also represents an important contribution for the region and the world for creating greater consciousness concerning crimes against humanity and the right to truth and justice.

In the Dominican Republic, State and civil society have collaborated to build a democratic system and to recover and protect historic memory. The documentary heritage and oral history of that period is a source of universal value for the construction of genuinely democratic societies. Recognition of this heritage will strengthen the resolve to prevent such crimes against humanity from ever occurring again.

Sir William Arthur Lewis papers

Inscribed 2009

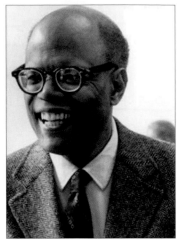

A statue on the Caribbean island of Saint Lucia, the birthplace of Sir William Arthur Lewis, who was a renowned economist and won the Nobel Prize for Economics in 1979, the first Caribbean to win this prize. ▶

What is it

These papers include biographical information, professional correspondence, reference files, minutes of meetings, reports, lecture notes, books, articles and audiovisual materials concerning the internationally renowned economist and Nobel laureate, Sir William Arthur Lewis.

Why were they inscribed

The Sir William Arthur Lewis papers document Sir Arthur's career as a scholar, an economic advisor to governments and international commissions and as a recipient of the Nobel Prize for Economics.

Where are they

Saint Lucia National Archives, Saint Lucia, and the Seeley G. Mudd Manuscript Library, Princeton University Library, USA

Sir William Arthur Lewis was born on 23 January 1915 in Saint Lucia. He won the sole island government university scholarship in 1932 and went to study at the London School of Economics. He subsequently pursued academic work in economics and taught at the universities of Manchester in the UK and Princeton in the USA. In 1948, when he became Stanley Jevons Professor of Political Economy at Manchester, he was the first black professor to teach at a British university, and he was, later, also the first West-Indian born Vice-Chancellor of the University of the West Indies. He died on 15 June 1991 in Barbados at the age of 76. His contemporaries such as Kwame Nkrumah of Ghana, Dr Eric Williams of Trinidad and Tobago, Sir Grantley Adams of Barbados, Norman Manley of Jamaica and José Luis Alberto Muñoz Marín of Puerto Rico viewed him as an individual who could assist in remedying all economic ills. In 1979, he became the first black man to be awarded an academic Nobel Prize (for Economics) for his analysis of economic growth and work on the structural transformation of the economies of Asia, Africa, the Caribbean and Latin America.

Sir Arthur was a pioneer in the field of development economics and his ideas had a direct impact on the growth patterns and development strategies adopted by newly independent countries. Sir Arthur's major concern was how to narrow the economic gap between these countries and the advanced industrialized countries. At the heart of these studies, which centred on an analysis of economic growth and on structural transformation and future economic growth in what was then called the 'Third World', are his *structural change theories*. These theories deal with policies which focus on changing the economic structures of developing countries from being primarily comprised of subsistence agricultural practices to being more modern, more urbanized and more industrially diverse manufacturing and service economies. For example, Sir Arthur's *two-sector surplus labour model* views agrarian societies as consisting of large amounts of surplus labour which can be utilized to spur the development of an urbanized industrial sector. In Puerto Rico, in the 1950s, the application of this model as a recipe for industrial development was so successful that it came to be named the *Puerto Rico Model*, a template for economic development which would be copied throughout the developing world. The economic model developed by Sir Arthur in the 1950s reshaped the thinking of international scholars of the time and provided a new practical economic approach for governments in less developed countries.

His life and work demonstrate integration between a productive academic career and his influence as an economic policy advisor. His published works encompass a wide range of topics, from the arcane theory and practice of economic development to a formula to have a more inclusive politics in West Africa and to the problems

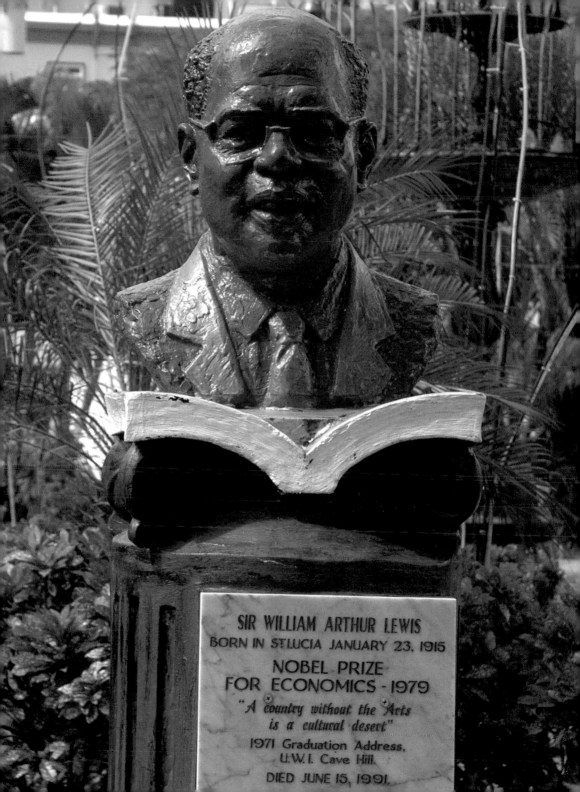

SIR WILLIAM ARTHUR LEWIS
BORN IN St.LUCIA JANUARY 23, 1915

NOBEL PRIZE
FOR ECONOMICS - 1979

"A country without the Arts
is a cultural desert"

1971 Graduation Address,
U.W.I. Cave Hill.

DIED JUNE 15, 1991.

of the peasantry and labour in the Caribbean. From the 1950s to the 1970s Sir Arthur served as Economic Advisor to Kwame Nkrumah of Ghana, as Deputy Managing Director of the United Nations Special Fund, and he also established the Caribbean Development Bank in Barbados.

The Sir William Arthur Lewis papers consist of his professional correspondence, meeting minutes, reports and writings. His scholarly papers include materials documenting his administrative work at the University of the West Indies and his lecture notes from his professorship at Princeton University. His advisory papers include correspondence, meeting minutes and reports, predominantly from his work in Ghana and the Caribbean, especially in Barbados. He also undertook to unify the Caribbean countries after the failure of the West Indies Federation (1962). He single-handedly tried to unite the islands of the Eastern Caribbean into the 'Little Eight'. Eventually, the majority of these islands formed the Organization of Eastern Caribbean States in 1981.

Thor Heyerdahl archives

Inscribed 2011

What is it

The archive of Norwegian ethnographer, explorer, adventurer and writer Thor Heyerdahl (1914–2002), comprising letters, photographs, manuscripts and films.

Why was it inscribed

Thor Heyerdahl's maritime expeditions and archaeological projects were characterized by a unique, practical approach that gained worldwide interest. His theme was the inter-connectedness of people, cultures and civilizations and his findings threw new light on the possibilities, technologies and societies of pre-history and those outside the bounds of modern culture.

Where is it

Kon-Tiki Museum, Oslo, Norway

Thor Heyerdahl was born in Norway in 1914. Originally trained as a zoologist, Heyerdahl became interested in cultural history while studying wildlife in the Marquesas Islands in the southern Pacific Ocean. His newfound interest would lead to a life of exploration, adventuring and active ethnographic study.

An expedition to Polynesia in the late 1930s caused Heyerdahl to question accepted theories that the islands had been populated from west to east by settlers coming from Asia. Instead, he connected the islands' flora and fauna, and their cultural monuments, as having an origin in South America.

These ideas were rejected by his peers and in 1947 Heyerdahl undertook his famous Kon-Tiki expedition to prove that it was possible to sail from South America to Polynesia using ancient seafaring technology. With his crew, he sailed in the balsa wood raft *Kon-Tiki* from Peru over 8000 km of the Pacific to arrive in Raroia Atoll 101 days later. The book of the expedition has sold over 100 million copies, while the film *Kon-Tiki* won the Oscar for Best Documentary in 1950.

This empirical approach to accepted academic theories characterized much of Heyerdahl's work. Subsequent

A line of moais or statues restored by Thor Heyerdahl after the Kon-Tiki expedition to Easter Island or Rapa Nui. ▼

expeditions brought experiments with reed ships and
between 1969 and 1970 he made two attempts to prove
that it was possible to sail across the Atlantic from Morocco
to Barbados in the papyrus boats *Ra* and *Ra II*; the second
voyage was successful, crossing 6100 km of ocean in
57 days. A third expedition followed in the reed boat *Tigris*
to prove the possible existence of ancient maritime links
between the civilizations around the Persian Gulf, the
Indian Ocean and the Red Sea.

Heyerdahl's practical approach also carried over into
his archaeological expeditions, including those to the
Galapagos Islands and Easter Island in the 1950s and
The Maldives in the early 1980s. His work on Easter Island
(now Rapa Nui) brought the island to the world's attention,
turning it into a tourist destination and modernizing
and enriching the island's economy. As with other
cultures Heyerdahl visited, including the Marsh Arabs
in Iraq, his work captured them at a point of transition
before modernization.

On an indirect level, his work changed how the West
regarded the technology of the ancient world and of the
native cultures of America and the Pacific. His findings
raised awareness of how other, oral-based cultures had
a history and practical knowledge overlooked, unknown
to or forgotten by modern man.

Heyerdahl's concern over the pollution of the world's
oceans grew out of his sailing experiments. In the 1970s
he became an influential spokesman in raising awareness
of the seas as a single, interconnected system and their
vital importance for the Earth.

The Kon-Tiki raft at the Kon-Tiki Museum in Oslo, Norway. ▶

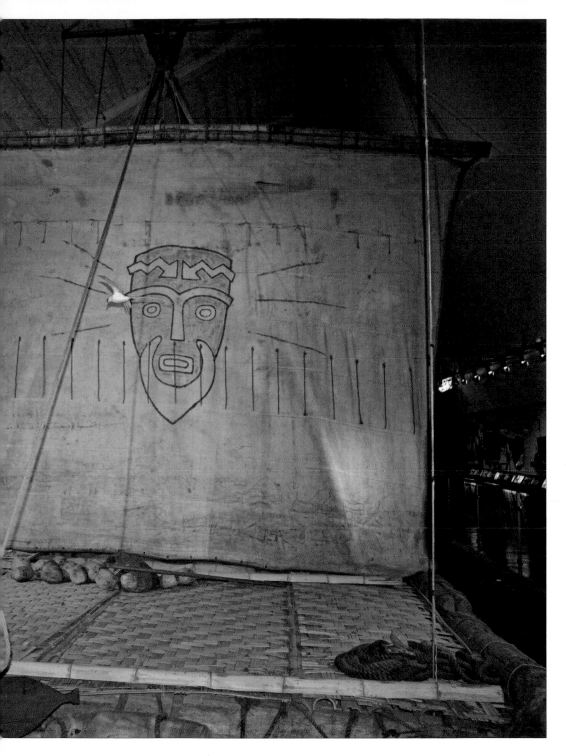

Ingmar Bergman archives
Inscribed 2007

What is it
Ingmar Bergman's personal archives, covering 65 years of artistic creation in the fields of cinema, theatre, opera, radio, television and literature.

Why was it inscribed
Ingmar Bergman's global stature as a filmmaker and director make his personal archives of unique significance. Although he worked continuously in a single country, the influence of Bergman's work on the art of cinema has been global.

Where is it
Swedish Film Institute, Stockholm, Sweden

▲ *Ingrid Thulin and Ingmar Bergman in* The Silence *(1963).*

Film poster for The Seventh Seal *(1957).* ▶

Ingmar Bergman (1918–2007) is recognized as one of the most accomplished and influential film directors of all time. He directed over sixty films and documentaries for cinematic release and for television, most of which he also wrote. He also directed over 170 plays and is acknowledged as a major writer: his screenplays and autobiography *Laterna Magica (The Magic Lantern)* have been translated into more than thirty languages. Bergman was active for more than six decades and in 1997 won the 'Palm of Palms' award at the Cannes Film Festival.

The Ingmar Bergman archives document the work of this outstanding director. They include hand- and typewritten original manuscripts, typescripts with personal handwritten annotations, drafts, notebooks, production papers, photographs and behind-the-scenes-footage from the shooting of eighteen of his films, biographica, and private and professional correspondence.

The script holdings give a unique insight into his creative writing process, from the first draft to the completed script. Furthermore the collections give glimpses of Ingmar Bergman's constant preoccupation with aesthetical issues pertaining to theatre, cinema, television and literature.

The archives originate from the donation in 2002 by Ingmar Bergman himself of his entire personal collection, covering some 65 years of artistic creation, to the Swedish Film Institute. Following the donation, the Film Institute set up Stiftelsen Ingmar Bergman, the Ingmar Bergman Foundation, together with the Royal Dramatic Theatre,

AB Svensk Filmindustri and AB Sveriges Television as co-founders. Its objective is to administrate and preserve, and to provide information about Ingmar Bergman's collected artistic works.

The Foundation website, 'Ingmar Bergman Face to Face', was voted Swedish Cultural Site of the Year in 2005. An English version is available and the website contains selected digitised images from the script collection.

Ingmar Bergman's position as one of the world's most widely recognized artistic creators of modern times makes the archives a significant resource for researchers and an important cultural landmark. The archives were put together and preserved by Mr Bergman personally, making them unique and irreplaceable.

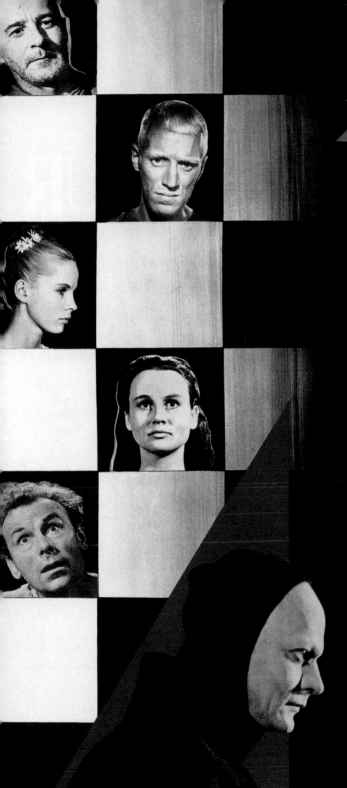

Ingmar Bergmans

Det sjunde inseglet

GUNNAR BJÖRNSTRAND
BENGT EKEROT
NILS POPPE
MAX VON SYDOW
BIBI ANDERSSON
INGA LANDGRÉ
ÅKE FRIDELL

The Wizard of Oz (Victor Fleming, 1939), produced by Metro-Goldwyn-Mayer

Inscribed 2007

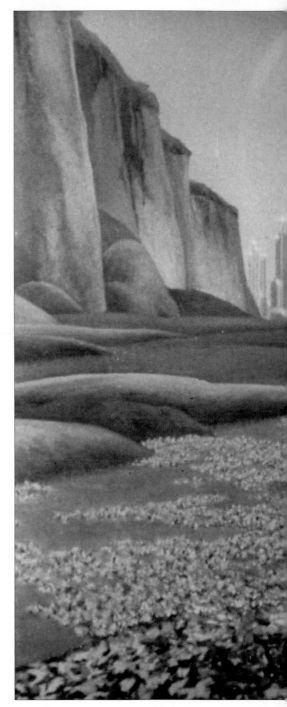

What is it
The original Technicolor 3-strip nitrate negatives and the black-and-white sequences preservation negatives and soundtrack of the film *The Wizard of Oz* (1939).

Why was it inscribed
The Wizard of Oz is a classic of world cinema and one of the most widely seen and influential films in cinema history. Its message is timeless: that love, the courage of one's convictions and the bonds of friendship when united in a single cause can overcome adversity and foster peace. This message resonates not just today but also in 1939 when the film was released, on the eve of war.

Where is it
George Eastman House, Rochester, USA

The Wizard of Oz is one of the best-known films in the history of cinema. Few other films have been seen by so many people in so many countries over so long a time. The film evokes Hollywood at the peak of its creative, cultural and economic influence as the world's dominant film industry.

The search for a better, trouble-free world is a perennial human aspiration that is often expressed through myth and fantasy. In the 20th century, cinema became one of the foremost means of expressing such myths and aspirations, and *The Wizard of Oz* depicts this perhaps more enduringly than any other film. Its pervasive imagery, its imaginative use of Technicolor, its memorable music and its universal messages have become synonymous with the best of human aspirations and striving for a trouble-free world.

The film is in Technicolor with a black-and-white beginning and ending. The colour portion, accounting for most of the film's length, is set in the Land of Oz while the black-and-white portions are set on Dorothy's farm in Kansas. The Technicolor camera simultaneously created three camera negatives, each representing a primary

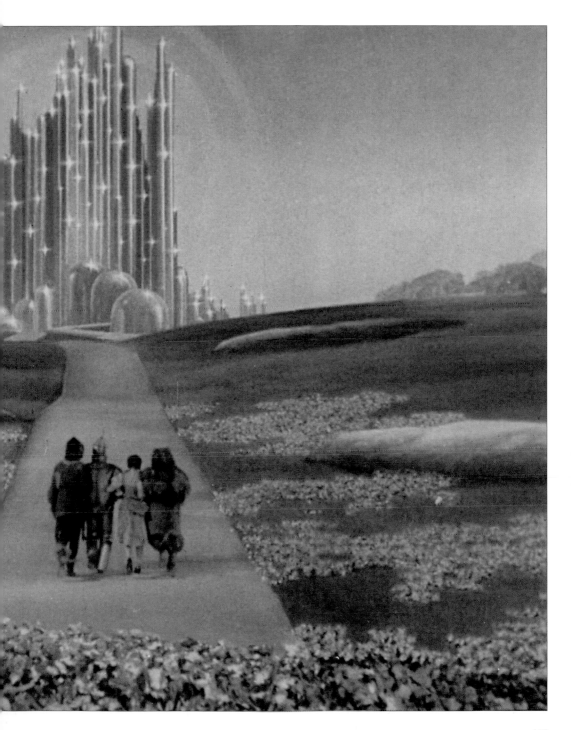

colour (red, green, blue) and their corresponding dyes (yellow, magenta, cyan).

The material listed on the Register represents the earliest generation master material on the film now in existence. The Technicolor separation nitrate negatives of 1939 are the original camera negatives. The soundtrack negative represents the earliest surviving generation of the final sound mix. The black-and-white picture segments (the beginning and end of the film) are intermediate elements taken from the original negative, which decomposed decades ago.

The original camera negatives of any film are irreplaceable as the first and best source material: the further one gets from the original source material, the more information is lost. All existing film prints, duplicate negatives and electronic copies of *The Wizard of Oz* derive from this original film.

The Wizard of Oz was released in the summer of 1939, weeks before the start of the Second World War in Europe. It was to have been the official United States entry at the 1940 Cannes Film Festival, but the event was cancelled because of the war.

Warsaw Ghetto archives
(Emanuel Ringelblum archives)

Inscribed 1999

What is it

A collection of 1680 items, or around 25,000 pages, retrieved from the ruins of the Warsaw Jewish Ghetto over four years between 1946 and 1950. The archives cover the period from 1939 to 1943 during the Second World War and the Shoah or Holocaust.

Why was it inscribed

The Ghetto archives represent the experience of Poland's Jews under German occupation and their resistance to the attempts to send them to concentration camps. They were intended by their creators to bear witness to the fate of the Polish Jewish community. Among the documents are the first detailed descriptions of the extermination camps of Chełmno and Treblinka in Poland.

Where is it

Jewish Historical Research Institute, Warsaw, Poland

The archives of the Warsaw Ghetto comprise government documents, materials concerning the resistance, testimonies of the fate of Jewish communities, literature, works of art and private correspondence, all systematically gathered and collected by the inhabitants of the Warsaw Ghetto to express what was happening to them and to pass on information about the Holocaust to future generations.

After the German invasion of Poland on 1 September 1939, occupying German forces set about systematically dismantling the country. In October 1940 the German authorities ordered the creation of a Jewish ghetto in Warsaw: all Jews in the city and the surrounding areas were rounded up and corralled in the area which was then walled in and patrolled by German troops. The Jewish community in the city was the largest in Europe and it is estimated that the Ghetto population at its height was in excess of 400,000 people or around 30 percent of the

Emanuel Ringelblum ▶

▼ *One of the remaining parts of the wall built around the Ghetto.*

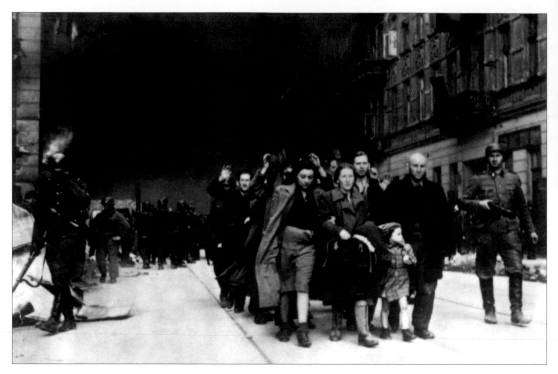

▲ *Captured Jewish civilians being marched out of the Ghetto.*

The destruction of the Ghetto ▶

city's population, all contained in an area of 3.4 square km (1.3 square miles). Conditions were so overcrowded and unhealthy that in 1941 alone, before deportations began, more than 43,000 of the inhabitants died.

One of the Jews moved into the Ghetto was Emanuel Ringelblum, a historian and organizer. He continued with his work inside the Ghetto, recording his own personal observations and heading a group that secretly collected and recorded information on the Jewish experience under German occupation and events inside the Ghetto and in German-occupied Poland. The group met on Saturdays and the project became known as Oneg Shabbat (Joy of the Sabbath). His collection began in October 1939 and went on until January 1943.

The collection was systematically planned and deliberately designed to be multifaceted, with materials from various sources. The documents reveal every aspect of life in the Ghetto and all the actions people took to survive on a day-to-day basis, including underground activity. There are also accounts from other ghettos in Poland. Personal papers, diaries and letters were gathered, including farewell letters from those about to be deported to the camps.

In late 1941, the archive group received the testimony of an escaped deportee from Chełmno camp, detailing that those deported from the Ghetto had not been resettled in other areas as had been assumed, but had been systematically gassed. Lists of deportees were kept, as were records of those killed within the Ghetto itself. The mundane minutiae of German oppression on an everyday level are also revealed through the identity documents, the food-rationing cards, the certificates of employment and the official forms, documents and pronouncements.

In the summer of 1942, over 250,000 people – more than half the Ghetto's population – were deported to Treblinka extermination camp. More German deportation raids the following January triggered plans for resistance by the Ghetto inhabitants; the uprising lasted from then until May 1943, when German troops levelled the entire area. The Warsaw Ghetto Uprising

marked the end of Ringelblum's archive, which was buried in house basements for safe keeping.

The documents of the Ghetto archives are generally regarded as the most important collection of primary-source material on the history of the Holocaust from the point of view of its victims.

After the war, Hersz Wasser, a member of the Oneg Shabbat group, was able to indicate where the documents had been hidden and to draw up the first inventory of the collection; one part has still to be recovered. Emanuel Ringelblum escaped the Ghetto with his wife and son, but in 1944 the family's hiding place was discovered and they were shot. Nearly all the creators of the Ringelblum archives perished, either in the Ghetto or in the extermination camps to which the inhabitants were shipped.

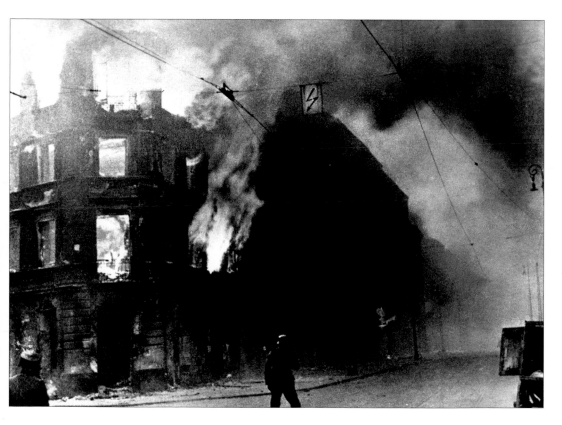

Astrid Lindgren archives

Inscribed 2005

What is it

The archives of the renowned Swedish children's writer Astrid Lindgren (1907–2002), comprising original and unpublished manuscripts, shorthand drafts, press cuttings and correspondence.

Why was it inscribed

Astrid Lindgren was among the most popular children's writers of the 20th century and an enthusiastic advocate for children's rights. She helped to establish children's and young people's literature as a global literary genre.

Where is it

Royal Library, Stockholm, Sweden

One of the most famous Swedes of the 20th century, Astrid Lindgren is among the most translated and best-selling authors in the world. Her achievements in children's literature and as an advocate of children's rights were acknowledged during her lifetime in more than eighty Swedish and international awards and in four honorary degrees. She remains a popular author in this century and her books are still regarded as classics, even after the vast growth in the numbers of children's books and the awareness of children's literature as a separate genre, which she herself helped foster.

Astrid Lindgren's works are now translated into more than eighty-five languages and her books have sold in excess of 140 million copies across the world. The humour and inventive imagination of her writing have ensured that her characters – the best known of whom is probably Pippi Longstocking – are perennially popular not only in her native Sweden but around the world, and remain enduring favourites of both children and adults today.

Astrid Lindgren lived in relative obscurity, but in the last 25 years of her life she chose to step into the public eye with her support for children's rights and children's culture as well as a number of other interests, using the affection, respect and influence she enjoyed to further her chosen causes. These included her opposition to factory-farming methods and also to high levels of taxation – the subject

◀ *Astrid Lindgren sharing her work with a group of children in the 1970s.*

▲ *Astrid Lindgren with her most famous character, Pippi Longstocking.*

that prompted her first to speak out publicly, and the subject of a satirical tale she wrote.

The archives were compiled by Astrid Lindgren herself and they include draft material, letters, photos, audiovisual recordings and other material in addition to her manuscripts of books, films and plays. She rarely copied her own outgoing correspondence (although there are carbon copies of a few hundred of her letters), but there are tens of thousands of letters and notes from readers, approximately half of which are from children. The rest come from adults of all walks of life, including publishers, politicians, other authors, teachers, bus drivers and royalty. The correspondence also includes her personal and family letters, allowing a glimpse that spans Astrid Lindgren's public and private lives – a feature virtually unique among authors' archives. In all, the material stretches for approximately 100 metres of shelving.

The Appeal of 18 June 1940

Inscribed 2005

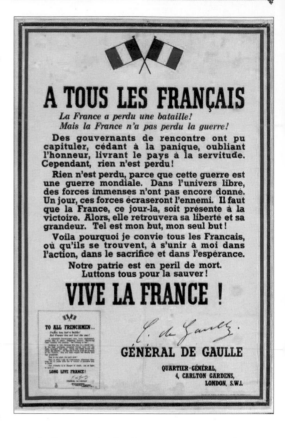

What is it

The spoken, written and printed text of the call made from London in 1940 by General Charles de Gaulle to his countrymen and women not to capitulate to the German forces that occupied France during the Second World War.

Why was it inscribed

The Appeal is one of the most important speeches in French history and came at a critical moment for the country. In offering France an alternative path to a future under occupation, de Gaulle's exhortation and rallying call marked the start of French resistance to the German occupation in the Second World War.

It also demonstrated the authority and the reach of the relatively new medium of radio in its ability to communicate with and organize isolated and scattered individuals.

Where Is It

Institut National de l'audiovisuel, Bry-sur-Marne, France; BBC, London, UK; Manuscript of 18 June Appeal: Admiral Philippe de Gaulle, Paris, France; Musée de l'Ordre de la Libération, Paris, France

The Appeal of 18 June 1940 was broadcast from London during the Second World War, over a month after the German invasion of France began and shortly before the armistice signed between the German and French governments. Under its terms, France would be split into a zone of German occupation in the north and west, including Paris, and a zone under a French administration approved by the Germans which would govern the rest of the country from Vichy.

General Charles de Gaulle (1890–1970), a member of the government, was one of several politicians who left rather than stay in German-occupied France. He fled to England, arriving in London on 16 June.

In London he received permission to broadcast through the BBC to the French people and first broadcast his speech on 18 June. That speech was not recorded and was said to have been heard by relatively few people in France. Another speech the following day was shorter, but the

speech of 22 June, the day the armistice was signed in France, was longer and stronger in tone. This speech was recorded and heard by far more people.

De Gaulle's Appeal is one of the most important speeches in French history. He refrained from criticizing his former army colleagues who now formed the French government and acknowledged that France had been overwhelmed by mechanized force. However, he called on French officers and soldiers, engineers and armament workers within the British empire, and those who could make their way there, to contact him. The speech confirmed de Gaulle as leader of what would become the Forces Françaises Libres, the Free French Forces.

The recording of 22 June is one of four items that comprise this listing on the Register, together with the handwritten text of the initial appeal broadcast on 18 June. The other two items are a poster that appeared in London on 3 August and the manuscript of the poster.

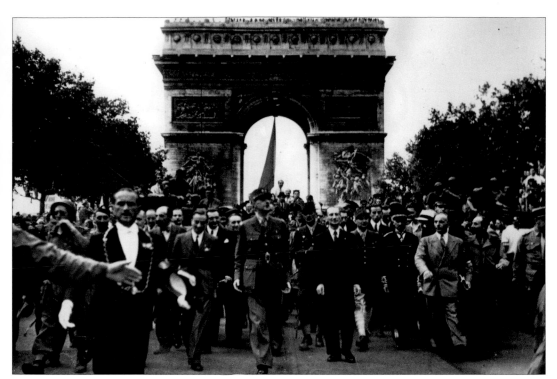

In July 1940, de Gaulle wrote the text, addressed to French citizens in Britain, urging them to join him in returning to battle. This text, sometimes known as the 'call to arms', was printed in the form of a poster addressed 'A Tous Les Français' (To All French People). A shortened version of the Appeal, it appeared quietly throughout the country at first, but then in larger numbers at the end of July. From 3 August, the poster was displayed in the streets of London. Many other versions of this poster were later printed across the world.

The Appeal marked the arrival of de Gaulle in political life; he would become one of the most important figures of the Second World War and in post-war France until his death in 1970. He was one of the first politicians to use the new methods of mass communication.

The Appeal also helped to lend credibility to radio. Only 20 years after radio services began broadcasting in Britain, radio had become a tool in warfare and a means of communicating ideas to vast numbers across great distances.

▲ *De Gaulle returning to Paris in triumph in 1944.*

Diaries of Anne Frank

Inscribed 2009

What is it

The diaries of Anne Frank, the Jewish girl who hid in an Amsterdam annexe during the German occupation of the Netherlands in the Second World War. The diaries date from 14 June 1942 to 1 August 1944, and there are associated writings, quotes and stories.

Why was it inscribed

Anne Frank's writings are those of one individual but her voice has come to represent a silent multitude who could not speak for itself: the millions of Jews who suffered and died during the Second World War. Anne wrote in extraordinary, oppressive circumstances in an Amsterdam annexe, while retaining her optimism and the voice of a normal adolescent girl.

Where is it

Anne Frank House, Amsterdam, the Netherlands

Anne Frank was born in Frankfurt in 1929, a German Jew and the second of two daughters of a middle-class family. Anne was three years old when Hitler's National Socialist German Workers' Party, or Nazi Party, came to power in 1933. Her parents, Otto and Edith, recognized the threat posed by the Nazis' anti-Jewish policies and moved the same year with the children to the Netherlands where Anne's father set up business.

The Netherlands had maintained an open-door policy to refugees from neighbouring German-controlled countries, and it is estimated that over 100,000 Jews were living in the country by the time of the German invasion in May 1940.

Anti-Jewish legislation began within months and intensified over the next two years with restrictions on jobs, education, finances and freedom of movement and association. By May 1942, every Jew of six years old and over was ordered to wear a yellow Star of David with the word 'Jew' inscribed on it.

In June, a plan was put into effect to deport the Jews of the Netherlands to 'work camps' in Germany and Poland. Children, the elderly and the sick were gassed on arrival while healthy adults were put to work in conditions of extreme brutality. The Jews still in Amsterdam knew nothing of this.

It was the arrival on 5 June 1942 of deportation papers for Anne's older sister Margot, that drove the Frank family into hiding on 6 July, in the upstairs annexe of Otto's business premises in 263 Prinsengracht. Four others hid there with them in a space approximately 100 square metres, unable to make any noise or go outside. Otto's closest colleagues helped support and hide the group for the 25 months.

On 12 June, her thirteenth birthday, Anne received from her parents the diary covered in red-and-white chequered cloth that has become an iconic image. Anne used her diary until December of that year and continued her entries in two hardcover school exercise books until 1 August 1944. These books are also part of the collection, together with an office accounts book filled with quotes she liked, and a second accounts book with her own short stories. Anne's ambition was to be a writer after the war was over, and she also kept 360 sheets of thin paper to edit and rewrite her diary entries.

As well as accounts of her daily life, Anne's diary entries deal with typical adolescent problems in terms still recognizable today, played out against a background of extraordinary circumstances.

The group hiding in the annexe was betrayed to the authorities. They were arrested in a raid on 4 August 1944 and four days later were sent to Westerbork transit camp in

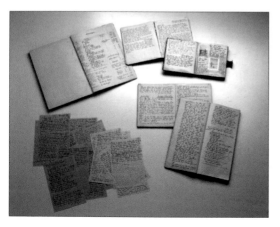

◄ Anne Frank's diary

Anne Frank ►

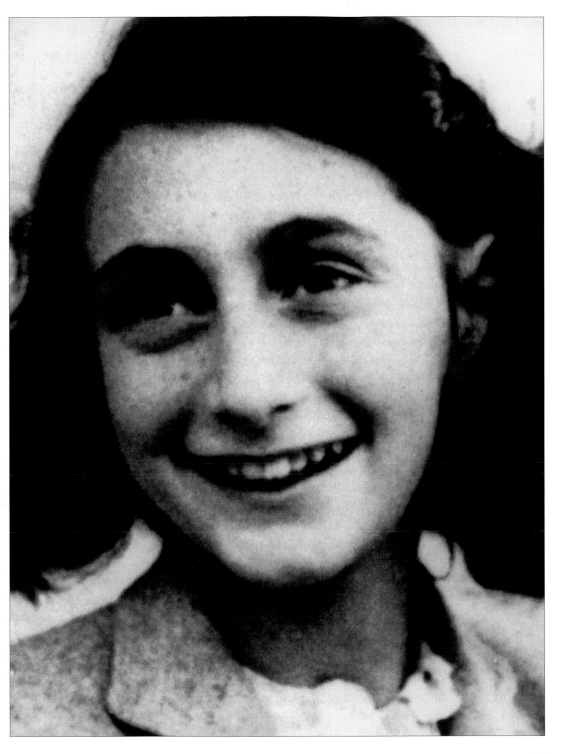

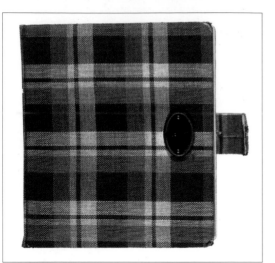

the Netherlands. By 6 September they were in Auschwitz-Birkenau camp in Poland. Her mother died of starvation and Anne and Margot were relocated to Bergen-Belsen camp where they died within days of each other in March 1945, weeks before the British liberated the camp.

Otto Frank returned to Amsterdam where he learned that he was the sole survivor of the annexe group. His friend Miep Gies who had supported the family, gave him Anne's diary and papers which she had recovered from the ransacked rooms after the raid. Otto edited Anne's diary for its publication on 25 June 1947.

The Diary of Anne Frank has sold more than 25 million copies worldwide and has been translated into sixty-five languages. Her inspirational story resonates with young people through the years and brings over a million visitors a year to her Prinsengracht hiding place. Her diary is used across the world to teach about the Holocaust.

One of Anne's final entries, from 21 July 1944, is one of the most poignant in the diary:

'It's difficult in times like these; ideals, dreams and cherished hopes rise within us, only to be crushed by grim reality. It's a wonder I haven't abandoned all my ideals, they seem so absurd and impractical. Yet I cling to them because I believe, in spite of everything, that people are truly good at heart.'

Archive of Warsaw Reconstruction Office

Inscribed 2011

What is it

The archives of the Polish organizations charged with rebuilding Warsaw after its systematic razing by German forces during the Second World War (1939–45). The documents both detail the city's destruction and chart its reconstruction from 1945 until 1953.

Why was it inscribed

The documents reveal the successful reconstruction of Warsaw – in the case of many buildings, from the foundation stones up – to be an immense organizational, physical and social achievement which later became a model for the preservation of heritage. The Polish capital, long planned for architectural and human eradication by the Nazis became, through its wartime uprisings and its post-war rebuilding, a symbol of the 'invincible city'.

Where is it

State Archives of the Capital City of Warsaw, Poland

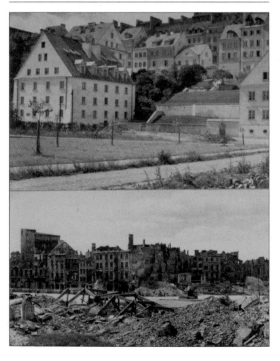

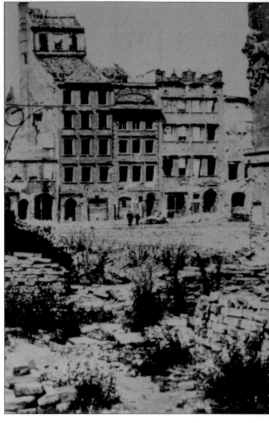

▲ *Entrance to Old Town Market Square: pictures showing wartime damage and the same scene after reconstruction*

◀ *The Old Town, seen from the Vistula river, before (bottom) and after (top) reconstruction*

The forces of Nazi Germany occupied Poland from 1939 to 1945, virtually the whole length of the war. An important part of the Nazis' plan for the country was laid out under the Pabst or Warschau Plan, approved in 1942, which now forms part of the Warsaw Reconstruction Office Archive.

The plan proposed the complete demolition of the Polish capital and its rebuilding as a new German model town, to be built over Warsaw's historic Old Town district, which was to be destroyed. The city's 1.5 million inhabitants were to be removed and replaced with 40,000 Germans.

The proposed destruction of Warsaw was part of the Nazis' idea of *Lebensraum*, the Germanification of eastern

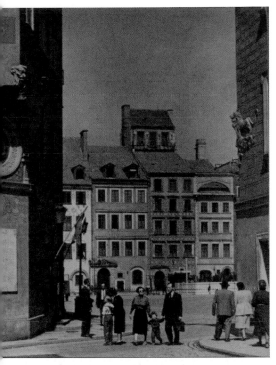

Europe which, in the words of the Nazi commander Heinrich Himmler, would 'give a terrifying example for all Europe'.

The Germans cleared large sections of the city of both its civilian populations and its buildings, especially after the Warsaw Ghetto Uprising of 1943 and the Warsaw Uprising of the following year. Demolition squads systematically burnt and destroyed houses, schools, churches, libraries and especially historic buildings and cultural monuments, while the citizens were killed or shipped out, usually to concentration camps.

In May 1945 the Warsaw Reconstruction Office began recording the scale of the physical damage to the city, 68 percent of which was destroyed, a figure that rose to 80 percent in the Old Town. The Reconstruction Office employed 1422 staff including engineers, technicians and other builders to assess the condition of surviving buildings, plan the rebuilding of infrastructure and detail methods of restoring historic complexes and monuments.

The statue of Christ carrying his cross from the Church of the Holy Cross which was destroyed by the Germans and rebuilt after the war. ▼

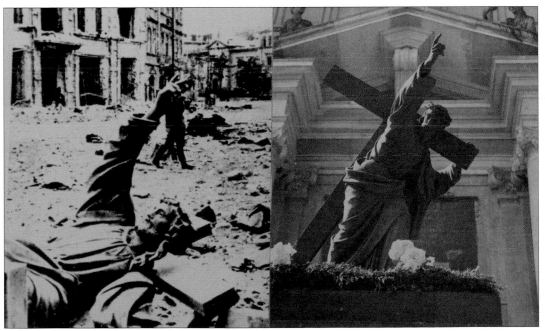

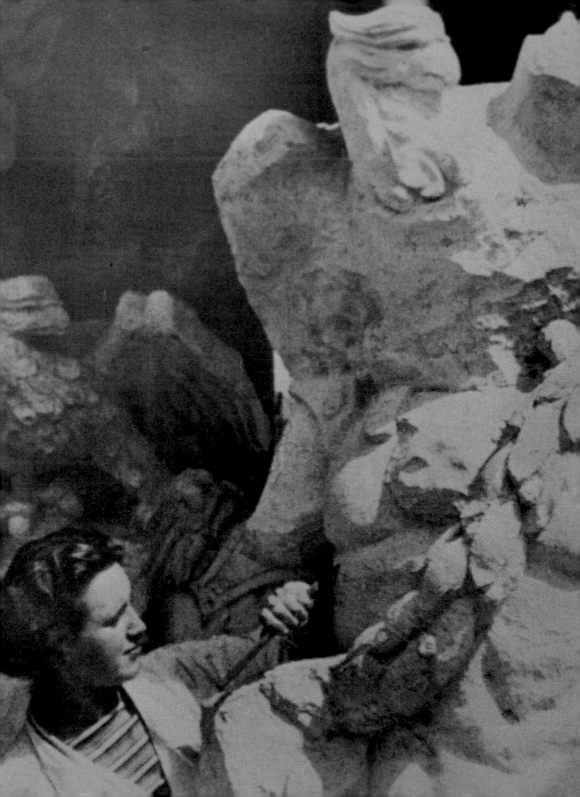

The archives detail their painstaking work through their documents and records, plans, charts, minutes of meetings, correspondence, drafts, statistical studies, contracts, accounts, cost estimates, court decisions, sketches, site plans, drawings and photographs. From these documents and plans, the city was reconstructed successfully – all the more remarkable for being carried out under another totalitarian occupying power, this time the Soviet Union (USSR). The rebuilt city later became a model for the reconstruction of destroyed churches in Moscow and Kiev and historic buildings in Dresden, and in 1980, the Old Town district and the Royal Castle were listed as a UNESCO World Heritage site.

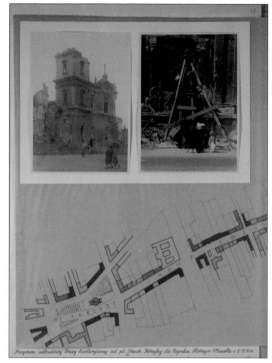

▲ *Plans for the reconstruction of Plac Trzech Krzyży (Three Crosses Square) in the Old Town.*

◄ *Restoration work on a sculpture from the Old Town.*

Archives of the Literary Institute in Paris (1946–2000)
(Association Institut Littéraire 'Kultura')
Inscribed 2009

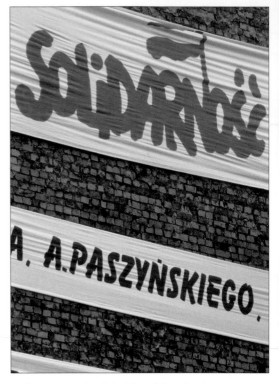

What is it

The Literary Institute was a centre of independent thought for emigrants from the Communist-controlled countries of Eastern Europe during the Cold War era and after.

Its archives include various types of documents, including a collection of letters to and from writers, artists, intellectuals and politicians from Western Europe and dissidents from the Soviet bloc, journals, editorial and publishing archive materials, recordings, films and photographs, and a book and art collection.

Why was it inscribed

The Institute contributed to the success of the peaceful transformation from Communist totalitarianism to democracy through its lengthy dialogue with intellectuals, writers and politicians in the decades of the Cold War. It also provided a means for intellectuals and dissidents behind the Iron Curtain to communicate through the Soviet information blockade and censorship.

Where is it

91 Avenue de Poissy, Maisons-Laffitte, France

▲ *The Literary Institute helped the Polish trade union Solidarity (see page 549).*

From its base just outside Paris, the Literary Institute created a post-war network of free thought for dissident thinkers and emigrants from Soviet-bloc countries such as Poland, Ukraine, Czechoslovakia and Hungary, as well as for those still caught behind the Iron Curtain.

From 1946 to 2000, the Institute organized support for dissidents and writers and helped dissident organizations such as the Czech Charter 77 and Solidarność (Solidarity) in Poland. It sought to educate writers and thinkers in the Free World about the true nature of the Communist system in the Soviet Union (USSR) and the threat it posed to the West. It published the journal *Kultura* for Eastern European intellectuals and fought censorship in their Communist-controlled countries.

Jerzy Giedroyc (1906–2000), a Pole of Russian birth, was the Institute's founder and editor of *Kultura*. Erudite, thought-provoking and influential, *Kultura* saw more

than 600 editions and was banned in Poland itself. Giedroyc's political vision foresaw the collapse of the Soviet empire and the re-emergence of free nations in Eastern Europe. His dedication to that cause saw him amass a collection of 100,000 letters with many of the leading international political and intellectual figures of his day including André Malraux, Albert Camus and Alexander Solzhenitsyn, Bertrand Russell, Henry Kissinger and Zbigniew Brzeziński, as well as with noted Polish writers and dramatists. Among the multiple honours Giedroyc received was the Officer's Cross of the French Legion of Honour.

The Institute aided dissident publishing houses in Eastern Europe, and translated and distributed in Eastern Europe the works of banned authors, including Orwell, Camus, Koestler, Solzhenitsyn and Pasternak.

The intellectual and political vision of its founders and leaders and their persistence over decades allowed this

▲ *The Czech dissident group Charter 77, shown here with later Czech president Václav Havel, were also among those supported by the Literary Institute in Paris.*

remarkable emigration institution to play a continuous role during the Cold War years and to be a factor in the collapse of the Communist system in Europe, one of the defining events of 20th-century history.

Federal Archives fonds

Inscribed 2009

What is it

The official records of The West Indies Federation, including files, registers, newspapers, films, flags, sound recordings, photographs and coats of arms.

Why was it inscribed

The records reveal the decisions and policies, plans and strategies, hopes and aspirations of West Indian peoples at a time when dramatic changes were taking place on the world scene.

Where is it

Federal Archives Centre, Cave Hill Campus, St. Michael, Barbados

▲ *Inauguration of West Indies Legislature, 22 April 1958, Port of Spain, Trinidad.*

The West Indies Federation (1958–1962) was a political federation of ten territories in the Anglophone West Indies: Jamaica, Antigua, Barbados, Trinidad and Tobago, Grenada, Montserrat, St Kitts/Nevis/Anguilla, Dominica, Saint Lucia and St Vincent. British Guyana and British Honduras were associated territories. Its formation signalled the beginning of a new era of decolonization for the region of the West Indies in the period after the Second World War.

The history of the West Indies is inextricably linked with the histories of other former British colonies, which include portions of Africa, Australia, New Zealand, Canada and the United States of America. The Federal Archives reflect the interconnectivity of these histories and document one of the decisive periods of 20th century history when territories, under the colonial rule of the British empire, first flexed their 'political muscles' and sought to become sovereign nation-states.

Undoubtedly, the West Indies Federation shared some commonalities with other contemporary federations particularly with regard to issues such as constitutional reform and overcoming nationalist interests. However, the West Indian experience was unique and distinct from all others mainly as a result of the geographical separateness of the territories by sea and the insularity of the territories, which historically related bi-laterally with England.

Additionally, there was the impact of extra- and intra-regional migrations on account of the colonial

plantation economies that were based on indentured servitude, slavery and imported labour. The most striking characteristic, however, was the swiftness of the time in which the Federation of the West Indies was established, despite the diversity and disparity in physical size, demographics and economies of the constituent territories.

The Federal Archives fonds spans the period 1947–66. The information documented relates to all these territories and gives a comprehensive view of the social, economic, political and cultural situation in the British West Indies at the time of the Federation. Records include administrative files, registers, the Federal flag, the Governor-General's flags, a metal seal encased, minute books, pamphlets, debates, statistical data, court cases, reports, card indexes, visitor's books, oath books, newspapers, press releases, sound recordings, reel-to-reel film, legal instruments, the Coat of Arms on a mahogany plaque, correspondence, Seal of the West Indies, savingrams, telegrams, gazettes, photographs, original instruments and architectural plans.

The strategic position of the West Indies between Europe and North America made them a transit hub for many cross-continental and cross-Atlantic activities. The records, therefore, transcend regional boundaries and bear witness to international economic, social and political developments. The fonds represents one of the most politically complex, socially cosmopolitan, multi-cultural regions of the world and its interactions with other major world powers during that period. The

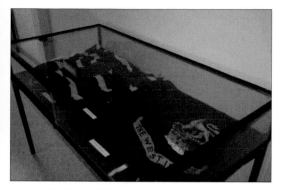

▲ *The original flags of the West Indies Federation.*

The Seal of the West Indies Federation. ▲

West Indies Federation was a unique conglomeration of island colonies whose sole mission was to attain self-governance and independence from Britain.

Audiovisual documents of the international antinuclear movement 'Nevada-Semipalatinsk'

Inscribed 2005

What is it
The archives of the Kazakhstan-based anti-nuclear movement 'Nevada-Semipalatinsk'.

Why was it inscribed
'Nevada-Semipalatinsk' gained wide international support and became a real historical factor in helping people fight nuclear threats and find solutions to global ecological problems.

Where is it
Central State Archives, Almaty, Kazakhstan

In 1947 the Soviet Union established its primary nuclear testing site at Semipalatinsk in northeast Kazakhstan. Officials claimed that the 18,000 km² area of steppe was uninhabited, but there was in fact a significant local population. The first device was detonated in 1949 and over the next 40 years a total of 456 nuclear weapons were tested at Semipalatinsk.

There was little attempt to protect people or the environment from the effects of the explosions. Approximately 2.6 million people were exposed to radiation from the site and 2 million hectares of farmland were contaminated. The incidence of birth defects and cancer in the area is much higher than for the rest of the country.

Kazakhstan was the only state in the world where the full range of nuclear-strategic programmes was carried out: mining and processing of the strategic raw materials, manufacture and testing of nuclear warheads and demolition of missile units.

'Nevada-Semipalatinsk' was a Kazakhstan anti-nuclear organization formed in 1989. Led by author Olzhas Suleimenov, it was one of the first major anti-nuclear movements in the former Soviet Union. It orchestrated a non-stop campaign of protests against nuclear tests at the site. This included thousands of meetings, peace marches, ecological initiatives and international and regional conferences at a time when political opposition to the Soviet regime was dangerous. Thousands of people supported its activities, which eventually led to the closure of the Semipalatinsk nuclear test site in 1991.

This collection documents the history of the movement and its struggle with Soviet authorities. It comprises printed works (newspapers, journal articles, monographs), photographs, films and sound recordings.

The archives detail the organization of actions directed towards the complete prohibition of nuclear tests, the banning of nuclear missiles and other types of weapons

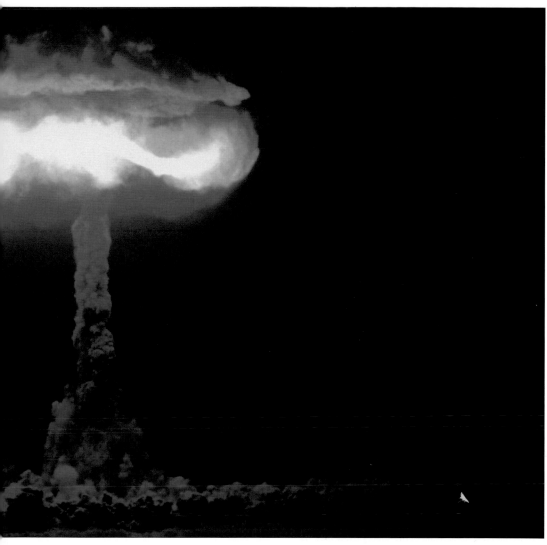

of mass destruction and the illegal burial of radioactive and
toxic wastes. They also document the movement's plans for
the protection and revitalization of the local environment,
community and economy.

'Nevada-Semipalatinsk''s success in fighting nuclear
threats and finding solutions to global ecological problems
attracted international support. Branches of the movement
were established in the USA, France, Germany, Turkey,
Mongolia, South Africa, Italy, Israel and Canada.

Detonation of a nuclear device ▲

UNRWA photo and film archives of Palestinian refugees

Inscribed 2009

What are they

A selection of photographs and films covering all the stages of the history of the Palestinian refugees, from their flight from the new state of Israel in 1948 up to the present day.

Why were they inscribed

During six decades UNRWA has produced and collected a comprehensive record of still photographs and film material covering most aspects of the lives and history of the Palestine refugees, providing a visual documentary heritage.

Where are they

The Photo Archive, United Nations Relief and Works Agency for Palestine Refugees (UNRWA) Headquarters, Gaza; Film Archive, UNWRA, Amman, Jordan

The Arab-Israeli War in 1948 forced more than 700,000 Palestinians to flee their homes and become refugees in camps in Gaza, the West Bank, Jordan, Syria and Lebanon. UNRWA, the United Nations Relief and Works Agency for Palestine Refugees in the Near East began its operations on 1 May 1950.

The UNRWA archives hold a substantial body of photographs of the flight of Palestinians from the newly created state of Israel in 1948. Some of the iconic images of Palestinians leaving their homes and arriving as destitute refugees on the beach of Gaza, in caves in the West Bank or in the mud of Nahr el-Bared camp in Lebanon were taken by photographers working for the United Nations and whose production was given to UNRWA. The first documentary film ever to be made about the Palestine refugees, showing starving children and the squalid living conditions in the camps in 1950 belongs to the UNRWA archives. The archive then continues with images from the establishment of functional camps in the 1950s, the second flight during the 1967 Arab-Israeli war in which Israel occupied East Jerusalem and the West Bank, the civil war in Lebanon, the turbulent periods in the second half of the 1980s and events up to the present day.

The UNRWA photo and film archives also depict the daily lives of the refugees and the relief efforts extended to them. The number of registered Palestine refugees has grown from 914,000 in 1950 to more than 4.4 million today. The images show the refugee education that produced the highest standard of learning in all the host countries, the health services that eradicated diseases and the vocational training that helped refugees obtain skills to become breadwinners for their families. The photographs and films produced over more than half a century have captured the Palestinians maintaining their culture, their traditions and their family structure.

The UNRWA photo archives contain around 10,000 photographs, 15,000 colour slides and an estimated 400,000 negatives with corresponding contact sheets from 1948 up to the present day. The UNRWA film archives contain seventy-five films produced between 1950 and 1984, as well as around 400 videotapes with UNRWA productions and archive material covering a period from the mid 1970s to the late 1990s.

The first collection of visual material was assembled in the agency's headquarters in Beirut. In 1982 UNRWA's headquarter was moved to Vienna because of the civil war in Lebanon. During the Vienna period several staff photographers and a film division travelled frequently to UNRWA's five fields of operations: Gaza, the West Bank, Jordan, Syria and Lebanon. A substantial part of the archives was created at this time. When UNRWA's Headquarters was moved to Gaza in 1996, the photo archive moved there while the film archive was relocated to the UNRWA offices in Amman.

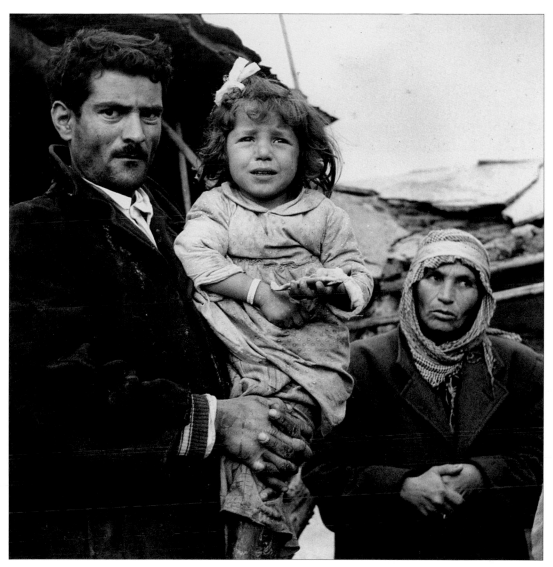

▲ In Lebanon in 1951 a Palestine refugee family waits to receive a
tent at an UNRWA emergency distribution centre after a severe
winter storm damaged their makeshift shelter.

Los Olvidados

Inscribed 2003

What is it

The original negative in cellulose nitrate in 35 mm black and white of *Los Olvidados*, the film made in Mexico City in 1950 by Spanish-Mexican filmmaker Luis Buñuel. The film depicts the nihilism and poverty of life in the slums of the city.

Why was it inscribed

Los Olvidados is an acknowledged classic of world cinema and the inscription relates to the original negative of the film. Although shot in Mexico City, its themes are universally relevant.

Where is it

Filmoteca de la UNAM, Mexico City, Mexico

The film was made in 1950 at a time of optimism in Mexico. The country had its first civilian president and the Mexican film industry was still experiencing the later stages of an acknowledged golden age. The films produced in Mexico reflected this national feeling of optimism, and *Los Olvidados* stood in stark contrast.

Los Olvidados translates into English as 'The Forgotten Ones', although it was released in the USA under the name 'The Young and the Damned'. It depicts the child and adult inhabitants of a Mexico City slum where, devoid of hope or purpose, their lives are followed out to brutal and pointless ends.

Shot in black and white, the film showed many influences – Italian neorealism, British documentary, French poetic realism and surrealism – and itself was influential in various realist cinematic movements that followed, including new Latin American cinema, French new wave cinema as well as several remarkable Indian, Spanish and Italian directors such as Pier Paolo Pasolini.

It was the third film Luis Buñuel had made in Mexico where he had lived since 1946 and it took him two years to research and write. His career had stalled since his self-imposed exile from Spain and his best work was assumed to be past.

Los Olvidados was filmed mostly on the streets of Mexico City in only 21 days and edited in three. Its themes were considered so controversial that several of his collaborators

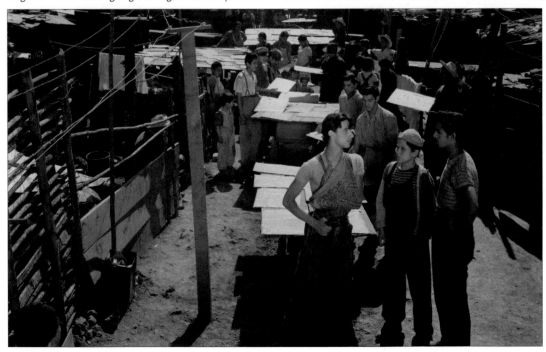

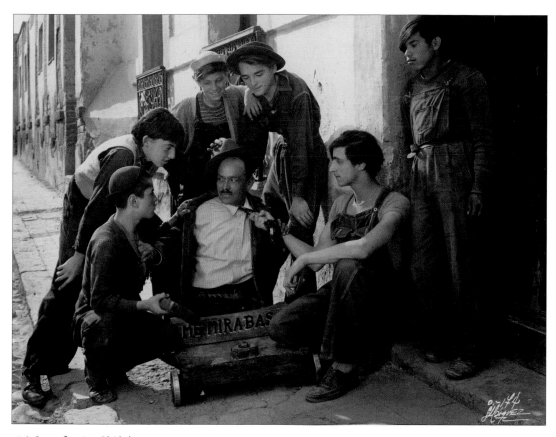

◀ ▲ *Scenes from Los Olvidados*

asked for their names not to be included in the credits.
Its producer, Óscar Dancigers, arranged for a second,
alternative, more optimistic ending to be filmed, fearing
that the film would be banned because of the brutality
and hopelessness of the original ending.

The film was not well received on its premiere in Mexico,
due in part to protests from organizations such as unions,
who accused it of presenting a false image of Mexico,
and it closed after only a week.

However, at the 1951 Cannes Film Festival, Buñuel
received the Best Director award. When the film returned
to Mexico, it was shown to great critical and public acclaim
and won him eleven Ariel awards from the Mexican
Academy of Film, including Best Picture and Best Director.
The alternative ending was not used and was virtually
unknown until its rediscovery 50 years later.

Nita Barrow collection

Inscribed 2009

What is it

The Nita Barrow collection is an extensive collection
that documents the life and times of one of the most
distinguished women of the 20th century.

Why was it inscribed

The collection demonstrates Dame Nita's advocacy
of and involvement in a range of world affairs,
principally gender equity and empowerment,
healthcare, anti-apartheid work and adult education.

Where is it

Main Library, University of the West Indies,
Cave Hill Campus, Bridgetown, Barbados

Dame Ruth Nita Barrow (1916–95), a nurse by profession,
was born in St Lucy, Barbados. She attended the
universities of Toronto and Edinburgh at a time when
few black women were able to pursue tertiary education.
Of great significance is the fact that Dame Nita, as a black
female from a small island developing state, occupied
leadership positions on the world's stage (for instance,
she was President, at various times, of three major
international bodies, the World Council of Churches, the
YWCA and the International Council for Adult Education)
and served as leader/convenor of several prestigious
international delegations.

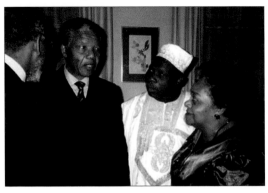

▲ Dame Nita Barrow with President Nelson Mandela and General
Olusegun Obasanjo at Mandela's inauguration as President
of South Africa in May 1994 in Pretoria, South Africa.

◀ 'Nativity', a painting by
Dame Nita Barrow, and now
in the Nita Barrow collection.

Dame Nita Barrow with six
other past presidents of the
World Council of Churches
Central Committee at a
reunion in Geneva. ▶

The principal thrusts of Dame Nita's work which enabled
her to make an impact on international affairs were adult
education, anti-racism, gender relations, health care and
poverty alleviation. These diverse disciplines and interests
served as the crucible in which Dame Nita's philosophies,
philanthropy and spiritual depth were shaped. Her sterling
efforts against racism led her to be named a member, and
the only female, of the Commonwealth Group of Eminent
Persons to South Africa whose efforts led to the cessation
of apartheid, the release of Nelson Mandela and the
introduction of democratic rule in South Africa. She
was appointed as the first woman Governor-General
of Barbados in 1990.

In 1978, she was appointed leader of the World Health
Organization delegation to the Primary Healthcare
conference held in Alma Ata (now Almaty), Kazakhstan.
Under the theme 'Healthcare for All by the Year 2000',
among the declarations of this conference was the need
to redress the unacceptable inequality in health standards
between developed and developing countries. She was a
convenor of the Nairobi Conference on Women, a pivotal
point for this movement and the largest gathering of
women in the history of the United Nations. On Dame
Nita's advocacy for women's rights and empowerment,
Joycelin Massiah, a former Caribbean Regional Program
Director of the United Nations Development Fund for
Women (now part of UN Women), wrote in 2001: 'Dame
Nita was an ardent supporter of the advancement of
women, which she described as "the most political of all
issues". She saw clearly that all of the major social, political
and economic issues facing the internationally community
could be more effectively understood and addressed if seen
through the lens of women and gender.'

The Nita Barrow collection consists of her unpublished papers and speeches (many of which are handwritten) as well as her personal correspondence with world leaders and documents relating to international organizations. The mid-1970s to the mid-1990s was a period of significant change in gender relations, healthcare issues, diplomatic relations, adult education and strengthening the United Nations' role on the global stage. Dame Nita's collection reflects her thoughts, actions, reactions and contributions to these significant changes at the international level. It is testimony to how she transcended national boundaries and dealt with issues encountered in her travels to more than eighty countries.

Dame Nita's life was an outstanding example of dedication, commitment and selfless international service to women, men and children, especially the poor, dispossessed and disadvantaged. Peggy Antrobus, in her 1998 presentation 'Women Leadership: Catalysts for Change' opened by paying tribute to Dame Nita as: *'. . . a woman whose values and style illustrate the kind of leadership that will move us toward a world where inequality based on class, gender and race is absent from every country, and from the relationships among countries. . . a world where basic needs become basic rights and where poverty and all forms of violence are eliminated'.*

The Archives of Terror

Inscribed 2009

What is it

A collection of official documents covering the 35 years of Alfredo Stroessner's dictatorship in Paraguay.

Why was it inscribed

The archives are evidence of police and political repression, torture, assassination and covert intelligence activity that are part of the larger Plan Condor.

Where is it

Centre of Documentation and Archives for the Defence of Human Rights (CDyA), Asunción, Paraguay

The Archives of Terror are official documents of police repression from the 35 years of Alfredo Stroessner's dictatorship. The archives were discovered in 1992, three years after the toppling of Stroessner's regime and the dictator's flight to exile in Brazil. The documents contain details of 50,000 people murdered, 30,000 people who disappeared and 400,000 people imprisoned. They also contain supporting evidence of the existence of Plan Condor, a campaign of political repressions involving assassination and intelligence operations implemented by right-wing dictators of Latin America (Argentina, Bolivia, Brazil, Chile, Paraguay, Uruguay).

The archives are largely made up of materials produced by the Paraguayan police force under Stroessner's regime. The chief of the Investigations Department, Pastor Coronel, showed an obsession for meticulous filing, if possible in duplicate, and the documents are extremely comprehensive. They include 1888 identity cards and passports, 20,000 photographs, 11,225 index cards and materials confiscated by the police: personal letters, political literature, photographs, pamphlets, books and newspaper clippings. The archives provide vivid proof of the systematic and widespread repression, torture, murder and forced disappearance by Stroessner's regime.

The Archives of Terror provide concrete evidence that allow people to investigate, analyse and reach a better understanding of how Stroessner's authoritarian regime damaged societal values, culture, social behaviour and human relations. The archives also demonstrate how the regime of terror imprisoned people arbitrarily, paralyzed

justice and caused Paraguayan citizens to emigrate en masse. In addition, the archives provide evidence that physical and mental torture became a systematic procedure employed by the regime to repress people with incompatible political ideas and beliefs.

The discovery of the archives has had two major consequences. Firstly, it led the national and international community to find evidence and proof against repressors. Secondly, it helped family members and others to discover more about what happened to lost, arrested or tortured victims. Thousands of Paraguayans and citizens from

other countries were victims of Stroessner's regime and Plan Condor. These archives made it possible to prosecute repressors and State agents involved in gross human rights violations. The Archives of Terror have also become a leading source of evidence for international human rights proceedings in courts across the world. Documents from Paraguay have been supplied to lawyers and judges in Spain, Italy, France, Chile, Argentina and Uruguay. Much of the case built against General Pinochet of Chile was made using the archives.

John Marshall Ju/'hoan bushman film and video collection, 1950–2000

Inscribed 2009

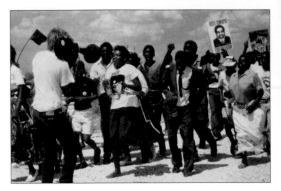

▲ *Tsamko Toma (in suit and tie) at a SWAPO political rally before Namibia's first democratic elections. An important leader in the Ju/'hoan community, Tsamko was the first president of the Nyae Nyae Farmers' Coop, a local governing body formed by Ju/'hoansi as they organized themselves and entered into Namibian politics in the 1980s.*

What is it

This collection, created over a span of fifty years, is an unparalleled historical record not only of an indigenous people's traditional way of life, but also of its transformation caused by the rapidly changing social and economic landscape, combined with the struggle for Namibian independence.

Why was it inscribed

It is one of the seminal visual anthropology projects of the 20th century, unique for the scope of its sustained audiovisual documentation of one cultural group, the Ju/'hoansi of the Kalahari desert in northeastern Namibia.

Where is it

Human Studies Film Archives, Smithsonian Institution, Washington, DC, USA

John Marshall first visited the Kalahari desert in northeastern Namibia in the 1950s, when his parents travelled there on sponsored expeditions between 1950 and 1958. These early visits were the start of a lifelong bond between him and the Ju/'hoansi, a group of hunter-gatherer bushmen from the Nyae Nyae area

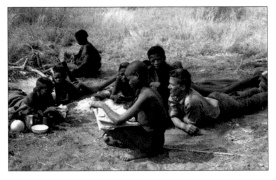

▲ *John Marshall relaxing with Ju/'hoan friends in 1955. Marshall immersed himself in Ju/'hoan life, learning to speak the language fluently and participate in rituals.*

of the desert. Marshall became one of the world's foremost anthropological filmmakers and his crowning achievement is the record he has made of the changing lifestyle of the Ju/'hoansi over fifty years. His relationship with them is close and he has created a foundation to aid their development and dedicated most of his adult life to advocacy on their behalf.

In the 1950s the Ju/'hoansi were still surviving using traditional hunter-gathering practices that had remained unchanged for centuries. In the decades that followed, their way of life was influenced by increasing contact with the modern world. As their opportunities to survive by hunter-gathering were reduced, Marshall recorded their difficult entry into the modern global community, including: their decline into malnutrition, influenced by their attempts at subsistence farming; the impact of alcoholism and domestic violence; their struggles for rights to traditional land and waters and their grassroots political campaigning. These changes happened against a backdrop of conflicting needs and interests of neighbouring ethnic groups, international aid programmes, the fight for Namibian independence and then dealing with Namibia's new democratic administration.

His work among the Ju/'hoansi has produced hundreds of hours of film, video and audio recordings as well as twenty-three edited films and a five-part video series,

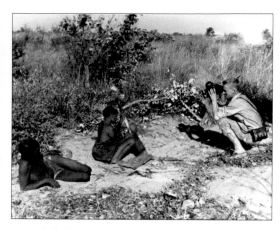

▲ Marshall talks with his Ju/'hoan friends as he films their
 daily activities.

A Kalahari Family (2002). His films are widely used in the
teaching of anthropology. The collection, which now holds
this material, reflects the evolution of anthropological
research from the study of cultures with little or no
contact with the outside world to those undergoing
transformation due to local and global economic and
political pressures. Because of the long timescale over
which the material was made, it also demonstrates the
evolution of film and video technology and its impact on
visually capturing a culture. The associated audio tapes
are an exceptionally valuable collection for the study of
the endangered !Kung language group containing three
dialects: Ju/'hoansi; San, whose name is now regarded
by the Ju/'hoansi to have negative connotations; and
Bushman, which ironically (given the derogatory history
of this term) is now preferred by the Ju/'hoansi as a term
of dignity.

 With the notebooks and photographs in the Bleek
collection at the University of Cape Town (see page 329),
these two archival holdings represent an astonishing
record of Bushman heritage from the mid-19th century
to the end of the 20th century.

Traditional music sound archives

Inscribed 1997

What is it

The most comprehensive collection of Chinese traditional music in existence, comprising ancient Chinese musical scores, manuscripts, instruments, photographs and sound materials.

Why was it inscribed

The archive is the result of years of systematic recording in the field in almost all provinces and regions of the country, covering the traditional music of more than fifty nationalities or cultural groups. As Chinese musical heritage was generally transmitted orally, the recordings allow access to music stretching back through the generations.

Where is it

Music Research Institute of Chinese Academy of Arts, Beijing, China

The archive is the richest and most comprehensive collection of Chinese music not only in China but also in the world. Chinese music scholars working in the field since 1950 have gathered most of the recorded material systematically, working in all regions of the country. Folk musicians and other holders of recordings have also recorded and gifted material. In all, there are more than 7000 hours of recordings in the archive as well as around 2000 musical instruments, 40,000 records of Chinese and foreign music, 50,000 photographs and 150,000 books on music and music scores.

The collection includes ancient songs, folk songs, *quyi* (musical storytelling), local opera, religious music, song-and-dance music, instrumentals, modern songs, operas and ballets, regional music, Chinese music played on Western instruments and sound recordings related to music, such as speeches, introductions and discussions. Many of the recordings are of folk rituals or folk religious rituals rather than performance music, making them irreplaceable expressions of the culture of the people.

Notable highlights of the archive include drum music from the Northwest China region of Xi'an, home of the terracotta warriors. Music from monks of the Zhi Hua Temple, founded in 1446, includes religious chants thought to date back more than 300 years. From the Xinjiang region, instrumental music, song and dance collectively known as the Twelve Mukam was gathered from the region of the Silk Road.

Qin music is among the most valued parts of the collection. The *qin* is a string instrument, thousands of years old and revered in Chinese music. Learning to play the *qin* was part of traditional education and the Institute has several hundred hours of recordings of traditional *qin* music. Local opera, another characteristic Chinese art form, is well represented, as are folk songs from every region.

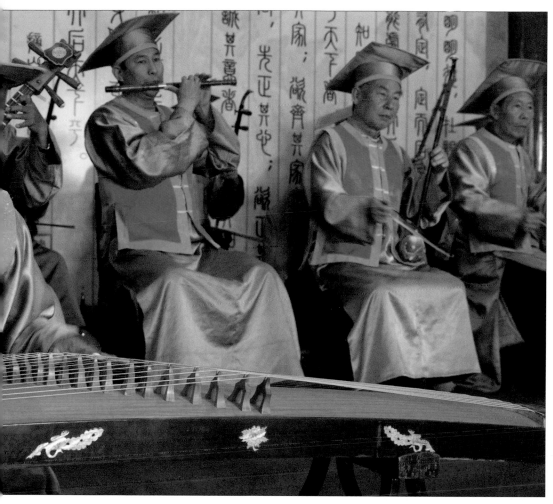

During the Cultural Revolution in China – when the Communist leader Chairman Mao and his supporters attempted to 'cleanse' China of all expressions of its cultural history – the archive was safeguarded by members of the Institute staff. However, political and economic modernization is now taking a toll where cultural repression failed and traditional music forms in China, as in so many countries, are coming under pressure. The Institute continues to collect, record, classify, store and reserve the traditional music of the country for present and future generations.

▲ *Musicians playing traditional Chinese music.*

Neighbours, animated, directed and produced by Norman McLaren in 1952

Inscribed 2009

▲ *A scene from* Neighbours

What is it

A movie made in 1952 by Scots-Canadian filmmaker Norman McLaren. Lasting 8 minutes and 6 seconds, *Neighbours* is a stylized anti-violence and anti-war parable about two men who come to blows over the possession of a flower.

Why was it inscribed

Neighbours was innovative and influential, and a strong personal comment on violence and war. McLaren used new techniques in sound and visuals in creating his film, which won the Oscar for Documentary (Short Subject) in 1953.

Where is it

National Film Board of Canada, Montreal, Canada

Norman McLaren (1914–87) is considered one of the world's most influential and original animators. Through a career which lasted almost 50 years, he was constantly developing new ideas and pioneering animation techniques. The scope of his activity ranged from abstract works drawn, painted or scratched directly on film, to paper cuttings and to live-action images of dancers repeated and transformed by use of an optical printer. His innovative, experimental approach and surrealist imagery strongly influenced generations of artists and filmmakers.

A student at the Glasgow School of Art, McLaren came to the notice of fellow Scot John Grierson, then head of the General Post Office Film Unit in London. Grierson hired McLaren first for the GPO in 1936, and then again in 1941 after Grierson moved to Canada to establish what became the National Film Board (NFB). Within two years, McLaren was head of its animation studio and as its creative leader he mentored a generation of Canadian animators. He remained with the NFB until his retirement in 1983.

The sixty-one films he created used a diverse range of techniques and their themes varied widely, but *Neighbours* was the one which brought him most success. It was a very personal film, a product of his beliefs, his experience and the political environment of the time. In particular, it was influenced by McLaren's pacifist sympathies, acquired as

a result of his experiences while filming in Spain during the civil war (1936–39).

The two main characters of *Neighbours* are next-door neighbours who become rivals, ultimately to the death, over an animated flower growing between their properties. As their actions become increasingly violent, they destroy their houses, kill their families and ultimately bring about their own deaths.

McLaren used two new techniques of animation for the film: pixilation, which used stop motion with live actors; and synthetic or animated sound, which he created by drawing on the sound track. McLaren did not develop pixilation but took it to a new level in *Neighbours*. There was no dialogue in the film and its communication through design, colour, movement and music made it universally accessible.

McLaren's talents were recognized by his contemporaries and *Neighbours* received multiple awards in Canada, Italy and the USA, most notably the Oscar for Best Documentary (Short Subjects). However, his own achievements went beyond the field of film. By establishing the power of animation as a means of serious social commentary, such as in *Neighbours*, McLaren made a valuable contribution to world art.

He himself viewed animation as an art of personal expression, and this philosophy has been influential in animation, and in live-action movies and continues to guide the NFB today.

José Maceda collection

Inscribed 2007

What is it

A collection of traditional music recorded and gathered between 1953 and 2003 from the Philippines and other parts of Southeast Asia. The collection was the work of Professor José Maceda and comprises 1760 hours of tape recordings in 1936 reels and cassette tapes, field notes, film and photographs of musicians and their instruments.

Why was it inscribed

The collection reflects the traditional music of the Philippines and Southeast Asia at a point before many musical styles vanished under pressure from social change and cultural globalization. It is a significant representation and memorial of the orally transmitted culture of the region.

Where is it

University of the Philippines Center for Ethnomusicology, Quezon City, Philippines

Professor José Maceda (1917–2004), the architect of this collection, was a composer and internationally renowned scholar of ethnomusicology. Over the course of 50 years from the mid-20th century, he and his staff recorded and gathered the traditional music of the Philippines, Indonesia, Malaysia, Singapore, Thailand and China. The collection was supplemented by contributions from other scholars elsewhere in the world and is unique in its size, scope, time and area.

Several international cultures shaped the multi-dimensional music of the Filipinos. The diversity of the repertoires in the recordings show the many outside influences and the composite culture that emerged in the islands from their dynamic interaction with other peoples, traditions and countries; these included India, Arabia, China, Spain, Mexico, the USA and the rest of Southeast Asia. The collection allows the tracing of Filipino musical relationships to these major world cultures and vice versa.

The Philippines has sixty-eight separate ethnolinguistic groups that reflect these historic, cultural and geographic relationships and the José Maceda collection has examples

Kulintang, *brass gong percussion instruments, in Indonesia* ▼

of all of these. Various levels of music theory and practice are represented: indigenous epics; life-cycle and occupational songs; sung poetries, debates and other forms of discourse; semi-court entertainment; pre-Christian and syncretized or combined rituals; para-liturgies or religious devotional services outside the recognized liturgy; and vernacularized romances and other folk expressions.

In addition to the material from the Philippines and its accompanying notes and images, the collection also includes studies of several music cultures in the region, from Indonesia, South China and Malaysia.

Taken as a whole, the collection reflects the expansion of modern influences to this part of Southeast Asia and the impact on local and regional styles of a globalized music industry. Since the recordings were made, many of these traditional music styles, dance and rituals that comprise the cultures of the islands have changed or in some cases, disappeared altogether.

◀ *Children playing traditional musical instruments at a festival on Sulawesi, Indonesia.*

Derek Walcott collection

Inscribed 1997

What is it

The Derek Walcott collection is made up of manuscripts, correspondence, papers, clippings, unpublished work, diaries, notebooks and paintings of the poet, playwright and Nobel laureate Derek Walcott.

Why was it inscribed

The collection is of world significance and consists of original, unique documents whose social, cultural and spiritual value transcends a national culture. Derek Walcott's literary output has won him many outstanding international awards, including the Nobel Prize for Literature in 1992.

Where is it

University of the West Indies at St Augustine, Trinidad and Tobago

Derek Walcott was born in 1930 in Castries on the West Indian island of Saint Lucia . His father died when Derek was young, and he was brought up with his twin brother, Roderick, and his older sister, Pamela, by his mother, who ran the local Methodist school in a largely Catholic community. He won a scholarship to St Mary's College in Castries and then went to the University of the West Indies at Mona, Jamaica. After graduation, he moved to Trinidad where he worked as a feature writer and theatre critic on local newspapers. In 1959 he founded the Little Carib Theatre Workshop (later to become the Trinidad Theatre Workshop). Since 1981 he has taught creative writing and English at a number of American universities, including Boston, Columbia and Harvard. In 2010 he became Professor of Poetry at Essex University in the UK. He divides his time between the USA and Saint Lucia .

Derek Walcott is renowned as a poet and playwright. He published by himself his first book of poetry, *25 Poems*, in 1948, and he received international recognition with the publication of *In a Green Night: Poems* in 1962. He has published many volumes since then, most notably *Omeros* in 1990, an epic poem set on a Caribbean island that draws upon Homeric themes, and *White Egrets*, published in 2010 and awarded the T.S. Eliot Prize in 2011. He has won many awards for his poetry including the 1988

Queen's Gold Medal for Poetry and in 1992, the Nobel Prize for Literature for 'a poetic *oeuvre* of great luminosity, sustained by a historical vision, the outcome of a multicultural commitment'. Walcott was the first person from the English-speaking Caribbean to win this literature prize. He has also written many plays, his writing drawing inspiration from the Caribbean experience. *Dream on Monkey Mountain* won an Obie (Off-Broadway) Award in 1971.

The Derek Walcott collection at the University of the West Indies at St Augustine primarily covers the period when Walcott lived in Trinidad and includes much material relating to the Trinidad Theatre Workshop – not just the drafts of his own plays but set designs, posters, scrapbooks and photographs linked to the many productions he was involved in. The collection includes original material for much of his prose and poetry written up to 1981, when he left Trinidad for the USA. It also includes manuscripts of the epic poem *Omeros*. His literary papers from the early 1980s to the mid-1990s were purchased by the University of Toronto in 1999 and are not included in this collection.

Derek Walcott, the first English-speaking writer from the Caribbean to win the Nobel Prize for Literature, in 1992. ▶

The Family of Man

Inscribed 2003

What is it

The 1956 version of the photographic exhibition, created by Edward Steichen for the New York Museum of Modern Art which consisted of 503 photographs taken by 273 photographers from sixty-eight countries, and described as the 'greatest photographic enterprise ever undertaken'.

Why was it inscribed

The exhibition, the scope of which has yet to be matched, was created to illustrate all aspect of human life, irrespective of geography, nationality or race. It influenced other exhibition organizers and stirred public interest in photography by communicating a personal, humanist message.

Where is it

Musée The Family of Man, Château de Clervaux, Luxembourg

After years of preparation by Edward Steichen, the Family of Man exhibition opened in 1955 at the Museum of Modern Art (MoMA) in New York. Stemming from a profound personal conviction of the ability of photography to communicate ideas and to explain mankind to itself, it offered infinitely diverse images of human beings living in the 1950s, but it nevertheless emphatically reminded visitors that they all belong to the same big family. The thirty-two themes, arranged chronologically, reflected a range of emotions in their subjects, from great joy to deep unhappiness, and with a longing for peace contrasted with the reality of bloody conflict. The themes emphasize the role of democratic structures and, in the exhibition's conclusion, the United Nations' role as the only body capable of saving the world from the 'scourge of war . . . and [of reaffirming] faith in fundamental human rights' (Charter of the United Nations).

It consisted of 503 photographs taken by 273 professional and amateur photographers, famous and unknown, from sixty-eight countries. A huge undertaking, with unique cultural and artistic dimensions, it had a considerable

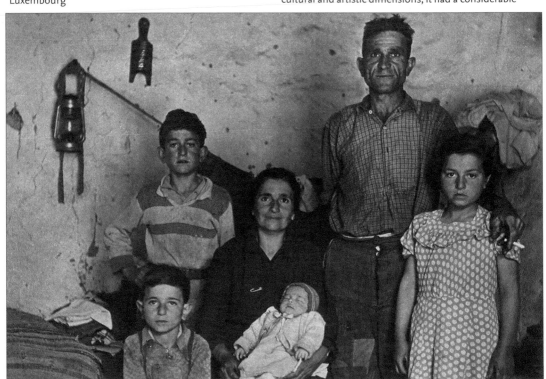

◄ ▲ *Two images from the Family of Man photographic*
exhibition created by Edward Strichen, first shown at the
Museum of Modern Art in New York in 1955 and now, slightly
modified, displayed at the Château de Clervaux in Luxembourg.

influence on other exhibition organizers, stirred public
interest in photography and its tremendous ability
to communicate, and conveyed a personal, humanist
message that was both courageous and provocative.

A European travelling version of the exhibition was
created in 1956. This version was donated in 1964
to Luxembourg, the country where Steichen was born,
and when he visited in 1966 he expressed a preference for
the exhibition to be staged in the Château de Clervaux.
His wish was granted twenty-five years later when the
Luxembourg government opened a permanent museum

in line with installation plans of the historic New York
layout and the hanging instructions circulated by the
MoMA photography department to the organizers of
all the travelling versions. The collection was restored
in 1990–91 by the Luxembourg Centre national de
l'audiovisuel (CNA) and comprises 483 panels instead of
503 and differs slightly from the original in some other
respects. Eighteen photos were lost before arrival in
Luxembourg, while some other photos were deliberately
replaced by Steichen himself in order to adapt this
travelling version to the places in which it was to
be shown.

Christopher Okigbo collection

Inscribed 2007

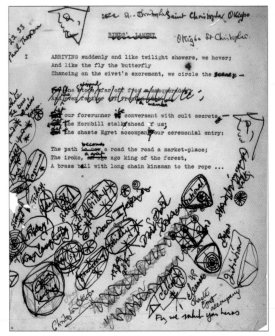

What is it

Christopher Okigbo's original manuscripts, notebooks, journals, correspondence, photographs, typescripts of interviews and other personal papers.

Why was it inscribed

Christopher Okigbo is widely acknowledged as the outstanding postcolonial English-language African poet and one of the major modernist writers of the 20th century.

Where is it

Christopher Okigbo Foundation, Brussels, Belgium

Christopher Okigbo was a Nigerian poet who died fighting for the independence of Biafra in 1967. The documents represent a much-awaited source of unique insights into hitherto unknown aspects of this outstanding poet's life and art.

The collection includes manuscripts (handwritten and typescript) of previously published and unpublished poems, experimental writing, literary projects, sketches, correspondence, journals, manuscripts of his contemporary authors, travel documents, photographs and typescripts of interviews, dating from 1956 until his death in 1967.

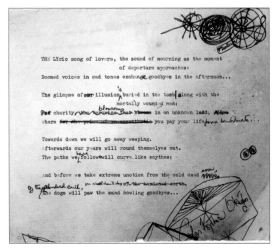

The papers in the collection exemplify African postcolonial literature in English and poems in the Igbo vernacular, demonstrating the possibilities for writing in African languages with an oral tradition. The papers are unique and irreplaceable, and possibly have the potential to provide new insights into the life and work of this major African literary figure.

There are original sections of his masterpiece *Labyrinths* and also unpublished works, including some experimental poems in his mother tongue, Igbo. Taken together with the cache of correspondence, notes, drafts, jottings and even doodles in the manuscripts, these papers show the canon of Okigbo's poetry in a new light. By extension they will have a profound influence on postcolonial African literature and even, on a larger scale, 20th-century modernist poetics.

The poet lost his life fighting for the freedom of the secessionist Republic of Biafra, in the firm belief that the massacre of Eastern Nigerians during the crisis of 1966 constituted a major act of inhumanity. Several of these documents were created in the short-lived Republic of Biafra, the name under which secessionist Eastern Nigeria asserted its sovereignty on 30 May 1967. They not only contain crucial information about the phenomenon

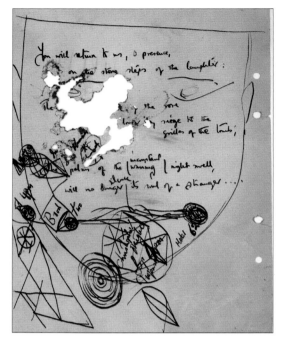

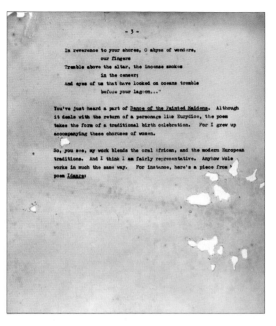

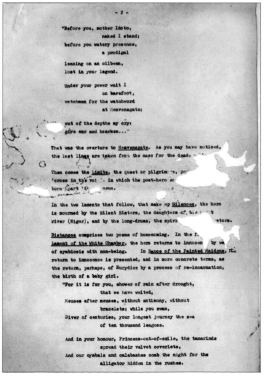

◄ ▲ ► *Some examples of the retrieved manuscripts of Christopher Okigbo, featuring previously unreleased poems in the poet's handwriting.*

of Biafra, but also represent one of the rare artistic outcomes of that vanished era.

The drafts of the poet's Anthem to Biafra (*Land of our Birth*) not only recapture the mood of the time and the basis of the poet's sacrifice, but also his fears, doubts and prophetic insights into the traumas destined to bring the Biafran dream to an unfulfilled end.

Eric Williams collection

Inscribed 1999

◀ Dr Eric Williams, scholar and Prime Minster of Trinidad and Tobago, who brought his country out of colonialism and led it for twenty-five years, dying in office in 1981.

The Red House Parliament Building in Port of Spain, the heart of the government of Trinidad and Tobago. ▶

What is it

The collection documents the life and times of Dr Eric Williams, Prime Minister of Trinidad and Tobago, international statesman and scholar, and his contribution to Trinidad and Tobago, the Caribbean region and the world during the period 1956–81.

Why was it inscribed

The collection, of worldwide significance, depicts various aspects of Dr Williams' life as a politician and scholar. His seminal work, *Capitalism and Slavery*, has made an indelible contribution to the historiography of slavery and has defined the study of Caribbean history.

Where is it

University of the West Indies at St Augustine and National Archives, Port of Spain, Trinidad and Tobago.

Eric Williams was born in Port of Spain in 1911 and won a scholarship to study at Oxford University in 1932. Graduating in 1935, he continued at Oxford as a graduate student, completing his DPhil, *The Economic Aspects of the Abolition of the Slave Trade and West Indian Slavery*, in 1938. The following year he moved to the USA to lecture at Howard University. His book, *Capitalism and Slavery*, which cemented his academic reputation and challenged many preconceptions about slavery, was published in 1944. It still continues to be the subject of much debate. He also wrote a number of other books on Caribbean history. He returned to Trinidad in 1948, and his political career began when he founded the People's National Movement (PNM) in 1956 and campaigned for independence not just from British colonialism, but also from the USA which maintained military bases in Trinidad at that time. He won the election in 1956 and became Chief Minister, and in 1958 he led Trinidad and Tobago from colonialism into a short-lived West Indies Federation. As the Federation floundered, Trinidad and Tobago and Jamaica became the first British West Indian colonies to become independent in August 1962. Trinidad and Tobago's achievement, guided by Dr Williams, is therefore an excellent case-study of the decolonization movement of the 1950s and 1960s and of the success of a multi-ethnic, multi-religious society's

entrance into the world family of nations. In 1976 Trinidad and Tobago became a republic, breaking its remaining constitutional links with Britain. Eric Williams died in office in 1981, having led his country for twenty-five years.

As an international statesman, Dr Williams was one of the founding members of the Governing Council of the United Nations University and was once courted as a possible successor to U Thant as Secretary-General of the United Nations. He was asked to assist in solving racial difficulties in British Guiana (now Guyana) and mediated the Venezuela, Guyana and Belize border disputes. He was one of only four prime ministers selected to visit Vietnam in the hope of solving that country's long and bitter conflict. He was the recipient of honorary degrees from a number of universities and of national awards from Liberia, Brazil, Venezuela and the United Kingdom.

The papers and documents represent an important and unique set of primary source material of relevance to the study of history, politics and the social and economic conditions of Trinidad and Tobago and the Caribbean region, as well as the life and times of Dr Williams himself. The collection includes his personal library of approximately 7000 books and journals, which has particular strengths in Caribbean, African and African-American history. His personal papers include correspondence from heads of state and academics as well as manuscripts and research notes related to his academic work plus much material relating to the founding of the PNM, his speeches and other political documents. That part of the collection which is held in the National Archives includes his official papers covering his time as premier as well as 1200 photographs and many audiotapes. The collection at the University of the West Indies continues to be added to and has an active oral history project,

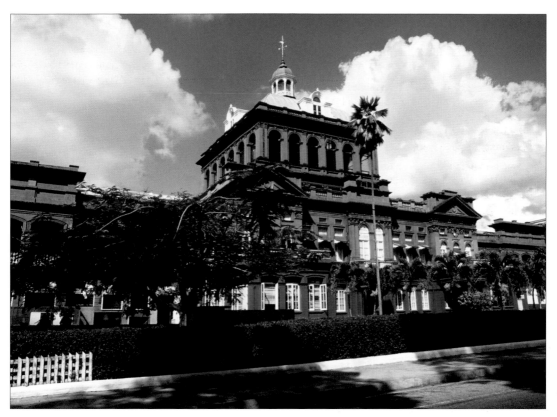

which, for example, contains over 150 calypsos that
comment on his political life. The university also hosts
a permanent exhibition celebrating the life and work
of Dr Williams as the founding father of the nation
who exhorted its people: 'Build the nation of Trinidad and
Tobago, bringing in all races . . . elevating lowly castes . . .
raising up the poor and the lowly and giving them a positive
stake in our society. . . . There can be no Mother India, there
can be no Mother Africa, no Mother England and no dual
loyalties. The only mother we recognize is Mother Trinidad
and Tobago, and mother cannot discriminate between
her children'.

The Mabo case manuscripts

Inscribed 2001

What is it

The personal papers of Edward Koiki Mabo and legal and historical materials relating to the Mabo case.

Why was it inscribed

This is a highly unusual case of pre-existing tribal law being formally recognised as superior to the fundamental law of invading culture (*Terra nullius* doctrine). The Mabo case was a seminal response to the effects of colonialism, and is a milestone for indigenous peoples of the world.

Where is it

National Library of Australia, Canberra, Australia

Eddie Mabo was an indigenous activist whose efforts resulted – shortly after his death – in the Australian High Court, in June 1992, overturning the doctrine of *Terra nullius*. The judgment unleashed profound change in Australia's legal and legislative landscape, influencing the status and land rights of its indigenous peoples and race relations generally. The significance of the Mabo case lies in it being an extremely rare instance in world history of pre-existing tribal law being formally recognised as superior to the fundamental law of the 'invading' culture, regardless of the economic and political implications.

The personal papers comprise diaries, correspondence, business papers, personal documents, financial papers, legal papers, newspaper cuttings and printed ephemera. The legal papers comprise exhibits, transcripts of evidence, submissions and correspondence between the plaintiff's solicitors and their clients and witnesses.

The papers date from 1959 to 1992. This is a crucial period in the history of race relations in Australia, with a series of battles and legal cases over the ownership and use of land, growing awareness of racial discrimination, and the social and health problems of indigenous peoples. It also saw the emergence of a small group of aboriginal leaders who became household names by the 1990s. The Mabo case papers include copies of documents relating to the ownership of land on the Murray Islands extending back to the first arrival of Europeans in the 19th century.

The Mabo papers, particularly the legal papers, are an extraordinary source on the history and society of the Murray Islands in Torres Strait. They also contain information on social and employment conditions in North Queensland. They document the struggles

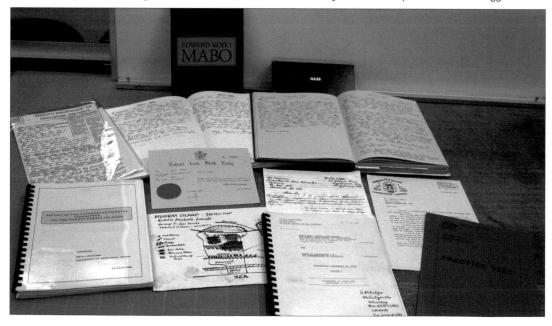

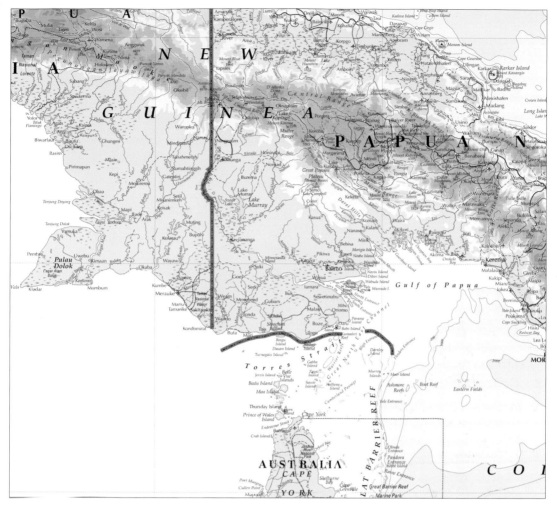

◄ Mabo case documents

Torres Strait Islands ▲

of indigenous peoples, particularly the Torres Strait islanders, to improve their economic position and affirm their legal rights.

The papers are of the utmost value to the indigenous peoples of Australia, especially the Torres Strait islanders. The Mabo case was one of the most famous of High Court cases and the judgment had an immediate and long-term impact on land claims throughout Australia. The papers are therefore of importance to both indigenous and non-indigenous Australians.

Moreover, these Australian discussions aroused considerable interest in New Zealand, North America and in other countries where the rights of First Nations, and

especially their land rights, have been hotly debated in recent decades.

They have also been used by Noel Loos, the biographer of Mabo, and they were drawn on extensively for an award-winning film about Mabo and the Mabo case. They have therefore indirectly had a great influence on popular perceptions of Edward Mabo and of public appreciation of the significance of the Mabo case.

Original negative of the Noticiero ICAIC Latinoamericano

Inscribed 2009

What is it

A collection of historical newsreels produced in Cuba.

Why was it inscribed

The newsreels are the most comprehensive record of the history of the Cuban Revolution. They also represent a unique view of wider events such as the world's growing bipolarization, the independence wars of African colonies and other popular uprisings.

Where is it

Cinemateca de Cuba, Havana, Cuba

The Cuban Institute on Cinematographic Arts and Industry (ICAIC) was the first cultural institution created after the Cuban Revolution, in March 1959. In those days of fervent revolutionary change, cinema was widely understood to be a powerful medium of communication. The law that created ICAIC proclaimed the new Cuban cinema to be 'the most powerful and suggestive medium of artistic expression, and the most direct and extended vehicle of education'.

With these two purposes in sight – artistic expression and education – ICAIC produced a Latin American newsreel every week from 1960 to 1990. It gave Cuban (and Latin American viewers in other countries) news about local and world events, making them participants in their own history and creating a climate for debate over the construction of the new country that was emerging.

As a record of the Cuban political process these newsreels are part of the world's archives, as the most comprehensive record of the history of the Cuban Revolution during its most vibrant period. Their significance, however, extends far beyond the local. They cover the development of the whole of Latin America in that period, and there are many episodes dealing with world events seen from a Latin American viewpoint.

The newsreels are held by the Cinemateca de Cuba (Cuban Film Archive) which also looked after short and feature-length fiction films, documentaries, cartoons and other reports produced in Cuba, as well as many Latin American films threatened by the dictatorships of the 60s and 70s. Besides safeguarding them, the Cinemateca de Cuba also duplicated the films that it considered important, subtitling then distributing them to other Latin American film archives.

Production of the newsreels ended when the Cuban economic crisis began to bite in 1990. There were also extensive blackouts caused by electricity shortages in the 1990s, which were a great blow to film preservation: the air conditioning and humidity control equipment, vital to film conservation, as well as the duplication, restoration and revision works were practically paralyzed due to lack of resources. The film archives of the Cinemateca de Cuba, which up to that moment had represented a model for Latin America, stopped being a safe haven.

Deprived of the necessary materials to carry on what constitutes a daily battle to preserve moving images in tropical countries, the mission of the Cinemateca de Cuba was further worsened by the hurricanes that uncovered some of its depots. At this point, important images like those chronicling Che Guevara's journey to the Republic of Congo were in danger of disappearing forever.

That they are now more safely preserved is a vital step to ensuring that the unique experience of the Cuban Revolution as witnessed by its protagonists can be more widely known.

◀ *Che Guevara and Fidel Castro in Havana, Cuba 1959.*

Construction and fall of the Berlin Wall and the Two-Plus-Four-Treaty of 1990

Inscribed 2011

▲ *The Two-plus-Four Treaty of 12 September 1990, which brought to a close the division of Germany. The pages shown are the title page and the signatures of the four powers.*

What are they

The fifteen selected documents are a chronological selection – from 1961 to 1990 – of television news items, TV and film documentaries, photographs and official documents, all focused on the Berlin Wall.

Why were they inscribed

The documents are fundamental and unique records of the political heritage and the collective memory of Germany, Europe and the world from 1961 until the end of the Cold War.

Where are they

Various archives in Berlin, Potsdam, Kleinmachnow and Hamburg, Germany

US President John F. Kennedy speaking in front of Berlin Schöneberg town hall on 26 June 1963, where he uttered his famous message of hope for West Berliners who lived in fear of a possible East German occupation. A film of the speech is one of the key documents inscribed. ▶

Hopes for a free, democratic Europe after the victory of the anti-Hitler coalition over Nazi Germany were not fulfilled. On the territories conquered by its army, the Soviet Union established communist dictatorships. The East–West

On 9 November 1989 people from East and West Berlin climbed on to the Wall at the Brandenburg Gate, bringing the division of the city to a dramatic end. ▼

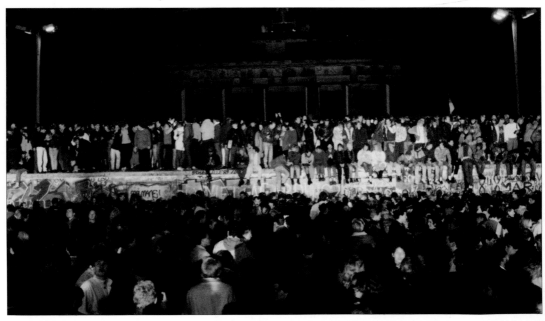

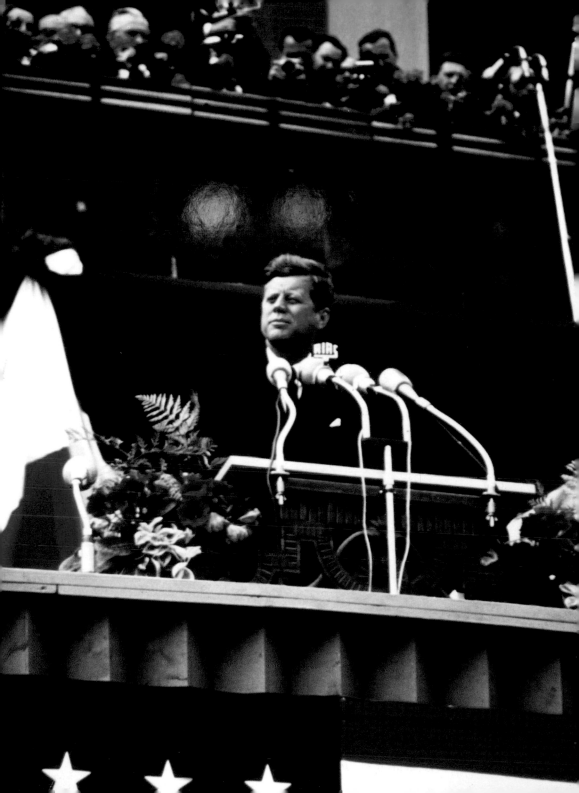

conflict and the Cold War started: two irreconcilable systems struggled worldwide for power and influence, and one main arena of this Cold War was the divided Germany – and Berlin. The building of the Berlin Wall on 13 August 1961 cemented the political division of Germany. The initial barbed-wire fence was systematically transformed into a concrete wall surrounded by a death strip, between 15 and more than 150 metres in width, with watch towers, electrified signal fences, guard dogs, anti-vehicle trenches and armed patrols who had the order 'shoot to kill'. This Wall was not defensive against external enemies; it was directed inwards, against the escape of its own people from the German Democratic Republic, against their voting with their feet. It became the worldwide symbol of political repression in the states of the Soviet empire. Accordingly, the fall of the Wall on 9 November 1989 symbolized not only the end of the political division of Germany and of the European continent, but also the end of the Cold War and the Eastern and Western bloc systems. The images of the fall of the Berlin Wall have become a symbol for democracy

A sentry of the East German border guards at the Sebastianstrasse checkpoint in the mid 1960s. ▶

◀ *This photograph of Peter Fechter, shot while trying to escape and bleeding to death at the Wall, 17 August 1962, is one of the documents inscribed.*

and personal freedom, a symbol of hope that change is possible without bloodshed.

The fifteen selected items are fundamental to understanding the history of the Wall. The eleven audiovisual records include the press conferences by Walter Ulbricht in 1961 and by Günther Schabowski in 1989, which mark the beginning and the end of the Berlin Wall, the construction proper of

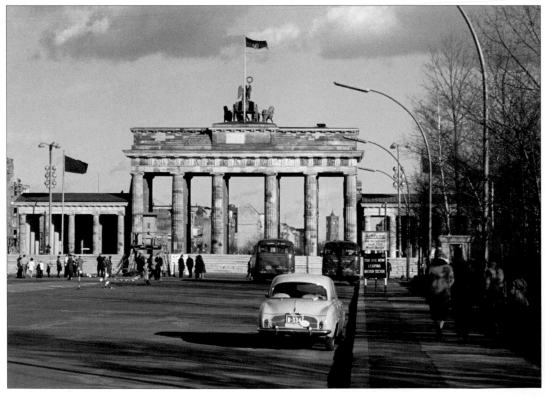

Construction and fall of the Berlin Wall and the Two-Plus-Four-Treaty of 1990

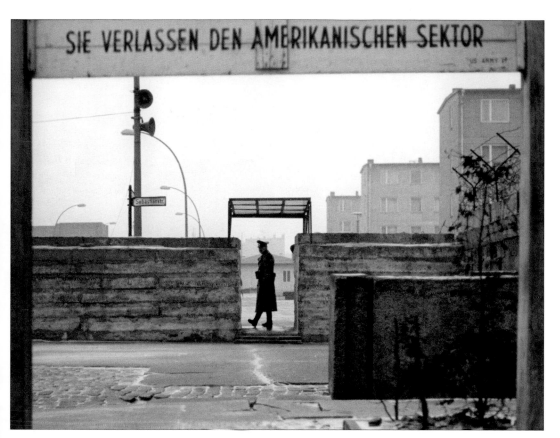

SIE VERLASSEN DEN AMERIKANISCHEN SEKTOR

the Wall, the subsequent construction of the sectoral border walls and, finally, the fall of the Wall. The photographs of the successful escape of border policeman Conrad Schumann (1961) and of the young man Peter Fechter (1962), shot while trying to escape and helplessly bleeding to death at the Wall, have become icons of world photography. The two Berlin speeches by the respective Presidents of the USA, John F. Kennedy in 1963 and Ronald Reagan in 1987, shaped the worldwide memories of the Berlin Wall. As most of the physical construction of the Berlin Wall has been destroyed since 1990, the public memory is very much based on films and photographs. The negotiations of the four victorious powers of Second World War with the representatives of both German states resulted in the Two-Plus-Four-Treaty of 1990, the last document selected, which enabled the unification of Germany and pushed forward the process of European integration.

◀ *Berlin was divided at the Brandenburg Gate*
when the Berlin Wall was constructed.

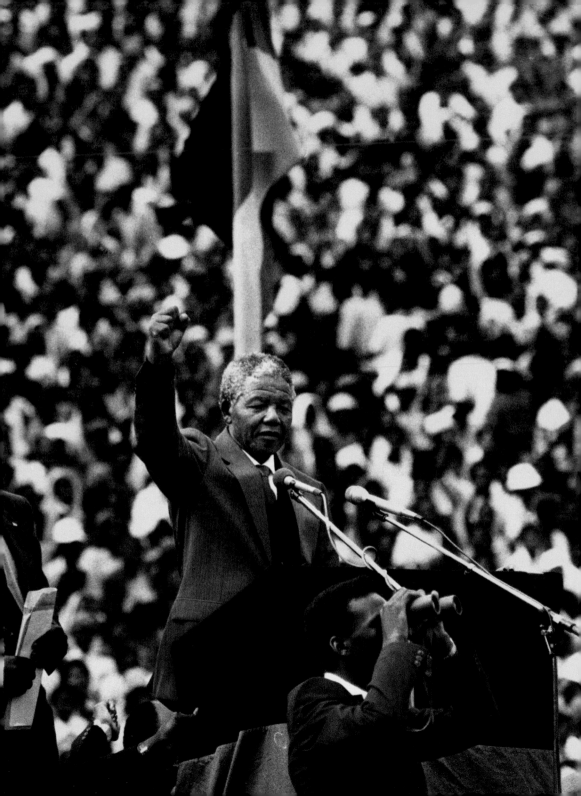

Criminal Court Case No. 253/1963 (The State versus N. Mandela and Others)

Inscribed 2007

What is it

Court records of the Rivonia Trial of the top leadership of the anti-apartheid organization, the African National Congress (ANC), leading to the imprisonment of Nelson Mandela. It includes documents and exhibits related to the trial.

Why was it inscribed

As a result of this trial, the world's attention was drawn to the iniquities of the apartheid regime. This strengthened the international movement against the system, leading the United Nations to declare apartheid 'a crime against humanity'.

Where is it

National Archives and Records Service of South Africa, Pretoria, South Africa

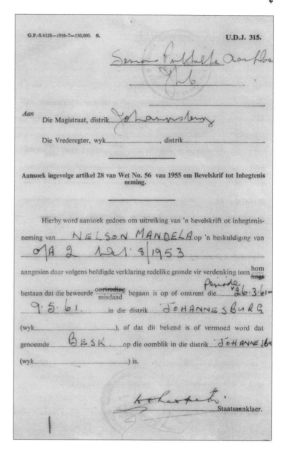

▲ The arrest warrant issued for Nelson Mandela ahead of his trial in 1963.

From the start of the 20th century black people in South Africa attempted to be recognized in their own country. On 8 January 1912, a few hundred Africans assembled in Bloemfontein, and the South African Native National Congress (ANC) was founded. In the beginning their protests were non-violent and included civil disobedience campaigns and supporting strike actions. The South African government, however, continued to adopt laws that took away even the little freedom that black people had. In 1955 the ANC adopted the Freedom Charter that became the cornerstone of ANC policy and the guiding principle of the Constitution of democratic South Africa.

On 21 March 1960 a crowd gathered outside the Sharpeville police station when the police opened fire and sixty-nine Africans were killed and 180 wounded. This tragic event focused world attention on South Africa and its policy of apartheid. Unrest grew in the country and the government banned the ANC and the Pan Africanist Congress (PAC) on 8 April 1960. This led to the establishment in 1961 of Umkhonto we Sizwe and Poqo as the military

◄ Nelson Mandela at a rally in Soweto shortly after his release from prison in 1990.

wings of the ANC and PAC respectively. Nelson Mandela was chosen as the leader of Umkhonto. He was arrested on 5 August 1962 after returning from an overseas trip and the remaining leaders of Umkhonto were captured at Lilliesleaf Farm, in Rivonia near Johannesburg, on 11 July 1963. Their trial, known as the Rivonia Trial (Criminal Court Case No. 253/1963, called The State versus N. Mandela and Others, heard in the Supreme Court of South Africa, Transvaal Provincial Division), started in October 1963 and ended in June 1964. Of the eleven accused one turned state evidence and was released, eight were sentenced to life imprisonment and two were released.

On 20 April 1964 Nelson Mandela read a statement from the dock. He realized that this was a rare opportunity

to present the rationale behind the actions of the ANC and Umkhonto to a wide audience in a country where censorship was strictly enforced. He ended the statement with the words: 'I have cherished the ideal of a democratic and free society in which all persons live together in harmony and with equal opportunities. It is an ideal which I hope to live for and achieve. But if needs be, it is an ideal for which I am prepared to die'. He was subsequently sentenced to life in prison but was released in February 1990 and went on to become the first president of a democratic South Africa on 10 May 1994.

The Rivonia Trial was the first time the white minority government successfully prosecuted the leadership of the ANC and thereby initiated the next phase of the struggle against apartheid that ended with the first democratic elections on 27 April 1994. Over the years most of the paper records disappeared from the holdings at the High Court in Pretoria and this archive contains those that remain, including three volumes of extracts of evidence by state witnesses, one volume of evidence for the defence, one volume of exhibits from Lilliesleaf Farm, the state's concluding address, the judgment and the judge's comments on sentencing and a recording of the complete trial, using Dictabelts, a popular recording medium of the time.

Network of information and counter information on the military regime in Brazil (1964–1985)

Inscribed 2011

What is it
Police, military and state documents from Brazil's dictatorship.

Why was it inscribed
The importance of these collections is in their insight into the espionage methods of the military regime and its police, and their value for victims of repression. These methods were part of Plan Condor, which resulted in human rights abuses in Latin America.

Where is it
Several public archival institutions in Brazil

▲ João Goulart giving a speech at Central do Brasil on 13 March 1964.

▲ Soldiers guarding the Guanabara Palace during the 1964 Brazilian coup d'état on 31 March 1964.

On 31 March 1964, the President of Brazil, João Goulart, was deposed in a coup d'état that ended democratic rule in the country for 20 years. On 9 April, the new military regime introduced the first act in a new series of legislative measures that restricted political rights. Despite initial pledges to the contrary, the military government would soon enact a new, restrictive constitution, and stifle freedom of speech and political opposition. The regime went on to censor all media, and torture and banish dissidents.

Over 6000 people were convicted by institutional acts or were sued based on the Law of National Security. About 50,000 underwent police interrogation while some 30,000 were tortured and hundreds died as a consequence; many people are still reported missing. Thousands of citizens were also denounced, charged and convicted by the Military Justice.

The archives produced over this period include documents on military police investigations and diligences, cancellation of rights, control of individuals, associations and organizations considered suspicious, military agreements and the Law of National Security. The gradual process of political liberation is also recorded, revealing the role of the resistance to the dictatorship, and the efforts to build and consolidate democracy.

This unique set of seventeen archives builds a striking picture of Latin American regimes in the second half of the 20th century. It covers records produced by the network of information and counter information on the military regime in Brazil and is linked to other Latin American countries that endured similar regimes, such as Argentina, Chile, Paraguay and Uruguay (see pages 498 and 543). It is an indispensable source of knowledge of military government policies and actions.

The archives have been published online, a project that combines state and society efforts to preserve and recover the memory of that period and to encourage social reflection about citizenship, democracy and human rights.

Now accessible to anyone, the holdings are an important testimony to world history, not only because in South America military governments worked closely together, but also because these military governments and those in other parts of the world were established and sustained thanks to the collaboration and permission of several developed nations on the pretext of averting communism.

For Brazil, the availability of these archives online represents a cornerstone in the democratization of the access to information and is an invaluable tool for building citizenship and a fairer and equitable society in line with the motto: 'lest it be forgotten, lest it happen again'.

First Byurakan Survey
(FBS or Markarian survey)
Inscribed 2011

What is it
The First Byurakan Survey (FBS or Markarian survey) was a major astronomical survey and the first systematic search for active galaxies.

Why was it inscribed
The survey was the first systematic low-dispersion astronomical survey and the largest spectroscopic survey. Its results, now digitized, provide a unique and irreplaceable database of global importance to the science of astronomy.

Where is it
Byurakan Astrophysical Observatory, Aragatzotn province, Armenia

Celestial bodies such as stars, nebulae and galaxies are evolving objects: their physical conditions change with time, and consequently the radiation emitted by them also changes. It is these radiation changes that astronomers measure in order to obtain information about the nature of celestial bodies. The need to keep observational data collected over the years has become more and more important to astronomers, so that changes in astronomical objects can be discovered by comparing observations made at different times.

A unique astronomical survey was carried out by the Byurakan Astrophysical Observatory (BAO) from 1965 to 1980 by Beniamin Markarian which his colleagues called the First Byurakan Survey (FBS or Markarian survey). The main purpose was to search for galaxies with ultraviolet (UV) excess, of which 1500 were found. However, the FBS revealed thousands of other new interesting objects, including quasars, planetary nebulae, white dwarfs, cataclysmic variables and carbon stars, and enabled optical identification of infrared (IR) and X-ray sources. The FBS was the first systematic objective-prism survey, a new method of searching for active galaxies. To date, it is the largest spectroscopic survey, having recorded 40 million spectra on 20 million objects of the Northern extragalactic sky and part of the Southern sky. The FBS survey with its discoveries and new approach to the study

of the nearby universe is considered to be one of the most important achievements of 20th-century astrophysics and the distinctive Markarian galaxies are probably still the most interesting objects in the universe.

The astronomical plates that hold this valuable information are made of glass covered by photographic emulsion that records and keeps the images and spectra of the celestial objects. Each image or spectrum is a few dozen microns large and there are risks of losing this information because the plates may be broken or scratched and the emulsion spoiled due to temperature and humidity effects. Though the FBS was carried out a few decades ago, many astronomers, even from the Byurakan Observatory, could not work with the plates, as they were unique, and no copies were available. To preserve this database, a project of digitization of Markarian plates started in 2002, creating an electronic version on DVDs and accessible through the internet. The Digitized First Byurakan Survey (DFBS) was carried out over four years in collaboration with Italian, US and German scientists. It required a substantial effort, including the scanning of 2000 plates at a very high resolution to preserve the information. Today the results are freely accessible to the world astronomical community. It was the first digitization project in Armenia and one of the first in world astronomy.

The 1-metre Schmidt telescope at the Byurakan Astrophysical Observatory that was used for the ground-breaking Markarian survey of the galaxies. ▶

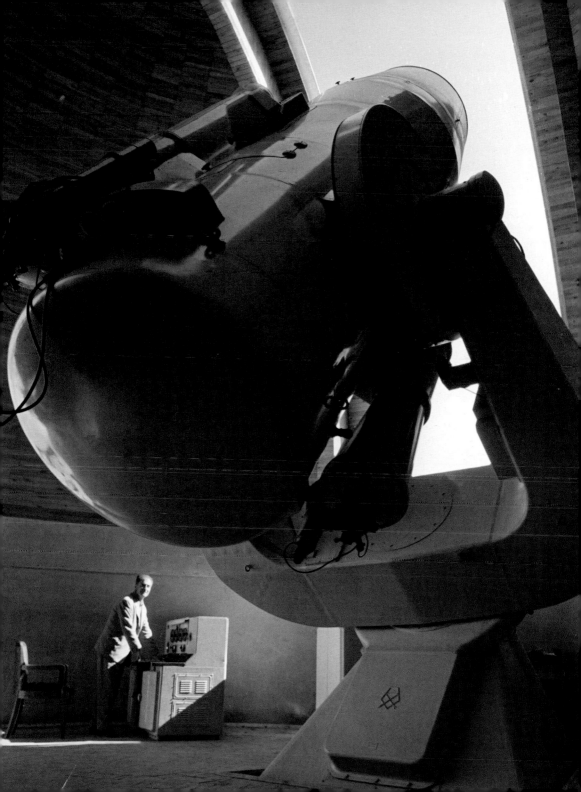

Aral Sea archival fonds

Inscribed 2011

What is it

The documents provide a unique record of the tragedy of the Aral Sea, of how it came to shrink to 10 percent of its size in the 1960s and the attempts to fight this.

Why was it inscribed

The archives document one of the biggest man-made ecological disasters with both local and international consequences.

Where is it

The Central State Archive of Kazakhstan, Almaty, Kazakhstan

The Aral Sea catastrophe has created ecological, social and economic crises not only for the Aral basin and the territories adjacent to it but also to areas beyond Kazakhstan. Up to 1960 the level of the Aral Sea had remained historically almost constant. Thereafter it shrank rapidly as a result of the intensive use of the Amu-Darya and Syr-Darya rivers that drain into the Aral Sea for irrigation of the vast areas of former desert for cotton and rice cultivation. The scale of irrigation was determined by the availability of land, the technical ability to deliver water from the source of irrigation, the economic viability of the irrigated land and the production capacity of the organizations engaged in water supply. However, as a result of the irrigation, the water balance of the Aral Sea changed, which led to the lowering of the sea level and a reduction in its area. In addition, poor design of the irrigation systems led to the flooding of some fields and the silting and salting of vast areas that could no longer be used for cultivation, forcing rice and cotton growers to cultivate more land and to use more fertilizer and more water to meet central plans for their crops.

These changes, in turn, led to the climatic changes in the region, with the winters becoming colder and the summers drier and hotter, and the appearance of the salt wind storms. This, in turn, caused the disappearance of local flora and fauna, the ending of the Aral Sea fishing industry (previously the major provider of food in the region), the deteriorating health of the local people from poor water quality and salt and dust in the atmosphere, and major social and economic dislocation caused by loss of jobs, emigration from the area and isolation of settlements once linked by the Aral Sea.

The archives contain documents mainly from the 1970s and 1980s that reflect the causes and consequences of the Aral tragedy, the attempts to save the Aral Sea and the activities undertaken to attempt to reverse the ecological disaster and its consequences in the region. They come from a number of Kazakh Soviet socialist republic ministries, prior to Kazakhstan's independence from the USSR in 1991. The documentary heritage characterizes the strengths and weaknesses of the socialist system in managing the use of natural resources. The available documents are the sole source for international research and for implementing activities dedicated to the revival of the ecological, social and economic prospects of the region.

An abandoned boat at the former Uzbek fishing village of Moynaq, now 18 km from the shore of the Aral Sea. ▶

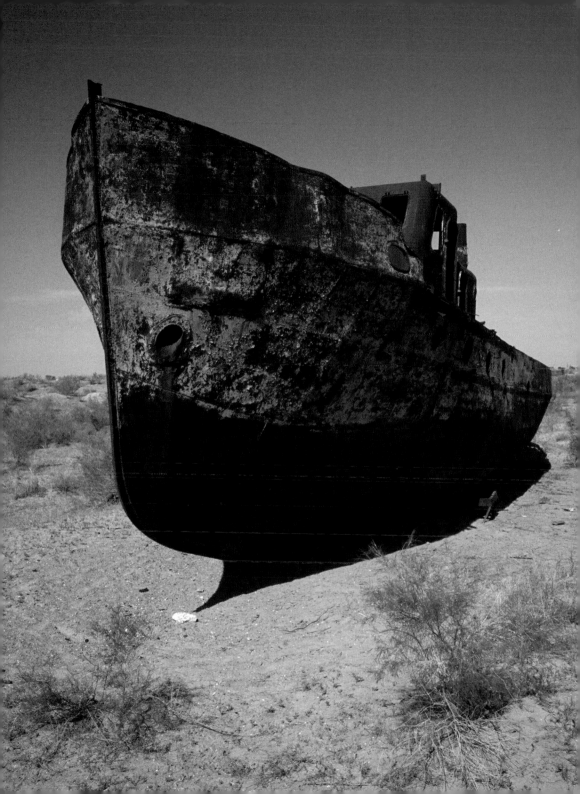

Landsat Program records: Multispectral Scanner (MSS) sensors

Inscribed 2011

What is it

The only accurate image record, spanning nearly four decades, of the Earth's land surfaces, coastlines, and reefs at a scale revealing both natural and human-induced change.

Why was it inscribed

The Landsat records are fundamental to understanding how the surface of the planet has changed. They provide insight into climate change, a higher and more frequent incidence of natural disasters and a much degraded natural environment.

Where is it

US Geological Survey, Virginia, USA and at http://earthexplorer.usgs.gov

The images that make up the Landsat Program records have been obtained and continuously updated by sensors onboard a series of land-imaging satellites that began with the launch of Landsat 1 in 1972. 'The Landsat Program was created in the United States in the heady scientific and exploratory times associated with taming the atom and going to the Moon', according to Dr John Barker of US National Aeronautics and Space Administration (NASA). In fact, it was the Apollo Moon-bound missions that inspired the Landsat Program. During the early test-bed missions for Apollo, photographs of Earth's land surface from space were taken for the first time.

The spatial resolution of 30 m by 30 m per pixel and the 185 km by 185 km area per Landsat 'scene' fills an important scientific niche because a Landsat satellite can provide global coverage on a seasonal basis, with images that are detailed enough to show human-scale processes such as urban expansion, agricultural irrigation and deforestation. By establishing baseline knowledge of Earth's land areas from the early 1970s

A Landsat image of the Suez Canal area ▶

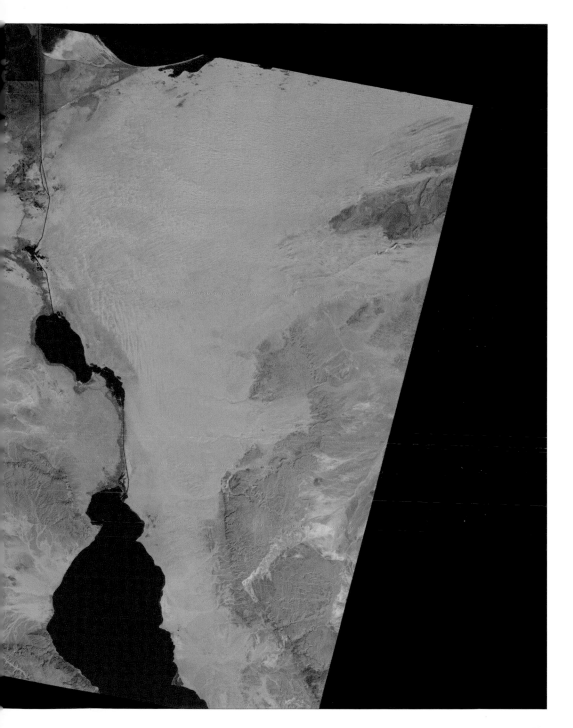

plus comparative 'overlay' images over time, Landsat allows scientists to detect and evaluate environmental change over time. Often, this baseline knowledge is represented in the form of a map. The first Landsat-derived map was produced in 1972. Since that time, Landsat-derived maps have been used to aid navigation of poorly charted areas, especially in the Arctic and Antarctic regions, to map geological faults and fracture zones and to find previously unmapped volcanic fields.

In 1975, NASA administrator Dr James Fletcher predicted that if one space-age development would save the world, it would be Landsat and its successor satellites. In recent years Landsat data have emerged as critical to the discovery, monitoring and understanding of changes to the Earth's surface caused by climate, human impact or natural disasters. Indeed, the historical and scientific value of Landsat data record increases with time. The societal benefits derived from worldwide uses of Landsat data are well documented and include the following

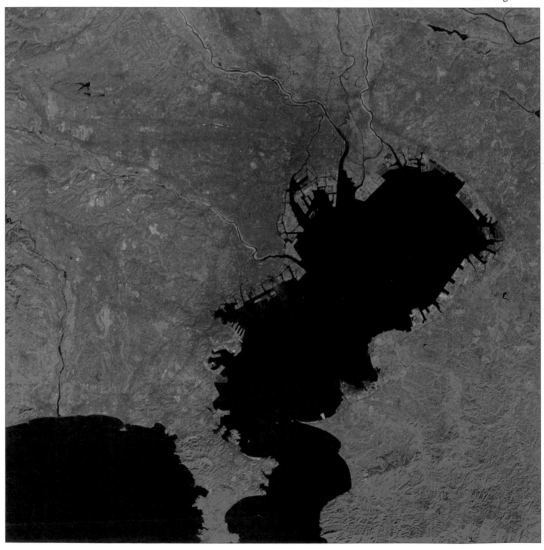

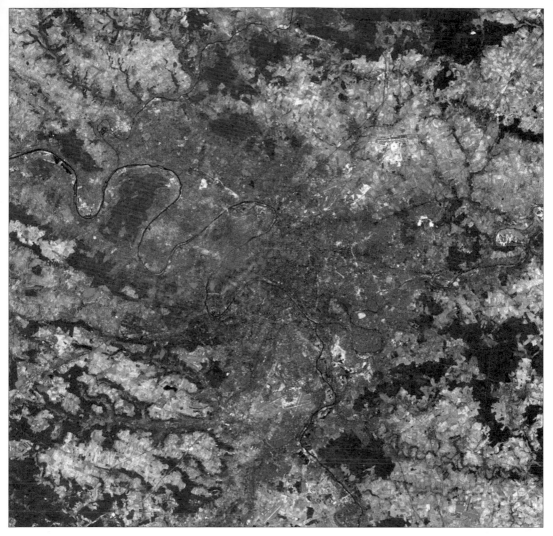

A Landsat image of Paris and the surrounding countryside. ▲ (overleaf) A Landsat image of dry valleys in Antarctica. ▶

◀ A Landast image of Tokyo Bay.

categories: disasters, health, energy, climate, water, ecosystems, agriculture and biodiversity.

The Landsat Program, managed under a partnership between the United States Geological Survey (USGS) and NASA, provides historical and current land-surface image data to users in over 180 countries via USGS archives and those of its international-partner ground receiving stations around the world.

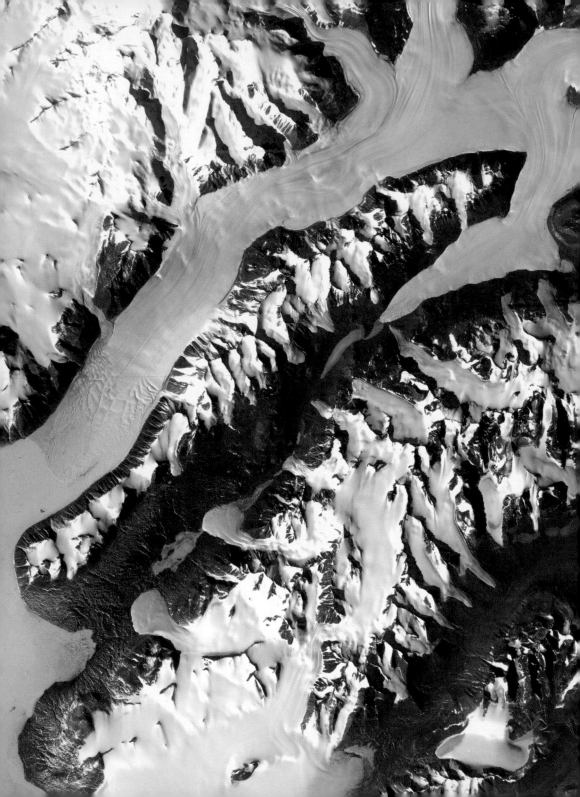

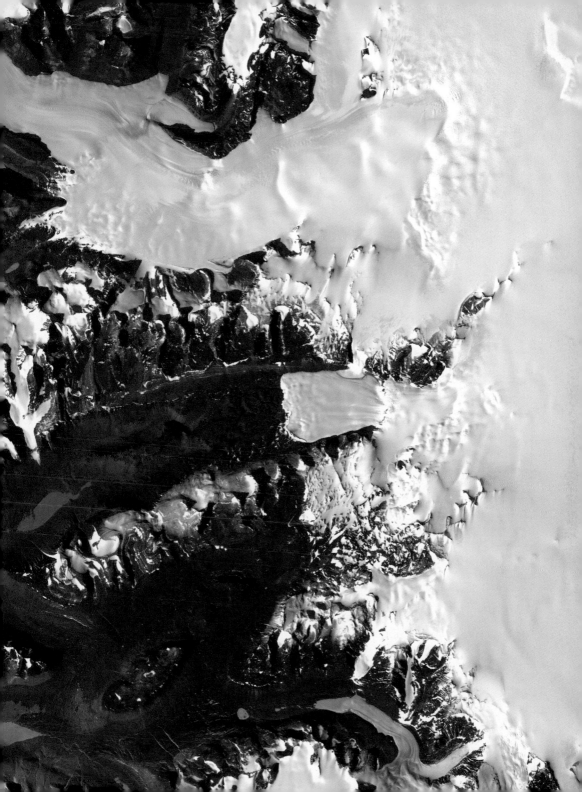

Human Rights Archive of Chile

Inscribed 2003

What is it

A collection of trial transcripts, newspaper reports, news clips, photographs and other historical documents kept by different institutions in Chile.

Why was it inscribed

This archive represents a unique history of the dictatorship period in Chile from 1973 to 1990, the effects of which are still reverberating today. It seeks to ensure that the memory of human rights violations and the defence of human rights is kept alive.

Where is it

National Archive of Chile, Santiago, Chile

From 1973 to 1990, Chile was ruled by the military dictatorship of General Augusto Pinochet. This 17-year regime was characterized by systematic suppression of political parties and the persecution of dissidents to an extent that was unprecedented in the country's history.

The Human Rights Archive of Chile aims to ensure that the historical memory of human rights violations and the defence of human rights, which is documented in various archives of national institutions, are preserved for future generations.

The archive seeks to safeguard this memory because it captures a specific historical moment of actions of solidarity with ,and defence of, persecuted and arrested persons during the military dictatorship.

The archive originated as a way of preserving information and supporting the search for those who disappeared during the military regime. The materials come in several different forms. There is a press archive of newspapers and magazines related to human rights issues from 1974 to 1990. Specifically, it includes news clips and historical articles related to the arrested, politically executed, banished, tortured and disappeared. An audiovisual archive has photographs of nearly 1000 disappeared persons.

There are historical heritage documents relating to the participation of human rights institutions in the social,

political and juridical life of the country and in the international community. Also preserved are leaflets, flyers and posters created by teams set up to denounce violations and disseminate information about the work of the human rights institutions. A judicial archive contains court testimonies and resolutions transcripts from trials concerning the disappeared.

In the last hundred years, Latin America endured a high number of authoritarian and totalitarian governments. Engendering respect for fundamental human rights is vital for the collective future of the region. Conserving the archives is necessary in order to set forth a public debate in these societies to enable them to question the presence or absence of the memory of human rights violations. To understand the raison d'être of democracy and respect for human rights, it is necessary to know and

Atacama desert, Chile: a cross marks the symbolic grave of many of the 'disappeared'. ▶

remember how the dictatorships functioned. Countries
will be able to choose a future free of terror and previous
mistakes only by knowing and reflecting on their past.

Tuol Sleng Genocide Museum archives

Inscribed 2009

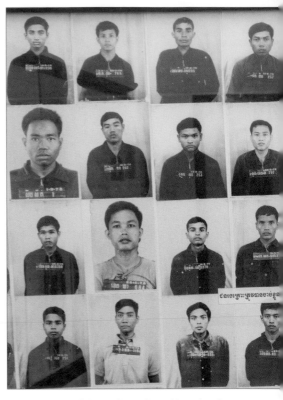

What is it

The archives of the Tuol Sleng Genocide Museum, the former S-21 prison and interrogation centre, contain photographs and biographies of over 5000 prisoners, as well as 'confessions', many extracted under torture, and other records of prisoners, prison guards and officials.

Why was it inscribed

It is estimated that over 15,000 prisoners were held in this former high school by the Khmer Rouge regime. Only a handful of them survived the ordeal. The archive bears testimony to man's inhumanity to man and its documentation confirms this genocide as of one of the most extreme examples of crimes against humanity in the 20th century, with a major impact on world history.

Where is it

Tuol Sleng Genocide Museum, Phnom Penh, Cambodia

The barbaric events during the Khmer Rouge regime in Democratic Kampuchea (1975–79) are revealed more clearly in this archive than in any other single source. The devastating consequences for the Cambodian people are hard to contemplate. Between 2 and 3 million people

▲ *All those detained had their pictures taken. Chan Kim Srung was photographed with her newborn child on 14 May 1978.*

▲ *Copies of* Revolutionary Flag, *a magazine of the Khmer Rouge left at Tuol Sleng after the fall of Pol Pot's Khmer Rouge regime.*

(over a quarter of the total population) lost their lives during the rule of the Khmer Rouge, and it is thought that hundreds of thousands of people were executed, following a period of imprisonment and torture.

The historic buildings that currently make up the Tuol Sleng Genocide Museum, were built in 1960 as the Chao Ponhea Yat High School. They were used during the Khmer Rouge regime as a prison and brutal interrogation centre. The school was enclosed by electrified barbed wire fencing, the classrooms converted into tiny prisons and torture chambers, and all windows were covered with iron bars and barbed wire to prevent escapes. At least 15,000 prisoners were held here, usually for two to three months, and most were executed at the 'Killing Field' of Cheung Ek or died in detention in Tuol Sleng prison. Initially those detained here were either linked to the previous government of Lon Nol or were skilled professionals including doctors, teachers and engineers, incarcerated as part of the Khmer Rouge's campaign against intellectuals. Later, the Khmer Rouge leader,

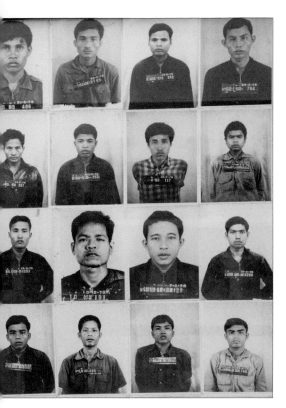

Type-written 'confessions' of detainees held at ▲
Tuol Sleng prison by the Khmer Rouge regime in Cambodia.

Pol Pot, became convinced that party members were plotting against him, and many leading party cadres were brought here as well.

The archives, which cover around a third of those imprisoned, provide an irreplaceable and chilling view of the machinery of terror. Prisoners were required to write their own biographies and were encouraged to betray family, friends and colleagues; over 5000 biographies (complete with photographs) exist. There are records of over 4000 'confessions', many obtained under torture, in which prisoners were forced to implicate themselves and others. The bureaucracy of terror is made manifest in Khmer Rouge notebooks, lists of prisoners arriving and those implicated in the confessions of others, prison statistics, and implements of torture and restraint, including over 1200 leg or arm shackles, for all prisoners were shackled.

While crimes of humanity have happened elsewhere in the world, nowhere have they reached the extremes of systematic and nationwide suffering inflicted on the people of Cambodia by their own regime. In the unique experiment in seeking justice for the victims, the Royal Government of Cambodia and the United Nations have joined together to establish a hybrid tribunal involving national and international judges, prosecutors and defence lawyers, working under national and international law and under national procedure to international standards. The first person charged by the Extraordinary Chambers in the Courts of Cambodia (ECCC) was Kaing Guek Eav, known as Duch, who was Chief of the Security Office-21 (S-21 prison). Evidence from this archive formed an essential part of his trial, in which he was found guilty of crimes against humanity and, after an appeal in 2012, was sentenced to remain in prison for the remainder of his life.

The site was turned into a museum after the fall of the Khmer Rouge in 1979 and the archives have achieved iconic status internationally because they tell the shocking tragedy of the crimes that were committed against the people of Cambodia and form an unflinching record of the inhumanity that can be committed by totalitarian regimes.

Human rights documentary heritage, 1976–1983 – Archives for truth, justice and memory in the struggle against state terrorism

Inscribed 2007

What is it

Complete records (including photos and sound recordings) held by eighteen institutions of the violations of human rights and fundamental freedoms in Argentina between 1976 and 1983.

Why was it inscribed

The archives are unique, as they contain testimonies of systematic and widespread acts of illegal repression, torture, extermination and forced disappearance, and document the struggle, resistance and the search for truth and justice over grave violation of human rights in Argentina.

Where is it

Eighteen institutions throughout Argentina, co-ordinated by Archivo Nacional de la Memoria (ANM), Buenos Aires, Argentina

A military junta controlled Argentina from 1976 to 1983. Under the motto *NUNCA MAS* ('NEVER AGAIN'), it is hoped that this archive will contribute towards guaranteeing that the odious and abhorrent crimes committed by the junta will never again occur anywhere in the world.

These archives represent the historic and social memory both of the violations of human rights and fundamental freedoms for which the Argentine state was responsible, and of the actions of institutions and civil society in support of human rights, justice and solidarity. Comprising various sources including national, provincial and municipal government institutions, human rights organizations and individuals, this material is indispensable for the clarification of events related to the

◀ *Mothers of the Disappeared (Madres de los Desaparecidos) on Plaza de Mayo, Buenos Aires, Argentina. Their campaign to find out what happened to their children who 'disappeared' during the rule of the Argentinean junta played an important role in ridding Argentina of military rule.*

forced disappearances of persons and grave human rights violations in Argentina, and is closely related to similar events in Chile, Uruguay, Paraguay, Brazil, Bolivia and Peru, as all participated in coordination for repression better known as Plan Condor (see pages 498 and 527).

This documentary evidence shows the widespread map of state terrorism in Argentina during the military dictatorship. It includes documents produced by state organizations that operated from 1976 to 1983, with some from before or after those dates; others made by human rights organizations and people who resisted the military dictatorship with their denunciations, national and international solidarity campaigns, searches for the victims of enforced disappearances and their actions to attain justice and truth. It also contains documents produced after the return to democracy in December 1983 by the national and provincial states, whose purpose was to elucidate human rights violations, the fate of the victims of forced disappearances, and to contribute to judicial proceedings in the cases of the crimes against humanity that were committed. Formed from testimonies, both written and oral, denunciations, photographs, legal and journalistic records, intelligence reports, lists of enforced disappeared persons, among other materials, this archive is clear evidence of the massive and systematic plan for the persecution, illegal detention and use of clandestine detention centres, torture and the forced disappearance of persons implemented by the military dictatorship.

This evidence was and continues to be used in court cases in Argentina and abroad. At the same time it makes an important contribution at a regional level towards the recognition of forced disappearances as a crime against humanity, and consolidates the so-called 'right to truth' and the protection of all persons from enforced disappearances. It has become a valuable pedagogical tool, and represents an important legacy to present and future generations for their appreciation and learning while strengthening a culture of peace based on tolerance, non-discrimination, dialogue and the fulfilment of human rights.

Liberation Struggle Living Archive Collection

Inscribed 2007

What is it

Unique audiovisual recordings documenting key events that occurred as part of the struggle against the apartheid government in South Africa. Footage includes many of the main leaders of the anti-apartheid movement.

Why was it inscribed

The apartheid struggle in South Africa was one of the defining racial and ideological confrontations of the 20th century and has had a global political and cultural impact.

Where is it

Doxa Productions/Visual History Archive, Cape Town, South Africa

Audiovisual material is a fundamental source in helping our understanding and knowledge of the history of South Africa in the late 20th century, and particularly once film makers acquired light electronic news-gathering video equipment and were present at major turning points of the struggle for liberation from the system of apartheid. Under the apartheid regime in South Africa, due to the developed infrastructure of the country, the foreign media were able to show the world what was happening within the country. Some local filmmakers were also able to document many nuances of the unfolding history of the country. However, many of the local inhabitants, both black and white, never saw that footage and are still unaware of what really happened in their country of birth.

With the democratization of South Africa, press freedom and freedom of speech are now considered to be secured rights and, in this context, archives are considered as important repositories of history and memory. However, much of the audiovisual archival material of the post-colonial liberation struggles in South Africa is not digitized and is degenerating. As a South African journalist working for international networks and agencies during the 1980s, Craig Matthew, of Doxa Productions, filmed the day-to-day events in the Cape Province as well as other significant events in the rest of South Africa, Angola, Mozambique and Namibia. Since

then, Doxa Productions has strived to preserve, maintain and develop a unique audiovisual archive. It is the first-hand realization of the fragility and the uniqueness of these important historical records that led Doxa to create the 'Liberation Struggle Living Archive Collection'. It is preserving crucial audiovisual archives and transferring resources on the history of the South African liberation struggle into a digital format to make them accessible.

The Doxa collection comprises 674 tapes from the 1980s to 1994. The archive holds some unique material, which documents key events during the struggle against the apartheid government as these unfolded in the Western

Cape specifically. The struggle against apartheid and in particular, the history of the African National Congress and the Black Consciousness movement are vital major aspects of this footage, as is material on Nelson Mandela and on the Truth and Reconciliation Commission.

▲ *Robben Island, where Nelson Mandela was imprisoned for 27 years, with Cape Town and Table Mountain in the distance. The Liberation Struggle Living Archive Collection holds films of Mandela after his release and of the struggle that led to the abolition of apartheid.*

Human Rights Documentary Heritage, 1980 – Archives for the May 18th democratic uprising against military regime, in Gwangju, Republic of Korea

Inscribed 2011

What is it

The documentary items related to the uprising, which took place in Gwangju, Republic of Korea between 18 and 27 May 1980, take the form of documents, publications and photographs, relating to the citizens' rebellion, the punishment of the perpetrators and compensation.

Why was it inscribed

The 18 May Democratic Uprising is widely considered as a turning point for democracy and human rights in the Republic of Korea, but it also affected other countries in East Asia, helping to dismantle Cold War structures.

Where is it

518 Archive of Gwangju City Hall, Archive of May 18 Memorial Foundation, and May 18th Research Center of Chonnam National University, Gwangju, Republic of Korea

Since 1961, the Republic of Korea (commonly referred to as South Korea) had been ruled by President Bak Jeonghui (Park Chung-hee) who came to power in a military coup. He was assassinated on 26 October 1979 by Kim Jae-gyu, a close colleague and director of the feared Korean Central Intelligence Agency. It was thought that Kim saw Bak as an obstacle to a return to democracy and there was some hope that the assassination might bring democracy closer. However, within weeks, military officers led by General Jeon Duwhan (Chun Doo-hwan took power through a military coup. In the following May students and trade unionists took to the streets in protest throughout the country. On 17 May the government declared martial law and sent special forces troops to the southern industrial city of Gwangju,

where, on the following day, 18 May, students and concerned citizens took to the streets and confronted the soldiers. The resulting violence meted out on the people of Gwangju by the soldiers greatly increased the tension in the city and many more people joined the demonstrations. On 21 May the soldiers opened fire on demonstrators, killing or injuring hundreds. The mass of citizens of Gwangju, some now armed, provided overwhelming resistance to

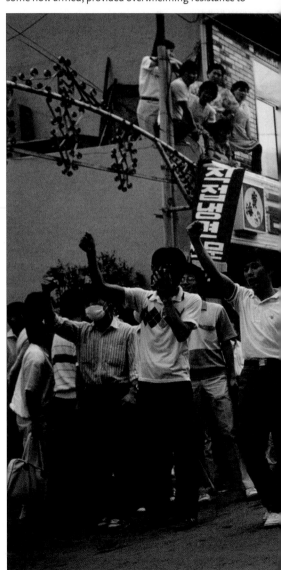

The suppression of the 1980 Gwangju Uprising led to more calls for the reinstatement of democracy in South Korea. This demonstration in Gwangju in 1987 helped towards the collapse of the military regime that had ordered the troops into Gwangju in 1980. ▶

the army, who retreated to the suburbs and then enforced a complete blockade of the city, letting nothing in and nobody out. Within the city people tried to continue their life as normal and Settlement Committees maintained order and negotiated with the military, in vain. In the early hours of 27 May the troops, now significantly reinforced, re-entered the city and swiftly and violently reimposed military control.

During ten days of resistance, 165 citizens died in and around Gwangju, seventy-six people went missing, 3383 were injured, and 1476 were arrested. In addition, 102 people later died due to injuries incurred during the siege and survivors suffered physical and emotional trauma as a result of their experiences during the uprising. Gim Daejung (Kim Dae-jung), at the time a prominent opposition leader, was arrested just before the rising

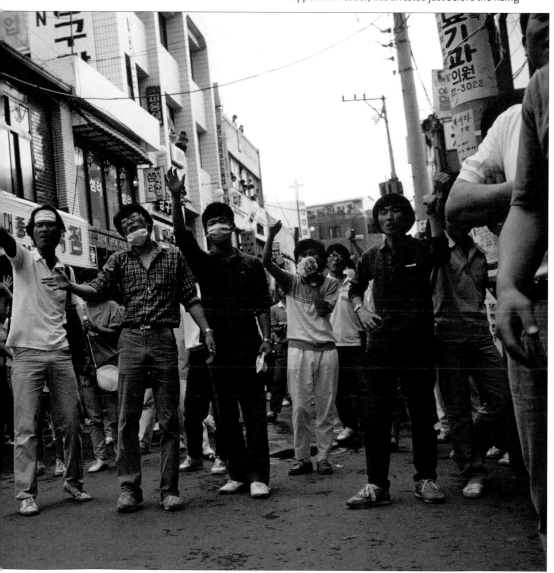

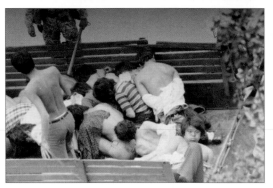

▲ *Scenes from the uprising in Gwangju in May 1980 and its suppression by the Korean army.*

and was accused afterwards of instigating it. He was sentenced to death, but, after international pressure, was later reprieved (he became a democratic President in 1998 and the Nobel Peace Prize winner in 2000). In the years that followed, in the face of government prohibition, the campaign of the bereaved families generated much popular support, which culminated in the reinstatement of democratic elections in 1987. In 1989 the 'Gwangju Riot' was officially renamed 'the May 18th Democratic Uprising' by the President.

Materials relating to the uprising are divided into three types. First, there are government documents, including records of investigations and trials by military judicial institutes and records of public officials during and after the incident as well as situation reports and compensation-related documents showing the severity of the damage inflicted on the city. Secondly, there are documents

produced at the time of the uprising (newsletters, declarations, handwritten posters and reporters' notebooks) that reveal just how urgent and desperate the situation was. Particularly compelling are the photographs taken by local residents and by foreign correspondents. In addition, over 1500 eyewitness accounts have been compiled and more are still being collected. Finally, there are documents produced by the National Assembly and the Supreme Court aimed at restoring the reputation of the people and discovering the truth about the incidents that took place under the military government following the uprising.

Twenty-One demands, Gdańsk, August 1980. The birth of the SOLIDARITY trades union – a massive social movement

Inscribed 2003

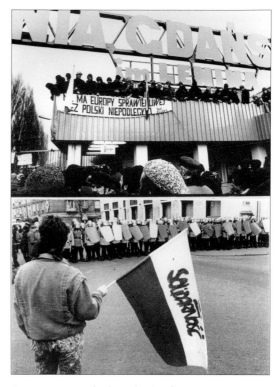

What is it

The twenty-one demands made by the Free Trades Union Strike Committee on 26 August 1980 in Gdańsk Shipyard: unusually, they were not only related to pay and working conditions but were also of a wider political, social and economic nature.

Why was it inscribed

The creation of the twenty-one demands marked a turning point: the events that followed led to the creation of Solidarity, the first free trade union within the Communist bloc in Eastern Europe and a dynamic movement for freedom and democracy in Poland until the fall of Communism in 1989.

Where is it

Polish Maritime Museum, Gdańsk; Karta Centre in Warsaw, Warsaw, Poland

The strike at Gdańsk Shipyard in Poland in 1980 took place against the background of the Cold War, not only in Europe but also around the world. Since the empire of the USSR (Soviet Union) was established at the end of the Second World War, unrest in its Eastern European satellite states, including Poland, had been ruthlessly

▲ *Protesters occupy the shipyard and confront riot troops.*

crushed and dissenting voices seemed temporary and marginal. In addition, the number of African and Latin American countries dependent on Soviet support appeared to be increasing.

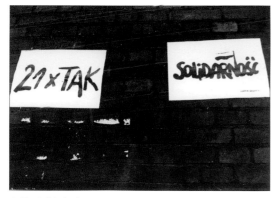

▲ *The Solidarity banner*

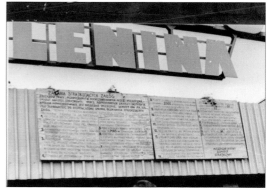

▲ *The board with twenty-one demands in place at the Gdańsk Shipyard.*

ŻĄDANIA STRAJKUJĄCYCH ZAŁÓG

ZAKŁADÓW PRACY I PRZEDSIĘBIORSTW REPREZENTOWANYCH PRZEZ MIĘDZYZAKŁADOWY KOMITET STRAJKOWY. MKS REPREZENTUJE ZAŁOGI I INSTYTUCJE KTÓRYCH FUNKCJONOWANIE JEST NIEZBĘDNE SPOŁECZNIE. KOMITET ÓW MA NA CELU DOPROWADZIĆ DO ROZMÓW, KTÓRE SPEŁNIĄ OCZEKIWANIA STRAJKUJĄCYCH ZAŁÓG.

▲ The board on which the workers wrote their twenty-one demands.

A rise in food prices provided the immediate impetus for the strike and some of the strikers' demands were pragmatic. Others, however, went much further than the terms of pay dispute and struck at the nature of Communist rule. The striking workers demanded the establishment of free trade unions, the abolition of censorship and the release of all political prisoners. The strike leader was Lech Wałęsa, an electrician by trade and a union leader and long-time political dissident.

Sympathetic strikes broke out in other industries and although the government quickly agreed to significant pay increases, the strike did not stop. The Communist government then agreed to implement the twenty-one demands – a concession with immediate and long-term consequences.

The practical result of the acceptance of the demands was the foundation of the independent free trade union Solidarność (Solidarity), which grew to more than 10 million members and became a massive and broad-based social movement. It was active for more than a year until December 1981 when it was outlawed by the introduction of martial law in Poland under pressure from the Soviet Union.

However, Solidarity had gained too much momentum to be suppressed and survived throughout the 1980s as an underground organization. Finally in 1989, their team of negotiators held the Round Table Talks with the

American President George Bush and First Lady Barbara Bush were among those who travelled to Poland to meet Solidarity leader Lech Wałęsa. (top) British Prime Minister Margaret Thatcher also visited Gdańsk to meet the Solidarity leadership. (bottom) ▶

weakening Polish government. The government was forced into concessions which led to the first democratic elections in the Communist bloc.

Subsequently, the elections became an impetus for other countries behind the Iron Curtain to fight for freedom and gave momentum to the collapse of the Soviet empire in 1989. In retrospect, the success of the Gdańsk strike in 1980 marked a turning point in the overthrowing of the Communist system.

Listed on the Register is the actual board on which the striking workers wrote their twenty-one demands in August 1980, together with other written, printed, recorded and photographed material which forms much of the archive of Solidarity from August 1980 to December 1981.

551

National Literacy Crusade

Inscribed 2007

What is it

A unique collection of letters, interviews, first-hand accounts, diaries, maps, cassettes and literacy exercise books and textbooks that were created during a mass literacy campaign in 1980.

Why was it inscribed

The Nicaragua Literacy Crusade of 1980 reduced illiteracy in Nicaragua from 50 percent to 12 percent in five months. It serves as a model for literacy instruction in developing countries throughout the world.

Where is it

Institute of History of Nicaragua and Central America, Managua, Nicaragua

The National Literacy Crusade (CNA) was a unique event in the history of Nicaragua. It followed the victory of the Sandinista People's Revolution in July 1979 over one of the bloodiest dictatorships of Latin America. The entire country found itself in a profound process of transformation of its political, economic and cultural structures. The subsequent burst of collective energy and sense of national unity helped the country address one of its most pressing problems: education.

The Crusade attracted 60,000 young people who, for five months, lived in the rural areas of the country and taught more than half of the poor and illiterate population of Nicaragua to read and write. At the same time, entire brigades of voluntary teachers from sixteen countries joined in the Crusade, helping with technical organisation, the preparation of teaching materials and preparing young Nicaraguans for their mission.

With this large-scale effort the illiteracy rate was brought down in five months from 50 percent to 12 percent. The National Literacy Crusade is the greatest educational and cultural achievement in the history of Nicaragua. It was a major experience for the young from the cities who taught people to read and, at the same time, discovered the conditions of neglect and poverty in the other half of the country, the legacy of 50 years of dictatorship.

With its massive, participatory and united character, the Crusade became a unique national and international experiment that won the recognition of UNESCO, through the award of two Nadezhda Krupskaya medals.

The National Literacy Crusade generated a variety of material and documents, which have been assembled and preserved by the Institute of History of Nicaragua and Central America (IHNCA). These include letters, interviews, first-hand accounts, diaries, maps, cassettes and literacy exercise books and textbooks in Spanish, 'Creole' English, Miskito and Sumu (languages of the ethnic minorities of the Caribbean coast of Nicaragua).

The documents describe the situation of oppression and crisis affecting the people, its survival economy, the plundering of its land, and how it stood up to the Somoza dictatorship. They recount the role of clandestine radio broadcasts and the part played by women and children. They explain how people managed to obtain food and medicines at crucial times, what armed actions they took part in and how it felt to lose a companion. They also reproduce the war songs and the poems that buoyed the spirit.

The Crusade illustrates the importance of organization and citizen participation to overcome the major social and cultural problems of the Third World.

Matchbox cover used as part of Nicaragua's adult literacy campaign 'Literacy is Freedom'. ▶

N

Nicaragua

**ALFABETIZACION
ES LIBERACION
 I ARAGUA LIB É**

Radio broadcast of the Philippine People Power Revolution

Inscribed 2003

What are they

Unedited recordings of the live radio broadcasts that were made during the peaceful popular revolution against the rule of President Marcos in Manila in 1986. This was one of the first times that the events during a popular uprising had been broadcast live to the world.

Why were they inscribed

The broadcasts had a great influence on later popular uprisings and set a pattern for the future coverage by the broadcasting media of events such as the fall of the Berlin Wall. They provide a unique record of one of the first popular uprisings that marked the closing decades of the 20th century.

Where are they

Philippine Information Agency, Quezon City, Philippines

The collection is a complete and unedited account of the revolution in the Philippines from the time the rebellion started in 22 February to the time when President Marcos fled the country on 25 February 1986. These four days marked the transition from dictatorship to democracy through a peaceful popular uprising which resolved a dangerous military standoff without the use of armed force or loss of life.

It is made up of sound recordings on forty-four audiocassette tapes (61 hours and 33 minutes) and one mini disc (25 minutes) that document the unedited day-to-day radio broadcasts of Radio Veritas (a Catholic-owned radio station at the outskirts of Manila), DZRJ/DZRB, Radio Bandido (a privately owned radio station in Quezon City then under the Ministry of National Defense), DZRH (a privately owned radio station in Manila) and Voice of the Philippines (a government-owned radio station taken over by the people led by Radio Veritas on 24 February 1986).

The radio recordings document the course of events along Epifanio de los Santos Avenue, better known as EDSA, in Manila. Unbidden, tens of thousands of people packed the short stretch between the two military camps on EDSA. Here, for four days, they prayed, sang and offered flowers to the armoured military flanking them at both ends. On the third day, a miracle happened – the loyalist military defected to the side of the rebels. On the corner of Ortigas Avenue there is now a shrine in honour of Our Lady of EDSA, Queen of Peace, symbolic not only of an unprecedented non-violent protest that toppled the twenty-year dictatorship of Ferdinand Marcos, but also of the Filipinos' yearning for peace and freedom. Nearby stands a 'people's power' monument, erected as a tribute to those who packed this historic place over those four days.

The People Power Revolution saw the peaceful overthrow of an entrenched dictatorship through a spontaneous popular uprising, documented and influenced by the 20th-century medium of radio. The radio broadcasts played a major role in the successful conclusion of the four-day rebellion. The audio recordings provide insights into radio's potency as a communication medium to effect change and as a tool for development. The world listened, watched and read. The event will forever be a reference point for the peaceful resolution of deep national crises.

The crowds that came out on to the streets of Manila in support of the People Power Revolution that toppled the dictatorship of Ferdinand Marcos. The radio recordings of this mass peaceful demonstration provide invaluable evidence of the success of the rising. ▶

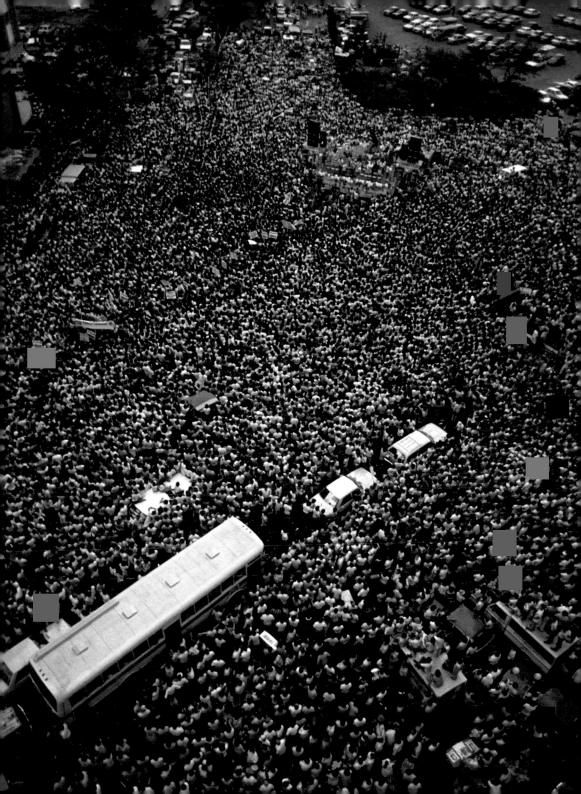

The Baltic Way – Human chain linking three states in their drive for freedom

Inscribed 2009

What is it

The Baltic Way was a political demonstration that took place on 23 August 1989, uniting the states of Estonia, Latvia and Lithuania in peaceful protest. The intention driving the protest was to highlight the secret protocols of the 50-year-old non-aggression pact, agreed on 23 August 1939, between Germany and the USSR (Soviet Union): these carved up Europe between them and handed the Baltic States to the Soviet Union.

Why was it inscribed

The Baltic Way was an expression of non-violent protest through the joint commitment of more than one million people across three states. It drew attention to the secret aspects of the treaty and proposed more freedom of information. It also encouraged the cause of national self-determination of Estonia, Latvia and Lithuania as well as democratic movements across the Soviet Union itself.

Where is it

National Archives of Estonia, Tartu, Estonian Film Archives, Tallinn, Estonia; Museum of the Popular Front of Latvia, Riga, Latvia; and Lithuanian Central State Archive, Vilnius, Lithuania

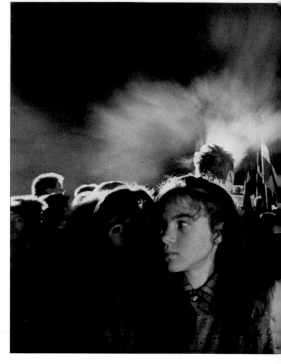

On 23 August 1989 over a million people living in three nations by the Baltic Sea joined hands to create a 600-km-long human chain that stretched from the foot of Toompea in Tallinn to the foot of the Gediminas Tower in Vilnius, crossing Riga and the River Daugava on the way.

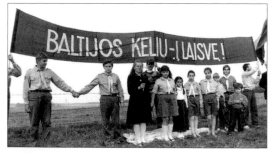

The purpose of their protest was twofold: to call for the recognition of the secret clauses in the Molotov-Ribbentrop pact of 1939 and the re-establishment of the independence of the Baltic States.

The pact was a non-aggression treaty between Nazi Germany and the Soviet Union, signed just over a week before the Germans invaded Poland, so triggering the Second World War. However, what was not generally known in 1939 was that another agreement within the pact planned the carve-up of post-war Europe into German and Soviet spheres of influence. By the end of the war in 1945, the Soviet Union already occupied the Baltic States and the existence of the secret agreement was denied throughout the years of the Cold War.

In the 1980s the Soviet leader Mikhail Gorbachev introduced his perestroika and glasnost reforms in Soviet government and society. For the Baltic States, this brought a loosening of Soviet repression and on 23 August 1988, the secret protocols of the Molotov-Ribbentrop pact were publicly revealed at mass meetings in Vilnius, Riga and Tallinn, the three Baltic capitals. In the spring of 1989 representatives of the three Baltic nations at the Congress

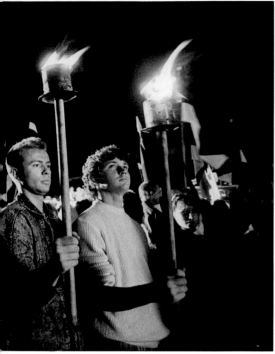

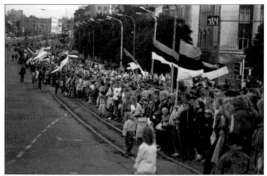

of People's Deputies of the USSR demanded that the pact be evaluated on legal grounds. National movements in each of the Baltic States planned the demonstration for 23 August, the fiftieth anniversary of the signing of the pact.

The Baltic Way was non-violent, was based on cross-border solidarity, and it was successful. Participants included Estonians, Latvians, Lithuanians, Russians, Byelorussians, Poles, Tatars and many people of other nationalities. By the end of that day, the question of the Baltic States was no longer an issue only for local politicians and civil servants but was now part of a larger agenda. In December, the People's Deputies Congress of the Soviet Union in December of 1989 declared the secret protocols of 1939 legally null and void. The democratic process which began timidly after perestroika now gained confidence and strength both in the Baltic States and in the Soviet Union.

Seen in retrospect, the Baltic Way symbolized the end of the Cold War and the end of the direct consequences of the Second World War. It was a unique and peaceful demonstration that united the three countries in their drive for freedom and in its simplicity it represented a triumph of humanity over totalitarianism.

The documents, photographs and film in the collection preserve the memory of the Baltic Way, with Estonia, Latvia and Lithuania having seven, eight and twenty-three documents respectively.

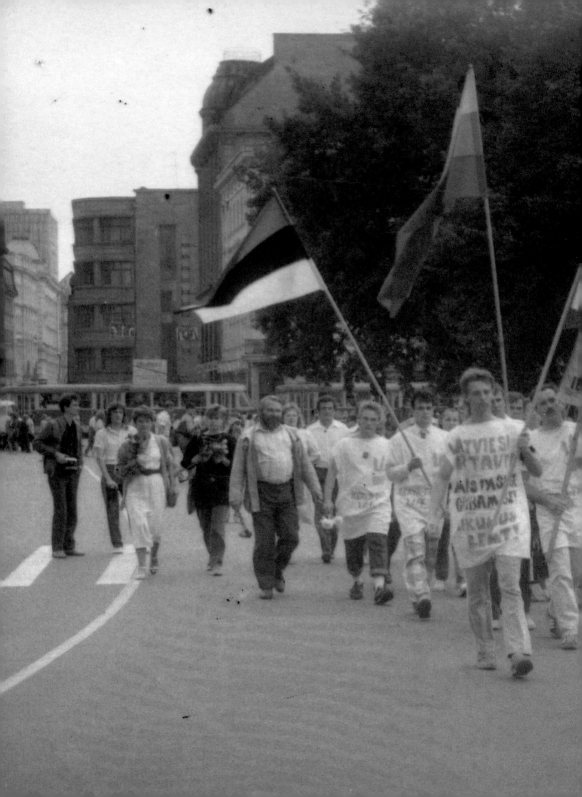

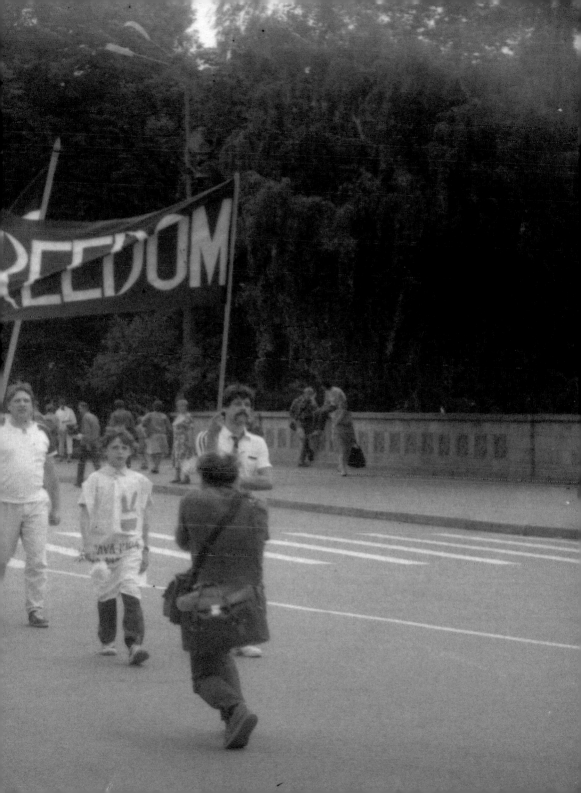

INDEX

Country index

Albania
Codex Purpureus Beratinus.. 44

Angola
Arquivos dos Dembos / Ndembu archives*..........................253

Argentina
Documentary heritage of the Viceroyalty of the Río
de la Plata .. 292

Human rights documentary heritage, 1976–1983543

Armenia
Mashtots Matenadaran ancient manuscripts
collection .. 38

First Byurakan Survey (FBS or Markarian survey)............. 528

Australia
The Endeavour journal of James Cook 288

The Convict Records of Australia.. 298

Manifesto of the Queensland Labour Party to the people
of Queensland... 391

The Story of the Kelly Gang (1906)...................................... 422

The Mabo case manuscripts ..516

Austria
Papyrus Erzherzog Rainer.. 28

Tabula Peutingeriana ... 92

Vienna Dioscurides .. 46

Collection of Gothic architectural drawings........................134

Bibliotheca Corviniana* 149

Mainz Psalter at the Austrian National Library153

Tabula Hungariae*... 164

The Atlas Blaeu–Van der Hem ... 242

The Vienna City Library Schubert collection311

Final document of the Congress of Vienna 324

Brahms collection.. 350

Arnold Schönberg estate.. 370

The historical collections (1899–1950) of the Vienna
Phonogrammarchiv..406

Azerbaijan
Medieval manuscripts on medicine and pharmacy 86

Bahamas
Registry of Slaves of the British Caribbean
1817–1834*.. 326

Farquharson's Journal ..345

Barbados
Documentary heritage of enslaved peoples of the
Caribbean ..209

Silver men: West Indian labourers at the Panama
Canal*.. 376

Federal Archives fonds...488

Nita Barrow collection ...496

Belarus
Radziwills' Archives and Niasvizh (Nieśwież) Library
collection*.. 130

Belgium
Bibliotheca Corviniana* 149

Archives Insolvente Boedelskamer Antwerpen..................... 160

Business archives of the Officina Plantiniana 190

Belize
Registry of Slaves of the British Caribbean
1817–1834*.. 326

Benin
Colonial archives, Benin.. 362

Bermuda (UK overseas territory)
Registry of Slaves of the British Caribbean
1817–1834*.. 326

Bolivia
American colonial music: a sample of its documentary
richness*.. 188

Documentary fonds of Royal Audiencia Court of
La Plata (RALP) ..191

Brazil

Dutch West India Company (Westindische Compagnie) archives* .. 220

The Emperor's collection 358

Network of information and counter information on the military regime in Brazil (1964–1985) 527

Bulgaria

Enina Apostolos, Old Bulgarian Cyrillic manuscript (fragment) of the 11th century 68

Cambodia

Tuol Sleng Genocide Museum archives 540

Canada

Quebec Seminary collection, 1623–1800 (17th–19th centuries) .. 224

Hudson's Bay Company archival records 250

Neighbours, animated, directed and produced by Norman McLaren in 1952 504

Chile

Jesuits of America ... 206

Human Rights Archive of Chile 538

China

Huang Di Nei Jing 黄帝内经 (Yellow Emperor's Inner Canon) .. 35

Ancient Naxi Dongba literature manuscripts 36

Ben Cao Gang Mu 本草纲目 (Compendium of Materia Medica) ... 200

Records of the Qing's Grand Secretariat 239

Golden Lists of the Qing dynasty imperial examination 244

Qing dynasty Yangshi Lei archives 280

Traditional music sound archives 502

Colombia

Negros y Esclavos archives 169

American colonial music: a sample of its documentary richness* .. 188

Croatia

Tabula Hungariae* .. 164

Cuba

'José Martí Pérez' fonds 366

Original negative of the Noticiero ICAIC Latinoamericano .. 519

Curaçao (Netherlands overseas territory)

Dutch West India Company (Westindische Compagnie) archives* .. 220

Archives of the Middelburgsche Commercie Compagnie* .. 274

Catecismo corticu pa uso di catolicanan di Curaçao (first catechism written in Papiamentu language 336

Czech Republic

Collection of medieval manuscripts of the Czech Reformation ... 112

Collection of 526 prints of university theses from 1637 to 1754 .. 232

Collection of Russian, Ukrainian and Belarusian émigré periodicals 1918–1945 442

Denmark

The Arnamagnæan manuscript collection* 87

MS. GKS 4 2°, vol. I–III, Biblia Latina. Commonly called 'The Hamburg Bible' 100

Sound Toll Registers 158

El Primer Nueva Corónica y Buen Gobierno 212

Archives of the Danish overseas trading companies 248

Linné collection .. 276

The Søren Kierkegaard archives 323

Manuscripts and correspondence of Hans Christian Andersen ... 340

Dominica

Registry of Slaves of the British Caribbean 1817–1834* .. 326

Dominican Republic

Book for the Baptism of Slaves (1636-1670) 228

Documentary heritage on the resistance and struggle for human rights in the Dominican Republic, 1930–1961 ... 457

Egypt
Deeds of sultans and princes .. 65

Persian illustrated and illuminated manuscripts.................118

Memory of the Suez Canal...352

Estonia
The Baltic Way – Human chain linking three states in
their drive for freedom*...556

Ethiopia
Treasures from National Archives and Library
organizations...127

Finland
Radziwills' Archives and Niasvizh (Nieśwież) Library
collection*.. 130

The A.E. Nordenskiöld Collection ... 364

Fiji
Records of the Indian indentured labourers*...................... 344

France
Bayeux Tapestry ...80

Bibliotheca Corviniana* ... 149

Library of the Cistercian Abbey of Clairvaux at the
time of Pierre de Virey (1472) ... 150

Beatus Rhenanus Library...165

Châtelet de Paris banner register from the reign of
Francis I (National Archives Y9, France) 184

Original Declaration of the Rights of Man and of the
Citizen (1789–1791).. 302

Introduction of the decimal metric system,
1790–1837...306

Lumière films .. 398

The Appeal of 18 June 1940* ... 476

Georgia
Georgian Byzantine manuscripts.. 62

Germany
Illuminated manuscripts from the Ottonian period
produced in the monastery of Reichenau
(Lake Constance) .. 66

Song of the Nibelungs, a heroic poem from
medieval Europe ...94

The 42-line Gutenberg Bible, printed on vellum.................. 146

Bibliotheca Corviniana* .. 149

Universalis cosmographia secundum Ptholomaei
traditionem et Americi Vespucii aliorumque
Lustrationes*.. 162

Letters from and to Gottfried Wilhelm Leibniz 246

The literary estate of Goethe in the Goethe and
Schiller Archives .. 285

Kinder- und Hausmärchen (Children's and Household
Tales)..317

Ludwig van Beethoven: Symphony no. 9,
D minor, op. 125 ..332

Benz patent of 1886... 382

Early cylinder recordings of the world's musical
traditions (1893–1952)... 397

Metropolis – Sicherungsstück Nr. 1: Negative of the
restored and reconstructed version (2001) 454

Construction and fall of the Berlin Wall and the
Two-Plus-Four-Treaty of 1990...520

Ghana
Dutch West India Company (Westindische Compagnie)
archives* ... 220

Guyana
Dutch West India Company (Westindische Compagnie)
archives* ... 220

Records of the Indian indentured labourers*...................... 344

Hungary
Bibliotheca Corviniana* .. 149

Tabula Hungariae*...164

Csoma archive of the Library of the Hungarian
Academy of Sciences.. 328

János Bolyai: Appendix, Scientiam Spatii absolute veram
exhibens.. 348

Kalman Tihanyi's 1926 patent application 'Radioskop'....... 452

Iceland
The Arnamagnæan manuscript collection* 87

India
Rigveda .. 26

Saiva manuscripts in Pondicherry 40

Laghukālacakratantrarājatikā (Vimalaprabhā) 59

Tarikh-e-Khandan-e-Timuriyah 196

Archives of the Dutch East India Company* 214

The IAS Tamil medical manuscript collection 222

Indonesia
La Galigo* ... 117

Archives of the Dutch East India Company* 214

Iran
Al-Tafhim li Awa'il Sana'at al-Tanjim 76

The Deed For Endowment: Rab' i-Rashidi (Rab
i-Rashidi Endowment) .. 114

Collection of Nezami's Panj Ganj 120

'Bayasanghori Shâhnâmeh' (Prince Bayasanghor's
'Book of the Kings') .. 137

Administrative documents of Astan-e Quds Razavi
in the Safavid era ... 198

Ireland
The Book of Kells ... 54

Italy
Lucca's historical diocesan archives 52

The Malatesta Novello Library 142

Bibliotheca Corviniana* ... 149

Jamaica
Registry of Slaves of the British Caribbean
1817–1834* ... 326

Silver men: West Indian labourers at the Panama
Canal* ... 376

Japan
Sakubei Yamamoto collection 418

Kazakhstan
Collection of the manuscripts of Khoja Ahmed Yasawi 186

Audiovisual documents of the international antinuclear
movement 'Nevada-Semipalatinsk' 490

Aral Sea archival fonds .. 530

Korea (Republic of)
Printing woodblocks of the Tripitaka Koreana 98

Baegun hwasang chorok buljo jikji simche yojeol
(vol. II) ... 122

The Annals of the Joseon dynasty 124

The Hunminjeongum manuscript 141

Uigwe: The royal protocols of the court
of Joseon dynasty ... 213

Donguibogam: 'Principles and Practice of Eastern
Medicine' ... 218

Seungjeongwon Ilgi, the diaries of the royal
secretariat ... 227

Ilseongnok: Records of Daily Reflections 286

Human rights documentary heritage, 1980 546

Latvia
Dainu Skapis – Cabinet of folksongs 374

The Baltic Way – Human chain linking three states in
their drive for freedom* ... 556

Lebanon
Commemorative stelae of Nahr el-Kalb, Mount
Lebanon ... 30

The Phoenician alphabet ... 32

Lithuania
Radziwills' Archives and Niasvizh (Nieśwież) Library
collection* .. 130

The Baltic Way – Human chain linking three states in
their drive for freedom* ... 556

Luxembourg
The Family of Man ... 510

Madagascar
Royal archives (1824–1897) 334

Malaysia
Batu Bersurat, Terengganu (Inscribed Stone of Terengganu) ..116

Sejarah Melayu (The Malay Annals) 219

Hikayat Hang Tuah ... 236

Correspondence of the late Sultan of Kedah (1882–1943) ... 385

Mauritius
Records of the French occupation of Mauritius 256

Mexico
Sixteenth to eighteenth century pictographs from 'Maps, drawings and illustrations' Archives of Mexico 168

Collection of Mexican codices 172

Colección de lenguas indígenas 174

Collection of the Center of Documentation and Investigation of the Ashkenazi community in Mexico 179

Codices from the Oaxaca Valley 183

American colonial music: a sample of its documentary richness* .. 188

Codex Techaloyan de Cuajimalpaz 208

Biblioteca Palafoxiana .. 233

Los Olvidados ... 494

Mongolia
Lu.'Altan Tobchi': Golden History written in 1651 240

Mongolian Tanjur .. 279

Morocco
Kitab al-ibar, wa diwan al-mobtadae wa al-khabar 125

Namibia
Letter journals of Hendrik Witbooi 408

Netherlands
Library Ets Haim–Livraria Montezinos 108

La Galigo* ... 117

Archives of the Dutch East India Company* 214

Dutch West India Company (Westindische Compagnie) archives* ... 220

Archives of the Middelburgsche Commercie Compagnie* ... 274

Desmet collection .. 425

Diaries of Anne Frank ... 478

New Zealand
The Treaty of Waitangi .. 356

The 1893 Women's Suffrage Petition 394

Nicaragua
National Literacy Crusade 552

Norway
The Leprosy Archives of Bergen 308

Henrik Ibsen: A Doll's House 379

Roald Amundsen's South Pole Expedition (1910–1912) .. 428

Thor Heyerdahl archives 461

Pakistan
Jinnah papers (Quaid-i-Azam) 372

Panama
Silver men: West Indian labourers at the Panama Canal* .. 376

Paraguay
The Archives of Terror ... 498

Peru
American colonial music: a sample of its documentary richness* .. 188

Philippines
Philippine Paleographs (Hanunoo, Buid, Tagbanua and Pala'wan) ... 61

Presidential papers of Manuel L. Quezon 416

José Maceda collection 505

Radio broadcast of the Philippine People Power Revolution ... 554

Poland

Codex Suprasliensis*..71

Radziwills' Archives and Niasvizh (Nieśwież) Library collection*.. 130

Nicolaus Copernicus' masterpiece 'De revolutionibus libri sex'... 180

The Confederation of Warsaw of 28th of January 1573... 194

National Education Commission archives290

The masterpieces of Fryderyk Chopin.....................................314

Warsaw Ghetto archives (Emanuel Ringelblum archives)... 470

Archive of Warsaw Reconstruction Office 482

Archives of the Literary Institute in Paris (1946–2000) ...546

Twenty-One demands, Gdańsk, August 1980...................... 549

Portugal

Corpo Cronológico (collection of manuscripts on the Portuguese discoveries)................................... 128

Treaty of Tordesillas*...156

Letter from Pêro Vaz de Caminha...............................159

Arquivos dos Dembos / Ndembu archives*..........................253

First flight across the South Atlantic Ocean in 1922 449

Russian Federation

Codex Suprasliensis*..71

Ostromir Gospel (1056–1057) 78

Archangel Gospel of 1092 ... 83

Khitrovo Gospel ...123

Slavonic publications in Cyrillic script of the 15th century... 126

Radziwills' Archives and Niasvizh (Nieśwież) Library collection*.. 130

Tolstoy's personal library and manuscripts, photo and film collection .. 202

Collection of 18th-century maps of the Russian empire..260

Newspaper collections, Russian Federation......................... 264

The Historical Collections (1889–1955) of St Petersburg Phonogram Archives .. 386

Russian posters of the end of the 19th and early 20th centuries .. 412

Saint Kitts and Nevis

Registry of Slaves of the British Caribbean 1817–1834*.. 326

Saint Lucia

Silver men: West Indian labourers at the Panama Canal*.. 376

Sir William Arthur Lewis papers ... 458

Saudi Arabia

Earliest Islamic (Kufic) inscription ..48

Senegal

Fonds of the Afrique occidentale française (AOF)................ 402

Serbia

Miroslav Gospel – manuscript from 118090

Nikola Tesla's Archive .. 380

Slovakia

Illuminated codices from the library of the Bratislava Chapter House...84

Bašagić collection of Islamic manuscripts.............................176

Mining maps and plans of the Main Chamber – Count Office in Banská Štiavnica.. 230

Slovenia

Codex Suprasliensis*..71

South Africa

Archives of the Dutch East India Company*...................... 214

The Bleek collection ... 329

Criminal Court Case No. 253/1963 (The State versus
N. Mandela and Others) ..525

Liberation Struggle Living Archive Collection 544

Spain
Santa Fe Capitulations ..154

Treaty of Tordesillas* ..156

Sri Lanka
Archives of the Dutch East India Company* 214

Suriname
Dutch West India Company (Westindische Compagnie)
archives* ...220

Archives of the Middelburgsche Commercie
Compagnie* ...274

Records of the Indian indentured labourers*344

Sweden
Codex Argenteus – the 'Silver Bible' 42

Stockholm City Planning Committee archives 270

Emanuel Swedenborg collection272

Alfred Nobel family archives ..360

Ingmar Bergman archives ..464

Astrid Lindgren archives ... 474

Switzerland
Jean-Jacques Rousseau, Geneva and Neuchâtel
collections ..269

Tajikistan
The manuscript of Ubayd Zakoni's Kulliyat and
Hafez Sherozi's Gazalliyt ..110

Tanzania
Collection of Arabic manuscripts and books266

German records of the National Archives388

Thailand
The King Ram Khamhaeng inscription 104

Epigraphic archives of Wat Pho346

Archival documents of King Chulalongkorn's
transformation of Siam (1868–1910)369

Trinidad and Tobago
Registry of Slaves of the British Caribbean
1817–1834* .. 326

Records of the Indian indentured labourers*344

Constantine collection ..446

C.L.R. James collection .. 456

Derek Walcott collection ...508

Eric Williams collection ..514

Tunisia
Privateering and the international relations of the
Regency of Tunis in the 18th and 19th centuries 258

Turkey
The Hittite cuneiform tablets from Bogazköy 24

Kandilli Observatory and Earthquake Research
Institute manuscripts ... 70

The works of Ibn Sina in the Süleymaniye
Manuscript Library ..72

Ukraine
Radziwills' Archives and Niasvizh (Nieśwież) Library
collection* .. 130

Collection of Jewish musical folklore (1912–1947) 430

United Kingdom
Magna Carta, issued in 1215 ..96

Hereford Mappa Mundi .. 102

Dutch West India Company (Westindische Compagnie)
archives* ...220

Registry of Slaves of the British Caribbean
1817–1834* .. 326

Silver men: West Indian labourers at the Panama
Canal* ... 376

Historic ethnographic recordings (1898–1951) at the
British Library ..404

The Battle of the Somme..438

The Appeal of 18 June 1940*..476

United States of America
Universalis cosmographia secundum Ptholomaei
traditionem et Americi Vespucii aliorumque
Lustrationes*.. 162

Dutch West India Company (Westindische Compagnie)
archives*...220

Silver men: West Indian labourers at the Panama
Canal*.. 376

The Wizard of Oz (Victor Fleming, 1939), produced by
Metro-Goldwyn-Mayer..466

John Marshall Ju/'hoan bushman film and video
collection, 1950–2000..500

Landsat Program records: Multispectral Scanner
(MSS) sensors ...532

Uruguay
Original records of Carlos Gardel – Horacio Loriente
collection (1913–1935).. 432

Uzbekistan
Holy Koran Mushaf of Othman ... 50

The collection of the Al-Biruni Institute of Oriental
Studies..60

Venezuela
Colombeia: Generalissimo Francisco de Miranda's
archives ... 294

General Archive of the Nation: Writings of The
Liberator Simón Bolívar.. 320

Collection of Latin American photographs of the
19th century ..415

Vietnam
Stone stele records of royal examinations of the Le and
Mac dynasties (1442–1779)... 138

Woodblocks of the Nguyễn dynasty 254

Other
Christopher Okigbo Foundation (Africa)
Christopher Okigbo collection...512

International Committee of the Red Cross (ICRC)
Archives of the International Prisoners of War Agency,
1914–1923... 434

United Nations Office at Geneva (UNOG)
League of Nations archives 1919–1946................................. 443

United Nations Relief and Works Agency for Palestine
Refugees (UNRWA)
UNRWA photo and film archives of Palestinian
refugees .. 492

* Joint Inscriptions between 2 or more countries.

Index of inscriptions

A Doll's House (Ibsen)379

Administrative documents of Astan-e Quds Razavi in the Safavid era198

A.E. Nordenskiöld Collection, The364

Afrique occidentale française (AOF), fonds of the402

Al-Biruni Institute of Oriental Studies, the collection of the60

Al-Tafhim li Awa'il Sana'at al-Tanjim76

Alfred Nobel family archives360

Alphabet, The Phoenician32

America, Jesuits of206

American colonial music: a sample of its documentary richness188

Amundsen, Roald, South Pole Expedition (1910–1912) ...428

Ancient Naxi Dongba literature manuscripts36

Andersen, Hans Christian, manuscripts and correspondence of340

Annals of the Joseon dynasty, The124

Antinuclear movement, international, 'Nevada-Semipalatinsk', audiovisual documents of the490

Appeal of 18 June 1940, The476

Appendix, Scientiam Spatii absolute veram exhibens (Bolyai)348

Arabic manuscripts and books, collection of266

Aral Sea archival fonds530

Archangel Gospel of 109283

Architectural drawings, Gothic, collection of134

Archival documents of King Chulalongkorn's transformation of Siam (1868–1910)369

Archival records, Hudson's Bay Company250

Archive, Csoma, of the Library of the Hungarian Academy of Sciences328

Archive, General, of the Nation: Writings of The Liberator Simón Bolívar320

Archive, Human Rights, of Chile538

Archive, Nikola Tesla's380

Archive of Warsaw Reconstruction Office482

Archives, Alfred Nobel family360

Archives of Astrid Lindgren474

Archives, business, of the Officina Plantiniana190

Archives, Collection, Liberation Struggle Living544

Archives, Colonial, Benin362

Archives of the Danish overseas trading companies ...248

Archives of the Dutch East India Company214

Archives, Dutch West India Company (Westindische Compagnie)220

Archives, epigraphic, of Wat Pho346

Archives, Federal Archives fonds488

Archives of Generalissimo Francisco de Miranda: Colombeia ...294

Archives, Goethe and Schiller, the literary estate of Goethe in the285

Archives, Ingmar Bergman464

Archives Insolvente Boedelskamer Antwerpen160

Archives of the International Prisoners of War Agency, 1914–1923434

Archives, League of Nations archives 1919–1946443

Archives, Leprosy of Bergen, The308

Archives of the Literary Institute in Paris (1946–2000) ...486

Archives, Lucca's historical diocesan52

Archives, 'Maps, drawings and illustrations', of Mexico: sixteenth to eighteenth century pictographs from168

Archives of the Middelburgsche Commercie Compagnie ...274

Archives, National Education Commission290

Archives, National, German records of the388

Archives, National and Library organizations, treasures from ...127

Archives, National, Y9, France184

Archives, Negros y Esclavos169

Archives, Qing dynasty Yangshi Lei280

Archives, Radziwills', and Niasvizh (Nieswiez) Library collection ... 130

Archives, Royal (1824–1897)334

Archives, St Petersburg Phonogram, The Historical Collections (1889–1955) of ... 386

Archives, the Søren Kierkegaard323

Archives, Stockholm City Planning Committee 270

Archives of Terror, The 498

Archives, Thor Heyerdahl461

Archives, traditional music sound 502

Archives, Tuol Sleng Genocide Museum 540

Arnamagnæan manuscript collection, the 87

Arnold Schönberg estate .. 370

Arquivos dos Dembos / Ndembu archives253

Ashkenazi community in Mexico, Center of Documentation and Investigation of the, collection of the ..179

Astan-e Quds Ravazi, administrative documents of, in the Safavid era198

Astrid Lindgren archives ...474

Atlas Blaeu–Van der Hem, The 242

Audiovisual documents of the international antinuclear movement 'Nevada-Semipalatinsk'490

Australia, The Convict Records of 298

Austrian National Library, Mainz Psalter at the 153

Baegun hwasang chorok buljo jikji simche yojeol (vol. II) ..122

Baltic Way, The – Human chain linking three states in their drive for freedom556

Banská Štiavnica, Main Chamber – Count Office in, mining maps and plans of the 230

Baptism of Slaves, Book for the (1636–1670) 228

Barrow, Nita, Collection ... 496

Bašagic collection of Islamic manuscripts176

Batu Bersurat, Terengganu (Inscribed Stone of Terengganu) ...116

'Bayasanghori Shâhnâmeh' (Prince Bayasanghor's 'Book of the Kings') ..137

Bayeux Tapestry ..80

Beatus Rhenanus Library ..165

Beethoven, Ludwig van: Symphony no. 9, D minor, op. 125 ..332

Belarusian, Russian and Ukrainian émigré periodicals 1918–1945, collection of 442

Ben Cao Gang Mu 本草纲目 (Compendium of Materia Medica) ..200

Benin Colonial archives ..362

Benz patent of 1886 ..382

Bergen, The Leprosy Archives of 308

Bergman, Ingmar, archives 464

Berlin Wall, construction and fall of the, and the Two-Plus-Four-Treaty of 1990 520

Bible, The 42-line Gutenberg, printed on vellum146

Biblia Latina. Commonly called 'The Hamburg Bible', MS. GKS 4 20, vol. I–III 100

Biblioteca Palafoxiana233

Bibliotheca Corviniana ..149

Blaeu–Van der Hem, The Atlas 242

Bleek collection, The ...329

Bogazköy, the Hittite cuneiform tablets from 24

Bolívar, Simón, The Liberator, Writings of the: General Archive of the Nation 320

Bolyai, János: Appendix, Scientiam Spatii absolute veram exhibens ...348

Book for the Baptism of Slaves (1636–1670) 228

Book of Kells, The ... 54

Brahms collection .. 350

Bratislava Chapter House, illuminated codices from the library of the ... 84

Brazil, military regime in, network of information and counter information on the, (1964–1985)527

British Caribbean, registry of slaves of the
1817–1834 ..326

British Library, Historic ethnographic recordings
(1898–1951) at the .. 404

Buddhist Priests, Anthology of Great, Zen Teachings,
second volume (Baegun hwasang chorok buljo jikji
simche yojeol (vol. II))122

Buid (Philippine Paleograph) 61

Bulgarian Cyrillic old manuscript (fragment) of the
11th century, Enina Apostolos 68

Business archives of the Officina Plantiniana 190

Byurakan Survey, First (FBS or Markarian survey)528

Byzantine Georgian manuscripts 62

Cabinet of folksongs (Dainu Skapis)374

Capitulations, Santa Fe154

Caribbean, documentary heritage of enslaved
peoples of the .. 209

Caribbean, British, registry of slaves of the
1817–1834 ..326

Carlos Gardel – Horacio Loriente collection
(1913–1935), original records of432

Catecismo corticu pa uso di catolicanan di
Curaçao (first catechism written in Papiamentu
language) ..336

Center of Documentation and Investigation of
the Ashkenazi community in Mexico, collection
of the ...179

Châtelet de Paris banner register from the reign
of Francis I (National Archives Y9, France)184

Children's and Household Tales (Kinder- und
Hausmärchen) .. 317

Chile, Human Rights Archive of538

Chopin, Fryderyck, The masterpieces of314

Christopher Okigbo collection512

Chulalongkorn, King, archival documents of his
transformation of Siam (1868–1910) 369

Cistercian Abbey of Clairvaux, library of the,
at the time of Pierre de Virey (1472)150

Citizen, the, and Man, Original Declaration of the
Rights of (1789–1791) 302

Clairvaux, library of the Cistercian Abbey of, at the
time of Pierre de Virey (1472)150

C.L.R. James collection456

Codex Argenteus – the 'Silver Bible' 42

Codex Purpureus Beratinus 44

Codex Suprasliensis ..71

Codex Techaloyan de Cuajimalpaz208

codices, illuminated, from the library of the Bratislava
Chapter House ... 84

Codices from the Oaxaca Valley183

Colección de lenguas indígenas174

Collection of 18th-century maps of the Russian
empire ... 260

Collection of 526 prints of university theses from
1637 to 1754 ...232

Collection of the Al-Biruni Institute of Oriental
Studies, the ..60

Collection of Arabic manuscripts and books 266

Collection, Archive, Liberation Struggle Living544

Collection, the Arnamagnæan manuscript 87

Collection, Carlos Gardel – Horacio Loriente, original
records of (1913–1935)432

Collection of the Center of Documentation
and Investigation of the Ashkenazi community
in Mexico ...179

Collection, Constantine 446

Collection, Derek Walcott 508

Collection, Desmet425

Collection, Emanuel Swedenborg272

Collection, the Emperor's358

Collection, Eric Williams 514

Collection of Gothic architectural drawings134

Collection, the IAS Tamil medical manuscript 222

Collection of Jewish musical folklore (1912–1947) 430

Collection, José Maceda505

Collection of Latin American photographs of the
19th century ..415

Collection, Linné276

Collection of manuscripts on the Portuguese
discoveries (Corpo Cronológico)128

Collection, Mashtots Matenadaran ancient
manuscripts .. 38

Collection of medieval manuscripts of the
Czech Reformation .. 112

Collection of Mexican codices 172

Collection, Neuchâtel and Geneva,
Jean-Jacques Rousseau .. 269

Collection of Nezami's Panj Ganj 120

Collection, Nita Barrow 496

Collection of Russian, Ukrainian and Belarusian
émigré periodicals 1918–1945 442

Collection of the manuscripts of Khoja Ahmed
Yasawi ...186

Collection, Sakubei Yamamoto418

Collection, The A.E. Nordenskiöld 364

Collection, The Bleek329

Collection, Tolstoy's personal library and
manuscripts, photo and film 202

Collections, The Historical, (1899–1950) of the Vienna
Phonogrammarchiv406

Collections, The Historical, of St Petersburg
Phonogram Archives (1889–1955) 386

Colombeia: Generalissimo Francisco de Miranda's
archives 294

Colonial archives, Benin362

Commemorative stela of Nahr el-Kalb,
Mount Lebanon ... 30

Confederation of Warsaw, The, of 28th of
January 1573 ...194

Constantine collection 446

Construction and fall of the Berlin Wall and the
Two-Plus-Four-Treaty of 1990 520

Convict Records of Australia, The 298

Cook, James, The Endeavour journal of 288

Copernicus, Nicolaus, masterpiece
'De revolutionibus libri sex' .. 180

Corpo Cronológico (collection of manuscripts
on the Portuguese discoveries)128

Correspondence of the late Sultan of Kedah
(1882–1943) ..385

Criminal Court Case No. 253/1963 (The State versus
N. Mandela and Others) 525

Csoma archive of the Library of the Hungarian
Academy of Sciences328

Cuneiform tablets, Hittite, from Bogazköy 24

Cylinder recordings, early, of the world's musical
traditions (1893–1952)397

Cyrillic, Bulgarian, old manuscript (fragment)
of the 11th century, Enina Apostolos 68

Cyrillic script, Slavonic publications in,
of the 15th century ..126

Czech Reformation, collection of medieval
manuscripts of the .. 112

Daily Reflections, Records of: Ilseongnok 286

Dainu Skapis – Cabinet of folksongs374

Danish overseas trading companies,
Archives of the 248

de Caminha, Pero Vaz, letter from159

de Miranda, Generalissimo Francisco,
archives: Colombeia .. 294

'De revolutionibus libri sex' (Copernicus) 180

Decimal metric system, introduction of the,
1790–1837 .. 306

Deed For Endowment, The: Rab' i-Rashidi
(Rab i-Rashidi Endowment)114

Deeds of sultans and princes 65

Dembos, Arquivos dos (Ndembu archives)253

Derek Walcott collection ..508

Desmet collection ..425

Diaries of Anne Frank ...478

Diocesan archives, Lucca's historical 52

Documentary fonds of Royal Audiencia Court of
La Plata (RALP) ..191

Documentary heritage 1976–1983, Human rights543

Documentary heritage 1980, Human rights546

Documentary heritage of enslaved peoples
of the Caribbean ...209

Documentary heritage on the resistance and
struggle for human rights in the Dominican
Republic, 1930–1961 ..457

Documentary heritage of the Viceroyalty of the
Río de la Plata .. 292

Dominican Republic, documentary heritage on the
resistance and struggle for human rights in,
1930–1961 ...457

Donguibogam: 'Principles and Practice of Eastern
Medicine' ...218

Dutch East India Company, Archives of the214

Dutch West India Company, (Westindische
Compagnie) archives ..220

Earliest Islamic (Kufic) inscription 48

Early cylinder recordings of the world's musical
traditions (1893–1952) ..397

Eastern Medicine, Principles and Practice of:
Donguibogam ...218

El Primer Nueva Corónica y Buen Gobierno212

Emanuel Ringelblum archives (Warsaw Ghetto
Archives) .. 470

Emanuel Swedenborg collection272

Émigré periodicals 1918–1945, Russian, Ukrainian
and Belarusian .. 442

Emperor's collection, the ..358

Endeavour journal of James Cook, The 288

Endowment, The Deed for: Rab' i-Rashidi
(Rab i-Rashidi Endowment) ..114

Enina Apostolos, Old Bulgarian Cyrillic manuscript
(fragment) of the 11th century 68

Enslaved peoples of the Caribbean,
documentary heritage of .. 209

Epigraphic archives of Wat Pho346

Eric Williams collection ...514

Erzherzog Rainer, Papyrus .. 28

Ethnographic Historic Recordings (1898–1951)
at the British Library ... 404

Family archives, Alfred Nobel 360

Family of Man, The ...510

Farquharson's Journal ..345

Federal Archives fonds ... 488

Final document of the Congress of Vienna324

First Byurakan Survey (FBS or Markarian survey)528

First flight across the South Atlantic Ocean
in 1922 ... 449

First New Chronicle and Good Government, The
(El Primer Nueva Corónica y Buen Gobierno)212

Fleming, Victor, The Wizard of Oz, produced by
Metro-Goldwyn-Mayer .. 466

Folklore, musical, collection of Jewish (1912–1947) 430

Folksongs, cabinet of (Dainu Skapis)374

Fonds of the Afrique occidentale française (AOF)402

Francis I, Châtelet de Paris banner register from the reign
of (National Archives Y9, France)184

Frank, Anne, Diaries of ..478

French occupation of Mauritius, records of the256

Fryderyk Chopin, The masterpieces of314

Galigo, La .. 117

Gardel, Carlos, – Horacio Loriente collection
(1913–1935), original records of432

Gazalliyt, Hafez Sherozi's, and Ubayd Zakoni's Kulliyat, the manuscript of110

Gdańsk, Twenty-One demands, August 1980.............549

General Archive of the Nation: Writings of The Liberator Simón Bolívar320

Geneva and Neuchâtel collections, Jean-Jacques Rousseau269

Georgian Byzantine manuscripts62

German records of the National Archives388

Goethe and Schiller Archives, the literary estate of Goethe in the285

Golden History written in 1651: Lu.'Altan Tobchi'240

Golden Lists of the Qing dynasty imperial examination244

Gospel, Archangel, of 109283

Gospel, Khitrovo123

Gospel, Miroslav – manuscript from 118090

Gospel, Ostromir (1056–1057)78

Gothic architectural drawings, collection of134

Grand Secretariat, Qing's, Records of the239

Gutenberg Bible, The 42-line, printed on vellum146

Hafez Sherozi's Gazalliyt and Ubayd Zakoni's Kulliyat, the manuscript of110

'Hamburg Bible, The' (Biblia Latina), MS. GKS 4 20, vol. I–III100

Hang Tuah, Hikayat236

Hans Christian Andersen, manuscripts and correspondence of340

Hanunoo (Philippine Paleograph)61

Hendrik Witbooi, letter journals of408

Henrik Ibsen: A Doll's House379

Hereford Mappa Mundi102

Heyerdahl, Thor, Archives461

Hikayat Hang Tuah236

Historic ethnographic recordings (1898–1951) at the British Library404

Hittite cuneiform tablets from Bogazköy, The24

Holy Koran Mushaf of Othman50

Huang Di Nei Jing 黄帝内经 (Yellow Emperor's Inner Canon)35

Hudson's Bay Company archival records250

Human rights, of Man and of the Citizen, Original Declaration of the (1789–1791)302

Human Rights Archive of Chile538

Human rights documentary heritage, 1976–1983543

Human rights documentary heritage, 1980546

Human rights, documentary heritage on the resistance and struggle for, in the Dominican Republic 1930–1961457

Hungariae, Tabula164

Hungarian Academy of Sciences, Library of, Csoma archive328

Hunminjeongum manuscript, the141

IAS Tamil medical manuscript collection, the222

Ibn Sina, the works of, in the Süleymaniye Manuscript Library72

Ibsen, Henrik: A Doll's House379

ICAIC, Original negative of the Noticiero ICAIC Latinoamericano519

Illuminated codices from the library of the Bratislava Chapter House84

Illuminated manuscripts from the Ottonian period produced in the monastery of Reichenau (Lake Constance)66

Ilseongnok: Records of Daily Reflections286

Indian indentured labourers, records of the344

Ingmar Bergman archives464

Insolvente Boedelskamer Antwerpen, Archives160

International Prisoners of War Agency, Archives of the (1914–1923)434

Introduction of the decimal metric system, 1790–1837306

Islamic (Kufic) inscription, earliest48

Islamic manuscripts, Bašagic collection of176

James, C.L.R., Collection456

James Cook, The Endeavour journal of288

János Bolyai: Appendix, Scientiam Spatii absolute veram exhibens348

Jean-Jacques Rousseau, Geneva and Neuchâtel collections269

Jesuits of America206

Jewish musical folklore (1912–1947), collection of430

Jinnah papers (Quaid-i-Azam)372

John Marshall Ju/'hoan bushman film and video collection, 1950–2000500

José Maceda collection505

'José Martí Pérez' fonds366

Joseon dynasty, The Annals of the124

Joseon dynasty, Uigwe: The royal protocols of the court of213

Ju/'hoan bushman film and video collection, 1950–2000 (John Marshall)500

Kalman Tihanyi's 1926 patent application 'Radioskop'452

Kandilli Observatory and Earthquake Research Institute manuscripts70

Kedah, Sultan of (1882–1943), correspondence of385

Kells, The Book of54

Kelly Gang, the Story of the (1906)422

Khitrovo Gospel123

Khoja Ahmed Yasawi, Collection of the manuscripts of186

Kierkegaard, Søren, the archives323

Kinder- und Hausmärchen (Children's and Household Tales)317

King Ram Khamhaeng inscription, the104

Kitab al-ibar, wa diwan al-mobtadae wa al-khabar125

Koran, Holy, Mushaf of Othman50

Kufic inscription48

Kulliyat, Ubayd Zakoni's, and Hafez Sherozi's Gazalliyt, the manuscript of110

La Galigo117

Labourers, Indian indentured, records of the344

Labourers, West Indian, at the Panama Canal: Silver men376

Laghukalacakratantrarajatika (Vimalaprabha)59

Landsat Program records: Multispectral Scanner (MSS) sensors532

Latin American photographs of the 19th century, collection of415

Le and Mac dynasties, stone stele records of royal examinations of the (1442–1779)138

League of Nations archives 1919–1946443

Lebanon, Mount, commemorative stela of Nahr el-Kalb30

Leibniz, Gottfried Wilhelm, Letters from and to246

Lenguas indígenas, colección de174

Leprosy Archives of Bergen, The308

Letter from Pêro Vaz de Caminha159

Letter journals of Hendrik Witbooi408

Letters from and to Gottfried Wilhelm Leibniz246

Lewis, Sir William Arthur, papers458

Liberation Struggle Living Archive Collection544

Library, Austrian National, Mainz Psalter at the153

Library, Beatus Rhenanus165

Library, Biblioteca Palafoxiana233

Library of the Bratislava Chapter House, illuminated codices from84

Library, British, Historic ethnographic recordings (1898–1951) at the404

Library of the Cistercian Abbey of Clairvaux at the time of Pierre de Virey (1472)150

Library Ets Haim–Livraria Montezinos108

Library of the Hungarian Academy of Sciences, Csoma archive328

Library, The Malatesta Novello142

Library and National Archives organizations, treasures from127

Library, Niasvizh (Nieswiez), collection, and Radziwills' Archives 130

Library, Süleymaniye Manuscript, the works of Ibn Sina in72

Library, Bibliotheca Corviniana149

Library, The Vienna City, Schubert collection 311

Library, Tolstoy's personal, manuscripts, photo and film collection202

Lindgren, Astrid, archives474

Linné collection276

Literacy Crusade, National 552

Literary Institute in Paris, Archives of the (1946–2000) 486

Loriente, Noracio, – Carlos Gardel Collection (1913–1935), original records of432

Los Olvidados 494

Lu.'Altan Tobchi': Golden History written in 1651 240

Lucca's historical diocesan archives 52

Ludwig van Beethoven: Symphony no. 9, D minor, op. 125332

Lumière films 398

Mabo case manuscripts, The516

Mac and Le dynasties, stone stele records of royal examinations of the (1442–1779)138

Maceda, José, Collection505

McLaren, Norman, animated Neighbours, directed and produced by, in 1952 504

Magna Carta, issued in 1215 96

Mainz Psalter at the Austrian National Library 153

Malatesta Novello Library, The142

Malay Annals, The (Sejarah Melayu)219

Man, The Family of510

Mandela N., and Others, The State versus (Criminal Court Case No. 253/1963) 525

Manifesto of the Queensland Labour Party to the people of Queensland391

Manuel L. Quezon, presidential papers of416

Manuscripts and correspondence of Hans Christian Andersen 340

Mappa Mundi, Hereford 102

Maps, collection of 18th-century, of the Russian empire 260

'Maps, drawings and illustrations' Archives of Mexico, sixteenth to eighteenth century pictographs from168

Markarian survey528

Marshall, John, Ju/'hoan bushman film and video collection, 1950–2000500

Mashtots Matenadaran ancient manuscripts collection 38

masterpieces of Fryderyk Chopin, The314

Materia Medica, Compendium of (Ben Cao Gang Mu 本草纲目)200

Mauritius, records of the French occupation of256

Medical manuscript collection, the IAS Tamil 222

Medicine, Eastern, Principles and Practice of: Donguibogam218

Medicine and pharmacy, medieval manuscripts on 86

Medieval manuscripts of the Czech Reformation, collection of112

Medieval manuscripts on medicine and pharmacy 86

Memory of the Suez Canal352

Metric system, decimal, introduction of the, 1790–1837 306

Metro-Goldwyn-Mayer, The Wizard of Oz (Victor Fleming) produced by 466

Metropolis – Sicherungsstück Nr. 1: Negative of the restored and reconstructed version (2001)454

Mexican codices, collection of 172

Mexico, Center of Documentation and Investigation of the Ashkenazi community in, collection of the179

Mexico, 'Maps, drawings and illustrations'
Archives of, sixteenth to eighteenth century
pictographs from ..168

Middelburgsche Commercie Compagnie,
Archives of the ..274

Mining maps and plans of the Main Chamber –
Count Office in Banská Štiavnica 230

Miroslav Gospel – manuscript from 118090

Mongolian Tanjur ..279

MS. GKS 4 20, vol. I–III, Biblia Latina. Commonly
called 'The Hamburg Bible'100

Multispectral Scanner (MSS) sensors: Landsat
Program records ..532

Music sound, traditional, archives 502

Musical traditions (1893–1952), world's,
early cylinder recordings of the397

Nahr el-Kalb, commemorative stela,
Mount Lebanon ... 30

National Archives, German records of the 388

National Archives and Library organizations,
treasures from ...127

National Education Commission archives 290

National Literacy Crusade552

Naxi Dongba, ancient literature manuscripts 36

Ndembu archives / Arquivos dos Dembos253

Negros y Esclavos archives169

Neighbours, animated, directed and produced
by Norman McLaren in 1952 504

Network of information and counter information
on the military regime in Brazil (1964–1985)527

Neuchâtel and Geneva collections,
Jean-Jacques Rousseau 269

'Nevada-Semipalatinsk', international antinuclear
movement, audiovisual documents of the490

Newspaper collections, Russian Federation 264

Nezami's Panj Ganj, collection of 120

Nguyễn dynasty, woodblocks of the254

Niasvizh (Nieswiez) Library collection
and Radziwills' Archives 130

Nibelungs, Song of the, a heroic poem from
medieval Europe .. 94

Nicolaus Copernicus' masterpiece
'De revolutionibus libri sex'180

Nikola Tesla's Archive380

Nita Barrow collection496

Nobel, Alfred, family archives360

Nordenskiöld, A.E., The Collection364

Norman McLaren, animated Neighbours,
directed and produced by, in 1952504

Noticiero ICAIC Latinoamericano,
Original negative of the519

Oaxaca Valley, Codices from the183

Officina Plantiniana, Business archives of the 190

Okigbo, Christopher, Collection512

Olvidados, Los ... 494

Original Declaration of the Rights of Man and
of the Citizen (1789–1791) 302

Original negative of the Noticiero ICAIC
Latinoamericano ..519

Original records of Carlos Gardel – Horacio Loriente
collection (1913–1935)432

Ostromir Gospel (1056–1057) 78

Othman, Holy Koran Mushaf of 50

Ottonian period, Illuminated manuscripts from
the, produced in the monastery of Reichenau
(Lake Constance) .. 66

Palafoxiana, Biblioteca233

Paleographs, Philippine (Hanunoo, Buid,
Tagbanua and Pala'wan) 61

Palestinian refugees, UNRWA photo and film
archives of ... 492

Panama Canal, West Indian labourers at:
Silver men ..376

Panj Ganj, Nezami's, collection of 120

Papiamentu language, first catechism written in (catecismo corticu pa uso di catolicanan di Curaçao)336

Papyrus Erzherzog Rainer 28

Paris, Châtelet de, banner register from the reign of Francis I (National Archives Y9, France)184

Paris Literary Institute, Archives of the (1946–2000) ... 486

Patent, Benz, of 1886 284

Patent, Kalman Tihanyi's 1926 application, 'Radioskop'452

Pérez, José Martí, fonds 366

Persian illustrated and illuminated manuscripts118

Peutingeriana, Tabula 92

Pharmacy and medicine, medieval manuscripts on 86

Philippine Paleographs (Hanunoo, Buid, Tagbanua and Pala'wan) 61

Philippine People Power Revolution, Radio broadcast of the554

Phoenician Alphabet, The 32

Phonogram Archives, St Petersburg, The Historical Collections (1889–1955) of 386

Pictographs, Sixteenth to eighteenth century, from 'Maps, drawings and illustrations' Archives of Mexico168

Pondicherry, Saiva manuscripts in40

Portuguese discoveries, collection of manuscripts on the (Corpo Cronológico)128

Presidential papers of Manuel L. Quezon416

princes and sultans, deeds of 65

Printing woodblocks of the Tripitaka Koreana 98

Prisoners of War Agency, International, Archives of the (1914–1923)434

Privateering and the international relations of the Regency of Tunis in the 18th and 19th centuries258

Qing dynasty imperial examination, golden lists of the244

Qing dynasty Yangshi Lei archives280

Qing's Grand Secretariat, Records of the239

Quaid-i-Azam (Jinnah papers)372

Quebec Seminary collection, 1623–1800 (17th–19th centuries)224

Queensland, Manifesto of the391

Quezon, Manuel L., presidential papers of416

Rab' i-Rashidi (Rab i-Rashidi Endowment)114

Radio broadcast of the Philippine People Power Revolution554

'Radioskop', Kalman Tihanyi's 1926 patent application452

Radziwills' Archives and Niasvizh (Nieswiez) Library collection 130

RALP see Royal Audiencia Court of La Plata

Ram Khamhaeng, King, inscription 104

Records of Daily Reflections: Ilseongnok 286

Records of the French occupation of Mauritius256

Records of the Indian indentured labourers344

Records of the Qing's Grand Secretariat239

Regency of Tunis, privateering and the international relations of, in the 18th and 19th centuries258

Registers, Sound Toll158

Registry of Slaves of the British Caribbean 1817–1834326

Reichenau (Lake Constance) monastery, illuminated manuscripts from the Ottonian period produced in the 66

Revolution, Philippine People Power, radio broadcast of the554

Rigveda 26

Ringelblum, Emanuel, archives of (Warsaw Ghetto archives)470

Río de la Plata, Viceroyalty of, documentary heritage of the 292

Roald Amundsen's South Pole Expedition (1910–1912)428

Rousseau, Jean-Jacques, Geneva and Neuchâtel collections 269

Royal archives (1824–1897)334

Royal Audiencia Court of La Plata (RALP), documentary fonds of191

Royal protocols, of the court of Joseon dynasty (Uigwe)213

Royal secretariat, diaries of the, the Seungjeongwon Ilgi227

Russian, Ukrainian and Belarusian émigré periodicals 1918–1945, collection of442

Russian empire, collection of 18th-century maps of the260

Russian Federation, newspaper collections264

Russian posters of the end of the 19th and early 20th centuries412

Safavid era, administrative documents of Astan-e Quds Razavi198

St Petersburg Phonogram Archives, The Historical Collections (1889–1955) of386

Saiva manuscripts in Pondicherry40

Sakubei Yamamoto collection418

Santa Fe Capitulations154

Schönberg, Arnold, Estate370

Schubert collection, The Vienna City Library311

Sciences, Hungarian Academy of, Library of: Csoma archive328

Sejarah Melayu (The Malay Annals)219

Seungjeongwon Ilgi, the diaries of the royal secretariat227

Sherozi, Hafez, Gazalliyt and Ubayd Zakoni's Kulliyat, the manuscript of110

Siam, archival documents of King Chulalongkorn's transformation of (1868–1910)369

'Silver Bible', the (Codex Argenteus)42

Silver men: West Indian labourers at the Panama Canal376

Sir William Arthur Lewis papers458

Sixteenth to eighteenth century pictographs from 'Maps, drawings and illustrations' Archives of Mexico168

Slavery, enslaved peoples of the Caribbean, documentary heritage of209

Slavery, Negros y Esclavos archives169

Slaves, Book for the Baptism of (1636–1670)228

Slaves of the British Caribbean 1817–1834, registry of326

Slavonic publications in Cyrillic script of the 15th century126

Somme, The Battle of the438

Song of the Nibelungs, a heroic poem from medieval Europe94

Søren Kierkegaard archives, the323

Sound Toll Registers158

South Atlantic Ocean, first flight across, in 1922449

South Pole Expedition, Roald Amundsen's (1910–1912)428

Stockholm City Planning Committee archives270

Stone stele records of royal examinations of the Le and Mac dynasties (1442–1779)138

Suez Canal, Memory of the352

Suffrage Petition, The Women's 1893394

Süleymaniye Manuscript Library, the works of Ibn Sina in72

sultans and princes, deeds of65

Swedenborg, Emanuel, collection272

Symphony no. 9, D minor, op. 125 (Beethoven)332

Tabula Hungariae164

Tabula Peutingeriana92

Tagbanua (Philippine Paleograph)61

Tapestry, Bayeux80

Tarikh-e-Khandan-e-Timuriyah196

Terengganu, Inscribed Stone of (Batu Bersurat, Terengganu)116

Terror, The Archives of498

Tesla, Nikola, Archive380

The 42-line Gutenberg Bible, printed on vellum146

The 1893 Women's Suffrage Petition394

The A.E. Nordenskiöld Collection 364

The Annals of the Joseon dynasty 124

The Appeal of 18 June 1940 476

The Archives of Terror 498

The Arnamagnæan manuscript collection 87

The Atlas Blaeu–Van der Hem 242

The Baltic Way – Human chain linking three
states in their drive for freedom 556

The Battle of the Somme 438

The Bleek collection ... 329

The Book of Kells ... 54

The collection of the Al-Biruni Institute of
Oriental Studies .. 60

The Confederation of Warsaw of 28th of
January 1573 ... 194

The Convict Records of Australia 298

The Deed For Endowment: Rab' i-Rashidi
(Rab i-Rashidi Endowment) 114

The Emperor's collection 358

The Endeavour journal of James Cook 288

The Family of Man .. 510

'The Hamburg Bible' (Biblia Latina), MS. GKS 4
20, vol. I–III ... 100

The Historical Collections (1889–1955) of
St Petersburg Phonogram Archives 386

The historical collections (1899–1950) of the Vienna
Phonogrammarchiv ... 406

The Hittite cuneiform tablets from Bogazköy 24

The Hunminjeongum manuscript 141

The IAS Tamil medical manuscript collection 222

The King Ram Khamhaeng inscription 104

The Leprosy Archives of Bergen 308

The literary estate of Goethe in the Goethe and
Schiller Archives ... 285

The Mabo case manuscripts 516

The Malatesta Novello Library, 142

The Malay Annals (Sejarah Melayu) 219

The manuscript of Ubayd Zakoni's Kulliyat and
Hafez Sherozi's Gazalliyt 110

The masterpieces of Fryderyk Chopin 314

The Phoenician alphabet 32

The Søren Kierkegaard archives 323

The Story of the Kelly Gang (1906) 422

The Treaty of Waitangi 356

The Vienna City Library Schubert collection 311

The Wizard of Oz (Victor Fleming, 1939),
produced by Metro-Goldwyn-Mayer 466

The works of Ibn Sina in the Süleymaniye
Manuscript Library ... 72

Thor Heyerdahl archives 461

Tihanyi, Kalman, 1926 patent application
'Radioskop' .. 452

Tolstoy's personal library and manuscripts, photo
and film collection ... 202

Tordesillas, Treaty of 156

Traditional music sound archives 502

Treasures from National Archives and Library
organizations .. 127

Treaty, Two-Plus-Four-, of 1990 520

Treaty of Tordesillas 156

Treaty of Waitangi, The 356

Tripitaka Koreana, printing woodblocks of the 98

Tunis, Regency of, privateering and the international
relations of, in the 18th and 19th centuries 258

Tuol Sleng Genocide Museum archives 540

Twenty-One demands, Gdańsk, August 1980 549

Two-Plus-Four-Treaty of 1990, and the
construction and fall of the Berlin Wall 520

Ubayd Zakoni's Kulliyat and Hafez Sherozi's
Gazalliyt, the manuscript of 110

Uigwe: The royal protocols of the court
of Joseon dynasty .. 213

Ukrainian, Belarusian and Russian émigré
periodicals 1918–1945, collection of 442

Universalis cosmographia secundum Ptholomaei traditionem et Americi Vespucii aliorumque Lustrationes ..162

University theses from 1637 to 1754, collection of 526 prints of ..232

UNRWA photo and film archives of Palestinian refugees ... 492

Viceroyalty of the Río de la Plata, documentary heritage of the .. 292

Victor Fleming, The Wizard of Oz, produced by Metro-Goldwyn-Mayer ... 466

Vienna, the Congress of, final document of the324

Vienna City Library, The, Schubert collection 311

Vienna Dioscurides .. 46

Vienna Phonogrammarchiv, The Historical Collections of the (1899–1950) 406

Vimalaprabha (Laghukalacakratantrarajatika) 59

Virey, Pierre de, library of the Cistercian Abbey of Clairvaux at the times of (1472)150

Waitangi, The Treaty of .. 356

Walcott, Derek, Collection .. 508

Warsaw Ghetto archives (Emanuel Ringelblum archives) ... 470

Warsaw Reconstruction Office, Archive of 482

Warsaw, The Confederation of, of 28th of January 1573 ..194

Wat Pho, epigraphic archives of 346

West Indian labourers at the Panama Canal: Silver men ..376

Westindische Compagnie (Dutch West India Company) archives ... 220

Williams, Eric, Collection ... 514

Witbooi, Hendrik, letter journals of 408

Wizard of Oz, The (Victor Fleming, 1939), produced by Metro-Goldwyn-Mayer .. 466

Women's Suffrage Petition, The 1893 394

Woodblocks, printing, of the Tripitaka Koreana 98

Woodblocks of the Nguyễn dynasty254

Yamamoto, Sakubei, collection418

Yangshi Lei archives, Qing dynasty 280

Yasawi, Khoja Ahmed, Collection of the manuscripts of ...186

Yellow Emperor's Inner Canon (Huang Di Nei Jing 黄帝内经) ..35

Zakoni, Ubayd, Kulliyat and Hafez Sherozi's Gazalliyt, the manuscript of ..110

Contact information

The Hittite cuneiform tablets from Bogazköy 24

Directorate of Istanbul Archaeological Museums
İstanbul Arkeoloji Müzeleri Alemdar Cad. Osman Hamdi
Bey Yokuşu Sk, 34122, Sultanahmet / Fatih, Istanbul, Turkey
http://www.istanbularkeoloji.gov.tr/main_page

Directorate of Ankara Anatolian Civilizations Museum
Gözcü Sokak No:2 06240 Ulus, Ankara, Turkey
http://www.kultur.gov.tr/EN,39516/ankara---
anatolian-civilizations-museum.html

German Archaeological Institute, Istanbul Department,
Inönü Caddesi 10, 34437 Istanbul, Turkey
http://www.dainst.org/en?ft=all

Rigveda 26
Bhandarkar Oriental Research Institute, Pune, India
http://www.bori.ac.in

Papyrus Erzherzog Rainer 28
Austrian National Library (Österreichische Nationalbibliothek)
Vienna, Austria
http://www.onb.ac.at (with English option on landing page)
http://www.onb.ac.at/ev (English language page)

Commemorative stela of Nahr el-Kalb, Mount Lebanon 30
Nahr el-Kalb, Mount Lebanon, Lebanon
Directorate General of Antiquities, Ministry of Culture,
Beirut, Lebanon
http://www.culture.gov.lb

The Phoenician alphabet 32
Ministry of Cultural Affairs/ General Directorate
of Antiquities, Beirut, Lebanon

Huang Di Nei Jing 黄帝内经 (Yellow Emperor's Inner Canon) 35
National Library of China, Library of Ancient Books,
7 Wenjin Street, Xi Cheng District, Beijing 100034, China
http://www.nlc.gov.cn

Ancient Naxi Dongba literature manuscripts 36
Dongba Culture Research Institute, Black Dragon Pool
Park, Dayan Town, Lijiang County, Yunnan Province,
People's Republic of China, 674100

Mashtots Matenadaran ancient manuscripts collection 38
Mashtots Institute of Ancient Manuscripts
Mashtots Av. N53, YEREVAN 9, Armenia
http://www.matenadaran.am/v2_2

Saiva manuscripts in Pondicherry 40
Department of Indology, French Institute of Pondicherry,
11 St Louis Street, PO Box 33, Pondicherry 605001, India
http://www.ifpindia.org/

École française d'Extrême-Orient, 19 Dumas Street,
PO Box 151, Pondicherry 605001, India
http://www.efeo.fr

Codex Argenteus – the 'Silver Bible' 42
Uppsala University Library, Uppsala, Sweden
http://www.ub.uu.se/en

Codex Purpureus Beratinus 44
Director-General of the Albanian National Archives
"Rruga Jordan Misja", Tirana, Albania

Vienna Dioscurides 46
Österreichischen Nationalbibliothek (Austrian National
Library), Vienna, Austria
http://www.onb.ac.at/

Earliest Islamic (Kufic) inscription................48
Minister of Antiquities and Museums, P.O.Box 3734
Riyadh 11481

Holy Koran Mushaf of Othman...............50
The Muslim Board of Uzbekistan,Tashkent, Uzbekistan

Lucca's historical diocesan archives......................52
Archives of the Archdiocese of Lucca, Lucca, Italy

The Book of Kells..54
Trinity College Library, College Street, Dublin 2, Ireland
http://www.tcd.ie/Library/bookofkells/book-of-kells/

Laghukālacakratantrarājatikā (Vimalaprabhā).....59
The Asiatic Society, 1 Park Street, Kolkata 700 016, India
http://asiaticsocietycal.com

**The collection of the Al-Biruni Institute
of Oriental Studies**......................................60
The Collection of the Al-Biruni Institute of Oriental
Studies, 81, Kh. Abdullaev Street, 700170 Tashkent,
Uzbekistan

**Philippine Paleographs (Hanunoo,
Buid, Tagbanua and Pala'wan)**..................................61
Various Locations, Mindoro Province, Philippines

Various Locations, Palawan Province, Philippines

National Museum, Manila, Philippines
http://www.nationalmuseum.gov.ph

Georgian Byzantine manuscripts...........................62
National Centre of Manuscripts, Tbilisi, Georgia
http://www.manuscript.ge/?ln=eng

Deeds of sultans and princes.................................65
National Library and Archives of Egypt, Cairo, Egypt
http://www.nationalarchives.gov.eg

**Illuminated manuscripts from the Ottonian
period produced in the monastery
of Reichenau (Lake Constance)**...............................66
Bavarian State Library (Bayerische Staatsbibliothek),
Ludwigstrasse 16, 80539 München, Germany
http://www.bsb-muenchen.de

**Enina Apostolos, Old Bulgarian Cyrillic
manuscript (fragment) of the 11th century**..........68
Head of the Manuscript and Old Printed Books
Department, National Library
SS Cyril and Methodius National Library
88 Vasil Levski Blvd, 1037 Sofia, Bulgaria
http://www.nationallibrary.bg/

**Kandilli Observatory and Earthquake
Research Institute manuscripts**..............................70
Kandilli Observatory and Earthquake Research Institute,
Bogaziçi University, 81220 Çengelköy, Istanbul, Turkey
http://www.koeri.boun.edu.tr

Codex Suprasliensis....................................71
Head of the Manuscript Department of the National and
University Library in Ljubljana, Slovenia,
Turjaska 1 1000, Ljubljana

Chief of the Old-Russian Funds Sector at Manuscript
Department, the National Library of Russia
18 Sadovaya str. 191069, Saint Petersburg, Russia

Head of the Manuscript Department
The National Library, Pl. Krasińskich 3/5
00-207 Warszawa, Poland

**The works of Ibn Sina in the Süleymaniye
Manuscript Library**.....................................72
Süleymaniye Manuscript Library, Ayşe Kadın Mah. Hamam
Sokak, No: 35, Eminönü-Istanbul, Turkey
http://www.suleymaniye.com

Al-Tafhim li Awa'il Sana'at al-Tanjim 76
Library of the Islamic Consultative Assembly Baharestan
Square, Tehran, Iran

Ostromir Gospel (1056–1057) 78
National Library of Russia, St Petersburg, Russia
http://www.nlr.ru (Cyrillic with a little Union Jack for
English version; takes you to url below)
http://www.nlr.ru/eng

Bayeux Tapestry ...80
Médiathèque Municipale de Bayeux, Bayeux, France
http://www.tapestry-bayeux.com

Archangel Gospel of 1092 ... 83
Russian State Library, Moscow, Russia
http://www.rsl.ru/en

**Illuminated codices from the library
of the Bratislava Chapter House** 84
The Slovak National Archives
Bratislava, Slovak Republic
http://www.slovakia.culturalprofiles.net/?id=-12530

**Medieval manuscripts on medicine
and pharmacy**..86
Institute of Manuscripts of the Azerbaijan National
Academy of Sciences (IMANAS), Baku, Azerbaijan

The Arnamagnæan manuscript collection 87
The Arnamagnæan Institute, Department
of Scandinavian Research,
University of Copenhagen. Njalsgade 136, DK 2300
Copenhagen S.
http://arnamagnaeansk.ku.dk

Iceland: The Árni Magnússon Institute for Icelandic Studies
Árnagarði – Suðurgötu, IS-101 Reykjavík
http://www.arnastofnun.is

Miroslav Gospel – manuscript from 118090
http://www.narodnimuzej.rs (in Cyrillic but with a little
Union Jack for English page)
http://www.narodnimuzej.rs/code/navigate.php?Id=93
(English page)

Tabula Peutingeriana... 92
Österreichische Nationalbibliothek, Handschriften-,
Autographen- und Nachlaß-Sammlung (Austrian National
Library, Department of Manuscripts, Autographs and
Closed Collections)
Josefsplatz 1, 1015 Vienna, Austria
http://www.onb.ac.at (German)
http://www.onb.ac.at/ev (English)

**Song of the Nibelungs, a heroic poem
from medieval Europe**.. 94
Codex A: Bayerische Staatsbibliothek (Bavarian State
Library), Munich, Germany

http://www.bsb-muenchen.de
http://www.bsb-muenchen.de/Aktuelles-aus-der-
Bayerischen-Staatsbibliothek.14+M57d0acf4f16.0.html
(English though there is an English option on the German
landing page above)

Codex B: Stiftsbibliothek St Gallen (Monastic Library
of St Gallen), St Gallen, Switzerland
http://www.stiftsbibliothek.ch

Codex C: Badische Landesbibliothek (Regional Library
of the State of Baden), Karlsruhe, Germany
http://www.blb-karlsruhe.de
http://www.blb-karlsruhe.de/blb/blbhtml/org/eng.php
(English though there is an English option on the German
landing page above)

Magna Carta, issued in 1215.....................96
http://www.bl.uk
Lincoln Castle, Lincoln, UK
http://www.lincolnshire.gov.uk/visiting/historic-buildings/
lincoln-castle

Salisbury Cathedral Chapter House
Salisbury, UK
http://www.salisburycathedral.org.uk

**Printing woodblocks of the
Tripitaka Koreana**.........................98
Haeinsa Monastery
South Gyeongsang Province, Republic of Korea
MS. GKS 4 2°, vol. I–III, Biblia Latina.
Commonly called 'The Hamburg Bible'
100 The Royal≈Library
Copenhagen, Denmark
http://www.kb.dk/en (English language page)

Hereford Mappa Mundi...........................102
Hereford Cathedral Library, Hereford, UK
http://www.herefordcathedral.org

The King Ram Khamhaeng inscription...............104
The National Museum Bangkok, Na Phra That Road,
Bangkok 10200, Thailand
http://www.thailandmuseum.com

Library Ets Haim—Livraria Montezinos...............108
Portuguese-Jewish Seminary Ets Haim
Amsterdam, The Netherlands
http://www.etshaim.nl/

**The manuscript of Ubayd Zakoni's Kulliyat
and Hafez Sherozi's Gazalliyt**.................110
Director of the Central Scientific Library of the Academy
of Sciences of Republic of Tajikistan
Central Scientific Library, 734025, Rudaki Ave.33,
Dushanbe, Tajikistan

**Collection of medieval manuscripts
of the Czech Reformation**.........................112
National Library of the Czech Republic
Prague, The Czech Republic
http://www.nkp.cz (Czech landing page with
English option)
http://www.nkp.cz/_en (English)

**The Deed For Endowment: Rab' i-Rashidi
(Rab i-Rashidi Endowment)**.....................114
Tabriz Central Librar, Tabriz, Iran
http://www.tabrizlib.com (Arabic landing page
with English option)
http://www.tabrizlib.com/default.aspx/siteId/2 (English.)

**Batu Bersurat, Terengganu (Inscribed Stone
of Terengganu)**.............................116
Terengganu State Museum, Bukit Losong, 20566 Kuala
Terengganu, Malaysia
http://museum.terengganu.gov.my

La Galigo.................................117
Museum La Galigo, Makassar, Indonesia
http://museumlagaligo.com

Leiden University Library, Leiden, The Netherlands
http://www.library.leiden.edu

**Persian illustrated and illuminated
manuscripts**.........................118
The National Library and Archives of Egypt, Cornish El Nile
Ramlat Boulaq, PO Box: 11938, Cairo, Egypt
http://www.darelkotob.org

Collection of Nezami's Panj Ganj.........................120
ms no. 1 -- Sepahsalar Library (Shahid Mottahri),
Sepahsalar School, Tehran, Iran

ms no. 2 -- Golestan Palace, Tehran, Iran
http://www.golestanpalace.ir/en_site/collections/
e-history.htm

ms no. 3 -- National Museum of Iran, Tehran, Iran
http://www.nationalmuseumofiran.ir

ms no. 4 -- Malek National Library and Museum,
Tehran, Iran
http://www.malekmuseum.org/en

ms no. 5 -- Central Library and document centre of the
University of Tehran, Tehran, Iran
http://ut.ac.ir/en/contents/Library-Documentation/
Central.Library.and.Documentation.Center.of.the.
University.html

Baegun hwasang chorok buljo jikji simche yojeol (vol. II) ...122
Bibliothèque Nationale de France,
Paris, France
http://www.bnf.fr

Khitrovo Gospel...123
Russian State Library,
Moscow, Russia
http://www.rsl.ru (Russian with English option)
http://www.rsl.ru/en (English)

The Annals of the Joseon dynasty124
Kyujanggak Institute for Korean Studies (KIKS) at Seoul
National University, San 56-1, Shinrimdong, Kwanakgu,
Seoul, Republic of Korea
http://kyujanggak.snu.ac.kr/kiks/

National Archives of Korea, History Archives, 81 World-Cup
Road, Yeonje-gu, Busan, Republic of Korea
http://www.archives.go.kr

Kitab al-ibar, wa diwan al-mobtadae wa al-khabar..125
Library al-Quaraouiyine, Place es Saffarine BP 790,
Fez, Morocco
http://www.enssup.gov.ma/

Slavonic publications in Cyrillic script of the 15th century ...126
Russian State Library, 3 Vozdvihenka str., 101000
Moscow, Russia
http://www.rsl.ru/en

Treasures from National Archives and Library organizations ..127
National Archives and Library, PO Box 717,
Addis Ababa, Ethiopia
Corpo Cronológico (collection of manuscripts
on the Portuguese discoveries) 128
Instituto dos Arquivos Nacionais/Torre do Tombo,
Lisbon, Portugal
http://antt.dgarq.gov.pt

Radziwills' Archives and Niasvizh (Nieśwież) Library collection..130
Belarusian Research Centre for Electronic Records (general
coordinator of the project of virtual reconstruction of
the Niasvizh collection), Francisk Skaryna St., 51, Minsk,
220141, Belarus
http://archives.gov.by

National Historical Archives of Belarus, Kropotkina Str. 55,
Minsk, 220002, Belarus
http://archives.gov.by
Central Science Library of the National Academy of
Sciences of Belarus, Surganova Str. 15, Minsk, 220072,
Belarus
http://www.ac.by/organizations/library.html

National Library of Belarus, Nezalezhnasty Av. 116, Minsk,
220114, Belarus
http://nlb.by
Presidential Library of the Republic of Belarus, Sovetskaya
St. 11, Government House, 220010, Minsk, Belarus
http://www.preslib.org.by

National Library of Finland, Box 15 (Unioninkatu 36), 00014 Helsinki, Finland
http://www.nationallibrary.fi

State Historical Archives of Lithuania, Gerosios Vilties Str. 10, Vilnius, 03134, Lithuania
http://www.archyvai.lt/lt/lvat.html

Central Archives of Historical Records in Warsaw (Archiwum Główne Akt Dawnych w Warszawie), ul. Długa 7, PL 00-263 Warsaw, Poland
http://www.agad.archiwa.gov.pl

Library of the Russian Academy of Sciences, Birzhevaya line, 1, 199034, S-Petersburg, Russia
http://www.rasl.ru/

Science Library of Moscow State University, Lomonosovsky Av., 25, 119192, Moscow, Russia
http://www.msu.ru

Central State Historical Archives of Ukraine, Solomenskaya St., 24, 03110 Kiiv-110, Ukraine
http://www.archives.gov.ua

Collection of Gothic architectural drawings134

Academy of Fine Arts Vienna (Kupferstichkabinett der Akademie der bildenden Künste Wien), Schillerplatz 3, 1010 Vienna, Austria
http://www.akbild.ac.at

'Bayasanghori Shâhnâmeh' (Prince Bayasanghor's 'Book of the Kings')137

Golestan Palace, 15 Khordad (Arg) Square, Tehran, Iran
http://www.golestanpalace.ir

Stone stele records of royal examinations of the Le and Mac dynasties (1442–1779)138

Van Mieu–Quoc Tu Giam Scientific and Cultural Activities Center, Hanoi, Vietnam

The Hunminjeongum manuscript141

Kansong Art Museum, 97-1, Songbuk-dong, Songbuk-ku, Seoul, 136-020, Republic of Korea

The Malatesta Novello Library142

Istituzione Biblioteca Malatestiana, Piazza Bufalini 1, 47023 Cesena (Forlì-Cesena), Italy
http://www.malatestiana.it

The 42-line Gutenberg Bible, printed on vellum146

Niedersaechsische Staats- und Universitaetsbibliothek (SUB), Platz der Goettinger Sieben 1, 37073 Goettingen, Germany
http://www.sub.uni-goettingen.de
http://www.gutenbergdigital.de

Bibliotheca Corviniana149

National Szechenyi Library, Buda Royal Palace, Wing F, H-1827 Budapest, Hungary
http://www.corvina.oszk.hu

Austrian National Library, Josefsplatz 1, A-1015 Vienna, Austria
http://www.onb.ac.at/ev/index.php

Biblioteca Medicea Laurenziana, Piazza San Lorenzo 9, 501213 Florence, Italy
http://www.bml.firenze.sbn.it/

Herzog August Bibliothek Wolfenbüttel, Postfach 1364, D-38299 Wolfenbüttel, Germany
http://www.hab.de/index-e.htm

Bibliotheque Nationale de France, 58, rue de Richelieu, 75084 Paris cedex 02, France
http://www.bnf.fr/

Bayerische Staatsbibliothek, Ludwigstrasse 16, 80539 München, Germany
http://www.bsb-muenchen.de/index.php?L=3

Koninklijke Bibliotheek van Belgie, 4 Boulevard de l'Empereur, 1000 Brussels, Belgium

Library of the Cistercian Abbey of Clairvaux at the time of Pierre de Virey (1472) 150
Main Custodians:
Médiathèque de l'Agglomération Troyenne, Troyes, France
Bibliothèque Interuniversitaire de Montpellier
Montpellier, France
http://www.biu-montpellier.fr

Bibliothèque Nationale de France, Paris, France
http://www.bnf.fr

Subsidiary Custodians:
Bibliothèque Municipale de Laon, Laon, France
http://biblio.ville-laon.fr

Bibliothèque Sainte Geneviève, Paris, France
http://www-bsg.univ-paris1.fr

Bibliothèque Centrale, Université de Mons, Mons, Belgium
http://www.umons.ac.be

The British Library, London, UK
http://www.bl.uk

National Széchényi Library, Budapest, Hungary
http://regi.oszk.hu
http://regi.oszk.hu/index_en.htm (in English)

Biblioteca Medicea Laurenziana, Florence, Italy
http://www.bml.firenze.sbn.it

Mainz Psalter at the Austrian National Library 153
Österreichische Nationalbibliothek
(Austrian National Library), Vienna, Austria
http://www.onb.ac.at

Santa Fe Capitulations 154
Archive of the Crown of Aragon, Barcelona, Spain
http://www.mcu.es/archivos/MC/ACA/index.html
(Spanish; English link off landing page)
http://en.www.mcu.es/archivos/MC/ACA/index.html
(English)

Treaty of Tordesillas 156
Arquivo Nacional da Torre do Tombo (National Archive of the Tower of the Tomb)
Lisbon, Portugal (Lisboa, Portugal)
http://antt.dgarq.gov.pt

Archivo General de Indias (General Archive of the Indies)
Seville, Spain
http://www.mcu.es/archivos/MC/AGI

Sound Toll Registers 158
Danish National Archives
Copenhagen, Denmark
http://www.sa.dk (Danish with English option)
http://www.sa.dk/content/us (English)

Letter from Pêro Vaz de Caminha 159
Instituto dos Arquivos Nacionais/Torre do Tombo
Lisbon, Portugal
http://antt.dgarq.gov.pt

Archives Insolvente Boedelskamer Antwerpen 160
FelixArchief, Oudeleeuwenrui 29, 2000 Antwerp, Belgium
http://www.felixarchief.be

Universalis cosmographia secundum Ptholomaei 162
Library of Congress, Washington, DC, USA
http://www.loc.gov

Tabula Hungariae 164
National Széchényi Library, Buda Royal Palace, Wing F
H-1827 Budapest, Hungary
http://regi.oszk.hu/index_en.htm

Österreichische Nationalbibliothek
Josefsplatz 1, A-1015 Wien, Austria
http://www.onb.ac.at/

Nacionalna I Sveucilisna Knjiznica
Ulica Hrvatske bratske zajednice
10000 Zagreb, Croatia
http://www.nsk.hr/

Beatus Rhenanus Library............................165
Bibliothèque Humaniste, Sélestat, France
http://www.selestat.fr/spip_bh/

Sixteenth to eighteenth century pictographs
from 'Maps, drawings and illustrations'
Archives of Mexico 168
Archivo General de la Nación (National General Archives
of Mexico), Eduardo Molina 113, Penitenciaria, 15350
Mexico City, Mexico
http://www.agn.gob.mx

Negros y Esclavos archives 169
Archivo General de la Nación, Carrera 6 No. 6-91
Bogotá, Colombia
http://www.agn.gob.mx/

Collection of Mexican codices172
Biblioteca Nacional de Antropología e Historia del INAH,
Mexico City, Mexico
http://www.bnah.inah.gob.mx

Colección de lenguas indígenas...........174
Biblioteca Pública del Estado de Jalisco, Jalisco, Mexico
(University of Guadalajara is the custodian)
http://www.fondoshistoricos.udg.mx

Bašagic collection of Islamic manuscripts176
Bašagic's Collection of Islamic Manuscripts,
Univerzitná knižovnica/The University Library
Michalská 1, 814 17 Bratislava
http://www.ulib.sk/english/

Collection of the Center of Documentation
and Investigation of the Ashkenazi
community in Mexico...............................179
Director Centro de Documentación e Investigación
de la Comunidad Ashkenazí de México
Comunidad Ashkenazí de México, A.C.
Acapulco 70 2° piso. Col. Roma
C. P. 06700, Delegación Cuauhtémoc
http://www.amabpac.org.mx/wp/memoria-del-mundo/

Comunidad Ashkenazi de México, A.C.
Sierra Tarahumara # 315, Col. Lomas de Chapultepec
México, D.F. C.P. 11000

Nicolaus Copernicus' masterpiece
'De revolutionibus libri sex'....................180
Jagiellonian Library, al. Mickiewicza 22, 30-059
Krakow, Poland
http://www.bj.uj.edu.pl

Codices from the Oaxaca Valley.............183
Archivo General de la Nación, Mexico City, Mexico
http://www.agn.gob.mx

Châtelet de Paris banner register from the
reign of Francis I (National Archives Y9,
France) ... 184
Archives Nationales, Paris, France
http://www.archivesnationales.culture.gouv.fr

Collection of the manuscripts of Khoja
Ahmed Yasawi 186
National Library of the Republic Kazakhstan, 14, Abai
Avenue, Almaty, 050013, Republic of Kazakhstan
http://www.nlrk.kz

American colonial music: a sample of its
documentary richness............................ 188
Archivo y Biblioteca Nacionales de Bolivia, Sucre, Bolivia
http://www.archivoybibliotecanacionales.org.bo

Archivo de la Catedral de Bogotá, Bogotá, Colombia

Archivo Histórico de la Arquidiócesis de Oaxaca
Oaxaca, México
http://arzobispadodeoaxaca.org

Biblioteca Nacional del Perú, Lima, Perú
http://www.bnp.gob.pe

Business archives of the Officina
Plantiniana 190
Museum Plantin-Moretus, Vrijdagmarkt 22, 2000
Antwerp, Belgium
http://www.museumplantinmoretus.be

Documentary fonds of Royal Audiencia Court of La Plata (RALP) ..191
Director of the National Archive and Library of Bolivia
55 Plaza Yamparáez, Sucre, Bolivia

The Confederation of Warsaw of 28th of January 1573 ... 194
Central Archives of Historical Records in Warsaw
(Archiwum Główne Akt Dawnych w Warszawie), ul. Długa 7,
PL 00-263 Warsaw, Poland
http://www.agad.archiwa.gov.pl

Tarikh-e-Khandan-e-Timuriyah 196
Khuda Bakhsh Oriental Public Library, Patna, Bihar, India
http://www.kblibrary.org

Administrative documents of Astan-e Quds Razavi in the Safavid era .. 198
Astan-e Quds Razavi Library, Mashhad, Iran
http://www.aqlibrary.org

Ben Cao Gang Mu 本草纲目 (Compendium of Materia Medica) .. 200
Library of China Academy of Chinese Medical Sciences,
Beijing, China
http://www.catcm.ac.cn

Tolstoy's personal library and manuscripts, photo and film collection ..202
State Museum-Estate of Leo Tolstoy Yasnaya Polyana
Shchekinsky Rayon, Tul'skaya oblast', Russia, 301214

The State Leo Tolstoy Museum
11/8 Prechistenka Street, Moscow, Russia, 119034
http://www.uprava-hamovniki.ru/en/state_museum_of_
leo_tolstoy/

Jesuits of America ..206
Archivo Nacional de Chile, Santiago, Chile
http://www.dibam.cl/archivo_nacional

Codex Techaloyan de Cuajimalpaz208
Director of Information and Documentation
Archivo General de la Nación
Eduardo Molina y Albañiles
Colonia Penitenciaría Ampliación
Postal Code 15350, Mexico City, Mexico
http://www.agn.gob.mx

Documentary heritage of enslaved peoples of the Caribbean ..209
Barbados Museum & Historical Society
St Ann's Garrison, St Michael, Barbados
http://www.barbmuse.org.bb/

El Primer Nueva Corónica y Buen Gobierno ..212
The Royal Library, Copenhagen, Copenhagen, Denmark
http://www.kb.dk/en
http://www.kb.dk/permalink/2006/poma/info/en/
frontpage.htm

Uigwe: The royal protocols of the court of Joscon dynasty..213
Kyujanggak Institute for Korean Studies (KIKS) at Seoul
National University, San 56-1, Shinrimdong, Kwanakgu,
Seoul, Republic of Korea
http://kyujanggak.snu.ac.kr/kiks/

The Academy of Korean Studies, 323 Haogae-ro,
Bundang-gu, Seongnam-si, Gyeonggi-do,463-791,
Republic of Korea
http://intl.aks.ac.kr

Archives of the Dutch East India Company....... 214
http://www.tanap.net (Towards a New Age of Partnership in
Dutch East India Company Archives and Research)

Nationaal Archief (National Archives of the Netherlands),
Prins Willem-Alexanderhof 20, 2595 BE, The Hague
Postal address: P.O. Box 90520, 2509 LM Den Haag ,
The Netherlands
http://www.nationaalarchief.nl/

Western Cape Archives and Record Service,
72 Roeland Street, Cape Town
Postal address: Private Bag X9025, Cape Town 8000,
South Africa
http://www.westerncape.gov.za/eng/your_gov/154577

Tamil Nadu Archives, 28-29 Gandhi-Irwin Road, Egmore,
Chennai 600 008, Tamil Nadu, India
http://www.tnarchives.tn.gov.in

Department of National Archives of Sri Lanka, PO Box 1414,
7, Philip Gunawardena Mawatha (Reid Avenue), Colombo 7,
Sri Lanka
http://www.archives.gov.lk

Arsip Nasional Republik Indonesia (National Archives
of the Republic of Indonesia), Jalan Ampera Raya No. 7,
Jakarta 12560, Indonesia
http://www.anri.go.id

**Donguibogam: 'Principles and Practice
of Eastern Medicine'** .. 218
National Library of Korea, Seoul, Republic of Korea
http://www.nl.go.kr

Sejarah Melayu (The Malay Annals) 219
Dewan Bahasa dan Pustaka (Institute of Language and
Literature), P.O. Box 10803, 50926 Kuala Lumpur, Malaysia
http://prpm.dbp.gov.my
http://www.sabrizain.org/malaya/malays1.htm

**Dutch West India Company
(Westindische Compagnie) Archives** 220
Nationaal Archief (National Archives of the Netherlands),
Prins Willem-Alexanderhof 20, 2595 BE, The Hague
Postal address: P.O. Box 90520, 2509 LM
The Hague, The Netherlands
http://www.nationaalarchief.nl

Albany County Hall of Records, 95 Tivoli Street, Albany,
NY 12207, USA
http://www.albanycounty.com/achor/

Arquivo Nacional (National Archives of Brazil), Praça
da República, 173-Rio de Janeiro, RJ - 20211-350, Brazil
http://www.arquivonacional.gov.br

Nationaal Archief Curaçao (National Archives of Curaçao),
Scharlooweg 77-79, Willemstad, Curaçao
http://www.nationalarchives.an

Municipal Archives New York, 31 Chambers Street,
Room 103, New York, NY 10007, USA
http://www.nyc.gov/html/records/html/about/
archives.shtml

Nationaal Archief van Suriname (National Archives of
Suriname), Doekhieweg-Oost 18a, Paramaribo, Suriname
http://www.nationaalarchief.sr

National Archives, Kew, Richmond, Surrey, TW9 4DU, UK
http://www.nationalarchives.gov.uk

New York State Archives, New York State Education
Department, Cultural Education Center, Albany,
NY 12230, USA
http://www.archives.nysed.gov

Public Records and Archives Administration (PRAAD)
(formerly National Archives of Ghana), PO Box 3056,
Accra, Ghana
http://www.presidency.gov.gh/our-government/agencies-
commissions/public-records-and-archives-admin-
department

Walter Rodney Archives (National Archives of Guyana),
Homestretch Avenue, D'Urban Park, Georgetown, Guyana
http://mcys.gov.gy/na_about.html

The IAS Tamil medical manuscript
collection .. 222
Institute of Asian Studies, Chennai, India
http://xlweb.com/heritage/asian/

Quebec Seminary collection, 1623–1800
(17th–19th centuries) 224
Musée Canadien des Civilisations / Canadian Museum
of Civilization, Québec, Canada
http://www.civilization.ca

Seungjeongwon Ilgi, the diaries of the
royal secretariat .. 227
Kyujanggak Institute for Korean Studies (KIKS) at Seoul
National University, San 56-1, Shinrimdong, Kwanakgu,
Seoul, Republic of Korea
http://kyujanggak.snu.ac.kr/kiks/index.do

Book for the Baptism of Slaves (1636-1670) 228
Historical Archives of the Archdiocese of Santo Domingo,
Isabella la Catolica Street Number 5, Ciudad Colonial,
P.O. Box 186, Santo Domingo, D. N., Dominican Republic

Mining maps and plans of the Main Chamber –
Count Office in Banská Štiavnica 230
The State Central Mining Archives, Radničné námestie 16,
Banská Štiavnica, 969 01, Slovakia
http://www.banskastiavnica.sk

Collection of 526 prints of university theses
from 1637 to 1754 232
National Library of the Czech Republic, Klementinum 190,
110 00 Prague 1, Czech Republic
http://www.nkp.cz

Biblioteca Palafoxiana 233
Biblioteca Palafoxiana, Avenida 3 oriente # 209
Centro Histórico, C. P. 72000, Puebla, Puebla, Mexico
http://www.bpm.gob.mx

Hikayat Hang Tuah 236
National Library of Malaysia (Perpustakaan
Negara Malaysia), 232 Jalan Tun Razak, 50572
Kuala Lumpur, Malaysia
http://www.pnm.gov.my

Records of the Qing's Grand Secretariat 239
First Historical Archives of China, Xi Hua Men Nei,
Palace Museum, Beijing, 100031, China
http://www.lsdag.com

Lu.'Altan Tobchi': Golden History
written in 1651 .. 240
National Library of Mongolia, 4 Chinggis Avenue,
Ulaanbaatar – 210648, Mongolia
http://www.nationallibrary.mn

The Atlas Blaeu–Van der Hem 242
Österreichische Nationalbibliothek, Kartensammlung
(Austrian National Library, Map Department), Josefsplatz 1,
1015 Vienna, Austria
http://www.onb.ac.at

Golden Lists of the Qing dynasty
imperial examination 244
First Historical Archives of China, Xi Hua Men Nei,
Palace Museum, Beijing, 100031, China
http://www.lsdag.com

Letters from and to
Gottfried Wilhelm Leibniz 246
Gottfried Wilhelm Leibniz Bibliothek – Niedersächsische
Landesbibliothek (Gottfried Wilhelm Leibniz Library –
Lower Saxony State Library), Waterloostraße 8, D-30169
Hannover, Germany
http://www.gwlb.de

Archives of the Danish overseas trading companies 248
Rigsarkivet (Danish National Archives), Rigsdagsgaarden 9, DK-1218 Copenhagen K, Denmark
http://www.sa.dk/content/us/about_us/danish_national_archives
http://www.virgin-islands-history.dk/eng/high.asp

Hudson's Bay Company archival records 250
Archives of Manitoba, Winnipeg, Manitoba, Canada
http://www.gov.mb.ca/chc/archives

Arquivos dos Dembos / Ndembu archives 253
Arquivo Histórico de Angola, Rua Pedro Fèlix Machado, 49, Luanda, Angola
http://www.mincultura.gv.ao/bibliotecas.htm

Arquivo Histórico Ultramarine, Calçada da Boa Hora, 30, 1300-095 Lisbon, Portugal
http://www2.iict.pt

Woodblocks of the Nguyễn dynasty 254
State Records and Archives Department of Vietnam, Hanoi, Vietnam
http://www.archives.gov.vn

Records of the French occupation of Mauritius ... 256
Mauritius Archives, Development Bank of Mauritius Complex, Coromandel, Petite Rivière, Mauritius
http://www.gov.mu

Privateering and the international relations of the Regency of Tunis in the 18th and 19th centuries 258
National Archives of Tunisia, 122 Boulevard 9 Avril 1938, 1030 Tunis, Tunisia
http://www.archives.nat.tn

Collection of 18th-century maps of the Russian empire ... 260
Russian State Library, 3 Vozdvihenka str., 101000 Moscow, Russia
http://www.rsl.ru/en

Newspaper collections, Russian Federation 264
Russian State Library, Newspaper Department, Bibliotechnaya str., 15, Khimky, Moscow region, Russia
http://www.rsl.ru/en

Collection of Arabic manuscripts and books 266
Zanzibar National Archives, Kilimani, Zanzibar
Postal address: Department of Archives, Museums and Antiquities, Box 116, Zanzibar, Tanzania
http://www.zanzibarheritage.go.tz/Archives.htm

Jean-Jacques Rousseau, Geneva and Neuchâtel collections 269
Bibliothèque de Genève, Promenade des Bastions, CH-1211 Genève 4, Switzerland
http://www.ville-ge.ch/bge

Bibliothèque publique et universitaire de Neuchâtel, Place Numa-Droz 3, CH-2000 Neuchâtel, Switzerland
http://bpun.unine.ch

Société Jean-Jacques Rousseau, Institut et Musée Voltaire, Bibliothèque de la Société Jean-Jacques Rousseau, Rue des Délices 25, CH-1203 Genève, Switzerland
http://www.sjjr.ch

Stockholm City Planning Committee archives ... 270
Stockholm City Archives, Stockholm, Sweden
http://www.ssa.stockholm.se

Emanuel Swedenborg collection.............................272
Center for History of Science, The Royal Swedish Academy
of Sciences, Stockholm, Sweden
http://www.center.kva.se

**Archives of the Middelburgsche
Commercie Compagnie**...274
Zeeuws Archief (Zeeland Archive), Hofplein 16 ,
4331 CK Middelburg
Postal address: Postbus 70, 4330 AB Middelburg,
The Netherlands
http://www.zeeuwsarchief.nl

Linné collection.. 276
The Royal Library, Søren Kierkegaards Plads 1,
Copenhagen, Denmark
http://www.kb.dk

Mongolian Tanjur.. 279
National Library of Mongolia, 4 Chinggis Avenue,
Ulaanbaatar – 210648, Mongolia
http://www.nationallibrary.mn

Qing dynasty Yangshi Lei archives.........................280
National Library of China, 7 Wenjin Street, Xicheng
District, Beijing, China
http://www.nlc.gov.cn

**The literary estate of Goethe in
the Goethe and Schiller Archives**.......................... 285
German Nomination Committee for the Memory of the
World Programme, German Commission for UNESCO
Colmantstrasse 15, D-53115 Bonn, Germany

Ilseongnok: Records of Daily Reflections.......... 286
Kyujanggak Institute for Korean Studies (KIKS) at Seoul
National University, San 56-1, Shinrimdong, Kwanakgu,
Seoul, Republic of Korea
http://kyujanggak.snu.ac.kr/kiks/index.do

The Endeavour journal of James Cook............... 288
National Library of Australia, Canberra, Australia
http://www.nla.gov.au

National Education Commission archives........290
Polish Academy of Arts and Sciences, ul. Sławkowska 17,
31-016 Kraków, Poland
http://pau.krakow.pl

Central Archives of Historical Records, Długa 7 Street,
PL 00-263 Warsaw, Poland
www.agad.archiwa.gov.pl

Czartoryski Library
Św. Marka St. 17, PL 31-018 Kraków, Poland
http://www.muzeum.krakow.pl/
Czartoryski-library.271.0.html?&L=1

**Documentary heritage of the Viceroyalty
of the Río de la Plata**... 292
Archivo General de la Nación, Leandro N. Alem 246,
C1003AAP - Buenos Aires, Argentina
http://www.mininterior.gov.ar

**Colombeia: Generalissimo Francisco
de Miranda's archives**.. 294
Archivo General de la Nación, Foro Libertador,
Avenida Panteón, Caracas, Venezuela
http://www.agn.gob.ve

The Convict Records of Australia 298
State Records Authority of New South Wales, PO Box 516,
Kingswood 2747, NSW, Australia
http://www.records.nsw.gov.au

Tasmanian Archive and Heritage Office, Hobart LINC,
91 Murray Street, Hobart, Tasmania 7000, Australia
http://www.linc.tas.gov.au

State Records Office of Western Australia, Alexander
Library Building, Perth Cultural Centre, Perth WA 6000,
Australia
http://www.sro.wa.gov.au

**Original Declaration of the Rights
of Man and of the Citizen (1789–1791)**................. 302
Centre historique des Archives nationales, Musée de
l'histoire de France, 60 rue des Francs-Bourgeois, 75003
Paris, France
http://www.archivesnationales.culture.gouv.fr/anparis/

**Introduction of the decimal metric system,
1790–1837** .. 306
Archives Nationales, Paris, France
http://www.archivesnationales.culture.gouv.fr

The Leprosy Archives of Bergen 308
Norwegian National Commission for UNESCO
P.O. Box 1507 Vika, N-0117 Oslo, Norway
http://www.unesco.no

City Archives of Bergen, Allehelgensgt. 5, N-5016
Bergen, Norway

The Vienna City Library Schubert collection 311
Vienna City Library, City Hall, Stiege 6, 1st floor, 1082
Vienna, Austria
http://www.wienbibliothek.at

The masterpieces of Fryderyk Chopin.................314
The National Library, The Special Collections Department
Place Krasińskich 3/5, 00-207 Warsaw, Poland
http://bn.org.pl

**Kinder- und Hausmärchen (Children's
and Household Tales)** .. 317
Brüder Grimm-Museum / Museum of the Brothers
Grimm, Kassel, Germany
http://www.grimms.de

**General Archive of the Nation: Writings
of The Liberator Simón Bolívar** 320
Archivo General de la Nación, Foro Libertador, Avenida
Panteón, Caracas, Venezuela
http://www.agn.gob.ve

The Søren Kierkegaard archives 323
Det kongelige Bibliotek, P.O. Box 2149
DK-1016 Copenhagen K., Denmark
http://www.kb.dk

Final document of the Congress of Vienna 324
Austrian State Archives, Vienna, Austria
http://oesta.gv.at

**Registry of Slaves of the British Caribbean
1817–1834** ... 326
Department of Archives, P.O. Box SS6341,
Nassau, The Bahamas
http://www.bahamasnationalarchives.bs

**Csoma archive of the Library of the
Hungarian Academy of Sciences** 328
Oriental Collection, Library of the Hungarian
Academy of Sciences, Széchenyi István tér 9.,
H-1051 Budapest, Hungary
Postal address: PO Box 1002, H-1245 Budapest, Hungary
http://csoma.mtak.hu/en/index.htm

The Bleek collection .. 329
Manuscripts & Archives Department, University of Cape
Town Libraries, University of Cape Town, Private Bag,
Rondebosch 7701, South Africa

Special Collections Section, South African Library,
5 Queen Victoria Street, Cape Town, South Africa
Postal address: P.O. Box 496, Cape Town, 8000,
South Africa

**Ludwig van Beethoven: Symphony no. 9,
D minor, op. 125** ...332
Staatsbibliothek zu Berlin, Berlin, Germany
http://staatsbibliothek-berlin.de

Beethoven-Haus, Bonn, Germany
http://www.beethoven-haus-bonn.de

Deutsches Rundfunkarchiv, Frankfurt, Germany
http://www.dra.de

Royal archives (1824–1897) ..334
National Archives, 23 rue Karija Tsaralalàna,
101 Antananarivo, Madagascar

**Catecismo corticu pa uso di catolicanan
di Curaçao (first catechism written in
Papiamentu language)** ... 336
National Archives, Willemstad, Curaçao
http://www.nationalarchives.an

**Manuscripts and correspondence
of Hans Christian Andersen** 340
The Royal Library, Søren Kierkegaards Plads 1,
Copenhagen, Denmark
http://www.kb.dk

Records of the Indian indentured labourers 344
National Archives of Fiji, PO Box 2125, Government
Buildings, Suva, Fiji
http://www.info.gov.fj/archives.html

National Archives of Guyana, Homestretch Avenue,
D'Urban Park, Georgetown, Guyana
http://mcys.gov.gy/na_about.html

Nationaal Archief van Suriname (National
Archives of Suriname), Doekhieweg-Oost 18a,
Paramaribo, Suriname
http://www.nationaalarchief.sr

National Archives of Trinidad & Tobago,
105 St. Vincent Street, Port of Spain, Trinidad & Tobago
http://natt.gov.tt/

Farquharson's Journal ...345
Department of Archives, P.O. Box SS6341,
Nassau, The Bahamas
http://www.bahamasnationalarchives.bs

Epigraphic archives of Wat Pho 346
Wat Phra Chetuphon Vimolmangklararam
Rajworamahaviharn, Sanam Chai Road, Bangkok 10200,
Thailand
http://www.watpho.com

**János Bolyai: Appendix, Scientiam
Spatii absolute veram exhibens** 348
Department of Manuscripts and Rare Books, Library of the
Hungarian Academy of Sciences, Széchenyi István tér 9,
H-1051 Budapest, Hungary
Postal address: PO Box 1002, H-1245 Budapest, Hungary
http://bolyai.mtak.hu/index-en.htm

Brahms collection.. 350
Gesellschaft der Musikfreunde in Wien,
Musikvereinsplatz 1, 1010 Wien, Austria
http:// www.musikverein.at

Memory of the Suez Canal....................................352
Centre des Archives du Monde du Travail (CAMT)
Roubaix, France
http://www.archivesnationales.culture.gouv.fr/camt/

Archives Nationales, Paris, France
http://www.archivesnationales.culture.gouv.fr

Bibliothèque de l'Arsenal, Paris, France
http://www.bnf.fr/fr/la_bnf/sites/a.site_bibliotheque_
arsenal.html

Suez Canal Authority, Ismailia, Egypt
http://www.suezcanal.gov.eg

Bibliothèque de l'Institut du Monde Arabe (IMA)
Paris, France
http://www.imarabe.org/bibliotheque

Bibliothèque Nationale de France, Paris, France
http://www.bnf.fr

Bibliothèque Forney, Paris, France
http://equipement.paris.fr/Bibliothèque_Forney

Institut National de l'Audiovisuel (INA), Paris, France
http://www.ina.fr

Memory of Suez Canal
http://suezcanal.bibalex.org

The Treaty of Waitangi..356
Archives New Zealand
Wellington, New Zealand
http://archives.govt.nz

The Emperor's collection...358
Fundação Biblioteca Nacional (National Library)
Rio de Janeiro, Brazil
http://www.bn.br

Alfred Nobel family archives...............................360
National Archives (Riksarkivet), Box 12541, SE–102 29
Stockholm, Sweden
http://www.riksarkivet.se

Regional Archives in Lund (Landsarkivet i Lund), Box 2016,
SE–220 02 Lund, Sweden
http://www.riksarkivet.se

Colonial archives, Benin .. 362
Directorate of National Archives (Direction des Archive
nationales), Ouando, Face à l'Ecole Régionale de la
Magistrature, Porto-Novo, Benin
Postal address: BP 629, Porto-Novo, Benin
http://www.anbenin.bj

The A.E. Nordenskiöld Collection 364
National Library of Finland, Box 15 (Unioninkatu 36),
FIN-00014, Helsinki
http://www.nationallibrary.fi/services/kokoelmat/
adolferiknordenskioldinkarttakokoelma.html

'José Martí Pérez' fonds ... 366
Centro de Estudios Martianos, Calzada No. 807,
esq. a 4, El Vedado, Plaza de la Revolución, La Habana, Cuba
http://www.josemarti.cu

**Archival documents of King Chulalongkorn's
transformation of Siam (1868–1910)** 369
National Library of Thailand, Ta Wasukree, Tewes,
Samsen Road, Bangkok 10300, Thailand
http://www.nlt.go.th

National Archives of Thailand, Ta Wasukree, Tewes,
Samsen Road, Bangkok 10300, Thailand
http://www.nat.go.th

Arnold Schönberg estate .. 370
Dr. Christian Meyer, Director of the Arnold Schönberg
Center Private Foundation
Arnold Schönberg Center Private Foundation
Schwarzenbergplatz 6, A-1030 Wien, Austria
http://www.schoenberg.at/

Jinnah papers (Quaid-i-Azam)372
National Archives of Pakistan, Pakistan Secretariat,
Block N, Islamabad, Pakistan
http://www.nap.gov.pk

Dainu Skapis – Cabinet of folksongs374
Head of the Archives of Latvian Folklore
Archive of Latvian Folklore
Akademijas laukums 1, LV 1050 Riga, Latvia
http://www.lfk.lv/lfk_eng.html

Director of National Library of Latvia
Chairman of Latvian Memory of the World Committee
National Library of Latvia, Kr.Barona iela 14
LV 1423 Riga, Latvia

**Silver men: West Indian labourers
at the Panama Canal** ...376
Barbados Department of Archives, Black Rock St Michael,
Barbados, West Indies

Barbados Museum and Historical Society, St Ann's
Garrison, Bridgetown, Barbados, West Indies
http://www.barbmuse.org.bb

Jamaica Archives and Records Department, Corner of
King and Manchester Streets, Spanish Town, St Catherine,
Jamaica, West Indies
http://records.jard.gov.jm

Museo del Canal Interoceánico de Panamá, San Felipe,
Plaza De La Independencia, between Fifth and Sixth Street,
PO Box 0816-06779, Panama, Republic of Panama
http://www.museodelcanal.com/

Saint Lucia National Archives, Vigie, Clark Avenue, Castries,
Saint Lucia , PO Box 3060

National Archives at College Park, 8601 Adelphi Road,
Maryland 20740-6001, USA
http://www.archives.gov/dc-metro/college-park/

George A. Smathers Library, University of Florida, PO Box,
117011, Gainesville, Florida-32611-7011, USA
http://www.uflib.ufl.edu
National Archives Kew, Richmond, Surrey, TW9 4 DU, UK
http://www.nationalarchives.gov.uk

Henrik Ibsen: A Doll's House379
National Library of Norway
P.O. Box 2674 Solli, N-0203 Oslo
http://www.nb.no/english/

Nikola Tesla's Archive ...380
Nikola Tesla Museum, Krunska 51, 11000 Belgrade, Serbia
http://www.tesla-museum.org

Benz patent of 1886 .. 382
Daimler AG Collection, Archive and Collection, Gebäude
120, EG, Mercedesstrasse 120, 70372 Stuttgart, Germany
Postal address: BC/CA, HPC C107, 70546
Stuttgart, Germany
http://www.mercedes-benz-classic.com

**Correspondence of the late
Sultan of Kedah (1882–1943)**385
National Archives of Malaysia, Kedah/Perlis State Branch,
Alor Merah, 05000 Alor Setar, Kedah, Malaysia
http://www.arkib.gov.my

**The Historical Collections (1889–1955) of
St Petersburg Phonogram Archives**386
The Institute of Russian Literature
St Petersburg, Russia
http://www.pushkinskijdom.ru (Russian with
English option)
http://www.pushkinskijdom.ru/en (English)

German records of the National Archives 388
Tanzania National Archives, Records and National Archives
Division, PO Box 2006, Upanga, 7 Vijibwene Street off
Magore Road, Dar es Salaam, Tanzania
http://tanzania.ninabosanac.com

**Manifesto of the Queensland Labour Party
to the people of Queensland** 391
State Library of Queensland, Brisbane, Australia
http://www.slq.qld.gov.au

The 1893 Women's Suffrage Petition 394
Archives New Zealand, Wellington, New Zealand
http://archives.govt.nz

**Early cylinder recordings of the world's
musical traditions (1893–1952)** 397
Ethnologisches Museum, Berlin, Germany
http://www.smb.museum/smb/sammlungen/details.
php?lang=en&objectId=56&n=1&r=4

Lumière films ... 398
Archives Françaises du Film (French Film Archives)
Bois-d'Arcy, France
http://www.cnc-aff.fr

**Fonds of the Afrique occidentale
française (AOF)** ... 402
Direction des Archives du Sénégal, Immeuble
administratif, Avenue Léopold Sédar Senghor,
Dakar, Senegal
http://www.archivesdusenegal.gouv.sn/fondsaof.html

**Historic ethnographic recordings (1898–1951)
at the British Library** 404
The British Library, London, UK
http://www.bl.uk

**The historical collections (1899–1950)
of the Vienna Phonogrammarchiv** 406
Phonogrammarchiv
A -1010 Wien, Liebiggasse 5, Austria
http://www.phonogrammarchiv.at/

Letter journals of Hendrik Witbooi 408
National Archives of Namibia, 1-7 Eugene Marais Street,
Windhoek, Namibia, P O Box: Private Bag 13349

**Russian posters of the end of the
19th and early 20th centuries** 412
Russian State Library, Moscow, Russia
http://www.rsl.ru (Cyrillic landing page with
English option)
http://www.rsl.ru/en (English landing page)

**Collection of Latin American photographs
of the 19th century** ... 415
Audio-visual Archive of Venezuela, National Library
of Venezuela, Caracas, Venezuela
http://www.bnv.gob.ve

Presidential papers of Manuel L. Quezon 416
The National Library of the Philippines, Filipiniana
Division, Quezoniana Section, T.M. Kalaw Avenue,
Manila, Philippines
http://web.nlp.gov.ph

Bentley Historical Library, University of Michigan,
1150 Beal Avenue, Ann Arbor, MI 48109-2113, USA
http://bentley.umich.edu/

Jorge B. Vargas Museum and Filipiniana Research
Center, University of the Philippines, Diliman,
Quezon City, Philippines
http://vargasmuseum.wordpress.com/
Senate of the Philippines, Congress of the Republic of the
Philippines, Batasan Hillls, Quezon City, Philippines
http://www.senate.gov.ph/

Sakubei Yamamoto collection 418
Tagawa City Coal Mining Historical Museum, Ohaza-Ita
2734-1, Tagawa City, Fukuoka Prefecture, Japan 825-0002

Fukuoka Prefectural University, Ita 4395, Tagawa City,
Fukuoka Prefecture, Japan 825-8585
http://www.y-sakubei.com

The Story of the Kelly Gang (1906) 422
National Film and Sound Archive, Canberra, Australia
http://www.nfsa.gov.au

Desmet collection .. 425
EYE Film Instituut Nederland, Amsterdam, Netherlands
http://www.eyefilm.nl

Roald Amundsen's South Pole
Expedition (1910–1912) .. 428
Norwegian Film Institute, Oslo, Norway
http://www.nfi.no (with English option on landing page)
http://www.nfi.no/english (English language page)

National Library of Norway, Mo i Rana, Norway
http://www.nb.no (with English option on landing page)
http://www.nb.no/english (English language page)

Collection of Jewish musical
folklore (1912–1947) .. 430
National V.I Vernadsky Library of Ukraine, Kiev, Ukraine
http://www.nbuv.gov.ua
http://www.nbuv.gov.ua/eng (in English but info page only
with no links off)
http://www.archives.gov.ua/Eng/NB/Phonoarchive.php
(item-specific page in English)

Original records of Carlos Gardel –
Horacio Loriente collection (1913–1935) 432
Archivo General de la Nación, Calle Convención, 1474
Montevideo, Uruguay

Archives of the International Prisoners
of War Agency, 1914–1923 .. 434
International Red Cross and Red Crescent Museum
Geneva, Switzerland
http://www.micr.ch

The Battle of the Somme 438
Imperial War Museum, London, UK
http://www.iwm.org.uk

Collection of Russian, Ukrainian and
Belarusian émigré periodicals 1918–1945 442
Czech Commission for UNESCO
Skokanská 3, 169 00 Prague 6, The Czech Republic
http://www.mzv.cz/unesco

League of Nations archives 1919–1946 443
Library of the United Nations Office at Geneva,
Palais des Nations, CH - 1211 Geneva 10, Switzerland
http://www.unog.ch/library

Constantine collection ... 446
The Heritage Library Division, National Library and
Information System Authority (NALIS), Corner of
Hart and Abercromby Streets, Port of Spain, Trinidad,
Republic of Trinidad and Tobago, West Indies
http://www. nalis.gov.tt

First flight across the South
Atlantic Ocean in 1922 ... 449
Arquivo Central / Arquivo Histórico, Edifício da Antiga
Fábrica Nacional de Cordoaria, Rua da Junqueira,
1300 - 342 Lisboa, Portugal
http://www.marinha.pt

Kalman Tihanyi's 1926 patent
application 'Radioskop' .. 452
National Archives of Hungary, 2–4 Bécsi Kapu Square, 1014
Budapcst, Hungary
Postal address:, PO Box 3, 1250 Budapest, Hungary
http://old.mol.gov.hu

Metropolis – Sicherungsstück Nr. 1:
Negative of the restored and reconstructed
version (2001) .. 454
Friedrich Wilhelm Murnau Foundation
Wiesbaden, Germany
http://www.murnau-stiftung.de (German landing page;
no access to English)
http://www.murnau-stiftung.de/en/00-00-00-
willkommen.html (English version)

C.L.R. James collection... 456
West Indiana and Special Collections Division, Main
Library, University of the West Indies, St Augustine,
Trinidad, Trinidad and Tobago
http://sta.uwi.edu

**Documentary heritage on the resistance and
struggle for human rights in the Dominican
Republic, 1930–1961** ...457
Memorial Museum of Dominican Resistance,
210 Calle Arzobispo Nouel, Ciudad Colonial, Santo
Domingo, Dominican Republic
http://www.museodelaresistencia.org
Sir William Arthur Lewis papers 458
Saint Lucia National Archives, Vigie, Clark Avenue, Castries,
P.O. Box 3060, Saint Lucia

Seeley G. Mudd Manuscript Library, Princeton University,
Princeton, NJ 08544, USA
http://www.princeton.edu/mud

Thor Heyerdahl archives... 461
The Kon-Tiki Museum, Oslo, Norway
http://www.kon-tiki.no

Ingmar Bergman archives 464
Ingmar Bergman Foundation, Swedish Film Institute
Box 27126, SE-102 52 Stockholm
http://www.ingmarbergmanfoundation.com/

**The Wizard of Oz (Victor Fleming, 1939),
produced by Metro-Goldwyn-Mayer**...................466
George Eastman House, Rochester, USA
http://www.eastmanhouse.org

**Warsaw Ghetto archives
(Emanuel Ringelblum archives)**470
Zydowski Instytut Historyczny Instytut Naukowo-
Badawczy (Jewish Historical Research Institute)
Warsaw, Poland
http://www.jewishinstitute.org.pl (Polish landing page with
English option)
http://www.jewishinstitute.org.pl/en (English)

Astrid Lindgren archives...474
The Royal Library, Stockholm, Sweden
http://www.kb.se
http://www.kb.se/english/ (alternative in English)

The Appeal of 18 June 1940...................................... 476
Record:
Institut National de l'Audiovisuel
(National Audiovisual Institute)
Bry-sur-Marne, France
http://www.ina.fr (English option off landing page)

BBC
London, UK
http://www.bbc.co.uk

Manuscript of 18 June Appeal:
Admiral Philippe de Gaulle, Paris, France

Manuscript of poster and printed poster:
Musée de l'Ordre de la Libération (Museum of the Order
of the Liberation), Paris, France
http://www.ordredelaliberation.fr (English option off
landing page)

Diaries of Anne Frank.. 478
Anne Frank House, Amsterdam, Netherlands
http://www.annefrank.org

Archive of Warsaw Reconstruction Office.......... 482
State Archives of the Capital City of Warsaw,
Warsaw, Poland
http://www.warszawa.ap.gov.pl
http://www.warszawa.ap.gov.pl/angielski/zasob.html

**Archives of the Literary Institute
in Paris (1946–2000)** .. 486
91 Avenue de Poissy, Maisons-Laffitte, France

Federal Archives fonds ... 488
The Federal Archives Centre, The University
of the West Indies, Cave Hill Campus
Barbados, West Indies
http://www.wifac.org/

Audiovisual documents of the international antinuclear movement 'Nevada-Semipalatinsk'..........................490
Abai av., 39. Almaty, Kazakhstan, 480091

UNRWA photo and film archives of Palestinian refugees...........................492
UNWRA Headquarters Gaza, Gamal Abdul Nasser Street, Gaza City, Postal address: PO Box 371 Gaza City
http://www.unrwa.org

Los Olvidados494
Los olvidados, Mexico City, Mexico
http://www.nbuv.gov.ua

Nita Barrow collection...........................496
The Nita Barrow collection, Main Library, The University of the West Indies, Cave Hill, P.O. Box 1334, Barbados BB11000
http://www.cavehill.uwi.edu/mainlibrary/home

The Archives of Terror...........................498
Centre of Documentation and Archives for the Defence of Human Rights (CDyA), Palace of Justice
Testanova y Mariano Roque Alonso, Asunción-Paraguay
http://www.pj.gov.py/cdya

John Marshall Ju/'hoan bushman film and video collection, 1950–2000...........................500
Human Studies Film Archives, Smithsonian Institution Museum Support Center, 4210 Silver Hill Road, Suitland, Maryland 20746, USA
http://www.nmnh.si.edu/naa

Traditional music sound archives...........................502
Music Research Institute of Chinese Academy of Arts Beijing, China
http://www.accu.or.jp/ich/en/links/O_CHN3-more.html (unesco site listed as the official website for the organization)

Neighbours, animated, directed and produced by Norman McLaren in 1952...............504
National Film Board of Canada
Montreal, Quebec (or Montréal, Québec)
http://www.nfb.ca
http://www.nfb.ca/film/neighbours_voisins (goes direct to the film's own page)

José Maceda collection...........................505
University of the Philippines Center for Ethnomusicology
Quezon City, Philippines
http://www.upethnom.com

Derek Walcott collection...........................508
The West Indiana and Special Collections Division, Main Library, The University of the West Indies, St Augustine, Trinidad, Trinidad and Tobago
http://www.mainlib.uwi.tt

The Family of Man...........................510
Musée The Family of Man, Château de Clervaux, L-971201 Clervaux, Luxembourg
Postal address: Melle Anke Reitz, BP 31, L-9701 Clervaux, Luxembourg
http://www.family-of-man.public.lu

Christopher Okigbo collection...........................512
Christopher Okigbo Foundation
83 Chaussée de Boondael, 1050 Bruxelles, Belgique

Christopher Okigbo Foundation
6 Highland Avenue, Montaclair, NJ 07042, USA
http://www.christopher-okigbo.org/

Eric Williams collection...........................514
The West Indiana and Special Collections Division, Main Library, The University of the West Indies, St Augustine, Trinidad, Trinidad and Tobago
http://www.mainlib.uwi.tt

The National Archives of Trinidad and Tobago, 105 St Vincent Street, PO Box 763, Port of Spain, Trinidad, Trinidad and Tobago
http://natt.gov.tt/

The Mabo case manuscripts516
National Library of Australia
Canberra ACT 260
http://www.nla.gov.au/selected-library-collections/
mabo-collection

**Original negative of the Noticiero
ICAIC Latinoamericano** ...519
Instituto Cubano de Arte e Industria
Cinematográficos (ICAIC)
Calle 23 No.1155 e/10 y 12 Vedado, C.P. 10400
Plaza de la Revolución, Ciudad de La Habana, Cuba

Cinemateca de Cuba
http://www.cubacine.cult.cu/

**Construction and fall of the Berlin Wall
and the Two-Plus-Four-Treaty of 1990** 520
Deutsches Rundfunkarchiv, Marlene-Dietrich-Allee 20,
D-14482 Potsdam-Babelsberg, Germany
http://www.dra.de

Rundfunk Berlin-Brandenburg, International Relations
Department, Fernsehzentrum, Masurenallee 8-14, D-14057
Berlin, Germany
http://www.rbb-online.de

Landesarchiv Berlin, Eichborndamm 115-121, D-13403
Berlin, Germany
http://www.landesarchiv-berlin.de

Staatsarchiv der Freien und Hansestadt Hamburg,
Kattunbleiche 19, D-22041 Hamburg, Germany
http://www.hamburg.de/staatsarchiv
Spiegel TV, Brandstwiete 19, D-20457 Hamburg, Germany
http://www.spiegel.de

Polizeihistorische Sammlung des Polizeipräsidenten in
Berlin, Platz der Luftbrücke 6, D-12101 Berlin, Germany

Stiftung Archiv der Parteien und Massenorganisationen
der DDR im Bundesarchiv, Finckensteinallee 63, D-12205
Berlin, Germany
http://www.bundesarchiv.de

Sanssouci Film GmbH, Hohe Kiefer 159, D-14532
Kleinmachnow, Germany
http://www.sanssouci-film.de

Auswärtiges Amt, Politisches Archiv, D-11013
Berlin, Germany
http://www.auswaertiges-amt.de

**Criminal Court Case No. 253/1963
(The State versus N. Mandela and Others)**.........525
The National Archives and Records Service of South Africa
24 Hamilton Street, Arcadia, Pretoria 2000, South Africa
Postal address: Private Bag X236, Pretoria 0001
South Africa
http://www.national.archives.gov.za

**Network of information and counter
information on the military regime in
Brazil (1964–1985)**..527
Arquivo Nacional
Praça da República, 173 – Rio de Janeiro,
RJ – 20211-350, Brasil
http://www.arquivonacional.gov.br

**First Byurakan Survey
(FBS or Markarian survey)**.......................................528
Byurakan Astrophysical Observatory (BAO), Byurakan
378433, Aragatzotn Province, Armenia,
http://www.bao.am
DFBS: http://www.aras.am/Dfbs/dfbs.html

Aral Sea archival fonds .. 530
The Central State Archive of Kazakhstan, 39 Abay Avenue,
Almaty, 050000, Republic of Kazakhstan
http://www.cga.kz

**Landsat Program records: Multispectral
Scanner (MSS) sensors**..532
US Geological Survey, Mail Stop 517,
12201 Sunrise Valley Drive, Reston, Virginia, USA 20192
http://earthexplorer.usgs.gov

Human Rights Archive of Chile538
Archivo National
Miraflores 50, Santiago, Chile
http://www.dibam.cl/archivo_nacional

Tuol Sleng Genocide Museum archives............. 540
Tuol Sleng Genocide Museum, Phnom Penh, Cambodia
http://www.tuolslengmuseum.com

**Human rights documentary
heritage, 1976–1983** ..543
Archivo Nacional de la Memoria, Av. del Libertador 8151,
Ciudad Autónoma de Buenos Aires, Argentina
http://www.derhuman.jus.gov.ar/anm/

**Liberation Struggle Living
Archive Collection**... 544
Doxa Productions, PO Box 26476, Hout Bay 7872,
South Africa
http://www.doxa.co.za
under construction: http://www.visualhistoryarchive.org/

Human rights documentary heritage, 1980....... 546
The May 18 Memorial Foundation, 502-859 Republic
of Korea, Gwangju Seogu Naebangro 152
http://518.org/
http://eng.518.org

**Twenty-One demands,
Gdańsk, August 1980** ... 549
The Polish Maritime Museum, Gdańsk, Poland
http://www.cmm.pl

The Karta Centre in Warsaw, Warsaw, Poland
http://www.karta.org.pl

National Literacy Crusade ..552
Universidad Centroamericana (UCA), Rotonda Rubén
Darío 150 mts. al oeste. Apartado Postal 69,
Managua, Nicaragua
http://www.uca.edu.ni/

**Radio broadcast of the Philippine
People Power Revolution** ..554
Philippine Information Agency, PIA Building, Visayas
Avenue, Diliman, Quezon City, Philippines
http://www.pia.gov.ph

**The Baltic Way – Human chain linking
three states in their drive for freedom**556
The National Archives of Estonia
Tartu, Estonia
http://rahvusarhiiv.ra.ee/et (Estonian w/ English option)
http://rahvusarhiiv.ra.ee/en/national-archives (English)

Estonian Film Archives, Tallinn, Estonia
http://www.filmi.arhiiv.ee
http://www.filmi.arhiiv.ee/index.php?lang=eng (English)

Museum of the Popular Front of Latvia, Riga, Latvia
no website
Lithuanian Central State Archive
Vilnius, Lithuania
http://www.archyvai.lt/lt/lvat.html
http://www.archyvai.lt/en/archives/centralarchives.html
(English)

Note: No web address is given when the institution listed
has no dedicated web address.

Acknowledgements

With thanks to:
The United Nations Educational, Scientific and Cultural Organization (UNESCO) for their assistance in producing this publication, Joie Springer at UNESCO and the various organizations and institutions who gave permission for their images to be included. Text edited by Collins Geo. Based on official information made available by UNESCO.

Photo credits

While every effort has been made to trace the owners of copyright material reproduced herein and secure permissions, the publishers would like to apologize for any omissions and will be pleased to incorporate missing acknowledgements in any future edition of this book.

Alamy (www.alamy.com):

24 © peace portal photo; 24-25 © Images & Stories; 26-27 © Dinodia Photos; 28 © Photos 12; 29 © The Art Archive; 31 © Paul Doyle; 32-33 © The Art Archive; 34 © imagebroker; 36-37 © Thomas Boehm; 37 © dk; 39 © Richard Wareham Fotografie; 40-41 © Topsy4; 43 © EmmePi Travel; 44 © CuboImages srl; 46 © INTERFOTO; 47 © INTERFOTO; 50-51 © Oleksii Sergieiev; 52 © Christian Ostrosky; 77 © The Print Collector; 78 © ITAR-TASS Photo Agency; 79 © Ivan Vdovin; 85 © imagebroker; 96 © Steve Gill; 97 © Pictorial Press Ltd; 98 © LOOK Die Bildagentur der Fotografen GmbH; 99 © Picture Press; 102 © The Art Archive; 103 © The Art Gallery Collection; 108-109 © AA World Travel Library; 110 © Idealink Photography; 111 © The Art Archive; 113 © Ivy Close Images; 114-115 © The Art Archive; 119 © The Art Archive; 121 © Georgios Kollidas; 132 © The Art Archive/Alamy; 135 © Stock Connection Blue; 138-139 © Mary Evans Picture Library; 140 © MelannpixRF; 151 © The Art Archive; 157 © The Art Archive; 160-161 © imagebroker; 162-163 © Antiquarian Images; 169 © The Art Archive; 170-171 © The Protected Art Archive; 172-173 © The Art Archive; 175 © The Art Archive; 177 © Ian Shaw; 180 © INTERFOTO; 182 © PRISMA ARCHIVO; 185 © PRISMA ARCHIVO; 186-187 © ITAR-TASS Photo Agency; 191 © Eye Ubiquitous; 192-193 © Robert Harding Picture Library Ltd; 196 © Classic Image; 199 © dbimages; 202 © Larry Lilac; 202-203 © Joeri DE ROCKER; 204 © INTERFOTO; 205 © Lebrecht Music and Arts Photo Library; 207 © Prisma Bildagentur AG; 209 © AA World Travel Library; 210 © jeff gynane; 210-211 © Ailsa Kilpatrick; 219 © The Art Archive; 220-221 © World History Archive; 222-223 © Topsy4; 224-225 © Jeff Greenberg; 226 © Ed Lefkowicz; 228-229 © Andria Patino; 233 © vario images GmbH & Co.KG; 235 © The Art Archive; 237 © Stuart Forster; 238 © Mary Evans Picture Library; 241 © Sonia Halliday Photographs; 242-243 © Prisma Bildagentur AG; 243 © Corbis Premium RF; 244-245 © Robert Harding Picture Library Ltd; 247 © North Wind Picture Archives; 248-249 © Hornbil Images; 250-251 © Pictorial Press Ltd; 252 © Cindy Hopkins; 255 © Picade LLC; 256-257 © The Art Archive; 259 © Mary Evans Picture Library; 260-263 © Niday Picture Library; 261 © INTERFOTO; 265 © ITAR-TASS Photo Agency; 267 © J Marshall - Tribaleye Images; 268 © Photos 12; 270-271 © Iconotec; 275 © Bert Hoferichter; 277 © Pictorial Press Ltd; 278 © The Art Gallery Collection; 284 © Chris Howes/Wild Places; 289 © Andalucia Plus Image bank; 291 © Vito Arcomano; 298-299 © Mary Evans Picture Library; 300-301 © J Marshall - Tribaleye Images; 307 © INTERFOTO; 308 © Jon Arnold Images Ltd; 308-309 © BL Images Ltd; 310 © The Art Archive; 311 © Lebrecht Music and Arts Photo Library; 312 © Elvele Images Ltd; 314-315 © Ian Dagnall; 316 © GL Archive; 320 © Classic Image; 321 © PRISMA ARCHIVO; 322 © Mary Evans Picture Library; 323 © Ivan Vdovin; 324-325 © North Wind Picture Archives; 329 © Author's Image Ltd; 330 © Ros Drinkwater; 335 © The Print Collector; 340-341 © The Art Archive; 342 © GL Archive; 343 © Hilary Morgan; 346-347 © Anchalee; 351 © Ball Miwako; 353 © Pictorial Press Ltd; 354 © Trinity Mirror/Mirrorpix; 355 © Photoshot Holdings Ltd; 358-359 © Adrian Buck; 361 © Lordprice Collection; 363 © INTERFOTO; 366-367 © MARKA; 368 © Images & Stories; 369 © Tosporn Preede/ Alamy; 370 © The Art Archive; 371 © The Art Archive; 372-373 © Dinodia Photos; 378 © The Print Collector; 381 © INTERFOTO; 389 © Thomas Cockrem; 390 © INTERFOTO; 392-393 © The Print Collector; 395 © Eye-Stock; 396 © Art Directors & TRIP; 397 © John Henshall; 398-399 © Photos 12; 400-401 © Idealink Photography; 402-403 © Ariadne Van Zandbergen; 405 © Paul Kingsley; 406 © Lynden Pioneer Museum; 407 © Ilene MacDonald; 413 © World History Archive; 414 © World History Archive; 428 © Lordprice Collection; 429 © MARKA; 430-431 © PhotoStock-Israel; 432 © JORDI CAMÍ; 432-433 © Wiskerke; 435 © Archive Pics; 436-437 © The Protected Art Archive; 438-439 © The Art Archive; 440-441 © John Henshall; 444-445 © Jon Arnold Images Ltd; 447 © Keystone Pictures USA; 450-451 © Stuart Forster; 459 © M. Timothy O'Keefe; 461 © Neil Julian; 462-463 © imagebroker; 464 © AF archive; 465 © Pictorial Press Ltd; 466-467 © Moviestore collection Ltd; 468 © Pictorial Press Ltd; 470 © Thibaut PETIT-BARA; 471 © Photos 12; 472 © World History Archive; 473 © Photos 12; 474 © INTERFOTO; 475 © dieKleinert; 477 © INTERFOTO; 479 © Pictorial Press Ltd; 486 © peter jordan; 487 © CTK; 490-491 © Stocktrek Images, Inc.; 498-499 © Gianni Muratore; 502-503 © Danita Delimont; 509 © Stacy Walsh Rosenstock; 505 © James Freeman; 506 © dbimages; 515 © GlowImages/Alamy; 518 © Salas Archive Photos; 520 © imagebroker; 521 © Keystone Pictures USA; 522 © fStop; 523 © INTERFOTO; 524 © Alexander Caminada; 529 © RIA Novosti; 531 © Thomas Lehne/ lotuseaters; 538-539 © Network Photographers; 542 © Jon Crwys-Williams; 544-545 © Images of Africa Photobank; 546-547 © Nathan Benn; 553 © Mike Goldwater; 555 © David Hodges; 556-557 © Tiit Veermae

UNESCO

26 © Bhandarkar Oriental Research Institute x3; 30 © UNESCO; 35 © The National Library of China; 42 © Lars Munkhammar; 48-49 © UNESCO; 50 © Astan Qods Razavi Central Library, Museums and Archives Centres; 52 © Archivio Storico Diocesano di Lucca; 53 © Archivio Storico Diocesano di Lucca; 59 © Asiatic Society, Kolkata x5; 54-58 © Copyright 2010, The Board of Trinity College Dublin x5; 62-64 © National Centre of Manuscripts x6; 66-67 © Bayerische Staatsbibliothek (Bavarian State Library) x9;

ADDITIONAL IMAGE SOURCES